The Fair Women

Cartoons running throughout the book are from *Samantha at the World's Fair* (1893) by Marietta Holly, who wrote under the pseudonym "Josiah Allen's Wife". The artist is Baron C. DeGrimm.

The Fair Women

Jeanne Madeline Weimann

Introduction by Anita Miller

Academy
Chicago

Academy Chicago 1981

© 1981 by Jeanne Madeline Weimann
Introduction © 1981 by Anita Miller

Academy Chicago
360 N. Michigan Avenue
Chicago, IL 60601

Library of Congress Cataloging in Publication Data

Weimann, Jeanne Madeline, 1943-
 The fair women.

 Bibliography: p.
 Includes index.
 1. Feminism--United States--History--19th century.
2. Chicago. World's Columbian Exposition, 1893.
I. Title.
HQ1419.W44 305.4'0973 80-23193
ISBN 0-915864-67-3 AACR1
ISBN 0-89733-025-0 (pbk.)

CONTENTS

To My Mother, Who Never Stops Giving

AUTHOR'S ACKNOWLEDGEMENTS

A book of this kind cannot, obviously, be written without the active help of many people. The official papers of the Board of Lady Managers were given by Bertha Palmer's heirs to the Chicago Historical Society, and I have done most of my work there. Archie Motley, the Curator of Manuscripts, gave me help and encouragement. His kindness meant more to me than he can know. In Chicago I worked also at the Art Institute, the Public Library and the Newberry Library. Space requirements prevent me from giving sufficient thanks to individuals at those institutions as well as at Radcliffe's Schlesinger Library, the Sophia Smith Archives at Smith College, at the Yale library, at the Library of Congress, the Frick library, and the public libraries of Boston, Bridgeport and New Haven. Individuals who donated materials were M. Alves, S. E. Anderson II, K. Clark, J. Doolin, V. Marshall, M. P. Smith, M. Stacuzzi and T. and L. Diddle.

I want to thank the Manuscripts Dept of the Southern Historical Collection at Wilson Library, the University of North Carolina at Chapel Hill for giving me access to Sallie Cotten's diaries, and Lyman R. Cotten for granting me permission to reprint from them.

I must thank my editor, Anita Miller, who contributed time and effort far above the call of normal duty, including background chapters on Chicago, Jordan Miller, who organized the layout of the book and did much of it physically himself, and Bruce Miller, who took many photographs from old books. I must give special thanks to my family, and to David who would, if he could, give me a week at the Woman's Building itself.

Jeanne Weimann
Milford, Connecticut
March 1, 1981

INTRODUCTION

The World's Columbian Exposition was an astonishing sight. Photographs of it astonish us today, and it was undoubtedly more astonishing on more levels to visitors in 1893. Henry Adams said, "The first astonishment became greater every day." The architectural unity of the Fair, the careful planning of the White City, was a remarkable achievement at a time when cities were eclectic and straggling. The style of architecture chosen by the Fair architects was not of course connected in any way to the prairie city in which it was placed. Adams commented that "classical standards were imposed on plastic Chicago"; these standards "leaped directly from Corinth and Syracuse and Venice . . . over the heads of London and New York." There was nothing behind these imposing buildings, to the "Western people" they were "a stage decoration; a diamond shirt-stud; a paper collar." They were all show. But it was impossible to shake off the impressiveness of the Fair. "All trader's taste smelt of bric-a-brac," Adams said, with his predictable snobbery, "Chicago at least tried to give her taste a look of unity." And later in his essay he said, "Chicago was the first expression of American thought as a unity; one must start there."

Adam's reaction to the architecture of the Fair was the reaction of most sophisticated architectural critics over the next eighty years or so. Lewis Mumford commented that the Beaux Arts style had poisoned American architecture after the Fair: Roman temples were built everywhere, without thought to the demands of modern life. At the Fair, he said, the great gleaming exhibit halls did not attract enough business; consequently "hucksters, tricksters and freaks" were invited onto the Midway to boost attendance.

Now, nearly one hundred years later, the architecture of American cities threatens to approach a unity of glass, steel and concrete which is deadening to the spirit. It is not surprising that in 1978 Ada Louise Huxtable took a new look at the Columbian Exposition:

> After years of being downgraded as a vacuous exercise in empty styles this assemblage of monumental palaces, this Olympian stage set of colonnaded arcades, peristyles, porticoes and pavilions with a trumpeting of allegorical statuary, is an incredibly impressive achievement.

She quotes Thomas Tallmadge in his *Story of American Architecture,* published in 1936: "Imperial Rome in the third century," he wrote, "might have approached but did not surpass" the White City. Miss Huxtable concludes, "By a curious turn of the Ferris wheel of fate, the Chicago fair is in fashion again."

Despite Adams' conclusion that Chicago saw "the first expression of American thought as a unity," he complained that the Exposition "defied philosophy . . . since Noah's ark, no such Babel of loose and ill-joined, such vague and ill-defined and unrelated thoughts and half-thoughts and experimental outcries as the Exposition, had ever ruffled the surface of the Lakes." The exhibits raised far more questions than they answered. The historian was stunned by the scientific, industrial displays. Men, he said, "who had never put their hands on a lever—had never touched an electric battery—never talked through a telephone, and had not . . . a notion what amount of force was meant by a *watt* or an *ampere* or an *erg,* or any other term of measurement introduced within a hundred years" were shaken into wondering about the significance of everything they saw.

Adams does not mention the Woman's Building. He understood, of course, the significance of the exhibits there. Women were, as usual, asking for equal rights. In that sense the Woman's Building exhibits were not "vague" and "ill-defined". Unlike the rest of the Fair, however, they looked to the past. The Woman's Building celebrated the craftswoman, the individual artist. The educational displays in both the Woman's and the Children's Buildings looked to the future, but the displays of lace and embroidery were exercises in nostalgia. The emphasis on private philanthropy was also backward-looking. The questions raised by the existence of the Building were as real, however, and as pertinent today, as the questions raised for Adams by the tremendous machines which he examined, with uneasiness, in the Manufactures Building. Mrs Palmer's words have not lost their significance after more than fifty years of woman suffrage:

> . . . the women of today . . . having had a taste of independence, will never willingly relinquish it. They have no desire to be helpless and dependent. Having the full use of their faculties they rejoice in exercising them . . . the trend of modern thought . . . is in the direction of establishing proper respect for human individuality and the right of self-development . . . Ignorance is too expensive and wasteful to be tolerated. We cannot afford to lose the reserve power of any individual.

The question naturally arises: what effect did the Woman's Building have on society? This is a difficult question. Its existence does not appear to have brought the vote for women any closer; the first World War appears to have accomplished that, with a

good deal of groundwork, of course. Undoubtedly the displays in the Building and in the Children's Building did help to gain acceptance for new techniques in education: kindergarten classes, home economics, school workshops, lipreading for the deaf, scientific childcare and that sort of thing. These were not minor matters. As always, woman's interests were philanthropic; what she achieved for herself is a question. Some individual women said that their careers were helped by their exposure in the Woman's Building. But Sophia Hayden, the architect, and Alice Rideout, the sculptor, both sank into oblivion after the Fair. Bertha Palmer herself, who of all people deserved most credit for the Building, never repeated that triumph, and credit for her achievement, when it is mentioned at all, is almost invariably given to Susan B. Anthony, who was a charming visitor, but served the Board in no capacity.

Some modern feminists tend to denigrate many of the philanthropies, as maternalistic and condescending, and to object to the volunteerism of the women's clubs, which channeled off so much feminine energy.

In any case, this book is an attempt to recreate the Woman's Building, and to demonstrate the accomplishments of women in the late nineteenth century. The reader can decide for herself and for himself what value can be placed on those accomplishments. It is important to connect the present with the past; it is important to remember.

One comment on the style of this book. The manuscript submitted to us by Jeanne Weimann referred to women by their last names only, without "Miss" or "Mrs." This is now preferred style. I have however chosen to use the archaic titles. Apart from the fact that "Palmer" could refer to Thomas Palmer or Potter Palmer as well as Bertha Palmer, I felt that the women themselves would object to being deprived of title. Lucy Stone had, after all, called herself "*Mrs* Stone" even though her husband's name was Blackwell, a name she never took. To balance matters somewhat, and to preserve the Victorian atmosphere which abounds here, we have given the men titles as well, although we recognize that their titles give no hint of marital status. Only in moments of desperation are women called by their first names: after pages of "Miss Couzins" we found an occasional "Phoebe" and decided to leave it. In any case this matter of titles was an editorial decision with which the author did not agree. I take full responsibility for it.

Anita Miller
Chicago, Illinois
March, 1981

PRELUDE

HE Philadelphia Centennial of 1876 was the first American Fair of real international importance in the years following the Great Exhibition in London in 1851. The Chicago Columbian Exposition of 1893 would be the next American Fair. From 1857 to 1876 the United States had participated in European expositions without any wholehearted national commitment to them. The Centennial, however, marked a national milestone: it brought thousands of European visitors, and changed American attitudes toward expositions in general. These fairs were intended to demonstrate to the world the state of "civilization", as it was reflected in the fine arts and in industrial technology. The United States was growing proud of its accomplishments in both areas. After 1876 and until the era of great international fairs ended after the second World War, America produced more and bigger expositions, at greater expense, than any other nation.

The Centennial not only awakened Americans to their position in the world: on its grounds in Philadelphia's Fairmount Park was the first exposition building entirely planned, funded and managed by women, and devoted to women's interests and accomplishments. It was called the Woman's Pavilion. Without it the Chicago Woman's Building of 1893 might never have existed. Lessons had been learned at Philadelphia which were put to good use by women in Chicago.

The Philadelphia exposition had originally been planned without women: only men were on the Centennial Board which was put together, among other things, to raise money for the fair. But by February of 1873, after a year of work, it had become obvious to the Board members that they were still far short of their goals. They needed the active co-operation of women. Because of this they decided to institute a Women's Centennial Committee, to which they appointed thirteen women: one for each of the original states. Elizabeth Duane Gillespie was invited to head this Committee. She was a great granddaughter of Benjamin Franklin, and had proved her administrative abilities during the Philadelphia Sanitary Fair of 1874. Mrs Gillespie accepted the appointment, on one condition: in return for their time and energy, she and her co-workers wanted a display of women's work in the Main Exhibition Hall.

Elizabeth Duane Gillespie

In May of 1873, at the annual meeting in Philadelphia of the Centennial Commission, the directors endorsed the women's plans, and promised "ample space" in the Main Building. Mrs Gillespie began her work with high hopes. By the end of 1874 there were Centennial Committees in nearly every state. Women everywhere raised money by selling stock subscriptions for the Exhibition, holding Centennial Tea Parties, selling Martha Washington medals and other souvenirs. And while women everywhere were creating a lively interest in the Fair, they were planning their own women's exhibit.

As a result of this national effort, Elizabeth Gillespie was able to give $93,330.87 to the Fair's Board of Finance. A good part of this sum had been earned by June 11, 1875; on that day the "cup of hope was dashed from our lips." Mrs Gillespie received two letters together: one from the Director General explaining that there was no space, after all, for the women's exhibit, and suggesting that for about $30,000 they could build a very creditable building of their own; the second from the Chairman of Grounds, Plans and Buildings expressing sorrow that there was no money in the coffers to contribute towards the women's building.

Elizabeth Gillespie never forgot "the utter misery of those first moments, for the women of the whole country were working not only from patriotic motives, but with the hope that through this Exhibition their own abilities would be recognized and their works carried beyond needle and thread." Mrs Gillespie's courage rose "like the thermometer on a warm day"; anger revitalized the fundraisers. Exhibit materials, volunteers and money flowed to Philadelphia. The Woman's Pavilion was

entrusted to the architect of the Main Exhibition Hall; construction began in October 1875. "We never thought of employing a woman architect!" Mrs Gillespie recalled, "and thus made our first *great* mistake."

On May 10, 1875, the Woman's Pavilion opened its doors. It was a wooden building, ninety feet high at mid-point, from the ground to the top of its cupola. Wings extended outwards on four sides, surmounted by arched roofs. There were many windows framed in elaborate gingerbread, and the whole structure was painted a pale blue-grey. It enclosed 40,000 square feet and housed 600 exhibits, a library, art gallery, kindergarten annex, and the offices of the *New Century for Women*—the only regularly published newspaper at the Centennial. The *New Century* rolled weekly from presses powered by a Baxter steam engine: a young Canadian named Emma Allison was the engineer. Visitors often asked her if she were not afraid of blowing the Pavilion to bits. Emma Allison replied that it was cleaner, safer, and much easier than firing up a wood cook stove every day. "Teaching school is much harder," she added, "and one is not paid so well."

Among the exhibits was a statue of Iolanthe carved in butter. The artist was known as the "Butter Woman". Harriet Hosmer, a well-known feminist sculptor working in Rome, sent a "beautiful animal covered with gold-leaf," with extra gold to repair shipping damages. Elizabeth Gillespie, hammering the gold patches over a worn spot one morning, heard a little boy call out "Mother, come; here is another Butter Woman!" The unfortunate Iolanthe became the butt of many jokes and some bitterness; many more important exhibits and works of art were forgotten.

The same day the Pavilion opened, May 10, Matilda Gage, president of the National Woman Suffrage Association, told a meeting of that organization in New York City: "Let us take as our credo for the centennial year the words of Abigail Adams. 'We are determined to foment a rebellion, and will not hold ourselves bound by laws in which we have had no voice or representation.'" Susan B. Anthony, Matilda Gage, and several other women decided they would go to Philadelphia "not to rejoice but to declare our freedom." Suffragists around the country supported the plan of writing a "Declaration of Rights for Women" to be presented on July 4. "Days and nights were spent on that document. After many twists from our analytical tweezers . . . it was at last, by a consensus of the competent, pronounced to be very good," Elizabeth Cady Stanton wrote. Thousands were ordered to be printed. Susan Anthony asked the Chairman of the Centennial Committee for a place in the July 4 program in Independence Hall, and for fifty tickets, so that at least one woman from each of the states could attend. The Chairman refused to allow a reading of the Declaration, or even a mention in the program; he later sent half-a-dozen tickets.

*Iolanthe Dreaming
A Model in Butter by
Caroline S. Brooks*

In the light of the Centennial Commission's action, the Woman's Pavilion—a hard won victory—seemed to many feminists almost an insult. Elizabeth Stanton said that it was all very well to exhibit a woman engineer, but that "the Woman's Pavilion on the centennial grounds is an afterthought, as theologians claim woman herself to have been." The little building "was no true exhibit of woman's art" and did not reflect much of woman's true situation. If it were to have been "grandly historic," Mrs Stanton said, its walls should have been decorated with "the yearly protest of Harriet K. Hunt against taxation without representation . . . framed copies of all the laws bearing unjustly upon women—those which rob her of her name, her earnings, her property, her children, her person . . ."

On July 4, 1876, Susan Anthony and five associates, using the tickets they had been given, entered Independence Hall with several copies of the Declaration of Rights for Women. One of these women was Phoebe Couzins, who would play a dramatic role in the intrigues behind the Woman's Building at the World's Columbian Exposition. The women presented their Declaration to the master of ceremonies and to other gentlemen present. This time, before a startled but friendly crowd, the men did not refuse to accept it. Then the women quietly withdrew to Independence Square and stepped upon the platform which had been built for musicians, which was empty just then. There Miss Anthony read the Declaration to a receptive crowd. "While the nation is buoyant with patriotism, and all hearts are attuned to praise, it is with sorrow we come to strike the one discordant note," she began, and went on to explain that women in 1876 had "greater cause for discontent, rebellion, and revolution than had the men of 1776."

The Woman's Pavilion, created through the efforts of women all over the country—not all of whom were feminists, of course—had, in the final analysis, no great symbolic significance. Its birth pangs had been made too agonising. Elizabeth Gillespie could not forget the manner in which the Centennial Committee had dismissed her and her workers: "Get up a side show for yourselves, pay for it yourselves, and be—happy."

In the summer of 1889, while the famous Paris Exposition was still in progress, the newspapers were filled with talk of the Columbian Exposition, which was to be held in 1892, to celebrate the four hundredth anniversary of Columbus' discovery of the New World. Important businessmen and politicians hoped to make it the biggest fair of the century, to out-shine even Paris and its magnificent Eiffel Tower. Privately these influential citizens had already agreed that "those suffrage women should have nothing to do with the World's Fair." These men were probably thinking vaguely of women like Elizabeth Cady Stanton, Julia Ward Howe and Susan B. Anthony, who had founded

the National Women's Suffrage Association. They were thinking of determined women from the eastern seaboard who had moved naturally from the struggle for abolition to the struggle for woman suffrage. The backgrounds of these women were Puritanical and rather Spartan; they were devoted to the public good.

What the men did not see was that change was taking place all around them. As the country grew in industrial power, a new class of millionaires arose: self-made men with social and cultural aspirations. Their wives were strong personalities as well—at least some of them were. Women who became leaders of society because of their money, their family connections, their intelligence, their energy and their appeal to the press could not

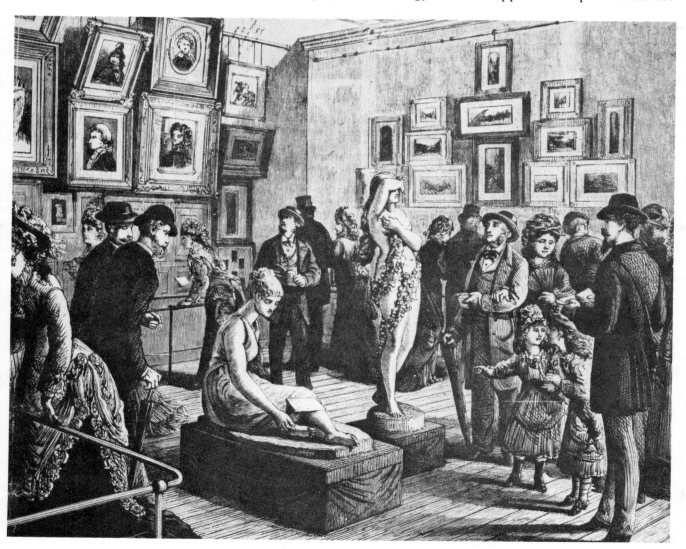

Art in the Woman's Pavilion, Philadelphia 1876. Two sculptures by Blanche Nevins

be shrugged off as "suffrage women." It was these "New Women" who were to demand representation at Chicago's fair. The demand for recognition of women's problems and achievements was already being voiced in the ornate parlors and Moorish corners of bourgeois castles. The voices were soft; it was a tactful, well-mannered demand. It came from within the power structure of Chicago, the "Paradise of Parvenus," the "most American of cities."

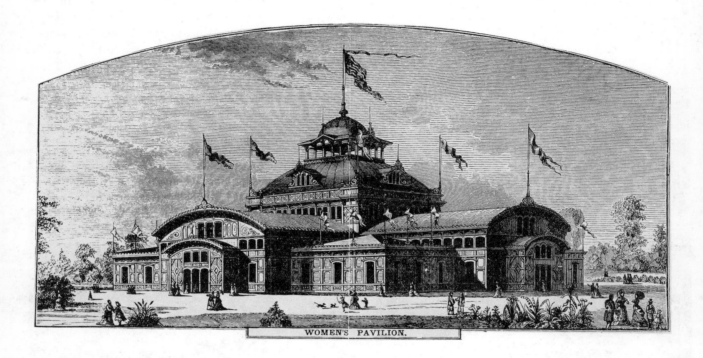

WOMEN'S PAVILION.

"CHICAGO is one of the most miserable and ugly cities which I have yet seen in America, and is very little deserving of its name, 'Queen of the Lake': for, sitting there on the shore of the lake in wretched dishabille, she resembles rather a huckstress than a queen." This was the impression of Frederika Bremer, a Swedish writer who visited the city in 1850, when Chicago was barely twenty years old. At that time wooden sidewalks covered the mud and dust of the streets, flimsy buildings had been thrown together to accommodate the swelling population; as many as two hundred wagons of grain a day rumbled into the city's markets over plank roads extending as far as eighteen miles to the west. Just before the advent of the railroad it was a rough and busy, growing city: there were more saloons than churches, more than two dozen newspapers clamoring for the attention of twenty thousand people. The city's energy was legend. Frederika Bremer found Chicagoans to be "the most agreeable and delightful people that I have ever met with anywhere . . . people who are not horribly pleased with themselves and their world, and their city, and their country as is so often the case in small towns . . ." But Chicago in 1850 was not a small town; it was the natural commercial center of a vast territory, with a fine harbor. It was a metropolis.

In 1852 the Michigan Southern and Northern Indiana Railroad reached Chicago. This was the first direct rail communication with the East: the effects upon the city were immediate. It became the undisputed grain market of America, and its population doubled to over forty thousand in the next two years. Among the many enterprising men who came with the railroad was Potter Palmer, a young Quaker from New York State. He arrived in 1852 and with his small capital bought a dry goods store on Lake Street, at the north edge of what is now the Loop. The store, called "P. Palmer & Co.," showed a profit in the first year, the result of imaginative merchandising and long hours of hard work. Palmer began soon to stock expensive and varied items imported from the East for the expanding carriage trade. He established a novel system of credit and liberal exchange privileges.

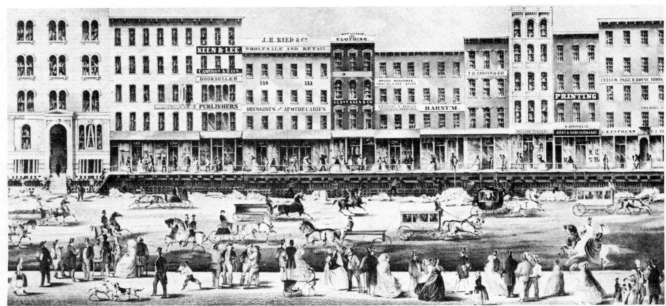

Lake St. Chicago. 1860.

Shopping at P. Palmer's became part of afternoon outings for fashionable women in a city where money was flowing freely. Palmer invested his profits in real estate.

At that time land was selling for fifty dollars an acre; building lots on Michigan Avenue could be bought for one hundred dollars. Business was booming in the fifties: Cyrus McCormick had built a factory for the production of his famous reaper, George Pullman was converting railway cars into sleeping coaches. Thousands of immigrants—Germans and Swedes at first, later Irish and Eastern Europeans—poured into the city to work in these factories and in the stockyards. Samuel Carson and John T. Pirie came from Scotland in 1854; the Scott brothers, George and Robert, arrived in 1856: together they established the firm of Carson, Pirie, Scott and Company. There were other energetic men from the East: Levi Leiter of Maryland and Marshall Field of Massachusetts were to become involved with Potter Palmer in the dry goods business; Joseph Medill of Cleveland bought an interest in the *Chicago Tribune* in 1855.

And people came from the South. The Kentucky Colony was centered around Union Square, on Ashland Avenue, then called Reuben Street, in the vicinity of Jackson Boulevard. This is now an industrial area: it was then rural, set in unspoilt prairie. Henry Honoré came first from Louisville; he invested in real estate for himself and for friends who came to live in the pleasant neighborhood. Elegant houses were built, and staffed by many servants; there were stables for thoroughbred horses. Honoré had six children: four boys and two girls, the eldest of whom was Bertha,

born in Louisville in 1849. The Honorés and their neighbors kept Southern traditions: during the Civil War the women of the Kentucky Colony gave food and clothing to Confederate war prisoners at Camp Douglas. The Honorés were interested in politics and public service, as became conscious aristocrats. They worked in the Sanitary Commission Fairs of 1863 and 1865: these were exhibitions of nursing techniques held to raise money for field hospitals for Union soldiers.

The war was not an immediate threat to the Honorés, since the brothers—Adrian, Henry, Nathaniel and Lockwood—were too young to serve in either army. Bertha, who had begun school at St Xavier's Academy in Chicago, went in the early sixties to the Dearborn Academy on the north side. She was a proper young lady, paying calls with her mother and greeting visitors at home, where the nucleus of a Chicago elite was being formed. Potter Palmer was naturally a part of that group: the war was making him a millionaire through his speculation in cotton and real estate. He saw Bertha for the first time in the Honoré house in 1862 when he was thirty-six and she was thirteen. She had dark hair and eyes and an obviously quick intelligence. The story is that Palmer decided then that he would marry her when she was older. It would probably not be excessive to say that Potter Palmer had some idea of establishing a Chicago dynasty. It would be fitting: Chicago was a cross-roads for the North and the South.

At the end of the war Palmer was worth seven million dollars. In 1864 he had sold his store to Levi Leiter and Marshall Field; he remained a partner for two years until Leiter and Field bought him out in 1866. The war brought a good deal of activity to Chicago because of its critically important central position. And after the war George Armour brought his meat packing plant to the city which was the unchallenged Queen of the West. On Michigan Avenue real estate prices rose from five dollars a square foot in 1857 to one hundred dollars a square foot in 1865. The city was smoothing out its ramshackle image. Streets were graded; hydraulic jacks raised buildings out of the mud. The architect John Mills Van Osdel had built the first cast iron buildings on Lake, South Water and Randolph Streets. The strong, light prefabricated walls did away with the need for heavy stone pilings that sank and shifted in the clay pan that underlay the city. Chicago, with its wide streets, was beginning to assume architectural prëeminence over older American cities.

There was beginning to be time for cultural pursuits. In 1862 a correspondent for the *London Times* called Chicago "a wonderful city of fine streets, luxurious hotels, handsome shops, magnificent stores, great warehouses, extensive quays, capacious docks . . ."; though the unpaved streets still gave "anguish to horse and man." The population of 200,000 now supported

Potter Palmer at Age 42.

theatre, public and private schools, bookshops and a library.
Northwestern University had been founded in Evanston in 1853.
The wealthy continued to build fine houses, especially on Prairie
Avenue to the south, and on Michigan Avenue north of the busi-
ness district, near the lake, where Henry Honoré moved his
family after the war. He sent his daughter Bertha East to school,
to the Visitation Convent in Georgetown, where she spent two
years.

In 1867 she was graduated with honors. She returned to make
a debut from the new Michigan Avenue house. Her life was the
expected social round of balls, receptions and concerts. She her-
self sang and played the harp. She was a most eligible heiress.
Potter Palmer, newly returned from Europe, had business deal-
ings with her father, with whom he was buying land on State
Street at two hundred dollars a square foot. Both men had great
faith in the future of State Street. Palmer had built a six story
marble building on State and Washington Streets for the
expanded operations of Leiter and Field. He was beginning to
build his hotel, the Palmer House, also on State Street. Van
Osdel was the architect. Ultimately the building would cost three
million five hundred thousand dollars.

Bertha Honoré and Potter Palmer were married in August,
1870, at a small ceremony, followed by a grand dinner at
Kinsley's Restaurant on Adams Street between Dearborn and
Clark Streets. She was twenty-one and he was forty-four. They
honeymooned in Europe. For Bertha this was the first trip; she
returned with jewels, gowns and art objects that Palmer had
bought for her. They had planned to live in the Palmer House.
Since it was not finished they moved into Palmer's country house,
quite close to the city. The summer and fall of 1871 were
unusually hot and dry. On October 8 Bertha was alone; Palmer
had gone East on family business. A faint glow in the sky early in
the evening grew brighter during the night. Before morning she
learned that both the Honoré and the Potter fortunes had gone
up in the flames of the great Chicago fire.

Four square miles of the city were destroyed. The State Street
stores burned to the ground, along with the Palmer House, the
new Grand Pacific Hotel, the Sherman House, Crosby's Opera
House . . . Losses were estimated at $200-$500 million. At the
Tribune smoke overcame the pressmen who were trying to put
out a special fire edition. When the rollers melted, Joseph Medill
fled with a handful of men to a job-printing plant on the west side
and put out a paper dated Wednesday, October 9. He exhorted
the ruined city to "CHEER UP! In the midst of a calamity with-
out parallel in the world's history, looking upon the ashes of
thirty years accumulation, the people of this once beautiful city
have resolved that CHICAGO SHALL RISE AGAIN."

Field & Leiter's Establishment.
Built by Potter Palmer.

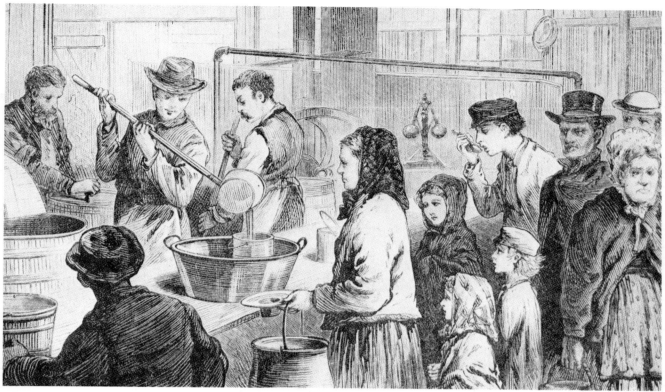

Soup Kitchen. Staffed and Funded by Cincinnati Volunteers.

An obscure poet named George Frederick Root picked up the idea:

> Ruins! Ruins! Far and wide
> From the river and lake to the prairie side.
> Dreary, Dreary, the darkness falls,
> While the autumn winds moan through blackened walls.
> But see! The bright rift in the cloud
> And hear the great voice from the shore!
> Our city shall rise!
> Yes, she shall rise!
> *Queen of the west once more!*

The banks assured depositors unconditional payments, although records had been destroyed. Some businessmen went East to secure the necessary credit for rebuilding. The Honorés, the Palmers, the Leiters and others borrowed heavily. While farm wagons carried away the rubble, merchants set up temporary headquarters in their west side warehouses. Most of the building was well underway by 1872: streets were repaved and trees were planted. In 1872, on the anniversary of the fire, the new Chamber of Commerce building opened its doors after a parade and dedication ceremonies; the Board of Trade shared the building. In 1873, the "Crystal Palace" was erected. This was a glass and steel building that stood on Michigan Avenue between Adams

Crystal Palace

Street and Jackson Boulevard until its demolition in 1892. The first Inter-State Industrial Exposition took place there. The city's revival was impressive, although there were setbacks: a financial panic in 1873, and another large fire in 1874 which caused more than a million dollars in damages. While millionaires had been wiped out in the first fire, a tremendous burden had, of course, fallen upon ordinary workers. A fire relief fund had been established, to which Potter Palmer, among others, contributed; but labor unrest was growing in Chicago, exacerbated by the fire.

Potter Palmer, who had certainly landed on his feet, was actively involved in the rebuilding of State Street. He wanted to make his Palmer House a showplace for the city; to that end he took Van Osdel on a tour of Europe to study the great Continental hotels. Before the Palmer House officially opened, it was sufficiently completed for the Palmers to move into and make it their home. In 1874, their son Honoré was born there; and in 1875 their second son, Potter. In 1874, Ida Honoré, Bertha's younger sister, married Frederick Dent Grant, the oldest son of President Ulysses S. Grant. An elaborate celebration took place at the Honoré house on Michigan Avenue, where millionaires rubbed elbows with Washington celebrities; silver was supplied by the Palmer House. The Palmers now had a firm link with the White House, where Mrs Palmer was a regular visitor. The President used the Palmer House as his Chicago headquarters. The hotel opened officially in 1875: its decor suited the social position of its owner. The Grand Dining Room had been copied from the salon of the palace of the Crown Prince at Potsdam, and one parlor was furnished throughout in the style of the ancient Egyptians.

After the fire it was not enough simply to rebuild the city's buildings. Some of the women who were social leaders thought it necessary to improve the cultural and social climate as well. The leading men of the town had their own gathering place, called the Chicago Club, the tone of which is evident from their unwritten motto: "Dogs, women, Democrats and reporters need not apply." In 1874 Mrs Palmer met Ellen Martin Henrotin at meetings of the newly formed Fortnightly Club, the first women's literary association in the city. The Fortnightly was founded by Kate Newell Doggett, of whom it was said that "she wore her hair short" and had radical opinions. Mrs Palmer and Mrs Henrotin read papers to the Club, and their subjects turned from literature to social problems by the 1880's. Mrs Palmer discussed "The Obligations of Wealth"; Ellen Henrotin and her sister Kate Martin discussed "The Social Status of European and American Women."

Ellen Martin Henrotin was born in Portland, Maine in 1847, but lived and went to school in Europe. Her father had many investments in the city, to which he brought the family in 1868. In 1869 Ellen Martin married Charles Henrotin, banker, president of the Chicago Stock Exchange, and for some years the Belgian Consul; they had three sons. Early in the 1880's she joined the Chicago Woman's Club, which had been founded in 1876, and encouraged Bertha Palmer to join. In 1887 Ellen Henrotin founded the Friday Club, which like the Fortnightly, was concerned with art and literature. But Mrs Henrotin was interested in all sorts of reform; through the Woman's Club she effected changes in the way juvenile offenders were treated by the courts. All her life she was an active seeker of solutions to social problems, in Chicago and throughout America; she was an able administrator, and a feminist.

The Chicago Woman's Club was a remarkable organization which helped to support women in public work in the city. In the early nineties the Club had five hundred members who were drawn from almost every walk of life. There were no age or marital status limits: members included ordinary housewives as well as business and professional women, and "social leaders" like Mrs Palmer. The Club was headquartered in the building of the Art Institute. Meeting rooms and classrooms were there, as well as a kitchen, dining room and tea room—all open every day for members' use. Literary meetings, at which women read papers, were held every two weeks. Classes led by lecturers were open to all members.

Ellen Henrotin was at one time its president, as were Dr Julia Holmes Smith, who was to figure actively in the struggle for the Woman's Building, Mrs Helen S. Shedd, and Ada Sweet. The Club provided a way for women to influence the institutions of the city.

Ellen Henrotin.

Mrs Shedd, for instance, led an investigation into the County Insane Asylum and the Poorhouse. The shocking conditions the women found led them to put strong pressure on the County Commissioners to appoint a woman physician to the Asylum staff. After some difficulty, Dr Florence Hunt was appointed to the staff at a salary of $25 a month. She raised standards for the nursing staff and put a stop to the wholesale drugging of patients. The reforms were striking enough so that women doctors became permanent additions to the staff, not only of the County Asylum, but of all Illinois public asylums in the last decade of the nineteenth century. The Club women were able also to effect the segregation of children from the mass of patients at the mental hospital at Dunning.

The question always asked by the women was "What are you doing with the women and children?" Politicians, who preferred to handle these affairs without outside interference for reasons of patronage, if nothing else, attempted to discourage the women by suggesting strongly that it was not ladylike to pry into seamy public areas. The standard answer of the Club women was that if women were present in any public place, the responsible women of the city had to demand a voice in the administration of that place.

The Woman's Club set up the Protective Agency for women and children. This Agency placed night matrons in police stations where previously women had been at the mercy of men after four o'clock in the afternoon when the matrons left for home. A Woman's Advisory Board was appointed by the Chief of Police to look after the quarters of all women and children in jail and of the station house matrons. It took eight years for the women, led in this case by Ada Celeste Sweet, to achieve prison reform for women and children. They succeeded in having women and juveniles kept separate in nine police stations, to which all women and children had to be taken. A chief matron was installed in the bridewell to look after female prisoners and care for young girls who needed protection until they could be sent home. These girls and first offenders stayed in the matron's annex, which had comfortable beds and pictures on the walls. The Chief Matron sat on the Police Trial Board to hear all cases in which women complained of abuse by policemen.

The Protective Agency gave legal advice to help mothers keep their children, and to get divorces for battered or deserted wives. It brought suit for poor women who might have been swindled out of their wages and it helped to find guardians for homeless children. The Agency also sought strong punishment for men found guilty of rape. The position they took was that women must not be slighted in court because there were questions about their personal lives, or even if they were actually prostitutes.

In the late eighties Chicago men attempted to found an

industrial school where homeless boys could learn a skill and be put out for adoption. The men could not accomplish their goal. The plan was foundering when the Chicago Woman's Club came to the rescue. In three months they raised $40,000 to build the school. The men then founded the Illinois Manual Training school in a suburb. The women maintained an advisory board to continue fund-raising and to look after the children's welfare in general.

The Club pushed through an act calling for compulsory education, which was being neglected. They were responsible also for the first legislation and work for the blind, pioneering work for social hygiene, the installation of a psychologist in the bridewell, the introduction of manual training, domestic science and sewing into public schools, the establishment of a scholarship at the Art Institute, and the establishment of scholarships in philosophy and sociology at the University of Chicago.

Jane Addams was a member of the Chicago Woman's Club. In an attempt both to help the poor and to provide an outlet for the energies of young college educated women, she and Ellen Gates Starr founded Hull House, a settlement on the west side in a decayed section of the city populated largely by immigrants. The house was on Halsted Street, one mile west of State Street, which was the heart of the business district and one mile east of Ashland Avenue, then a fashionable place to live. The house had been built in 1856 as a suburban residence, and had been surrounded by open country. In 1889, when Jane Addams took it over, it stood in the midst of foreign colonies. In 1889 Chicago had a million citizens: of these almost three-quarters had been born outside the United States. There were 400,000 Germans and 215,000 Irish. On Blue Island Avenue, south and west of Hull House, was the Pilsen district, where 42,000 of the city's 54,000 Bohemian population lived. Between Halsted Street and the River were 10,000 Italians. To the south were Germans, including German Jews; Polish and Russian Jews lived near them on side streets. North of Hull House was a huge Irish ghetto.

Hull House existed for the purpose of helping these diverse elements melt down into the American mainstream in as painless a way as possible. Classes were given, in art and Latin, as well as American history and manual training. A day care center was set up, and a clinic and a boarding house for working girls. A kitchen was built, too, but the people preferred their own kinds of food. Playgrounds were built for the children, and the women of Hull House attempted to build bridges between the immigrants and their American children. Besides Miss Addams and Ellen Starr, the early residents in the House were Florence Kelley, Julia Lathrop and Alice Hamilton. The Woman's Club offered support of all kinds.

Inevitably the Hull House group was to take up a fight for the

Jane Addams 1888

rights of the people it was trying to help. Garbage collection and general municipal corruption became targets, as did child labor and sweatshop conditions. The city establishment, which had welcomed the settlement workers, were later to grow uneasy because of their unswerving loyalty to the population they were determined to serve. The powerful interests of the city, which controlled its banks, real estate and manufacturing were all American-born: Armours, Swifts and Libbys, the meat-packers; and the Fields, the Leiters, McCormicks, McNallys, Medills, Ogdens, Pullmans . . . even the Mandels and the Rosenwalds were born in America. By and large the feeling was that agitation and danger came from the foreign born. Labor unions were organized by them; many of them were anarchists. Even Mrs Palmer was later to turn her back on Hull House because of Jane Addams' willingness to deal with anarchists.

Matilda Carse and Frances Willard, both also suffragists, undertook to fund the construction of a "Temple" for the Women's Christian Temperance Union, which they had helped to found in 1874. Mrs Carse was called by Chicago newspapers "the chief business woman of the continent." She formed a corporation in 1887 which was capitalized at $600,000. $400,000 worth of stock was bought with money that was considered to have come from one hundred thousand piggy banks. Bonds were issued for $600,000. The cornerstone was laid in 1891 at LaSalle and Monroe Streets on land owned by Marshall Field, who contributed $50,000 on the pledge that $250,000 would be raised by 1898. The building was thirteen stories high. Unfortunately the last public meeting held in the building was in February, 1898: it was the funeral of Frances Willard. The WCTU lost the building. But like others in Chicago, Matilda Carse made no little plans.

Ellen Gates Starr

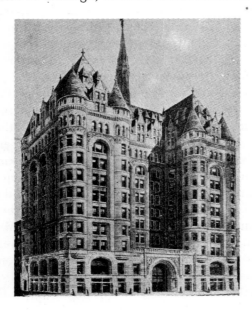

Woman's Temple

While Bertha Palmer was moving into the area of public service, she and her husband began to build an enormous house on the north side. People with money lived on Prairie Avenue or Michigan Avenue. But Potter Palmer decided to drain and fill three thousand feet of marsh land which he owned on the lake front: he created what became Lake Shore Drive. Henry Ives Cobbs and Charles S. Frost were the architects of what was, virtually, a palace in the robber baron style of the time. It had a great tapestried hall, an eighty-foot tower reached by a spiral staircase, marble mosaic floors, a Louis XVI drawing room, and a grand staircase of carved oak with newel posts bearing the Honoré coat of arms. All this is to say nothing of Bertha Palmer's Moorish bedroom in ebony and gold; her dressing room contained a sunken tub shaped like a swan. She slept in a Louis XVI bed and washed her face in a mother-of-pearl basin.

Furnishing the Castle absorbed a good deal of energy. Mrs Palmer became an avid collector of American and French Impressionist paintings, most of which hung in her ballroom on red velvet walls. Attention had to be paid to the sixty-foot long conservatory which was added to the finished house. But the Palmers always had time for the city with whose history they were already deeply enmeshed. Potter Palmer worked with the YMCA, and as a park commissioner helped establish Jackson and Washington Parks and the boulevard between them. Socialism was growing among the ranks of labor. Mrs Palmer opened her house to the women millinery workers of the city and helped them form a union. The doors of the Castle were opened, in fact, to many different kinds of people, though not all at the same time.

Many of the friends the Palmers made during the early, bustling days of the city were suspicious and fearful of labor organizations. In 1877 when railroad workers struck in sympathy with the workers on the Baltimore and Ohio, Chicago businessmen armed the National Guard. Employees of Field and Leiter were armed against "agitators," and the store's delivery wagons

carried policemen into German neighborhoods when socialist fer-
ment was suspected. Strikes plagued the city during the next ten
years: in 1880 stockyard workers struck, in 1885 streetcar
employees, and International Harvester in 1886. Joseph Medill
told a Senate investigating committee in 1885 that the miseries of
the workers stemmed from their own bad habits, a statement that
no doubt reflected his own firm conviction. In 1886 the worst
fears of the city's leaders were realized when a bomb was hurled
into a crowd of workers and policemen in Haymarket Square,
killing one of the latter. The notorious Haymarket "Riot" led to
the arrest and conviction of seven anarchists, some of whom were
hanged, although their guilt was uncertain. John P. Altgeld ran
for governor on the promise that he would pardon the three
anarchists still in jail: he was supported by Bertha Palmer and by
Lyman Gage, the "eccentric" vice-president of the First National
Bank. Bertha Palmer supported temperance work without worry-
ing about the profitable Palmer House bar; and in the same way
she entertained the Cyrus McCormicks and the George Pullmans
apparently without alienating them by her labor sympathies. In

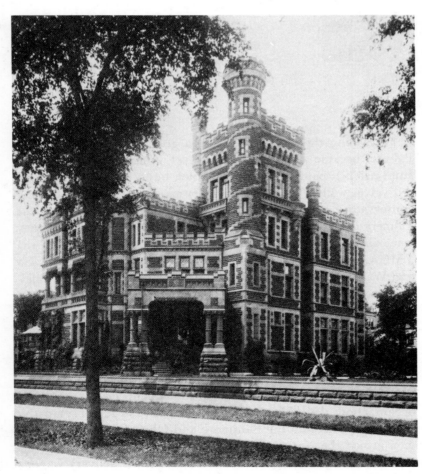

Palmer Mansion

1889 she helped Jane Addams and Eliza Gates Starr develop the Hull House settlement at the corner of Polk and Halsted Streets, and supported the Women's Alliance in the fight for legislation to control sweatshops.

Despite their long exclusion from the men's clubs, the women of Chicago were very much a part of the bustle and push of the city. Working women had strong partisans in the leaders of the Chicago Woman's Club. With the coming of the telephone and the building of office towers such as the Monadnock, the city's first skyscraper, more and more women joined the work force. By 1889 the University of Chicago opened its law school to women, and there was a women's college at Northwestern University of which Mrs Palmer was a trustee for a time.

A solid city had risen from the ashes of the 1871 fire. By the summer of 1889 it was ready and anxious "to vindicate its position as a great center of industrial and intellectual activity."

HE Paris Universal Exposition of 1889 set a high standard for world's fairs. The general feeling in Europe was that the French Fair could not be equalled, let alone surpassed. However, the United States was planning its Columbian celebration for 1892: Americans saw the Paris fair as a challenge and not as a deterrent.

The site of the Columbian fair was not a foregone conclusion, as it had been for England and France and would be for any country with only one major metropolitan center. In the east, Philadelphia, New York and Washington, D.C. entered a claim to consideration. In the midwest, Cincinnati, Chicago and St Louis all wanted the fair. In 1883 the Chicago *Inter Ocean* suggested that Chicago's central location and "accessibility as a railroad center," along with its "literary and artistic status," would attract many visitors. "It would introduce the North and the South anew in a city free from prejudices and animosities." In 1885 the Chicago Inter-State Industrial Exposition Company took up the matter. At that time the Philadelphia Fair was considered to be the one which Chicago could and must surpass. In 1885, in response to interest in the fair in St Louis, the Chicago *Tribune* derided that city as "impotent . . . a country town." Cincinnati suggested it would put forth its claim at a later date. The *Tribune* responded by calling the Ohio city "the toothless witless old dotard of American civilization . . . a cold and clammy corpse . . ." and demanded to know whether it had any blood in its body. "Isn't her heart all shriveled up, til it is no bigger than a pea and is totally incompetent to perform its functions?"

These comments seem to smack somewhat of ingratitude when one recalls that in the immediate wake of the Great Chicago Fire, St Louis sent over $185,000 from public and private purses to the citizens of Chicago, along with over ten carloads of provisions. And Cincinnati, despite its senile condition, had sent $100,000 from its Common Council, and its citizens had formed a committee to come to Chicago, first with eleven carloads of supplies, four thousand blankets and $15,000 in cash, and then a week later, on October 18, 1871, had opened a kitchen on North Peoria Street

from which Cincinnatians had personally served over four thousand gallons of hot soup to the desperate victims of the fire.

In 1886 businessmen in Washington, D.C. formed an organization to work for the Columbian Exhibition to be held there. Congress and other groups were petitioned for support. New York newspapers attacked the claims of Washington, and Chicago papers joined in once more: Washington was not good for a fair site, but it was better than New York. Both cities were of course inferior to Chicago.

These were merely sporadic bursts of interest in the Columbian celebration. The full efforts did not begin in a connected, intense way until 1889, three years before the celebration was scheduled to take place. In 1889 the cities organized for battle: the real struggle was between Chicago and New York. Within the cities themselves groups began to agitate for attention.

On July 17, 1889, Mayor Grant of New York called a meeting of business and labor leaders at City Hall to discuss plans for the fair. Five days later, the Chicago City Council instructed Mayor DeWitt Cregier to appoint a committee of two hundred and fifty citizens to raise money to bring the fair to Chicago.

The Chicago press perceived New York as the chief obstacle in Chicago's path. The *Tribune* said that New York was not really an American city. It was not patriotic, had no public spirit and was too snobbish to want an American celebration. It only pretended to want it, to hide its real motives. The *Tribune* said that intelligent Americans all knew that "the prominent citizen" of New York was a "partially civilized hog ..." In addition to, or because of, being hogs, New Yorkers were interested only in profit, being "mean" and "on the make"; their management of a Fair would "reek with ... fraud." What New York really was after, the *Tribune* revealed, was no less than the "absorption and destruction of the trade of other Eastern cities."

New York, ignoring Chicago as beneath consideration, began the discussion of possible local sites for its Fair. The *Tribune* announced that New York had no proper site. The "hawks, buzzards, vultures, and other unclean beasts, creeping crawling and flying," of that city, were warring over the site and could not agree. They were all fighting for "the chance to shear the most sheep." Central Park was too small and other locations too rocky. On top of all this, the menagerie of New Yorkees struggled for life in a climate unbearably hot in summer. Chicago had "refreshing breezes from the lake, and while New Yorkers at night desport themselves upon housetops, gasping for a breath of air, Chicagoans are comfortably asleep in their rooms beneath a blanket or two."

New York newspapers would not lower themselves to argue on Chicago's level. They pointed out, however, that their city was the

WORLD'S FAIR, PARIS, 1889

hub of the Western hemisphere, "the fourth city of the world." Chicago was raw and new: it lacked culture and tradition, and was totally materialistic. Anyway, Europeans would not want to go so far inland as Chicago; the trip was too taxing. This assertion stung Chicago anew. Going first to New York without seeing Chicago would be like going to France "without seeing Paris." Chicago was "the heart of the continent." New York, in addition to being run by hogs, buzzards and criminals, was the Liverpool of America, "a mere tassel on the fringe of the continent." Ignoring the possibility of overkill, Chicago newspapers pointed out that New York lacked money, transportation, and water and health facilities. Modestly, the *Chicago Herald* put forth its city's claim: "There is no other city so easy to inhabit, no other city so easily quitted. The power of the nation is centered here. The sympathy and spirit of the nation are focused here. Never before has Chicago asked the nation for aught. Now we offer our petition . . ."

"CHICAGO IS THE VERY CENTRE OF THE EARTH."

Chicago was doing more than offering petitions. An Executive Committee had been named by the two hundred and fifty "representative men," with Cregier as chairman. It met on August 1, 1889, incorporated itself as "The World's Exposition of 1892" and appointed a Finance Committee and a Steering Committee. Its goal was a guaranteed amount of five million dollars, divided into five hundred thousand shares at ten dollars each. The goal of the Corporation was twofold; to create sympathy throughout the country for Chicago to have the fair, and to raise money for the guaranteed amount. The Steering Committee appointed ten committees, dealing with expenses, congressional action, local and national publicity, transportation and hotel accommodation. The one hundred fifty men on these standing committees were all members of Chicago's aristocracy: they had a great deal of money, and they were used to getting things done. Four men are generally credited with the bulk of the Company's achievement during the interim period of fund-raising publicity and general planning: Thomas B. Bryan, Edward T. Jeffrey, George R. Davis and Lyman J. Gage, Chairman of the Finance Committee, who was at that time vice-president of the First National Bank of Chicago, and who had helped to found the Economics Club and the Civic Federation.

No women were named to any committee during this "preliminary organization" for the fair. But the involvement of women in cultural and civic affairs was a kind of tradition in Chicago—if so young a city can be said to have had traditions.

The women of Chicago were enterprising, to say the least, and accepted responsibility for the accomplishment of tasks that might—and had been known to—make strong men quail. They were capable of undertaking tremendous fundraising activities long before they tackled the Columbian Exposition.

The tradition of energetic Chicago women went back, as a

Mary Livermore

matter of fact. to the Civil War. Mary Livermore, an editor and the co-founder of the Home for Aged Women and the Hospital for Women and Children, had with Jane Hoge, become associate manager of the Chicago Branch of the United States Sanitary Commission. Their job was to inspect field camps, raise money and solicit, store and dispatch supplies for the aid and comfort of Union soldiers. This proved to be an immense task. During the Battle of Vicksburg Mrs Livermore herself brought 3500 supply boxes down the Mississippi, visiting nearly every Union hospital on the way from Cairo, Illinois, to Young's Point, Mississippi, near Vicksburg. She shipped her cargo on barges and boats from St Louis, while the Chicago Commission sent a thousand barrels of food south on the Illinois Central Railroad. All but about one third of the aid received by Grant from the U.S. Sanitary Commission came from Chicago.

Nevertheless a greater effort was needed to supply medicine and food to the troops. Mary Livermore and Jane Hoge suggested the idea of a money-raising fair. And this, the Great Northwestern Sanitary Fair, which was held in Chicago in the autumn of 1863, was the precursor of the women's contribution to the Columbian Exposition, and became the prototype for fundraising fairs. The male officers of the Commission gave their permission only: the rest was done by women. Ten thousand flyers were printed, asking for help. Mementos were donated for auction, dinners were planned to be cooked and served by volunteers, with produce donated by local farmers; concerts, tableaux and lectures were planned for the evening hours.

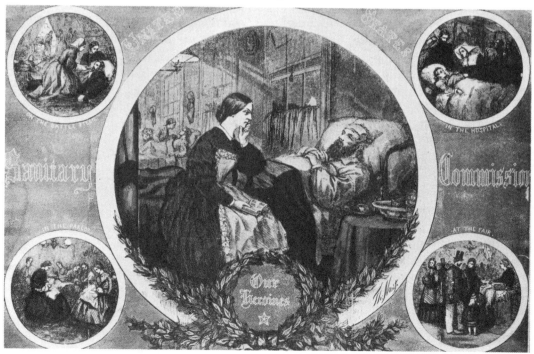

Jane Hoge

A Woman's Convention was held in September with five hundred delegates. Hundreds of fair meetings were organized in towns all over the North. Gifts arrived from as far east as New York. The entire Fair was planned and executed entirely by women, with Mrs Livermore and Mrs Hoge as co-directors. During the last weeks men caught the fever; even agricultural implements began to pour in. The downtown area of the city was jammed with produce, machines, sacks of goods. By the time the Fair opened on October 27, the whole city suspended all activity. Bryan Hall, the center of the Fair, located at Clark and Randolph, was packed from eight in the morning till ten at night. Goods and people overflowed to a Manufacturer's Hall constructed for the occasion, to the McVicker's Theatre where an art museum had been created, and to Metropolitan Hall where nightly entertainment was held. Between eighty-five and ninety thousand people bought tickets at Bryan Hall: the Fair netted more than $86,000. It was the great accomplishment of Mary Livermore's life, although after it was over she spent much of her energies on woman suffrage. She had become convinced as a result of her work on the Fair that married women did not have sufficient protection; before that time she had not supported the suffrage movement. In 1868 she organized the first Chicago suffrage convention, which was a great success. Susan Anthony and Elizabeth Cady Stanton came to speak. Shortly after that, Mrs Livermore became president of the Illinois Woman Suffrage Association. Myra Bradwell was the secretary.

Mrs Bradwell had also worked in the Sanitary Commission. She had studied law because her husband was a judge and made his library available to her. She founded the *Legal News* in 1868; she battled against legislation which prevented women from retaining their own earnings, and she won both that fight and another campaign to admit women to the law school of the University of Chicago. Her most famous battle came in 1869 when she was refused admission to the bar "by reason of the disability imposed by [her] married condition." Mrs Bradwell went all the way to the Supreme Court to fight this. The Court upheld the Illinois ruling with only one difference: Mrs Bradwell was prevented from practicing law because she was a woman, regardless of marital status. "The hot strifes of the bar, in the presence of the public . . . [might] tend to destroy the deference and delicacy with which" the "ruder sex" treated women, according to the Chief Justice. Mrs Bradwell continued her fight and had the satisfaction of seeing Alta Hulett become the first woman to be admitted to the bar in Illinois on June 4, 1873. Myra Bradwell herself was admitted to the Illinois bar but she did not practice law; she applied herself instead to constant work for legal reform.

It was Myra Bradwell, and Emma R. Wallace, representing the activist women, who went in August of 1889 to consult with the

Fair committee of "representative men." The women wanted official recognition for a woman's auxiliary to the Fair committee. Emma Wallace was a member of the Chicago Woman's Club, the president of the Women's Universalist Association and the Illinois Industrial School for Girls at Evanston, and active in the Woman's Relief Corp, the Woman's Exchange and on the board of the Home for the Friendless. She was one of the first women to suggest an official Women's Department for the Fair.

Mrs Bradwell and Mrs Wallace struck a responsive chord. On October 1889 a mass meeting was held to further demonstrate the desire of women to help to bring the Fair to Chicago, and to help to make it a success when it was brought there. Two thousand women attended this meeting. Mayor Cregier presided, and the gentlemen of the Fair Committee made "eulogistic speeches." Important women spoke also; there was no question of the kind of treatment women had received at the hands of the committee for the Philadelphia centennial celebration. The women were just as interested as the men in securing the Fair for Chicago; that was uppermost in the mind of Rena Michaels, for instance, who was dean of the Women's College of Northwestern University, and who gave reasons why the Fair should be held in Chicago and not in New York or Washington. "Because the West represents the advanced line in all the philanthropies in which women are engaged and in co-education, the education of the future . . ."

It is interesting that Dean Michaels should have emphasized the role of women in philanthropies and in education, rather than explicitly in feminist endeavor. The Chicago Women's Department, which is sometimes also called the Women's Auxiliary, was heavily weighted with women who had devoted most of their time and energy to public service of various kinds. Many of them were also suffragists, but this was not their first interest. The Executive Committee of the Women's Department included the following people: 1) Emma Wallace (Mrs M. R. M. Wallace); 2) Mrs Leander Stone, who was for many years the president of the YWCA; 3) Myra Bradwell; 4) Mary Logan (Mrs John Logan) an influential writer, the founder and editor of the monthly woman's magazine *Home*. She wrote autobiographical books about her Civil War experiences. John Logan had been a circuit judge and was elected to Congress from southern Illinois. 5) Marian Mulligan (Mrs James A. Mulligan) was the commissioner of the U.S. Pension Office in Chicago; 6) Margaret Isabella Sandes was president of the Women's Relief Corps for four successive terms. She was appointed secretary of the Woman's Auxiliary; 7) Mrs Nelson Morris, the wife of a wealthy meat-packer, had lent her name to the promotion of many charitable enterprises; and finally 8) Mrs G. B. Marsh and Mrs J. S. Lewis. Neither Mrs Morris nor Mrs Marsh became members of the Board of Lady Managers; the other women on this Executive Committee were later appointed to

Marion Mulligan

that Board.

This Women's Department or Auxiliary Executive Committee set three goals for itself: it wanted the erection at the Fair of a Woman's Pavilion devoted to the exhibition of women's industries; it wanted audience rooms for an international convention of "reformatory" and charitable workers; it pledged its members to sell as many shares of Fair stock as possible. Certainly the men in the Fair Corporation expected that the women would do a great deal of fund raising. Most of these women moved in wealthy social circles and had helped to raise money for many philanthropic organizations. The women were prepared also to help lobby in Washington to get the Fair site awarded to Chicago. Myra Bradwell went to Washington, and so did Margaret Isabella Sandes.

The Women's Auxiliary were not the only women's group interested in the World's Columbian Exposition. There was another group whose dedication to work for suffrage and equal rights for women was stronger than any interest in charity work. These were mostly professional women: lawyers and doctors, who began early to think about the Columbian celebration; they wanted to celebrate the achievement of a woman, and they fixed upon the figure of Queen Isabella of Castille. They considered that she had enabled Columbus to make his voyage, and that she should be honored at the Fair. In mid-August of 1889 the Queen Isabella Society was formed in Chicago. The goals of the Society were twofold: to provide a statue of Queen Isabella which would stand on the Fair grounds and be officially unveiled during the Fair ceremonies, and to build a Woman's Pavilion, an international club house and assembly rooms for use during the Fair. The idea of the statue was first suggested by Catherine Van Walkenburg Waite who, with Mary Livermore and Myra Bradwell, had helped to found the Illinois Woman Suffrage Association. In 1871 she was one of the Illinois women who came to the polls; her husband, who was a judge, had attempted court action to challenge the refusal to let her vote. Like Mrs Bradwell, Mrs Waite had studied law with her husband. She entered Union Law School and was graduated in 1886. Again like Myra Bradwell, she edited a law periodical: her *Chicago Law Times* devoted more space to issues of interest to women that did Mrs Bradwell's *Chicago Legal News*. Mrs Waite conducted a real estate business in Chicago; she developed housing projects, acting to a large extent as her own architect and contractor.

Headquarters for the Isabella Association was in the offices of Dr Frances Dickinson at 70 State Street. Dr Dickinson was an ophthalmologist who had received her medical training in Berlin. It has been said that "everyone of the two hundred women doctors in Chicago" sent their patients to Dr Dickinson who was a dedicated suffragist. Susan B. Anthony was her cousin. At the first meetings of the Isabella Association Dr Julia Holmes Smith was

Myra Bradwell

chosen President. She had begun her medical training in Boston after having been widowed and remarried, and completed it in Chicago, where she moved with her second husband. She was active in women's clubs, including the Fortnightly and the Chicago Woman's Club of which she was a president. In 1884 she helped to form the Illinois Women's Press Association; she had been a writer before her medical training. She was appointed by Governor Altgeld the first woman trustee of the University of Illinois. She also was organizer and first president of the Woman's Medical Association, and the first woman intern at Cook County Hospital in Chicago.

Eliza Allen Starr was named vice-president of the Isabella Association. She was the aunt of Ellen Gates Starr who had helped Jane Addams to found Hull House. Miss Starr was an active and extremely devout Catholic. She taught art in the Mother House of the Holy Cross, at Notre Dame, was well known as an artist and author on Catholic subjects.

Mrs Corinne S. Brown was one founding member of the Isabella Association who was not a professional woman. She was the wife of a prominent banker and the mother of two children. Although she did not work for her living, Mrs Brown had radical opinions about labor. She was the corresponding secretary of the International Labor Congress and was president of the Woman's Alliance, handling all labor and economic matters.

These women, with Frances Hale Gardner, who was foreign secretary, started a national movement to promote the Isabella Idea. They mapped congressional districts. Mrs Waite organized leaders in each district to enroll members at one dollar apiece and to sell shares at five dollars each to raise money for the statue of Queen Isabella. The officers served without salary, and often exchanged official duties with one another.

Since the Isabella women were all suffragists, and since Frances Dickinson was Susan B. Anthony's cousin, it is not surprising that in September of 1889 Miss Anthony and a Mrs Thomas of a woman's club called Sorosis, wrote to Mayor Grant of New York urging him in the name of Isabella to erect perma-

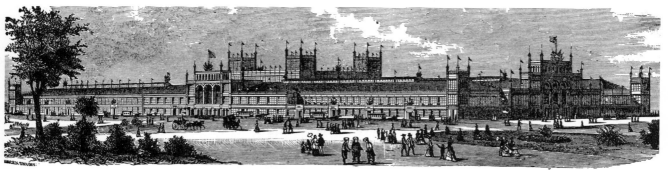

CENTENNIAL EXHIBITION, 1876—MAIN BUILDING.

nent buildings at the Fair for the use of women. Miss Anthony lived in New York state; she would naturally turn to the mayor of New York with her suggestions. The Isabellas had in fact decided to leave nothing to chance: they wanted to become the official women's organization of the Columbian Exposition, wherever it might be held. Though the basic group were Chicagoans, they had connections with suffrage associations throughout the country. In quick succession they opened offices in New York, St Louis and Washington, D.C.

Late in September of 1889 Elizabeth Cady Stanton publicly urged the rights of the Isabellas to represent Woman at the Exposition, and mentioned the necessity of halls for women's congresses. Also in September the Women's National Industrial League of America under the leadership of Charlotte Smith passed a resolution that Congress appropriate money for a statue of Queen Isabella. The League complained that women were being ignored by the committees which were working to bring the Fair to Washington, and also commented officially that no answer had been given to Susan Anthony's request to the New York promotion committee for a permanent woman's building if the Fair were held in New York.

There was actually division of opinion about the question of a building for the women at the Fair. The Women's Department or Auxiliary had gone on record as wanting a woman's pavilion which would exhibit women's "industries"; the Isabellas also wanted a pavilion, but they did not want to segregate women's activities from the rest of the Fair. The Isabella Association by and large stood for equal rights and for competition with men on an equal basis. The women of the Auxiliary were not as a group anxious to emphasize equality, but wanted rather to demonstrate the philanthropic accomplishments of women, and their handiwork.

The Women's Auxiliary were already members of the Chicago establishment; most of them had worked long and hard for Chicago institutions. Others had prestige because of their husbands' wealth and connections. They found easy acceptance, and moved into offices in the Adams Express Building at 185 S. Dearborn St. This was the same building in which the Fair Corporation had its offices. This symbolic union did not augur well for the ambitions of the Isabellas.

The battle for the Fair site went on apace. In October of 1889 Edwin Walker and Edward Taylor of the Fair Corporation, and Myra Bradwell of the Women's Department established lobbying headquarters in Washington, D.C. Congress was not yet in session but Washington was filled with people lobbying for the Fair. St Louis, Washington and New York were still very much in the running. Susan Anthony too was in Washington: she was working more or less behind the scenes to get women appointed to an official capacity on the governing board of the Fair. A group of influ-

ential Washington ladies were invited to the Riggs House, a Washington hotel, to meet in a private parlor with socially acceptable suffragists. Miss Anthony herself remained secluded in her room upstairs; she was too controversial a figure to approach the ladies directly. The idea of a commission of women and a women's exhibit at the Fair was most interesting to the Washingtonians: they were willing to sign and circulate a petition to Congress supporting the Anthony proposal.

In December 1889 the Fifty-First Congress convened. Petitions, memorials and resolutions of all kinds poured in. Miss Anthony submitted a petition to the Senate with one hundred names of influential individuals. On January 13 Senator Orville Hitchcock Platt of Connecticut read into the record:

> I present the petition of sundry ladies of Washington City, including the wives of Chief Justice Fuller, Justices Field and Harland, and the wives of many distinguished officials and citizens of Washington, praying that in the legislation organizing the international exhibition of 1892 provision may be made for the appointment of women on the board of managers of said exhibition, in view of the fact that there will be in the exhibition a presentation of the share taken by women in the industrial, artistic, intellectual and religious progress of the nation.

This petition, like all the others, was referred to a Quadro-Centennial Committee, which was enlarged from nine members to fifteen at Chicago's request. Chicago was closely watching all congressional action in order to guard its prerogatives. On December 19 Senator Cullom of Illinois introduced a draft of a world's fair bill that was very much like the bill that was finally adopted; this too was referred to the Quadro-Centennial Committee. In the House these bills and petitions were referred to the Committee on Foreign Affairs. Since the chairman of this committee was Robert Hitt of Illinois, Chicago wanted world's fair matters to be left to his committee and fought all attempts to create a special world's fair committee in the House.

The Quadro-Centennial Committee of the Senate heard arguments in favor of the contesting cities in January, 1890. St Louis, Washington and New York came in succession, and on January 11 arguments were made for Chicago. Spokesmen were Mayor Cregier, Thomas Bryan and Edward Jeffrey. For the most part they repeated points already made by the Chicago newspapers. Bryan said that "the West" wanted the fair held in Cicago.

> Chicago declares that the West shall be gratified in the interest of the entire country. In other words, the interest of the entire country is for the West, and the West is for Chicago . . . New York has no claim, and St Louis has no claim, and Washington has no claim. That is all true . . . but the West has a claim. It is her turn.

Chicago suffered what it feared was a setback on January 17

when the House voted 140-136 to establish a world's fair commit-
tee of nine members. The establishment of this committee would
mean some delay on the decision for the site. The *Tribune* said that
delay was desired "by New York because it fears Chicago's
strength, and must wait till the ten million dollar bribe bill gets
through the legislature; by St Louis because it is the tail to the
New York kite; by Washington because it hopes to fall heir to New
York's votes . . ." Illinois congressmen Robert Hitt and William
McKendree Springer maneuvered procedural matters to help
Chicago in every way.

A tremendous number of speeches were given, very few of
which were "up to the standard of practical usefulness," accord-
ing to the *Tribune*. The speakers wanted their constituencies to
know that they had worked earnestly for them. On February 24 a
roll call of the House was made, and Chicago won on the eighth
ballot. As might have been expected, the city's solid support came
from the Midwest (Illinois, Indiana, Iowa, Kansas, Michigan,
Minnesota, Nebraska, Ohio and Wisconsin) as well as from the
far west (California, Colorado, Montana, Nevada, North and
South Dakota, Oregon and Washington State). It got votes also
from southern and border states (Florida, Kentucky, Louisiana,
Mississippi, North Carolina, Tennessee, Texas and West Vir-
ginia). Surprisingly Chicago also received half the votes of Maine,
Massachusetts, Rhode Island and Vermont, and more than half
the votes of Pennsylvania. It looked as though the country were
with Chicago. The *Tribune* derided the "deadly provincialism" of
New York. Chicago had won, it declared, "the moment it was de-
cided that the Fair should be American, not foreign; National, not
provincial; depending for its success on the citizens of the New
World and not of the Old."

Three weeks later the Quadro-Centennial Committee reported
the Fair Bill to the Senate, which passed it, by a vote of 43-13. The
Bill was returned to the House. Representative William Springer
of Illinois had written an amendment to the bill calling for the
creation of a Board of Lady Managers. When the Bill came back
to the House for a final hearing, the amendment was not read.
"Mr Springer called attention to this omission, and the chairman
of the Committee replied that it was unintentional—the amend-
ment having been left out, because the committee considered it of
no importance whatever, but that if desired it could yet be restored
to the bill, and this was consequently done." Springer's amend-
ment was accepted, but some other amendments were stricken: of
these one was for a memorial building in Washington and an-
other was for a statue of Queen Isabella. On the male side, an
amendment for a statue of Christopher Columbus was also
stricken out.

The Springer amendment consisted of two sentences in section

VI of the Bill, which set up specific duties for a National Commission:

> And said Commission is authorized and required to appoint a Board of Lady Managers of such numbers and to perform such duties as may be prescribed by said Commission. Said Board may appoint one or more members of all committees authorized to award prizes for exhibits which may be produced in whole or in part by female labor.

After some questions about Chicago's ability to provide its promised financial support, the House accepted the Bill with all of the amendments. On April 25, 1890, President Benjamin Harrison signed the Bill into law. Chicago was now the official site of the World's Columbian Exposition.

The city had poured energy and money into its quest for the Fair. Its citizens were used to working hard; they were used to organizing; men and women worked smoothly together for a common purpose. New York had suffered from internal dissension: its citizens could not agree on a proper place to locate the Fair within the city. In addition, the Tammany Democrats and the Republicans squabbled publicly in the state legislature over methods of raising the guarantee fund. The citizens of St Louis did not throw themselves wholeheartedly into the struggle for the site. Washington's dependency for funding upon the Federal Government hopelessly damaged its claims. Chicago profited from the failures of others, but it could claim credit for victory in its own right.

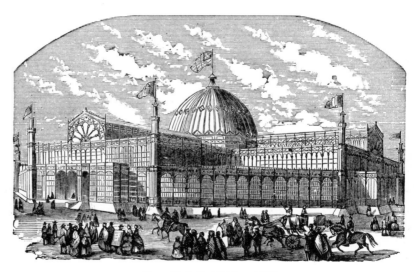

New York Exhibition 1853

HE agitation over the decision to give the Fair to Chicago went on while Congress was actually voting on the Fair Bill. Representatives from New York, Washington and St. Louis were "sorry and sore" that their cities had lost. No one paid too much attention to the Springer Amendment, for instance; it was dropped incidentally and put back good-naturedly. Disgruntled losers implied strongly that Chicago could not honor its financial commitment; there were dark mutterings about "beggars and mendicants" on the shores of Lake Michigan, whose foul waters would doubtless poison the visitors. Chicago had little to offer but "pumpkins, beans, pigs and wind." In fact it was called "the windy city" not because of its climate, but because its supporters had talked so much about its ability to mount the greatest Exposition that ever was.

Possibly because of this suspicion of Chicago, the Fair Bill set up a body called the World's Columbian Commission, to work more or less in conjunction with the Chicago Corporation. Generally the Commission was to be responsible for those affairs which lay in the area of national interest: dealing with foreign governments and awarding prizes. The Chicago Corporation, or Directory, as it was to be called, had the responsibility of putting the Fair together. But the Commission had to approve the general scope and planning done by the Corporation. This situation had built-in problems: it was loose, and it invited tension and confusion.

The Commission as it was set up was really too large to do anything easily. There were 108 Commissioners: two each from every state and territory and from the District of Columbia, and eight commissioners-at-large, appointed by the President upon nomination by governors.

As we have noted, the Springer amendment empowered the National Commission to appoint a "Board of Lady Managers." Neither the number of ladies nor their duties were specified. Only one job was specifically assigned to the women: the

appointment of "one or more members" to any committees which awarded prizes to exhibits "produced in whole or in part by female labor." The amendment thus gave the women very little: Susan Anthony and the suffragists had not wanted anything like this Board. In fact they had not wanted a separate "Ladies' Board" at all. The wording of Miss Anthony's petition is clear: it asks for legislation providing for women to be appointed to *"the board of managers of said exhibition . . ."* (Italics added.) Miss Anthony wanted women on the National Commission. Insofar as this was her intention, her petition failed.

The Women's Department or Auxiliary in Chicago had been intent upon securing the Fair site for that city; but that was only part of its intention. One of its goals had been to erect a women's pavilion to hold exhibits of women's accomplishments from all over the world. They proposed to "begin with the Sandwich Islands and encircle the world in collecting an exhibit of women's work." They too were dismayed by the weakness of the amendment.

Frances Willard of the WCTU, wrote later:

Frances Willard

> The framers of the World's Fair bill probably builded better than they knew when incorporating the section which created the Board of Lady Managers. They can scarcely have anticipated the importance this unprecedented body was destined to assume. Nothing like it had ever existed before; its creation was entirely experimental, and in fact the potential Section Sixth did little more than call the Board into existence, barely breathing life into it . . . Its vagueness is extraordinary.
>
> Not only is there no specification of the duties and privileges — with one most important exception — of the body thus created, but there is, moreover, no indication of the number of women constituting the Board. Indeed, the paragraph is as minute a germ as anything of corresponding consequence ever grew from.

The name "Lady Managers" did not go down well either. Frances Willard commented that "the name of the Board was not well chosen, conveying little impression of the earnest usefulness which it almost immediately developed." Another woman wrote in 1892:

> There has been a great deal of unfavorable comment on the ridiculous title 'Lady Managers'. . . and the criticism is just, but the fault . . . is not with the women. The title Congress gave us conveys the impression that we are a useless ornament —; idle women of fashion; whereas our board comprises as many workers, as much representation of the active industries of the country, as if it were composed of men. There are doctors, lawyers, real-estate agents, journalists, editors, merchants, two cotton planters, teachers, artists . . .

Frances Willard sounded a positive note: "But notwithstand-

ing these disadvantages, the creation of the Board was an opportunity, and the American woman at the end of the century has availed herself of it to the utmost. She received generous aid on all sides . . . The first meeting of the Board . . . drew upon it the attention of the world. It was an unprecedented spectacle. An executive body composed wholly of women, acting with government authority, was a sight to fix the gaze."

In a more hyperbolic vein, *Campbells' Illustrated Fair Weekly* later said of the amendment, "Let every woman . . . in every quarter of the earth, mark the day with a white stone . . ."

The general impression has lingered that the Springer amendment was brought about by suffragist activity. Representative Springer himself was not an avowed suffragist. In 1890 he opposed the admission of Wyoming to the Union: part of his argument rested on the fact that Wyoming's proposed constitution allowed woman suffrage and women had voted to ratify that constitution. He argued also that only six thousand people, men and women, had voted to ratify, and that was not a sufficient number. Mr Springer, a Democrat from Springfield, Illinois, was interested primarily in obtaining statehood from the Republican House for New Mexico, which was predominantly Democratic. His move against Republican Wyoming was purely political, for bargaining purposes. The maneuver did not succeed. New Mexico was not admitted to the Union until 1912, while Wyoming was admitted in 1890 over Springer's opposition. Mr Springer served twenty years in the House; he was a politician before anything else. He had no animus against women. His wife was a novelist and poet, whose work was eventually exhibited in the Library of the Woman's Building.

However, since his attitudes were somewhat murky, suffragists claimed that pressure from them had induced Mr Springer to write his amendment and to insist on its inclusion in the final Bill. In 1893, at the convention in Washington, D. C. of the National American Woman Suffrage Association, Mary Lockwood, a member-at-large of the Board of Lady Managers, proclaimed: "The Board of Lady Managers owe their existence to Susan B. Anthony and her co-workers. It was these women who went before Congress and not only asked but demanded that women should have a place in the arrangement of this Columbian Exposition — and they got it!" This, as may perhaps already be apparent, is a considerably simplified view of the development of what was eventually to be Bertha Palmer's famous Board. Certainly Susan Anthony labored mightily for women. She collected 111 signatures for the petition which she heard Senator Platt read into the record. In December, 1889, the Washington *Star* quoted her as saying "it was probable that the board of promotion at the capital would decide to permit women a part in the organization and management of the enterprise." That was what

Rep. William M. Springer

she hoped for; what she got, of course, was Mr Springer's addition to Section Six: the right for some women to judge some products of women's labor and to give some prizes.

Later, in 1892, when emotions were still raging over the appointment of the Lady Managers, Mrs Palmer wrote a letter in which she said that Mr Springer had acted solely from a sense of justice; he had told her so. And that was all right with Mrs Palmer. "I am more proud of our origin coming from a pure and abstract sense of justice," she wrote pointedly, "than if it had been produced by clamor and persistence." Mrs Palmer said that Mr Springer had not known about any "monster" petitions, and had heard nothing of a demand for a woman's Fair board.

This may be so. But Mr Springer would have had to be singularly ignorant or totally distracted to be quite unaware not only of the actions of the "influential" Washington ladies, whose petition, it is true, was read in the Senate and not in the House, but of the interest in a woman's board in his home state of Illinois, where both the Auxiliary and the Isabellas were intelligent, well-connected and vocal. He would supposedly not have spent time with Myra Bradwell, then, when that spirited feminist was in Washington lobbying for the Fair site; nor would he have spoken with Margaret Isabella Sandes, the secretary of the Auxiliary, when she came to Washington to lobby for Chicago with Mayor Cregier, who had himself presided over a mass meeting of women in Chicago. Yet Springer was one of the two key Illinois representatives who deftly maneuvered Chicago's claims through the House.

It strains belief that Springer could have acted entirely on his own. It suited Mrs Palmer's purpose to praise his "pure and abstract sense of justice" at the time that she mentioned it, as we will see. But it is difficult also to make the necessary connection between Miss Anthony's little band in Riggs House, and Mr Springer's selfless gesture months later in the House of Representatives. Partly because of a good deal of bad feeling that arose during the course of the Fair, direct connections between any individuals and the Springer amendment seem to have become impossible to trace. Representative Springer attended meetings of the Board of Lady Managers. He said there that when he wrote his amendment he had "no comprehension of the magnitude and importance of the work in which" he was engaged. The truth of his statement is reflected in his amendment. But, he said further, he would stand by the actions which he had initiated. "In the rest of your noble work, ladies," he cried, "I am your champion." He had a reputation for basking in the limelight.

The Chicago Fair Corporation held a mass meeting on the lakefront in April of 1890. Forty-five directors were chosen: active, public-spirited men. Lyman Gage, the politically liberal vice-president of the First National Bank, was named President.

Thomas B. Bryan and Potter Palmer were first and second vice-presidents, respectively. Ten committees were set up, overseeing Finance, Grounds and Buildings, Transportation, Fine Arts and so on. On June 12 at another meeting the name of the Corporation was changed from "World's Exposition of 1892" to "World's Columbian Exposition", since Congress had set the date of the Fair in 1893. After the June 12 meeting the directors met weekly in the Adams Express Building, where they remained until January, 1891, when they moved to the Rand McNally Building, 168 Adams Street.

On June 26, 1890, the Columbian Commission met for the first time, in Chicago. Thomas Palmer was elected President. He was a former senator from Michigan who had made his fortune in lumber, and an active supporter of woman suffrage. He was not related in any way to Bertha and Potter Palmer. The other officers of the Commission were bankers, railroad men, publishers, politicians and former Army officers. The Commission was to share the fourth floor of the Rand McNally Building with the Corporation and the Lady Managers after January, 1891.

The organization of the Fair's supervisors was now complete.

Both the Women's Department, or Auxiliary, and the Isabella Association were anxious that their group only should dominate the Board of Lady Managers. The Isabellas were, as we have said, suffragists. They did not want a segregated women's exhibit on the grounds of the Fair. The Women's Department, on the other hand, had set the building of a woman's pavilion ("as did our Centennial sisters") as one of their original goals; it will be remembered that they wanted congresses emphasizing "woman's place in the charitable and reformatory work of the world."

The Isabellas wanted the Queen to share Columbus' glory. Eliza Allen Starr's book *Isabella of Castile* was written to this end: "A long-delayed tribute to Isabella of Castile as Co-discoverer of America." The choice of Isabella was not a universally popular one. The Isabellas saw her as a woman who had pawned her jewels to help Columbus, who had spent thirty years as a head of state, and cared for her subjects with great compassion. Others saw Isabella as a religious bigot, a fanatic, the founder of the Inquisition, a ruler who had usurped her niece's throne, and drained her people through cruel taxation. Mention was made of Spanish actions in the West Indies, and it was suggested that Isabella had sent Columbus to sea in three leaky little ships in order to get whatever she could as a result of his explorations.

The Isabellas would have none of this. They took the position that nobody is perfect: "Doubtless she had her faults; but faults of her race and time . . ." They still wanted their statue of Queen Isabella to be unveiled at the World's Fair.

To this end they had already, in 1889, commissioned the sculptor Harriet Hosmer to execute the task. The statue was to be paid

Thomas Palmer

for out of a fund for which the Isabellas had sold one dollar certificates. Harriet Hosmer lived in Rome, in a colony of women sculptors. She was emancipated, as befit the first successful American woman sculptor: she wore men's clothing and worked in baggy Zouave trousers. Elizabeth Barrett Browning thought her eccentric put pure; Nathaniel Hawthorne, a fellow New Englander, called her peculiar but unaffected. Her "Zenobia", which had been exhibited in London, Boston and New York, was an unusual rendering of a female figure, magnificent in defeat. She was capable of more whimsical work: her statue of Puck sitting on a toadstool playing with a beetle and a lizard had been purchased by the Prince of Wales. Mrs Palmer owned one of the fifty copies, which had sold for a thousand dollars each. By the time the Corporation was reorganized, and the National Commission was organized, in the early summer of 1890, Harriet Hosmer was already at work on the statue of Queen Isabella.

The Isabellas began to send bouquets of flowers to the Chicago Directory. They were not daunted by the fact that the Women's Department already had offices in the Adams Express Building, with the Directors. The Women's Department sent bouquets to the Directors, too. Both groups, in their anxiety to control the Board of Lady Managers, overlooked the fact that the amendment empowered the National Commission to appoint the Lady Managers, and not the Chicago Directory. The Directors, no doubt somewhat relieved to be exempted from this situation, informed the women.

The National Commission received bouquets of flowers from both groups. Along with the flowers came arguments. The Isabellas, aware that the Auxiliary had strong roots in Chicago, argued that Lady Managers should come from all over the country and not from Chicago alone. The Isabellas, having ties with national suffrage organizations, wanted a national women's Board. The Auxiliary argued from their more narrow boundaries that they were active, competent citizens with experience of community service. Some of the Auxiliary may have spoken privately to some Directors, and asked them to say a word to the Commissioners.

Toward the end of the summer of 1890 the National Commission began to appoint the Lady Managers. They tried to some extent to satisfy both the Auxiliary and the Isabellas. Despite their own unwieldy size, the Commissioners appointed the women by the same method which had governed their own appointment: two from each state and territory and from the District of Columbia, and another eight members at large. The appointees were nominated by politicians and other prominent citizens; in some cases they nominated themselves. Thus the Lady Managers came from all over the country, as the Isabella Association had requested. But in order to satisfy the Auxiliary,

Harriet Hosmer & Statue of Sen. Thomas Benton

the Commissioners chose nine additional delegates from Chicago: eight from the Auxiliary itself and, in a rather unconvincing attempt to appear even-handed, one delegate from the Isabella Association. This was Dr Frances Dickinson, the ophthalmologist in whose State Street office the Isabellas held their meetings.

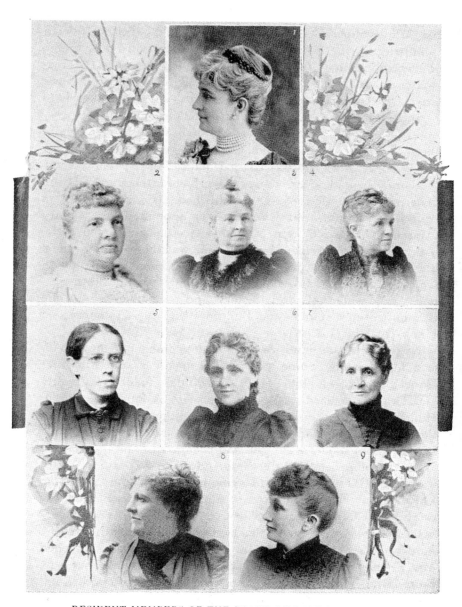

RESIDENT MEMBERS OF THE BOARD OF LADY MANAGERS.

1. MRS. BERTHA M. HONORÉ PALMER,
 Chicago, Ill.

2. MRS. SOLOMON THATCHER, JR.,
 River Forest, Ill.

3. MRS. L. BRACE SHATTUCK,
 Chicago, Ill.

4. MRS. JAMES A. MULLIGAN,
 Chicago, Ill.

5. FRANCES DICKINSON, M. D.,
 Chicago, Ill.

6. MRS. M. R. M. WALLACE,
 Chicago, Ill.

7. MRS. LEANDER STONE,
 Chicago, Ill.

8. MRS. JAMES R. DOOLITTLE, JR.,
 Chicago, Ill.

9. MRS. MATILDA B. CARSE,
 Chicago, Ill.

In all, there were 117 Lady Managers, with an equal number of alternates. The National Commission numbered 108, with 108 alternates. They had created a women's Board which was larger than their own.

Of the nine Chicago delegates, three had been active in the Auxiliary: one was Myra Bradwell. The second was Marion Mulligan, widowed by the Civil War, who was the U.S. Pensions Officer in Chicago for five years and had run a losing race for County Superintendent of Schools in 1890 — the first woman nominated in the history of the county. The third was Emma Wallace, the active Clubwoman who had first suggested the creation of a woman's department for the Fair. Jennie Sanford Lewis was the fourth delegate from the Auxiliary; she resigned early to be replaced by her alternate, Julia B. Shattuck.

Of the four Chicago delegates who had not been members of the Auxiliary, one was Matilda Carse, the veteran fundraiser for the WCTU. A second was Clara Doolittle, twice widowed, the mother of three children whose father, Joel Matherson, had been governor of Illinois 1852-1856. She had been active only in church work until 1891 when Cregier appointed her sanitary inspector. A third delegate, Matilda Gresham, resigned early, like Mrs Lewis; also like Mrs Lewis she was the wife of a judge. She was replaced by her alternate, Clara Thatcher. The fourth Chicago delegate was Bertha Palmer, whose husband was the second vice-president of the Directory, and a member of both the Committee on Grounds and Buildings and the Committee on Fine Arts.

Of the nine alternates, two had been members of the Auxiliary: Mrs Leander Stone, the YWCA member, and Margaret Isabella Sandes, who had gone to Washington to lobby with Cregier. Frances Willard was a third alternate. A fourth was Sarah Hallowell, an expert on impressionist painting who lived part of the time in France and who helped to educate Potter and Bertha Palmer about modern art. She had organized exhibits of art in Chicago before, at the Inter-state Industrial Expositions. Fifth was Annie Chetlain, who held a commission signed by Abraham Lincoln as the first postmistress in America. She was a founder of the Friday Club and manager of the "Home of the Friendless." Sixth and seventh were Martha Ten Eyck and Annie C. Meyers. Finally, Mrs Shattuck and Mrs Thatcher, who had succeeded Mrs Lewis and Mrs Gresham, were succeeded as alternates by Emma Dunlap, the wife of a politician and real estate broker and the mother of six children and Evaline Kimball, the wife of the piano manufacturer.

One Illinois delegate who happened to live in Chicago was Frances Shepard, the wife of Judge Henry Shepard, and a founding member of the D.A.R. in Chicago. It was she who first proposed the Woman's Building to the Chicago Fair Directors, on

behalf of the Board of Lady Managers.

The women of Chicago claimed credit for the Board of Lady Managers, and since they had nine delegates of their own, credit was certainly given to them. There were objections to this Board from leaders of national women's organizations. Charlotte Smith of the National Industrial League pointed out that although her group had spent both time and money working to promote the interest of women in the Fair, there was no factory worker on the Board. Phoebe Couzins, who had been at Independence Square in Philadelphia with Susan Anthony in 1876, and who had been a worker for women's rights for years, wrote to newspapers in August claiming credit in the name of suffragists for the existence of the Lady Managers. Miss Couzins complained that Miss Anthony had not been appointed to the Board, even though her petition had "saved the day." Phoebe Couzins herself was nominated to the Board, and, ironically, because of this nomination she was later to abandon, in bitterness, her work for woman suffrage.

JOSIAH'S "IDEE" OF "THEM LADIES."

Across the country women were named to the Board who had made some mark on society—even though they might describe themselves, as some did, as "domestic executive" or "the presiding genius of the home." There were a great many widows, some of whom had carried on their husbands' businesses, and some of whom had launched new ones. There was a "mining millionairess" and a "cattle queen." Many of these women, active in arts, philanthropies and various clubs, already knew one another. There were no black women on the board, and, as Charlotte Smith had noted, no factory workers, although it would seem that the long hours of factory labor would militate against any working woman's ability to serve on the Board, especially since nomination involved travelling to Chicago.

In September of 1890 at their second meeting, the Commission announced the nominations to the Board of Lady Managers. Since letters had already gone out, the announcement was a formality. Battle lines had already been drawn in Chicago: the Women's Department and the Isabella Association represented dramatically the split in the woman's movement between those who wanted women to work for general reform, and those who wanted women to work primarily for their own equal rights.

N November 18, 1890, the Board of Lady Managers convened for the first time. The Directors had been engaged in their work for some months and were swamped by it. The National Commission had been hard at work, too, attempting to limit the grandiose plans of the Directors. Neither body had time to concern itself with the Board of Lady Managers, for whose meeting the Commission hired the banquet hall of Kinsley's Restaurant on Adams Street.

Thanksgiving and Christmas holidays were near, but family responsibilities could not keep the women at home. They made the long journey by stagecoach, train and steamship from California, Florida, Maine . . . all parts of the country. More than one hundred Lady Managers, Alternates and spectators crowded into the hall, which soon became hot and stuffy. The Ladies requested a larger room, but there was none available. Windows could not be opened because street noises would drown out the speakers' voices.

The invocation was given by Florence Kollock, a Universalist minister from Englewood, Illinois, and the meeting called to order by Thomas Palmer, President of the National Commission. He was a familiar figure to suffragists. Lady Manager Helen Barker of South Dakota, for one, had distributed copies of his speeches along with literature provided by Susan B. Anthony, during suffrage campaigns in South Dakota. Mr Palmer said, "I shall not address you in the fanfarade of former custom whereby women were conceded no right but to promote sentimental enterprises." He expressed his confidence that women could perform public duties as well as men could. The Secretary of the Commission, John T. Dickinson, then presented each Lady and each Alternate with a parchment certificate that measured two feet wide by two and a half feet long. Commissioner Palmer said that future generations would cherish these certificates as proof of their descent from Lady Managers.

The Board then proceeded with the business of the day. Rebecca Felton of Georgia was elected temporary chair. In the

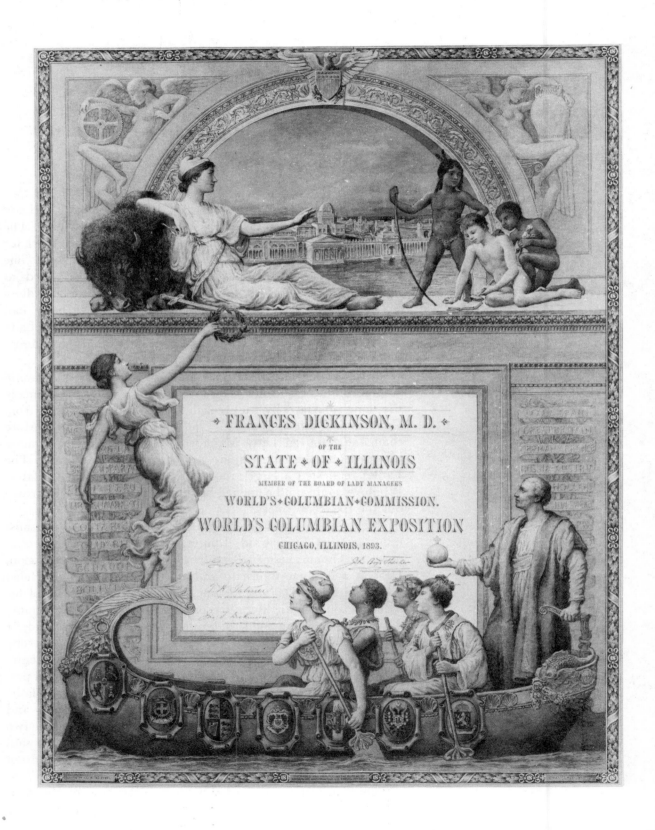

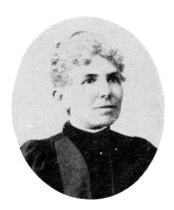

Florence Kollock

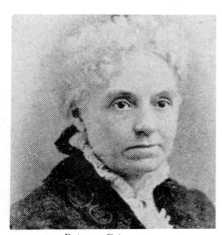

Rebecca Felton

true style of modest Southern womanhood, Mrs Felton protested that she had never presided over so large a body. She experienced such "thrills and nervous chills" that she had to ask for a few minutes' grace to recover from "the agitation consequent upon this novel and trying experience." Mrs Felton was not altogether unused to public life: she had been her husband's campaign manager and press secretary when he ran successfully for the U. S. House and again, later, when he ran for the Georgia legislature. She had been called "a belligerent feminist from the backwoods" who pushed her husband vicariously into office. During her grace period she recovered sufficiently to write a competent speech on the backs of two envelopes she found in her reticule: "I know no North, no South, no East, no West," she said; possibly in the emotion of the moment she believed this to be the truth. Her speech ended with a warning: "Let us remember we are on trial before a great nation. There is a large class in this country who are inimical to us . . . who suppose that we are a superfluous appendage to the . . . Commission." After her speech the Board adjourned.

On November 20 at ten in the morning they reassembled to elect an officer whom they wished to call "President"; the title "Chairman" had been rejected because it sounded "too masculine." Mary Cantrill of Kentucky rose to make the first nomination: she represented a Southern caucus, and her fellow Kentuckian Bertha Palmer was her choice. This was not unexpected. Apart from her position in both Northern and Southern camps, as a Kentuckian who had grown up in Illinois, Mrs Palmer's nomination was attractive to the Commission, because Potter Palmer was a Democrat, while Thomas Palmer and Lyman Gage were Republicans. Thus Mrs Palmer could be a sort of Democratic figurehead to balance things out.

Mrs Palmer's nomination was applauded, but approval of it was not unanimous. Mary Trautman of New York rose to nominate Mary Logan of Washington, D. C., the editor and publisher of a popular women's magazine, *The Home*. She was 53 years old, the widow of General John Logan, a liberal Senator from Illinois and a friend of Abraham Lincoln. Mrs Logan had known Bertha Palmer for years and would have nominated her herself if Mary Cantrill had not done so. Mrs Logan was to have been nominated only if Mrs Palmer declined the honor. Consequently Mary Logan said, "Under no circumstances can I serve you, ladies."

The way was now clear for Mrs Palmer's election. What was not clear were the mechanics of balloting. There was a flurry of motions and secondings. A reporter noted dryly, "The famous Board of Lady Managers got into quite a tangle." Cora Payne Jackson, temporary Secretary, proposed a roll call vote. This was unanimous, except for Mrs Palmer who refused to vote for herself.

Mrs Palmer had social and political connections and great wealth; she had also, obviously, a magnetic personality and a good deal of charm and tact. She had no parliamentary experience; few of the Ladies had such experience. In her maiden speech she said:

> I regret, after such a mark of confidence, that I have to ask the indulgence of the ladies for my inexperience in presiding. I hope when we have been holding meetings as long as the other sex, a knowledge of parliamentary law will be taken as a matter of course in every woman's training. In the meantime we may amend an amendment just a few times too often, or be put in confusion by some experienced and wily tactician springing the previous question.

She urged the women not be overwhelmed by their new responsibilities, but seek aid from one another, and try to keep open minds.

> We must be generously willing to leave for a time the narrow boundaries in which our individual lives are passed . . . In this fresh, breezy atmosphere . . . we will be surprised to find that many of our familiar old conventional truths look very queer indeed in some of the sudden side lights thrown upon them.

Isabella Beecher Hooker

When the Board adjourned for lunch, Frances Dickinson, up till then the lone Isabella, took aside two women whom she had recently recruited: Isabella Beecher Hooker of Connecticut, and Matilda Carse of the Chicago WCTU. Miss Dickinson had been very active: she had also recruited Phoebe Couzins, the redoubtable suffragist, to the Isabella cause. In a little klatsch of Isabella intrigue, the Ladies decided that Isabella Hooker would nominate Miss Couzins for the position of Secretary of the Board. Mrs Hooker, the half-sister of Harriet Beecher Stowe, had founded the New England Woman Suffrage Association in 1868. At nearly seventy, she was the oldest Lady Manager, a hard worker and a strong speaker.

When the meeting resumed at 2:30, the Isabella faction went about electioneering for their candidate. Virginia Meredith of Indiana rose to resolve that the Board confer at once with the Commissioners for an elaboration of their duties. Mrs Meredith was a widow who had enlarged her husband's ranch, successfully bred shorthorn cattle and Southdown sheep and become an authority on livestock and agricultural education. She was also a descendant of Oliver Cromwell. All this did not intimidate Isabella Hooker who objected to Mrs Meredith's resolution. With stern New England independence, Mrs Hooker said that the Ladies should "do their business in their own way." "In a dignified way," Mrs Meredith said, not to be outdone. She was soon

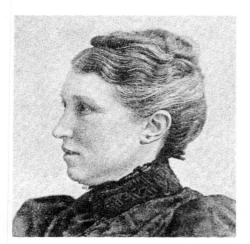

Virginia Meredith

to become Mrs Palmer's parliamentarian. At this point she stopped the busy Isabella electioneering and prompted the new President to call for nominations.

Isabella Hooker spoke first. She called the Board "a kindergarten." Then, perhaps in order to mitigate any resentment her words might cause, she became jovially condescending. "You have shown yourselves good listeners and able to sit still when you have nothing to say, and that is more than some members of Congress are able to do after years of experience." But the Board needed a Secretary who was more than well-behaved; it needed "a woman who can write and who can read loud enough to be heard from one end of the country to the other." She then nominated Phoebe Couzins, of Missouri, whom she had known for twenty years, who had a law degree, and who was the first woman to be appointed a U. S. Marshall.

There were five more nominees for Secretary. One was Frances Dickinson, who immediately withdrew in favor of Phoebe Couzins. Of the remaining four the strongest was Susan Gale Cooke of Tennessee, nominated by Mary Busselle of New Jersey. Mrs Cooke was originally from New York, where she had been administrator of the Brooklyn Orphan Asylum. She had moved to Knoxville with her husband and had remained there after his death working in local charities. She was an amiable woman who inspired loyal friendships. On the second ballot she won a plurality. But no one withdrew. The moderate forces were divided; some had been rather put off by Mrs Hooker's novel approach to campaigning. The Couzins supporters were strong-minded, to say the least, and their candidate finally won over Susan Cooke on the fourth ballot: the votes were fifty-one to thirty-two. In the midst of the applause could be heard murmurs of disagreement.

Phoebe Couzins was at this time fifty-one years old. She had stood with Susan Anthony in Philadelphia to present the Declaration of Women's Rights. Young and wealthy women were now taking up the cause of suffrage: many of them belonged to the American Woman's Suffrage Association, which in 1890 was merging into Miss Anthony's and Mrs Stanton's older and more radical National Woman's Suffrage Association. Miss Couzins was poor and needed the Secretary's salary. She tended to resent the socialite newcomers. She also felt that the Board needed to be reminded of what it owed to the pioneers in the woman suffrage movement.

In her acceptance speech Miss Couzins implied that her election would help to heal the breach between Chicago and her hometown of St Louis, caused by Chicago's rather pushy campaign for the Fair site. "We women," said Miss Couzins, "cemented the bond of union, and in token thereof, I give you, Mrs Palmer, the right hand of fellowship." In the euphoria of the

moment she gave Mrs Palmer high praise as "a woman of gentle birth and high breeding" and "one to whom all our hearts turned in instantaneous allegiance." She complimented the Board particularly on their choice of herself as Secretary, echoing somewhat Mrs Hooker's patronizing tone: "You displayed clear grit straight through the contest . . . You recognized the fact that you needed, in this office, one whose knowledge of public affairs would enable your organization to keep clear of the entanglements oftentimes incident to new and untried bodies . . ." She ended on a note that would seem sadly ironic in the light of things to come: "I trust that no regrets may ever come . . ."

Bertha Palmer unquestionably had doubts about this suffragist and her Isabella-ish supporters. Miss Couzins and her group certainly did not feel at ease with the fashionable President. Mrs Palmer, at the age of forty, had a considerable reputation as a reformer and a patron of the arts. She was a well-known hostess — not the sort of thing to win Isabella Hooker's heart. She had never undertaken anything like the Board of Lady Managers. In addition, she was not a suffragist. She believed in women's right to equal pay and more or less equal opportunity, and she intended that women's participation in the Fair should shed light on their economic situation around the world. The Commissioners and Directors wanted the Fair to prove America's industrial and commercial power, but Mrs Palmer's view of this sort of progress prevented her from joining wholeheartedly in the boosterism of the Fair authorities. Despite her lavish style of living, it is apparent from her impressive public statements that she knew quite well how far behind most women were in the struggle to make an honest living.

But despite her far-sighted activities on behalf of laboring women, Mrs Palmer had an ante-bellum Southern attitude to womanhood in general. She believed in the "womanly" virtues: tenderness, sympathy and intuition. While women should be able to do what they wanted, they should not want to do everything. Their methods in attaining their own ends should never be anything but gentle and womanly. This attitude was certain to spark future disagreements. And it expressed itself in a somewhat disturbing way in the Woman's Building itself.

The question of a woman's building was on many minds during the first Board meeting, but it was not raised. There were more fundamental questions to be dealt with. The Commission had not yet formulated the Board's duties, an omission which caused many of the Ladies to suffer from uncertainty. Most of them were not used in any case to being in the limelight. One woman, E. Nellie Beck of Florida, a former newspaper editor, expressed these feelings in a letter to Mrs Palmer:

Absolutely unaccustomed to recommend myself by my own voice, and as wholly new to public speaking, a total stranger and alone, you will see that I am at a disadvantage. Realizing that so much is expected of me in my own state and that . . . I must not allow myself to be ignored, in very desperation I have tried to 'speak out in meeting' but always with a lump in my throat and a flutter in my heart, not to say a general blankness in my head.

It was natural therefore that some women would come forward as experienced leaders. Isabella Hooker was appointed to head the Committee on Permanent Organization which was to define the structure of the Board: its rules, committees and officers. This Committee of ten, including Myra Bradwell, decided that there should be eight vice-presidents. Eight were duly elected. However six were Republican by marriage or conviction. The Commissioners reported that the Democrats were "dissatisfied," but Thomas Palmer said, "No one has any right to complain of the politics of a lady until she is permitted to vote."

With organizational matters thus entrusted to a committee, the Board began to talk about their Building. Bertha Palmer later wrote:

This was a burning question for upon this subject everyone had strong opinions and there was a great feeling on both sides, those who favored a separate exhibit believing that the extent and variety of the valuable work done by women would not be appreciated or comprehended unless shown in a building separate from the work of men. On the other hand, the most advanced and radical thinkers felt that the exhibit should not be one of sex, but of merit, and that women had reached a point where they could afford to compete side by side with men, with a fair chance of success, and that they would not value prizes given upon the sentimental basis of sex.

Those who had seen the exhibits at the Centennial Woman's Pavilion, or at Julia Ward Howe's Woman's Department at the New Orleans World's Industrial and Cotton Centennial in 1884, knew that the work of women could appear to be trivial, to say the least. Women's labor on farms and in factories was important, but it could rarely be separated from men's work; if it were not somehow separated, it would not be noticed. Most delegates thought there should be a woman's building. But it would have to be different from the two women's exhibits that had gone before.

The women decided finally that their Building would be a special exhibit, something like a museum, illustrating the progress of women through four hundred years. It would be the administrative center for the work of the Board: which was to solicit and process women's exhibits throughout the Fair, and to make sure that they were given fair and equal treatment with the men's exhibits. Frances Dickinson had devised a questionnaire to

accompany entry blanks which would be sent to exhibitors in all
categories. It asked, among other things: "Was this article pro-
duced in whole or in part by female labor?" The Lady Managers
planned to analyze these questionnaires and prepare placards for
each exhibit, telling the public which proportion of each was the
result of women's work. In point of fact, manufacturers rarely
bothered to supply the necessary information, so the plan was
frustrated. It seemed like a good idea at the time, however.

A Committee on Conference was appointed, with Rebecca
Felton at its head, and including Virginia Meredith, the Crom-
wellian cattle breeder, and Mary Logan. On November 24 this
Committee presented a proposal to the Commission. "We do not
request a separate building for women's work . . . We request that
a suitable building be provided and placed under the control of
the Board of Lady Managers for official and other purposes."
The Commission replied to this that they would consider only
whether such a building would be suitable to the overall plan of
the Exposition; the site and the money would have to come from
the Directory.

On November 26 Frances Shepard of Illinois, the regent for
the Daughters of the American Revolution, petitioned the Direc-
tors for "a building to be known as the Woman's Building," and
asked "that competitive designs for this building be invited from
the women architects of this country as well as from men, said
designs to be submitted to the Board at the time of its next meet-
ing . . ."

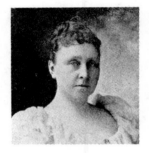

Frances Shepard

This petition was referred by the Directors to the Committee
on Grounds and Buildings, which was just completing its lengthy
negotiations for the use of Jackson Park with the Chicago Park
Commission. This Committee had been working since the end of
April, when the Fair Bill had been signed into law. Early in the
spring the Directors had hoped that the Fair could be situated on
the lake front. They had asked Frederick Law Olmstead to act as
consulting landscape architect with Daniel Burnham and John
Root, the architects of the first Chicago skyscrapers. Abraham
Gottlieb was named consulting engineer. These men looked at
the lake front and reported that it would need dredging, filling
and expansion. The expense was determined to be too great.
Jackson Park then came under consideration, along with Wash-
ington Park and the mile-long Midway that connected the two.
The Directors did not like these partially developed areas which
lay south and west of the city; they were forced to compromise,
however, on a plan to divide the Fair between Jackson and Wash-
ington Parks and the lake front. The Commission repeatedly
requested that they scale down their plans, but they refused to do
so.

They were making plans that were more ambitious than any
that had been made for a previous Fair. The Exposition would

not be housed in a single building, or even a small group of buildings: the Fair would be an actual city with buildings of a unified design set in its own landscape. At the time of the Lady Managers' first meeting the Directors had arranged to pledge to the City for the use of 469 undeveloped acres in Jackson Park, a $100,000 bond, which would be forfeited if the land were not "restored" when the Fair were over.

The bleak stretch of dunes, swamps and scrub oaks offered unlimited scope to the imagination of the planners. Olmstead devised a general scheme of hills, lagoons and terraces; Burnham and Root proposed classical unity of architecture and harmony of scale. Commissions were sent to prominent architects across the country. By November 1890 the Commission had not yet given their approval to this ambitious scheme. They would not do so until February, 1891, and the huge work of dredging and filling did not begin until spring of that year. It was as well for the Lady Managers that the Directors' scheme had not been finally approved in November: the men had no excuse to reject the Woman's Building for aesthetic reasons.

One morning toward the end of the November session the National Commissioners helped the Lady Managers into fifty carriages and took them to lunch at the Washington Park Driving Club. After lunch the carriages rolled through Jackson Park. The scrub oaks stood leafless amid the desolation of "low and marshy areas, partially covered with water," the ground was covered with sand dunes and ridges. It was difficult if not impossible to imagine buildings rising from the swamp, particularly since the Ladies had not been able to get any commitment for their building.

It was nearly the end of their November session and they felt they should have a clearer picture of what lay in store for them than they had been able to get so far: they had in fact no clear picture at all. They were growing impatient. The Commissioners had merely taken them for a ride, so to speak. Phoebe Couzins and Isabella Hooker were beginning to say that the Board owed nothing to the Commissioners, and that it should make its own plans. This did not appear to be a realistic idea, however, to most of the women: they knew the Board had no money of its own, that they must apply to the Commission for everything and that they must have the Commission's instructions and approval.

On the day before the November session adjourned, Thomas Palmer came to the Board meeting with six of his associates. The men were apologetic. Mr Palmer admitted that the Commissioners were anxious to get home for Thanksgiving; he was sorry that they had not had time to deal with questions raised by the Board of Lady Managers. He assured the Board that it would have its building; the task assigned to it, about which the women had many questions, would be to solicit general interest in the

Exhibition. It was not expedient to formulate the Ladies' role any more exactly than that. Judge E. B. Martindale, a Commissioner from Indiana, said that the Commission had just held a "rebellious and stormy session"; they were trying to settle on a site for the Fair. He added, in an obvious attempt to win sympathy, that the press had charged the Commissioners with neglecting their duties.

The Ladies were in no mood to be sympathetic, since they felt they had their own problems. Congress had made no provision for another meeting of the Board, and in fact Mrs Palmer had received the distinct impression that there would be no further Board meetings; they were therefore most disappointed that they had not been able to get a firm picture of their future from the Commission, the body that was responsible by law for their direction and goals. Mrs Hooker, never the soul of tact, spoke briskly to Mr Martindale: "As I understand it, we are to do whatever our hands find to do, not merely to the promotion of women's industry, but we have to join with you, our brothers, in making a glorious success of the whole Exposition."

Commissioner William King of Iowa, the President of Cornell College, told the women that in a sense the relation of the Board and the Commission was that of a marriage. "I hope," he said, "that we will be able to go on together in the united relation pleasantly." Mrs Hooker asked if the Commissioner were making a proposal. "I am sorry if I have been so misunderstood," he said. "I thought we were already married." The Ladies were not disposed to find this amusing. They insisted on a formal definition of their duties. Thomas Palmer attempted to use flattery against them. "I always opposed giving you any instruction . . . Woman has common sense. She has ceased to be a doll or plaything. She has brains, she has energy, she has intelligence . . . We want your ideas to be original; we want you to assert yourselves, and I believe you will do it." Under the circumstances these remarks could only act as an irritant. The women asked when they would meet again. "The Executive Committee of the Commission will come together, if necessary to authorize you to come together," Mr Palmer said. Virginia Meredith thanked the gentlemen for their visit "though they have not touched upon the question." The session then ended.

The Board of Lady Managers, like the Commissioners, were paid six dollars a day while on official business. Many of the Commissioners, and of course many of the public, felt that it would be too expensive for the Lady Managers to reconvene as a full board. Congress was annoyed because the Commissioners had already held two full sessions with little concrete result. The Lady Managers had held a week-long session at the taxpayers' expense. In November, a Congressional investigating committee descended upon the Chicago offices of both the Board and the

Commission in order to see whether they were earning their pay. Some months would pass before the committee's findings were made public, but the Commissioners expected the worst; they were not anxious, therefore, to increase bad publicity by arranging for a second meeting of the full Board of Lady Managers.

While the Board was still in session, the Chicago *Herald* was already exercised about expenses:

> The simple truth is that in its unintelligible and fantastic manner of creating the Women's Board . . . the government of the United States recognized woman neither adequately nor in any sense as a taxpayer . . . Adequate recognition . . . would have led the government to include a number of women on the National Commission. The Board created as a recognition of them is simply a chivalric chimera . . . It is agreeable of course to Chicago to extend the chivalric chimera many social attentions but it ought to be remembered by both hosts and guests that every day the chimera remains officially sitting it costs the people of the United States nearly $1000. As individuals, Chicago is charmed with the Board of Lady Managers; as officials, their spasmodic life ought to be as brief as it is illusory.

The Board meeting ended on November 27. Bertha Palmer and her staff remained in their Chicago offices; their immediate purpose was to settle the question of the Building. Early in December at the request of Chief Burnham, Mrs Palmer's office submitted to him a pencil sketch of the proposed structure. It was roughly 200 by 500 feet, with a central gallery under a skylight. Around the gallery were exhibit and meeting rooms on the first and second floors. A draftsman recopied the sketch and it was submitted to the Directors, who reduced the building's dimensions by 100 feet. On December 26, 1890 the Committee on Grounds and Buildings met, and instructed Burnham to draw up more complete plans. On the following day the Chicago *Herald* said, "Mrs Potter Palmer will probably be successful in her efforts to secure a separate building for a separate exhibit of women's work."

The word "separate" was to some people like a red flag to a bull. It will be remembered that the Isabella Association was still very much in evidence in Chicago, that they were recruiting members and that they had in fact recruited members from the Board itself, under Mrs Palmer's very nose, so to speak. The Isabellas did not want women's work to be separate from men's. Their influence was wide in Chicago, and Mrs. Palmer suspected that some bad press was a result of Isabella propaganda. As for instance this comment from the Chicago *Evening Post*:

> It is gravely to be hoped that the Directors will permit no irrelevant or fantastic argument to weigh unwisely with them as to wasteful expenditure of money, injudicious application of space, or foolish

experiment in purpose. A Woman's Building is utterly without warrant in sound sense . . . a special building that only one visitor in every fifty thousand will care to visit . . .

The Isabellas, like the Board of Lady Managers, kept extremely careful records. In an Isabella scrapbook can be found a clipping from a newspaper. The headline runs: "A Chicago Lady Protests against the Proposed Display of Woman's Work," and the story quotes someone "familiar with the affairs of the Board of Lady Managers," an identification calculated to rouse the suspicions of even the most quiescent Lady Manager. Obviously spies were at work within the organization, and only the Isabellas would be organized enough, and fanatical enough, to tell tales behind the Board's back.

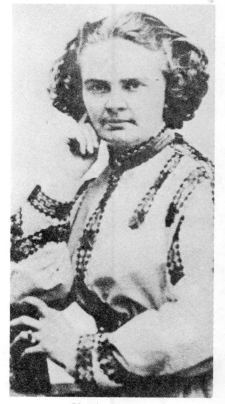

Harriet Hosmer

Your column of World's Fair news in yesterday's paper was of a nature to raise some knotty problems in the mind of a disinterested outsider [writes the anonymous lady]. The doings of the local members of the Board of Lady Managers may appear all right to themselves, but they look a little peculiar, to say the least, to the casual observer. When the Lady Managers were assembled in Chicago, they declared positively and unequivocally against any form of special or separate exhibit of woman's work, and now we are told that a building is to be erected for the display of special exhibits of woman's work, and *O dei immortales!* these exhibits are to be confined to the work of royalty. The query naturally arises, by whose authority is this being done? No such enterprise was even hinted at in any meetings of the Board. Of what use to gather women from all parts of the nation, at an expense to Uncle Sam of $10,000, if the moment their backs are turned all their work is to be overrruled, and new measures instituted which were not even discussed by them? But setting aside the fact that all work done by the local members which has not been authorized by the Board of Lady Managers is illegal and entirely out of order, how could such an idea as that or a building to especially exhibit and protect the work of royal women emanate from an American brain? What a spectacle to present to the gaze of the civilized world! A body of ladies called into existence by the hard work and quick wits of an organized body of working women erecting a building to especially exhibit and protect the work of royalty . . .

The intention in this article was certainly subversive: the Lady Managers did intend to request exhibits from reigning monarchs, but it had never crossed anyone's mind to restrict exhibits to royalty. Mrs Palmer knew that there were Isabellas in her midst, and that they were planning to erect a statue of Queen Isabella, and to build their own Pavilion; they did not want the Board of Lady Managers to exist. All editorial comment hostile to the Board was saved and kept in the Isabella scrapbooks. Much of it may well have been written by the Isabellas; Dr Smith was a journalist herself.

Even suggestions made at the Board meeting were seized upon

and derided in the press, the comments coming from dissident Lady Managers.

> Furnishing cheap boarding places for women who attend the fair was one thing that received much attention. I believe that women who come to the fair, can be trusted to look out for themselves; with what aid they might receive from any ordinary bureau of public information.

This was in reaction to the suggestion that the Board provide an inexpensive Dormitory for women visitors, a suggestion which was in fact carried out.

> Forming classes for the study of American history is doubtless a very laudable enterprise, but I fail to see the necessity of an act of congress to provide funds for plans like that. I can study history whenever I choose. Organizing world's fair clubs in every small town to enable women to come to the exposition, is all very well but it does not need the help of the Board of lady managers of the fair . . . Instead of hunting for plans to educate women before the fair, they should provide an exhibit that would educate women while they are here.

Mrs Palmer was the target of a good deal of hostility.

> The trouble with the ladies who are in charge of the workings of the executive committee, can be stated in one point. Their instincts are to help women by being charitable to them instead of by giving them opportunities to work for what they want. Women who are wealthy society leaders, naturally incline that way. Women of the industrial or professional class would rather . . . furnish a grand display of the work and success of women that would help all who came to see it. Schemes for cheap boarding houses and world's-fair-trip-for-a-prize clubs would never occur to them.

The dissatisfied Lady Manager expressed some ill-will toward the work of the Board.

> The time is now getting so short that I am afraid the building will be finished long before any work has been done toward filling it. However, the committee may have some plans so grand and far-reaching that I cannot grasp them. If so, it is doubtful if they can be carried out in time.

She began to make a list of positive acts, but bogged down after a short time into further criticism.

> My own idea would have them to make a particularly fine exhibit of actual operations . . . I would have a complete exhibit of the silk industry . . . women from all countries where lace is made . . . engaged in that process . . . There should be a display of every operation of making pottery . . . There is no possible use in illustrating kindergarten methods, for that . . . will be . . . covered in the

educational department . . . I have no faith [in congresses] . . . that would draw attention from the Woman's Christian Temperance union . . .

This idea of Mrs. Palmer's to have a working committee of three to serve three or four weeks and then another to succeed them and so on until all the lady managers have had a turn, is one of the strangest things I ever heard of. The result would be a regular piece of patchwork. Who can believe that by the time the work had passed through the hands of thirty or forty committees, each with different ideas, it would have any resemblance to the original? It would be ridiculous. There should be some chief with executive ability. I suppose that it was the intention that Mrs Palmer should fill that position.

If this sort of thing was calculated to enrage Mrs Palmer, it would appear to have succeeded, as we shall see. This same article, which appeared after the succession of Susan Cooke to the secretaryship, to the mortification of the Isabellas, added the remarks of another lady manager to the first:

Another lady manager, who is thoroughly posted on the subject, said: 'At the first meeting of the executive committee the principal topic of discussion was how to provide cheap boarding houses. All their attention has been devoted to such things as that. Time is passing very rapidly and prospects for the woman's exhibit get worse every day. Many members of the board of lady managers are seriously considering the necessity of radical measures of relief. No practical work is being done, and there is no executive ability in charge. Mrs Palmer has not even procured one of the eight vice-presidents to take her place in the president's office during her trip to Europe. Mrs Susan Gale Cooke, whose tenure of office is extremely uncertain, being now dependent on the courts, is left in charge, with the assistance of the clerks. It is only solicitude for the real good of the fair that has caused these members of the board to make their fears public.'

Mrs Palmer was moved to go to the editors of Chicago newspapers and convince them not to print any more attacks upon the Board. In January of 1891 she wrote to Josephine Shakespeare, a Lady Manager, that the newspapers were "antagonistic"; she particularly commented on the Board's having been called a "chivalric chimera," and said: "Since then we have talked to the editors and have shown them how wrong their impressions were and how absurd the pretentions of any other body of women to occupy this field." She wrote to another Lady Manager, also in January, complaining that the Isabellas were "flooding the women with literature" and offering vice presidencies to them. The Isabellas on the Board preserved a bland exterior. Miss Dickinson wrote to Mrs Palmer, a few days after the destructive newspaper articles appeared, "I see by the paper this morning that our Administrative Building is to be in Jackson Park, and possibly a building on the Lake Front erected by the women of

Illinois, which with the Isabella Pavilion will make three struc-
tures in the interest of women on the Fair grounds . . . Certainly
the women of this country can in no better way demonstrate the
power of women in this land and the advance which they have
made in all lines of thought and industry, than to secure on the
World's Fair Grounds several buildings, which should not be
considered a division among women any more than [any other]
various buildings for special interest . . ."

Mrs Palmer did not believe for one moment that Frances
Dickinson was sincere. "It is very surprising," she wrote to a
friend, "that Fanny Dickinson should continue on our board
when she is stabbing us to the heart on all occasions." She said of
the Isabellas, "The deadly enmity they feel toward our board is
most unfortunate." It was hardly likely that she would forgive
the slurs on her executive ability, nor the criticisms of her as a
"wealthy society leader." Mrs Palmer was determined to see to it
that there would be no Isabella building on the Fair grounds.
The battle between the factions was conducted with politeness;
smiles and invitations were the rule. When Isabella Beecher
Hooker was installed as honorary president of the Isabella Asso-
ciation, Mrs Palmer was invited to the ceremony to address the
audience. She declined the honor with thanks. "As I was not pre-
pared to give this seeming endorsement to the Isabella Associ-
ation, I declined to attend," she wrote, with restraint. Her feel-
ings toward Mrs Hooker were cool to say the least. "Mrs Hooker
will do mischief for us," she wrote, by speaking to the Isabellas
with apparent Board endorsement. The Board, however,
"enthusiastically voted down" everything Mrs Hooker proposed
at a recent meeting. Mrs Palmer said, "They do not consider her
a representative member" of the Board. She began to use her
considerable influence to see to it that the Isabellas were
thwarted without positive proof that the thwarting came from
her.

The Isabellas, undisturbed by the fact that they had made at
least one powerful enemy, went on with their plans for a Pavilion
and a statue. Harriet Hosmer, true to her word, had labored
mightily on the statue. Eliza Allen Starr reported to readers of
the *Queen Isabella Journal* that "The 'Statue Fund Certificate', at
the small sum of five dollars, places this honor [of contributing to
the creation of the statue] within the reach of women who cannot
be called rich, while the taking of several certificates, allows the
daughters of opulence to indulge a generous impulse toward one
who has been regarded, during four hundred years, as a woman
whom all may delight to honor."

"Isabella" was intended to be cast in bronze; the queen was
depicted in the act of stepping down from the throne and hand-
ing her jewels, just taken from her neck, to the presumably
excited and grateful Christopher Columbus.

Seal Queen Isabella Association

Souvenir Edition.

Queen Isabella Journal

Issued Quarterly by the Queen Isabella Association to promote the interests of WOMEN at the **WORLD'S FAIR 1893.**

HEADQUARTERS: BAY STATE BUILDING, 70 STATE ST., CHICAGO.

Vol. 3. No. 4. FOURTH QUARTER, 1892. Twenty-five Cents per Year. Single Copies, 10 Cents.

THE ONLY ORIGINAL PAINTING IN THE WORLD OF THE ILLUSTRIOUS QUEEN.

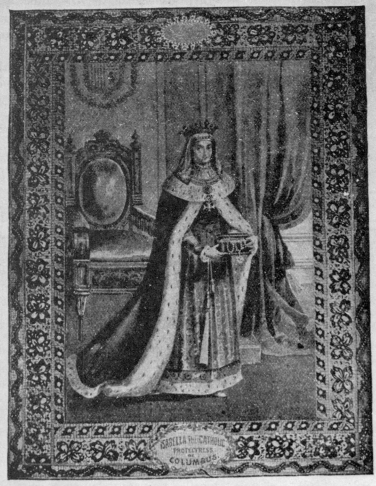

TAKEN FROM THE "STORY OF COLUMBUS."

In addition to Miss Hosmer's commission, the Isabellas had engaged the architect Minerva Parker Nichols to design their Woman's Pavilion. Miss Nichols was to design in 1893 the Century Clubhouse in Philadelphia. This was the first such building planned and built by women. The Pavilion was to be Moorish in style, after the Alhambra, where Queen Isabella was buried. It was to include an assembly hall for congresses, where professional women could read and discuss learned papers: it was hoped that women would derive from these congresses a feeling of equality with men which would enable them to campaign strongly for suffrage. The Isabella Association never lost an opportunity to point out that their Pavilion, unlike the Woman's Building, would be privately funded by devoted members of their Club. The Lady Managers were thus spending public funds to duplicate needlessly buildings and programs which the Isabellas could provide — this position was taken despite Frances Dickinson's sugary assurance to Mrs Palmer that "several buildings" would not signal any "division" in women's interests. The *Woman's Journal* for April 11, 1891 said that Dr Dickinson saw no conflict between two organizations: The government-sponsored Board ought to do what it could and would; it would still leave a broad area of action for the independent Isabella Association.

Early in 1891 the Isabellas made an application for space on the Fair grounds to build their Pavilion, and place their statue. Mrs Palmer was ready for them. On February 13, 1891 the Directory adopted a resolution that the Board of Lady Managers must approve all applications for "ground, pavilions and other structures intended for the exclusive use or entertainment of women in the Exposition." This was a decided blow to the Isabellas who withdrew their application and retreated from the field to plan another assault. The Chicago *Herald* asked rhetorically, "Queen Isabella, Where Art Thou?" and suggested that, after its "severe shock . . . the society may be compelled to go out on the prairie and hold a little exposition all by itself."

Minerva Parker Nichols, Isabella Pavilion

A rumor began to spread that the Isabellas were not receiving sufficient money and that the Association was on the point of dissolution. An Isabella named Mrs Hopkins gave a press conference in August, 1891, to scotch these rumors. She said that the Association had never been "in a more flourishing condition than at the present moment." She could not give an exact figure for membership, nor for cash. She thought the treasury held about $10,000 although "subscriptions are coming in right along at the rate of $50 per day." Ordinary memberships she said, were one dollar, but special memberships, which would allow entrance to the Isabella Pavilion, cost $5. She was asked where "on the lake front" the Pavilion would be located.

"Ah! Mrs Hopkins said. "We have that all fixed . . ."
"With the consent of the Lady Managers?"
"No sir, without."
"How could you do so without their consent?"
"By becoming predominant," she said, "while they are passive."
"What do you mean by that?"
"I can't explain now," she said.

In April of 1891 the Phoebe Couzins Affair had reached the press; the resultant uproar naturally delighted the Isabellas, who saw in it proof that the Board of Lady Managers could not control their membership, nor properly conduct their business. The Association raised money to publicize the Affair — as we shall see in the next chapter — but their collections for the statue of Queen Isabella had bogged down. Harriet Hosmer went on working in Rome, and sending cheery letters to the *Queen Isabella Journal*, while she waited for the money to come to cast her statue in bronze. She was to wait all through 1891, 1892 and through a good part of 1893.

In November of 1891 the Isabellas rallied and submitted an application once more to the Directory. On December 1, 1891 A. W. Sawyer, the Secretary to the Committee on Grounds and Buildings, responded to Corinne Brown of the Association:

Dear Madam:
I have the honor to acknowledge receipt of a communication from the Queen Isabella Association, under date of Nov. 27th, desiring space upon the Lake Front, at Jackson Park, for the purpose of creating a pavilion and statue of Queen of Castile, to be unveiled at the time of the Columbian Exposition. Said communication was submitted to the Committee on Grounds and Buildings at its meeting yesterday, and is receiving the attention its importance demands; as soon as a decision is reached in reference thereto you will be duly informed.

The next day, December 2, Mr Sawyer wrote again to Mrs Brown.

Dear Madam:

In further answer to your communication of Nov 27th . . . I have the honor to inform you that said communication was again considered by the committee at its meeting of yesterday, and upon investigation it was the order of the Committee that said communication be returned to you with a copy of the resolution governing communications of this character, adopted by the Board of Directors at a meeting held on Feb 13, 1891, which is self-explanatory, and is transmitted herewith.

You will readily observe from this that the committee has no jurisdiction in this matter until it comes to it through this channel; hence the communication is respectfully returned to you for its proper reference.

WITH ALL HER WOMANLY FAITH, AND ALL HER EAR-RINGS AND BREAST-PINS, ETC., ETC.

The text of the resolution accompanied the letter.

Resolved, That for the purpose of facilitating business and avoiding misunderstandings in administration, the Executive Committee recommends that the Board of Lady Managers of the Commission be regarded as a channel of communication in all matters pertaining to applications for ground, buildings, pavilions and other structures intended for the exclusive use or entertainment of women in the Exposition, and that in respect to these and similar things the advice and approval of the Board of Lady Managers should be obtained before taking definite action.

Mrs Palmer had carefully boxed the Isabellas in. Nothing daunted, Mrs Brown informed Mr Sawyer on December 6 that she was applying to the Lady Managers as he had instructed, and did on the same day write to Mrs Palmer.

Dear Madam:
In accordance with instructions from the Committee on Grounds and Buildings of the World's Columbian Exposition, we have the honor to refer to you the inclosed application and trust it will receive immediate attention.

Susan Gale Cooke responded to Mrs Brown on December 9.

Dear Madam:
Your communication of recent date, containing application by the Queen Isabella Association, for space within the grounds of the Columbian Exposition, has been received in this office, and will receive early attention. As soon as action has been taken upon it, we will communicate with you further.

A delay then ensued, which can only be called unaccountable, unless one assumes that Mrs Palmer was deliberately building suspense, or giving a great deal of thought to the manner in which she planned to handle the request. Of course, it was the busy holiday season.

On January 19, 1892, Mrs Cooke wrote again to Mrs Brown.

Dear Madam,
I am instructed to inform you that the application of the Queen Isabella Association for space upon the grounds of the Exposition, having come before the President of the Board of Lady Managers for action, she herewith returns the same, to be presented to the proper authorities for the allotting of space upon the grounds of the Exposition, with the following recommendations: —
1st — That the request that space be allotted for the erection of a bronze statue to Queen Isabella be granted, for the reason that there is an evident appropriateness in placing a statue of Queen Isabella within the grounds of an Exposition commemorative of the discovery of America by Columbus; and, furthermore, the material of which the statue is to be made, and the name of the sculptor, Har-

riet Hosmer, sufficiently guarantee the artistic excellence of the proposed work.

2nd — That the request for space for a pavilion for the use of the Queen Isabella Association, receive from the Exposition authorities, as favorable consideration as would be given a like application from any similar club of men seeking such accommodations for the convenience and benefit of its members.

Mrs Palmer knew quite well that no men's clubs were to be allowed on the Fair grounds. She had no desire to cross swords with Harriet Hosmer, whose work she admired herself. In fact while Susan Cooke's response to the Isabellas was hanging fire, Mrs Palmer herself wrote to Miss Hosmer, who was still waiting in Italy for Isabella funds:

We have been expecting you back all winter, with new treasures evolved from your fertile brain and I am anxious to know how the Lincoln is getting on . . .

By the way, how is the statue of Queen Isabella coming on? We hear of it from time to time and I am curious to know if there is really to be a statue . . . if so, what the material is which is to be used . . .

There is no record of any reply from Harriet Hosmer who, in any case, did not want her statue put in the Woman's Building because she did not believe in segregating women's art.

On January 28 Mrs Brown wrote once more to Mr Sawyer, enclosing once again the Isabella Association application for space on the grounds, along with Mrs Palmer's "recommendation." A few days later, on February 5, Eliza Allen Starr, the biographer of Isabella, wrote a long letter to General George Davis, the Director General of the Exposition, earnestly requesting that he use his influence with the Committee on Grounds and Buildings to persuade them to grant space to the Association, particularly for the statue, but also for the Pavilion. Miss Starr's letter was written in a tortured prose which betrayed some mental anguish:

No one doubts that space will be given on the grounds for the noble and significant statue, the exponent of the New World's gratitude towards its benefactor; but the Directors of the Queen Isabella Association earnestly desire to have this space decided upon and officially designated, so as to allow them to take prompt measures for its suitable occupation; as the Gentlemen of the Committee on Space and Buildings can readily understand. This petition granted, the Queen Isabella Association, as a body, believes that the courtesy of the Directors of the World's Columbian Exposition, will be extended to them, through their Grounds and Building Committee, as to an Association which was the first to step into the field of preparation for the fourth centenary of the discovery of America by Christopher Columbus; having been incorporated on the 17th day of August, 1889; and from that date, never having flagged in its

Director-General George Davis

object to secure such a representation of Isabella, as would be for the lasting honor of the American continent, as well as of Isabella; and this, not by soliciting aid from any Legislature or even the National Congress; but, by so rousing the patriotism of the women of America — North America, South America, East, West, as to secure voluntary contributions sufficient to defray, not only the cost of the Statue, but all the expenses connected with it, and to offer their hospitality to the women of the world in such a way as to honor womanhood while honoring Isabella.

That the courtesies of the Grounds and Buildings Committee will be extended to them as a body, for the erection of a Pavilion suited to these purposes, the ladies of the Queen Isabella Association sincerely believe: inasmuch as to accept their offering of a work of Art, like that of Isabella, in bronze, of heroic size, from an Artist like Miss Hosmer, and yet not to allow them, as an incorporated body worthy of recognition, a roof under which they may find shelter, in no way carries out the popular idea of the respect of America for her women to say nothing of chivalry.

Therefore, the Association earnestly and respectfully ask that their application for Space now before the Grounds and Buildings Committee, receive a speedy as well as a favorable answer.

In the name of the Queen Isabella Association. Yours with profound respect . . .

One can imagine the dismay with which Mr Davis digested this letter. On February 13 he acknowledged to Miss Starr that he had received her letter, and informed her that he had referred it to "the Board of Lady Managers of the World's Columbian Commission for consideration and recommendation." This was a far cry from using his influence on the Committee on Grounds and Buildings, and was in fact pointless, since supposedly the Board of Lady Managers had already recommended that the Isabella petition be accepted.

On February 24, 1892, Mr Sawyer responded to Mrs Brown

The Committee are compelled to respectfully decline the application, owing to lack of space on the one hand, and to a previously established rule, on the other hand, that they would not grant any space for the erection of any building of the character of a club-house. It is the opinion of the committee that the Woman's Building should furnish ample opportunity for all purposes of a like character.

The Association expressed its disappointment in March, Mrs Brown saying

The Board of Directors of the Queen Isabella Association have instructed me to express their regret that your Committee did not afford them an opportunity to present their claims in person as agreed upon.

It would appear that the last thing any of the Directors would want would be a presentation of claims by Eliza Allen Starr in person.

The Isabellas were nothing if not persistent. Foiled in their attempts to settle on the Fair grounds, they found a site two blocks from the entrance to the Fair amusement park: on 61st Street and Oglesby Avenue they finally built their Club House. It was not Minerva Nichols' Moorish design, but a sober six-story building in pressed brick and grey stone; next to it they established the Isabella Hotel for women attending the congresses — this despite their earlier cavils at the Board's dormitory idea.

ISABELLA
CLUB HOUSE
....AND....
CONGRESS HALL....

CORNER OGLESBY AVENUE AND 61ST STREET,

CHICAGO, ILLINOIS.

Isabella Club House

They had woefully underestimated Mrs Palmer. She was determined to keep them out of the Fair grounds and she succeeded. The round robin of letters between Mrs Brown and the Directory was a charade. On December 26, 1891 Daniel Burnham wrote to Mrs Palmer, "My understanding is that you will write me regarding the Isabella Pavilion, and that I am then to send to you or to them in reply . . ."

Mrs Palmer went after not only the Isabella Association, but after Queen Isabella herself. She wrote to a friend of hers in the State Deparment named William Curtis, an expert on Spanish and Latin American affairs, to inquire after Isabella's real contribution to Columbus' discovery. Curtis replied that it was "pretty well established that Columbus got his first ideas from papers belonging to his father-in-law, who was a noted admiral." Mrs Palmer toyed with the idea of making a heroine of Columbus' wife, Felipa Monez Perestrello, whose dowry had included her father's maps and charts, and who was herself strongly interested in geographical exploration, having in her childhood made a number of hazardous voyages with her father in unfamiliar waters. She had made many geographical drawings which Columbus used. According to another researcher, Jane Meade Welch, she was highly educated and had enthusiastically encouraged her husband to continue his search for the Indies. Queen Isabella, however, had a firm position in the public imagination, and there was really not enough time to build up Dona Felipa, whose last name was a trifle exotic for Anglo-Saxon ears. Mrs Palmer therefore referred in her speeches to the Queen's generosity and vision, and later secured an act of Congress which enabled the Board to sell an Isabella Memorial Quarter, as a kind of distaff partner to the Columbian Half Dollar sold by the Commission.

In December 1892 the indefatigable Frances Dickinson sent Bertha Palmer fifty tickets for the benefit of the Queen Isabella Statue Fund, with a note, "believing that you will be pleased to honor these by your check." Mrs Palmer resolutely ignored all these solicitations, but she found them irritating in the extreme.

In June of 1893 Harriet Hosmer wrote to Frances Dickinson from Rome, "I thought to be in Chicago before summer . . . but I soon saw that that was difficult, and later saw that it was impossible. I shall soon now be leaving Rome, taking Isabella with me, of course, and after a little stay in England shall set sail and be with you in early autumn." The delay was due to Miss Hosmer's wish to have a duplicate statue made in plaster, in case something should happen to the one she was bringing to Chicago. She had been waiting for a considerable period for the Isabella Association to raise the money to have her statue cast in bronze, and the news reaching her from America did not augur well. "I hear that Isabella has had some hard knocks," she wrote to Frances

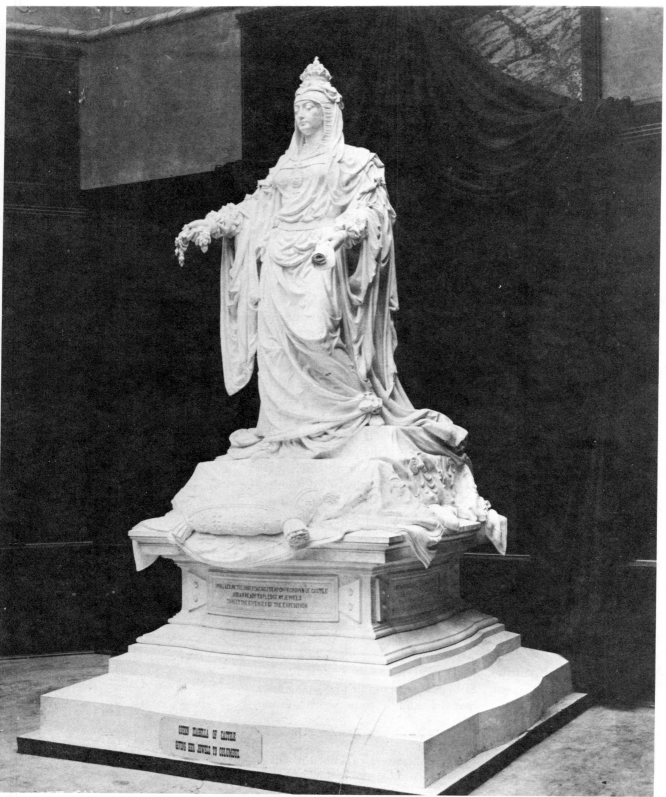

Harriet Hosmer: Statue of Queen Isabella

Dickinson. By the summer of 1893 she had grown somewhat dis-
illusioned with the furor around her statue. She brought it to
America with the idea of taking it to California and having it cast
in bronze for the Mid-Winter Fair in San Francisco. She was no
longer interested by that time, in the Isabella Association, and
she had earlier rejected a bid from Mrs Palmer for the Woman's
Building. Harriet Strong of California asked for the statue for the
California Building. Miss Hosmer accepted this offer and
Isabella, in plaster, came to rest outside the Pampas Palace, a
peculiar structure made wholly of grass. To round out the
curious story of the Isabella statue, we should note that a bronze
replica of it was sold by Miss Hosmer to the Pope, and that the
plaster model, after its sojourn outside the Pampas Palace
appears to have travelled to Golden Gate Park in San Francisco,
from which it disappeared. A story persists that the Jewish
population of San Francisco, irritated by a memorial to a figure
involved to some extent in the Spanish Inquisition, demanded its
removal.

The Isabellas had no idea of the strength of will of the enemy
against whom they had engaged in battle. Mrs. Palmer did not
take lightly the trouble these women had cost her. She was deter-
mined to remove the Isabella Association, not merely from the
Fair grounds, but if possible from the memory of humankind. In
late 1891 or early 1892 Mary Newbury Adams, a member of the
Literature Committee of the Woman's Branch of the World's
Congress Auxiliary wrote the history of the Board of Lady Man-
agers for a book to be called *The Story of Columbus and the World's
Columbian Exposition*. Mrs Adams had given the publisher, F. B.
Dickerson of Detroit, permission to change anything which Mrs
Palmer did not like in the book. After a good deal of difficulty,
Mrs Adams was able to get hold of the proofs of her section of the
book to find it "very different from what [she] sent."

She wrote a troubled letter to Mrs Palmer, since it was obvious
that that lady was responsible for many of the changes. Mr
Dickerson had in fact told Mrs Adams this. "He said in answer to
my inquiries as to what you wished changed that you preferred to
omit entirely what I said of the Isabella Association. I have no
sympathy with them or their object *but without their exertions* we
should have had no Woman's Department . . ." Mrs Adams
recognized that it was necessary to foil the Isabellas "to prevent
the rally under a Spanish Catholic Queen and an association not
controlled by Government." Still, her sense of fair play was under
seige; she was torn between what she thought to be right, and her
considerable respect for Mrs Palmer.

Mary Newbury Adams

Mrs L. H. Stone was greatly pleased the way I explained it. She
had not seen it so before. Still "the least said the quickest mended."
I submit to letting it alone for you are at the head with facts perhaps

I have not, but I took this book to write away from women who wanted to make it sensational. I tried to have it the truth, and without their foresight and previous work at Springfield we should not have the Department. I think in writing up the history they should have due credit for what they did do. Still, I shall change any corrections you gave Mr Dickerson.

Mrs Adams was apparently not satisfied with leaving her letter there; she added a postscript marked "Private of course," and took up the argument again.

I realize how provoking some women have been, but many thousand women have put their money into the Association in 1890 and 1889 and thought that *something must* be done to secure a Woman's Department at a Worlds [sic] Exposition. No other women did the Zouave work that they did, in arousing interest, with *demand* for *woman to have a place.* No space can be allotted them as an Assoc'n anymore than you can the W. C. T. U. or the Federation of clubs or other Associations. All must come under the National Board, but when it is possible to allay the bitter feeling they all have as if their rights had been curtailed, I think it well to do so. One step in injustice to women who work nobly for women will injure the credit of the Woman's Department. I say this not because I insist upon putting in what I wrote but I wrote it so to *in history give them due credit* for what good they did do. The successful can always afford to be magnanimous to the defeated and it is such a disappointment to them after taking the initiative to be put aside as was necessary to give the National Board full power. I thought it better to err on the side of justice than to ignore so important a factor.

This letter was dated March 26, 1892. Mrs Palmer responded on March 27 in an attempt to justify her censorship by denigrating the Isabella contribution to the Woman's Department.

As soon as the Fair was talked of, before it was located in Chicago, two groups of women met in our city and each — almost simultaneously — apparently the same day — organized associations looking to the creation of a board of women to take care of the Woman's Department at the Fair. One organization was called "the Woman's Auxiliary" and its special object was to agitate the subject, under the auspices of the government if possible. The other was the Queen Isabella Association, organized ostensibly to erect a statue of Isabella, but especially to secure recognition as the Woman's Board . . . These two organizations, both wishing to secure the appointment as the Board of Lady Managers (which it was thought would not number more than ten or fifteen) soon were engaged in a most lively war of words . . . The Isabella Association, finding the Woman's Auxiliary a much finer body of women — much more popular — fearing they would lose the game, changed their tactics and asked that the Woman's Board be not local but national — This clamor secured the nine additional representatives from Chicago — one Isabella representative and eight from the Woman's Auxiliary were appointed. Their perseverance gained nine Chicago representatives, but that was all.

On the other hand, suffragists from all over the country claimed loudly that they had been working in Washington with the legislators, and had caused the Board to be included in a section of the Act — That they had but prepared and were on guard for months, got up monster petitions, etc., and they did it. Then Charlotte Smith appeared and said that she was certainly the creator of the Board of Lady Managers; that she sent out 3000 circulars and as many letters . . . appeared before Congressional committees and secured it. Miss Couzins claimed she and other suffragists put it in . . .

Mrs Palmer assured Mrs Adams that Mr Springer himself had told her that he knew nothing of all this activity when he wrote his amendment and that therefore the Isabella Association had done nothing but make trouble, and certainly no one wanted to immortalize an undignified quarrel between women.

On March 31 Mrs Adams responded, again marking the letter "Private."

It was only my desire to have my book correct that I asked you to be sure before the Isabella Association was entirely *omitted*. I wrote nothing to Mr Dickerson about it but told him I consented to omit anything or change anything about the Lady Managers *sessions* that you thought best. Mrs Bagley was so very bitter against the Isabella Association, yet she could give me no facts against them that I thought she was unduly prejudiced. She was determined I should write the part of the book so to keep it from hands that were anxious to make it *sensational and sell.* Now you see I did not want to go to the other extreme but to have it judicially *true.* I knew nothing about the facts of the wrangle as in the very beginning I declined to be even a member of any Isabella Association. *I belong to the Nation.*

Mrs Adams thanked Mrs Palmer for the information, and apologized for having put her to so much trouble. All she really had had to say, Mrs Adams assured her, was "the facts in the case made omission necessary" and she would have been satisfied.

Mrs Adams later had her name removed from the book. Alas for the Queen Isabella Association!

MUNICH EXHIBITION, 1854.

N the fall of 1890 the Board of Lady Managers was being rocked by attacks from the Queen Isabella Association and by difficulties within their own ranks. Along with this, the Ladies were agitated by the physical presence of a quorum of the special House Committee on World's Fair matters. The chairman was John Candler of Massachusetts; other influential members were Roswell P. Flower of New York, Nathan Frank of Missouri, and Representatives Hitt of Illinois and Wilson of West Virginia. It was no secret that Chairman Candler believed that the existence of the Columbian Commission was a foolish waste of time and money, because the Chicago Directory could accomplish everything that needed to be done. It was assumed that Candler's hostility to the Commission would naturally extend to the Board of Lady Managers, which was by law a creation of the Commission. And in fact both the Commission and the Board were larger than they needed to be, or should be, for efficient operation. The Commission had had two full sessions during 1890 at a cost to the taxpayers of $35,000, with little to show for it.

Because there were no clear lines of authority between the Commission and the Directory, an air of antagonism had arisen between these two bodies. Word of this had reached Washington. By November of 1890 Thomas Palmer of the Commission and Lyman Gage of the Directory had created a joint body to smooth out problems. This was a Board of Reference and Control of the commission, consisting of the President and Vice-President of the Commission and six members appointed by the President of the Commission; and a similar board from the Directory. Together they were called the Committee on Conference. This committee had "all the powers and duties of the Executive committee" when that committee was not in session. All "matters of difference" were to be referred to it, and its action was considered to be conclusive.

It was the Board of Reference and Control of the Commission which was to play a leading role in the fortunes of the Board of Lady Managers in the months following November of 1890. Commissioners J.W. St. Clair of West Virginia and E.B. Martindale of Indiana were to become embroiled in a controversy with Phoebe Couzins, the lawyer, ex-U.S. Marshall and suffragist who was elected Secretary to the Board of Lady Managers at its first meeting. At the time of her election in November Miss Couzins believed that John Dickinson, the Secretary of the Commission, had, along with Commissioner Williams of Tennessee, been energetically campaigning for Susan Gale Cooke, also of Tennessee, the Lady whom Miss Couzins had defeated for the office of Secretary. So to the uneasy atmosphere of the Board of Lady Managers caused by the basic lack of rapport between suffragists (professional women — Isabellas) and philanthropists (clubwomen — socialites) was added a brooding suspicion of the men of the Commission and their Board of Control.

Therefore, although both the Commission and the Directory felt that their plan for a combined committee would obviate all serious difficulties in the future, there was a good deal going on in November of 1890 to cause them headaches. On November 14 a quorum of Mr Candler's committee arrived in Chicago to investigate the work done by both governing bodies in preparation for the Exposition, and to make inquiries about what lay ahead. The staff of the Board of Lady Managers were interviewed, and their books were examined. When the committee returned to Washington to prepare their report, the press began to carry dark hints of Mr Candler's intentions. Alarmed, Thomas Palmer, George Davis and Major Moses Handy went at once to Washington to attempt to deflect what they felt could be the very damaging results of the Candler report to the Fair. Mrs Palmer, remaining in Chicago, wrote anxious letters to Ladies in Washington in an attempt to get "authentic information from the inside." No one could give her the reassurance she sought.

In December Phoebe Couzins was settling down to her work as Secretary. She was the auditor of accounts for the Board; without her signature no vouchers could be presented to the Treasury to pay Board bills.

It was her duty also to assemble all minutes of Board meetings so that they could be printed in "digested form." Miss Couzins had undoubtedly made clear to Mr Dickinson her dissatisfaction with him in the matter of his alleged campaign for her rival Susan Gale Cooke: she had no intention of signing a voucher he presented to her in December for payment of a salary to a Lady Manager from Kentucky who had sat in his office registering Lady Managers before the Board meeting. Miss Couzins was convinced that that same Kentucky Lady had, on Mr Dickinson's instructions, told each Lady to "be sure and vote for Susan Gale Cooke" before she registered them. This outrage, combined

with the fact that the sum requested was in excess of six dollars a day, the limit set for Lady Manager recompense, Miss Couzins felt to be justification for her refusal.

Mr Dickinson, frustrated by Miss Couzins' iron will, lashed back at her in the matter of the minutes. He suggested that Mrs Palmer name three Ladies to go over the minutes with Miss Couzins, unquestionably to check up on her. Mrs Palmer appointed the Ladies, and Miss Couzins accepted them, but with the rider that she alone had authority for the printing of the minutes by Rand McNally. The minutes were in a considerable mess, since the Board meeting had been adjourned from Kinsley's hall to the Palmer House clubroom and everything had been "thrown into a sack helter-skelter," and brought by two clerks to Miss Couzins' hotel room. She spent several days sorting them out; by which time she needed to go home to St Louis for the Christmas holidays. On the second of December, therefore, she called her three Ladies together (and they came, except for Mrs Thatcher) and told them that she planned to leave everything as it was until she came back in a week or two. She told them she would give the reorganized minutes to them when she got back. The two Ladies agreed. Mrs Palmer, however, asked Miss Couzins if she could have the proceedings of the last two days' meetings to look at while the Secretary was gone, and Miss Couzins thereupon left everything with Mrs Palmer, and went home.

She returned on December 25 and settled down to work. She had an assistant whom she had hired, Mrs Bullene, a Lady Manager, but she had gone away in her turn for two weeks, and consequently Phoebe was forced to write "out every line and page" of the official minutes herself. Although her health was not good, she sat up nights, according to her later testimony, reviewing every word of the official record of the Board of Lady Managers, "comparing it with the reports, with the resolutions . . . , with the stenographic minutes, with the journal and roll calls." While she was in St Louis, Mrs Palmer had written to her and asked if the digest of Tuesday and Wednesday's proceedings, which had apparently been made by someone other than the Secretary, could be published. Miss Couzins agreed to that.

As she sat burning the midnight oil, and carefully comparing the reports on bylaws with the stenographic minutes which she had, she was considerably jolted to find that one of the bylaws concerning the Executive Committee had been altered in pencil, so as to change its meaning: the President was given complete power to appoint the Executive Committee in its entirety, and the Secretary had no access to that Committee without the President's agreement. There was no longer any access for the heads of the twelve standing committees. The effect on Phoebe

Couzins, with her irascible and suspicious temperament, can be imagined.

She immediately sent for Clara Thatcher, the only member of the Bylaw Committee who was in Chicago at that time, asking her for an explanation of the change, since nothing in the stenographic reports or any of the records accounted for it. Mrs Thatcher replied vaguely that she thought Miss Ives of Connecticut had made the interpolations and that the revised law was the one which would be acted upon. Miss Couzins, now convinced of a conspiracy, immediately wrote letters to every member of the Bylaw Committee and the Committee on Permanent Organization of the Board of Lady Managers asking them if according to their recollection the law forming the Executive Committee had not required that the Secretary and the heads of twelve standing committees should be members of that Committee. According to Phoebe, a majority of the Ladies agreed with her version of the minutes.

COPY OF MUTILATED BY-LAW IN POSSESSION OF MISS COUZINS, SECRETARY BOARD LADY MANAGERS.

On January 15 she brought together all the members of the two committees at a meeting; Mrs Palmer and Frances Shepard were there also. She read to them from her minutes so that they could comment on them. At that time Mrs Palmer, according to Miss Couzins, "could not or would not" give her any definite information about the altered bylaw. Miss Couzins then returned to her work and changed the law back to what she understood it was at the end of the November Board meeting.

Shortly thereafter, on January 17, Candler introduced his report into the House. It was as hostile to the National Commis-

sion as had been expected. It stated that the Commission had usurped powers and duties not intended for it by the act of Congress and that it should virtually stand aside and allow the Fair to be managed by the Directory who had raised all the money in the first place. The Report specifically criticized the organization of the Board of Lady Managers and recommended a reduction in salary for the officers of the Commission.

This Report stirred up a good deal of emotion. The press conjectured that sectional feeling was responsible for this attack upon a National Commission and that Candler wanted to denationalize the Fair. Mrs Palmer sent a letter to all Lady Managers over her signature and Phoebe Couzins':

> In view of the near approach of the convening session of Congress, and the possible modification of portions of the Bill which incorporated the World's Commission, it behooves each and every member of our Board to be especially vigilant concerning that section (6) which relates to the creation and duties of the Board of Lady Managers. And to that end, you are earnestly directed to communicate with the Senators and Representatives of your States immediately, with instructions to carefully guard this section at every point and prevent any change in the status of the law.
>
> The first session of the Board of Lady Managers has fully justified the action of the World's Columbian Commission, which authorized the convening of this Board and prescribed its duties in accordance with the spirit of the Act of Congress, and has indicated to the world that the Commission made no mistake in its numerical ensemble of the Board, while the calm dignity and wise deliberations which have characterized its meetings has compelled the enthusiastic endorsement of a hitherto skeptical public.
>
> It becomes therefore our most serious and imperative duty to see to it that no carping spirit shall overthrow the will of the people in this initial success, and with the eternal vigilance which is ever the price of all good, let us indicate to the World's Columbian Commission our appreciation of its wise comprehension of the act, by directing our legislators to carefully watch, protect and uphold the law as indicated in the Act of Congress.

Mrs Palmer went to Washington on February 21, 1891, as a delegate from the Board to the Women's Council. Before she left, Phoebe Couzins said, "she came to my room and asked if I would postpone the printing of those minutes until she returned. I told her certainly, that it was not my purpose to publish or print anything without her approval."

In Washington Mrs Palmer asked for the support of all the women's organizations which were represented in the Women's Council. Her presence in the capital was fortunate, because Congress at that time appropriated only $42,000 for the administration of the entire Fair. Mrs Palmer immediately telegraphed the members of the Board's Special Finance Committee to meet her in Washington on February 23. She had told them all before she left Chicago that they might be needed in Washington, and that

there were no funds for their travelling expenses. Isabella Hooker, the Chair of the Finance Committee, was already in Washington on Women's Council business; Mrs Russell Harrison was spending the winter there. Among the women who came were Rebecca Felton, Virginia Meredith of Indiana, Matilda Carse and Martha Ten Eyck of Chicago, Mary Cantrill, Mrs Palmer's friend from Kentucky, and Mrs William Reed of Baltimore. On March 2 Mrs Felton wrote Mary Logan:

> I went to Washington—on telegram from Mrs Potter Palmer. I received dispatch Saturday 21st ult to 'go immediately.' I left next day—arriving in Washington Monday 4 P.M.
> Went to Riggs House—saw quite a number of Ladies' Board of Managers—and understood all the Finance Committee had been summoned. I believe I saw them all except yourself in the next two days. I was anxious to see you . . . Mrs Palmer deprecated the idea of going in a body before the Senate Committee to implore them to be just to us—but thought it best to see them individually—each Lady Manager calling on those with whom she was acquainted . . .

Mrs Felton did see three Senators with whom she was acquainted but she told Mrs Logan she "struck hard slate all the way round . . . I felt so discouraged that I came home on Thursday—reaching our town 5:20 A.M. Saturday—a long expensive trip." Other things were on Mrs Felton's mind besides the fortunes of the Fair. She wrote Mrs Logan that she did not go to the "Council over to the Suffrage Convention a single time," because she was "so disgusted with that Farmer's Alliance woman that I kept away—with the hope that our names might never be recorded on the same page or mentioned in the same breath." She had dropped in on the President's family "but missed all but himself," an evident disappointment. The greater part of her letter detailed her irritation with the Farmer's Alliance and her desire that the Republican Party should improve its image in the South.

Mrs Felton's discouragement, partly caused by rain and the vestiges of "la grippe," may well have been compounded by Mrs Palmer's reluctance to allow her and the other Ladies to go before the Senate Committee. Mrs Palmer herself, however, testified before both the Senate and the House appropriation committees. In the House, Frank Nathan of Missouri announced his conviction that the only duty of the Lady Managers should be to staff awards juries, a duty which six women could perform adequately. 115 women, he said, would only "meet and wrangle to no purpose."

Mrs Palmer had to respond to this, and to justify her request for $52,000 for the Board of Lady Managers alone. She described at length, with well-bred passion, the work begun by the Board, and she presented the following estimate of expenses for 1891:

For the expense of one general meeting $15,000
For expenses of two meetings of the Executive
 Committee . 4,000
For expenses of sub-committees, constantly at work 12,000
For salaries of officers, clerks, stenographers,
 typewriters, and messengers . 10,000
For stationery, printing, postage and incidentals 6,000
For other expenses that cannot at this time be
 estimated . 5,000
In all . $52,000

"Is it just," she asked the gentlemen in her soft Southern drawl, "is it wise or practical, virtually to abandon the project, to waste the efforts, to nullify the progress made, to discredit the scheme so well favored in the inception?" Hardly anyone in the room would find such waste and abandonment to be just, wise or practical. "To prevent the work from being crippled in the most fatal manner, we feel that we must have the small sum that has been mentioned."

John Candler balked at paying $15,000 for one meeting of the Board, but he felt the sums for the work of various committees to be reasonable. He assured Mrs Palmer that he was "heartily in favor of women's work." Although he retained his hostility toward the Commission, he could not find it in his heart any longer to criticize the Lady Managers. He told Mrs Palmer that he believed that her Ladies would be "more economical and discreet" in their use of public funds than would the Commissioners. Her reference to $52,000, more than the original appropriation for the entire Fair, as a "small sum" did not cause the entranced committee chairman to bat an eye.

Mrs Palmer was thus able to report a "favorable result of the efforts of our special Finance Committee, except in the matter of the allowance for the meeting of our full Board . . . " Only Mrs Hooker, always something of a thorn in Mrs Palmer's side, refused to accept the lack of funding for a full Board meeting, and insisted that she had a "plan" which would get them the necessary money. "This plan she has doubtless taken the necessary steps to have carried into effect," Mrs Palmer said in her report, with wary forbearance. She had her own plan, which was to get the money for the Ladies' trips to Washington from the Board of Reference and Control, and she was not going to waste a lot of time arguing with Mrs Hooker.

Both Isabella Beecher Hooker and Phoebe Couzins, recruits into the Isabella Association, were basically out of sympathy with their President and watched her graceful maneuverings with a rather sour cynicism. While she was in Washington Mrs Palmer made arrangements with both the Secretary of State and Thomas Palmer to be allowed authority to appoint representatives to go to Latin American countries as emissaries of the Board of Lady Managers. This action Mrs Hooker later called

"remarkable": it would involve appointing "several women to go abroad and gather exhibits of women's work in Columbia, Venesuela [sic], Ecuador, Peru, Bolivia, Brazil, Paraguay, Uruguay, Chile, the Argentine Republic and Central America." Mrs Hooker saw a direct connection between these junketings and the lack of funds for a full meeting of the Board.

> In other words [she wrote] thousands of dollars of our scanty store are to be spent in collecting exhibits from foreign women, while eighty-one members of the board of lady managers are denied an opportunity during the coming fiscal year, not only of meeting each other for conference and comparison of views, but are robbed of the opportunity to make the acquaintance of the resident members of the commission proper . . . And this too when it is manifest that our brothers of the Commission will have foreign agents everywhere on good salaries, with whom our President could communicate in her own admirable manner, and who would not fail, at her request, to prosecute the work for exhibits from women at the same time with those of men.

Like Phoebe Couzins, Mrs Hooker particularly disliked the Board of Reference and Control. Both women distrusted these men and did not recognize their right to act for the Board of Lady Managers. Phoebe Couzins considered that Mrs Palmer and her friends were inexperienced socialites who did not understand the realities of life; the suffragists thought that the men on the Board of Control could easily manipulate the women to gain their own ends. Mrs Hooker saw these men in a dark light:

> . . . I am driven to the conclusion that the board of control has failed to comprehend the great purposes for which the board of lady managers was created by congress . . . We read in the good book that no man can serve two masters, but the board of control has decided that the women of the board of lady managers shall serve three masters—namely, Congress, the Commission and the Board of Control; and have constituted themselves sole interpreters of the meaning and intent of the various Acts of Congress and of the Commission in our behalf. For myself, I repudiate this action . . .

Mrs Palmer returned victorious from Washington at the end of February. Phoebe Couzins, on February 24, having received no satisfactory answer to her question about the altered bylaw called Thomas Palmer into her office to ask his opinion "of this business." He said that the report of the Committee on Permanent Organizations must prevail, and nothing interpolated in lead pencil, even by the Bylaw Committee, could supercede decisions reached after long discussion by the Committee on Permanent Organizations.

At this point Miss Couzins began to feel ill, with chills and fever; there was an influenza epidemic in the city. One might

assume that Mr Palmer would have urged her to go home, but in any case he had a sofa sent into her office and helped her to lie down. She testified later that she put the minutes into her desk and locked it, and then went back to her hotel, where she became so ill with influenza and with erysipilis in her face and neck, that her mother and brother had to be summoned from St Louis to care for her.

On February 23 Miss Couzins had refused to sign a voucher for Mr Dickinson for what she called "extravagant furniture, unwarranted and unnecessary expense in excess of the appropriation for the fiscal year." She later quoted Commissioner St Clair as saying "She had the right to sign vouchers and pass bills and we did not intend that she should." Yet on February 25 she wrote a cordial and confident letter to the Board of Reference and Control with which both Dickinson and St Clair were connected, asking for approval of two clerical assistants.

> Mrs Emma Jay Bullene was highly recommended to me by Mr Thomas B. Bullene, of Kansas City, who is one of the Missouri Commissioners. She is the widow of a nephew of Mr Bullene . . . She came to me on the 27th of November, 1890, and has been with me ever since, save a short absence in January, fulfilling her duties as record and file clerk and accountant in the most thorough and satisfactory manner; and in view of the constantly increasing business in this division, I most cordially submit her name for approval.
> Miss Annette C. Crocker came to this office on the 10th of January, at a time when we were especially filled with stress of business, and needed a stenographer and typewriter at once. Her application . . . for a position as a linguist and translator had been made in Secretary Dickinson's office and in that of the Director-General . . . I herewith append, copies of her letters of indorsement . . .
> As to the salaries these ladies ought to have, I leave that to your judgment and consideration, in view of the complicated developments in Washington, but I ask for your approval of my choice.

This letter was referred to Mrs Palmer, when she returned from Washington, most probably by John Dickinson. Mrs Palmer communicated directly with the Board of Control on her return. She had saved the day for the Commission: in fact Representative Candler went back to the House with a new appropriations bill for the Fair, which was passed on March 4: the Fair was given $95,000 of which the Lady Managers were to have $36,000. Mrs Palmer requested that the Board of Control authorize a full meeting of the Lady Managers in the spring of 1891, a request that had already been denied by the Congress, since it involved an expenditure of $15,000. Mrs Palmer then requested that her Executive Committee be given expanded powers, so that "the Board may still live and temporarily retain its integrity." The Board of Control found no problem with that. Mrs Palmer also asked that the Board of Control "prescribe the

John T. Dickinson

duties of the Board of Lady Managers" and that it obtain payment from the Treasury for her Finance Committee's journey to Washington. During the time she spoke with members of the Board of Control, Phoebe Couzins lay ill in the Grand Pacific Hotel in Chicago.

On March 11 the Board of Reference and Control obliged Mrs Palmer with an agreement to obtain payment for her Finance Committee and with a set of resolutions that would gladden her heart.

One said:

> That in conducting the work herein assigned . . . the same shall in all things be done under the direction and supervision and with the approval of the president [Mrs Palmer] who shall have full and complete control, subject to the approval . . . of the Commission . . . and that all correspondence, clerical and working force and expenditure of money shall be directed, ordered and approved by the president . . .

The other stated that "the Executive Committee of the Women's Board, or its subcommittee [be empowered] in the absence of the board to exercise any and all powers which the said board might exercise in session."

Certainly the wording of these resolutions suggests that Mrs Palmer was intent upon gathering into her hands reins which were being pulled by someone else. Only two members of the Board of Control were present at this March 11 meeting, according to Phoebe Couzins: J.W. St Clair and E.B. Martindale, with John Dickinson, as she sarcastically put it, as "amanuensis." Miss Couzins testified later that "No chairman was present, also that Vice-President McKenzie was in the chair, when at that very moment Mr McKenzie was seriously ill in bed at the Palmer House, of grippe, and President Palmer was down with the same at Detroit (see Chicago papers of date). No quorum was present, although Mr Dickinson says there was, and that Vice-President McKenzie then and there signed reports."

The Board of Control, then, in the persons of two members, offered Mrs Palmer a salary of $5000 a year, which she graciously declined. The Secretary's salary was raised by $1000 a year—a sign, perhaps, that the Secretary was not going to be Phoebe Couzins much longer. Five was the necessary number for a quorum. The President or Vice-President and two members could consider business; two other members could concur to decisions later in writing. On March 31 Commissioners Waller, Massey and Lindsay signed their names to the Board of Control's March 11 decisions.

On the twelfth of March Miss Couzins sent proofs of the minutes to Rand McNally for printing. On March 15 her desk in her private office was opened, as she said darkly, "by a duplicate

Elijah B. Martindale

key and my official data taken therefrom, in order to invalidate proof contained therein which would overthrow the further proposed revolution . . . " This revolution was the appointment of "an illegal Executive Committee . . . or a sub-committee out of it" which would seize the power to change the bylaws. If it were not a revolution, it was certainly a coup.

Mrs Palmer had come back from Washington with the determination to remove Miss Couzins. On March 7 she wrote a letter to the Board of Control, or more likely to Mr Dickinson, responding to Miss Couzins' letter of February 25 which had asked permission to hire Mrs Bullene and Miss Crocker as clerks. Mrs Palmer's letter was clearly intended to help build a case against the Secretary.

> Gentlemen: Your communication of March 6, containing an application from Miss Couzins for the appointment of two clerks in her office, has been handed to me. By our By-Laws our Executive Committee is authorized to recommend such employes and agents as may be necessary, and to define their duties, which fact Miss Couzins must have overlooked at the time she wrote you. I respectfully ask, therefore, that you refer this matter to the Executive Committee of the Board of Lady Managers and, by so doing, you will greatly oblige, yours truly . . .

At this time Miss Couzins had no reason to believe that she was not a member of the Executive Committee herself, since the original bylaws had placed her on that Committee. In addition, Mrs Palmer knew quite well that Miss Couzins had hired Mrs Bullene, at least, and in a letter written to the Secretary in St Louis the previous December she had acknowledged this without cavil:

> I am very glad you wrote me, as I have been hoping to hear from you, although I am sorry to learn that you have been ill. The work has been going on quietly and smoothly in the office, with Mrs Bullene in charge, and we hope to have the minutes as soon as possible . . .
> I have been receiving agreeable letters from many of the ladies, expressing their interest in our work. I hope you will soon be able to return and take charge personally but you must not expose your health by coming too soon.

Three months later Mrs Palmer was writing once more to an ailing Phoebe Couzins, once more in a soothing tone: this time Miss Couzins was aware of the iron hand beneath the President's velvet glove.

> My dear Miss Couzins: I am glad to hear such encouraging reports of your rapid improvement. Pray do not feel nervous about getting back to your desk, but take your time to get well. I heard that you had finished the minutes and sent them to be printed, and I got a

proof which I have partially looked over. As I find there are serious errors, I think the printing should be stopped. Hoping that you may continue to gain rapidly, I am, very truly yours . . .

On March 15 Miss Couzins responded heatedly to this gentle note:

I have just gone over the mass of confused official and unofficial debates again and again, trying to digest the material substance and eliminate the extraneous matter, and I do not understand what you mean by "serious blunders," unless you have reference to the report of the Committee on Bylaws. The Committee made a most "serious blunder" and wholly illegal construction of the Executive Committee, and if that is what you refer to, the "blunder" is theirs not mine. You will remember that just as you were leaving for New York [sic. Did she mean Washington?], I said to you and Mrs Shepard that the minutes were all ready for printing, and that I thought after the proofs were all ready, and I had them, we had better come together again and review them carefully before the final printing. So many interruptions occurred that I did not get the full quota from the printers until after I was ill, and I have not yet received them, nor ordered the printer to go ahead, so that whoever informed you that they were being printed and ought to be stopped told you what is not true and has officiously meddled in what does not concern them whatsoever . . . I have no recollection of ever assuming to act in my office on official matters without conferring with and deferring to you, and in this I proposed to let things stand until I was well enough to review them all again carefully with you.

On March 27 Miss Couzins learned from Mrs Palmer that the Board of Control had passed resolutions to empower Mrs Palmer and her subcommittee with total control over the Board of Lady Managers. On March 28 she went to her office, although Mrs Palmer had apparently requested that she stay away, and spoke with the President and with Mr McKenzie, who told her, possibly for his own protection, that he had signed the Board of Control's report in his hotel bedroom without reading it carefully. Mrs Palmer then told Miss Couzins that she was going to appoint an Executive Committee of twenty-five women, whom she had already chosen, and that no standing committees would be involved with this, nor would Miss Couzins herself. Miss Couzins did not yet know that her desk had been raided: she told Mrs Palmer that these projected actions would not correspond with the official instructions in the minutes. Mrs Palmer was adamant: she told Miss Couzins to notify the Ladies of the appointment of the twenty-five "favored few."

These women came mostly from the North, and included such Palmer favorites as Virginia Meredith of Indiana, Katherine Minor of Louisiana, Mary Cantrill of Kentucky, Mary Logan of Washington D.C., Frances Shepard of Illinois, Amey Starkweather of Rhode Island and Martha Ten Eyck, Clara Thatcher, Marion Mulligan and Emma Wallace of Chicago.

Rebecca Felton, who was in close touch with Phoebe Couzins, wrote to Mary Logan on March 30:

> I congratulate the country on your election—as member of Mrs Palmer's Ex-Committee. Your name and position demanded it, and it came as a matter of course. Mrs P. also selected all of our old Committee of Conference *except myself*—and several of the Finance Committee—also. This was her privilege. Nobody complains.
> She, I think, has made a mistake in selecting this Committee at present, which I presume now takes control of the entire business, until she had become better acquainted with the ladies. Haste has been very evident, for some reason. It was a mistake not to notice so elegant and experienced a lady as Mrs Gov. Stone of Miss. Wisconsin has no member on either board. *From Washington city to the Mississippi river*, the six *states* of Va.—S. & N. Carolina, Georgia, Ala and Miss—not *a single lady*. But Mrs Palmer has a will of her own, and the opportunity to exercise it, and I do not complain.

Mrs Felton then interrupted what might be construed as her complaints, to discuss a few rumors that were circulating: one from Mrs Palmer that people were saying that Mary Logan had actually written Mrs Felton's speech which she gave at the first Board meeting. Mrs Palmer, after agitating Mrs Felton with this information, had assured her that she, Mrs Palmer, always took pains to deny its truth. Mrs Felton obviously wondered whether Mrs Logan herself had spread this report. "I discover a good deal of politics in the movement," she wrote, "or I think I do."

> I see there are to be persons, members of the Board, sent to the Latin-American States—ladies. If the places are not all filled will you speak a good word for me? I write to you freely for your private eye. As Va.—*N. & S. Carolina—Geo. Ala. and Miss.* have no voice— I can only *speak by proxy or go out* without defense, will you be so kind as *to remember us?*
> These *were the states that endured the shock* of civil war—*bound by ties of the strongest nature*—blood-suffering and death—*and yet Mrs P has not noticed a single one*—I was so anxious this should be a Peace Congress of women—*genuine*—but we are despised for some reason. If she had ill will to me—why make the others suffer? The thing is so marked that it will be sure to have its effect. I presume we will not see each other for a long time, perhaps never. I think the *Board has been so emasculated,* and the ninety *remaining will have so little to do, that the play is about over.*

Certainly Mrs Palmer had appointed what she considered to be "an harmonious group" of women; possibly in her haste— because she did move very rapidly when she came back from Washington—she did not consider that she would outrage not only Isabella sympathizers but many Southern women as well.

On April 1 the Commission assembled to consider, among other things, the actions taken on behalf of the Board of Lady Managers by the Board of Reference and Control. Mr Dickinson in advance sent out a form letter to the Commissioners, telling

them that no important business was on hand and their presence was not actually required. This, combined with bad weather and the influenza epidemic, kept down the number of men assembled for the meeting. A fierce blizzard was raging on April 3, according to Phoebe Couzins, "fit emblem of the deed to be done at the close of that dark and stormy day": the deed was the acceptance of the Board of Control's resolutions. Mr Bullene of Missouri read Phoebe Couzins' objections into the record. Nevertheless, the decision to accept the resolution was recorded as "unanimous." Mr St Clair told the Commissioners that Mrs Palmer could safely be entrusted with all the power that they were giving her: she was "not only a grand woman for her character and her intelligence" but she had "in the most dignified, prudent and proper manner . . . saved this Commission from a condition of humiliation which would otherwise have followed from the act of Congress of the United States."

Miss Couzins wrote to Rebecca Felton that she believed her life had been spared, after her illness, "to fight this battle for the Board—for a more infamous attempt at usurpation of all the powers of our Board, has never been known in the history of organizations." She said that she had had to appeal to Vice President McKenzie in order to get a copy of the resolutions of the Board of Control; he had had to order John Dickinson to send her a typewritten copy. Mr Bullene's reading of her protest "was fought bitterly by Dickinson and others" who attempted to pigeonhole it afterwards in the Judiciary Committee from which it was rescued, to very little purpose, as it happened. "Mrs Palmer and all her friends and the members of the Exposition Commission" resident in Chicago were, she told Mrs Felton, "greatly disturbed" over this protest, "as though it were a *personal* matter; whereas it is a question of principle, of right, of vital life of our Board. Whether we shall have an aristocracy with an Executive Committee empowered to change the Bylaws, *if it so please.*"

The Chicago *News* for April 4, 1891 said, "By a practically unanimous vote the Commission vested the President of the Board of Lady Managers with almost autocratic power . . ." Dr Frances Dickinson "who has been most active in opposition to Mrs Palmer's exercise of authority" was present, and conferred with Commissioner Bullene. On Commissioner St Clair's motion, that section of the report endowing Mrs Palmer with full authority, passed.

Dr Dickinson arose as soon as the vote was announced and started to read a protest. Chairman DeYoung told her she could not make an address as she was not a member of the body. Angry at the snub she left, indignantly calling DeYoung "a real mean man!"

On the evening of April 3 Mr Martindale came to the Grand

Pacific Hotel, according to Phoebe Couzins, and told her that his "resolutions had become law," that she was only a "clerk, subject to orders . . . " Apparently he had come to her room once before, after the March 11 meeting of the Board of Control and told her triumphantly that "they had passed nearly $1000 worth of bills for the Board of Lady Managers," to which she had replied that they were illegal without her signature and unauthorized.

As if she were not harassed enough, on April 4 Miss Couzins was summoned to St Louis, where her brother, who had just returned there from Chicago, had suddenly been stricken with influenza. Miss Couzins was herself convalescent, as was her "feeble mother," who had caught the 'flu five days after she arrived to nurse her daughter. They both left at once for St Louis.

After Miss Couzins left, Bertha Palmer notified Rand McNally to stop printing the minutes. On April 8 the Executive Committee met. Mrs Palmer said that "harmonious action" was necessary to the success of the Board; it was difficult to convince the "doubting public and press" of the Board's "clearly defined mission" when the President was "afraid to state [her] plans without antagonizing various opinions." Phoebe Couzins had sent a telegram on April 8 saying she would return as soon as "the slightest change in the invalid was perceptible." This change must have occurred most suddenly, because Miss Couzins was back in Chicago on April 9 and "reported for duty" in the meeting room. She was a little late: with the lightning speed with which Mrs Palmer was capable of moving when aroused, Susan Gale Cooke had just been appointed Secretary *pro tem.* Miss Couzins was "invited to leave the room after roll call." No one who knew her would expect her to obey that invitation. She refused, and Mrs Palmer dissolved the meeting. Miss Couzins never saw the Executive Committee again

> save as an occasional onslaught was made upon my office by squads of two or three, who charged down with demands for reports and inspection which, in my recent depletion of strength and mental anxiety in regard to the invalids at home, brought forth an imperative order from my physician to comply at my peril . . .

The Committee demanded a Secretary's report from Miss Couzins: on April 13 she sent the report. She said that it was "a subject of congratulation" that the Board's work "in the first quarter seems to have accomplished more in proportion to results than the work in the first quarter of the National Commission," since the Board had not only "inaugurated active work in the States and Territories, but, by vigorous Congressional labor through its President and Finance Committee at Washington, saved the National Commission from complete

overthrow which, it is to be regretted, it ungallantly returned by putting us under bonds."

Except for the little slap at the Commission, that was the good news. The bad news was that her work as Secretary was seriously hampered by the President's refusal to allow the mail to be delivered to her office. Also she needed a letter-press and other machinery, which she expected to receive as a result of the Congressional appropriation. She mentioned her letter of February 26th to the Board of Control asking for salaries for her two clerks who had been paid "thus far . . . a meagre sum through borrowed funds." She asked for a retroactive clause for their salaries and mentioned that she knew her letter had been referred to Mrs Palmer for a decision. She did not realize that this request was to be used as a complaint against her.

In conclusion she protested her exclusion from the Executive body, calling the Committee's attention to the fact that they held their offices simply by appointment, while the position of the Secretary and the President was "fixed by election and adoption under the report of the Committee on Permanent Organization November 21st and 22nd . . ."

On the same day, April 13, Phoebe Couzins also wrote a letter to Mr Haynes at Rand McNally.

> I sent you a line yesterday to see me at the hotel, as I am anxious to have those minutes in shape; and it was my purpose to send the proofs to St Louis, but upon consultation with the Committee who were appointed to revise with me the minutes (save Mrs Thatcher), I have concluded to have them printed here; and we are now taking steps to have them paid for independently of the Board of Lady Managers. If you are agreed to this I will be over in the course of an hour and indicate a few changes in the proof of the last two or three days. I am also legally advised that the President cannot control the minutes of the Secretary, especially if the Committee, appointed by the Board at its last session, agree with the Secretary as to the correctness and revision which a majority do. So, please print nothing save by my order.

This action further agitated the Executive Committee. At the afternoon session of April 14 Mrs Mulligan, who was one of the members of the committee of three appointed to revise the minutes with Miss Couzins, said that she had seen Miss Couzins a week or two before the holidays and that her understanding was that the Secretary was "to make those minutes out in good shape" and "submit them to the President for approval." Mrs Mulligan added that she had never had a proof of the minutes nor had she received any official notification of the meeting of the committee on revision. Clara Thatcher said that she was chairman of the committee appointed to revise the minutes and had never been asked, either verbally or in writing, to take any action on those minutes.

The Executive Committee now felt justified in drawing up a

series of resolutions against Phoebe Couzins. These were passed unanimously, according to the record:

> WHEREAS, The Secretary of the Board of Lady Managers of the Columbian Commission has not performed, in an acceptable manner, the duties of her office; and
> WHEREAS, Either by negligence or intention, the minutes of the November session have been grossly distorted; and
> WHEREAS, She has taken steps to have printed, at the expense of some party or parties other than the Board of Lady Managers, the alleged minutes of that body, not yet approved by the Committee appointed at the November session of the Board; and
> WHEREAS, She has incurred unnecessary expense in conducting the business of her office; and
> WHEREAS, She has, in response to a request for a report, transmitted to this Committee a communication disrespectful both to the Board of Lady Managers and the Columbian Commission; and
> WHEREAS, She has written disrespectful letters to and concerning the President and other members of the Board of Lady Managers; and
> WHEREAS, She has given expression through the public press to opinions and sentiments that tend to destroy, in public estimation, the dignity and standing of the Board of Lady Managers; therefore be it
> RESOLVED, That a committee of three be appointed to notify the Secretary . . . that charges have been preferred against her, and summon her to appear before the Executive Committee and answer said charges at 11 o'clock tomorrow, Wednesday, April 15.

On April 15 the committee appointed to speak with Miss Couzins reported that they could not find her in her office that morning, nor had she been there the previous afternoon. They left the meeting to present the resolutions to her at her hotel and ask her to appear at noon. Miss Couzins had sent a letter addressed to Mrs Palmer and the members of the Executive Committee:

> I am just in receipt of a resolution without date requesting me to appear tomorrow (Wednesday, April 15) [sic] which has not been authenticated by the President, summoning me before the Executive Committee, on the ground that charges are to be preferred against me. In the absence of any knowledge as to the definite character of the charges to be preferred, I must refuse to appear. Although I do not legally recognize your right to arraign me before the bar of your Committee, I am most heartily willing to appear and answer any charges; such charges must, however, be clearly set forth in writing and sent to me before I appear.
> A supposed criminal has the right to know before appearing whether he or she is arraigned for grand larceny or murder, and make suitable preparations for defense. And inasmuch as we are a body organized for national work and national inspection of our proceedings, this examination must be conducted with open doors.

When she did not appear at noon, the Committee extended

the time for her appearance to 3 p.m. At that time, she did not, of course, appear; a committee was sent to give her the following message:

> In view of the fact that the relations existing between the Secretary of the Board of Lady Managers and members of that Board are so strained as to interfere with the discharge in the best manner of the business of her office, and in order to promote the harmony that it is imperative should exist between the Lady Managers and its officers if the grand work of the Board of Lady Managers is to be carried to a successful issue — in view of all this, it seems to us desirable that you should resign your office.

As a sort of compromise the Committee suggested that they would "very possibly" agree "upon certain conditions" to allow her resignation to take place June 1, and to grant her leave of absence from that date. They ended the message with a rather nervous recapitulation of the charges in the resolutions:

> We have reached this conclusion after considering several charges that have been informally made in regard to you as the Secretary . . . and your method of conducting the business of this office. You have, we think, incurred unnecessary expense in carrying on the business of your office. You have sent to this Committee, in response to a request for a report, a communication that is disrespectful to President and members of the Board . . . You have written letters to and concerning the members of the Board that tend to produce discord and destroy the usefulness of the Board of Lady Managers.

Miss Couzins was informed that final action would be taken at 4:30 p.m. At that hour a resolution was unanimously adopted that since Phoebe Couzins had been notified to come before the Committee to answer "complaints of misconduct and neglect of duty" and had not come, and since the Committee was satisfied that these complaints were "well founded" and that the "public business" of the Board could not be properly conducted while she held office, and that she would not discharge her duties in proper co-operation with the President and members of the Board, she was thereby removed from office.

On April 16 at 12:11 p.m. Miss Couzins sent telegrams from Chicago:

> Executive Committee have declared my office vacant I call upon the women of the South to stand for Justice and right.

Another telegram sent the same day read:

> Address our Secretary simply Phoebe Couzins Grand Pacific Hotel Otherwise no mail reaches her.

The uproar that ensued from this action of the Committee was

considerable. The "business and professional women" of the city of Chicago held a "mass meeting"in the clubroom of the Sherman House Hotel on April 16; all but two women signed the following resolutions:

> RESOLVED, That we view with much solicitude the differences which have arisen between the Executive Committee of the Board, acting under the authority of the Board of Control, and the Secretary of the Woman's Board; a solicitude based not merely upon our desires for harmony in the Board . . . or even exclusively upon our desire for the success of the Fair itself, but upon our fear that such proceedings will result very unfavorably to women's interests generally throughout the world.
> RESOLVED, That we do not understand how the Board of Control can have any right or authority to change the by-laws of the Woman's Board, much less to authorize any committee or subcommittee to change them without the consent of the Lady Managers.
> RESOLVED, That the effect of this entire proceeding, if carried out, would be to destroy the Woman's Board as a national organization.
> RESOLVED, That we condemn most emphatically the ruling of the Board of Control which transfers the correspondence of the Woman's Board from the Secretary to the President as a most unprecedented and unjust proceeding.
> RESOLVED, That we have viewed with amazement the unbusinesslike and unjust methods employed in attempting the removal from office of the Secretary . . . and that we extend to Miss Couzins . . . our hearty sympathy, and promise her our co-operation and support.
> RESOLVED, further, That we call upon her to stand firmly in her position as Secretary of the Board of Lady Managers.

On April 17 Rebecca Felton wrote to Phoebe Couzins:

> We are told that you were not only discharged but locked out of your office and this goes to the whole country. Can this be possible? Whatever complaint may be lodged against you you are entitled to get a proper trial before a competent authority—a trial by your peers.

On the same day Isabella Beecher Hooker, who was firing letters off to various members of the National Commission, wrote to Rebecca Felton:

> I shall probably resign to give my whole time to Queen Isabella—who being a Queen in her own right cannot be subject to any Board of Control. I cannot understand Mrs P—I loved and admired her.

If Mrs Hooker's attitudes seem contradictory to us, they were no less so to the Board. Josephine Allen called Mrs Hooker "an enigma. Sometimes she is bitter and sometimes complimentary—we seem never to know where to find her."

On April 23 Emma Jay Bullene, Miss Couzin's employee, wrote to Rebecca Felton:

Miss Couzins is clearly in the right but we must still accept the fact
that justice does not always obtain the ascendancy over wrong. Mrs
Wise of Virginia is so indignant she has resigned—[This act was
done] by a few lovers of self-aggrandizement.

Mrs Eva Douglas Wise of Virginia did indeed write an open
letter to Mrs Palmer which duly appeared in the newspapers.
She had written to Phoebe Couzins in January to tell her that
she recalled perfectly that the Executive Committee was to be
comprised of the members of twelve standing committees and
she had a copy of the printed minutes of November 21 which
corroborated her memory. Mrs Palmer was responsible for those
minutes: she had accepted paragraph four of the report of the
Committee on Permanent Organization where the description of
the Executive Committee was printed. That description had
never been amended, and Mrs Palmer's action was a complete
shock to Mrs Wise. She had in fact written at once to Mrs Palmer
demanding an explanation of how she could have appointed the
entire committee herself, and had not received a reply.

The Chicago *Times* for April 16, 1891, carried part of a letter
from Eva Wise to Phoebe Couzins:

Eva Douglas Wise

> It seems that the process of swallowing itself began in the commis-
> sion itself, almost immediately after our meeting adjourned. The
> commission created out of itself a smaller body, called a board of
> control, and that swallowed the executive committee, which com-
> mittee had already swallowed the commission . . . The board of
> lady managers had been swallowed by our own president.

This was washing dirty linen in public with a vengeance. The
Board's Executive Committee was left attempting to defend their
action. On April 27 Mary Logan wrote loftily to Rebecca Felton
that "Miss Couzins was without physical strength or comprehen-
sion of the duties of her position and had failed utterly in the dis-
charge of them." Virginia Meredith wrote on May 5 to Mrs
Felton, who was obviously greatly disturbed by the treatment
Phoebe Couzins had received, "To my mind the worst offense of
the Secretary was disrespectful letters she wrote to members
about other members."

On April 27 the Board of Control convened: the twenty-six
women of the Executive Committee went before them and
preferred charges against Phoebe Couzins. She was summoned
to come before both men and women of the Board and the Com-
mittee, a thing she certainly would never do. At this time her of-
fice was opened by Mrs Palmer so that her papers could be
examined. She then sought an injunction in the circuit court of
Cook County against the actions of the Board of Control and the
Board of Lady Managers.

Her position was that the Board of Reference and Control of

the Commission had no right to legislate for the Board of Lady Managers, since the direct Congressional appropriation of March 4 of $36,000 for the Board of Lady Managers made that group a separate entity in its own right. If Congress had given the appropriation to the Commission with instructions to give it to the Ladies, then that would have indicated that they were an arm of the Commission. Congress did not do that.

The Board of Control protested Miss Couzins' injunction, and managed to have the case transferred from the circuit court to a Federal court. The argument was made by Edwin Walker, a member of the Board of Reference and Control of the Directory. It would appear that this case belonged under Federal jurisdiction, since Phoebe Couzins was suing a body brought together and funded by the United States Congress. In any case, the Federal judge, Judge Gresham, had recently drawn up a will for Potter Palmer, and had told Mrs Palmer that he believed the Board of Control's actions were legal. He therefore had to disqualify himself, and Judge Henry Blodgett, his colleague, took over the case.

If Mrs Palmer wished to present a unified front to the country, she had attacked the wrong woman. Letters were flying all over the country; many of them from Isabella Beecher Hooker who wrote to the President of the Commission, to all the Lady Managers, and to the Secretary of the Treasury, asking him

1. To whom will the $37,000 [sic] given by Congress for the use of the Board of Lady Managers be paid and for what purposes?
2. As Chairman of the Committee of Finance have I any duties present or prospective in relation to this appropriation? Permit me to add that I was chairman of the committee on permanent organization and do know that with entire unanimity our Board decided that the President should appoint twelve standing committees on classification to correspond with those of the Commission and that the member selected by each committee for that purpose should become a member of the Executive Committee and the other twelve members of the Executive Committee should be appointed by the President who was to be chairman of the committee and the Secretary to be a member of it in order to record its proceedings but without a vote . . . it was with surprise and regret that I learned from the newspapers that under the influence of the Board of Control [Mrs Palmer] had appointed the whole Executive Committee and summoned them to meet in Chicago on the 8th of April.

Inevitably, letters went to Representative William Springer in Washington. He attempted to bring the "Phoebe Couzins Case" before the World's Fair Committee of the House. He asked for a resolution saying that since Miss Couzins had been deposed, and since a serious doubt existed as to whether the president had the power to depose the secretary, the World's Fair Committee believed it to be in the best interests of the Fair that Miss

Couzins should be reinstated as secretary until she was legally deposed by the vote of the entire Board of Lady Managers. He did not want a vote on this matter at once, but wanted the resolution on the record.

As often happens in matters concerning women, the committee members chose to make merry over this resolution. The Chicago *Times* of May 13, 1891, made everyone look foolish.

> Decorum was an unknown quantity when this [resolution] had been read. A dozen members were gesticulating and indulging themselves in alternately asking recognition and poking fun at Mr Springer. Mr May moved to table the resolution, but Mr Springer . . . had not relinquished the floor and wished to speak further. He said he did not know Miss Couzins, whereupon there were derisive shouts, necessitating the use of a paper-weight by Capt. Farrell with renewed vigor. This warmed Mr Springer up and he scored the committee for ridiculing his utterances which were made in good faith. He was simply acting in response to communications he had received urging him to do what he had. He maintained that the resolution was introduced not for action, and consequently the committee could not exercise jurisdiction over it until he moved its disposition.
> "It is not in the hands of the committee yet," reasoned Mr Merritt.
> "The clerk has received no copy yet."
> "It has been passed over on the table," retorted Mr Paddock.
> "I simply passed it over to the clerk of my own committee," explained Mr Springer.
> "There is nothing before the committee," insisted Mr Merritt.
> "The committee can do nothing with the resolution until the member introducing it moves its disposition."
> "Well, if there is nothing before the committee what is all this argument about?" queried Mr Reed of Gallatin.
> When Dorsey Patton, in the interest of harmony, sagely remarked that the resolution should be treated seriously and proper respect shown Miss Couzins.
> "We don't want to hear anything about Miss Couzins," interjected Capt. Farrell. "I do not think the gentleman should bring up anything here regarding Miss Couzins."
> "A motion to adjourn is in order."
> "Ain't I in order, Mr Chairman?" petulantly inquired Mr May.
> "There is nothing before the committee," was Chairman Farrell's decision, and he declared the committee adjourned.

Also in May the Chicago *Daily News* carried a news item headed "They Have been Idle. Complaint of Lady Managers. No showing of Woman's Work Arranged for the World's Fair." The complaining Lady Managers are not identified, but appear to be "the local nine" who "object to the small part allowed them in the management" and

> argue that under the act of congress they were to be the executive board of the management [and] . . . that the methods recently adopted by the executive committee . . . are not conducive to concentrated effort. They criticize the delay in appointing committees

to push the work [which] is in a state of lethargy, and that no one knows what to do.

The unidentified Ladies said that

everything is stopped in the line of providing exhibits or seeking appropriations for the women's department. Mrs Potter Palmer went to Europe last week for three months. Her trip is not made in the interests of the fair, although she will spend much of the time in Paris, getting information about the Paris exposition, but is merely her summer vacation in Europe.

The above article was pasted up in the Isabella scrapbook, with the annotation by Frances Dickinson that she did not know with whom the interviews were held.

Throughout the summer the scandal continued. Judge Blodgett brought in a decision against Phoebe Couzins, supporting Mr Walker's claim that the Board of Lady Managers belonged totally to the National Commission which could alter it in any way it chose. Miss Couzins and her lawyer, Judge C.B. Waite, then amended their original bill, before making an appeal. Miss Couzins' position was, still, that the Board of Lady Managers could not come before Congress for an appropriation, as it continually did, if it were simply a subcommittee of the Commission.

In June Isabella Beecher Hooker wrote to Mrs Palmer, telling her that she should have consulted Rebecca Felton and Mary Trautman before taking her actions, and that she had made a "calamitous" mistake in omitting the South from the Executive Committee. Everywhere she went she met inquiries about the "women's quarrel"; if she spent all her time explaining this, she would have little time for anything else. Mrs Palmer, she felt, had betrayed the trust given her for "this great cause of womanhood." The Board had been "practically annihilated."

Mrs Palmer wrote back to Mrs Hooker from Europe in July. "I cannot agree with you as to our Board being annihilated . . . I am certainly in a position to know better than anyone else, for I have daily to ask recognition and favors of all kinds for it and . . . it has grown steadily in power and prestige . . ." Mrs Palmer admitted that she was "much annoyed" that Miss Couzins was "making daily antagonistic and derogatory statements about us in the papers" but she was satisfied that Phoebe's "little ripple of excitement" would do no permanent harm. She noted also that "many ladies whom she claims as her supporters" say they have been misrepresented by her. She agreed with Mrs Hooker that a meeting of the full Board was necessary so that the Ladies could understand fully both "money matters" and the "misleading literature" which had been "so prodigally sent out"

by people "whose object must surely be the destruction of your Board."

Mrs Palmer was not without support. On July 11 Julia Ward Howe wrote to her from Newport, Rhode Island, that although she realized that the President was not connected with any suffrage association, "a good many of the best of the suffragists are with us." Mrs Howe did not care for Phoebe Couzins: "The suffragists with whom I work have always been against her, finding her full of conceit, arrogance and assumption." Mrs Howe did not think Miss Couzins had any abilities "except in putting herself forward and in making great claims upon public recognition." Mary Lockwood, who had supported Phoebe for Secretary, Mrs Howe called "another sounding brass." She sympathized with Mrs Palmer in her difficulties; she too had had many experiences in the past with organizations where, she noted, "a good many of the women were on the make."

Mrs Palmer returned from Europe to find the controversy still raging; doubtless she had hoped it would die down while she was gone. She gave up her August in the mountains to try to pull the ravaged Board together and get ready for a full meeting in September. She wrote some letters about Phoebe Couzins ostensibly more in sorrow than in anger. To Mrs Busselle of New Jersey Mrs Palmer said that Couzins "is a very frail poor woman and quite worn by the constant anxieties of her life. The fragments that have reached me are quite pitiful. Unfortunately instead of softening they seem to have made her bitter and suspicious." Actually Mrs Palmer was not eager to relieve poor Phoebe of her constant anxiety. She wrote to Mary Logan, with whom she could be frank, that both Thomas Palmer and the Board of Control felt sorry for Miss Couzins and wanted to send her abroad as a foreign commissioner. This appointment would have relieved her financial distress and helped to soothe the humiliation inflicted on her by her dismissal and the accusations of incompetence against her. Mrs Palmer had strongly objected to the foreign post for Miss Couzins; she feared that the former Secretary would "spread antagonistic views throughout the world." Miss Couzins consequently did not get the appointment.

Mary Busselle

To Mary Trautman of New York, who had been upset by the Executive Board's actions, Mrs Palmer took a tone of injured compassion. She wrote that when Miss Couzins took her seat

> she couldn't see and she couldn't write, so the typewriter told me . . . without her hand swelling up and becoming painful . . . She got a stenographer to serve as her maid and take off and put on her gaiters . . . I saw all that at once and never mentioned it because I felt sorry for her and it was only when she began to show bad faith and spread discord in addition to her incompetence that I felt it was not fair for our Board to be imposed upon.

Mrs Trautman commented tactfully that "it seems too bad

that such petty things will be allowed to divide such a splendid organization." Indeed, Mrs Palmer's comments here are not convincing. Mary Trautman, however was sincere: she urged Mrs Hooker to ask Phoebe Couzins to drop her agitation against the Board "and join us in peace and harmony." Miss Couzins refused. She had come all the way to New York in August to attend Mrs Hooker's golden wedding anniversary. The unpredictable Isabella Hooker was surprised to see her, but not overjoyed. She was growing tired of the controversy and commented that Phoebe "should not expect sympathy."

Mrs Palmer did receive sympathy from some of the Ladies she contacted. Josephine Allen wrote to her that she had received "liberal supplies of printed matter from Frances Dickinson." She had apparently not spent a lot of time reading them because she wrote to Bertha Palmer

> Your sensitive nature must be wounded continually. And it does seem such a shame that the attention which you would so gladly give to the Cause must needs be divided and partly given to plans for dealing with mischief makers.

The "call" for the full Board meeting, to be held September 2, was sent out on August 15, 1891. Though Congress had denied Mrs Palmer $15,000 for a full meeting, they had not specified what the $36,000 appropriation could be spent for. Mrs Palmer believed that she had to justify herself to the Ladies quickly. She wrote later that she dreaded the first day of that meeting but she "felt it absolutely essential to the preservation of good feeling in carrying out our work. I felt whether my head or that of Miss Couzins fell in the basket, the board should meet, decide as to its record, and put a stop to the scandal Miss Couzins was creating."

The dissidents gathered around Isabella Beecher Hooker before the meeting began: among them were Cora Payne Jackson, once Miss Couzins' clerk, Rebecca Felton and, of course, Frances Dickinson. Commissioner St Clair met with these women in an attempt to dissuade them. He took responsibility for giving the Executive Committee the power to amend the bylaws: this, he said, was an emergency measure that had to be taken because Miss Couzins had refused to sign vouchers. He hinted at a possibility that the Board of Control would rescind this power, as well as Susan Cooke's appointment as Secretary; there might be a diplomatic post for Miss Couzins and an open election for Secretary if she and her supporters would drop their quarrel.

Mary Logan, whom Miss Couzins referred to as "a political marplot in petticoats," was angered by Mr St Clair's overtures. She wrote a letter of complaint to Thomas Palmer, saying that his duties did not involve the appeasement of ill-tempered peo-

Josephine Allen

Susan Gale Cooke

ple; the Government should not be asked to hire them out of pity. Mr Palmer backed off: he deeply regretted that Miss Couzins had behaved so stridently. The diplomatic post for her was now out of the question, since any such action toward her would reflect badly on Mrs Palmer and Mrs Logan. "I do not see how she can be suppressed," Mr Palmer said sadly.

The meeting began on the morning of September 2, 1891 at the Apollo Music Hall at 69 State Street. The hall was crowded, as might be expected after so much public squabbling. Mrs Palmer faced the room across a table banked with flowers. Next to her sat a Colonel Payton who had been hired by the Commission to act as temporary secretary. Next to him sat Phoebe Couzins, armed with a printed members' roll and a pencil. As the Colonel called out the Ladies' names, Miss Couzins grimly checked them off. No one had attempted to interfere with her. Everyone was in fact nervous: the Commissioners were prepared to call in a marshall, if necessary, and to adjourn the meeting if trouble started.

Mrs Palmer announced that since the last meeting, in November of 1890, the office of Secretary had been declared vacant, and that it must be now filled through election. Mrs Bagley of Michigan nominated Susan Gale Cooke; this nomination was seconded.

Frances Dickinson asked for the floor, stood up and paused. At this point Miss Couzins rose. "Ere you proceed further," she said in ominous, Gothic tones, "it is desirable to know whether a committee, a few, have the right to usurp the functions and undo the work of the full Board." Shouts of "Out of order!" followed this question or statement, and she resumed her seat. The voting then began at once, with only one nominee. Mrs Cooke received seventy-three votes; seventeen women abstained, including Mrs Hooker. Mrs Cooke, who had in fact been Secretary since the previous April, gave a short speech: "I realize that the least heard from me at this time, the better, but I cannot allow this opportunity to pass without assuring you how deeply I feel this expression of your favor and confidence . . . I thank you heartily."

Mrs Palmer then rose to give a very long speech indeed; it filled thirty-two pages of the minutes. Most of it was an attempted refutation of the charges which had been levelled at the Board of Control and the Executive Board over the past five or six months. The Board of Control, she said, was legally in charge of the Board of Lady Managers; the resolutions which the Board of Control passed were merely "a change in our methods of organization." Furthermore, they increased the power and scope of the women's Board.

The general tenor of her address ran thus. She was occasionally interrupted from the floor by comments and questions.

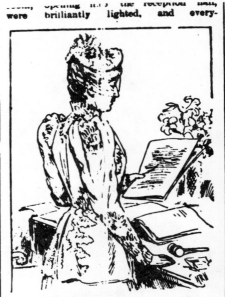

were brilliantly lighted, and every-

THE PRESIDENT READING HER REPORT.

where were chrysanthemums of various colors in profusion. The dining-room in which refreshments were served was also similarly decorated. Music was furnished by a mandolin orchestra.

The gathering afforded an excellent opportunity for the members of the different boards and committees working for the success of the Columbian Exposition to become acquainted with each other. All the principal officers were present, and, with few exceptions, all the States of the Republic were represented in the persons of members of the Board of Lady Managers and National Commission.

Mrs. Palmer wore an exquisite costume by Worth, in silver white silk en traine, with diamond necklace and tiara of brilliants. She was assisted in receiving the guests by those of the Vice-Presidents of the Board of Lady Managers in the city.

Mrs. Trautman, the First Vice-President, wore a handsome corn-colored brocade, with lace and diamonds.

Miss Miner of Louisiana wore a heliotrope silk with feather ornaments and diamonds.

Mrs. Ashley was dressed in black silk and lace and pearl ornaments.

Mrs. Flora Ginty was dressed in black and wore no ornaments.

Mrs. John A. Logan wore a costume of gray silk en traine with diamonds and roses.

SUSAN GALE COOKE IS SECRETARY.

She Is Elected by the Board of Lady Managers Without a Dissenting Voice.

Apollo Hall was too small. It was evident long before 10 o'clock yesterday—the hour for assembling—that the Board of Lady Managers of the World's Fair ought to have secured the Auditorium for its meeting.

The hall contained a sufficient number of seats for the members of the board, of whom there were more than 100 present, but the audience was large and interested. There were women who desired to witness the chosen members of their sex deliberate, and there were men interested in the Exposition, and others desirous of getting points on parlia-

THE BOARD OF LADY MANAGERS, IN SESSION AT CHICAGO, SEPTEMBER, 1891.

Mrs. Palmer presiding. Taken by THE ILLUSTRATED WORLD'S FAIR, after a vote by the Convention.

When she was asked why she had not appointed the standing committees, her answer was that "it was against the best interests of the Lady Managers to do so." The Executive Committee she had had to appoint, because the Commission had refused to pay for a meeting of the full Board, and, among other pressing matters, the plans of the Woman's Building had to be approved before contracts were given out. The entire episode of Miss Couzins was recounted, and all the charges against her repeated. Mrs Palmer said that she was happy that Miss Couzins had filed suit, since the Board of Control had borne the brunt of that suit, and since the courts had been able thus to decide that all the actions of the Board of Control and of Mrs Palmer had been proper and legal.

She also talked a good deal about her trip abroad in the spring, which the Isabellas had criticized. She said that she had left the office in the hands of Susan Cooke and Mrs Starkweather; but everything that occurred was told her in detail, by post, so that she "was really in charge of the office and directing its business, while absent." As part of her flood of information on various points, she said, "I considered . . . calling one of our Vice-Presidents to take my place during my absence, but as our By-laws did not seem to instruct me to do so, I gave up the idea . . . the Commission was having some difficulty in providing money . . . we could scarcely ask one of our Vice-Presidents to leave her home and remain in Chicago at her own expense . . ."

The rebels were virtually buried under a cascade of justification, well-bred accusation, facts, details and glowing pictures of the future. She ended on a note of uplifted oratory. "Are we great enough to join hands, and move forward like a band of sisters, giving up our own individuality and throwing ourselves into this grand movement? . . . Can we forget ourselves and our personal ambitions and littlenesses, and be worthy of the work we have been called to do?"

Some of the Ladies were reduced to tears. The rebels were at least speechless. Isabella Beecher Hooker rose to say, "Friends, I think you will all join with me in saying that our first duty is to thank God for this magnificent report, and next to thank Mrs Palmer." The response was enthusiastic.

The only real problem that remained was how to get rid of Phoebe Couzins. She was an appointed delegate. Mrs Palmer later appointed her to the committees on mining and on beekeeping. For some reason this treatment did not appear to soften her heart. On March 17, 1892, she appeared before the House Committee on World's Fair Expenditures. Her statement was long, detailed and convincing, if rather heated. The Washington *Sun* commented that her statements were "sensational in the extreme and appear to be fortified with facts," although they vitiated this comment by placing it under the

others desirous of getting points on parliamentary practice. In consequence the slender capacity of the elevators in the Central Music Hall Building which conveyed passengers up to Apollo Hall were well taxed. The hall had been increased in seating capacity by the addition of a large number of chairs placed in the rear of the President's desk. Adjoining rooms were also filled.

As one result of the preliminary meeting Mrs. Susan Gale Cooke of Tennessee, who has temporarily officiated as Secretary, was elected to the position formerly held by Miss Phœbe Couzins. There were no votes recorded against her. After disposing of this matter and other business, including the reception of Mrs. Palmer's report, the meeting adjourned to carriages and the members were driven to Jackson Park to look over the work generally and to particularly

MISS COUZINS REFUSES TO VACATE.

note the progress made on the building for the Women's Department. A view of the World's Fair in miniature, now on exhibition in the ... ception at Mrs. Palmer's res

heading "Mad Phoebe Couzins."

Miss Couzins said that she had done all the work that Mrs Starkweather, Miss Loughborough, Mrs Crocker, Laura Hayes and Mrs Cooke were now doing, and her salary was only $2000 a year. Among other things she did "the work that comes up in public affairs on the resolutions and eulogies of those who died" since she was "accustomed to public methods . . . and Mrs Palmer—this is personal—Mrs Palmer not only seemed to appreciate it, but she constantly referred these things to me and if my own mother had hit me with a hammer I could not have been more astonished than when I read the charges of Mrs Palmer."

Mrs Palmer herself testified before the House Committee: her recollection of the crucial bylaw was that it "was changed in committee and some even remembered all the incidents connected with it, and also recalled the fact that because the bylaw—which was interlined with lead pencil, rather indistinctly—when it was read from the platform at our meeting the chairman of the bylaws committee (who is now dead, unfortunately) . . . [showed] the reading clerk . . . where to skip and where the writing changed it, and all the full committee stated on oath these facts . . . the matter is all settled." This rather impressionistic reply contrasted interestingly with Miss Couzins' incredibly detailed testimony.

Phoebe Couzins had sued the Commission to regain her job, her back pay and her "position as an honorable woman and a faithful servant of a public trust." Because of her poverty and ill health and the basically temporary nature of the Board of Lady Managers the suit never went beyond Judge Blodgett's court. She won only one thing: $221 from the Treasury to reimburse her for the printing of her minutes in St Louis. She had mailed them to the Lady Managers at her own expense.

Four years after the Fair, she lay in a St Louis sanitarium, so crippled by arthritis that she could not walk. She renounced the cause of woman suffrage to which she had given her life. "Women," she said bitterly, "are no better than men." She said that young women should choose housekeeping rather than public affairs. Women's rights "rings," she said, were "cliquish"; she denounced Susan B. Anthony and Bertha Palmer. She had seen women under fire, and she had seen them fall "ignominiously." The tyranny imposed on women at the World's Fair would never have been endured by men. She believed in rebellion.

Phoebe Couzins had been a fighter all her life. At her death she no longer believed she had fought the good fight. She had tried to save the Board and had almost destroyed it. The "band of sisters" moved forward without her.

City of Chicago, Mrs. Palmer, Mrs. Thatcher Jr., Mrs. Shattuck (alternate), Mrs. Mulligan, Miss Dickinson, Mrs. Wallace, Mrs. Bradwell, Mrs. Doolittle Jr., Mrs. Carse.

"There being a quorum present we will proceed to business," said Mrs. Palmer. "The first matter before us will be the election of a secretary, there having been a vacancy made in that office since our last meeting."

Mrs. John A. Logan, who with Mrs. Isabella Beecher Hooker, occupied one of the front row of seats, moved that such election be proceeded with at once. Thereupon after it had been moved that all nominations be made without speeches Dr. Frances Dickinson of Chicago arose to a question of privilege. Dr. Dickinson is an adherent to the cause of the deposed Miss Couzins.

"Mme. President," she began, "I desire to know when and in what manner the office became vacant? I would like——" But it was apparent that Dr. Dickinson's remarks were beside the question of privilege, and she was called to order. Then the redoubtable Miss Couzins herself obtained the floor.

"Ere you proceed further," she said, "it is desirable to know whether a committee, a few, have the right to usurp the functions and undo the work of the full board?"

"Out of order! Out of order!" cried Miss Couzins' colleagues, and as the speaker could not proceed she sat down. The motion to nominate without speeches was carried, and Mrs. John J. Bagley named Mrs. Susan Gale Cooke of Tennessee. There were no other candidates, and Mrs. Cooke received 73 votes —all that were cast. Mrs. Hooker first requested the leave of the house to refrain from voting, and her example was followed by many others. Miss Dickinson varied the formula by a clear "Decline to vote." Mrs. Cooke made a brief speech of thanks and at once began her duties.

Congressman Springer's Address.

This matter having been adjusted Mrs. Palmer said: "We have with us Mr. Springer, who is the author of 'Sec. 6' of the World's

MRS. ISABELLA BEECHER HOOKER.

Fair bill, and to whom we owe so much. We would like to hear a few remarks from him."

Congressman W. M. Springer, who had been an interested spectator, responded with the following:

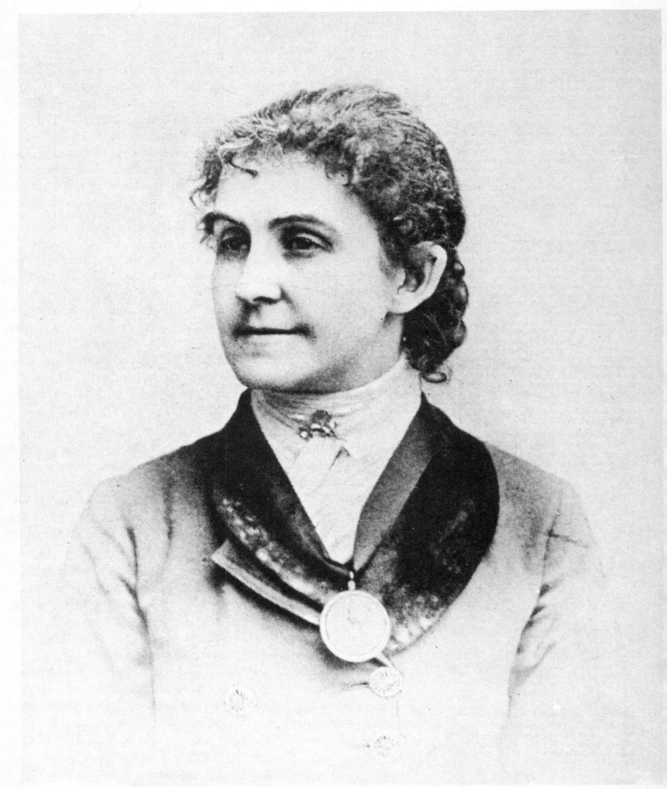

Phoebe Couzins

I N November of 1890 there was another woman's group, unconnected with the Isabellas, which was dissatisfied with the composition of the Board of Lady Managers. At the first Board meeting on the morning of November 25, Mary Logan presented a resolution which had been formulated the night before by the "colored women of Chicago" at a "mass-meeting at Bethesda Baptist Chapel":

WHEREAS no provisions have, as yet, been made by the World's Columbian Exposition Commission for securing exhibits from the colored women of this country, or the giving of representation to them in such Fair, and WHEREAS under the present arrangement and classification of exhibits, it would be impossible for visitors to the Exposition to know and distinguish the exhibits and handiwork of the colored women from those of the Anglo-Saxons, and because of this the honor, fame and credit for all meritorious exhibits, though made by our race, would not duly be given us . . .
RESOLVED that for the purpose of demonstrating the progress of the colored women since emancipation and of showing to those who are yet doubters, and there are many, that the colored women . . . are making rapid strides in art, science and manufacturing, and of furnishing to all information as to . . . what the race has done, is doing and might do, in every department of life, that we, the colored women of Chicago request the Columbian Commission to establish an office for a colored woman whose duty it shall be to collect exhibits from the colored women of America . . .

The Board apparently could think of no way to respond to this resolution. Mary Logan moved that it be referred to the Commission; this motion was adopted, to the dismay of the black group whose leader, Lettie A. Trent, requested an audience with the Board the next day. At that time she emphasized the black women's desire to have a legally empowered black woman in an executive position handling the black exhibits. Mrs Palmer appointed a committee of three to meet with Mrs Trent over lunch: they were Mary Logan, Helen Brayton of South Carolina, who had supported charity work for families of lynch victims, and Mrs Palmer's friend, Mary Cantrill of Kentucky. The matter

was obviously one that required delicate handling. The Civil War had ended twenty-six years earlier. Northern and Southern women had come together on this Board to work in a spirit of national solidarity. The black women's resolution elicited some ugly feeling almost at once. The Chicago *Times* for November 26, 1890, reported that when Frances Dickinson suggested that Lettie Trent fill a vacancy on the Board, a "Southern Lady Manager exclaimed, 'We will speak to negroes [sic] and be kind to them as employees, but we will not sit with them.' "

In the afternoon the committee of three brought in its report. It noted that "colored people" had requested that the Board recommend to the Commission that "colored people" be recognized "in securing exhibits by their race" and in "designating persons to solicit exhibits" and that the President, when she appointed the Executive Committee, "be respectfully requested to appoint some Lady Manager on that Committee to represent the interest of the colored people."

The fuzzy wording of this report betrayed uncertainty about the entire endeavor. It was as much a postponement of action as referral to the Commission would have been. Some Ladies may well have been unsure that "colored women" should have a segregated exhibit, just as many of the more radical women did not want a segregated Woman's Building. Frances Dickinson's suggestion that a black Lady Manager be appointed was undoubtedly aimed at drawing black women into the exhibits in general. At the same time there is no question that there was less benign motivation for this vague report.

In addition, Lettie Trent's group, which was soon to call itself the Woman's Columbian Association, did not seem sure about its own goals. Mrs Trent was apparently willing to forego the idea of a black woman in an executive position. She appeared, after the meeting, to want women that black women could trust appointed to the Executive Committee. Her first choice for a Lady Manager "to represent the interest of the colored people" was Mary Logan.

Inevitably, a counter black group organized in Chicago. In February, 1891, the Women's Columbian Auxiliary Association was registered as an Illinois corporation. There were fourteen women on its board: seven directors and seven officers; Mrs R. D. Boone was president. The Auxiliary Association had, in addition, an "advisory panel" of seven black men, including doctors and lawyers. This group wanted an integrated exhibit of the work of both black men and black women: they were interested primarily in demonstrating black accomplishment since the Emancipation Proclamation. Women's work was only one of the areas of achievement which the Auxiliary wished to demonstrate, but in that area it announced its intention to "supplement" the work of the Board of Lady Managers.

Mrs Palmer, as we have seen, did not enjoy having her work

"supplemented." In the spring of 1891 she was attempting to extricate herself from the Phoebe Couzins muddle, and at the same time encourage support in the states and territories for the Board; it was obvious that women had to be included on state Fair commissions and their work had to be supported by public funds.

In December of 1890 the Commission had sent out a prototypal "Fair Bill" to each of the state legislatures; this model Bill contained no hint or suggestion that women be appointed to state Fair boards. Mrs Palmer approached the Director-General with her usual tact and charm, and he agreed to send out a revised model Bill. Thus Mrs Palmer achieved the official sanction of the Columbian Commission for the appointment of women to state Fair commissions and for the assignment by each state of a portion of its Fair appropriations to the Board's work. Letters were sent from Mrs Palmer's office to Lady Managers in each state and territory, urging them to try to be appointed to their local commissions. The President emphasized that "to avoid confusion" state and national work should be "concentrated in the same hands, so that it might proceed upon well-defined and uniform lines."

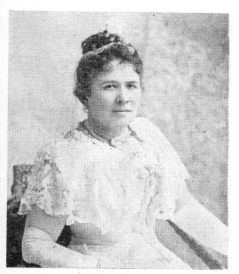

Mary Cantrill

Mrs Palmer wished power to be concentrated in her hands; she was then perhaps less than pleased to note in the spring of 1891, when she was appointing her Executive Committee, that the black women's groups had grown from two to four, and that her office was receiving a stream of letters and petitions. On the other hand it might have occurred to her that goals fragmented into four parts could not have the effect of a single, uniform goal. In April she appointed her friend Mary Cantrill to represent the "colored people." Mrs Palmer knew that all four black organizations had been in touch with the Couzins-Isabella factions of the Board. Mrs Trent was disappointed with Mrs Cantrill's appointment: she said that the minutes had been tampered with—a familiar complaint—and that originally it had been decided that a permanent committee of three Lady Managers would represent black interests. Mrs Boone did not care about the minutes or Mrs Cantrill, or about Mrs Trent; she still wanted to supplement the Board's work.

Despite these distractions Mrs Palmer set about persuading the Illinois legislature to fund a separate state women's Fair commission, in order partly to set an example to the other states. She gave an elaborate reception for legislators in her mansion, and on May 12, 1891, addressed a session of the legislature in Springfield, submitting estimates of expenses that a women's commission might incur. Her efforts proved successful: Illinois created the Woman's Exposition Board and placed the sum of $80,000 at the absolute disposal of its eight members. This bill was finally approved in August.

In May, at the same time as Mrs Palmer's successful onslaught

on the Illinois legislature, the Colorado legislature appointed its Lady Managers to the state Fair board and, in addition, allowed the Ladies three field workers at a state salary of $100 a month. Two of the workers were to canvass the state for exhibits for the Board, and the third was to "collect the native flora." Fifteen percent of Colorado's total Fair appropriation was allocated to the Lady Managers.

This was good news at a time when the President was beset by troubles which had certainly come home to roost. Mrs Palmer later called it "an unfortunate time, when our first and only unpleasantness was being commented on in the press . . ." By this she meant Phoebe Couzins: the black women were receiving no publicity. Mrs Palmer decided that this was a propitious moment to leave the country. She had planned a trip abroad for some time; she said later that because of the Couzins difficulties she had "almost relinquished it." The trip, at her own expense, was to be to England, France and Austria for the purpose of gaining co-operation for the Board's foreign exhibits. She considered that the influence of these three countries was so powerful that "their example, almost as a matter of course, would be followed by others in case favorable action was secured."

She had contacted the Secretary of State, James G. Blaine, early in the winter; her plan was to have each American ambassador abroad name committees to co-operate with the Board of Lady Managers "in the country to which he was accredited. The original idea developed, however, into the much stronger one of inviting the foreign governments to appoint these committees" for the Board, so that the committees would be funded and have official status "consequently [helping] the position of women in each country where [the Board's] invitation was accepted." Unfortunately Mr Blaine fell seriously ill just before Mrs Palmer's departure, so that she was unable to see him in New York and he did not give the necessary instructions to the State Department to be forwarded to the ambassadors. She had been assured that her request for co-operating committees would be "complied with by every country which had signified its intention of participating in the Exposition." She knew that refusal to co-operate could only come "from the unprecedented nature of the request" and the State Department's consequent hesitation "to put itself in an attitude to receive a rebuff from conservative governments." She had set all her hopes on having U.S. diplomats exert influence to see that strong committees were formed in foreign countries. With Mr Blaine's illness that seemed out of the question.

Mrs Palmer set sail from New York on May 18, 1891 with a small group of devotees, among whom were her husband, her private secretary Laura Hayes, and Mary Logan and her son and daughter-in-law. Susan Gale Cooke and Amey Starkweather

BUST OF PRINCESS CHRISTIAN.

Seal of New York Board of Lady Managers

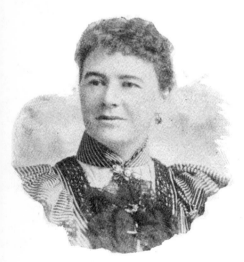

Ishbel Aberdeen

remained behind in charge of the Board offices. Business nevertheless pursued Mrs Palmer on the high seas: the New York Lady Managers, distraught at the failure of the legislature to appropriate funds for them, received a letter from Mrs Palmer, written mid-ocean, which, according to the *Woman's Journal*, was "as stirring as a bugle-call: 'Canvass New York; find out what women are doing and what they want to do.' In response, the Lady Managers of New York met in June, perfected plans" and forged ahead, led by Mary Trautman. A year later the legislature chartered the New York Board of Women Managers, with an appropriation of $25,000.

In London Mrs Palmer contacted her friend Robert Todd Lincoln, the American Ambassador. He arranged a meeting with Princess Christian, the third daughter of Queen Victoria, who, like the Queen, "was most conservative in her views regarding the higher education of women and their entrance into the professions, deprecating every influence that would draw them from their homes." However the Princess was the head of the Royal School of Art Needlework: she had founded this school for the partial purpose of obtaining suitable employment for distressed gentlewomen; thus she was aware that it was often necessary for women to support themselves by their labor. She suggested that she help with the formation of an English Woman's Committee.

Mrs Palmer spoke also with Lady Aberdeen and the Baroness Burdett-Coutts, both of whom were enthusiastic about a British exhibit. Lady Aberdeen wanted space for her Irish Industrial Association which encouraged the production of Irish lace and homespuns. The Baroness wished to show the work of students in technical training schools.

This was most encouraging. In addition, Mrs Palmer received an offer of support from Lady Somerset of the English Women's Christian Temperance Union, to whom Frances Willard had written a letter of introduction. Another interested woman was Harriot Stanton Blatch, Elizabeth Cady Stanton's daughter; Mrs Blatch was married to an Englishman and lived in Hampshire; she was active in the suffragist Franchise League. Through her political connections Mrs Palmer was able to attend a meeting of the Women's Liberal Federation, a group considerably less radical than the Franchise League. She came away much impressed both by the professionalism of the women and the deference shown them by male politicians. British women she found to be more advanced politically than her own countrywomen.

From London the Palmer entourage crossed the channel to Paris, where Theodore Stanton, another child of the ubiquitous Elizabeth Cady Stanton, had lived for twelve years as a correspondent for the Associated Press. Laura Hayes was agreeably impressed by Mr Stanton:

He was an extremely handsome and amiable man . . . Perhaps to me he seemed especially good to look at because he was so American in his speech and dress; and in the cheerful enthusiasm that pervaded his manner. It was a comfort to see a real countryman after the many insipid imitations we had seen in the streets of London, who were ashamed to be American, and could not be successfully English, and who, as a result, were a type of nothing under the sun . . . [Mr Stanton] began to ask at once about the part women were to take in the World's Fair and handled the woman question with an ease and fearlessness that could only have come from deep conviction and early training.

Theodore Stanton introduced Mrs Palmer to some prominent Frenchwomen, among whom was Emiley de Morsier, who had headed the committee which was in charge of the Congress of Feminine Works and Institutions for the Paris Exposition of 1889. Mrs Palmer took a two week trip to Vienna; when she returned to Paris she gave a reception at her salon in the Grand Hotel. Laura Hayes arranged the afternoon, ordering coffee, tea, chocolate, and "delicious little cakes" from Boissiers, and "masses" of flowers from the flower market "on the corner by the Madeleine."

Mrs Palmer's salon had tall lace-draped windows opening onto a large balcony: the walls of the salon were hung with red brocade, contrasting with white enamel woodwork. Hundreds of crystal oak leaves hung from candelabra scattered about the room and suspended from the ceiling. Miss Hayes had filled a Japanese punch bowl on the centre table with blue carnations and "the tall bronze jars on the marble cabinets between the windows blossomed over with snowy lilies [reflected] in the mirrors behind them . . ."

More than forty people came to the reception, among them several prominent members of the Chamber of Deputies. The wife of Yves Guyot, the Minister of Public Works, was there with her daughter. Sara Hallowell, the art agent who had introduced the Palmers to Impressionist painting, was there, invited by Mrs Palmer, as was May Wright Sewall of Indianapolis, who had been the American delegate to the Congress of Women at the Paris Exposition. Mrs Palmer was asked to explain the Board's policy on exhibits for the Woman's Building, which she duly did, in French. Laura Hayes described the impression made by Mrs Palmer:

As I saw the interest deepening on every face, turned to the slender young woman, and noted the deferential attention given, not to her beauty or her position, or to the grace of her manner, but to her wonderful intelligence, and to the clear reasoning that dominated her hesitating speech, I felt a strange sense of emotion. Miss Hallowell leaned over to me and whispered, 'I never expected to see such a sight as this,' and I noted the moisture in her eyes.

The meeting soon broke into informality over cups of tea and

chocolate. Laura Hayes noted that the day was a great success:

> Soon after this, and without her own seeking, Mrs Palmer had an audience with several important people, including Madame Carnot, who complimented her by presenting her with the President's box at the Comedie Française, and it was on the Saturday following the reception that the members of the World's Fair Committee in the Chamber of Deputies expressed their willingness to have women appointed officially to co-operate with the Board of Lady Managers, in collecting the exhibits of women's work for the Exposition.

Mrs Palmer had gone to Vienna partly to visit her sister Ida, whose husband, Frederick Grant, was American Ambassador there. The atmosphere in Vienna was much cooler than it had been in Paris: high U.S. tariffs had hurt the pearl-button industry. Mrs Palmer was informed by a government official that Austrian women were conservative and would attend only to their social duties. However Mrs Palmer was able to talk with the Princesses Metternich and Windisgratz, who were interested in the promotion of peasant arts and crafts. Princess Windisgratz had recently opened a salesroom in Vienna for peasant crafts— rugs, basketry, etc.—and was eager to send these things to Chicago and open new markets. These aristocrats persuaded the Empress Marie Therese to chair the Austrian Women's Commission.

Mrs Palmer could thus leave Europe satisfied that she had helped to lay the groundwork for a worldwide organization of women, whose work was essential to the success of the Woman's Building. On the Saturday after she left France, that country's Exposition Committee informally voted 300,000 francs for a woman's commission: a larger sum than the Board of Lady Managers had yet received from Congress. Madame Carnot, the wife of the President of France refused Mrs Palmer's request that she chair a woman's Fair board. She had never served on any committee, and did not approve of women acting outside the domestic circle. When, however, the French women's board was officially organized in 1892, she had changed her mind: it had by then become "a positive lack of distinction" for European women of rank not to be included in Exposition work.

Mrs Palmer returned to Chicago to find that in her absence the Couzins furor had increased, if anything. She wrote to many Lady Managers, defending and explaining her actions, insofar as they were explicable. She soon saw that letters were not enough. In July Isabel Linch of West Virginia wrote to her suggesting that she postpone a full Board meeting until the middle of winter, at least, since state work was progressing well, and would slow down anyway in the winter months. She thought it best that the Commission deal with Phoebe Couzins: "it is so much easier

for a man to convince and argue with a woman than one of her own sex."

This advice had no merit from any point of view. It was obvious that only a full Board meeting could bring things back into control. Mrs Palmer believed that whether her head or Phoebe Couzins' head fell into the basket, a confrontation had to be held. The Couzins affair was a magnet which was drawing unrelated grievances around it. Not the least of these were the grievances of the black women. They had been canvassing the Board all summer, with little positive response. They were not happy with Mary Cantrill of Kentucky as their "representative," nor did they feel comfortable with most of the Executive Board, seven of whose twenty-five members came from Southern or border states: Susan Gale Cooke of Tennessee, Mary Eagle of Arkansas, Rosine Ryan of Texas, E. Nellie Beck of Florida, Josephine Shakespeare of Louisiana, Isabel Linch of West Virginia and Katherine Paul of Virginia.* Mrs Paul, a correspondent for the Associated Press, had worked for co-operation with the black women of Virginia: she had organized special committees, and sent out circulars and personal letters soliciting black exhibits.

Nevertheless Lettie Trent specifically said that only Phoebe Couzins, Mary Lockwood, Mary Logan, Helen Brayton and Isabella Beecher Hooker were openly committed to justice for black women. Mrs Boone announced that three women on the Board had responded positively to her letters; the rest, she said, either ignored her or were openly hostile and threatened resignation if a black woman were appointed to a position of authority.

Mrs Palmer believed that the Isabella factions were planning and encouraging the black women's petitions and canvasses. She was afraid that the dissidents would take drastic action that could threaten the Board's existence. On August 11, 1891, she wrote to Mrs Price of North Carolina:

> I think their [the black women's] plan is to appear before Congress, as soon as it convenes and make a strong protest against our Board, and then Mrs Hooker and Miss Couzins will enter their complaints, so that we will seem guilty of acts of wrongdoing and Congress may hesitate to give us an appropriation.

The tension generated over getting an appropriation for 1891 would, she knew, be repeated in 1892; each year the same process would have to be repeated. The Board had strengthened in some ways during the year, but politicians were susceptible to bad publicity and the Isabella-Couzins group were generating a great deal of it.

Bertha Palmer suspected Matilda Carse of spurring the black women on; Mary Cantrill thought that Mary Logan was behind it. In fact, on the sixth day of the full Board meeting in Septem-

Isabel Linch

*Evidently added in response to complaints that there were no Southern women on Executive Committee.

ber, 1891, it was Matilda Carse who asked Mary Cantrill for a report of her activities as a committee of one to represent the black women. Mrs Cantrill, obviously in a dither, said that she needed more time to get her report together. She was given no longer than the next morning, when her report was scheduled as the special order of business. The report indicated that at best Mrs Cantrill was out of her depth. She said that the questions she had received did not come within her purview; she had referred some of them to the Illinois Woman's Exposition Board. In point of fact Mrs Cantrill had done nothing, most probably because she did not know what to do.

There is no official record of the sense of the meeting about the non-actions of Mrs Cantrill's pathetic "committee." A resolution was adopted, suggested by Mrs Paul, that "the work of arousing interest . . . among the colored people" in the states and territories should best be left to the Lady Managers of those states and territories. The majority of the women went on record as opposing "unjust discrimination in color" and favoring putting both white and black women "on the same footing." A smaller group wished the black women to be treated separately and their exhibit placed by itself. Whether this latter preference was influenced by bigotry or the absence of bigotry is hard to say; the black groups themselves seemed to want separate treatment.

The *Woman's Journal* for September, 1891, reported:

> An important decision was made regarding the share the colored people are to have in making the Fair. It was determined by the Board of Lady Managers—and in this they followed the ruling of the Commission—that there should be no discrimination upon the score of race, and that colored women should have precisely the same chance that white women had, by being given equal opportunity, neither more nor less, to do the best work they are capable of.

The black groups did not see the "decision" in quite this cheerful a light. Mrs Trent had not been given her special assistance, and Mrs Boone was convinced that the Board wished to prevent the advancement of the "Negro race", because there was to be no supplementary black work. As if this were not bad enough, unfortunate remarks were said to have been made by the Lady Managers during the course of the session, all insulting to black people.

One positive result of this—although a temporary one—was that both Mrs Trent and Mrs Boone were united in outrage over the Lady Manager's response to them. There had long been a feeling among educated black women that they needed a national organization of their own. Hallie Q. Brown of Wilberforce University had urged a Federation of black clubs that

Katherine Paul

could then enter an exhibit in the Woman's Building along the lines of clubs like the WCTU and the YWCA, both of which had black auxiliaries. Black mutual aid societies had been organized immediately after Emancipation to deal with the severe problems of the homeless and destitute.

In Washington D. C. the Colored Women's League had been formed by a group of black women's clubs. It was to Washington that Mrs Trent and Mrs Boone and their groups intended to go to present grievances against the Board to black women, to a Methodist Conference, and possibly even to Congress. Circulars were issued by the Women's Independent Organization appealing to "the representative colored women of the United States . . . to resent the insult hurled at the women of our race at the last session of the Board of Lady Managers." This was given publicity in Washington newspapers. A second circular called for a mass meeting of black women in Washington on October 21, 1891, to discuss some action in connection with their participation in the Fair. Lettie Trent signed this circular, as did, among others, Hallie Brown and Fanny Jackson Coppin of Philadelphia, a woman who had been a slave until she was thirteen years old and, having been bought free by her aunt, completed a B. A. and did graduate work in Classics at Oberlin. Mrs Coppin has been cited for her temperance in the discussion of racial matters; the circular was rhetorically effective but not particularly temperate in tone.

Derogatory remarks about blacks were said to have been made at the Board meeting, and were attributed to Lady Managers identified by state and not by name. A Lady from Arkansas was quoted as saying she wanted to exhibit the work of "poor white cotton pickers," a desire supposedly concurred with by a Lady from Georgia. The "Democratic representative from Texas" was quoted: "The darkies are better off in white folks' hands. The Negroes in my State do not want representation." The "Representative from Washington, D.C." wished to have "a delegation of colored women heard," according to the circular, but she was told by the President "that if she ever brought up the colored question, she would never be forgiven for it." The black delegation had been told this by "the Representative from Washington."

The circular went on:

Mary Harrison

> Shall the Negro Women of this country have a creditable display of their labor and skill at the World's Columbian Exposition? The Board of Lady Managers, created by an act of Congress, says no . . . Shall five million of Negro women allow a small number of white women to ignore them in this the grandest opportunity to manifest their talent and ability in this, the greatest expression of the age? . . . Ought not the work of the Negroes . . . be placed in the hands of Negro women? It ought or else the work of all the bureaux of white women should be placed in the hands of colored women . . .

"THE GAYEST CORNER OF THE GAYEST STREET IN PARIS."

This was stirring stuff. It was reprinted in Washington papers and in the Boston *Courant*. The Lady Managers responded with their usual cascade of letters to one another. Isabel Linch of West Virginia wrote to Mrs Palmer on October 15, quoting the Women's Independent Organization's appeal for resentment of "insults hurled at our race." Mrs Linch did not know to what insults this circular referred. Mrs Palmer wrote to Mary Logan in Washington, calling the circular "a tissue of lies" and asking Mrs Logan to contact "Fred Douglass and Bishop Fowler at once." Bishop Charles Fowler had lived in Chicago and had been President of Northwestern University in the '70's. Since he was a Methodist Bishop Mrs Palmer undoubtedly wanted him to exert his influence so that the Methodist Conference in Washington would refuse to hear the black women. Frederick Douglass was of course the ex-slave, writer and diplomat. Mrs Palmer never hesitated to pull any strings that were available to her. At the President's request, Mrs Russell Harrison of Montana wrote her father-in-law, President Benjamin Harrison to try to ensure a frosty reception in Washington for the black groups.

Mrs Palmer wrote to Mrs Logan, expressing her great annoyance at all this uproar. She wanted all the Southern Lady Managers to send Mrs Logan "an expression of their goodwill and wish to help the colored people in their respective states."

This expression of good will was codified in a pledge, signed by all Lady Managers and returned to Mrs Logan. Not just Southern women signed it, because Mary Trautman of New York received and signed one as well as Sallie Cotten of North Carolina, who signed hers "cheerfully" and Anna Fosdick of Mobile, Alabama, who said she was happy to sign hers. Various comments appeared with the pledges. Josephine Shakespeare of Louisiana wrote Mrs Logan:

I sign the document most cheerfully and conscientiously as I have lived in the South all my life and have always been friendly to them. For the past three years I have been connected with a colored mission Sunday School . . . in one of the very worst neighborhoods in our city and we have the very worst element to deal with . . .

A sour note was sounded by Florence Olmstead of Georgia:

They never originate anything of themselves. There is always someone behind to push them on. Do you know who it is in this instance?

From Little Rock, Emma Edgerton of Arkansas ventured a possible reply to Mrs Olmstead:

I am thoroughly satisfied that it is one more offer of the disaffected Couzins party to produce trouble and because it is entirely manufactured of falsehoods is all the more vile.

Emma Edgerton

I am only too glad to sign the accompanying papers by Mrs Palmer's request ... I trust the quick response by each and every Lady Manager will help to allay the fever which has so unfortunately attacked our dusky sisters.

E. Nellie Beck of Florida wrote:

My idea is to include colored people without discrimination, as, to make any exception against them, actually or theoretically, is not in the spirit of the act of Congress creating our Board, while for them to ask for special legislation is to deny the potency of the Fifteenth Amendment to the Constitution. It is the grand opportunity and I hope they will profit by it.

Mary Logan wrote to Mrs Palmer on October 16:

It was unfortunate that the interests were left in Mary Cantrill's hands because notwithstanding her protestations of friendship for the Negro they imagined that she betrayed her natural prejudice against them even while discussing the question ...

E. Nellie Beck

Rebecca Felton of Georgia wrote to Mary Logan on October 17. She was most distressed about the situation, irritated with Mary Cantrill, and as usual hurt because she had been left out of everything.

I know of no animosity to the colored people in regard to this matter. It is preposterous to raise a fuss over nothing. I went to Atlanta and talked with the colored woman at the Passenger Depot who has charge there—and who sees every person passing through, and told her I was ready and anxious to do all I could in this line & if it could be so arranged I would like to talk with them about it when they wished information. I think it has all grown out of Mrs Cantrill's assuming the entire command. I heard of dissatisfaction when I was in Chicago but as I had no authority—had no influence—and was considered so inferior, by the "powers that be" I did not volunteer advice, for I was afraid to incur more of such displeasure, & therefore I let it all alone. This of course is for *your* eye alone. I think it very unfortunate that [Mrs Cantrill] was placed in charge. She was not the person to harmonize matters. You should take it in charge at once. Mrs Palmer alone should help you to do it. I know that Mrs C. is not the choice of those colored women in Chicago, that is, if Mrs Brayton was correctly informed.

Mrs Palmer, embarrassed by her choice of Mary Cantrill to "represent" black interests, wrote a self-justifying letter to Mary Logan:

Our Board was entirely willing to appoint a national representative for the Negro women and only refrained from doing so because they were quarrelling so among themselves and could not decide on a candidate. There were four organizations in the field, each struggling for supremacy and each abusing the other three.

Mrs Palmer at this point reverted to her suspicion that Phoebe Couzins "to serve her own ends . . . relying upon discontent" had supplied the black women with the idea that "insults" had been hurled at their race during the Board meeting.

Some very specious arguments must have been used to make them find an offense in the friendliness always felt and shown toward them by our Board. Mrs Trent hopes to go to the Methodist convention and "capture the convention" in the Board's favor.

Mrs Trent had in fact come around: but by November it became obvious that her demands could not be met: she wanted her own organization with "a President, a Secretary, stenographers and clerks and officers . . ." The Board, Mrs Palmer noted, had no power to give them "five cents toward their work." In any case Mrs Palmer was not in the habit of encouraging supplemental Ladies' Boards. Mrs Trent, out in the cold, wrote to Mary Logan who suggested she offer her services to the Illinois Women's Commission, as Mrs Boone had already done. Mrs Logan told her, "The rivalry for individual recognition was really the beginning of your trouble."

Mrs Palmer did not forget the black women's statement that "the representative from Washington wished to have a black delegation heard, but was told by the President" that if she "brought up the colored question she would never be forgiven for it, as there was a bitterness against the colored people by the Board," and that the black delegation had been told this by the "Representative from Washington."

Delicately, Mrs Palmer wrote to Mary Lockwood, who was from Washington, D.C., and who certainly sympathized with the black women and sympathized also with Phoebe Couzins, about the black delegation; Mrs Palmer said she did not recall any such delegation asking to be heard at the Board meeting. Mrs Lockwood replied that she had never made the statement obviously attributed to her. No "delegation of colored women" had asked for a hearing before the Board.

Mary Trautman, whose New York Board was finally the only official woman's Fair group which appointed a black member, wrote to Mary Logan:

I enclose a copy of the letter rec'd from Mrs Palmer which I have signed—and hope you will be able to counteract any assertions the colored women may make against our board—I for one am in hearty sympathy with the race and have been a strong Abolitionist all my life—but I cannot sustain them in any unreasonable action, and I consider this one is unwarrantable—and I am very sorry this entire question was not left in the hands of Mrs Brayton and yourself—and cannot understand why the charge was made . . .

Mrs Brayton, of South Carolina, was sympathetic to the black women. She wrote an optimistic letter:

> [The Negro population of South Carolina] will . . . be stimulated to show something creditable and surprising to friends, as well as to those who knew little of the latent possibilities concealed in this race.

Mrs Palmer remained concerned for months over the black women and their possible actions. At one point, writing to Frederick Barnett of the Afro-American League, she attempted to reject the idea of a special black exhibit because "our Board considered that they [black women] would prefer to be on the same footing as the Germans, French or Americans." She said that it had been suggested that a special black exhibit might encourage other ethnic groups to ask for special treatment. It might even cause the Southern Confederacy to bestir itself and ask for its own exhibit. This last suggestion smacked of scare tactics.

In January of 1892, Mrs Palmer wrote to Mrs Brayton to ask her about the possibility of appointing black women to the state boards. It was not so much a question as a statement: the President explained that some Lady Managers objected to this because "it would take away their prerogative." Presumably she meant the prerogative of the state boards. Mrs Palmer gave much thought to the black exhibits: she was partial to the idea of bales of cotton housed in a rice pavilion, and asked her staff for "statistics of the field of labor of women in South Carolina, both white and colored." She suggested working through ministers rather than politicians to reach black women, and asked that circular notices be sent to "churches of colored people."

In March of 1892 she wrote a friendly letter to Mary Cantrill, despite the fact that many influential Lady Managers blamed Mrs Cantrill for the difficulties with black women. She told Mrs Cantrill that she feared the black women would make public complaints during the installation of exhibits. If a large number of black exhibits had to be rejected "they [the would-be exhibitors] will probably claim they have been discriminated against." Although this sounds like an excuse for racial discrimination (and it may well have been), it is true that the rejection of exhibits was a worry to Mrs Palmer: at least since the fall of 1891 she had had visions of an angry mob of rejected exhibitors storming headquarters. She told the second Board meeting:

> . . . we should not be content to show . . . conventional repetitions of familiar articles. But we should have new and original exhibits, created especially for this occasion . . . It will . . . be difficult to stimulate women . . . to create new and original work, without bringing out a vast mass of duplications, and a great deal that is inartistic. This will be a very serious problem for us to deal with . . . the work of discrimination will be largely intrusted to the Chiefs of Depart-

Helen Brayton

ments . . . But we can now foresee a vast army of disappointed women, whose work will be rejected, probably before it leaves its native State. This is the distressing feature in the case . . .

In December, 1891, the Commission appointed two clerks in the Installation Department to solicit exhibits of black work. These appointments had been suggested by Fannie Barrier Williams, the wife of a Chicago lawyer. Mrs Williams, described to Mrs Palmer as a "graceful and accomplished young colored woman" who possessed not only "intellectual gifts but personal beauty," held that religion and education, such as that offered by the Hampton Institute, were important factors "in solving the Negro problem." She herself taught art and music at a Chicago study club.

The black women in Washington were angered by the implementation of Mrs Williams' suggestion. They could not get a hearing from Congress, nor from the Methodist Conference and were reduced to condemning the actions of the Board of Lady Managers at a relatively small meeting of their own. In December, 1891, they passed a resolution against Mrs Williams and the Commission:

> Whereas we understand that a request has been made by a woman representing no organization or workers, for two clerkships to satisfy nine millions of citizens, we do emphatically protest against such an action as we already have a very capable young gentleman of our race filling such a position . . . we sincerely believe this woman's proposals to be detrimental to our works . . .

The black women's groups faded away in a miasma of embittered hopes. Hallie Q. Brown had been the only black woman whom Mrs Palmer had seriously wanted in a responsible post: she had tried to get Miss Brown into the Department of Publicity and Promotion to "write for the colored papers, keep in communication with the women of her race; and keep them informed . . . so that they would feel they had a 'friend at court' and were receiving proper attention . . ." The Fair authorities would employ her, but the Board of Lady Managers would supplement her salary; Mrs Palmer was willing to pay her out of her own pocket if there was not enough money left for the Board to do it. Mrs Palmer had been impressed with Miss Brown's intelligence and her "dramatic and telling" rhetoric. However, Hallie Brown, a University administrator, was receiving a good salary and had her own secretary. As Mrs Palmer put it, she would not "step down" to the black liaison post. In July of 1892 Mrs Palmer, having received no answer to her query about an acceptable salary, wrote to Hallie Brown presuming "that you did not find the position one you cared to fill. Lamenting that this is the case, I certainly cannot blame you . . . hoping we may yet find the proper person to take the place . . ."

Fannie Barrier Williams

In April Miss Brown had written Mary Logan a strong letter from her home at 4440 Langley Avenue in Chicago:

It seems to be a settled conviction among the Colored people, that no adequate opportunity is to be offered them for proper representation in the World's Fair. A circular recently issued and widely distributed makes that charge direct. That there is an element of truth in it seems apparent, since neither recognition has been granted, nor opportunity offered. And further it is known that the intercourse between the two races, particularly in the Southern States, is so limited that the interchange of ideas is hardly seriously considered. If, therefore, the object of the Woman's Department of the Columbian Exposition is to present to the world the industrial and educational progress of the bread-winners—the wage woman— how immeasureably incomplete will that work be without the exhibit of the thousands of colored women of this country. The question naturally arises, who is awakening an interest among our women, especially in the South where the masses are, and how many auxiliaries have been formed through which they may be advised of the purport of a movement that is intended to be so comprehensive and all-inclusive? Considering the peculiar relation that the Negro sustains in this country, is it less than fair to request for him a special representation?

Presuming that such action would be had, several colored men and women, including the writer, have endorsements of unquestionable strength from all classes of American citizens. These endorsements are on file in the President's office of the Woman's Commission in this City.

It is urged at Headquarters that the Lady Managers would seriously object to the appointment of a special representative to canvass the various States. Permit me to emphasize the fact, that the matter is in earnest discussion among the representatives of eight millions of the population of the United States.

I address this circular to you, kindly requesting your opinion upon the suggestions made herein . . . at your earliest convenience.

Mrs Logan's response was not what Miss Brown had expected from her. She mentioned the four black groups at odds with one another, and the unpleasant charges spread by the circulars. Miss Brown responded with some heat, acknowledging to begin with

the good that you and many other noble women, have tried to do for the race, but I cannot, in justice, allow the charge of vindictiveness to go unchallenged.

First as to the colored people being united. They certainly were united in this general proposition of desiring representation. Had there been an earnest desire to accord this, the fact that two factions, or local societies, were opposing each other should not in all fairness have militated against the nine millions of colored people of this country . . .

Are nine millions of American citizens to be humiliated in the eyes of the world by the absence of even *one* dark face in the administrative corps of the Fair?

These questions seem to me far more *pertinent* than vindictive. I ask not for self-emolument nor personal aggrandizement but I stand upon the broad platform of justice and equity, pleading for the women of my race.

Salary, she said, was "a secondary consideration." She wanted to be granted special powers and special funds, and to be a member of the Board of Lady Managers—Frances Dickinson had already noted that there were vacancies. But what Mrs Palmer could do, or would do, was limited. Apart from money, which was tight, the Board was attempting to play a role in sectional reconciliation after the Civil War. That conflict was still fresh in the memories of both Southern and Northern women. Nevertheless even those who still strongly believed in Confederate or Union ideals were anxious to heal the wounds of the nation. The atmosphere had to be one of mutual courtesy and concession. Everyone strained to avoid antagonizing the Southern Ladies.

Isabella Beecher Hooker, a most forthright Northerner, to whom Hallie Brown had at first turned for help in becoming a representative of black interests, had prepared a circular for use in state work in Connecticut which illustrated the importance to the Board of the relationship between Southern and Northern women. It contained the following paragraphs:

The most impressive feature to me in our first gathering last November was the patriotic devotion of the Southern women and their earnest desire to become trained workers in this great enterprise. During the first three days, when all was chaos . . . these ladies sat quietly listening to the debate, but taking no part in it, and seldom attempting to vote, till finally one said to me in private, 'We are distressed to be of so little service here. We have never before been called to transact public business of any sort, are unfamiliar with parliamentary rules, and fear we must be counted as worthless members.' Reporting this to the Convention, I said: 'Dear sisters, take courage. You have shown yourselves good listeners, and able to sit still when you have nothing to say that is worth the saying and that is more than some members of Congress are able to do, after years of experience.' For this I was thanked almost with tears, and before we closed our session it was said to me by more than one: 'We are going home to study these matters of industry and social progress, and we are going to study parliamentary methods also, and teach our daughters as well, and some day you will find us better able to help in all good work, both local and national, by our coming here.'
And toward the last a noble Southern woman, a leader of thought and in beneficent work in her own State, said to me with equal dignity and frankness: 'I came here with prejudices against Northern women, and against you in particular, but I wish to say to you that every prejudice is now removed . . .''

This Southern woman wrote Mrs Hooker a letter in which she said that she wished to know more of her:

I almost long to see your face and hear you tell me of your life, your childhood, maidenhood and wifehood. That it has been a brave true life I am ready to vouch for; as Solomon said, 'A gracious woman retaineth honor.' In the life to come (please God we shall meet beyond the river), we will have time to tell each other of the pilgrimage, where it seems one must get old enough to be almost ready to depart before we can learn to agree, and at the same time learn to differ in an agreeable way.

With this sort of careful reaching out going on—and a good many other things as well—one can understand Mrs Palmer's hesitancy in challenging the state boards' "prerogatives." Her request for signed pledges to help black women received immediate compliance. Beyond that, she tried, after the failure with Hallie Brown, to provide another liaison officer. Mrs Curtis, a Chicago black woman and the wife of a doctor, was appointed "secretary of colored interests" and given a desk in the President's office. This relationship was a failure: a letter went from Mrs Palmer's office to Major Handy's office suggesting that Mrs Curtis be transferred to full-time work there, on black affairs, since she needed "constant supervision for Woman's Building work."

On a third try, Mrs Palmer named Fannie Barrier Williams, the bane of the Woman's Columbian Association, to help Mrs Starkweather with installation of exhibits in the Woman's Building. Mrs Williams accepted this unsalaried position early in 1893. In the summer of that year she, like Mrs Curtis, was transferred to Major Handy's office. Mrs Williams' position there, however, was a paid one. Mrs Palmer had recommended her highly:

I am very sure that you could give her an appointment with confidence that any duty entrusted to her will be discharged. My own experience with her has been very satisfactory. In addition to excellent character and pleasing address, she has considerable literary ability and is, moreover, a very fair typewriter.

By July, however, Major Handy's office was apparently required to cut staff, and Mrs Palmer was notified that Mrs Williams had been made redundant. Mrs Palmer consequently appointed her once more to work in the Woman's Building; Mrs Williams however, wished to receive a salary there which was not included in the Ladies' budget. She wrote to Mrs Palmer:

Before my temporary transference to Major Handy's office, I endeavored to prove my usefulness in every way possible that was consistent with my slight connection with your office. I now feel confident, on account of this experience, of being able to be more than an experiment in any appointment you may deem expedient to make for me.

Aside from any efficiency that may be accorded to me by Major
Handy and others, I also feel that my employment in your depart-
ment has been and will be accepted in part as a gracious recogni-
tion of a large number of colored women of intelligence in this
country who would like to be interested and inspired by women's
work as displayed in your department. I do not wish to be unduly
urgent in my own behalf nor to ask you to do an impossible thing,
but you have been so kindly considerate of me heretofore, and you
are by this time so well acquainted with my aspirations and
whatever merits I may have, that I have felt safe in sending you this
note.

Mrs Palmer was not able to give Mrs Williams a salary; in
August she wrote to her to reject a further "request for compen-
sation"; the President was somewhat annoyed. By October of
1893 the subject of money was apparently still not exhausted,
although Mrs Williams had spoken for the Board, to the great
edification of the *Woman's Journal.* Mrs Palmer wrote to Mrs
Williams, reminding her that she had made a considerable effort
to obtain a salaried position for her.

In the end, only J. Imogen Howard, a black New York City
schoolteacher who was appointed to the New York Board of
Women Managers, made a positive contribution to "the race."
Miss Howard worked untiringly for the Board for two years
without compensation, and at the same time continued to teach.
The executive committee of the New York Board gave her
authority to form her own committees and do whatever she
thought best. She decided at first to collect statistics of black
women's work, to show samples of the best of it, and to provide
an account of the progress they had made. During her vacations
she travelled over New York state, organizing sub-committees
and circulating written and printed appeals to black women to
contribute their efforts. She did not think that black women
could compete in various lines of women's work with white
women: the executive committee, however, believed that they
could, and they urged Miss Howard to form an Afro-American
exhibit.

When she began to work on this, she found so much interest-
ing material that the committee authorized her to extend her
efforts outside New York state. She contacted black newspaper
editors, schoolteachers and other influential, knowledgeable
black people. Sub-committees were formed by her in Philadel-
phia, Washington and Boston to gather statistics about black
women: Philadelphia had responsibility for the middle Atlantic
states, Washington for Southern and Western states, and Boston
for all of New England. The job turned out to be overwhelming.
The Washington and Philadelphia sub-committees had to con-
fine their work to those two cities and the Boston group decided
it could cope only with Massachusetts. Miss Howard then wrote
personally to over one thousand women across the country and

The Afro-American Exhibit

received a satisfactory response to her letters. Miss Howard's New York State statistics were incorporated into the Board's report on New York women. Miss Howard transcribed the other information. On the basis of her work the Board reported:

> It was found that those colored women who had done the most to show their capabilities are teachers, authors, artists, doctors, designers, musicians, nurses (trained), engravers, missionaries, lawyers, inventors, clerks, librarians, bookkeepers, editors, etc.

Facts gathered by Miss Howard filled a goodly number of pages. These were bound into a book and exhibited by the New York Board on a "table bookcase" in the south record room of the Woman's Building. The case for the Afro-American exhibit was furnished by the National Board of Lady Managers "who desired to show their interest."

The National Board's concern over their difficulties with the black women was reflected in an article in *Halligan's Magazine* for May, 1892:

> A number of journals at home and abroad have printed short paragraphs to the effect that the Board of Lady Managers have refused to admit the work of colored women to the Columbian Exposition. It can readily be seen that this action would not only be unjust but would be impossible to carry into effect, as it cannot be known whether applicants for space are white or colored unless they voluntarily reveal their identity. It may be definitely stated that the Board of Lady Managers has no desire to make any such discrimination. It is endeavoring to show the work of industrial women for all countries in the world without discrimination as to race, or color, and it will certainly feel an especial interest in securing such a representation from the colored women of the country as will fully illustrate their rapid advancement since the emancipation of their race.

Unquestionably there was truth in this comment. In addition, if one desired that black women be approached separately from white women, the story of Imogen Howard and the New York Board of Women Managers is a positive one. But the White City was a white city in more ways than one. In response to pressure, the Columbian Commission appointed one black man as an alternate from the state of Missouri. Three blacks held clerical positions on the Fair's administrative staff. There were no black guards at the Exposition. Embarrassingly and lamely, in retrospect at least, August 25, 1893, was declared by the Directory to be "Colored People's Day." Most "colored" were employed at the Fair as janitors, laborers and porters—and not a very high proportion of those.

At the Congress of Representative Women, black women's voices were heard. An interesting statement was made by Mrs A.J. Cooper of Washington, D.C., the corresponding secretary of the Colored Woman's League. She said that if she could crystallize the sentiment of her constituency for the Congress of Women she would say:

> Let woman's claim be as broad in the concrete as in the abstract. We take our stand on the solidarity of humanity, the oneness of life, and the unnaturalness and injustice of all special favoritisms, whether of sex, race, country or condition. If one link of the chain be broken, the chain is broken. A bridge is no stronger than its weakest part, and a cause is not worthier than its weakest element. Least of all can woman's cause afford to decry the weak ... The colored woman feels that woman's cause is one and universal; and that not till the image of God, whether in parian or ebony, is sacred and inviolable; not till race, color, sex and condition are seen as the accidents and not the substance of life ... not till then is woman's lesson taught and woman's cause won—not the white woman's, nor the red woman's, but the cause of every man and every woman who

has writhed silently under a mighty wrong. Woman's wrongs are thus indissolubly linked with all undefended woe, and the acquirement of her "rights" will mean the final triumph of all right over might, the supremacy of the moral force of reason, and justice, and love in the government of the nations of the earth.

BOARD OF LADY MANAGERS,

World's Columbian Commission.

RAND-McNALLY BUILDING.

Chicago Ill. U.S.A. Nov. 6ᵗʰ 1891

Numa — La.

As a Lady Manager of the State of *Louisiana* I shall do all in my power to further the interests of the colored women of my State, and will take pleasure in giving them all the information and assistance possible, by sending them the publications issued by the Board of Lady Managers, and in every other way striving to promote their interests.

I shall be glad to co-operate with any person appointed to represent the colored people in this State, in order that the whole exhibit of our State may be brought out. This is entirely in accordance with the feelings of our whole Board, and with a resolution passed at our last meeting.

Very respectfully

Katharine L. Minor

4ᵗʰ Vice President B. L. M.

IN September, 1891, at the second session of the full Board, Mrs Palmer said, "The proper adjustment of the relations between our own and the state boards is a topic that will require delicate handling . . . With these boards we must at once put ourselves in communication, or the great work that we are attempting will fail." The work had gone forward well, although Mrs Palmer was never content to rest on laurels. She reported at the same meeting:

> The organization of state boards has been slowly perfected and we have at present thirty-seven States, two Territories, Alaska and the District of Columbia in which there are committees composed of able and influential women either upon the State or Territorial Boards or forming independent organizations.

The volume of correspondence that went out from the Board in Chicago was equalled only by the Department of Publicity. Circulars covered projects ranging from a projected Children's Building to statistics gathering to decorations for the Woman's Building. In Connecticut, Kate Knight, the President of that state's board, was overwhelmed by the flood of printed matter. "Nothing," she said, "was left untouched. Women, it seemed, had an astonishing part in the development of things."

In January, 1892, the *Queen Isabella Journal* reported that Pennsylvania had set aside $10,000 for the use of its Committee on Woman's Work and each county in the state had organized an auxiliary committee

> to aid in ferreting out the numerous occupations in which women are engaged. In Luzerne County a large mine had been discovered to be owned and personally managed by a woman. So far through the State, the committee has found two civil engineers, two blacksmiths, many doctors, lawyers, wood-carvers, artists, authors and poultry breeders and typesetters. Pittsburgh, Philadelphia and Harrisburg will each furnish a panel for the Woman's Building carved by a woman.

In February, 1892, Josephine Allen wrote from Oregon to re-

port the success of her work there, noting that "women have responded so heartily that the gentlemen are beginning to feel that the indifference which has thus far characterized them is no longer becoming."

In May of 1892, Laura Hayes wrote to Mrs Palmer, who was in Europe for her second visit for the Board:

> Mr Dickinson said to me, when I spoke of the heavy work in the office, that he thought perhaps ladies wrote more letters than were necessary and rather laughed at their being unbusinesslike. I cannot say that I agree with him, for I do not believe a moment is wasted during the day in the office of the Board. I notice that we are always the first to arrive in the morning and the last to leave at night, and when I go home at six o'clock, there is not a man to be seen in the building.

In June of 1891 the Governor of New Jersey had refused to authorize the appointment of women to the state Fair board; on June 28, 1892, his decision was reversed by the state legislature. In fact, by August, 1892, refusals to accept women on state boards were reversed in Colorado, Iowa, Nebraska, Oklahoma South Dakota, Virginia, West Virginia, Arizona, Utah, Montana, and Louisiana.

Methods of recruiting women varied from state to state. In New York state the legislature created a Board of General Managers which was instructed to appoint a Board of Women Managers. Twenty-one women were appointed to work with the General Managers to promote

> the interests of the World's Columbian Exposition, and to assist the representative women of the nation in obtaining . . . a full and complete portrayal of the industrial and social conditions of woman and her achievements and capabilities in all the avenues of life . . . They shall meet . . . at Albany, upon the call of the chief executive officer . . .

The Woman Managers were given rooms with the General Managers: they elected a president (Mrs Erastus Corning), two vice-presidents, a secretary, and an executive committee of six. The sum of $25,000 was set aside for them. At their first meeting on June 7, 1892, seventeen of twenty-one appointed women, representing the eight judicial districts of New York, were present, and a Bureau of Applied Arts was planned, with Candace Wheeler as director. Mary Trautman, first Vice-President of the National Board, and Susan Cooke were at the first meeting to give advice and moral support. Even this was not sufficient, because the New York Women Managers were most insecure about their lack of experience. A committee went to Chicago to talk with Mrs Palmer and her aides and returned feeling better,

and aware of the need to interest women throughout New York state in the Exposition.

Some of the women wrote letters to clergymen, others tried to reach prominent women to form sub-committees. One of the Managers enlisted a woman in each large town, to become chairman of a sub-committee and bombarded her with weekly letters of inquiry. Another Manager held meetings in different counties to draw groups of women who could form committees. Letters were sent, circulars distributed, and press releases and interviews given. Books by women authors were sought, as were work in applied arts, loans of lace, and colonial collections during the autumn of 1892 and the winter of 1893. Hundreds of women gave time and often money without any personal ambition or compensation.

In Connecticut the Board of Managers recommended to the Governor the appointment of sixteen women and sixteen alternates to a Board of Lady Managers. In January of 1893 Kate

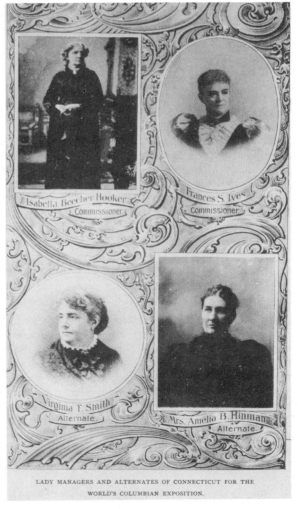

LADY MANAGERS AND ALTERNATES OF CONNECTICUT FOR THE WORLD'S COLUMBIAN EXPOSITION.

Lady Managers & Alternates from Connecticut

Connecticut's $300 was the first contribution from any state to the Children's Building.

Women in Nebraska and the rural areas of the Middle West did a great deal of recruiting at the state and county agricultural fairs.

In New Mexico, the Committee of San Juan was located fifty miles from the nearest railway station. Consequently L.R.E. Pauline travelled in a buckboard, spreading the word to isolated ranches. She made the rough journey every day for months, with a baby strapped to her waist and her three year old child tied to the buckboard seat.

The *Woman's Journal* reported in the summer of 1891 on the activities of an old friend:

Down in Georgia—where no appropriation has been made—one of the most interesting incidents happening in connection with the Exposition took place on the Fourth. Mrs Felton, Lady Manager for the state, and temporary Chairman of the Board, was invited to address a large concourse of women and girls who are operatives in the great cotton and woolen mills of Georgia. It was a magnificent opportunity to present the purpose and plans of the Board to the very persons it is most anxious to reach; and Mrs Felton was equal to the occasion.

This same issue of the *Journal* reported upon other states:

Massachusetts has appointed three women upon a State Commission of five. Rhode Island has four women in a State Commission of sixteen members ... Pennsylvania has recognized the Lady Managers as State officers upon its commission ... North Carolina has made the Lady Managers members of the State Commission, and as one of them is the manager of a large cotton plantation, the Women's Board will have a hand in the exhibit of that staple as well as silk ... Mrs Lucas, the Lady Manager from Pennsylvania, has been for years the president of the largest silk-growing association in the United States ...

In May, 1891, The Lady Managers of Colorado sent out an appeal:

We ask from those who are interested, suggestions as to the best method of showing to others what we can do, and are doing, as bread-winners and workers in this 'New West.' Let us make known what our hands, our hearts, and our brains are doing toward ameliorating and elevating mankind; from the preparation of meals—doubtless woman's first employment; the training of children; pantry and dairy stores; needle-work, drawing, etching, painting, pottery, and home decoration; wood-carving, taxidermy, manufactures, poultry and bee culture, stock-raising ... inventions, journalism, the 'making of books,' and the management of associations and institutions, benevolent and industrial.

In July 1892 a circular went out headed "Address to the

Women of Iowa by the Iowa Board of Lady Managers." The President was Ora E. Miller of Cedar Rapids. The circular said, in part:

Ora E. Miller

To the Women of Iowa: The Iowa Board of Lady Managers desires to call your attention to our State Exhibition of women's work and through this circular to enlist your assistance and co-operation in securing for Iowa at the World's Columbian Exposition such a representation of woman's skill and industry as shall be second to none in America.

The Iowa Board of Lady Managers was created by a recent Act of the Iowa Columbian Commission, for the purpose of organizing throughout the State ... County World's Fair Associations and Clubs, and also for the purpose of achieving a creditable exhibit of woman's work and achievements ... This Board of eleven women can do very little toward effecting this great object unless they have the sympathy and active co-operation of all the intelligent women of our state. They are the more in need of this co-operation because of the short time allotted them for this work and because of their hampered financial condition owing to the failure of the Iowa Legislature, to appropriate any money for their use ... we ... hope to make the Iowa exhibit of women's work such a one as will make every Iowa woman feel proud of the attainments of her sex.

Our desire is to exhibit ... all articles which illustrate woman's share in the industrial, educational, artistic, religious and philanthropical activities of Iowa ... to indicate the progress women have made in all these ... during the comparatively few years of our state's existence.

The Iowa Board attempted to list the types of things they were seeking, more as a guide than a specific request:

(a) Noticeably, fine specimens of every industry carried on by women in our state; this to embrace every department of women's work.

(b) Copies of all books, pamphlets or newspapers now or heretofore written or edited by Iowa women.

(c) All books and papers illustrated by Iowa women.

(d) Scientific collections of every kind made by Iowa women, if of genuine scientific value.

(e) A list of all inventions made by Iowa women, and whenever possible small models of the same not exceeding twelve inches in any one dimension.

(f) Colonial relics owned by residents of Iowa.

(g) Statistical and graphic representations of the educational and charitable works of women; graphic representations ... by ... maps so marked ... to indicate the locations of schools and charities operated in whole or in part by women.

(h) Representations for a historical exhibit of women's work which will illustrate how Iowa women have grown with the state ...

Exhibitors will be furnished blanks containing the question 'What per cent of labor was furnished by women?' The answer to this question will be used in the preparation of statistics that will entitle women to one or more members of the jury of award in each department.

Knight was elected President and Mrs Franklin Farrell Vice-President. Mrs Knight also served as Secretary. Five women constituted the executive committee. At their first meeting a committee of three was appointed to act with the general Building Committee to have charge of the furnishing and decoration of the Connecticut House at the Fair. Although this House was called a general Connecticut exhibit the Connecticut Board of Lady Managers considered the House to be a women's exhibit. They worked also, of course, for the Woman's Building itself. Circulars were sent out in May, 1892:

Dear Sir:
The Board of Lady Managers of Connecticut for the World's Columbian Exposition desire to obtain immediately the names of women, residents of this State, who are skilled in wood carving. They also wish the names of women who are particularly skilled in fancy work and domestic manufacture, and of such persons or corporations as employ female help largely, with the class of goods made.

Notes were sent to the women themselves:

The Board of Lady Managers of Connecticut ... desire that the State of Connecticut shall be creditably represented in the Woman's Department. I have been advised that you are skilled in _____ . Please inform me whether you have or are willing to make any articles for exhibition at Chicago. A Committee of the Board of Lady Managers will examine all articles offered, and such as are accepted will be forwarded and placed on exhibition, without expense to the exhibitor.

A circular of rules was issued:

BOARD OF LADY MANAGERS
of Connecticut
WORLD'S COLUMBIAN EXPOSITION
Hartford, Dec _____ 189 _

There has been a committee of Experts appointed by the President of the Board of Lady Managers of Connecticut whose duty is to make decision upon the merit of articles for which application for space is to be made in the Woman's Building; and no article will be installed by the Director of the Woman's Building which has not been approved by the Committee of Experts.
Specimens of painting are to be sent to either Miss Lucy P. Trowbridge, 210 Prospect Street, New Haven, or to Mrs Morgan G. Bulkeley, 136 Washington Street, Hartford. China Painting to Miss Trowbridge, and needle-work to Mrs Bulkeley.
Every applicant for space in the Woman's Building will have space assigned to her by the Secretary of the National Board of Lady Managers, if her article is marked of the first order of merit in its

class. Articles of the second order of merit will, very often, be quite eligible to a place on the General Departments of the Exposition.

RULES

In FINE ARTS, copies will not be admitted.

In EMBROIDERIES, only original designs will be admitted; stamped patterns will be strictly excluded.

IN THE LIBRARY, only books of scientific, historical, and literary value will be received.

MAGAZINES and press articles of the women writers of the State may be bound together, making a State volume.

IN PATENTS, only drawings and photographs will be allowed, except in rare cases of peculiar value, when working models will be admitted.

The exhibitor must be the manufacturer or the producer of the article exhibited, except in the case of the loan and retrospective exhibit.

An appropriation was requested from the Connecticut fund. Five thousand dollars was granted to the women; this sum was later raised to seven thousand. This money was to cover the following expenses:

For decorating and furnishing the Connecticut Room in the Woman's Building; for exhibit of literature, including the publication of Selection from the Writings of Connecticut Women; for assuming the entire expense of the Connecticut women making exhibits in the World's Fair; for such carved panels as were not gifts in the Woman's Building; for the collection of statistics and the general expenses of the Board in carrying on their work as managers.

Connecticut was late getting started in its Fair work because of political struggles. "Public sentiment and private citizenship," wrote Mrs Knight, "gave the first subscription of $50,000. The Scriptural tenth was devoted to the Woman's Board ... "

Early in May, 1892, the Board voted three hundred dollars towards the Children's Building, of which $226 was raised by the managers themselves and $74 drawn from their state funds. The Connecticut women were inspired to work for the Children's Building by their observations at the state and county fairs, which Mrs Knight called

one of New England's most cherished institutions. We had all seen the young and anxious mother with rows of tense little fingers clutching her skirts, and in her arms a fretful little bundle of nerves with which she was constantly compelled to divide her interest in the many-pieced bedquilt, the biggest pumpkin ... To be counted among those who could help change such conditions as these for the things promised in the children's building was like being granted a foretaste of the Millennium.

The Iowa Board further asked women to help organize "world's fair county associations in every county and world's fair clubs in every village and township in Iowa to help raise funds for exhibits and to educate the people about the Fair through meetings and correspondence." The second purpose of organization was to encourage Iowa women to enter competitive exhibits, and thirdly to secure "works of superior merit for the gallery of honor in the Woman's Building."

A final report of the Iowa Board of Lady Managers showed that forty-one World's Fair Societies had been organized in the state, with a total of 1558 members. The total amount subscribed was $1558, at a dollar a member. Thirty percent was retained by the local societies. Miss Miller listed the accomplishments of the women of the associations:

Centerville, coke exhibit; Sioux City, splendid corn decorations; Iowa City, clock of Iowa marble, built in the form of the State University of Iowa; Vinton, carved table and chairs of native wood; Burlington, large bird's eye view of that city, done in oil, and framed in hand carved native wood frame: Ft Dodge decorated two rooms in Iowa Building in cementico, a product of that vicinity; Dunlap, a massive carved chair; Decorah, a table of native marble; Mitchell County, a beautiful large banner; Dubuque, grotto of minerals; Maquoketa, exhibit of polished woods.

Iowa women ran the school of corn cooking and were represented in the various congresses, and exhibits in every department in the Woman's Building. "Exceptionally fine was the exhibit in lace, receiving the award of first merit and competing successfully with a large amount of foreign competition."

Women were represented also in the general exhibits throughout the Fair where the "idea of sex was eliminated as far as possible." A testy note crept into the Iowa report in the discussion of accomplishments by local societies:

Owing to the inefficiency of the commissioner in charge of this department, or his lack of adaptation to the work in hand, or from other causes, the plan of association organizations was not as thoroughly exploited and popularized throughout the state, and did not produce results as great, as he had anticipated.

No one could accuse the Iowa women of inefficiency.

In twenty-two states and territories the Lady Managers were members of State boards, and worked to secure state funds, contributions and exhibits. These states were Colorado, Indiana, Delaware, Iowa, Kansas, Louisiana, Maine, Minnesota, Missouri, Montana, Nebraska, Nevada, North Carolina, Ohio, Oregon, Pennsylvania, Rhode Island, Virginia, Washington, Arizona, New Mexico and Utah. In six states—Alabama, Arkansas, Florida, Georgia, Idaho, and Maryland—the national Board had

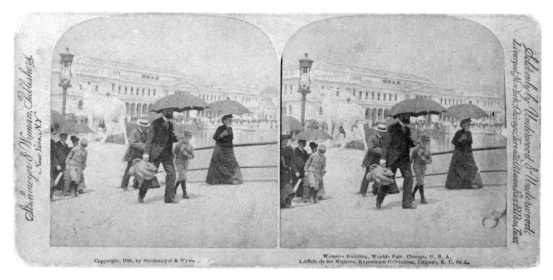

Postcard

Anna M. Fosdick

to secure exhibits. Special women's commissions worked with the national Board in California, Connecticut, Illinois, Kentucky, Michigan, New Jersey, New York, North and South Dakota and Texas. In Massachusetts the National Board were abetted by a women's commission and a separate volunteer committee called the Women's Columbian Exposition Committee, which raised $5,563.12. The state appropriated nothing for the women.

Alabama, Mississippi and South Carolina had no official Exposition boards. In Alabama Lady Manager Anna M. Fosdick set up unofficial committees: from Mobile her Women's World's Fair Association provided furniture and wainscotting for the platform of the Woman's Building Assembly Room.

Louisiana's state board was not set up until August, 1892; motivation behind the board came almost exclusively from the women of the state.

Missouri had no appropriation for women's work but the women commissioners raised $7000 through auxiliary organizations and were able to furnish seven rooms of the Missouri Building.

In North Dakota the women received no appropriation, but Sadie Davidson was appointed Superintendent of Women's Work by the executive of the state board. The national Lady Managers helped her to organize Columbian Clubs in all parts of the state: more than $3000 was raised for a women's handiwork exhibit and to furnish nearly the entire second floor of the North Dakota Building.

The Woman's World's Fair Association of Texas supplied the Texas Building and all its contents as a woman's exhibit. The original Fair commission of Texas dropped its plans for a build-

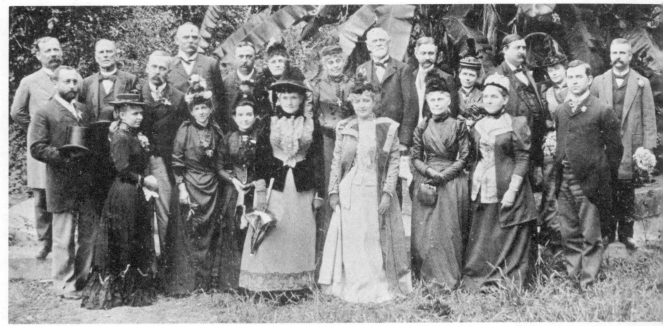

Mr & Mrs Potter Palmer & World's Fair Party
San Antonio, Texas. Nov 2, 1891

ing, which was then taken over by the women of the state under Bernadette Tobin. Literary works by Texas women were gathered into the Woman's Building Library by Rosine Ryan, although the contribution of Texas women to the Woman's Building was limited by their activity on behalf of the Texas Building itself.

Mrs Palmer returned to Europe in the spring of 1892, to do more ambassadorial work for the Woman's Building. She went to Belgium, where she had not gone the previous year. While she was gone, Laura Hayes wrote to her:

> I do not find it easy to work at the office, as there seems to be such constant confusion and so many interruptions. If I am to stay there, I shall insist upon having some quiet corner where I can write. The Lady Managers come in and use your room with perfect freedom and I had to move out this morning for a meeting of the Chicago Nine.

In January Mrs Palmer had reminded James Blaine, now restored to health, of his promise to send Board letters through diplomatic channels. She composed one such letter to Queen Victoria, which she hoped would reach the Queen through the State Department. It was addressed "To Her Majesty, Victoria, Queen of the United Kingdom of Great Britain and Ireland, Empress of India, etc." without any attempt at democratic downplaying of the respect due to royalty:

> The world knows of your interest in, and devotion to the welfare of women, and for that reason I am emboldened to address you

directly, begging that the work of the Board of Lady Managers of the World's Columbian Exposition may receive the approval and patronage of Your Imperial Majesty. [The women of America] ... hope and desire that a committee of women may be appointed, with your Imperial sanction and patronage to provide for such an exhibition at the World's Columbian Exposition at Chicago, as will most fitly and fully illustrate the progress and achievements of the women of Great Britain. I ask the privilege also of expressing the profound and universal esteem and admiration in which Your Imperial Majesty is held by the women of America, and beg leave, to be ... Your Majesty's most obedient servant, Bertha Honoré Palmer ...

The ingratiating tone of this letter did not, as might be expected, sit well with many Ladies, several of whom did not hold the Queen in profound esteem or even admiration, and who did not want her to approve of them or patronize them. "Writing diplomatic epistles has its own embarrassments," Margaret Salisbury of Utah wrote to Mrs Palmer tactfully. The State Department adjusted Mrs Palmer's rhetoric; Thomas Cridler was charged with the duty of writing letters to foreign governments for the Board. It was a cumbersome job, attempting to reach women in so many distant places.

Mrs Palmer had not gone to Spain or Russia, nor to Scandinavian, African or Middle Eastern countries. She relied on the State Department and whatever private leads she could find. Spain—the land of Isabella—had no American ambassador in 1892: when women there finally got news of the Board's work their exhibit had to be assembled in unseemly haste. The Ladies were able to reach women in countries with shaky diplomatic relations with the United States. The usual Exposition rhetoric was not used by the women: they did not speak of trade or exchange of goods, but of the role of women in a rapidly changing world; they did not talk about the benefits of industrialization, but of the conditions under which women had to work in industrial societies. They did not promote commerce; they promoted instead the highest human values. They relied on women the world over to understand and respond to their appeals.

Rosine Ryan

Mrs Palmer had planned to go to Mexico, but under the weight of opposing forces, and her own two trips to Europe, she could not manage this. Congress had refused to supply the money to send Lady ambassadors to Latin America. As Mrs Hooker had once suggested they should, the Ladies turned to the Commission's Latin American specialists. William Curtis of the Commission promised to write letters for them. Virginia Dodge, one of the many women who had offered to go to Latin America for the Board, told Mrs Palmer that it would be difficult to reach Latin American women because the men did not want them "to think, or to extend their interest beyond their own walls." Mrs Palmer wrote to Carmen de Diaz, the wife of the

President of Mexico. The letter was hand-delivered by a Mexican Commissioner to the President's house in Mexico City. Señora de Diaz replied on August 30, 1892 that her "desire and the desire of the ladies who are assisting in this work is that Mexico, that cannot compete with many nations in artistic masterpieces, at least may present something characteristic and unique in its nature." In July Señora de Diaz summoned the wife of every provincial governor, or prominent women from provinces of unmarried governors, and asked them to gather products of their regions: pottery, woven goods like serapes and ponchos, basketry, silver and onyx. Carmen de Diaz chose what she considered the most attractive pieces to send to Chicago. On a lighter note, Señora Diaz added demonstrations of the making of chocolate and tamales, and a female orchestra dressed "in rich costume."

Carmen Romero Rubio De Diaz

For the rest of Latin America, only Mr Curtis could serve the Ladies. Cuba, Brazil and Guatemala sent officially funded exhibits to the Woman's Building. Peru, Colombia, Chile and Ecuador were represented there by privately funded exhibits. Male commissions created official Latin American exhibits for other Fair buildings through the Columbian Commission which had many representatives in Latin American countries. Nicaragua announced an official commission, but a revolution prevented any further developments.

In 1892 Mrs Palmer noted a lack of response from overseas: "the inaction in France we thought inexcusable," she said later, "until we looked to Washington and saw there the same unaccountable procrastination ... " Thomas Cridler of the State Department had been charged with acting for the Board in Europe; Mrs Palmer was not happy with his performance. "I am writing to the Republics," he told her at one point, responding to some tactful prodding, "but I find difficulty in doing this, since I have no way of learning whether each President has a better half." This kind of thing would not go down well with Mrs Palmer, who knew how to get things done, and expected quick action. After some brooding over the problem, which obviously originated with Mr Cridler, she wrote him briskly:

> Mr Curtis told me you did not want to discharge some clerk who was incompetent for fear of hurting his feelings. Please allow no such motive to restrain you in connection with our work, as we make capacity the first requisite and employ no one who cannot in the best manner possible, perform the duties for which he or she is engaged ... We certainly do not wish our work held back by incompetent people ... Our whole foreign work will fail and has been greatly damaged already by this delay.

The strong hints in this letter jarred Mr Cridler into action: Mrs Palmer was able to report positive accomplishments to the

third Board Meeting in October, 1892: "After a long period of inaction the enrollment of foreign women was rapidly effected, and we are now possessed of the most powerful organization that ever existed among women . . . "

> The members of the English Committee, under the patronage of the Queen and of which Princess Christian is President, have been chosen with singular discretion. Each Chairman is a power in herself, as well as perfect mistress of her own line of work, and all are enthusiastically following the leadership of their much loved President. To give an indication of the strength and efficiency of this committee, I need only mention such names as the Duchess of Abercorn, the Marchioness of Salisbury, the Countess of Aberdeen, Lady Somerset, Lady Brassey, Baroness Burdett-Coutts, Lady Knutsford, Lady Jeune. In France Madame Carnot has finally taken the active presidency of the committee, notwithstanding the fact that last year she declined to do so. She has secured committees of the most earnest, influential, and competent women to second her own efforts. This will surely result in a remarkable exhibit from the tasteful, expert and intelligent women of France. We can say the same of our committee in Germany, which is working energetically under the direction of the Princess Friederich Carl, Fraulein Lange, Frau Morgenstern and other noted leaders.
> Italy was almost the first to announce its committee, under the special patronage of Queen Margherita, who is personally directing the work, and who will send her marvelous collection of historical laces, some of which date back 1000 years before Christ, having been taken from Egyptian and Etruscan tombs. They are both personal and Crown property, having never before left Italy. This royally generous response to our appeal was doubly welcome, for it came when diplomatic relations between the two countries were severed, and it was intended as a special mark of friendship. Accompanying this lace exhibit will be a collection of the work of the Italian women of today, a prominent feature of which is the lace made by the peasant women in the societies organized by, and under the direction of, the Queen . . .

Mrs Palmer was particularly pleased with the response from Belgium, where she had gone on her second trip to Europe in April and May of 1892.

> There has nowhere been more intelligent cordiality shown toward our work than in Belgium, where we are honored by the special patronage of the Queen, and the active presidency of the Countess of Flanders. Countess de Denterghem, who has charge of the work, is a most influential woman, of remarkable executive ability. She organized, last spring, a special exhibition of women's work for the benefit of a charity in which she was interested, taking the idea from the suggestions contained in the circulars of the Board of Lady Managers . . .
> The difficulties in our way in Austria seemed insurmountable, and I have until a very recent time been very doubtful about the success of the strenuous efforts made there, on our behalf, by our Minister and his wife, as well as myself. I have recently had the pleasure of receiving a cable informing me of the appointment of a strong com-

mittee of women . . . This is the more gratifying, as Austria is one of the most conservative strongholds of Europe.

Russia, which has a committee organized by the Empress herself, will send its remarkable laces and embroideries, and many curious national costumes, which are very picturesque . . . the ladies are working with great enthusiasm.

Japan had at first been a problem. The Ladies had been sent word by the Emperor's representative that the women of his country "were not sufficiently advanced to successfully undertake an enterprise of this kind." Fortunately, however, Professor de Guerville had given an illustrated lecture before the Japanese royal family, which included information about the Fair, and the Empress had become so interested in the work of the Board that she had personally authorized the appointment of a woman's committee, paying for it out of her private purse.

China presented a different sort of problem, and Mrs Palmer had tackled it with her usual vigor, as she reported to the Board:

China . . . has never officially participated in any exposition. It is contrary to the custom of the country; but Lord Li . . . has given us to understand that a semi-official committee would be formed to send exhibits to us, provided our laws could be modified so as to allow the necessary attendants and persons in charge, to bring the exhibits into this country. The Chinese deeply feel the humiliation of the Exclusion Laws, and their desire for a better knowledge of our country is shown by the fact that Lord Li proposes, in case this exhibit should be made possible, to send his wife, as will also several of his friends of high position, to take charge of the exhibit, so that they may be enabled to make the journey through the country and study our civilization. Upon learning these facts I wrote immediately to Washington and was fortunate enough to find that one of the final acts of Congress before its adjournment was the passage of a bill allowing the Chinese to accompany their exhibits. I at once communicated this fact to our Chinese correspondents, and hope . . . that a semi-official committee of Chinese women may soon be announced . . . this . . . will be a great point scored by us, as the Chinese are represented in the general buildings only by their merchants, and have no official standing whatever.

Despite Mrs Palmer's optimism, a Chinese committee does not appear to have been sent to the Woman's Building. A few examples of weaving and embroidery were sent without a representative. Some disappointment over this fact may lie behind comments made by Maud Howe Elliott, the daughter of Julia Ward Howe, in her discussion of the Woman's Building:

The religions of the Orient, which teach that man only is capable of civilization, and have made woman man's slave, are partly responsible for the long period of triviality in women's work . . . Orientalism is responsible for the idea that woman is the inferior of man, and when I hear women lightly professing a belief in Buddhism, I

always feel like reminding them that one of the fundamental ideas of that religion is that the female principle in the universe is the principle of evil.

Not only China failed the Ladies. The diplomatic snubs that Mrs Palmer knew would irritate the State Department came from other countries as well, proving that women needed to work for women:

That this work is needed is evidenced by the pathetic answers from some of the countries where our invitation had been declined. For instance, a letter received from the Government of Tunis states that a commission of women cannot be formed in that country, because local prejudice will not allow the native women to take part in public affairs. Syrian correspondents write that it will be impossible to secure the official appointment of a committee of women ... as custom prevents women from taking hold of such work, and the government will lend no aid, but that an effort will be made to send a small exhibit, unofficially. Other Oriental countries make the same reports—no schools—women not intelligent enough to undertake the work—public prejudice, etc. It seems incredible that the governments of these countries would be willing to make admissions which reflect so much upon themselves, or that they would allow these shameful conditions to continue.

Bertha Palmer

Even Mrs Palmer confessed herself defeated by "the oppressive bonds laid upon women, both by religion and custom" which were in some cases "so strong as to be insurmountable," at least "during the present generation." The women of India could only be helped by the creation of a desire within them "for something better ... " She bounded back, however, with encouraging facts: Russia, "which is usually regarded as being far behind the average modern thought, has numerous colleges and higher institutions of learning for its women. They have a medical college for training women physicians, and six hundred of the latter are ... practicing their profession." She had found a female professor of astronomy in a "man's college in Denmark"; she also found evidence of women professors, doctors, lawyers and writers in Italy, although unfortunately in the fifteenth century.

Forty-one countries responded in one way or another to the circulars, letters and personal appeals of the Board of Lady Managers. The Commission was itself surprised by this response.

Bertha Palmer spoke of "the freemasonry" among women and "the exalted and influential personages" abroad who could not enjoy "the ease of their own lives without giving a thought to their helpless and wretched sisters," some of whom attempted to respond "feebly" to the call, hampered as they were by "the tremendous bonds of religion and custom." She saw "pathetic evidence of an inward and suppressed desire to respond" in these

downtrodden women; she hoped that the Woman's Building would help the women of the world who for the first time worked together for a common purpose. Certainly the Ladies' frail bark was still afloat in 1893; its iron-jawed helmswoman had steered it through storms which would have overwhelmed a less dedicated crew. Mutinies had been stopped by drastic measures. "Individuals are but insignificant atoms," Mrs Palmer had said in 1891. "It is the grand purpose that is everything."

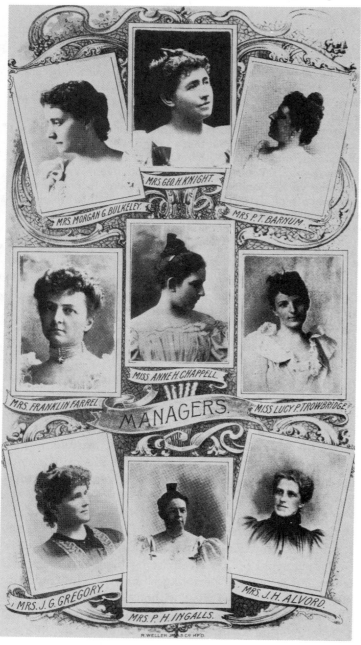

Connecticut Board of Lady Managers

A T the first Board meeting in November, 1890 Frances Shepard offered a resolution asking for a Woman's Building; on November 26 her resolution was adopted unanimously. Mrs Palmer wrote to Lyman Gage on December 8:

> These resolutions recommend the erection of a suitable building on the Exposition grounds, to be placed under the control of the Board of Lady Managers, to be known as the Woman's Building, in which will be placed special exhibits of woman's work, which on account of their rare merit and value the exhibitors would prefer to have placed under special care and custody of the Board; said building to be used as the official headquarters of the Board of Lady Managers, and for such other purposes as it may deem proper and expedient.

The resolutions asked for the submission of plans for the Building by both men and women at the next Board meeting, if they could be ready by "April next" or if not, submission to the Board's Executive Committee, which was, as we know, not yet named.

The architectural design of the Fair was supervised by the Chicago firm of Burnham and Root in conjunction with the Directory's Committee on Grounds and Buildings. Daniel Burnham was named Chief of Construction in October of 1890, while John Root remained consulting architect. Frederick Olmsted and Henry Codman were consulting landscape architects; Abram Gottlieb was consulting engineer. When Jackson Park was finally selected as the site, the plan was to create a large court formed by impressive buildings of harmonious design, enclosing a lagoon. A canal would flow north from the court to other buildings and lagoons.

Burnham wanted to "abandon the conservatory aspect of other expositions"—the Crystal Palace idea—"and ... suggest permanent buildings—a dream city." Burnham and Root realized early on that they could not themselves design the Fair buildings: not for want of ability or desire, but because of the

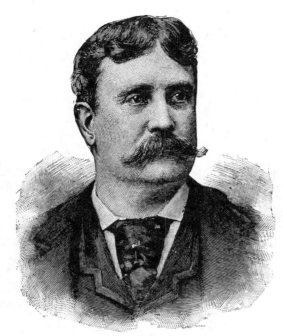

Daniel Burnham

pressure of time, the resentment of local architects and the need for the Fair to be a national enterprise. Architects from all over the country should be involved in its design. An open competition was considered, as well as a less democratic competition restricted to selected architects. It was Burnham who decided to eschew democracy in this case and choose the Fair architects. His choices were New York firms of Richard Morris Hunt, McKim, Mead and White and George Post; Peabody and Stearns of Boston, and Van Brunt and Howe of Kansas City. On December 31, 1890, after some initial difficulty with politicians on the Directory, who could not in any case come up with a unanimous suggestion, formal letters of invitation went out stating that Burnham's office would supply "data about materials, sizes, general disposition and cost of buildings" and be in charge of "constructional features" and "execution of the entire work." The architects were to approve of "artistic parts" and must "from time to time . . . visit the work" either individually or as a group, depending on whether they themselves decided to work jointly on the whole design, or each plan separate buildings.

Burnham was disappointed that only Henry Van Brunt of Kansas City responded immediately to this invitation. It was necessary for the Chief of Construction to go to New York to win over the Eastern architects, who were doubtful that this enterprise in Chicago was worth their time and effort. Burnham managed to win them over completely because of the magnitude of his vision. He returned to Chicago to find unrest over his neg-

Sophia Hayden. Sketch for Second Story Woman's Building

lect of local architectural firms. The committee on Grounds and
Buildings authorized him to select five Chicago firms; his choices
were Adler and Sullivan, Burling and Whitehouse, Jenney and
Mundie, Henry Ives Cobb and Solon S. Beman.

He went personally to these houses and received acceptance
from all except Adler and Sullivan. There was some bad feeling
between Adler's firm and Burnham and Root. After some hesita-
tion, Adler complied. Burnham then called all the architects to
Chicago to see the site. On the day that they went to Jackson
Park, Root was already feeling ill; he remained in the office. The
architects took fire, infected by Burnham's immense enthusiasm
and faith: they named themselves a board with Hunt as chair-
man and Louis Sullivan as Secretary.

A few days later Root was dead of pneumonia. The shock to
Burnham was enormous. It was necessary, however, for the plans
to move ahead: Burnham chose Charles Atwood, a New Yorker
recommended by the people Burnham knew at Columbia
University, to become consulting architect of the Fair. Dion

Geraldine became general superintendent, and Augustus St Gaudens and Frank Millet, sculptor and painter respectively, were named chief advisors on art.

Early in 1891, while Burnham was engaging in these delicate negotiations with famous architects, the Ladies decided to revise their resolution and request that the architect for their Building be chosen by a competition restricted to women. Mrs Palmer had written to Root on January 13, 1891, three days before his death:

> Mr Waller [a vice president of the Directory] alarmed me last evening by saying that he understood that Mr Hunt was to build our building. Of course we will not have a man called in until the woman architects have tried and failed to produce a suitable plan.

Richard M Hunt

Mrs Palmer's feelings toward Daniel Burnham appear to be somewhat ambiguous. His choice of Richard Morris Hunt to design their building could only be a compliment to the Ladies. Hunt was the founder of the American Institute of Architects; he had studied in Europe and knew a great deal about Renaissance style, which was the style agreed upon for the Fair buildings. He was possibly the most honored architect in America, and was, as we have seen, the natural choice for chairman of the board of Fair architects. Considering the difficulties which Burnham had encountered in persuading Hunt, and the other Eastern architects, to work on the Fair, he could not have considered the assignment of the Building to this man as anything less than an honor.

After Root's death, it became necessary for Mrs Palmer to deal directly with Burnham. Root had been an educated Southern gentleman; Burnham was generally considered the less talented of the two: certainly he had not attended a university and had had humble beginnings. It is perhaps not surprising that Mrs Palmer had chosen to write to Root about Burnham's choice of architect, rather than to Burnham himself. In any case she argued to Burnham that "the announcement of the competition and the sending in of a number of good designs by competent women would attract attention to our work, and also be an advertisement for all the women who entered the competition . . ." She pointed out that there was no woman who had "such a reputation for planning public buildings as would justify us in giving our building to her with the same assurance of success as in the case of a male architect" and that "the best design might come from the most unexpected source . . ."

There were in fact practicing women architects at this time. Louise Blanchard Bethune of Buffalo, New York, shared an architectural firm with her husband: together they built schools and public buildings as well as houses. In 1888 Mrs Bethune was the first woman admitted to the American Institute of Architects.

A year later, she became its first female Fellow. She had opened her architectural firm in 1881, when she was twenty-five years old, and had married her partner Robert Bethune three months later. Mrs Bethune estimated in 1891 that the number of American women with degrees in architecture could "hardly exceed a dozen." In fact between 1878 and 1894 eight women completed four academic architectural programs in the United States. Cornell, Syracuse, Cooper Union and MIT were among the few schools offering degrees in architecture to women. Mrs Bethune herself, like most women interested in architecture, apprenticed in an architect's office. Frances Mahony of Chicago, the first woman licensed to practice architecture in Illinois, received her degree from MIT in 1894.

The first woman to complete the four year course in architecture at MIT was Sophia Hayden, who had been born in Chile in 1868, and had lived in Jamaica Plain, outside Boston, from the time she was six years old. After her graduation from West Roxbury High School her father, who was a dentist, moved the family to Virginia. In 1890 Miss Hayden returned to Jamaica Plain to teach mechanical drawing after she received the Bachelor of Architecture degree from MIT. In that same year, Lois Howe, a friend of Sophia's, completed a special two year course in architecture at MIT.

Julia Morgan of California received a degree in engineering from the University of California at Berkeley in 1894, and went on to found her own architectural firm in San Francisco. Admittedly, her education was finished a little late for the Board's purposes. Thus there were not really many women architects whose

Hotel LaFayette. Louise Bethune.

names might be known to the Board of Lady Managers or their
friends. There was always Minerva Parker Nichols, of course: she
had been graduated from the Philadelphia Normal Art School in
1882 and gone to work at the age of 21 as a draftsman for the
Philadelphia architect Frederick G. Thorn, in whose office she
remained for six years. When Mr Thorn retired in 1888,
Minerva Parker absorbed his business into her own office. In
1891 she married William Nichols, a Unitarian minister. Most of
her buildings were houses, but she built factories too, and two
New Century Clubs for women, one in Philadelphia and one in
Wilmington, Delaware. Unfortunately for Mrs. Nichols, she had
already designed the Isabella Pavilion for women whom Mrs
Palmer considered, with some reason, to be her arch enemies. On
top of that, Frances Dickinson, whether from malice or insen-
sitivity, or both, had actually submitted Mrs Nichol's design for
the Isabella Pavilion to Mrs Palmer's office for consideration as a
design for the Woman's Building. "I send the enclosed to add to
the many schemes proposed you," she wrote. Mrs Nichols'
Moorish design could not possibly blend with the neoclassic look
that the Fair required, apart from everything else.

The Board had received other applications before the com-
petition was announced. John Dickinson had forwarded a letter
from Sallie T. Smith, an Alternate Lady Manager from Alabama,
who said she was a partner in her father's architectural firm. "I
am one of the few women architects of this country," she wrote,
"and would like an equal showing with the men." Further in-
quiry revealed that Sallie Smith had misrepresented herself; dis-
couraged, she did not attempt to enter the eventual competition.
Lois Howe had written on the stationery of Allen and Kenway, of
Devonshire Street in Boston, where she had recently begun
work, that "Mr Robert Peabody" of the firm of Peabody and
Stearns, already engaged by Burnham, "wishes me to offer
myself as a candidate for designing the Woman's Building."
Indeed, the Boston architects had mentioned to Burnham "the
remarkable ability shown by clever young women who had
finished architectural courses in various Eastern institutes."

These comments from Peabody and Stearns may have in-
fluenced Daniel Burnham to look with favor on the Lady
Managers' plans for their Building. Mrs Palmer showed him
pencilled sketches of what the President envisioned the Building
to be: 200 by 500 feet in size, with a central gallery surrounded
on two main floors by large exhibition rooms. The second floor
would open onto large balconies. Mrs Palmer's design included a
skylight and interior recessed colonnades. The design was attrac-
tive and blended well with Burnham's own conception of the
Fair. Although he could be forceful when he felt he needed to be,
Burnham was not an unpleasant man; there was no reason to
upset the Ladies by forcing Richard Hunt upon them. It was

Burnham's office, after all, which really had responsibility for construction of the buildings. In addition, Mrs Palmer's plan offered some cost-saving: the architectural firms were to receive $10,000 each, plus travelling expenses: $3000 was to be paid on the completion of preliminary sketches, $6000 on the acceptance of the completed designs, and a final $1000 on the completion of the actual buildings. The Ladies' architect would get a fee of $1000 and expenses. Even with the addition of second and third prizes of $500 and $250 respectively, the Woman's Building would be a bargain, with some interesting publicity thrown in, a considerable asset in itself.

Mr Burnham's office consequently drew up a circular, which was issued by the Fair's Department of Publicity and Promotion:

> Sketches are asked for, on or before March 23, 1891, for the Woman's Building of the World's Columbian Exposition. None but those made by women will be considered. Applicants must be in the profession of architecture or have had special training in the same, and each must state her experience, in writing, to the Chief of Construction. All sketches must be sent in sealed, with only a motto on the envelope, which must contain a second envelope inclosing name and address of the designer. The selected design will carry with it the appointment of its author as architect of the building. She will make her working drawings in the Bureau of Construction, and receive an honorarium of $1,000 besides expenses. A prize of $500 and one of $250 will be given for the next two best drawings. A simple light-colored classic type of building will be favored ... The general outline of the building must follow closely the accompanying sketch plans, the extreme dimensions not exceeding two hundred by four hundred feet; exterior to be of some simple and definite style, classic lines preferred; the general effect of color to be in light tints. Staff, stucco, wood, iron and equivalents to be used as building material, with discretion as to the disposition and ornamentation, so as not to render the building too costly. First story, eighteen feet high; second story, twenty-five feet high ... to come within the limit of ... $200,000. The plans should show the outline desired, leaving all detail to the ingenuity of the competing architect, who is expected to give them a thorough study, locating openings, etc., so as to give easy access and exit to the constant flow of passing crowds. The main entrance will lead down a series of steps to the water landing. Drawings must be made to a scale of one sixteenth of an inch to the foot. They must include elevations of one front and one end as well as one perspective.

Louise Bethune

Louise Bethune did not enter this competition. The American Institute of Architects opposed architectural competitions on principle and she agreed with them. But she was especially annoyed by the competition for the Woman's Building.

> The idea of a separate Woman's Board expresses a sense of inferiority that business women are far from feeling. The Board desires a woman architect, and the chief has issued a circular not-

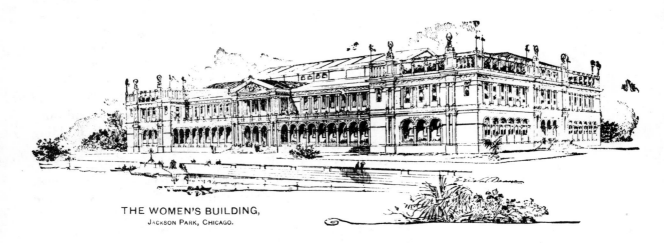

THE WOMEN'S BUILDING,
Jackson Park, Chicago.

withstanding the fact that competition is an evil—and nearly vanquished. It is unfortunate that it should be revived in its most objectionable form on this occasion by women and for women.

Thirteen women did enter the competition, including Minerva Parker Nichols. They had had only six weeks from the announcement of the contest in which to submit their sketches and a statement of their credentials. The competition closed the morning of March 24, 1891. Mrs Palmer received a message on that day to come to Mr Burnham's office at two o'clock in the afternoon for the opening of the sealed envelopes. Mrs Palmer later told the Board that she went

with some sinking of heart, fearing there might be nothing as creditable as we had hoped for, and you can well imagine our surprise and delight, as drawing after drawing was opened and spread before us, until we had thirteen plans, almost all of which were good, and five or six excellent.

Mrs Palmer wished to discuss the Board's decision with her Executive Committee the following week, but Mr. Burnham insisted she make her decisions on the spot. He had already had difficulties over his own architectural decisions with the Directory; he knew what committee decisions could be like. Frances Shepard and Amey Starkweather had accompanied Mrs Palmer to his office; he considered that they were capable of making an intelligent decision. Sophia Hayden won first prize. She had designed a Renaissance Musem of Fine Arts for her thesis at MIT, and her design for the Woman's Building was modeled closely on that. The three judges chose Miss Hayden's design partly because "with its balconies, loggias and vases for flowers, it was the lightest and gayest in its general aspect, and consequently best adapted for a joyous and festive occasion."

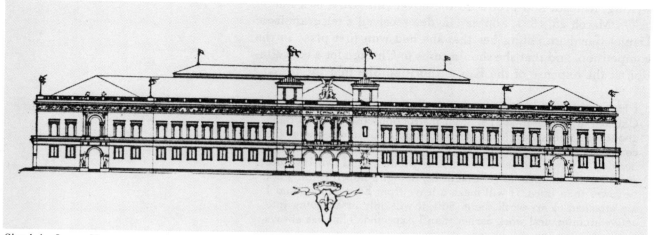

Sketch by Laura Hayes.

Lois Howe, who had encouraged Sophia Hayden to enter the competition, won second prize. She was, as we have pointed out, already a practicing architect. She was to go on, in 1913, to found a successful architectural partnership with another woman, and always made it a point to hire women graduates from MIT.

The third prize of $250 went to Laura Hayes, Mrs Palmer's private secretary. Despite Mr Burnham's emphasis on "credentials," Miss Hayes won without any. She came from Knoxville Illinois, and had worked as a bookkeeper for the government, until a change in administration turned her out. Her great advantage lay in knowing Mrs Palmer's tastes. She had "studied" in the six weeks before she submitted the design. Mrs Palmer wished to incorporate some of Miss Hayes's ideas into Miss Hayden's design: a foretaste of trouble even before the winners were notified. Mrs Palmer hoped for a bright future for Miss Hayes in architecture, but the young woman turned briefly to

Sketch by Lois Howe.

writing, instead, and produced the novel *Three Girls in a Flat*.

On March 25, 1891, Sophia Hayden received a telegram from Daniel Burnham telling her that she had won first place in the competition, and that she should come to Chicago for a consultation at the expense of the Fair authorities. She told the press:

I had not thought of competing ... until some friends of mine in Chicago urged me to ... I sent for instructions and received them about four weeks ago. Miss Howe took pains to inform me of the competition, although I heard of it mostly from Chicago. We both decided to enter and see what fortune would attend two Institute girls. I did not expect to get first prize, though I hoped I would not be lower than third. It will mean a leave from Eliot School, and I am attached to my work there. Still, it will only mean going into active architectural work earlier than I expected. That has always been my intention.

In her Architect's Report, given to the Board of Lady Managers at the end of April, 1894, Miss Hayden said that in her design for the building she kept

very closely to the sketch plans. The principal deviation, in the original drawings, was the addition of an open arched arcade with balcony over ... added to the east and west side. Subsequently I added a third story, with roof promenade, to the north and south wings, to meet new requirements that had risen.

The main feature of the plan is the large exhibition hall, 65 by 120 feet. Around this the smaller rooms are grouped, the wings forming large exhibition rooms, on this floor. The entrances are placed north, south, east, and west on the axes of the building. At the four corners of the large hall, staircases lead up, from corridors, to the second story. In the second story, the rooms are arranged around the main hall, intercommunication being obtained by means of a gallery overlooking the hall. In the north wing a large assembly room was placed. The third story was planned to extend only over a portion of the north and south wings. At first this part was subdivided into smaller rooms, designed for committee rooms. Subsequently the partitions were removed, in the south wing, as it was used for a different purpose.

On the exterior the subdivision of the stories is plainly marked in treatment. The building rests on a continuous base five feet in height. The first story is treated with an order of round arches, carried on Ionic columns, and corresponding blank arches, carried on Doric pilasters. In the second story, a modified Corinthian order is used, with coupled pilasters, which carry a broad frieze developed over the east and west entrances, into a low pediment. The third story additions and roof gardens are surrounded by an open screen of small columns and caryatides which support a light entablature.

Thus the exterior expression of the building is evolved quite naturally from the interior conditions. It is not modeled after any precedent. In style it may be called Classic or Italian Renaissance, although it follows, strictly speaking, neither style ... It is the result of careful training in classical design and is the expression of what I liked and felt.

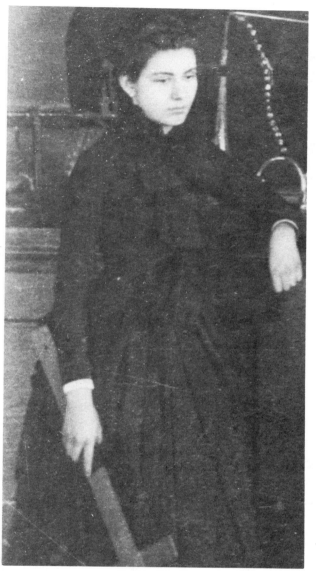

Sophia Hayden

Miss Hayden came to Chicago at the end of March, 1891. A workroom was given to her which connected with the Construction Department. The dredging and filling of Jackson Park, which had begun on February 11, was nearly finished at this time. The contract for the Woman's Building was to be assigned in June. Miss Hayden, in her early twenties and working on her first building, had a tight deadline. She also had a lot of help. Chief Burnham was well aware that she could be "an architect who had been gifted enough to make a good design, but who knew nothing of construction, and would not be able to carry out the working drawings, or make such modifications as might be suggested." It was not a particularly good sign that she had

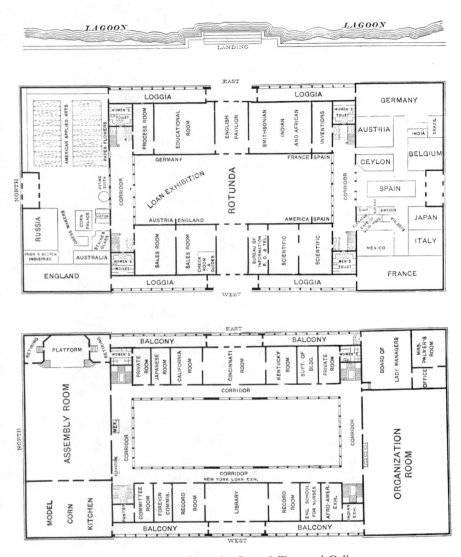

Sophia Hayden: Plans for Ground Floor and Gallery.

chosen to become a teacher of mechanical drawing rather than apply her degree to actual architectural work, as Lois Howe had done with less training. Experienced architects knew that "modifications" would be suggested: in this case such suggestions were inevitable, with Burnham and Charles Atwood in the next office, and Mrs Palmer, Frances Shepard and Laura Hayes always eager to lend a hand. The Woman's Building was comparatively small, covering 1.836 acres. Only the Administration Building, covering 1.274 acres, was smaller. But the proposed exhibits seemed to demand a good deal of space, and new features were to be added: a library, an assembly hall and as a "novelty," a roof-top garden.

It is possible that Miss Hayden had not foreseen all these suggested changes. She mentioned them in her architect's report:

The design was first remodeled, to meet new requirements that had arisen. Under these new conditions, the third story rooms and colonnades were added to the two wings. I also made some changes in one or two minor details at the suggestion of Mr Atwood, who was chosen, at this time, Consulting Architect.

Mr Burnham appears to have been reasonably satisfied with Sophia. He suggested that she open a firm in Chicago, where "she could soon be at the head of a lucrative business." Miss Hayden, however, was not happy with the number of changes she was required to make, and with the pace at which she had to work:

Finally I made one quite notable deviation from the original drawings, in the treatment that I desired, for the upper portion would add materially to the cost. . . I deferred to their wider experience and left the clerestory practically unstudied. I think now that the work was unduly hurried at this point, and that some mistakes might have been avoided if I had been able to give the drawings more careful study. Naturally your President wished to see the work progress, consequently the Woman's Building was the first one commenced and the first one finished, in construction.

These changes and this stress were as nothing compared to the difficulties which Daniel Burnham was encountering in his role as Chief of Construction. He was responsible for the architecture of all the buildings, and did not hesitate to make suggestions for extensive changes to all the architects; he had also to oversee the actual construction and be sure that the architects' designs were realistic. He was responsible for all personnel involved in construction, (woodcarvers, plasterers etc.) and had to oversee and coordinate all services: water, electricity, railroads, etc. In addition to all this he was the Fair's spokesman to the press, had to look after hoards of distinguished visitors descending upon Jackson Park, and was in constant correspondence with foreign exhibitors and heads of Fair Departments. The Manufactures Building, designed by George Post, was the largest building in the world: it covered forty acres. Shortly after construction began, it became apparent that it was already too small for its exhibits: two planned interior courts had to be changed into exhibition rooms, a large dome which was to unite the courts had to be eliminated and a gigantic glass roof held up by steel arches had to be substituted—all at high speed. Burnham was responsible for the planning and execution of these changes.

Nevertheless Miss Hayden, intent only on what she herself had to do, found herself beleaguered. She worked with two draftsmen under her immediate supervision to complete working

Left to right: Burnham, Post, M.B. Pickett, Van Brunt,
Frank Millet, M. Armstrong, E. Rice, St Gaudens, Henry
S. Codman, G.W. Maynard, Charles McKim, E.R. Graham,
Dion Geraldine. May 1891.

models "including elevations, plans and sections" and then she
went home, abruptly, less than two months after she had arrived.

> I judged . . . that my obligations, under the rather vague conditions
> that I had undertaken the work were discharged, as the Construc-
> tion Department had charge of all constructional details of the
> World's Fair buildings. When the half inch to the foot scale work-
> ing drawings were completed, I returned to Boston, May 26, 1891.

As we have seen, all the architects were told by Burnham that
his department would have ultimate charge of construction. Miss
Hayden's reference to "the rather vague conditions" of her work
may mean that she had expected to work alone on the Building,
and execute her original design, and that she had not been per-
mitted to do so. Whatever she meant, she was not present when
the Building began to be constructed on July 7. She missed what
Louise Bethune called "the brick-and-mortar-rubber-boot-and-
ladder-climbing period of architectural education" without
which an architect must "remain at the tracing stage of
draughtsmanship." She did not see the wood and metal skeleton
go up. In September workmen were applying plain staff, a mix-
ture of plaster and hemp that looked like granite; in October
ornamental staff was laid over it. By December, the roof was in
place, the windows glazed, and the scaffolding about to be
removed, all under the supervision, apparently of Burnham and

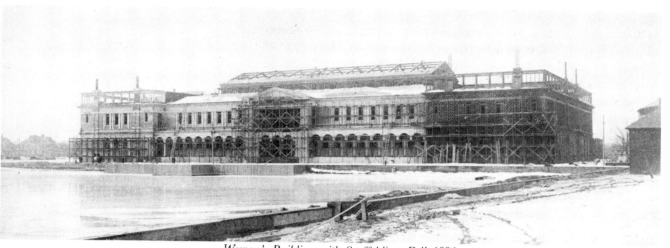

Woman's Building with Scaffolding. Fall 1891.

Atwood. After that, all that remained to be done was rough carpentry work. Mrs Palmer wrote to her, "I am delighted with the plans and think you deserve great praise for their execution." And in point of fact Sophia Hayden had executed the plans, but she was not there to execute the building. She did not see, as Mrs Palmer did, the Woman's Building grow "like Aladdin's Palace in the last few weeks. It has reached the roof and is beautiful even now in its unfinished state with its caryatids supporting the roof garden and with its frieze which is molded into the graceful Greek garlands." What Mrs Palmer called the Ladies' "lovely child" had had to be raised by foster parents.

In August, Mrs Palmer, having returned from her first trip to Europe, wrote to Sophia Hayden, saying that she had shown the plans of the Building abroad and people there were "astonished they were done by a girl of twenty-one." She said that she was

Woman's Building under Construction.

sorry not to have seen Sophia before she left, "to express our
satisfaction in your admirable work which has been warmly com-
mended by all of the architects who have seen it." Mrs Palmer
then commented on the support posts of the Building. She asked
Miss Hayden whether having "used them so freely" was her idea
or Mr Burnham's. She said she thought Mr Burnham might have
suggested this use for reasons of economy, whatever that might
mean, "and I consider that the wooden supports all through the
building are much too near together. Otherwise I am delighted
with the plans . . ."

Why Mrs Palmer wrote in this vein to Sophia Hayden is any-
one's guess. There was nothing the young woman could have
done at that distance to alter anything, and if Mrs Palmer had a
quarrel with Mr Burnham she could easily have spoken to him in
Chicago. If she expected Miss Hayden to criticize Daniel
Burnham to her she was expecting too much. Laura Hayes has
given a description of Sophia Hayden in *Three Girls in a Flat*:

> Miss Hayden is of medium height, slender, with soft dark hair, and
> a pleasant manner that is shy, without the least lack of confidence.
> She is of Spanish parentage, and inherits the soft, dark eyes of the
> Latin race; though, perhaps, it is her long residence in Boston that
> has made her so quiet and reserved. She is always willing to talk of
> her work, but she says that she has been obliged to devote so much
> time to study that she has been unable to acquire the arts that make
> society attractive . . . Mr Burnham expressed himself as very much
> pleased with her and said that she has great adaptability, and could
> readily seize a new idea, while it was generally known about the
> Construction Department that no one could change, by any
> amount of persuasion, one of her plans when she was convinced of
> its beauty or originality. She was always quiet but generally carried
> her point.

In August of 1891 Mrs Palmer decided to hold a second com-
petition, this time for a woman to sculpt the ornamental figures
for the Building. There were, of course, more women working as
professional sculptors than were working as professional
architects. We have already mentioned Harriet Hosmer and her
group in Rome. There was also Blanche Nevins, who had studied
in Venice and now lived in Philadelphia, where she had
exhibited in the Woman's Pavilion at the Centennial Exposition.
Her "Maud Muller", from a poem by John Greenleaf Whittier,
had earned her a measure of fame. Miss Nevins was at this time
over fifty years old. There were younger women sculptors study-
ing under Loredo Taft at the Art Institute in Chicago. The best
known of these was Nellie (Helen Farnsworth) Mears; there were
also Bessie Potter, Julia Bracken, Caroline Brooks and Ellen
Rankin Copp. Irene Jackson, a Lady Manager from West
Virginia, had sold some pieces of sculpture, although she was

Woman's Building during Construction

better known as a painter, apparently. Her father was a Federal district judge in West Virginia; she was a close relative of Andrew Jackson.

With so many qualified women available to the Board (one of whom was actually *on* the Board and possessed of influential connections) it is understandable that Mrs Palmer would feel more comfortable holding an open competition rather than risk various complaints by having the sculptor chosen directly. She planned to turn the decision-making over to male judges, so that no one could accuse her of playing favorites. To make doubly certain that she would escape censure, such as she must have received because of the awarding of third prize in the architectural contest to her secretary Laura Hayes, she planned a trip to the East on Board business during the period of decision.

Consequently the following circular was drawn up:

The Board of Lady Managers of the World's Columbian Exposition invite designs for the sculpture work on the Woman's Building and offer a public competition, open to female sculptors, under the following conditions:
Designs to be submitted in the form of miniature models or by original drawings in pencil, ink or water-color, accompanied by a typewritten description of the principal features of the design . . .
First—One group of figures in high relief, to fill the pediment over the main entrance.
Second—The group of statuary standing free above the attic cornice . . . These groups consist of a central winged figure standing about ten feet high to the tips of the wings, and supported by smaller sitting figures . . .

These compositions should be typical of woman and woman's work in history. Each design submitted shall be accompanied by an estimate of the cost of full-size plaster models, delivered at Jackson Park, in Chicago ... on or before November 15, 1891 ... and the authoress of the design accepted will receive the contract for the execution of these full-scale models, provided the estimate is satisfactory to the Chief of Construction ...

This circular was dated August 20, 1891. At about this time Mrs Palmer began to hear about a twenty-two year old sculptor named Enid Yandell. Miss Yandell lived in Louisville and had made herself known to, among others, Mrs Palmer's relatives there. Mrs Palmer received letters praising Enid Yandell from the president of the Kentucky Centenary, and from the husband of Alice Barbee Castleman, president of the Louisville Training School for Nurses and a member of the Board of Lady Managers. Mrs Palmer wrote Mr Castleman that she was really looking for a sculptor who had "taken medals for beautiful designs at the

Enid Yandell

Paris salons" but, she added in an unguarded moment, she did not know "if they would care to compete." This uncertainty about the calibre of the sculptors who would compete encouraged Miss Yandell's Kentucky backers. A nameless cousin wrote again, enthusiastically offering to accompany Enid to Chicago. Mrs Palmer responded tepidly, "If you think it is desirable for her to come to Chicago, I shall be most happy to see you both and give you any information."

Before she mailed this letter she thought about it a while, made inquiry at the Board of Construction, and was able to add a more encouraging postscript:

> P.S. I have been making inquiries this morning and I find there may be an opportunity for Miss Yandell to get some of the relief decoration in the interior of the Woman's Building. The grand gallery is to have some ornamentation. The contract for this plaster work has been let, but the modeling has not yet been commenced, and the contractor is willing to give Miss Yandell the opportunity to do it rather than any of the men he has now in his employ. While there might be very little money in this, there would probably be a great deal of reputation to be gained if her work was particularly successful.

She added that the contractor had limited time; Miss Yandell would have to reply at once and must come immediately to see if she could manage the work. Mrs Palmer said that she would of course introduce Enid Yandell to the contractor, but she was preparing for the second Board session to be held in September, and she would not be able to give Miss Yandell much attention. The second Board session was being held without much time for preparation, as we have seen, and with the major distraction being caused by the Couzins-Isabella factions, among other things, it is surprising that Mrs Palmer was able to give thought to the Kentucky sculptor at all.

Miss Yandell, whose bags may have been packed for some time, left immediately for Chicago. She was, as might be expected, not at all shy or retiring, and fit in well with Mrs Palmer's young associates. She moved into Laura Hayes' apartment near Jackson Park and, with Jean Loughborough, became one of the three girls in the novel *Three Girls in a Flat*, where she was referred to as "Miss Wandell" or alternatively as "the Duke."

At the Fair she was given an assignment different from the one mentioned by Mrs Palmer in her letter to the Kentucky cousin. Miss Yandell began to design the caryatid which was to support the roof garden of the Woman's Building: this caryatid was a single female figure which was to be repeated twenty-four times. Enid had no trouble acclimating herself to the Fair studio, where all the other workers were males who accepted her without ques-

Caryatids on Woman's Building

tion, "perhaps," Laura Hayes thought, "owing to the fact that almost all the workers were foreigners, and abroad it is not so unusual for women to do industrial work."

Mrs Palmer was pleased that she had provided a live woman artist who could be seen at work by the members of the Board at the September session, where it was necessary for the President to make as good an impression as possible, so that Phoebe Couzins' head, rather than hers, would fall into the basket. Sophia Hayden had gone home, but Mrs Palmer had Enid, a fact she noted in passing in an announcement to the Ladies:

Through the courtesy of the Directors, we have recently been given permission to invite competition by women for the statuary upon the exterior of our building. Circulars stating the details of the competition are now ready. We are to have eight figures above the roof line, and a relief composition in the main pediments ... The circulars will be handed you, to be sent at once to artists, the limit of time for the execution of the study models being short. In this connection I may also mention the fact that the decorator who has the contract for the relief work on our building has, at our request, been kind enough to allow a gifted young girl of twenty-two years to make the models for the caryatids. She takes the place of a man who had already commenced the work, and is now enthusiastically engaged in doing this modeling at Jackson Park. Thus the entire

Enid Yandell at Work

exterior of the Woman's Building, with all its artistic features, will be the result of the inspiration of woman's genius.

This clever move may well have been one of the things that inspired Isabella Beecher Hooker, the doughty feminist, to pledge her allegiance to Mrs Palmer at the second session. After the adjournment of this session, the Lady Managers were to go to Jackson Park to examine the Woman's Building. Mrs Palmer planned also to take them to the studio. She had written to Enid five days before the Board was to convene, to make sure that everything would go smoothly:

The ladies of our Board expect to go to Jackson Park on Wednesday afternoon to see our building, and I hope they will find you there at work. Don't be afraid to wear your blouse or apron or whatever you usually have on while modeling for it will please me very much to have you give them a practical illustration of our woman decorator at work. I believe the outfit of a sculptor is rather picturesque—is it not?

Miss Yandell apparently took this hint, and was found by the delighted Ladies sitting on a scaffolding, surrounded by small models of Grecian figures on which she was basing her large caryatid. Her long brown hair was picturesquely swept up inside a beret to protect it from what would have been marble dust, if the sculptor were working in marble, which she was not.

Mrs Palmer showed off her young sculptor again, on October 7, 1891. The occasion was the unveiling of the equestrian statue of General-President Grant in Lincoln Park: Mrs Palmer gave a reception for Mrs Grant at her house, from which guests would have a good view of the procession moving down Lake Shore Drive to the Park. The "three girls" were invited. They were delighted with the sight of the mansion which,

with its battlemented turrets, outlined against the blue sky, gave the appearance of an old feudal castle. A great silken flag shook out its folds in the breeze that came from the lake, and over the porte-cochere a gaily striped awning had been placed, making a pavilion from which the procession could be watched.

When the girls entered through "the large double glass door" Mrs Palmer was receiving her guests in "the high vaulted hall." She pounced upon Enid Yandell, while Laura Hayes and Jean Loughborough went into the library. Mrs Palmer was most anxious to introduce Miss Yandell to Julia Dent Grant, the President's widow.

"I want to introduce you to Mrs Grant," she said, taking Enid's hand. "Let me present to you Miss Yandell, the young sculptor; she is at work on the Woman's Building and we are very proud of her and think we have conferred on her an honor."

Mrs Grant, a woman of few words, said: "A sculptor! You cut marble?"

Miss Yandell replied that she did indeed cut marble.

"I met one before," Mrs Grant said, fixing Enid with a steely eye. "She was a great deal about the General, but I don't approve of women sculptors as a rule."

Mrs Grant was evidently referring to Vinnie Ream Hoxie, who had created a storm of controversy when she was commissioned to execute a statue of Lincoln for the capital; she was only fifteen at the time. Evidently she had spent a lot of time with General Grant.

Mrs Grant's response cast a damper over the conversation; Mrs Palmer tactfully introduced another guest. But a little while later, Miss Yandell spotted Mrs Grant sitting alone in the "Japanese room" which was hung with black satin curtains covered with heavy gold dragons. Undaunted, she took up the subject once more.

"So you do not approve of me, Mrs Grant?"

Mrs Grant said that it was nothing personal. "I don't disapprove of *you*, Miss Yandell, but I think every woman is better off at home taking care of husband and children. The battle with the world hardens a woman and makes her unwomanly."

"And if one has no husband?" Miss Yandell asked.

Mrs Grant had an answer to that. "Get one," she said.

Miss Yandell refused to give up. "But if every woman were to choose a husband the men would not go round; there are more women than men in the world."

Mrs Grant could handle that one too. "Then let them take care of brothers and fathers," she said. She then waxed eloquent. "I don't approve of these women who play on the piano and let the children roll about on the floor, or who paint and write and embroider in a soiled gown and are all cross and tired when the men come home and don't attend to the house or table. Can you make any better housewife for your cutting marble?"

"Yes," Miss Yandell said energetically. "I am developing muscle to beat biscuit when I keep house."

This slowed Mrs Grant down considerably. Miss Yandell was not content to quit when she was ahead. "But, Mrs Grant," she said, "are there no circumstances under which a woman may go to work?"

Mrs Grant thought it over. "I may be old-fashioned," she said. "I don't like this modern movement. But I don't think so. And yet, there are certain sorts of work a woman may well do; teaching, being governess, or any taking care of children."

Miss Yandell forged ahead. "But," she said, "suppose a case: A young brother and two strong sisters. The young man makes a good salary but can't get ahead because all his earnings are consumed in taking care of the girls. Hadn't they better go to work and give him a chance to get ahead and have a house of his own, they being as able to work as he? Are they being unwomanly in so doing? Or, the case of a father with a large family of girls and a small income — are they less gentlewomen for helping earn a living, lessening the providing of food for care of so many mouths by adding to the family funds?"

Mrs Grant stared out the window at the lake. "You may be right. In that case," she said slowly, "they ought to go to work."

Enid Yandell then retired from the field victorious. Whether she had widened Mrs Grant's view or just worn her out, was a question. Her perseverance was to stand her in good stead at the

Fair, where she won a medal for her caryatid, and where she also helped to sculpt a statue of Daniel Boone for the Kentucky Building. And after the Fair she sculpted a huge statue of Athena which stood in front of the "Parthenon" erected at the Nashville Exposition of 1897. Mary Logan called this "the best figure ever designed by a woman," a comment which was probably ignored by Harriet Hosmer, among others. Moving on from expositions, Miss Yandell organized a summer school for artists in Martha's Vineyard in 1907, and in 1910 showed a small bronze at the Art Institute of Chicago in an exhibit sponsored by the National Sculpture Society of New York of which she was by that time a member. She belonged also to the National Arts Club, the New York Municipal Art Society, and the National Society of Craftsmen. She won commissions for memorials to Carrie Brown and Emma Willard, in Providence and Albany, respectively. Her statue "Victory" can be seen in the Municipal Museum in St. Louis.

Alice Rideout

In that fall of 1891, however, her immediate goal was to win the competition to become official sculptor of the Woman's Building. She worked at night on her small models: one was a bas relief of the Statue of Liberty with women in various national costumes bowing before it. These models and the typewritten descriptions required by the guidelines she submitted to the Board before the November 15, 1891 deadline.

Mrs Palmer, as planned, left for the East on an organizing tour before the close of the contest. Jean Loughborough, her record and file clerk, was custodian of the entries. Living as she did, with Enid Yandell and Laura Hayes, the architectural prize winner and novelist, Miss Loughborough was not without ambitions of her own. "My good luck in securing the third prize suggested the idea of the Arkansas Building to Jean," Miss Hayes said later. And in fact Miss Loughborough did design a French rococo building for her home state of Arkansas, and in March 1892 her design was selected as the winner. She became downcast when she learned that the $10,000 to be spent on the building would not allow Arkansas hardwood to be used; the French rococo building consequently had pine floors and steps, a touch that would have interested the Bourbons.

On November 15, 1891, Miss Loughborough gathered together the entries to the sculpture contest—which must have made several armloads—and brought them to Charles Atwood in his office in the Construction Department. Seventeen women had entered the competition. Blanche Nevins had told reporters that her models did not do justice to her capacity for detail and that they had been injured in transit from Philadelphia. These models were designed to illustrate woman evolving from ancient bondage to the advanced ideas of the nineteenth century. Goddesses resting on a globe had been submitted as a design by Kühne Beveridge, a seventeen year old girl who had already visited the offices of the Board to argue her talents. Miss Beveridge was later to study with Rodin in Paris and to exhibit in London at the Royal Academy. Her "Venus Voilée" would receive an honorable mention at the Paris Exposition of 1900.

Nellie Mears provided a clay model of a woman with a winged eagle. Under the title "Genius of Wisconsin" this became a nine foot statue in the Wisconsin Building. After the Fair it was displayed in the Wisconsin State Capitol. Bessie Potter, Julia Bracken, Caroline Brooks and Ellen Rankin Copp, Miss Mears' fellow students at the Art Institute, executed "Art", "Faith," "Charity" and "Maternity," respectively. These were later chosen for the Illinois Building by Frances Shepard, Chair of the Fine Arts Committee of the Illinois Woman's Board.

Alice Rideout of San Francisco had sent groups of models to illustrate both woman's admirable self-sacrifice, and her keen intelligence. Miss Rideout, who was nineteen years old, was the

ward of John Quinn, the well-known art collector. Like Miss Yandell, Miss Rideout had many friends in her home state. Miss Rideout's friends were perhaps more impressive in their own right than Miss Yandell's, although they were not related by blood to Mrs Palmer. On November 15, the day before the contest closed, a U.S. Senator from the state of California wrote to Mrs Palmer:

> Dear Madame
> Will you kindly permit me to call your special attention to the three [sic] groups of "plaster models" executed and sent to the World's Fair Commissioners for inspection by Miss Alice Reidout [sic]. Miss Reidout's high character and genius have won for her many friends in California who have taken a special interest in the matter. . . .

Other models were sent by Marian Michiner, also of San Francisco, Misa Heideman of Washington, D.C. and F.E. Wesselhaft of Cambridge, Massachusetts. Eliminated from the competition because they sent only sketches were Minnie H. Vickers of Denver, and three women who resided in Europe: Alice Garnett of Glasgow, Reta Theresa Mathews of Paris and Jean Glasse of Rome.

All the contributions were brought into a private room by Mr Atwood and Miss Loughborough. No one was supposed to see them. Miss Loughborough reported later to Mrs Palmer that Mr Atwood had "kindly allowed" her to remain while he unpacked the entries and arranged them carefully without names or "other indications of locality." His caution was commendable but somewhat useless because of leaks to the press: on November 17 the *Chicago Tribune* described in detail the entries of Blanche Nevins, Kühne Beveridge and Enid Yandell. Mr Atwood did indicate to Miss Loughborough some of his opinions of the works. "Mr Atwood thinks most of the sketches are entirely too amateurish," she reported to Mrs Palmer. "The sketches by Miss Yandell will not be considered I fear .. " He appeared to favor Bessie Potter's sketch, described by Jean Loughborough as "an angel blowing a long slender trumpet." She too found this "exceedingly artistic." She thought the idea was good, too: "proclaiming woman's freedom to all nations of the world."

Mr Atwood's opinions, although interesting, were presumably not important, since he was not one of the judges. They were Daniel Burnham, William Pretyman and F.M. Whitehouse, a critic and art collector. After two weeks of consideration, they announced their decision on December 4: the winner was Alice Rideout of San Francisco. The judges found her work to be "far in advance of the remainder of those who submitted models," a comment that could be said to add insult to injury.

On the evening of December 4, 1891, Mrs Palmer alighted at 9 P.M. from a Michigan-Central train; her organizing trip to New York and Boston had been hectic, but had kept her out of town. She could not be held responsible for the judges' actions. On December 8 she wrote to Henry Watterson, the editor of the *Louisville Courier Journal,* who was much disappointed that Enid Yandell had not won. "I have always been much interested in her and personally was very anxious for her to be the favored competitor," Mrs Palmer wrote. "She was the only one of the aspirants whom I knew." On the same day Mrs Palmer dispatched a telegram to one of Miss Rideout's many friends in California, "assuring you of my pleasure in Miss Rideout's success . . . " No European gold medal winner had materialized to enter the contest, so it may have been all the same to Mrs Palmer. It is true that Laura Hayes did later reply to an inquiry from an interested person about the possibility of Enid's being commissioned to do a statue of the wife of Christopher Columbus: "I fear that Miss Yandell would not be able to do the work as she has not yet earned sufficient reputation to merit the placing of her work in the Gallery of Honor." This was probably a straightforwardly truthful comment, since the Gallery of Honor was envisioned by Mrs Palmer as a museum for great work. The somewhat negative phrasing of the reply ("would not be able to do the work") might have meant merely "could not qualify." Miss Hayes herself, although she was Miss Yandell's friend, was not above a little sniping, as we have seen in her references to Sophia Hayden.

Alice Rideout had been born in Marysville California, where she began in early childhood to dream of sculpting. Her little friends made fun of her for "dabbling in mud" and so Alice turned to woodcarving. She made a railway train out of old cotton spools that was the talk of the Broadway Grammar School. When she moved to San Francisco to attend high school— presumably when she became Mr Quinn's ward—her art teacher, recommended her to the sculptor Rupert Schmid. It was arranged that she go to his studio in San Francisco to discuss becoming his pupil. Being a carefree teenager, and apparently disliking going anywhere by herself, Alice took her dog along. When she arrived at the studio, Mr Schmid was not there. The dog became playful, and knocked over one of Mr Schmid's statues, smashing it to bits. Alice, never without hope, began to try to piece it together. Mr Schmid entered his studio, and observing her deft movements, became convinced of her sculptural abilities. He took her on as a pupil. There is no record of what happened to the dog.

She worked at Mr Schmid's studio every afternoon, spending her mornings at the high school and, after six months, at the San Francisco School of Design. By the time she entered the Board's

John Wellborn Root

competition she had been studying sculpture for two years and was engaged on a bust of President Benjamin Harrison: doubtless through her political connections the President knew of the bust and was said to be quite pleased with it.

Miss Rideout was notified of her victory around the second week of December. *The American Architect* commented on it with satisfaction:

> The New York *Sun* appears to be surprised that anything by a woman artist should have been good enough; but the female artists who try to gain appreciation by their brains and hands, and not by their curls, need not now fear to enter into competition with painters and sculptors of the other sex.

This was gratifying. There was however a snag in the arrangements which became apparent almost immediately. On December 12 Mrs Palmer wrote to John Quinn, in response to an inquiry from him about whether it was necessary for Alice to go to Chicago. The competition circular further had not said specifically that the work must be executed at the Fair, but it certainly had implied that. Mrs Palmer wrote diplomatically that she would find out whether Miss Rideout's presence was necessary. On January 6, 1892, Mrs Palmer forwarded the following letter from Daniel Burnham to Miss Rideout:

Owing to the limited time in which our work at Jackson Park must now be completed, it is of the utmost importance that the enlargement of your models should be commenced at once. I have conferred with Mrs Palmer and it has been agreed that I write asking that you come to Chicago prepared for the execution of the work, at the very earliest day that it is convenient for you to do so. Will you kindly advise me when we may expect you.

Mrs Palmer enclosed a note with this letter saying she wished to impress on the young woman the importance which Mr Burnham attached to her presence. Mrs Palmer made it clear that she agreed with the Chief of Construction:

We feel that the work should be begun immediately upon the large models in order that you may not be too much hurried in carrying your ideas to the artistic completion they merit.

A letter from Alice Rideout crossed in the mail. She was working on the bust of President Benjamin Harrison and was reluctant to leave San Francisco . Burnham wrote her again on January 14:

... I wrote you sometime since, endeavoring to impress upon you the urgent necessity for your coming to Chicago at once for the execution of your work. I cannot request too strongly, that you make arrangements to be here at the earliest possible moment, at which time we will take up further, the questions contained in your last letter, January 8th.

Woman's Building with Roof Posts in Place, Awaiting Sculptures

This second request did not budge Miss Rideout, who was uncertain about travelling alone all the way to Chicago, and about what would happen to her when she got there. She wanted to know if she could do the sculpture in San Francisco. Burnham, in the midst of coping with the manifold problems of construction, took time out to write her a longer and more thoughtful letter.

> We have yours of the 28th ultimo and do not see how you can possibly execute the work in question in San Francisco. I will, however, write you further after some investigation which I desire to make. There has been some question as to whether the models sent us by you were *entirely* your own work and it is due yourself that you be perfectly frank with us in this matter in every respect, informing me fully as to this point. Please understand that I feel a great delicacy in addressing you on this subject and only do so because it is but fair and just to yourself that such an impression should be removed. It is also right and proper that you place me in a position to deny this rumor. These assertions have not been confined to yourself alone, but the same assertions have been circulated concerning other young women who were in this competition. If you will come on to Chicago in four or five weeks you will find the weather not only good, but delightful. We will give you a studio upon the grounds in Jackson Park situated in a delightful locality, where you will be among the other sculptors, and you will, I am sure, enjoy greatly being with them. So many changes and adaptations must be made in your work before it can be exhibited that it does not seem at present possible for you to execute it in San Francisco in a manner satisfactory to Mrs Palmer and others who have the right to criticize. I believe it would be better in every way for you to come here and surely your reputation can in no way suffer from your coming.

Even this kindly letter with its suggestion that Miss Rideout's behavior was causing grave doubts to arise about her capabilities, did not get her out of California. She had her present work to get on with, and she was very nervous about her unchaperoned sojourn. On February 17, 1891, three months after the sculpture competition had closed, Burnham, whose patience was at times obviously inexhaustible, wrote Miss Rideout again:

> I have yours of the 12th instant and realise now more fully than when last I wrote you the impossibility, at times, of making oneself understood. I myself, am an architect, trained all my life in art matters and have, therefore, entire sympathy for your views; it will not, however, be possible for you to go on with your work in San Francisco. It is not that you are in any way doubted, for I know now that the work is yours and that you are entirely capable. This I have from San Francisco authorities, whose judgment I am compelled to respect. The designing will require modification and when you come here and look over the building, your ideas will change so materially that you will see and feel it is to your interest, first of all,

to adapt the final work to the building and its surroundings.

The Woman's building is up so that it can be seen and you can form very clear ideas about your work. As I wrote you before, we will surround you with the most pleasant conditions possible and you will have the active sympathy of many noble sculptors who are at work upon their buildings. I wish to make your work successful and will do anything in my power to help you. I hope you will now feel, therefore, that it is better to trust my judgment than your own, not only for yourself, but for the work here. I have in San Francisco two friends versed in art matters, both of whom are quite near and dear to me. To them you should go and inquire as to the treatment you will receive here. I make this suggestion because you are young and a woman and have been so little absent from your home.

He then gave her the names of two men, one of whom was a minister. Even after this, however, Miss Rideout remained in San Francisco. Mr Burnham had now tried his all. Finally, on March 28, Mrs Palmer wrote a crisp letter, referring again to doubts about Miss Rideout's actual talents, which Mr Burnham had assured the young woman, on February 17, had been laid to rest.

Mr Burnham and I both realize that you feel timid about leaving your master, but both feel that it is essential that you should cut loose from him, more particularly as numerous letters have been received making intimations that you owe a great deal to his work on the sketch models.

We feel that it is only justice to you that you should come here and do your work, and that the suggestions you will get from these gifted men now working in Chicago, will be far more valuable to you than any you may receive from your master, as these men are all more or less known to fame . . . You can understand that neither Mr Burnham nor the Board of Lady Managers can take the chance of your finishing something in California which might not be acceptable. If you were working here where it could be seen from day to day, any little changes that seem necessary could be suggested. I realise your timidity but urge you strongly to come and sign your contracts . . .

At about the same time Mrs Palmer wrote a letter to Mrs Reed of Maryland, who was a member of the Board's Art Committee, that made it clear that everyone's patience with Alice was at an end.

. . . our intercourse with Miss Rideout is not satisfactory. She wishes to remain in San Francisco under the influence of her instructor and [Mr Burnham] wants her in Chicago. It may be the contract will not be given to her.

Mrs Palmer apparently achieved what Mr Burnham could not. Three weeks after this letter, Alice Rideout arrived in Chicago and signed her contract for $8,200. On April 17, 1892 she took her models to the Jackson Park studio. She told the

GROUP OF DECORATION ON WOMAN'S BUILDING.

press that to carry out her work "to the highest degree of perfection with artistic finish from start to finish from life models" would cost $2,500 for each group of figures and $3,200 for the pediment.

She too was a "picturesque" worker. Isabel McDougall reported in *Leslie's Weekly* that she was touched "by the sight of a slight, dark-haired girl of nineteen, fresh from the San Francisco School of Art, working away, employing of necessity men for the heavier parts, but going over every detail herself." The central winged figures were finally nearly twelve feet high. Her eventual work—the pediment of the building—depicted, as Maud Howe

GROUP OF DECORATION ON WOMAN'S BUILDING.

Elliott said, "woman's work in the various walks of life." Her winged groups, Mrs Elliott says, were "in delightful contrast to the familiar and hackneyed types that serve to represent Virtue, Sacrifice, Charity and the other qualities which sculptors have personified, time out of mind, by large, heavy, dull-looking stone women." Mrs Elliott comments also that the Fair sculpture in general deserved a more lasting form than it had at the Fair. Indeed, it took Miss Rideout longer to come to the Fair than it did to execute her sculpture, and it is a tribute to the patience of the Chief of Construction and the determination of the President of the Board of Lady Managers, that she ever executed it at all.

The San Francisco *Call* reflected the pride of her city in the young sculptor:

Miss Rideout is very girlish and unassuming. Perhaps her unconsciousness of her own ability is one of her greatest charms. There is no doubt as to her possessing this ability ... Her energy, combined with her youth, which leaves her so many years in which to study her work, will no doubt make this name a great one before another twenty years have passed over her head.

But Alice Rideout disappeared from history after the Fair.

Two of Alice Rideout's Sculpture Groups on Roof of Woman's Building

Miss Hayden's Report states that "her official connection with the Exposition", which she obviously considered ended when she left for Boston in May, "was not resumed until December 1891" when she received a letter from Daniel Burnham telling her that it would be his "pleasant privilege" to send her

photographic views of the work to date upon your building. In forwarding these to you I desire to again sincerely congratulate you upon the success of your plans, which is further evidenced by the construction. I would, in addition to this, suggest that if it may be convenient to you, it would be of great advantage to have you here for a few days at least to inspect the work, and give us any further ideas you may desire carried out.

Miss Hayden returned to Chicago "in compliance," as she put it, "with his request." The impression she conveys is that she would not have returned if she had not had a specific invitation to do so, from the Chief of Construction. She found the exterior of the building "about completed and judged it to be satisfac-

tory" except for the clerestory which she had left "unstudied" because of her deference to "their" wider experience. This she was determined to correct with the stubbornness at which Laura Hayes hinted and the Construction Department complied, at a cost of $3,078.

At this time Miss Hayden says she saw "for the first time" the models for the building's sculptures, the contract for which had been awarded to Alice Rideout. One senses here some feeling on the architect's part that she should have been consulted about the sculpture. It was Mrs Palmer, perhaps, who tended to treat Sophia Hayden more like a paid employee—a governess?—than a woman of professional standing.

"While studying the changes," Miss Hayden writes, without elaborating on this cryptic phrase, she tried "to help the Lady Managers in disposing of some of the materials that had been generously offered, by members of the Board, toward the construction and decoration of the building." At the second Board meeting in September 1891, Mrs Palmer had said that there were many places in the Woman's Building where ornamental work could be shown to advantage, and invited contributions of marble columns, carved balustrades and porcelain tiles. The Ladies were then figuratively smothered under piles of carved panels, marble columns, balustrades, window grills and other impedimenta which enthusiastic state commissions shipped off to Chicago. Miss Hayden was put to a lot of trouble measuring window openings and wall spaces. She did not like most of this stuff and in any case could understandably have felt, as a result of her "careful training in Classical design", that it should all have been integrated into the Building when it was first planned, and not stuck in here and there to get rid of it. "I found," she said

that very little could be done to advantage with these, as the temporary nature of the construction and materials of the building would not permit it, besides it was too late to give these details the study that would have been necessary in any case.

Another grievance surfaced in the Architect's Report:

I also wished at this time to undertake the interior decoration but as it was determined to have the decorations a part of the exhibit, I gave the idea up as it was practically impossible to separate the two, in this building.

The interior decoration of the Building certainly presented a problem: Candace Wheeler herself, a much older and more experienced decorator, was to be frustrated by the influx of donated materials. In April, 1892, Flora Ginty attempted to donate a door, carved out of the woods of her native Wisconsin, to the Woman's Building. Miss Hayden refused to accept it. This

incident caused hurt feelings and complaints to the President's office. Mrs Palmer was at that time on her second trip to Europe. Susan Cooke apparently attempted to apologize to Mrs Ginty, who responded:

> I had achieved my donation for the Woman's Building through a path set with a thousand rough places, but it makes no difference. I have given the door to the State Building . . . It is so lovely that it did not go begging . . . I do not blame you, my dear woman, but it has taken the energy and faith out of me. When I think of the days I worked and the miles I travelled to achieve these things for the Woman's Building, my ire rises a little yet.

This was unfortunate. Laura Hayes had reported to Mrs Palmer promptly, a few days before Mrs Ginty wrote to Mrs Cooke, even though Mrs Palmer, en route for Europe, would not receive the letter until, presumably, this storm in a teacup had died down. Laura Hayes said she did not blame Mrs Ginty for

> feeling hurt; neither do I blame Miss Hayden . . . Still, as I told Miss Hayden, I think it would be better to have the building look like a patchwork quilt, than to refuse these things whch the Lady Managers have been to such pains in soliciting . . . Miss Hayden's chief desire in this matter is to please you, and she is refusing things simply because she fears you will think she is not living up to her standard.

Flora Ginty

It is most doubtful that Miss Hayden wanted the Woman's Building to look in any way like a patchwork quilt, but this unfortunate suggestion may well have haunted her. Miss Hayes was in any case very quick to report all Miss Hayden's activities to Mrs Palmer in her bright and lively style.

In that same month of April Miss Hayden decided against accepting some copper grillwork which had been offered by Sara Angell of Michigan. She dictated a letter for Laura Hayes to type and mail to Mrs Angell:

> A few days ago I sent you the design for the metal grills for the Woman's Building. Since then it has been decided not to make the change that would be required for their insertion. In my plan for decorating the roof garden, there are some 180 feet of balustrade required. I need 1,800 pounds of copper . . .

Miss Hayes mailed the letter to Mrs Angell, and sent a copy of it to Mrs Palmer, with her own comments attached:

> Miss Hayden told Mrs Angell they would be acceptable, sent for designs and dimensions, and did not notify her that they would not be needed until they were ·almost finished . . . I don't think Mrs Angell's friends would be willing to donate the 1800 pounds of copper wire Miss Hayden modestly asks.

This sort of tale-bearing and sprightly back-biting made relations most difficult between the inexperienced young architect and the President of the Board. When Mrs Palmer returned from Europe in early summer, it must have become increasingly obvious that she did not trust her architect to design the interiors. It was at this time that she began to write to Candace Wheeler about the possibility of her appointment as official interior designer of the Woman's Building. In mid-June Miss Hayden wrote a letter to Mrs Palmer asking to speak with her. Mrs Palmer did not answer this letter for a month. On July 18 she wrote to Miss Hayden, who had been visiting friends in Evanston:

> I have been so busy since my return from Washington that until today I have not opened the mail and consequently did not receive your communication. I write this line to learn if you are still in Evanston and upon hearing from you shall make an early appointment for a talk on the question under consideration. I appreciate your position in regard to the Woman's Building and value your suggestions. Hoping to hear from you and trusting that it is not too late to consider these questions together . . .

But it was too late to consider these questions, whatever they were. At some point in the summer, Sophia Hayden went to pieces. It is difficult to pinpoint dates, but it would appear that some time after she wrote to Mrs Palmer requesting a talk, she went into Mr Burnham's office and had what Sara Angell later called "a severe breakdown." She went voluntarily after that to a rest home of some sort, suffering from "melancholia."

Much to everyone's surprise, she turned up in October at the dedication ceremonies of the Exposition. No one had expected her: it would have been difficult to hide the evidences of a "severe breakdown" in the offices of the Chief of Construction of an Exposition, and Mr Burnham, understandably upset, believed that Miss Hayden would end her days like Mr Rochester's wife, locked away in an attic. *The American Architect and Building News* for November 26, 1892, commented that everyone was surprised but pleased to see Miss Hayden at the ceremonies, and went on to discuss her situation in a spirit of manly frankness:

> Miss Hayden had an especially aggravating experience with her superiors, the 'Lady Managers', in their desire to incorporate into her building all sort of bits of designs and work, whether they harmonized in any particular with it or not, simply because they had been the work of women . . . It is reported that the Lady President has been of all others especially trying in this respect, forgetting in her zeal for women in general, what was due to the architect as an architect.

It would appear that Miss Hayden felt some bitterness against Mrs Palmer in particular.

The *American Architect,* having made these helpful comments, went on to say that a question remained unanswered

> how successfully woman with her physical limitation can enter and engage in the work of a profession which is a very wearing one. If the building of which the women seem so proud . . . is to mean the physical ruin of its architect, it will be a much more telling argument against the wisdom of women entering this especial profession than anything else could be.

To this Minerva Parker Nichols replied in the same journal two weeks later:

> It is not fair because one woman makes a doubtful success, to draw conclusions from her example . . . Because one woman suffers from exhaustion in the daily wear and tear of her household duty, you would not say that women were unfitted for domestic life . . . And because one inexperienced woman, tried by a new position, perhaps discouraged by the results of her own work, from which she expected so much, is ill, you rush into the ranks to save all other women from a like fate.

This back handed defense of Miss Hayden could easily have caused her to lapse into melancholia again, if indeed she had ever recovered: little is known about this.

In December of 1892 the *American Architect* gathered itself together and struck again, trying perhaps to apologize for its earlier misogynist stance, by protesting the injustice suffered by Sophia Hayden:

> an injustice which has not been wrought by the criticism of her accomplished work, but by the ignorant self-confidence of her fellow-women. The Lady Managers have taken the ground, seemingly, that because some women, through long personal training and experience have equalled and surpassed men's work, therefore any woman, simply because she is a woman can do any work as well or better than men . . . and when they find that competent critics do not agree with them as to the real merits of the result, they and their friends seem disposed to ascribe all adverse criticism to indifference and sexual prejudice. It is painful to learn that Miss Hayden has been victimized by her fellow-women . . . the unkind strain would have been the same had the work been as unwisely imposed upon a masculine beginner who had acquired only the same imperfect training and was guided by the same immaturity of judgment and experience.

After the Dedication Ceremonies were over, Sophia went to Ann Arbor to visit friends.

Sara Angell lived in Ann Arbor, where her husband was president of the University of Michigan. She was not angry about the

copper grill incident, despite Laura Hayes's comments. She wrote Mrs Palmer on October 31:

> Miss Hayden, our architect, is here with friends for a few days and I shall ask her to the house and try to make it pleasant for her while she remains.

Mrs Palmer was uncomfortably aware of Miss Hayden's possible grievances. On November 11 she wrote to Mrs Angell that Sophia

Sarah Angell

> did not let me know she was in Chicago at the time of dedication or we should have seen that she had a place of honor. I had thought she was ill and would not come. She had been in an institution being treated for melancholia for a number of months. I did not see her during this time, but understood that she considered she had been greatly wronged in every way.

Mrs Palmer added that Miss Hayden was not on speaking terms with her parents, possibly to reinforce the idea that she was difficult to get along with. Mrs Angell wrote back that Miss Hayden had suffered "a severe breakdown ... with a violent attack of high nervous excitement of the brain" in Mr Burnham's office. Mr Burnham feared she would never recover.

> I was careful in allusions to her physical condition. I told her I knew she had been suffering from over-work and nervous strain and I hoped she would be allowed time for recovery.

Mrs Angell had asked Sophia if she were "proud and happy" at the dedication, and Sophia responded that she was. Mrs Angell added that Miss Hayden spoke with "much enthusiasm" of Mr Burnham, and was even enthusiastic about making plans for a possible Memorial Building for the Lady Managers.

Mrs Palmer, choosing to ignore Miss Hayden's "enthusiasm" about Mr Burnham, wrote to Mrs Angell on December 3:

> Mr Burnham intimated she might never get well. I wish to know if it is not possible that he might take this standpoint in order to explain away any remarks she might make about him or the treatment she received while she was in his department.

This did not seem very likely even to Mrs Palmer, who went on:

> I fancied that she was much disappointed in some way, although she is so reticent that I have never had any statement from her on the subject.

These nervous comments did not make Mrs Palmer look guilt-

less in Sophia's collapse. The *American Architect* report that Miss Hayden had had an "especially aggravating experience with the Lady Managers . . . the Lady President had been of all others especially trying . . ." was to be reinforced by Miss Hayden's own report of 1894 in which she singled out Mrs Palmer for reproof: "the work was unduly hurried . . . your President wished to see the work progress . . ." Throughout the fall and winter of 1892-1893 the accusation hung in the air that Mrs Palmer had hounded Sophia Hayden to the brink—or over the brink—of madness.

Mrs Palmer attempted, in a letter to Harlow Higinbotham, to justify her refusal to allow Miss Hayden to decorate the interior of the Woman's Building:

> As Miss Hayden was very inexperienced in the actual use of color materials . . . and never having had any work in the direction of finishing interiors, I said to him [Burnham], very confidentially, that I saw Miss Hayden was frightened by the subject and that I would greatly prefer Mrs Candace Wheeler, who had more experience that anyone in the country, man or woman.

Miss Hayden received extra compensation of $450 for her work, and $527.60 for her expenses, exclusive, one assumes, of medical expenses. Her Building received an award "for delicacy of style, artistic taste, and geniality and elegance of the interior hall." She herself did not attend the official opening of the Fair in May, 1893. The Lady Managers gave a reception in her honor in mid-July, 1893. Mr Burnham among others was officially invited to attend..

Where she was in May, and why her reception could not be given until the following July, is not known. In 1894 she married William Bennett, an artist. This act does not in itself presuppose sanity. She does not appear ever to have designed another building. Unlike Phoebe Couzins, Sophia Hayden made no public comments about the influence her encounter with the Board had on her later life. She lived until 1953, an enigma to the end.

I N February of 1892, while the struggle to lure Alice Rideout to Chicago was going on, and the Ladies' enigmatic architect was "helping" to sort out odds and ends, Mrs Palmer faced the necessity of choosing a woman artist to execute two great murals for the main gallery of the Woman's Building. The two spaces to be covered were each fourteen feet high and fifty-eight feet wide. It was understandable that, after Mrs Palmer's two experiences with the winners of competitions, she should conduct a private search for a muralist. This method might be less democratic, but it might prove less exhausting in the long run.

It was natural that Bertha Palmer should turn for advice in this matter to a remarkable woman of her acquaintance named Sara Tyson Hallowell. Miss Hallowell had come with her mother from Philadelphia to Chicago about twenty years earlier. In 1873 she became secretary of the art department of the newly founded Interstate Industrial Exposition of Chicago. Many such fairs were held in the South and the Midwest in the latter part of the nineteenth century: they emphasized commerce, agriculture and industry, and they all had their cultural side as well. The Directors of the Philadelphia Centennial had commissioned a march from Richard Wagner and a hymn from John Greenleaf Whittier. Its art building was one hundred and fifty feet high, and contained paintings as well as industrial art. Maud Howe Elliott, among others, remembered all her life how these paintings, imported from Paris and Munich, had awakened in her a passion for art. The Centennial displays—not all of which were made of butter, even in the Women's Pavilion—were generally credited with raising the artistic consciousness of the country and improving national taste.

In 1883 Mrs Palmer's native state held a successful Exposition at Louisville. Here too an art building was included: the 386 paintings, borrowed from Eastern collectors, were of the Barbizon school, of whom the painters best known to Americans were Corot and Millet. Their landscapes, romantic but earthy,

were the forerunners of more experimental French painting.

The Chicago Interstate Industrial Exposition, held in the "Crystal Palace" on Michigan Avenue where the Art Institute now stands, outdid all these other fairs: mining, manufacturing, agriculture, horticulture, inventions and sculpture and painting were shown together. The art exhibits of the Interstate Exposition dwarfed previous exhibits of this kind. The work of American artists Whistler, Sargent, William Chase and Eastman Johnson were shown, along with the Barbizon painters and their followers. These exhibits were a great success. The Exposition had an active Art Committee, whose members were among the most influential and wealthy citizens of Chicago, but credit for the high calibre of the exhibits went to Sara Hallowell.

In 1885 Montague Marks, a New York critic, wrote in the *Art Amateur:* "Largely due to the personal efforts of that extremely intelligent and energetic lady, Chicago this year has anticipated New York, Boston and Philadelphia in exhibiting the important American pictures from the last [Paris] Salon." This was indeed music to the ears of Chicagoans. "Bravo Chicago!" Mr Marks cried, "and particularly bravo, Miss Sara Hallowell!"

It was at the Interstate Industrial Exposition of 1890 that Miss Hallowell introduced Impressionist art to Chicago and through Chicago to the nation. There were six Monets, four Pissarros, and one Degas, all borrowed from the avant-garde French dealer Paul Durand-Ruel, and all hanging in their own booth amidst the machinery and agricultural displays. Harriet Monroe, writing for the *Art Amateur*, was impressed with most of the canvases, but she found some blotchy, with clashing colors. The *Inter Ocean* liked one of Monet's seascapes, but thought another badly done.

Potter Palmer, a member of the Art Committee of the Exposition, was much taken with these Impressionist paintings. He and Mrs Palmer, among others, became wealthy patrons of Miss Hallowell: she acted as an agent to help them build up their collections. She became a consultant too, to American museums. Since she spent much of her time abroad, and was knowledgeable about developments in the art world, she was the ideal person to advise Mrs Palmer in the search for women painters. Many people believed that Sara Hallowell was the ideal person to direct fine arts for the Columbian Exposition.

On September 16, 1980, Mark McDonald, a Commissioner-at-large from California sent Mrs Palmer the following letter on the stationery of the Commission's headquarters in the Pullman Building:

It is the earnest desire of President Palmer and myself that you accept the position of one of the Board Lady Managers [sic] of the World's Fair. We are very anxious that Ladies like yourself will accept the position to give character to the Lady Board Managers

[sic] of the Commission. You will not necessarily have to devote all your time to this, and in your absence you can notify your alternate to take your place. And in order to make it convenient for you we propose that the President nominate your friend Miss Hallowell as your alternate. . . . the nomination . . . will not mitigate [sic] in the least against Miss Hallowell getting the position she desires, but will assist her in securing the position . . .

Mr McDonald, whose syntax was idiosyncratic, closed by asking Mrs Palmer to write him or President Thomas Palmer "recommending a few more names of the Chicago Ladies suitable for that position of Lady Manager," and to telegraph him her own decision in the matter.

Thus it is apparent that it was widely expected that Miss Hallowell would become Director of Fine Arts of the Exposition; this expectation was not confined to Chicagoans. On October 18, 1890 the *New York Times* commented:

Sara Hallowell is most favorably spoken of for the position [of Director of Fine Arts]. She has proven her wide knowledge of art and executive ability by making the Interstate exhibit second to none in the country.

Mrs Palmer knew that sex prejudice could keep the Directorship from Miss Hallowell; she was determined to do everything in her power to secure the post for her friend. At the beginning of the first session of the Board in November, 1890, Mrs Reed, who was president of the Baltimore Decorative Society, offered this resolution:

Sara T. Hallowell of Philadelphia, universally recommended by great collectors, artists and directors of fine arts museums, is eminently qualified to fill the position of Fine Arts Director of the World's Columbian Exposition . . . Her sex is being urged as a disqualifying factor by some of the Committee on Fine Arts, who admit the same endorsement would ensure a man's appointment . . .

This resolution was offered by Mrs Reed, but it had been written by Bertha Palmer. Agreement to it by the Ladies was not unanimous. Mary Trautman of New York voted "No" in a voice vote. Miss Hallowell later discussed Mrs Trautman's action:

At the convention in Chicago when you so kindly had the resolution regarding my application offered, I perfectly understood Mrs T.'s position when I heard the opposing *No* come . . . from her. On my honor I bore her no ill will for this, it was all so clear to me, with Ellsworth in the background.

James Ellsworth was a member of the Fine Arts Committee of the Directory: it was he who objected strenuously to Miss

Monroe's "Columbian Ode" and who attempted to jettison the Ladies' participation in the Dedication Ceremonies. He was most strongly against appointment of a woman to the Directorship. The choice of the Directors and the Commission was Allen Marquand, an expert on Italian art. Miss Hallowell and Mrs Palmer both believed that Mr Marquand was qualified to be Director, but Miss Hallowell, who knew him well, was sure he would not accept the post. On January 5, 1891 she wrote Mrs Palmer that she had attempted to see M. H. De Young, of California, second vice-president of the Columbian Commission and a member of the Fine Arts Committee. Mr De Young did not keep his appointment with Miss Hallowell, who wrote, "It is only too evident that Mr De Young would not see me and it is all almost sickening to me." About Mr Marquand she said:

It is too absurd for them to keep harping on Mr Marquand, to whom the idea of being a figurehead is most distasteful, yet whose age and personal affairs prevent his taking an active part. They will labor in vain in that direction.

In the same letter Miss Hallowell had to deal tactfully with an offer Mrs Palmer had made her of a post on the Board of Lady Managers:

As to the Woman's Department, I cannot tell you how useless I feel my services would be when I do not see a clearly defined work before me. I mean a particular aim to be achieved in a field in which one feels at home—some *definite* landmarks ever in view. In my own work I feel myself literally charmed by the exclusion of everything else. With your wonderful ability to grasp many ends, to embrace a wider vision, it is so different, but my work, lying in one direction for so many years, has narrowed me for broader general range, and only as a *specialist* can I be of the value I must be . . . Able to control one's own time, one can afford to experiment— certainly it is less selfish. I cannot tell you how deeply I appreciate your consideration of me, and I only wish I were worthy of consideration—but when it comes to believing myself of value in any but one field, an appalling sense of unfitness comes over me. With such a distinct aim in view as the magnificent collection which *must* be shown in the Art Department of the World's Fair, already one sees the obstacles set aside, difficulties overcome, which the initiated know will be presented at almost every turning. But in thinking of any other department of work, a sense of vagueness comes over me which fairly stupefies me and utterly obscures my vision.

In January Mrs Palmer wrote to Chauncey DePew, the politician, who was a Commissioner from New York, in an attempt to get him to support Miss Hallowell at the meeting:

Dear Sir:
May I recall myself to your remembrance in order to ask a favor of you? Having been selected as one of the women who are to take

charge of the interests of our sex at the coming exposition, I do not know how I can advance them more signally than by interesting you in the cause I have to plead.

You are a member of the Art Committee, the sphere of usefulness of which has been terminated by the concentration of power in the hands of the Director-General.

The Committee however will have one more meeting in New York on the 25th of February in order to make its report and express its choice as to the Art Director. We who have the good of the Exposition at heart have urged that Mr Marquand or Mr Walters of Baltimore be secured to fill this place in order to give prestige to this Department; but they have positively refused to act, and so have four other men not nearly so satisfactory.

The most capable candidate for the place is now Miss Hallowell of Philadelphia—a woman of high birth and breeding, who has worked for years in creating art exhibits, and who has the warm endorsements both of artists and art patrons. She is also strongly endorsed from the practical stand-point by the gentlemen who have worked with her and have had charge of the more practical departments of the Exposition. They say that in the thirteen years she has had charge of the art exhibit, there has never been a picture lost or misplaced, never one injured and never any controversy of any kind—that she is absolutely safe, from the business standpoint and that there is no man in this country who has had her experience in securing exhibitions and returning pictures from all parts of this country and Europe.

Three members of the Art Committee are so narrow as to oppose Miss Hallowell's election on the ground of sex, saying frankly that any man with her endorsements would be elected.

Will you not then do our sex the great favor to go yourself to the coming meeting of the Art Committee instead of being represented by your alternate, who votes against Miss Hallowell? If you go, and elicit the facts in the case, I do not doubt what your vote will be— and in this I pay you a great compliment. . . .

The other applicants are men infinitely inferior in experience, ability and general knowledge of the subject, as you can easily find out by asking a few questions. I say this with the knowledge that Mr Charles Hutchinson of Chicago may be persuaded to allow his name to be used.

I shall be very much gratified if I can prevent a gross injustice to a charming woman, who has supported herself and her mother by her signal ability in a new field of work, and who should not be shut out from any emoluments and distinctions which lie before her in her chosen line of work, simply because she is a woman.

This letter testifies to the intensity of Mrs Palmer's desire that Miss Hallowell receive the post. Mrs Palmer was as eager as Miss Hallowell herself. On January 16 Miss Hallowell, in an apparent response to urging by Mrs Palmer to make sure that Mr Marquand was really out of the running, wrote to her,

For the reason that Mr Marquand told me so positively that nothing would induce him to take the Art Directorship, I hardly felt at liberty to question him again.

Miss Hallowell went to New York in February; Mrs Palmer had suggested that Mr DePew could be influenced by Mary Trautman or one of the other Lady Managers from New York who had been appointed by him. From the tone of Miss Hallowell's letter it would seem that Mrs Palmer was also anxious to know what sort of women the New York Lady Managers were. Since Mrs Trautman had voted against the resolution recommending her appointment to the Directorship, Miss Hallowell was unfriendly to her and doubted that Mrs Trautman could be helpful even if she wanted to:

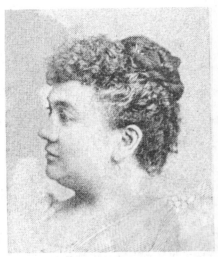

Mary Trautman

> Mrs Trautman, I *think*, has not even met Mr DePew as yet. although she *is* his appointee ... She sometimes meets Mrs DePew at meetings of some charitable association ... I had a long talk with her and although by people here I had been somewhat prejudiced against her, I find her an able and interesting woman. She is illiterate and without position and her interest in my cause would I am sure do it no service ... The opinion or good will of one so little informed on the subject in question could have no weight with Mr DePew.

Miss Hallowell's opinion of Mr DePew was to undergo a drastic revision within the next year, but at the moment she was concerned mostly with her "cause". She told Mrs Trautman that she was aware of her opposing vote:

> ... yesterday I liked her very much and told her I really cared nothing at all—or rather that I appreciated her right to her opinion—for her action at that time. All she could say on the subject now was that 'it was premature at that time.' She is most anxious to have you think well of her and I could fill my letter with her praise of you—and she has a hearty manner which is rather 'fetching.'

Although Sara Hallowell was absorbed mostly in her own plans for the future, she did attempt to give Mrs Palmer some idea of Mrs Trautman's potential as a leader:

> Of the Washington situation she knows nothing. Her idea is to go to Albany in person with the other ladies at an early day to request an appropriation, to go direct to the factories for information about women's work rather than first to have parlor meetings, according to Mrs Hooker's idea. Mrs T. is a natural-born speaker and her illiteracy I fancy is most noticeable in *private* conversation. I do not doubt she understands that parlor meetings in New York organized by her would be failures. Being an ambitious woman and realizing the opportunity now before her she *may* be able to attain great results, and understandably she appreciates the importance of the situation ... Knowing that among the *prominent* women of New York, there are brilliant minds and enthusiastic workers, is it not a pity that one of influence is not in this position? A principal, to represent the great state of New York, should be in a position akin to your own.

Miss Hallowell then reverted to the subject which obsessed her:

> As those able to fill the position which I have sought—I should say those with experience—would not accept it, I appreciate the difficulty of the authorities in finding a man who is suitable. It sounds very egotistical but I know so well there *is* no person in this country of equal experience with my own—understanding the innumerable details connected with an exposition I find myself growing a little independent in the matter albeit I am probably making a virtue of a necessity.

She then put forth an alternative plan she had, if she did not get the post.

> I have a thought of establishing an agency in Paris from where I could forward collections for exhibition in America, the Boston, Phila. and St Louis museums already agreeing to appoint me their agent, I often having been requested to act for them when my hands were tied by my Chicago position. My expenses would be less than if I were filling the World's Fair position. And . . . there is as much money in it without the awful responsibility. With me as Art Director much more would be expected than from a man—no shortcomings on my part would be tolerated. Please say nothing of my little scheme which I pour into your ear because of all your kindly interest throughout the whole affair. You see I am simply preparing the way for my retreat.

There was nothing she would prefer to the Director's post. Returning to Chicago before the meeting of the Fine Arts Committee, she visited Charles Hutchinson at the Art Institute: he told her that Halsey D. Ives, Director of the St Louis Museum of Fine Arts, was most likely to be appointed to the post she so desperately desired. But she was not left entirely without hope.

Halsey Ives

> . . . it seems that Mr Ives is about decided on for the Art Director with the undertaking that he is left entirely free to appoint his own assistants, a sort of idea existing, somehow, that I am to be first.

She added, "Mr H. does not desire the post. He denounced Mr Ellsworth in strong terms." Mr H. was of course Charles Hutchinson.

The Committee did recommend Mr Ives, and the Director-General approved his appointment. Miss Hallowell was willing to be his assistant, and he appeared willing to accept her.

On July 11, 1892, Mrs Palmer wrote, "greatly delighted to know that Mr Ives had finally put himself on record in a satisfactory way, and that your connection with the Art Department . . . is now an assured fact." However Mrs Palmer's delight was premature.

The Fair authorities did not object to Miss Hallowell assisting

Mr Ives, but they balked at allowing her the salary which she felt she must have. On August 6, 1891, she wrote sadly to Mr. Ives:

> ... for all you have done for me in the matter I am most grateful, but the fact of the finance committee reducing the salary recommended by you compels me to respectfully decline the offer. My circumstances do not warrant my considering patriotism the only motive as my personal expenses can hardly be less than $3000 a year and as I am in a position to earn more than this amount in another chance than that of the great Expo, I must abandon the idea of connection with a work in which naturally I would have taken much pride.

About a week later she wrote to Potter Palmer telling him that she had written Ives in London "requesting him to suspend action on my former letter (of refusal) until I had an opportunity to talk with him." She could not bring herself to refuse finally:

> It is really a wretched thing to have any matter so much at heart as I have this. No event of my life—which has not been an entirely uneventful one—has seemed to have the significance this has. Your sympathy leads me into egotism.

By October, 1891, matters were resolved so that Miss Hallowell felt she could accept the post which she so desperately wanted. On October 29, 1891 Mrs Palmer wrote to her, delighted that she had accepted "the position in the Art Department, which I hope will prove just what you desire." Mrs Palmer was elated. She knew that Miss Hallowell would build an impressive collection of lent pictures. "She turns disdainfully from all but one or two gems owned by each collector," she wrote. "By keeping her standards high she will make everyone anxious to have his pictures admitted." Montague Marks of the *Art Amateur* could not understand what the fuss was about in the first place. Sara Hallowell was his first choice for director and always would be. "Certainly," he wrote, "she has done more for the art education of Chicago and the West generally than all your millionaires who have been buying costly old masters and exhibiting them at the Art Institute. Furthermore, she is a good judge of modern paintings, has remarkable executive ability, and is on the most friendly terms with artists at home and abroad."

In fact, Miss Hallowell was appointed Secretary to Mr Ives, not assistant. That post went to Charles Kurtz of New York, who had organized the art exhibit at the Louisville Southern Exposition in 1883. The Chicago *Inter Ocean* said that "Miss Hallowell had many strong endorsements for the position held by Mr Ives, but the fact that she was a woman appeared to militate against her." Nevertheless Sara Hallowell could not have made a greater

contribution to the Exposition if she had been named Director of Fine Arts. In September 1891, after a period at her French home, she set to work to gather a Loan Collection for the Fine Arts Palace. She knew many collectors and attempted to reach others through influential acquaintances. In December, 1892, she wrote a long letter to Potter Palmer, in the course of which she mentioned a gentleman who had already disappointed her once:

Really Mr Depew is no good at all, so little interest as he has in the whole thing, and it was a mistake on my part to think that the fact of his being a Commissioner would have any weight in such a matter as this work of mine. Anybody owning great pictures can only satisfactorily be reached through those who are truly interested in the subject of art ... who are in possession of fine works themselves ...

In the same letter she offered suggestions, obviously in response to a query from Mrs Palmer, for what appears to a list of women qualified to be nominated to the Fine Arts Jury of the Exposition:

I should have more time than this. I fear there are too many names given. Although Mrs Keith (Dora Wheeler) is a far better painter than Mrs Wheeler, I name the latter in preference to a committee. If not too many the daughter's name should be added. [Dora Wheeler Keith was Candace Wheeler's daughter.] If more than one should be named from Chicago, I would add Mrs E.S.S. Adams' name. Perhaps Mrs Van Rensselaer should not be on, since she is not a practitioner.

Mariana Alley Griswold Van Rensselaer was a perceptive critic of art and architecture for whom Sara Hallowell and many others had great respect. Known professionally as Mrs Schuyler Van Rensselaer, she wrote articles and books on American architecture, English cathedrals, American figure painting and landscape gardening. Miss Hallowell recommended that the Palmers read Mrs Van Rensselaer's perceptive comments on the architecture of the Exposition.

In the fall of 1892 Miss Hallowell was struggling to gather her collection; she had also the responsibility of providing paintings for the various national exhibits at the Fair, advising Mrs Palmer and the Board of Lady Managers, and acting as private agent for Potter Palmer, for whom she was negotiating the purchase of the Impressionist painter Alfred Sisley's "Street at Moret." In return for these favors, Mrs Palmer had rather ungratefully requested that Miss Hallowell not try to borrow any of the Palmer's paintings for the Loan Collection. Miss Hallowell refused to accept this, and turned to Mr Palmer:

Unless Mrs Palmer rebels altogether at my persistence, I think our

great loan collection must count on you for (besides the Corots),
your beautiful Puvis de Chavannes, Cazin's "Judith" and
"Elsinore" . . .

She asked also for three works by Jean François Raffaelli, a
contemporary painter, and for a Delacroix. She apologized by
saying she was "lost to all sense of consideration at this time":

. . . you have the most fascinating collection in the country and it is
a matter of such pride to me to have this fact recognized even by
the showing of a few of your pictures.

In all, Miss Hallowell got fifteen paintings from Potter
Palmer: Romantic, Barbizon and Impressionist, a mixture that
characterized her Loan Collection as a whole. Other wealthy
Chicago art collectors co-operated with her: Charles Hutchinson
lent one painting, Robert Hall McCormick lent three, Martin
Ryerson four and Charles Yerkes twelve paintings and one
sculpture. Miss Hallowell went outside Chicago to Cleveland
and Detroit to fill out her collection and outside the Midwest as
well: Isabella Gardner of Boston contributed, as did Philadel-
phia collectors, one of whom was Alexander Cassatt, Mary
Cassatt's brother. Mr Cassatt and another Philadelphia man,
Frank Thomson, between them contributed eight outstanding
paintings by Degas, Monet and Pissarro. New York collectors
were also tapped heavily by Miss Hallowell: she received loans
from Albert Spencer, a pioneer in the collecting of Impressionist
paintings, and from Cornelius Vanderbilt, Collis Huntington,
Henry Havermeyer, Crist Delmonico and Jay Gould. She
reached even to San Francisco, to William Crocker. In addition,
she was sent paintings by museums in Boston, Philadelphia and
St Louis.

On February 24, 1892, while Miss Hallowell was in Paris
working frantically on her projects, Mrs Palmer, who had her
own problems, wrote her a long letter about the murals for the
Woman's Building:

My Dear Miss Hallowell,
Mr Palmer tells me he has just received a long and satisfactory let-
ter from you. Such an interval has elapsed we felt that we had lost
you from our horizon, although I quite understood you were hav-
ing a beautiful winter in Paris surrounded by the artists and new
creations.
Mr McEwan and I have been discussing which of the many paint-
ers could be most safely entrusted with the two panels in our main
gallery, and he has finally come to my belief that Elizabeth
Gardner is the one who should be selected as she has so many
points in her favor to say nothing of the advantage of a very expert
master. Miss Robbins I do not feel so sure about. It is so commonly
reported that her work is done by her master, Carolus, that I fear it

would be used against her in case we selected her to do any work in our building. I inferred from remarks that I heard, that her character was not above reproach, and we could not afford to have any women about whom there could be the slightest doubt, as we would want to have social relations with her and do her honor in case she came to Chicago. Could you let me hear about this?

May I not ask you to do us the favor of speaking for us to Miss Gardner, as it is so difficult to write and convey all of our meaning, and I think you could understand better than an absolute stranger, the position here.

We are promised $6000 for the decoration of the two panels in our building, although it has not yet been positively voted. This means $3000 each for two decorations 58 X 12 of which I send you blue prints. Of course we should want something symbolic showing the advancement of woman. My idea was that perhaps we might show woman in her primitive condition as a bearer of burdens and doing drudgery, either an Indian scene or a classic one in the manner of Puvis, and as a contrast, woman in the position she occupies today, but I should be quite willing for the artist to propose her own subjects and submit the sketches for our decision.

Do you think this project would interest Miss Gardner, and that she would see the fine opportunity to achieve a great reputation? The sum we can offer is . . . small . . . but . . . I think the women may prove to have as much patriotism as the men, especially as it is much more rare for them to have an opportunity given them.

Of course if we cannot find American women who are willing to undertake this work we shall have to secure those of other nationalities and I feel that Madame Demont-Breton would be my next thought.

Mr McEwan has faintly suggested Mrs MacMonnies, but finally said he thought perhaps she would not have the necessary knowledge of drawing and composition.

We can have Miss Gardner do both or select some other American artists abroad. It is desirable that the panels be painted in the same country so that the artists can consult about the color scheme, and the two decorations be made to harmonize. I should only wish to propose one of these panels to Miss Gardner at present, and think if she adopted the treatment I have suggested that the second would be the best adopted to her style . . .

Do let us have a few lines from time to time and believe that by trying to stimulate the patriotism of Miss Gardner and any other Americans who are abroad painting, you will be doing a great service not only to the Exposition but to Yours Sincerely . . .

This letter demonstrates clearly that at the end of 1892 Mrs Palmer had decided that Elizabeth Gardner should do at least one of the large murals, and instructed Sara Hallowell to that effect. Miss Gardner, a native of New Hampshire, had spent the greater part of her professional life in Paris. She was a student of Bougereau, an academic painter highly popular in his day. In 1877 the London *Daily News* remarked that Miss Gardner was outstanding "among the lady artists resident in Paris." Miss Gardner, however, wrote to Miss Hallowell on March 14, 1892, rejecting the proposal, which she called attractive. She was much

tempted by the honor but she knew that she "should not be equal to the physical fatigue necessary in painting on a high ladder. Believe me, I am very sorry to refuse."

On March 26 Mrs Palmer wrote a long letter to Mrs William Reed of Baltimore, in the course of which she mentioned Miss Gardner, but without enthusiasm. The letter, interesting because it demonstrates the number of matters with which Mrs Palmer was concerned, begins with congratulations to Mrs Reed and Mrs Alexander Thomson on the "welcome intelligence" that the Maryland legislature had passed the World's Fair Bill and granted an appropriation of $60,000. Mrs Palmer "trusts" that Mrs Reed and Mrs Thomson will become members of the Maryland State Board and that "a share of the appropriation bill [will] be set aside for the use of the women." In a postscript Mrs Reed was urged "to keep an eye on Washington" and "be ready to go there when called to help secure the appropriation", meaning of course the annual Congressional appropriation for the Exposition. Mrs Reed's acquaintance with her state legislators "is of the greatest value, especially Senator Gorham. Do what you can to have him vote right."

The postscript launches into a long discussion on the difficulties surrounding the appointment of the women to the Jury of Awards: Mrs Reed should influence acquaintances on that Jury to help the Board.

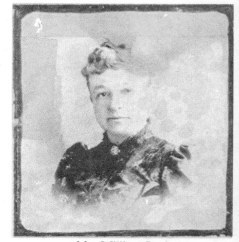

Mrs William Reed

There is quite a disposition on the part of Mr John E Thatcher of New York and Mr Sewell of New Jersey and one or two others, to prevent our appointing our members on the Juries of Awards. They want to have the appointment of them in case we are allowed any, and they disapprove of our having such a large proportion as the resolutions passed by the Commission would give us. Of course our right of appointing these members comes to us from an act of Congress and I do not see how they can do away with it, but they are disposed to try, consequently, our friends should be on guard and ready to vote in our interest. If the $700,000 is passed paying for jury service . . .it brings so much valuable patronage to the men, that they will surely try to keep it all to themselves. If no appropriation for jury service is made, we will stand a much better chance of having justice done us.

Mrs Palmer urged Mrs Reed once more to push forward her state work and her "decorative art work," because when the appropriation for the Board came through and it became clearer "just what we can undertake" she would want Mrs Reed often to come to Chicago "on committee service." Mr Palmer wished to go abroad to see the Spring art exhibitions and sales; they were therefore going "over for a short trip of six weeks." Mrs Palmer's trip was directly connected with the choice of artists for the panels.

The sum of $8000 has just been voted by the Directors for the mural decorations in the main gallery of our Building, and the Construction Department has allowed me to decide who shall execute this work. I have been in consultation by means of letters, with artists abroad, but it has been rather unsatisfactory so that I shall be much pleased to discuss the matter with those who are most strongly recommended to do this work. The two American women who have the strongest claims are Elizabeth Gardner, a favorite pupil of Bougereau, and Mrs MacMonnies, who is the wife of a prominent American sculptor, and who is more qualified to do decorative work than Miss Gardner. We may have one done by an American and one done by a French woman as there may not be two American women who are competent and willing to do this work. The sum allowed, $3000 for each panel, is very small pay, so that the artists need some enthusiasm in order to be willing to undertake the work, more especially as none of these have ever done so important a piece of work and they may feel that success is more or less uncertain. Of course I have thought of Rosina Emmet and Dora Wheeler, but they have not had the drill that is necessary for this work, and they will be otherwise represented at any rate. Besides it is a tremendous advantage to have it done abroad under the influence and criticism of the tremendous number of critics who are interested in these matters. That in itself would be half the battle. I feel the importance of having it well done.

The "tremendous number of critics" who could influence the work seems to be Sara Hallowell. Mrs Palmer refers here to the depressing situation with Alice Rideout, with whom the Board's "intercourse" was "not very satisfactory," and who might well have to be dropped in favor of someone else. These matters were "becoming of the utmost importance" because of lack of time.

The appropriations bill will come before Congress "the third week in April and will linger possibly for some weeks before it is disposed of." Mrs Palmer would be back from Europe "and ready to begin work as soon as we are sure of the result." She assured Mrs Reed that she would return home "at any moment" if she was cabled that the appropriation was endangered. She felt confident that the appropriation would be made.

Mrs Palmer's second trip abroad enabled her to renew her acquaintance with the influential people whom she had met in 1891 in London, Paris and Vienna. The Belgians, who had had no interest in the Fair in 1891, had now had a change of heart, demonstrating the growth of the prestige of the Board over the year. The Queen of Belgium had announced her willingness to head the Belgian Women's Committee. The Queen's Maid of Honor, Countess de Denterghem, had arranged a spring exhibit of women's work, inspired by the Board's circulars. Mrs Palmer was especially invited to attend this exhibit in Brussels.

The Palmers sailed on the *Umbria* on April 9, 1892, arriving in Paris three weeks later. Sara Hallowell introduced Mrs Palmer to Mary Fairchild MacMonnies, whose husband, Frederick Mac-

FREDERICK MacMONNIES,
Sculptor.

Monnies, had been commissioned to sculpt the massive fountain for the Grand Basin of the Fair. Mrs MacMonnies had been born in New Haven in 1858, had lived in St Louis, and had studied art in Paris for a number of years, most significantly working in the studio of Puvis de Chavannes. Mrs Palmer was taken with Mrs MacMonnies and her work; she was perhaps equally impressed with the fact that Frederick MacMonnies had rented four large studios on the Left Bank of the Seine in which he and a crew of workers were executing the fountain for the Fair. Mrs Palmer saw at once that these studios would provide excellent space for the execution of a great mural; with that space would come masculine assistance, both artistic and physical. The President offered a commission for one of the large murals to Mary Mac-Monnies, who accepted with alacrity.

With one rather large hurdle out of the way, Miss Hallowell reminded Bertha Palmer that there was still another American woman painting in Paris: this was Mary Cassatt, who had been working at her craft since 1861, in Philadelphia, Paris and Rome. In reaction against the conservatism of the Paris Salon, in which she had exhibited, she had joined the independent group of Impressionist painters. Degas in particular was her mentor and friend. Sara Hallowell believed that Mary Cassatt, then little known, was the finest American woman painter. It was odd that Mrs Palmer should have overlooked her, since she had met her in Paris in 1889 through Miss Hallowell. At that time, at Miss Cassatt's suggestion, Mrs Palmer had bought a Degas called "On the Stage" for $500 from Durand-Ruel, whose gallery was the first to exhibit the work of the Impressionists.

Miss Cassatt, who was nearly fifty years old in 1892, had never married. Her mother had said that her daughter was "intent on fame and money . . . After all, a woman who is not married is lucky if she has a decided love for work of any kind and the more absorbing the better." Mary Cassatt appeared to admire Mrs Palmer's "organizing powers and her determination that women should be *someone* and not something." When Miss Hallowell brought these two women together, the decision about the second muralist was made.

Mrs Palmer could sail home with a feeling of accomplishment. Laura Hayes noted on June 16, 1892 that the President "reached home this morning looking well and sunburned from her ocean trip." The President had not discussed contractual matters in Paris; those she had left to Frank Millet of the Department of Construction.

Frank Millet was a noted painter who had replaced William Pretyman in May, 1892, when Pretyman left the Fair in a dispute with Burnham over the color of the buildings. Mr Pretyman wanted them painted in bright colors, as John Wellborn Root had supposedly intended. Daniel Burnham wanted the "White City," and Pretyman consequently resigned. Frank Millet who got on well with Mr Burnham, had charge of exterior and interior color of the buildings, of the decorations, music and illuminations for processions and ceremonies, and of sculpture and murals. It was he who was responsible for the issuing of contracts to Mary MacMonnies and Mary Cassatt.

As soon as her contract arrived Miss Cassatt cabled Mrs Palmer: "Contract received. Conditions impossible. If maintained I must resign."

Mrs Palmer telegraphed to Sara Hallowell in alarm inquiring to what conditions in the contract Mary Cassatt objected. Miss Hallowell wired back: "October completion. Submitting sketch. Terms of payment. Expenses of delivery."

In the next mail Mrs Palmer received a letter from Mary Mac-Monnies which enclosed the contract. She too refused to sign because of the October deadline (it was already July), because she was not to be paid anything until her work was finished, and she was to bear all charges for freight and installation of the mural. She did not object to the low fee; she knew that low fees were the rule. Actually in some cases fees were not discussed at all; Mrs Palmer liked to suggest that patriotism and the "enhancement of reputation" should be as good as money. In that same mail was a letter from Miss Hallowell enclosing a letter she had received from Miss Cassatt, elaborating on her telegram.

Sara Hallowell sympathized completely with the artists, saying, "The outlay is so enormous in doing a work like this—models and all else—that it seems so strange for Mr Millet (himself a painter) to o.k. such a contract." Miss Cassatt suspected

that the women were being treated differently from the men. Mrs Palmer had early made attempts to guard against that sort of discrimination. In May of 1891 Mrs Starkweather had asked Miss Hallowell whether men and women received the same remuneration from the Paris Salon, and had been told that they did indeed.

Immediately after reading her mail, Mrs Palmer consulted with Mr Millet. She was not so inclined as Sara Hallowell to sympathize with the artists: possibly her attitude was influenced by the knowledge that Miss Cassatt came from a wealthy Philadelphia family, and that Frederick MacMonnies was a most successful sculptor. She wrote Miss Hallowell on August 3, 1892:

> Mr Millet says that it is the invariable rule for decorators to place their own decoration and assume the expense of it, and that he never knew of any case to the contrary. I think it is only owing to the inexperience of our decorators that they object to this. Mr Millet feels also that as Mr MacMonnies is such a very great beneficiary (he is quite sore about the difference between the compensation to architects and sculptors and to painters, the two former receiving large prices and making a profit out of their work while the latter are altogether out of pocket) and such a great gainer by the Exposition artistically and financially, that Mrs MacMonnies should be the last to ask for any special privileges not allowed to similar artists or to object to the terms of payment. I think this matter will not affect Miss Cassatt.
> As to the date of delivery and the submission of the sketch, Mr Millet waives the conditions of the previous contract and Mr Burnham will appoint you the agent to accept the sketches of Mrs MacMonnies and Miss Cassatt; I, of course, am equally willing to trust to your taste and discretion. I think these concessions will perhaps bring our decorators into line again. There is a great deal of feeling, I may say, on the part of the painters. They are certainly not having as good an opportunity either financially or artistically as the architects and sculptors have had. The former were provided for at the outset by the Construction Department and now at the last moment when the money is nearly exhausted, the artists are called in and have made their work largely a matter of patriotism. I regret that this is so, but it is the plain fact.

Mrs Palmer wished to make clear that there was no sex discrimination against the two women painters. She pointed out that J. Gari Melchers and Walter McEwen, two male artists, had been given their commissions at a higher rate than the other artists, and that Mrs MacMonnies and Miss Cassatt had been given the same rate as Melchers and McEwen.

She was aware that Miss Cassatt had had to go to the expense of building her own studio at her country house, Bachivillers, fifty miles north of Paris, but "she is well enough off to make this a tremendous step on the road to fame." French artists would work for practically nothing, Mrs Palmer said; living in Paris was much cheaper than in America, where living expenses and

models were costly. Yet the American artists by and large were being paid less than the two muralists who lived in France. Mr Millet had mentioned that his own Fair salary did not cover his living expenses.

To Mrs MacMonnies Mrs Palmer acknowledged receipt of her letter and the return of the contract for "revision". She explained that Mr Millet was willing to allow Miss Hallowell to approve the sketch for the mural, and to move the date for delivery from October to February 15, 1893. Mrs MacMonnies and Miss Cassatt had both asked to be given until May of 1893, but Mrs Palmer said that was impossible. There were "urgent reasons" why the work must be done more quickly than that. All the important work that required scaffolding to be built had to be done so that the scaffolding could be gotten out of the way at least one month before the opening of the Fair, and the installations in the Main Gallery could be "perfected." Mrs Palmer was friendly but firm:

> We are anxious to do everything we can to meet your wishes but Mr Millet feels that as he is holding all the men to the same rates of payment that he has proposed to you, you should not object to the time.

She added that she had heard from Miss Hallowell that Mary MacMonnies' designs were beautiful.

Miss Hallowell wrote on August 12 from the MacMonnies' house at Impasse du Maine on the Left Bank:

> The enclosed letter from Miss Cassatt will show you that everything is again serene. I return the copy of Mr Millet's letter sent me by Mrs Cooke only that you may see the blunder made in the amount named.

Miss Hallowell then reverted to her problems with Halsey Ives, whom she apparently did not trust.

> I am anxiously awaiting a letter from Mr Ives in answer to my request for his approval of my returning not later than September 1st. The answer is just about due. In a letter from him of July 25th, he advises work for me to do here. Should he delay more in speaking positively about my return I will proceed in good earnest to carry out my work by correspondence from Paris, which method in fact he suggests. Should he this time *not* answer my question plainly ... promptly and decidedly I can only at last conclude that he wants to keep me away from the scene of action. Mais, nous verrons.

Miss Hallowell had come to Paris from her summer home in Moret to discuss the Art Palace exhibit with Antoine Proust, the Minister of Fine Arts who was Director of the French art section

Drawing Room
of Sara Hallowell's French Chateau

of the Exposition. She also went to the Palais d'Industrie to see the Exposition of Women's Arts and Crafts which, like the Brussels exhibit, had been inspired by circulars sent from the Board of Lady Managers in Chicago. She found this exhibit "most interesting in parts—especially in the section devoted to beautiful objects (borrowed) worn for the adornment of women . . . It would all interest you so much. I wish you were here to see it."

Mrs MacMonnies, she said, was

getting on beautifully with her work, devoting herself to it untiringly and enthusiastically from early until late. She has been

fortunate in securing a number of wonderfully fine models from whom she is making all her *studies* in the nude. In her original sketch she has been making some changes and so is delaying a little in forwarding it but has herself written to you on the subject.

Mrs MacMonnies thanked Mrs Palmer for her letter concerning the contracts. She said that it was too bad that no one had mentioned terms while Mrs Palmer was in Paris. She was willing to accept the revised date for delivery:

The date February 15, though it will hurry me a little more than I like, is still possible, and I will deliver my work in Chicago by that time. As far as I know, Miss Cassatt's objections to the contract were identical with mine, except that I am willing to send a small sketch, which is now waiting for the contract to be determined.

She added, obviously annoyed at Mr Millet's insinuation that she and her husband were fattening themselves at the public trough:

I am surprised that there should be any question about acceding to our wishes in arranging payments and in placing the decorations at the expense of the Exposition, and still more surprised at Mr Millet's statements concerning these matters.

In September Mrs Palmer wrote a note to Frank Millet, urging him to action, since it was obvious that Mrs MacMonnies would not send the sketch until she had a satisfactory contract, and that she herself did not want to write to Millet:

With reference to the MacMonnies-Cassatt contracts, they feel that I am their medium of communication with you, and I perhaps have not given you all of the letters I have received from them and from Miss Hallowell. Pray pardon my oversights in this case. Will you not have the contracts made out with such modifications as we discussed, extending the time of delivery until February fifteenth (not later), and appointing Miss Hallowell to accept the sketches, etc. Please be as liberal about terms of payment as you find it consistent to be . . .

On September 25 Mrs Palmer wrote to Mrs MacMonnies that she impatiently awaited the promised sketch, and that she hoped the contractual arrangements would be satisfactory.

The emendations were satisfactory to both artists, who signed and returned the contracts to Mr Millet. Miss Cassatt, like Mrs MacMonnies, felt somewhat pressed by the deadline. In September she wrote Mrs Palmer that

. . . all I could wish would be a little more time. I am afraid my work will show signs of hurry and it would have been better if we could have had two long summers instead of one.

It has mistakenly been said by Miss Cassatt's biographers, and others who have written about her mural, that she did work on it for two long summers: the assumption being that Mrs Palmer made only one trip to Europe for the Board—her 1891 trip—and that it was in 1891 that she commissioned the muralists. However, we have seen that as late as February of 1892 no muralist had been commissioned: Mrs Palmer was considering Elizabeth Gardner for the mural. Lack of information about Mrs Palmer's second trip in the spring of 1892 has given rise to the assumption that the artist had twice the time she actually had to work on the mural, and that Mr Millet had dragged his feet over the contracts and the payments, when in fact the contracts were amended and returned to the artists without delay, considering the confusion caused by Construction Department clerks attempting to deal with a mass of detail. On September 10 Mary Cassatt wrote to Mrs Palmer:

> Thanks to your kind offices all my difficulties with the board of construction seem to be arranged, and my contract is here although not yet in my hands, as it was sent by mistake to Mrs MacMonnies and hers to me. I sent her hers but she has not yet sent me mine having heard at Durand-Ruels that I had already received one! However I suppose I shall get it sometime. Between you and me I hardly think women could be more unbusinesslike than some of the men are. Here is Mr Millet sending me "the exact size of those tympana" at this hour of the day. It will entail on me a good deal of extra work which he might just as well have spared me by sending the exact size at first.

In September Mrs Palmer asked Miss Cassatt to give her a description of the mural for the next Board meeting. Mrs Palmer's letter arrived too late for Miss Cassatt to answer her before the Board meeting, which began on October 18, 1892, but Mary Cassatt complied with her request anyway. She was rather annoyed by a clipping she had received from a New York newspaper, which reported that Miss Cassatt's subject was to be "The Modern Woman as Glorified by Worth"—referring to the dress designer, and not to an allegorical quality. "That would hardly describe my idea, of course," Miss Cassatt wrote. She wished to make it clear that she was not doing an illustration for a fashionable lady's magazine or pattern book:

> I have tried to express the modern woman in the fashions of our day and have tried to represent those fashions as accurately and as much in detail as possible. I took for the subject of the center and largest composition young women plucking the fruits of Knowledge and Science. That enabled me to place my figures out of doors and allowed of brilliance of color. I have tried to make the general effect as bright, as gay, as amusing as possible. The occasion is one of rejoicing, a great national fête. I reserved all the

Mary Cassatt: Sketch for Mural

seriousness for the execution, for the drawing and painting. My ideal would have been one of those admirable old tapestries brilliant yet soft. My figures are rather under life size although they seem as large as life. I could not manage women in modern dress eight or nine feet high ... An American friend asked me in rather a huffy tone the other day, 'Then this is woman apart from her relations to man!' I told him it was. Men I have no doubt are painted in all their vigor on the walls of other buildings; to us the sweetness of childhood, the charm of womanhood, if I have not conveyed some sense of that charm, in one word if I have not been absolutely feminine, then I have failed. My central canvas I hope to finish in a few days ... I will still have place on the side panels for two compositions ... I shall begin immediately ... Young Girls Pursuing Fame. This seems to me very modern and will give me an opportunity besides for some figures in flowing draperies. The other panel will represent the Arts, Music (nothing of St Cecilia) Dancing and all treated in the most modern way. The whole is surrounded by a border, wide below, narrow above, bands of color, the lower cut with circles containing naked babies tossing fruit, etc. ... I think my dear Mrs Palmer that if you were here and I could take you out to my studio and show you what I have done that you would be pleased indeed. Without too much vanity I may say I am almost sure you would.

She then mentioned the thing which had bothered her from the beginning: the height at which the pictures would be hung. She was haunted by the experience of Paul Baudry whose work

had been hung "quite out of sight" at the Grand Opera; she believed her murals would be hung "much higher" than Baudry's.

> When the work reaches Chicago, when it is dragged up 48 feet and you will have to stretch your neck to get sight of it at all, whether you will like it then, is another question . . . the architects [are] evidently . . . of [the] opinion [that painting is no longer needed]. Painting was never intended to be put out of sight.

She descended temporarily into graciousness again:

> This idea however has not troubled me too much, for I have passed a most enjoyable summer of hard work.

She then returned immediately to the "idea" which did obviously trouble her.

> If painting is no longer needed, it seems a pity that some of us are born into the world with such a passion for line and color. Better painters than I am have been put out of sight. Baudry spent years on *his* decorations . . . then they were buried in the ceiling of the Grand Opera.

Mrs Palmer could do nothing about the height at which the murals would be hung, and did not worry about it, although Sara Hallowell did. Mrs Palmer had to report to the Board on the murals, and make sure that no one objected to the commis-

Mary Cassatt: Central Panel Modern Woman

sions. At the meeting on October 18 she discussed the murals in glowing, positive terms:

> One of the most interesting duties we have had to perform at head-quarters has been the supervision of the finish and decoration of the Woman's Building, about which the Department of Construction has kindly allowed us to decide everything. The Directors have shown their interest by voting, in addition to our general appropriation for decoration, $6,000 for two large mural paintings for the tympana at the ends of our main gallery. The selection of the artists to do this work was left to me, and it became one of my most serious interests while abroad to decide upon the women who were qualified to perform this service.

She added quickly, in case there should be objections to her finding artists "abroad"'

> It went without saying that an American should naturally be chosen. As this is an American Exposition, the creation of the building and all the adornments should naturally be the expression of American taste and skill. It would be a humiliating confession of weakness should we be obliged to ask other nations to perform this service for us.

Having forestalled objections to expatriate artists by emphasizing the importance of commissioning Americans, she went on to discuss the difficulties of the work, possibly so that no Board member would try to get the commissions for a friend or relative or even for herself:

> The immensity of the surfaces to be covered makes the undertaking one of great difficulty. As no American artists, either men or women, have had experience in decorative work, done on the scale required for Exposition buildings, it is a great opportunity for all who have been entrusted with panels. The panels to be decorated in our building are fourteen feet high and fifty-eight feet long. Enormous studios had to be secured to accomodate the vast canvases. These, in addition to the necessary models, costumes, etc., which were numerous, and had to be carefully chosen, made the preliminary expense very great for an artist.

Having talked about the expenses which the artists must incur, Mrs Palmer referred to the horrible example of Miss Gardner who, despite "having received more medals than any other American woman in Paris, was not strong enough to undertake such work, as it necessitates great physical strength in addition to artistic qualifications."

While the Ladies were presumably racking their brains trying to think of muscular, talented millionairesses of their acquaintance, Mrs Palmer hit them with her two ideal candidates, chosen "after an exhaustive investigation."

Mrs MacMonnies is the gifted wife of the sculptor who made the large fountain for the Exposition. She studied in Paris for many years under Julien and other well-known teachers, and has had the benefit of living in the artistic atmosphere of Paris. Her drawing of figures and landscapes is excellent, her color pure, fresh and harmonious, her imagination delicate and fanciful and her style essentially decorative.

Mrs Palmer reserved for last what may have been to her the most important thing about Mary MacMonnies:

Mrs MacMonnies could avail herself of the great studios which were secured by her husband for the modelling of his fountain.

Mary Cassatt, not having the advantage of a famous husband, had to be sold to the Ladies rather more thoroughly than Mrs MacMonnies:

Miss Cassatt had to build an immense glass-roofed building at her summer home where, rather than work on a ladder, she arranged to have the canvas lowered into an excavation in the ground when she wished to work on the upper part of its surface.

Having established that Miss Cassatt was wealthy and quick-witted, Mrs Palmer had to account for the fact that none of the Ladies had ever heard of her:

Miss Cassatt has lived in Paris ever since she went abroad many years ago to study her art. She had the good fortune to select Degas, one of the most eminent of modern French artists, as her master. She unfortunately embibed his prejudice against exhibitions, so that she has never been an exhibitor in Paris or in America, and her name is consequently unknown among us. In spite of this, she has a great reputation among the artists of Paris. The Luxembourg Gallery talked this year of buying one of her pictures, which fact alone is sufficient to establish her reputation. Having large means, she has been able to devote herself to what interested her without the necessity of doing the "pot boiling" which is the bane of so many young artists. She worked for several years to produce certain effects in lithographing with colors, and invented or revived some remarkable processes. Her sets of etchings are in the hands of the best connoisseurs in Paris and the United States, so that while her work is not generally known, it stands very high with those who have had the good fortune to see it.

It was doubtful that any Lady would question the taste of the Luxembourg Gallery and the best connoisseurs. Mrs Palmer then moved quickly to Candace Wheeler, the Board's new Colour Director whose name she linked with those of Mary Mac-Monnies and Mary Cassatt: with these three appointments the Construction Department had treated the Ladies "generously." Thus Mrs Palmer invoked the imprimatur of Daniel Burnham on

her choice of muralists, and launched into an encomium on the Building itself:

> As our building has approached completion, the caryatides of Miss Yandell and the pediments and groups of Miss Rideout have been placed in position, and the delicacy and beauty of Miss Hayden's creation have been fully appreciated and have received the highest encomiums from all of the artists familiar with it. While our building is smaller and less expensive than most of the others, its scholarly composition, beautiful proportions, refined and reserved details, hold their own even when considered in comparison with the ornate creations of the other great architects represented on the Exposition grounds. It is remarkable as being the first creation of a young girl.

Mrs Palmer now had the solid backing of the Board, although she herself still felt the responsibility for having chosen the muralists, as we shall see.

Mary Cassatt worked energetically throughout the autumn of 1892. Her mother wrote a vivid description of her daughter at work—a description embodying the genteel anti-Semitism that was part of the mental baggage of the Eastern American Establishment:

> Mary's help in the shape of a young Hebrew came out on Tuesday to work on the border of her decoration; such a slow creature you never saw. Mary got out of patience when he said it would take six weeks to do what he had to do, so yesterday she left her models to get at the border hammer and tongs and when the day was over she said his part would be done in six days instead of weeks to which he replies 'Well, yes we have worked!' All that he does is of the simplest and then a gilder will have to come to put in the gold required which won't take very long but will cost like the mischief Mary says.

As the winter wore on Mary Cassatt became somewhat despondent. She felt the loss of Degas, with whom she had quarrelled over the mural. As she explained to a friend:

> When the Committee first offered [the mural] to me ... at first I was horrified, but gradually I began to think it would be great fun to do something I had never done before. The bare idea ... put Degas into a rage and he did not spare any criticism he could think of. I got my spunk up and said I would not give up the idea for anything. Now one only has to mention Chicago to set him off.

Mrs Palmer wrote encouragingly to Miss Cassatt; in December the painter wrote to thank the President for her thoughtfulness:

> The fact is I am beginning to feel the strain a little and am apt to get a little blue and despondent ... I have been shut up here so

long now with one idea, that I am no longer capable of judging what I have done. I have been half a dozen times on the point of asking Degas to come and see my work but if he happens to be in the mood he would demolish me so completely that I could never pick myself up in time to finish for the exposition. Still he is the only man I know whose judgment would be a help to me. M. Durand-Ruel . . . was here . . . very kind and encouraging, said he would buy it if it were for sale, and of course from his point of view that was very complimentary but it was not what I wanted. He seemed to be amazed at my thinking it necessary to strike for a high degree of finish; but I found that he has never seen the frescoes of the early Italian masters, in fact he has never been to Italy except to Florence for a day or two on business. I asked him if the border shocked him, he said not at all, so it may not look eccentric and, at the height it is to be placed, vivid coloring seems to me necessary.

Degas was still angry in December. Camille Pissarro wrote to his son:

Speaking of Miss Cassatt's decoration, I wish you could have heard the conversation I had with Degas . . . I am wholly of his opinion; for him [decoration] is an ornament that should be made with a view to its place in the ensemble, it requires the collaboration of architect and painter. The decorative picture is an absurdity, a picture complete in itself is not a decoration . . .

Miss Cassatt's disturbance over the height at which her picture was to be placed did in fact bear out Degas' point: there was no collaboration between artist and painter in the Woman's Building.

To add to her discomfiture, the winter of 1892 was a severe one. Her sister-in-law commented to another family member:

She must get them done before Christmas and proposes to stay out there [at Bachivillers] until she finishes them. Entre nous, she will not be through before the first of March. I think they will freeze out there.

Mrs MacMonnies had an easier time than Mary Cassatt. She was comfortably ensconced in Paris, working alongside her husband, with a forge and two stoves going at constant red heat. She was interviewed by Eleanor Greatorex for an article in *Godey's Lady's Book* and told her how she had conceived her mural:

I began immediately to study the composition, rejecting . . . the idea of the savage, the prehistoric, the slave, the Oriental woman, or any that would require precision as to detail of costume, race or environment as being unfit to express an abstract and universal idea. I finally settled on the simplest draped figures of women, without special type or costume, in a landscape background that might be of any time or country and is certainly not in America . . . The women indicate with the completest possible simplicity the

FRAGMENT OF FRESCO.

MRS. MACMONNIES AT WORK.

bearer of burdens, the toilers of the earth, the servants of man, and more than this, being without ambition, contented with their lot.

Miss Greatorex said that Mrs MacMonnies considered this conception the most difficult part of the mural. She went to the Forest of Fontainbleau and made "a number of studies for the foreground, such as weeds and grass . . ." Each figure was taken from a different nude model. Three months were spent on preparatory sketches; and three months more on the actual execution, including a "working model" one third the size of the final mural.

Unlike Miss Cassatt's mentor Degas, Mrs MacMonnies' "master", Puvis de Chavannes, was delighted with the idea of the Woman's Building mural, and delighted with Mrs MacMonnies' execution of it, according to Miss Greatorex. "But it is a surprise!" he cried, "It pleases me greatly! . . . You are now fairly launched on the broad track . . . No woman has til now ever decorated a public building."

Puvis de Chavannes had told Mrs MacMonnies: "In all things clearness, clearness before all!" He hated nothing so much as "the vague and cloudy." Mrs Greatorex found "the young artist brilliantly, radiantly clear" and the fresco "luminous." She was charmed by Mrs MacMonnies altogether:

> The artist on her high ladder with a wing-like palette almost half her own size on her thumb, her lithe, young figure outlined against the expanse of white canvas on which she is brushing in, with the verve of a strong arm, primeval woman, nine feet high, is a charming symbol of the "Coming Woman."

It was, ironically, Mrs Palmer herself who caused the artists mental anguish during the course of their work. After her return from Europe, the murals were much on her mind. Mrs MacMonnies' "Primitive Woman" and Mary Cassatt's "Modern Woman" were of course related, since "Modern Woman" was to demonstrate the progress made since "Primitive Woman" toiled in the wake of the male hunter. As Mrs Palmer had written Sara Hallowell, even before the murals were commissioned, she wished "the two decorations to harmonize with one another."

It occurred to her in late fall of 1892, after the Board meeting was out of the way, and she had more leisure in which to brood about the murals, that since both were the same size, they should also correspond in the size of the figures and the size of the borders which enclosed them. Accordingly, she fired off a telegram to Mrs MacMonnies, telling her to make sure that both the border of her mural and her figures matched those of Miss Cassatt's mural in size.

Mrs MacMonnies was stunned: she had already worked for months: her picture was planned and the scale worked out. Now

Mrs Palmer was telling her to begin again. She wrote to Mary
Cassatt, who responded:

I hasten to answer your note at once. Certainly Chicago seems to
reserve endless surprises for us. I should fancy from what you told
me of your design and from what Miss Hallowell said your inten-
tion was as regards the size of your figures, it would be quite
impossible for you to put a border of the width of mine around your
composition. My object was to reduce the huge space as much as
possible by a border in such a way as to enable me to paint a picture
in each of the spaces left where the figures would be rather under
life size . . . Therefore, I designed a border of one metre in depth to
run along the whole base of the decoration consisting of bands of
color with designs and divided by lines of gold and into this I have
introduced at intervals circles in which naked babies are tossing
fruit, etc. The upper border is narrower, about 75 centimetres wide,
repeating the color and the design of the lower border. You will
perceive that I went to the East for the foundation of the idea. I
have divided the length into three by two panels of 80 centimetres
wide. You may remember that I told Mrs Palmer I intended doing
so. The border is the only attempt I have made at decoration pure
and simple.

Mary Cassatt: Medallion from Border of Modern Woman

Miss Cassatt did not think Mrs Palmer understood much
about the total effect the murals would have, nor about the prob-
lems of the artists, since obviously the border of her picture was
an important structural part of the whole. Mrs MacMonnies had
on the other hand concentrated mostly on her figures. As we
have noted Miss Cassatt was primarily concerned about the
height at which the pictures would hang. Her concern proved to

MARY FAIRCHILD MACMONNIES.

be justified. She refused to allow herself or Mrs MacMonnies to be rattled by Mrs Palmer's telegram:

> Considering the immense height at which the pictures will be placed and the distance apart they will be, we agreed that unity of any kind was not necessary ... When Miss Hallowell was here we thought the height would be at the top of the chimneys of this house, or about the fourth floor of the large apartment houses in Paris ... I think, if Mrs Palmer realized this, she would see that there would be no necessity for unity; if such a thing was in the scheme it is too late now.

Mrs MacMonnies remained calm. The situation was made clear to Mrs Palmer, possibly with the assistance of Sara Hallowell (whom Mr Ives had allowed to return to Chicago by September 20) or Frederick MacMonnies, who was at the Fair site at the end of the year. Mrs Palmer telegraphed an apology. But then the President received a photograph of Mrs MacMonnies' nearly completed mural, and was upset by what she considered the unnecessary nudity of the figures. She had already been told by Miss Hallowell that Mrs MacMonnies had done studies for the mural from the nude, and may have been braced for trouble when the photograph arrived. She began, in her tactful way, by praising what she could praise:

> I was very much pleased with the photograph which you so kindly sent. It carries quite a suggestion of Puvis and I can fancy an approach to his delightful grays and blues in the coloring. In fact your own small picture that I saw, representing a garden, was simply lovely in its delicate grays, greens and softened reds. I know it is to be a great success and simply charming ... The water in the distance, the landscape and the figures are all delightful ... The only point about which I would make a suggestion would be in the draperies. You know we have an infinite number of people taking the standpoint of the 'British Matron' and that art of any kind is so new to our country West of the Mississippi river that even semi-nudity attracts more comment than it would in an art center like Paris ... I suppose that as far as ... history is concerned, primitive women did really wear warm clothing rather than the floating drapery of goddesses so there seems to be no impropriety or impossibility in the suggestion of clothes.

She apologized for her unfortunate telegram about the border, with rueful charm:

> As I have not taken the opportunity to express my astonishment at the tranquility with which you took my telegram about the scale of your figures. I telegraphed you when I thought that Miss Cassatt's border was comparatively a narrow one. When I heard of its immense size and realized how it would reduce your figures, I saw the utter impossibility of your making any changes and as I did not hear from you promptly I feared I had driven you to suicide. Mr MacMonnies had confidence in your fortitude.

She added, possibly in an attempt to be funny, that she "was pleased to find that Miss Cassatt's figures were entirely clothed, there being not even a decolleté gown assigned to her modern woman."

This letter was dated January 4. Mrs MacMonnies, who appears to have had a refreshingly sunny disposition, did not hurry to reply to it. She may have been thinking of an answer. On January 20 she wrote to Sara Hallowell:

> ... the work will stop in about ten days. The border is now half done and is very good in effect, a sort of tapestry border we have all composed together ... with a constant differing and drawn "fore-hand" all the way around ... I shall almost blush to tell you the favorable things that have been said of it by distinguished people ... Had a really charming letter from St Gaudens which I shall treasure for the rest of my days.

On January 23 she settled down to write a long letter to Mrs Palmer. Among the other annoying things in her January 4 letter, Mrs Palmer had told Mrs Mac Monnies that Mr Millet had said that the Building could not be heated and that Mrs Mac Monnies consequently would not be able to put the finishing touches to her mural "in place" as she planned to do, but would have to work in a smaller room. Mary MacMonnies addressed herself to that point first and worked up to the others.

I CRIED AND WEPT IN FRONT OF IT, AND CRIED AND WEPT.

> Since Mr MacMonnies returned from Chicago and told me so much about the Fair in general and the Woman's Building in particular, I have thought it indispensable that I should *complete* my decoration *in place*. If it is going to be really necessary on the contrary to work, even in Chicago, "in a smaller room", then I may as well not leave Paris. But as you say the hall may be heated somewhat—and as we may expect a little more moderate weather in February and March, also as I am not particularly feeble, I feel very strongly inclined to risk it and to sail in a very short time from now. The work is practically done at present, I am occupied now in refining the details and finishing the border with which by the way I am greatly pleased. It is not the conventional border of the small sketch, of which you have the photograph, but a richly colored, harmonious design of fruits and flowers.

After that, she moved to the most exasperating point raised by Mrs Palmer:

> About my use of the nude:—I am entirely disposed to follow your wishes in this matter, and when you see the work in place I will do exactly as you think best about it. Let me first show you the effect as it is however. The Primitive Woman probably wore warm clothing in winter and nothing at all in summer—?—but I am doing an entirely allegorical-symbolical-representation of an Idea—not a picture of any particular epoch or people. The photograph is probably more startling than the painting, the latter not having anything like the contrasts in "Values" unavoidable in a photograph where some colors take too dark, others too light.

Here Mrs MacMonnies attempted to instruct Mrs Palmer:

> A decoration, like a tapestry, should be a superior sort of wall-
> paper, which gives first and above all a charming and agreeable
> effect as a whole, but does not strike the eye or disturb the attention
> by any vigorous or salient "spots". I think you will scarcely see my
> semi-nude women (I mean be aware of them) at all, if the work is
> successful *as a decoration*. I have made some changes in the appoint-
> ments of the draperies, since the photograph was taken, possibly
> these may cover somewhat your objections.

At this point Mary MacMonnies' irritation became noticeable.
She knew that the Fair grounds were to be filled with colossal
statues, by men, of nude or semi-nude allegorical female figures.

> I think that one of the objects of the Woman's Building is surely to
> show what I may call our "virility", which has always been con-
> spicuous by its absence. I don't know how much of the nude has
> been used by the men in their decorations—paintings—?—but I
> know that in their sculpture the whole exhibition is full of it. Well,
> are we going to recoil and once more bear the reproach of timidity
> and feebleness. Also, in matters of Art as in matters of Science,
> should not the ones who *know* impose their will, which is the right
> one, on those who do *Not Know*? A figure draped from head to foot
> may easily be made more immodest than one entirely nude.—All
> this does not mean at all that I do not wish to follow your desire in
> the matter, as I have already said. It is simply a statement of my
> point of view, in which I think you agree personally.

Mrs MacMonnies' last sentence was obviously meant to show
Mrs Palmer that she accepted her statements about the Philistin-
ism of Americans and that she knew that Mrs Palmer herself was
too sophisticated in matters of art to be personally upset by
nudity. From this point she launched into a small tirade about
the fact that her first payment, with the signed contract, had not
been sent to her as had been arranged.

> The men, none of them I am sure, have been required to finish their
> work with absolutely nothing official to show for it. It is too unbusi-
> ness-like. So may I ask once more that you will kindly see that the
> contract and payments due are sent immediately. I shall wait for
> their arrival before sending the work and leaving Paris for Chicago.

Undoubtedly aware of the uproar this announcement would
cause in Mrs Palmer's bosom—to say nothing of the Construc-
tion Department—she moved blandly in the same paragraph to
a discussion of the question of "what has been decided about the
method of applying the canvases to the walls." She had used a
"fine and strong quality" of canvas so that if it were fastened to
the wall by white lead or rye paste, it could easily be removed
after the Fair. If it were to be mounted on wooden stretchers she

Mary Cassatt: Modern Woman

needed to know immediately so that she could have them made to measure in Paris. She then became stern and business-like.

> There should be no question about the scaffolding being ready in time, as we have no time to lose in waiting after I arrive and the contract provides for this being done by the Exposition. I shall send the packages containing the decoration, third-size sketch, and all studies, in bond to Mr Millet, and unless delays occur everything will leave Paris between the 10th and 15th of February. I shall trust to Mr Millet's good nature to get the packages out of the Customs House as quickly as possible and I shall get to work without losing a minute.

Finally she responded to Mrs Palmer's comments about the telegram.

> You are very good to praise my "tranquility" about your cablegram relative to the border. I assure you my impressions at the time were the reverse—but on thinking it over I could see that there must be a misunderstanding, and I knew that a small explanation would probably clear it. I am very grateful to you for your second telegram telling me to go ahead—I should have been in despair otherwise.

On the same day she wrote hastily to Miss Hallowell, telling her that she had just received a "delightful letter" from Mrs Palmer:

> Mr Millet thinks the Building (Hall) cannot be heated and that I will have to work in a smaller room. But then the object of my going to Chicago will cease to exist, it being only to *finish the decorations in place*. If this is not possible I may as well stay here.

She informed Miss Hallowell of Mrs Palmer's objections to nudity:

> I have answered Mrs Palmer's doubts about the nude, but do please aid me in assuring her that I shall do about this whatever she wishes when she sees the work in place. I am in a rush and this is just a lit-

tle word to you to put you "au courant" if Mrs Palmer speaks to you about my letter.

Her comments about the contracts and the payment caused Mrs Palmer to go into immediate action. Miss Cassatt had complained also. Mrs Palmer wrote to her:

I was perfectly astonished to learn that you and Mrs MacMonnies had not received your contracts and payments long before this. I went to Mr Millet at once about the matter, and he was as much surprised as I, as he had made out the contracts some time ago, giving the necessary bonds for payments himself in order to facilitate matters. It has since developed that he sent these contracts to the office of the Construction Department to be forwarded, and that in some mysterious way a package containing six contracts was lost in transit. Had it not been for your inquiries, it would not have been discovered for some time as the clerk to whom they were consigned not having received them, did not know they had not been sent, and Mr Millet naturally supposed they had been forwarded. Mr Millet feels extremely sorry about it. Of course you will appreciate that I have nothing whatever to do with the financial matters of the Exposition outside of our immediate office but I have felt extremely annoyed to think of the inconvenience that you and Mrs MacMonnies have been caused by this delay.

On January 27 Mrs Palmer had dispatched a note to Frank Millet asking for an immediate response to Mrs MacMonnies' request: "Let me know when both payments and contracts go forward."

In the middle of March Mrs MacMonnies arrived in Chicago and worked at the painting on the scaffolding in the Great Hall. Possibly the chill in the air disposed her more favorably to protect her women from the elements, as Mrs Palmer had hoped she would. Certainly the picture contains nothing that would alarm the most timid of British Matrons.

Miss Cassatt did not come to Chicago. Mrs Palmer had tried to woo her on March 3:

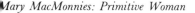

Mary MacMonnies: Primitive Woman

You certainly must come to the Exposition. We cannot consent to
allow you to go to the Ancients this summer. You must come here
instead and see if you receive no inspiration from the moderns.
I have not time to write a long letter and can only say I am looking
forward with the greatest eagerness to the arrival of the great
decoration. You must come and see it in its place. I shall feel that
the occasion is not complete unless you come to enjoy the work in
general and your own share of it in particular. We owe you a thous-
and thanks for having so kindly assented to our wishes, and under-
taken this painting which must have oppressed you, as it was so
exactng and the time so short. I congratulate you in advance upon
your success.

But Miss Cassatt did not come. In April her mural arrived in
Chicago and was hoisted high, high into place. Mary Cassatt had
known that Modern Woman and Primitive Woman would only
dimly be discerned, facing each other across the Hall of Honor.
Primitive Woman crushed grapes and carried water, burdened
by a babe in arms. Modern Woman picked fruit, plucked a lyre,
and gracefully pursued an Ideal. These two paintings, like the
Building in which they were placed, reflected what Mrs Palmer,
aflame with a passionate love of Beauty, was pleased to call "The
inspiration of woman's genius."

Sara Hallowell

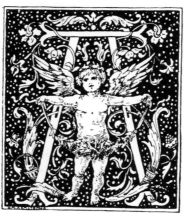

S early as August of 1891 the Fair authorities began to plan the Dedication Ceremonies of the World's Columbian Exposition, to take place in October of 1892. A Grand Ball was to be held; the Directory planned rockets, cannon salutes, parades and an impressive and expensive number of floats on the lagoons: twenty-four in fact. The Lady Managers began to plan their own share of the festivities. Everyone was still planning a year later, in August, 1892, when time was getting short. Mrs Palmer was not at all sure that the Ladies would be represented at the Ceremonies. She spent the summer of 1892 in the Adirondacks, but was in constant correspondence with Chicago people about Fair matters. Her friend Ellen Henrotin's husband Charles was a member of the Directory's Committee on Ceremonies, and Mrs Palmer attempted to work through him to achieve a place for the Ladies in the Ceremonies. These were to be held in the hall of the Manufactures Building. Mrs Palmer was much dismayed by the size of this hall: it covered thirty-two acres. She did not believe the audience there would be able to hear a thing. She preferred that the Ladies have their own ceremonies on the day of dedication in their own Building. However, she wrote to Mr Henrotin at the end of July: Mr Higinbotham, the Director who was President of the Fair's Council of Administration, had said that the Woman's Building "would not hold the number of people who would want to go in." Negotiations were clearly in order. Mrs Palmer wrote significantly to Ellen Henrotin, "I beg you to say to Mr Henrotin that we will be very glad to have him bring this matter up at the proper time."

The only piece definitely arranged for by the Ladies for the Ceremonies was a "Jubilate" or musical rendering of the Sixty-Fifth Psalm, composed by twenty-five year old Amy Beach of Boston, whose work had been performed by both the Boston and New York symphony orchestras. Miss Beach's work had been recommended by William Tomlins, the Choral Director of the

Fair. For this and any other reasonable addition to their program, the Ladies wanted at least fifteen minutes of time at the Ceremonies.

Mrs Palmer's special assistant was Amey Starkweather, who had been President of the Providence Women's Exchange for ten years. Mrs Starkweather had recently lost both her husband and only child; Lyman Goff, a Commissioner from Rhode Island, had asked Mrs Palmer to give her a position "that would occupy her mind." There was no question of financial need. Mrs Palmer wrote to Amey Starkweather on August 3: "This matter of our Ceremonies is taking a very peculiar course and I hardly know myself what is best. Mr Higinbotham is opposed to having the Ceremonies in our own building . . ." However Mr Higinbotham had offered the women two hours of time at the Dedication Ceremonies and $400 toward their expenses. Mrs Palmer was not certain about this offer. "This would do women more honor [than ceremonies held separately in the women's Building] but I feel very uncomfortable about any women getting up there and going through a pantomime performance, which it would be, for it would not be possible for the audience to hear her talk, and I think it would make us rather ridiculous. I should not consent to do anything myself, and in case this proposal should be adopted, I think it would be better to have a simple musical exercise. We could have Miss Beach's Jubilate, Mrs Julia Ward Howe's 'Battle Hymn of the Republic' . . . if we have any remarks, they should be made by women trained for public speaking."

Mrs Starkweather felt that it would be better for the women to go "into the general program, which is more honorable and complimentary, even if it is not so pleasant." Mrs Starkweather reported that the women had one implacable enemy on the Committee of Ceremonies: James Ellsworth, a Chicago millionaire and noted collector of antique porcelains and Oriental rugs. "Mr Ellsworth is opposing us vehemently, but is willing to let us have something on Saturday morning, after the Ceremonies are over and everybody has gone home," wrote Mrs Starkweather, who had a lively style and a sharp eye.

On August 18 Mrs Starkweather was at work in the offices of the Board in the Rand McNally Building at 168 Adams, pasting up scrapbooks and filing letters, when William Tomlins, Choral Director and one of three members of the Bureau of Music under the Commission, came in to see her in a rather irritable mood. He told her "of his own free will" that the Bureau had decided to drop Amy Beach's "Festival Jubilate" from the Ceremonies. It lacked "majesty and breadth" and "would take too long a time for the performance." In addition it was filled with "frills, quartets and ruffles" and no one would be able to hear it in the Manufactures Hall — a possibility already suggested by Mrs Palmer. He was rejecting the work because of his high regard for

Harriet Monroe

womenkind; he had too much respect for women to let an inferior performance cast doubt on their artistic abilities.

While Mrs Starkweather, according to her own testimony, "listened patiently," Mr Tomlins alluded to Miss Beach as a "composer of ordinary merit as compared with men, but as a woman, very good." Mrs Starkweather asked Mr Tomlins tartly why the Bureau had recommended Miss Beach in the first place. He responded by asking her if she knew "of any woman in this country who is a Beethoven or Mendelsohn?" Mrs Starkweather reported to Mrs Palmer that Mr Tomlins "was at that time quite angry, his little eyes snapped so ferociously" at her as he said this.

Mrs Starkweather, holding the fort alone, was somewhat harassed by the gentlemen of the Bureau of Music, who seemed to have a bee in their bonnets about the Jubilate. On August 26 Mr Wilson, the Secretary of the Music Bureau, descended upon her "again to know if we secured any recognition . . . I again evaded his questions . . . He volunteered remarks on Miss Beach's cantata, and I smartly reminded him of the high praise he gave it . . ."

These incidents appeared to confirm the Ladies' suspicions that the Corporation and the Commission intended to snub them at every opportunity. Mrs Palmer could hardly be blamed for feeling rather depressed in her letter of August 30: "The question has become so complicated I think we possibly had better have unofficial opening ceremonies in our own building either in October or May . . . Mrs Beach might feel that she was not fairly treated if her cantata was not played at a time when it would be well advertised and made very prominent." She was sorry "critics" disapproved of the work. Mrs Starkweather was made of sterner stuff; she and Mrs Henrotin urged Mrs Palmer to face up to the Ceremonies at the Manufactures Hall. Mrs Starkweather did not trust the men; she was even suspicious of Charles Henrotin when that gentleman presented himself at the end of August. He said that he had fought like a tiger against vigorous opposition, mostly from James Ellsworth, and from James St Clair of the Council of Administration, and that he had won. A resolution had been passed by the Committee on Ceremonies, saying that the Ladies should have a definite part in the Dedication. Of course the Ladies should make no plans that might conflict with any plans that the men might make. Mrs Starkweather wrote to Mrs Palmer, "I told him very pleasantly that I did not think that the resolution meant anything."

Shortly after this, word seeped through to Mrs Starkweather that Mr Ellsworth had decided that a mistake had been made in the inclusion in the program of Harriet Monroe's "Columbian Ode." Miss Monroe, a poet, was the sister-in-law of John Wellborn Root, the architect of the Fair. She was to found *Poetry* Magazine in 1912, and was already, at the age of thirty-two, an

Columbian Ode Design Will Bradley

independent spirit. She had noticed very early in the planning stages for the Ceremonies that poetry was being neglected; this seemed to her to be "unjust and ill-advised." Since she was acquainted socially with some members of the Committee on Ceremonies, she asked them to commission her to write a poem to be read at the Dedication. This they did, in March, 1891.

Harriet Monroe then began work on her Ode, somewhat hampered by various disabling symptoms of Victorian "nervous prostration." Her legs refused to hold her, she felt as though "little worms" were crawling inside her head and limbs and her eyes kept "swinging out of their orbits" and refusing to work. Nevertheless her design for the Ode was grandiose, to say the least: first,

> a salutation to Columbia followed by the procession of nations to the festival, led . . . by Spain; second . . . the coming of Columbus and the choral song of his sailors; third, the awakening of America — the wilderness, the pioneers battling with harsh nature and savage man, and conquering with a song of triumph; fourth, the procession of the great dead — the founders led by Washington, the fighters led by Lincoln, and the artists led by [John Root who had just died]; fifth, an invocation to the Columbia of the future . . . her leadership of nations to a modern world of liberty and love.

No classic images were used: Miss Monroe's Columbia was not to be crowned with laurels, but with "dewy flowers/Plucked from wide prairies and from mighty halls."

In early spring of 1892 the Ode was sent to James Ellsworth, who had been asking anxiously after Miss Monroe's health, and at the same time urging his Committee to give the commission for an Ode to John Greenleaf Whittier. Mr Ellsworth did not like Miss Monroe's Ode: he suggested she strike out her three and one half lines on John Root. She refused. Throughout the summer the Committee argued and fretted over the Monroe Ode. In September Harriet returned from a holiday with her final draft of the work, and presented it to the Committee along with a bill for a thousand dollars. The Committee was deadlocked and distraught. They decided to pay the thousand dollars and get rid of the poem. They tried to give it to the Lady Managers.

Mrs Starkweather tried to be politic with the Committee on this subject, and reported her discussion to Mrs Palmer. She told the men that Mrs Henrotin believed that

> Miss Monroe will be very indignant at having her Ode set apart for the Board of Lady Managers; that she will wish it to stand by itself as the composition of an individual, and not as the work of a woman. I asked Mr Culp if he fancied that Miss Monroe would have any objections to such disposition, and he answered me that 'she had nothing to say about it, it had been bought and paid for, it was a matter of barter and sale, and that it was their property and

Festival
JUBILATE

Composed for the
Dedication
of the
Woman's Building,
AT THE
World's Columbian Exposition.
Chicago, 1892.
BY
Mrs. H·H·A·BEACH·

Price 60 cts. net.

ARTHUR P. SCHMIDT.
Boston. London.
154 Tremont St. 73 Berners St.
Copyright 1892 by Arthur P.Schmidt.

they could do as they pleased with it.' It has been whispered to me that Mr Ellsworth will prefer to make this disposition of it, and therefore has favored it.

Mrs Palmer responded majestically to the Committee on Ceremonies from her mountain retreat. She did not want the poem either. "We will have nothing to do with the Ode . . . I fancy that will be the least successful portion of the dedication ceremonies, and at any rate, we wish to have nothing to do with it in future, as we have had nothing to do with it in the past. It was not written at our request nor in our behalf, or by any person we selected, or as a recognition of woman's work, and while I presume it will be very good, we do not wish to identify ourselves with it in any way."

This reply effectively lobbed the Ode back to the Committee, who made another desperate attempt to get rid of it by appealing to the Council of Administration, the governing body of the Fair. A hearing was held; the Committee lost. The Ode was cut to ten minutes but it would remain in the program, truncated but unfortunately still recognisable. The Council of Administration also rejected the Committee's twenty-four floats, for which they had spent ninety thousand dollars. This, added to Miss Monroe's thousand, was causing the Committee to go into the Ceremonies in a state of considerable irritation.

Finally, in late September of 1892 the Directors announced the program for the Dedication. The Lady Managers had been given eight minutes for their part in the Ceremonies. Since no one else had more than fifteen minutes, the Directors undoubtedly felt they had dealt fairly with Mrs Palmer. She had wanted fifteen minutes for her musical exercises. Besides, the eight minutes were obviously set apart for a speech, and she would be the only person who should make that speech. She attempted to pass the honor on to Judge George Massey of the Commission, apparently on the theory that his masculine voice would project through the thirty-two acre hall. The Judge refused to speak for the Board. On September 20 Mrs Starkweather informed Mrs Palmer that if the President of the Board of Lady Managers refused to address the audience, the Lady Managers would be stricken from the program. Mrs Palmer was given until the next morning to make up her mind: the programs had to be printed without further delay.

Mary Newbury Adams urged Mrs Palmer on, employing the kind of rhetoric that apparently leapt to the pens of friendly women whenever they addressed their Chief: "Queens and Empresses have ruled Empires, but dear Madame, you must now be Queen of Time . . . You stand for Womankind of the world. Let no one take your place, nor say your word." But, Mrs Palmer protested, "speechmaking right in the midst of all the

Dedication Ball

men . . ."! Nevertheless she accepted. She did not intend that
anyone should take her place, or say her word.

On the evening of October 20 the Dedication Ball was held.
The hall in the Manufactures Building was festooned in red and
yellow, the Spanish colors. Members of the Fair committees wore
sashes of red and yellow diagonally across their white shirt fronts.
At exactly 9:13 the designs "1492" and "1892" were switched on
to shine in electric lights. At that moment the New Marine Band,
directed by John Philip Sousa, began to play the "Coronation
March" from Meyerbeer's *Le Prophet*. All evening the band
played promenade music: twenty-one selections in all, ending
with "The Star Spangled Banner." By 9:30 the dress circle was
filled with people of fashion. The "patronesses" or hostesses
arrived after that: among these were Mrs Palmer, Mrs William
Armour, Mrs George Dunlap, Mrs Marshall Field, Ellen
Henrotin, Mrs W. W. Kimball, Mrs George Pullman, Annie
Chetlain, Mrs George Davis, Mrs Lyman Gage, Mrs Glessner,
Mrs Gresham, Mrs Higinbotham, Mrs Cyrus McCormick, Mrs
A. C. McClurg and Mrs Lambert Tree — the cream of Chicago
society.

Mrs Palmer arrived with Mrs Thomas Bryan, Mrs Palmer in
gold velvet and a diamond tiara. Mary Lockwood of Washington
D. C. was there in white satin covered with hand-painted leaves.
Not all the Ladies were so impressively turned out. Amey Stark-
weather wore grey silk *en traine*, Matilda Carse appeared in grey
faille, and Rebecca Felton of Georgia, reflecting the twin finan-

cial strains of an aged husband and cotton at six cents a pound, was dressed in coarse black poplin trimmed with lace.

At 10:14, just when the band was playing Thiele's march "The Great Republic", the Vice President of the United States arrived, with "a retinue of followers in gorgeous attire." It was a great night for Chicago.

The next morning, October 21, the Dedication Ceremonies took place. New York had pre-empted October 12 for its own celebration, so the Fair authorities put a good face on things by announcing that America was actually discovered on October 21 "by the new calendar." Harriet Monroe had vivid memories of the day:

Dedication Day . . . dawned fair and windless and autumnally warm. We were up betimes, and using our permit to drive through the cleared streets in which only official carriages were allowed to pass. I remember the gala spirit which seemed to be bubbling over in the air above the scoured, immaculate pavements—the joyous faces, the police shining in their new uniforms, the flags flying from houses and tall buildings, and the vivid blue sky above, with a blazing sun gilding the festival. Now and then a company of soldiers on horseback would gallop past our carriage saluting and smiling— troops of some state or foreign nation, proud riders in dress parade; and at the grounds one new young guard after another challenging us, examining our tickets. I remember the sputtering wrath of Theodore Thomas whose passage to me from the distant chorus (to discuss signals for the songs) had been disputed by fledgling boys in uniform armed with a little brief authority. I remember leaving my father, sister, and brother at their section, and trailing my new black-and-white gown up past the wide platform reserved for speakers and distinguished guests, and into my place among the ascending rows of seats provided for the five hundred artists of the Fair. I remember the blaring entrance of Vice President Morton and other celebrities (President Harrison's wife was dying, so he could not come), escorted by Mr Higinbotham and the high officials of the Fair—the band's fanfare, and the faraway white chorus rising with a flutter of handkerchiefs that looked like lilies in the wind. I remember the warm sunshine streaking through the newly glazed roof on the vast audience and kindling to splendor the reds, blues, greens, of the gay costumes of women. Every little while there was applause in the audience, music in the band at one end of the hall, and a flutter of white in the chorus at the other end, as some distinguished person or group entered and was recognized—governors of states, foreign ambassadors in grand array. There was no chance to be bored before, at last, at eleven o'clock, the audience hushed as the program began with Professor Paine's "Columbian March" and a prayer, followed by the Director General's introductory address, and a welcome from Mayor Washburne, granting the freedom of the city to the distinguished visitors from Washington and across the sea.

The "Columbian Ode" came next on the program, and the actress Sarah Cowell LeMoyne, statuesque and beautiful, looked like a queen as she advanced to the front of the platform and recited the lines. Her voice travelled farther than any other on that day unblest with microphones . . .

After the Ode, its author and its reader were given laurel wreaths "from the ladies of Chicago." Then Daniel Burnham, the Chief of Construction, gave officially to Harlow Higinbotham, the President of the Directory, the Fair buildings and presented "the master artists of construction." Mr. Higinbotham, in his turn, gave medals and a speech to the "sons of art," among whom were Alice Rideout, Mary MacMonnies, Enid Yandell, and Harriet Monroe.

Mrs Palmer's speech came next. Miss Monroe, still agog from her own honors, gave her relatively short shrift; she called her "handsome and quietly dignified" and telescoped her remarks into the second half of a sentence: ". . . speaking of the women's part in the Fair, and in the millenial era then on the way." Miss Monroe then has a little fun at the expense of pomposity:

again Mr Higinbotham, accepting the buildings from the builders, and tendering them to the National Commission; President Palmer, of that body, accepting the much-tendered buildings and tendering them in turn to the United States Government; and finally Vice President Morton accepting them and tendering them tenderly, in a duly gracious speech, to Humanity.

The Hallelujah Chorus rolled out grandly from the five thousand voices in the distance. Then there was much oratory from two men famous in their day — Colonel Harry Waterson of Kentucky, mustachioed iron-gray Southerner, delivering his romantic "Dedicatory Oration" in the old-school orotund gesticulatory style; and, after the "Star Spangled Banner" as a musical interlude, Chauncy M. Depew of New York, thin and bald and gaunt, offering with

Dedication Ceremonies Oct 22, 1892 Manufactures Building

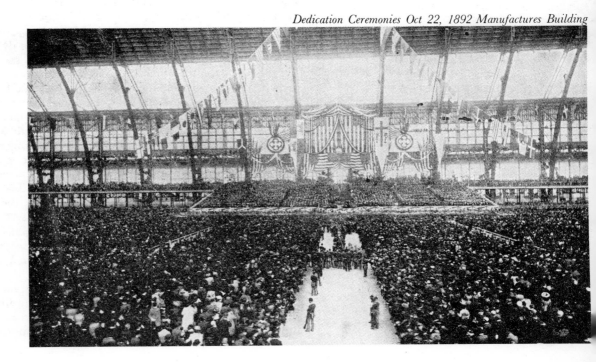

conventional eloquence the "Columbian Oration": both orators
waving their windy words toward a vast, whispering, rustling audi-
ence which could not hear. Then Cardinal Gibbons, dignified arch-
aristocrat, rising all-scarlet for a quiet prayer; and the Beethoven
chorale "In Praise of God" sounding for farewell as the audience
rose to depart.

Harriet went off "with the homebound crowd . . . in the half-
finished grounds, among the scaffolded buildings." She was feel-
ing rather pleased with the day.

> As we walked on, I thought of the command Mr Yerkes had given
> me a year and a half before, to 'write a poem that would live.' Well,
> the triumphal emotion of that day almost made me dream that I had
> obeyed him. At least my ode had a chance of longer life than any
> other word we had listened to; for no speaker had made the day his
> own forever, as Lincoln did at Gettysburg, by shaping the world's
> hope into a few sentences too beautiful to be forgotten.

Oddly enough, it may be Mrs Palmer's words which made the
day hers. They were not particularly beautiful, but they are prob-
ably the most memorable words spoken at the Dedication:

> Even more important than the discovery of Columbus, which we
> are gathered together to celebrate, is the fact that the general gov-
> ernment has just discovered women.

The Columbian Ode seemed a bit feeble for a poem that would
live. Harriet Monroe, confident of immortality, offered five thou-
sand copies of the poem for sale at a quarter each. The response
was less than gratifying: she used the copies for fuel that winter.
She decided that the problem lay in the pamphlet's appearance.
So she arranged for a smaller, more expensive "souvenir" edi-
tion. It was printed on hand-made paper and decorated by Will
Bradley, the Chicago artist whose magazine *The Chap Book* is
credited with bringing *art nouveau* design to the United States.
Permission was given for this edition to be sold in the Fair's
photograph booths. Once again Harriet found no takers. She
writes, "It was suggested that I set up a booth in the Woman's
Building, but that would have required a salaried saleswom-
an . . ." Whoever suggested this could hardly have known
about Mrs Palmer's frosty attitude toward the Ode, and possibly
toward its creator as well. In any case Harriet Monroe, who could
hardly be accused of lack of persistence, finally gave up. She was
forced to conclude that "evidently the public for poetry had
oozed away since the happy day when Longfellow received three
thousand dollars from the New York *Ledger* for 'The Hanging of
the Crane'."
Harriet Monroe's problems, while extremely vexing to her,
were as nothing to the problems facing Mrs Palmer in the

Woman's Building. Cold weather was imminent, and no one knew what to tell plumbers and electricians about where to put what in the interior. Lights, fountains, even interior walls, had to be properly placed, but it was difficult to decide where to place them until decisions had been made about the disposition of tapestries, carved panels, large pieces of furniture and so forth. Mrs Palmer had once used the services of Candace Wheeler, who had worked with Louis Tiffany in his Associated Artists group in New York to design interiors for people like Mark Twain and Chester Arthur, the President of the United States. Mrs Wheeler had left Tiffany, taking with her his department of textiles and embroidery design, which she had initiated, and the name of Associated Artists. In the early 1880's she bought a house at 115 E 23rd Street and produced tapestries, upholstery, wallpaper and rugs, furniture reproductions, and, in short, dealt with all aspects of interior decoration. She was assisted by a group of women, among whom were her daughter Dora, an artist who had studied with the American artist William Chase as well as in Germany and France.

In June of 1892 the New York Board of Lady Managers named Mrs Wheeler Director of their Bureau of Applied Arts. Her assignment was to assemble an exhibit of women's work and at the same time be responsible for the decoration of the Woman's Building Library, which was a special project of the New York Board.

Mrs Palmer, also, had contacted Mrs Wheeler in the summer of 1892, about the possibility of Mrs Wheeler's becoming Color Director of the entire Building to help solve all interior problems. Candace Wheeler was flattered by this offer and agreed at once. It was hardly likely that Mrs Wheeler would refuse Mrs Palmer, whose appearance and manner sent Mrs Wheeler into a frenzy of adulation, of the sort which is found in many of the Ladies' letters and reminiscences:

Candace Wheeler 1893

> Mrs Palmer was a delightful patron, her own enjoyment of art, in any of its forms, amounted to enthusiasm, and her great physical beauty, to a beauty lover, made every visit from her an epoch. I have never seen the face of an adult woman who has had the experience of wifehood and motherhood which retained so perfectly the flawless beauty of childhood. It was a great satisfaction to personally assist in the furnishing of the home of this beautiful aristocrat, whose own law allowed of no infringement by [us], having been shaped in a mind enriched by much classical study and constant acquaintance with the beautiful.

A few lines may well have been sketched onto Mrs Palmer's childlike brow by the results of the Lady Managers' third meeting in October when plans were discussed for the Grand Opening of the Fair in May, 1893, and for the ceremonies that would continue throughout the summer.

The Chicago Lady Managers considered themselves official hostesses. They were filled with anticipation: Columbus' only living descendants, the Duke and Duchess of Veragua, were coming to Chicago. The Ladies began to redecorate their houses and to examine their grounds, with an eye to outdoor receptions in the summer. Conversation clubs were set up, for the practice of French, Spanish and German. At this point some of the Ladies from outside Chicago began to feel restless. Mary Logan, the editor from Washington, D. C., suggested a committee on ceremonies which would handle matters of hospitality, and which would have members from out of state. Her proposal passed, apparently while some people were thinking of something else. Ten women were named; Mrs Logan was Chair. The closeness of these committee members to greatness caused some other Ladies to refer to them, with some bitterness, as "the favored few." One Lady, Emily Briggs of Nebraska, wrote heatedly to the sculptor, Vinnie Ream Hoxie on November 5, 1892:

> The Lady Managers voted what they did not understand — a Committee of 11 [sic] to . . . sit six months, to represent for all, do all the honors, receive foreign guests and get $6 a day. Mrs Logan got up the resolution — thus making her second to Mrs Palmer. The fool women did not understand and it was carried. So eleven have stolen all the thunder. Mrs Palmer tried to stop it by her rulings or delay it until it could be more fully understood but she was in the hands of the Philistines and could not help herself. I was so angry to see the great majority left out that I spoke my mind freely. I told Mrs Lockwood for the part she played she must get out of my life. I do so hate deception and taking advantage of those who have not wisdom to defend themselves. Those ladies who did not understand are not ignorant for as much as I know about parliamentary law I get mistaken. Everything is as mixed up as the House of Representatives.

Emily Briggs

Eight of the "favored few" were Bertha Palmer, Mrs Logan, Mrs William Reed of Maryland, Sara Angell of Michigan, E. G. Oglesby of Illinois, the wife of a former governor, Susan Gale Cooke of Tennessee, Martha Stevens of New York and Katherine Minor of Louisiana. Mrs Minor had introduced a resolution calling for the rotation of membership of committees from month to month during the summer, so that at least half the Board might have the chance to serve, but her resolution was not acted upon. This was unfortunate, because the resolution could have been employed to lighten jealousy and resentment.

Throughout the fall of 1892 Mrs Palmer was using her considerable energies to obtain official sanction for Candace Wheeler's appointment as Superintendant of Interior Works of the Woman's Building. A contract had to be drawn up, with a stipulated salary. And Mrs Wheeler wanted a draughtsman to assist her. On August 9 Mrs Palmer had received a communication from Burnham's assistant telling her that the arrangement

with Mrs Wheeler was "fully endorsed": the office of the Chief of Construction would recommend that she be paid $1200 for the work, and that a salary be requisitioned for her "first lieutenant." Mrs Palmer was urged to have Mrs Wheeler come at once, "as someone should be at the grounds continually until the work on your building is completed."

This seemed concrete enough. Mrs Wheeler planned to come to Chicago around the first of September. When the contract did not appear, she postponed her trip. Mrs Palmer was much harassed by decorating details. On September 6 she sent Mrs Wheeler a plan of the first floor of the Woman's Building with a rough indication of the division of space by countries and a note asking, "How high shall we allow the partition to go to do justice to the exhibitors and not shut off the light? . . . What class of objects should go into the Gallery — only oils etc. or tapestries too?"

Mr Burnham, in response to Mrs Palmer's urgings, suggested that she make definite arrangements with Mrs Wheeler, rather than wait for Frank Millet, the Director of Decoration in Burnham's Department of Works, who normally coordinated decorating functions for the Fair buildings. On September 16, therefore, Mrs Palmer wrote again to Mrs Wheeler, marking her letter "Private":

My dear Mrs Wheeler:
 I am very much annoyed to receive this morning a return letter from the Construction Department, dated Sept. 3rd, and saying that it was the understanding of that Department that I was to make the arrangement with you instead of Mr Millet. As this has not been done in other cases, it is unusual, and I fear not altogether friendly. Mr Burnham has been criticized for the employment of so many different Chiefs with large titles, and I think he wants to throw the responsibility of this upon our Board. We can stand that, however, if we are only fortunate enough to have the arrangement officially made and carried out.
 We need you greatly here at this moment, as there is much that is hanging upon your decision. I am simply wild that you are not to be here the 17th as planned. I therefore write you the proposal which will be put before the Board of Administration. In case you agree to the terms, will you not telegraph me your approval as soon as you receive this; or in case you wish any change made, let me hear by telegraph and letter as quickly as possible.
 Mr Millet seems to think that you and he had considered that $1200. would be a satisfactory compensation. I have no stipulation to add except that you be in Chicago at least one-half of every month, and all your work, of course, would have to be done subject to the approval of our Board. I know that you and I will understand each other and get on beautifully, so that I do not feel it is necessary to make any other conditions . . .

Mrs Wheeler accepted the conditions, with the substitution of

a stay in Chicago for a solid month rather than for two week periods. She wrote on September 20 that she would leave New York on September 24 and remain in Chicago until the scheme of decoration was completed. However, her trip was again postponed. On October 5 Mrs Palmer received a letter from Burnham telling her that the Council of Administration of the Fair had considered the appointment of Mrs Wheeler and rejected it. He suggested that the Ladies arrange for Mrs Wheeler's compensation through Congressional appropriation. Mrs Palmer, obviously embarrassed, wrote to Mrs Wheeler on October 11, in an attempt to allay her anxieties. Reports had appeared in the newspapers that the Council had refused to pay her salary. "It is only a question of which fund it should be taken from," Mrs Palmer wrote soothingly.

On October 27 Mrs Palmer wrote to Harlow Higinbotham, the Chairman of the Council of Administration, and asked for reconsideration of the Wheeler appointment, since the colors for the Dedication Ceremonies had to be chosen at once. The Council of Administration, which had two members from the Directory, (Mr Higinbotham and Charles Schwab) and two members from the Commission (James W. St Clair and Judge Massey) responded that the Director of Works (Burnham) would provide the "stands of colors" for the Dedication Ceremonies.

Around the first of November, Candace Wheeler decided to come to Chicago. She had to decorate the Library of the Women's Building for the New York State Board of Lady Managers, and she had a specific salary commitment for that. On November 7 she wrote Mrs Palmer that she was willing to do whatever she could "without reference to any action of the Bureau [sic] of Administration."

Mrs Wheeler was given an office in the Woman's Building; she stayed at a hotel near the Fair grounds. She had certainly had plenty of time to evolve a general approach to the decoration of the Building. "The general plan," she wrote later, "was an extremely simple one and contemplated only a distribution of soft tints of color which would make a good background for exhibits, and lead from the Main Gallery in gradually deepening tones to the rooms which were to be especially decorated. The Main Gallery . . . was of course the real and important center of the building, and . . . could appropriately absorb the best efforts of the decorator."

She chose ivory for the walls of the Great Hall, with a gold trim, since she believed that interiors should reflect exterior colors, and the building was ivory. The rotunda's seventy-foot arch and the skylight over it were connected visually with the lower chamber by a scrollwork frieze, designed by Mrs Wheeler, which bordered the room above the columns. Just below the frieze were carved panels bearing the "golden names of women who in past

and present centuries have done honor to the human race.''

Mrs Wheeler soon came to appreciate Sophia Hayden's difficulties with gifts from the states. Confronted with one monstrous piece, she appealed to Mrs Palmer: "As you are a woman of infinite resources, I have faith in your being able to tell me what to do about the dreadful table that is offered . . .'' She had also to determine what to do with gifts that were more attractive, and she relied to some extent upon Mrs Palmer for these decisions too: "Do you not think the two copper figures being designed by Miss Ruggles will do for the two thirty-foot standards on the main floor of the gallery — they could stand on high pedestals . . .'' She sorted through the contributions, asking that the Board solicit some which fit her needs, in order to balance those on hand which did not fit any precise need. She sent out a circular to the States listing "Suggestions for Donations for the Woman's Building.'' She asked for

1. Marble seats for the entrance porches and vestibules. Drawings of appropriate styles can be had by application. Tiles and slabs of marble for water closets.
2. Leaded glass windows in simple designs.
3. Good shaped wood chairs and well-shaped tables to correspond, for committee rooms; for reception rooms, elaborate chairs and small sofas and tables.
4. Flags of all nations, in silk or bunting, in four foot lengths, for Assembly Room. These can be made after color designs in printed sheets at bookstores.

The result of her careful labors was the most admired and comfortable interior of the White City.

She did not forget her contract, however. In late November, 1892 she wrote to Mrs Palmer, "I ought not to hold a position of apparent responsibility without anything to warrant it, except your kind opinion of my ability and your wish to have me in charge of the many interests in the Woman's Building. . .'' She did not really want to send color samples to the painter; how could she know they would obey her instructions? "[The work] must be carried out by those with the power to command and not by women who might find it impossible to carry out their plans.'' Nevertheless she wished to reassure Mrs Palmer that she would not desert her. "I do not want you to have the unnecessary strain of contesting a point which is being contested. . . If you agree with me that this is best, I will gladly give you all the help you need in harmonizing the gifts of the states and in fact hold myself at your service whenever you call upon me.''

Mrs Palmer did indeed need her, partly because Mrs Wheeler kept most information in her own head, and did not have the knack of delegating work, or working through committees. In February of 1893 Mrs Palmer wrote to her in New York, "I am

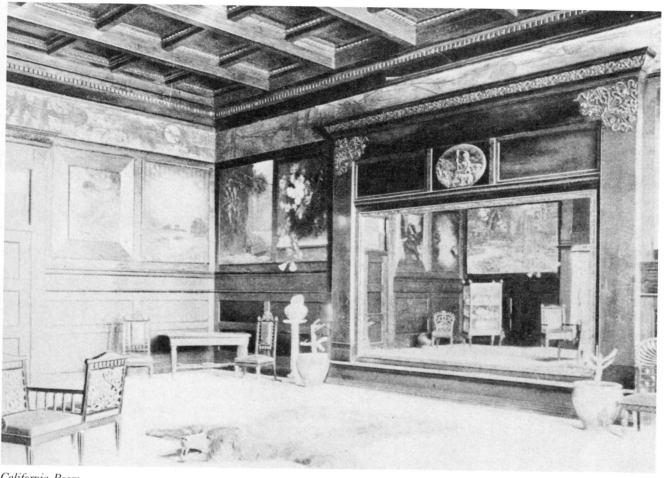

California Room

most anxious to ask you about a thousand and one things and lament you are absent. Pray come at once, we need you badly." And in March Mrs Palmer wrote to Anna Roosevelt of New York, "Mrs Wheeler's continued absences are really quite a distraction to us. For as soon as she leaves we begin to receive letters from all parts of the country asking questions which it is almost impossible for any one here to answer, because there is so little record of her decisions in our office. We either run risk of upsetting all her plans, or anxious visitors. — Can you relieve her in New York — She is now at her sister's bedside."

The six reception rooms on the second floor were designed to represent the important sections of the country: North and South, East and West. Cincinnati decorated its own room, as it had done for the Philadelphia Centennial. So did California. Eunice Wait, an Alternate from California was in fact the first to bring a decorating scheme before the Board. She proposed a cactus theme, since she had been advised by a California architect to ignore the Renaissance aspect of the Fair and follow the Spanish Mission style which was being used for the California Pavilion.

The Board was fascinated by cactus, and approved her scheme. Mrs Wait's artisans studied the Cactus Gardens of the Hotel Del Monte in Monterey for inspiration. In the ensuing California Room of the Woman's Building, cacti were woven into silk curtains, ground into window glass, and burned into leather portieres. The walls, the ceiling beams and the parquet floors were all made of handpolished California redwood. Painted scenes of Lake Tahoe and other attractions were set into the redwood wall panels. There were terra cotta pots of cactus, and a huge bearskin rug. Mrs Wait had been given $2500 by the California legislature; her bills came to $27,500. At the last minute the California women's commission was forced to do some energetic fund-raising to cover expenses.

Bertha Palmer was happy to grant a room to Kentucky: her portrait was to hang among the "bluegrass beauties" on the walls of the Kentucky Parlor. Ida Elmore Sims of Louisville wrote to Sophia Hayden for the exact dimensions of the room. Ten days later, having received no reply, she came to Chicago, measured the room herself, and returned to Louisville to find a decorator through a statewide competition. The winner was Josephine Carter of Versailles, a graduate of the Cincinnati Art Academy, who recreated a colonial interior, strongly influenced by French provincial. An American flavor was supplied by the rare furniture: a chair which had once belonged to Elder Brewster of the

Kentucky Parlor

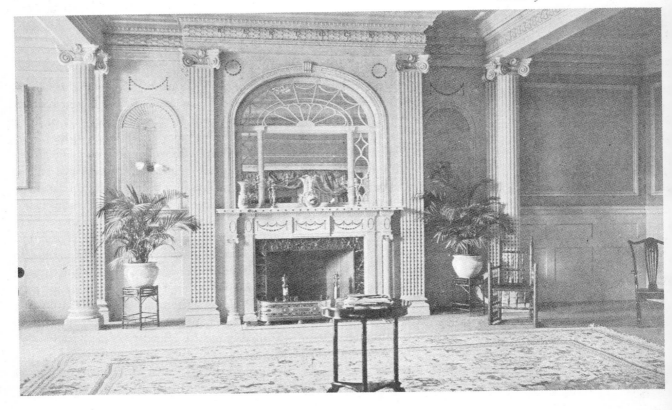

Plymouth Colony, a sofa that had been President Tyler's, the table at which the Missouri state constitution had been drafted. The Kentucky Parlor was not to be roped off, however: the antique piano was to be played at informal gatherings. When Susan Cooke of Tennessee saw the room nearly finished, she was flooded with nostalgia for the Southern mansion with its "orange blossoms, mosses and . . . dreamy quiet."

North Carolina's room was small, and was decorated with mountain flora and by the products of mountain crafts. It was used by women journalists, and came to be called "the Homespun Room."

A Victorian theme was chosen by Elizabeth Sheldon of New Haven for the Connecticut Room. "The unpretending simplicity of the architecture of the building, as well as its temporary character, clearly required simple interior treatment," she wrote, and set about filling the room with plaster gingerbread. She designed, modelled, stencilled and handpainted the plaster mouldings, using a huge tabletop which rested on eight sawhorses. Three hundred pounds of lead were required to paint the frieze, "all of which [she wrote] I mixed, strained, colored and spread myself, because I felt the necessity of its being, so far as possible, the work of a woman's hands as well as of a woman's head." The dimensions of the stencils were a matter of trial and error. Elizabeth Sheldon worked on them at home in Connecticut, nailing them to the rafters of her attic and piecing them together, making "experiments and corrections from the top of a ladder, but in this way I managed to avoid many mistakes, both in design and color. . . ." The walls were a deep apricot, and the frieze had glints of "lighter shades of the same color with the design worked out in the delicate greens of the half-ripe fruit, the dull pinks and reds of the sun-burned cheeks and the various greens and browns of stems and branches."

For their room, the Cincinnati Exposition Committee planned to gather together "the best works in the lines of woodcarving, sculpture, painting, pottery [and to bring them] into harmonious relation by giving them a beautiful setting." The women of Cincinnati had an impressive tradition of leadership in the Arts and Crafts movement. Agnes Pitman, a graduate of the respected Cincinnati Art Academy, was chosen to design the room. In January 1893 Candace Wheeler approved her rose motif. The walls, carpets and upholstery were done in varying shades of rose red and pink; a frieze of rose garlands with a border of buckeye leaves and blossoms circled the room. Miss Pitman was an accomplished woodcarver who had learned the craft from her father. Much of the furniture in the Cincinnati room came from the Pitman house: one table had been shown at the Philadelphia Centennial. Included in the room's exhibits were examples of Cincinnati and Rookwood pottery.

Space assigned in this way to selected states and cities cut into what was available for other states and foreign countries. At the beginning of 1892 the Board doubted that they could gather a sufficient exhibition of women's work. By October of that year they were forced to ask the state boards to screen exhibit materials rigorously, since there was room for only a fraction of what had been offered. The space originally assigned to foreign exhibits was pared away. In September 1892 the French Commissioner wrote to protest: France had been expecting six thousand feet and was being given two thousand. The French had been asked to canvass the country; the response had been gratifying, and it was painful to have to tell the applicants there was no more room.

It was not just the Woman's Building which was beginning to feel crowded; every department in the Exposition was pinched for space. The Board began to receive complaints and desperate pleas for space in the Woman's Building; it began to be obvious that women were being jettisoned from other exhibits. One woman who had patented a self-threading needle was denied space in Machinery Hall because she could not afford a large display. The Board intervened successfully in her behalf. Amey Starkweather said later that the inventor's exhibit was neither attractive nor artistic: "it did not show the evolution of the machine as a whole, nor did it compare favorably with the

Cincinnati Room

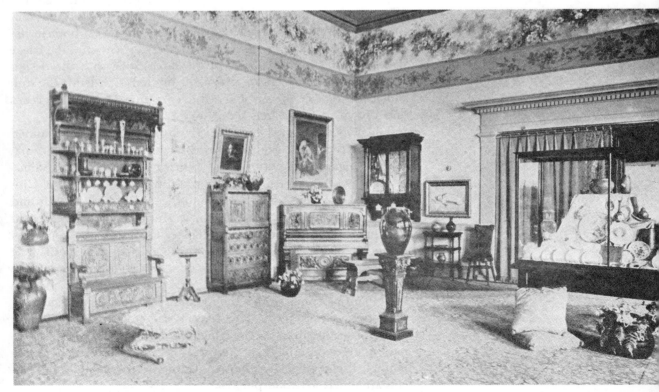

installation of exhibits in other . . . buildings. It did, however, secure for the exhibitor what the Board of Lady Managers hoped to gain for the women of the United States — a market for her invention; an award for merit; ample sales . . ." In short, the benefits of a display at an International Exposition.

In another case, a porcelain painter had been sent fruitlessly from Fine Arts to Manufactures to Liberal Arts: if she could not find a haven in the Woman's Building she feared she would not be able to exhibit at all. There were other cases: too many to be coincidental. In January, 1893, Mrs Palmer received from "friendly hands" certain letters marked "confidential." One of them said bluntly, "It is useless for the ladies to send in any more applications for ladies' work." Mrs Palmer was irritated. She asked for an audience with Commissioner Thomas Palmer, and brought him the proofs of misconduct by the Chief of Installations, and she told him:

> The action of Congress and of the National Commission in prescribing the duties of the Board of Lady Managers meant something, or else it meant nothing. It is impossible to believe that men acting in a responsible capacity . . . would vote money or membership to a body of women of which nothing was expected. If the action means anything it must mean that working women, being weak, financially and commercially, need to have some particular care given to their interest — care that is not likely to be given by the general management of so colossal an enterprise . . .
>
> The Act of Congress provided for an exhibition of the resources of the United States of America, their development, and the progress of civilization in the New World, with a view of illustrating ideas and affording individual opportunity. As the Exposition has been diverted from the original intention, and is now projected rather in the line of commercial advertising it becomes all the more imperative that the Board of Lady Managers should be enabled to perform the service for which it was appointed.

Mrs Palmer wrote to Mary Trautman, "I think it is safe to say that my letter made a great sensation . . . At any rate assignment of space stopped. You who have had so much experience in going before legislators, can appreciate my embarrassment in being obliged to appear personally before the Board of Control to present our case. It certainly took a great deal of courage, and I felt weak after making my speech." The end result, however, was to blur the Lady Managers' careful and crucial distinction between "special" and "separate" exhibits of women's work.

It was too late to find room for the rejected exhibits: except for five thousand square feet in the Manufactures Building, there was nothing left. Director General George Davis granted exhibit status to the Woman's Building: pleasant meeting rooms were thus turned into crowded exhibit halls. The Lady Managers accepted this status so that the Woman's Building could be opened to juried awards as the other exhibit buildings were. Pre-

viously, the Board had held the position that admission to the Woman's Building was in itself an award; now they had to accept displays which did not meet their earlier standards. It was necessary to make distinctions between exhibitors. The Commission delayed granting this request until the eve of the Fair. Possibly they desired, unconsciously, to pay the Lady Managers back for the embarrassment which Mrs Palmer's attack had caused them.

The Lady Managers now felt that they had a stake in the granting of awards: they pressed the Commission to tell them how many of the jurors would be women. The response showed what Mrs Palmer called "a lack of appreciation of the universality of women's work in the world . . . they were perfectly willing for us to name the entire jury that was to award prizes in departments where women's work was to be judged. This was so overwhelming that I modestly insisted that we name only one-half . . . otherwise, though I did not tell them so, we should have had the appointing of all the members of the juries of the Exposition."

The Commissioners, when they thought about it, withdrew their offer. It would have allowed women to pass judgment on thousands of items which were considered outside their realm of knowledge. The Commissioners were afraid that foreigners would be put off if they discovered that women were judging their exhibits. Susan Cooke wrote to Bertha Palmer, "Mr Sewell argued that when foreign exhibitors found out about women judges they would refuse to have their exhibits judged, as they did not entertain the foolish ideas about women that we seem to have adopted."

The Board suggested that the wording of the Springer amendment be applied: women should judge exhibits in proportion to the amount of female labor represented in each exhibit. The Commissioners hesitated. John Thatcher, Chairman of the Committee on Awards said frankly that he wished to remove all women jurors. Most exhibitors had neglected to fill in their applications properly: in four out of five cases it was impossible to tell whether women had worked on an exhibit at all. This situation was unfortunate for the Lady Managers.

They turned to William Springer, their knight in shining armor. He rose to the occasion once more. On March 3 and 4, 1893 he argued on the floor of the House for money for jurors, and especially for women jurors. "We were up all night on Friday and had a hard fight," he wrote. "We did not succeed until after 7 a.m. on Saturday. About 2 a.m. I went over to the Committee Room on Appropriations and the finishing stroke was being put on. I secured the amendment in the proviso and got my Senate compeers to stand firm, and assured them that the House would finally yield." Through an error, no doubt due to lack of sleep, the clerk writing up Springer's proposal, which had been

accepted, allotted the Board $570,000 and the right to name all the jurors. John Woodside, a Commissioner from Philadelphia, found this error amusing. "Poor Mr Thatcher," he said. "I feel sorry for him, for his position on this subject is no more, but he must now become an humble suppliant to the ladies." The error was rectified: the women got $100,000 and fifty-seven judges. Mr Thatcher, a villain to the end, tried churlishly to reduce the number of women judges to thirty-six. The Ladies were forced to appeal to the whole Committee on Awards, which overruled him. This Committee ruled also that half the jurors should be from countries other than the United States; the Board could not control the number of women foreign countries did or did not appoint. This was done as a gesture toward foreign exhibitors, who were irritated about many things, including the small amount of space available for them.

England, for instance, had requested 12,000 feet of space in the Woman's Building and had been allotted 2,000 feet, as had France, which had requested 6000. Representatives of both countries were "wildly indignant." The Director General received a storm of protest. Mrs Palmer dreaded receiving the mail. But nothing could be done. The women felt the Building should reflect American tastes, since it stood in the middle of an American Fair. The Ladies were warned against allowing their sympathies to interfere with their judgment: no matter how many orphans or widows sent in contributions, the work must be judged only on its merits, "without reference to the private sorrows of our producers."

Now that the Building was to contain juried exhibits, space was tighter than ever. A surveyor was brought in to measure every available inch. Rebecca Felton was put in charge of space asignments. She arrived from Georgia in March of 1893 to find "the building and its proposed contents in evident disproportion." She was in the eye of the storm, so to speak, but she was delighted to have been singled out. She appeared to forget her grievances against Mrs Palmer, who, she wrote, smoothed "away serious perplexities that presented stupendous difficulty." She added that only her love for the mission of the Board kept her from flinging up her hands in despair over the "tedious and perplexing work."

Another post needed to be filled now: Chief of Installation. This job required someone with administrative abilities, a flexible nature and nerves of steel. The Chief of Installation had among other things to assign jobs within the Woman's Building, and fend off thousands of starry-eyed women who wanted to help. It paid $125 a month. Mrs Palmer gave the position to Amey Starkweather, "knowing from the assiduous attention that you have previously given . . . that our interest could be placed in no better hands."

Amey Starkweather left the President's comfortable office to work in the Woman's Building which was damp and bone-chillingly cold. She "could demand of [herself] any labor, however disagreeable or uncomfortable" but was "loathe to impose the same on volunteers." Mrs Starkweather's staff were for the most part the Fair porters, hired by the Directors for their muscle rather than their brains. She had to supervise their hauling of carloads of exhibits from one end of the Building to the other. She studied methods used by Chiefs in other Fair buildings for checking-in and placing of exhibits and tried to adopt those which seemed most efficient. Unique to the Woman's Building was the problem of small exhibits without caretakers. Mrs Palmer had promised to provide exhibit cases for those exhibits whose owners could not afford to case them themselves. Her application for funds for this purpose had been before the Commissioners for months; they finally released the money in March of 1893 when manufacturers were backlogged with orders. It was impossible to secure most of these cases in time for the opening of the Fair. Mrs Starkweather thus had to attempt to find cases by any means: she had to beg, borrow or rent them, in addition to welcoming exhibitors, installing displays and keeping records. She cheerfully assumed these tasks, she said, and tried to delegate them so they would be done "by women for women."

Decorators and exhibitors began arriving in March. Elizabeth Sheldon shipped her frieze for the Connecticut Room, still wet and wrapped in oiled paper. She followed it a few days later. She thought she had come early, "hoping to complete the placing of the simple decorations in about three weeks which seemed an ample allowance of time." However when she arrived she found "the roads around the fairgrounds almost impassable for mud, the building so damp and cold as to benumb the most enthusiastic worker, and the rain pouring down in almost continuous torrents. For five weeks I lived in rubber boots, furs, and mackintosh, cold, wet and hungry from morning till night."

The Fair carpenters and small contractors went on strike in early April over a minimum wage and closed shop dispute. The strike lasted only one day; it was not popular to strike the Fair. However, a delay in Fair activities could have been used to fill out the endless forms the Ladies had devised: eleven different entries had to be made for each exhibit, and there was only one clerk to record 80,000 exhibits on tags, permits and varied lists. After all this, the exhibit had still to go on to the overworked Final Expert Committee to be accepted or rejected. Some women from Nevada thought they could avoid waiting because they arrived at the last minute: they found that their space had been given to another state. Their display—china and teacloths—was good enough, along with a personal interview, to get space re-assigned to then. Their lateness was not their fault: Nevada had

Amey Starkweather

suffered for two years with crop failures, mine strikes and cattle deaths, and the legislature had only been able to begin voting money for the Fair in February of 1893.

In March Candace Wheeler's sister fell ill in New York, and she had to go to her bedside, much to Mrs Palmer's discomfiture, as we have seen. "What is being done with our building?" Mary Trautman wrote anxiously. "When I think of the short time before us I get so nervous that I cannot rest." Mrs Wheeler returned to find the rooms filled with angry exhibitors. The Turkish Commissioner took his space assignment to be an affront to the pride of his nation.

> I was told the Turkish commissioner wished to see me. I made haste to wait upon his grandeur in the great exhibition hall . . . The Turkish commissioner himself, tall, portly, and intensely masculine so far as the self-indulgent side of masculinity was concerned, was surrounded by numerous lesser lights — interpreter, secretary, physician, and the various other human attachments which went to emphasize the importance of a Turkish dignitary.
> The matter in hand was the inadequate size of the floor space allotted to the Turkish exhibit. I had to explain through the interpreter that I had not the power to extend the space given to any country.

Connecticut Room

It was carefully based upon the relative amount of exports of purely feminine manufacture of each country, and not upon the amount a country could offer for this particular exhibition. All this was carefully repeated to the glittering commissioner, who thereupon continued his argument without the slightest reference to my statement. His speech set forth the importance of Turkish women in art, their importance and value to the world in general, and their superior claims to consideration in consequence. I listened to all this with great interest, as it gave me an entirely new view of Turkish women, both individually and as a part of the nation. I knew, however, that the exquisite products which were being unpacked in the section could not be certified as absolutely feminine, and I felt strongly in sympathy with the intention of the directors that the exposition should be an exposition and not a mere market-place for the world, as most of the foreign commissioners were inclined to consider it.

The Turks could be dismissed with amusement; English visitors were not so funny. Mrs Wheeler had been confronted on the staircase one day by an English lady who heaped upon her an "amazing load of abuse about the want of space allotted to the English exhibit." The English attitude toward the American women was one of open superiority. Rooms assigned to the States were still desolate, filled with packing boxes and uproar. The English exhibit was complete: the walls were hung with tapestries, and the cases filled with the handiwork of the women of the British Isles. "And we have travelled so far!" exclaimed one of these visitors to the press. "It is most astonishing."

Teresa Cope of British Exhibit

The English were actually unusual in being ready. Toward the end of April, 1893, the Building was the scene of furious activity. The Japanese and Siamese exhibitors had sent their own carpenters who worked diligently creating exotic pavilions. The halls and stairs were filled with half-opened boxes; women hurried about with arms filled with pottery, books and burlap wrappings. Mary Cassatt's mural arrived late and had to be rushed into place in the Grand Hall.

Five days before the building was to open, the State Parlors were finally finished. The Lady Managers began to arrive for the last grand reunion before the official opening. The *Tribune* reported on the event.

Long before the appointed hour the balcony to the assembly room was filled with delegates from every State and Territory . . . A large delegation had braved the storm and waded through mud to be present at the reunion . . . At 10 a.m. the corridors began to resound with merry laughter and the ceaseless tone of many voices as each new arrival entered the south entrance and wended her way up the stairway, dripping with water and splashed with mud. New spring suits with ruffles and folds were in a crestfallen state. The inclement weather, the beauty of the building, and the success of woman's work were topics of interest until lunch when ladies . . . [went] to indulge in coffee, sandwiches and gossip. The hour had passed

before the President took her place on the gaily decorated platform and called the assembled delegates to order. Three raps of the historic ivory gavel were sounded on the historic table which had aroused so much admiration. It is formed of historic woods — cedars of Lebanon, yoke of Liberty Bell, mulberry from the John Harris tree, oak from the ship Constitution, pine from Washington's headquarters at Valley Forge, walnut from Paxtary Curch built in 1740, and walnut from the original door of the State Capitol of Pennsylvania.

Part of Mrs Palmer's speech was reprinted:

We welcome the Board to the Woman's Building, even in its present unfinished condition, and congratulate them on the fact that our purposes have been accomplished so far as was possible within the limits of space, time and means at our command. Our members in every State have been unremitting in their zeal, although unfortunately in some cases they have not had the authority or money to realize their ideas.

On April 29, 1893 the Board gathered with their foreign guests and others to acknowledge officially the gifts to the Building. Their Assembly Room on the second floor was filled with palms, ferns and flowering plants. Behind the platform the afternoon light filtered through three stained glass windows, a gift from Boston, which had been put in place just in time for the reception. The Ladies compared the presentation rites to the ancient Oriental custom of bringing precious gifts to a god or a potentate. There was a turquoise-studded table from New Mexico, a chair made of buffalo horn from Kansas and from Japan a completely furnished room — a little simple, perhaps, for the Ladies' tastes. Candace Wheeler took advantage of the good feeling of the afternoon to announce that the interior of the Building would not be finished for ten days. This news did not dampen anyone's enthusiasm, however: everyone knew that other buildings were not ready either

On this first public occasion in the Woman's Building the audience of 1500 stood and sang Julia Ward Howe's "Battle Hymn of the Republic," which the Directors had refused a place in the May Ceremonies. In the '90's this stirring Abolitionist song had become a tradition at women's meetings, a fact which might explain its lack of appeal for the Directors.

On April 30 the Main Hall was cleared and the displaced exhibits stuffed temporarily into upstairs rooms. Sweepers and scrubbers worked around the carpenters who were building the temporary stage for the opening ceremonies. Plants, flowers and ornaments were used to hide the rough edges of the stage. The last of the packing boxes were cleared from the Halls. The interiors were all but completed: after the Ceremonies there would be some rearranging and straightening up. Candace

Wheeler had still not received a contract for her services, and she never would. On the afternoon of May 10 she was given a check for $1500, signed by Harlow N. Higinbotham, President of the Directory. That was the only formal acknowledgement of her commission as decorator of the Woman's Building.

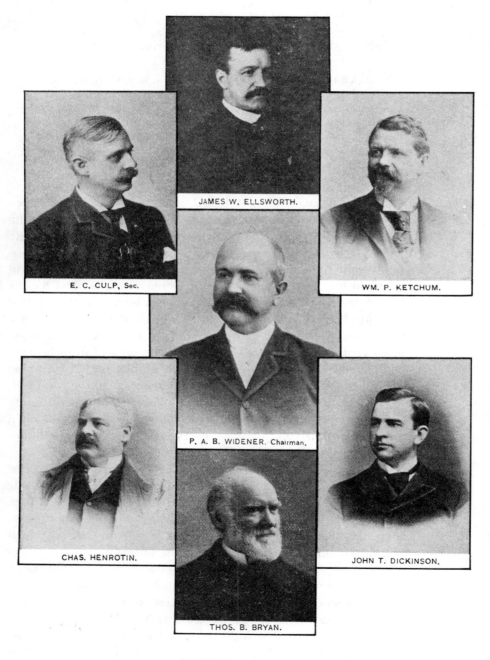

JAMES W. ELLSWORTH.

E. C. CULP, Sec.

WM. P. KETCHUM.

P. A. B. WIDENER. Chairman.

CHAS. HENROTIN.

THOS. B. BRYAN.

JOHN T. DICKINSON.

COMMITTEE ON CEREMONIES.

XI WOMEN IN THE WHITE CITY

O N May 1, 1893 the Columbian Exposition officially opened. The official *History of the World's Fair* described the scene:

As early as nine o'clock two thousand people had crowded before the circular platform on which the Presidential party was to sit. A drizzling rain was falling and the streets were heavy with yellow mud. Wagons piled high with ferns and palms were pushing their way through the crowd. Stretching their long lines diagonally from either end of the great platform troops were drawn up to present arms. By 10 o'clock the Iowa State band of musicians in gay uniform, plodded their way through the mud and disappeared in the direction of the State building. The water had been let into the MacMonnies fountain, and the dolphins and sea horses were afloat once more in their native element. Against the gray, gloomy skies the white palaces stood out in burnished beauty. On every roof, men, looking from the ground like ants, were climbing about, pulling up the thousand flags and banners in readiness for the touch of the President's finger which would give them to the breeze.

With every moment the crowd grew. Looking down upon it 250 feet above the earth, the hats and upturned faces, varied here and there by the bright bonnets of the women, seemed like the constantly changing facets of a kaleidoscope. Over the green waters of the white-walled basin electric launches pushed their way. About them the white-winged gulls soared and circled. Now and then a gaudy gondola shot by. Slowly the platform filled and as the members of the diplomatic corps, in their gaudy costumes, and the army officers, in all the glory of gold and crimson and black, took their places, the scene from above was a brilliant one.

At 10:30 o'clock, as if by providential interference, the clouds suddenly lifted and a golden gleam of sunshine fell upon the pure white beauty of the peristyle. The crowd, by this time numbering 25,000 people, greeted the sun with a cheer. Suddenly from the west forty Indian chiefs, led by Rain-in-the-Face, in all the barbaric splendor of red and yellow, pressed their way through the crowd. Again the expectant and impatient crowd struck up a cheer.

Far down on the projecting platform where the seats of the Presidential party were placed, men were laying Turkish rugs and preparing the last decorations. With the coming of the sunlight the waterproof which had covered the table upon which rested the golden key was removed. Mounted on a pillow of blue and crimson velvet the magical golden emblem rested upon the folds of a flag. Men, pressing closely about the circumference of the platform, saw it as it

glistened and greeted it with a cheer. All about the high columns and the jutting ledges of the east front of the Administration Building, men and women climbed and dangled in dangerous and exposed positions. From the little jets in the basin of the MacMonnies fountain water spouted into the air. The sky began to clear and great sweeps of sapphire stood ravishly out against the prevailing clouds of gray; and on all the buildings, high upon pillar and parapet, human beings swarmed.

. . . on Monday, May 1, 1893, in the presence of nearly a quarter of a million of people, amidst the unfurling of thousands of flags, the sounding of trumpets, the booming of cannon and the vociferations of the vast multitude . . . at precisely 12:08 o'clock President Cleveland stepped forward and pressed his finger on the golden key. The white-coated sailor standing at the main mast before the Presidential box tugged madly at the rope which bound the mighty flag in place. Slowly it fell and the wind swept its silken folds out over the seething mass of people below. They hailed it with wild cheers, and at the sign other flags leaped and blossomed from a thousand masts. At the right the crimson and gold flag of Spain fluttered beneath the gorgeous caravel. At the left the flag of the great Columbus fell from the folds which bound it. Down the long white roof line of Machinery Hall ran a sudden burst of crimson flame. From every tower and parapet fell and fluttered some brilliant ensign. The white palaces were abloom and ablaze with color. Citizens of half a hundred nations looked upward and cheered the flag of their devotion.

At that instant the drapery fell from the golden figure of the "Republic," backed by the classic peristyle, she stood forth in radiant beauty welcoming the world. From the electric fountains jets of water shot a hundred feet into the air, the mist falling on the upturned faces of the cheering crowd. But above their cheers came the deep thunder of the guns fired from the white and gold hull of the Michigan lying in the harbor. Steam whistles filled the air with a shrill din and the deep chiming of far-off bells added to the uproar. President Cleveland bowed and smiled and shook hands with Director-General Davis. The orchestra struck up the strain of the national anthem, and with one voice 10,000 human beings in the throng beside the platform carried the swelling chorus.

Before he touched the key which opened electrical currents to activate the great water pumps in the pumping station and "at least thirty great engines" in Machinery Hall, President Cleveland gave a brief address:

I am here to join my fellow-citizens in the congratulations which befit this occasion. Surrounded by the stupendous results of American enterprise and activity, and in view of the magnificent evidences of American skill and intelligence, we need not fear that these congratulations will be exaggerated. We stand today in the presence of the oldest nations of the world and point to the great achievements we here exhibit, asking no allowance on the score of youth.

The enthusiasm with which we contemplate our work intensifies the warmth of the greeting we extend to those who have come from foreign lands to illustrate with us the growth and progress of human endeavor in the direction of a higher civilization.

We who believe that popular education and the stimulation of the

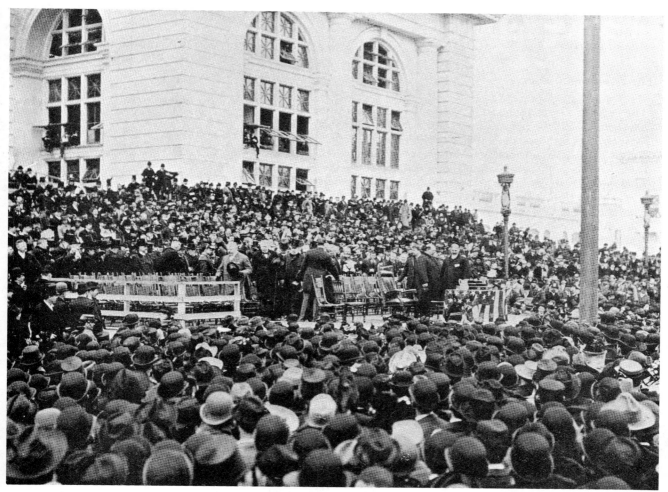

Opening Day May 1 1893

best impulses of our citizens lead the way to a realization of the proud national destiny which our faith promises, gladly welcome the opportunity here afforded us to see the results accomplished by efforts which have been exerted longer than ours in the field of man's improvement, while in appreciative return we exhibit the unparalleled advancement and wonderful accomplishments of a young nation, and present the triumphs of a vigorous, self-reliant and independent people. We have built these splendid edifices, but we have also built the magnificent fabric of a popular government, whose grand proportions are seen throughout the world. We have made and here gathered together objects of use and beauty, the products of American skill and invention. We have also made men who rule themselves.

It is an exalted mission in which we and our guests from other lands are engaged, and we co-operate in the inauguration of an enterprise devoted to human enlightenment; and in the undertaking we here enter upon we exemplify in the noblest sense the brotherhood of nations.

Let us hold fast to the meaning that underlies this ceremony, and let us not lose the impressiveness of this moment. As by a touch the machinery that gives life to this vast Exposition is now set in motion, so

at the same instant let our hopes and aspirations awaken forces which in all time to come shall influence the dignity, and the freedom of mankind.

The *History* continues:

The Duke of Veragua stepped forward and congratulated the Director-General and the people broke into a tremendous shout. Back from the post of honor the guests slowly passed, the thunder of the guns over the lake still coming to their ears. Gondolas and launches, laden with flags, shot and skimmed over the waters like things alive. In a hundred directions the great crowd surged at once. Like a torrent released from a dam which holds it, it beat and broke. On every hand the White City was crowned with flags, running the gamut of color. But above the splendor of imperial banners, the starry folds of "Old Glory" rose and fell . . . Men pressed about the Presidential box and tore pieces of cloth from its sides as mementoes of the occasion. Ladies crushed into the jam were lifted over the rail and hurried to places of safety. The strain was over. The Columbian Exposition had been opened to the world.

The immediate focal point of the White City was the Court of Honor and the Grand Basin, around which were grouped the most imposing buildings of the Fair. The Grand Basin, a lagoon 250 feet wide by 2,500 feet long, contained two monumental

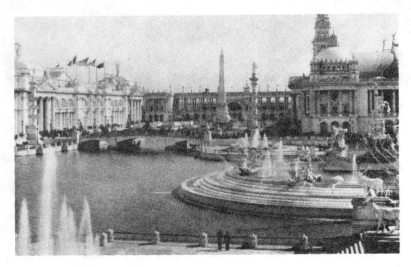

Court of Honor looking south

pieces of sculpture: at the eastern end Daniel C. French's gilded statue of the Republic, sixty-five feet high; at the western end, in front of the Administration Building, Frederick MacMonnies' Columbia Fountain: a barge containing allegorical figures, surrounded by plunging horses, dolphins, water jets, and flanked by two fifty foot columns on which eagles perched. The fountain was wired for illumination. Richard Hunt's Administration Building with its golden dome, Peabody and Stearns' Machinery Hall with tall towers and massive female allegorical statuary; McKim, Mead

and White's Agricultural Building on the gilded dome of which stood Augustus St Gaudens' gigantic figure of Diana; George B Post's Manufactures and Liberal Arts Building, covering thirty acres, the largest building in the world under one continuous roof; Solon Beman's Mines and Mining Building with enormous arched entrances; Van Brunt and Howe's Electricity Hall, with 700 foot long exterior walls composed of continuous Corinthian columns five feet six inches wide and forty-two feet high, with 169 foot spires at each of its four corners — these composed the Court of Honor, an arrangement suggested by Charles Eliot Norton, the art historian.

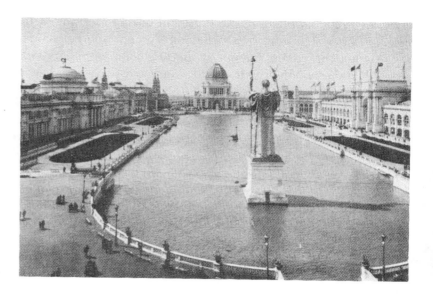

Court of Honor looking west

Terraces, canals, walkways and bridges, ornamented with colonnades, friezes and statues, connected the Court of Honor with the rest of the Fair. In the "northern court," in another ring of buildings, was Louis Sullivan's Transportation Building with its "golden door"; its plain facade and single dramatic entrance had been suggested by Daniel Burnham. Facing the north lagoon with the Sullivan Building were the Woman's Building and William Jenney's Horticulture Building, one thousand feet long, with a crystal dome 187 feet in diameter and 113 feet high; its exterior statuary had been done by Lorado Taft. Close by was Henry Ives Cobb's polygonal Fisheries Building — this and the Transportation Building were exceptions to the prevalent neoclassic architecture. Cobb used only fish and sea motifs for Fisheries ornamentation: in the rotunda of his building was a huge expanse of rock from the crevices of which water spurted onto a mass of semi-aquatic plants directly below it, and from there into a pool, twenty-six feet in diameter, filled with golden fish. Facing south across the north lagoon, and closing the northern court, was Charles Atwood's Palace of Arts with a glass transept and a mas-

sive dome surmounted by a colossal winged figure. This building was temporary like the others, but unlike the others it was fire-proof: its main walls were solid brick, covered with "staff", the roof, floors and galleries were made of iron. Its north front faced a wide lawn which connected the Government Building and state and foreign pavilions to the Fair.

In the galleries of the Manufactures Building a light lunch was served to nearly 70,000 ordinary visitors. In the Administration Building President Cleveland and the distinguished guests dined elegantly, on consomme, soft-shell crabs, julienne potatoes, cucumber, filet mignon, French peas, broiled snipe, celery, tomato salad, and strawberries and cream.

Mrs Palmer sat opposite the President on the east side of the room. On her right was the Duchess of Veragua and her daughter. Among the Ladies present at the luncheon were Mrs Gresham, Katharine Minor, Mrs Reed, Mary Logan, Sarah Angell, Mrs Stevens, Mrs Oglesby, and Susan Cooke. The only wine served at the luncheon was champagne, the press noting that the Ladies' champagne was "a little less dry" than the gentlemen's. Before the cheese and coffee were served, Mrs Palmer whispered to the Duchess that it was time to leave for the Woman's Building. The Ladies rose, causing some confusion. In the heat of the moment Mrs Palmer had forgotten the protocol: the President of the United States had not yet signalled that the luncheon was over, for the very good reason that it was not; and the result was considerable embarrassment.

If Mrs Palmer was ruffled by her gaffe at the luncheon, her reception in the Woman's Building must have soothed her considerably. Five thousand invitations had been issued for the Ladies' ceremonies; one had been hand-delivered by Mary Logan to Frances Folsom Cleveland, the President's wife, who was however too ill to come to Chicago. The official *History* of the Fair commented on the formal opening of the Woman's Building:

That the opening ceremonies of this building should be held in its own main hall was peculiarly appropriate. A long room, whose arches and columns were decorated delicately in white and gold, whose walls were hung with the praiseworthy products of nineteenth century woman artists — this is what met the vision of those who entered for the first time. And this was not all. On the temporary platform erected at the west entrance were palms and potted plants, gracefully grouped, while above it on either side were draped the commingled colors of Spain and America. Palms, too, filled in the spaces between the arches of the north and south ends of the gallery, from which rows of smiling faces looked on at the ceremonies.
At the north end of the Hall of Honor was massed the great World's Fair chorus, which on this occasion interpreted only the music of woman composers. The remaining space, when Mrs Potter Palmer arose to open the exercises, was filled to overflowing with a gathering whose enthusiasm as it caught sight of the gracious President of

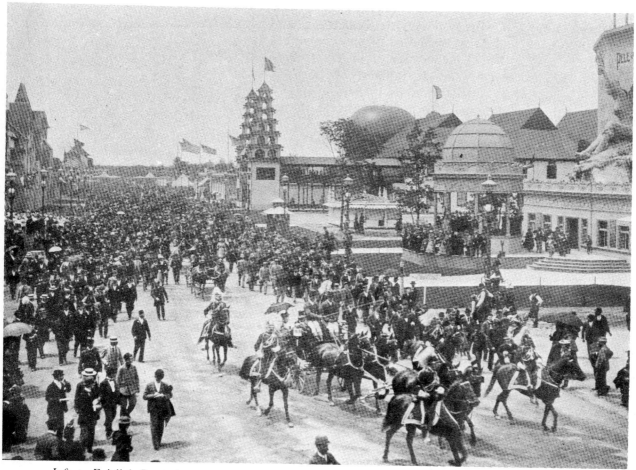

Infanta Eulalia's Procession

the Board of Lady Managers found vent in cheers, applause and a fluttering of white handkerchiefs. When some thoughtful individual well versed in the art of delicate flattery took upon himself the task of removing from the platform the palms and the big bunch of American beauty roses, behind which when she was seated, she was half concealed, the demonstration broke out with renewed vigor.

Mrs Palmer, wearing a dress shot with gold thread and trimmed with jet and ostrich feathers, sat at a table from Pennsylvania, on which were a block made of yew taken from the Washington State Building, a golden nail from Montana, a silver jewel studded box from Colorado. On a small table of New Mexican onyx at her left reposed, in its leather case, the hammer donated by Nebraska with which she was to drive the golden nail into the block of yew. Seated behind Mrs Palmer were a group of distinguished women, both foreign and American. The visitors were the Duchess of Veragua and her daughter, the Hon. Maria del Pilar Colon y Aguielera, Mme Mariotti, Lady Aberdeen, Mrs Bedford Fenwick, Frau Professor von Kasetowsky of Germany, Princess Mary Schahovskoy of Russia, Miss Hulda Leinden of Russia, Sen-

ora d'Oleivria Austen of Brazil, Mrs Dickens, the Duchess of
Sutherland, Lady Wolf, Miss Windeye, Mrs Robert Austen, Lady
Arnot, Miss Arnot and Miss Weiner, all from England, Mme
Meaulle of Austria, Mrs Linchee Suriya of Siam, Baroness
Thornberg Rappe of Sweden and Mrs Romero of Mexico. Ameri-
can guests included Mrs Adlai T. Stevenson, the wife of the Vice-
President of the United States, Mrs John P. Altgeld, the wife of
the Governor of Illinois, and Flora Wilkinson, daughter of W.E.
Wilkinson of the University of Chicago. Candace Wheeler was
there, as Director of Decoration of the Woman's Building. The
Lady Managers present were Mary Logan, Katherine Minor,
Mary Trautman, Mrs Walter Gresham, Sarah Angell and Vir-
ginia Meredith. Chances are great that the same Lady Managers
who were at the luncheon were honored at the opening ceremo-
nies, and that these women were the "favored few" about which
there was already a good deal of grumbling on the Board.

A grand march composed by Frau Ingeborg von Bronsart of
Weimar was played by the orchestra under the baton of Theodore
Thomas; Frau von Bronsart's work had been praised to Mrs Pal-
mer by no less a figure than the German Emperor. Miss Ida Hut-
ton offered the prayer, and the orchestra then launched into a
"dramatic overture" composed by Frances Ellicott "of London,
England." At this point Flora Wilkinson stepped forward and
read her "Ode to Isabella" which had been chosen at another of
the Ladies' competitions. This Ode was considerably shorter than
Harriet Monroe's. A merciful brevity was its only recommenda-
tion:

ONYX TABLE OF NEW MEXICO

> From the lovely land of Alhambra and out from the mists of the
> years,
> Let us summon a presence before us, as spirits are summoned by
> seers.
>
> Behold, a woman is standing, the glitter of gems in her hands,
> With far gazing eyes that are turned toward the river of invisible
> lands.
>
> Behold, royally bending to heed a stranger's appeal,
> With gift of grace and of godspeed, Isabella, the Queen of Castile.
>
> Let us join to man's glory the woman's, the glory of faith and of
> deed,
> That cheered the brave mariner on in the day of his desperate need.
>
> He, sailing and sailing, and sailing into the sunset seas,
> Little dreamed of the land that he sailed to, the sage and sad Gen-
> oese.
>
> She, dreaming and dreaming, and dreaming apart in her palace of
> Spain
> Little dreamed of the future awaiting the land of the Western main.
>
> The future, a plant of God's garden, unfolding in beauty supreme
> To blossom into the splendor of this White City of dream.

Not as Queen but as woman we hail Isabella, and crown her to-day
In these halls that women have built and illumined with costly array.

Here, gravely let us be grateful, as heirs of a generous past,
for the pleasures and powers and duties fallen to woman at last.

They have yielded to her their kingdoms, science, and letters and art,
And still she controls undisputed the realm of the home and the
heart.

On the reception accorded this poem the *History of the World's Fair*
is silent. We are told, however, that "Mrs Palmer's rising for the
purpose of delivering her address was the signal for another out-
burst of applause."

Mrs Palmer's speech on this occasion contrasts interestingly
with that delivered by President Cleveland. She did not indulge in
patriotic self-congratulation but instead chose to discuss problems
from a cosmopolitan point of view. After giving recognition to
"able foreign committees" and "effectively co-operating" state
boards, she ran quickly over the difficulties that had beset the
Board:

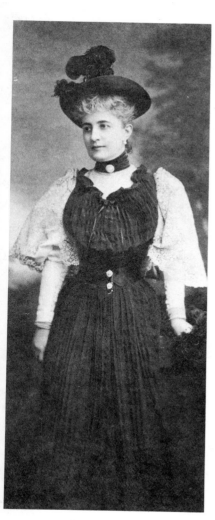

Bertha Palmer

We have traveled together a hitherto untrodden path, have been sub-
jected to tedious delays and overshadowed by dark clouds, which
threatened disaster to our enterprise. We have been obliged to
march with peace offerings in our hands lest hostile motives be as-
cribed to us. Our burdens have been greatly lightened, however, by
the spontaneous sympathy and aid which have reached us from
women in every part of the world, and which have proved and added
incentive and inspiration.

Applause here interrupted her. She then spoke again about the
"unity of human interest, notwithstanding differences of race,
government, language, temperament and external conditions."
She found that "the people of all civilized lands" were studying
the same problems. She did not shrink from mentioning these
problems.

The few forward steps which have been taken during our boasted
nineteenth century — the so-called aid of invention — have pro-
moted the general use of machinery and economic motive powers
with the result of cheapened manufactured articles, but have not af-
forded the relief to the masses which was expected. The struggle for
bread is as fierce as of old. We find everywhere the same picture pre-
sented — overcrowded industrial centers; factories surrounded by
dense populations of operatives; keen competition; many individuals
forced to use such strenuous efforts that vitality is drained in the ef-
fort to maintain life under conditions so uninviting and discouraging
that it scarcely seems worth living. It is a grave reproach toward en-
lightenment that we seem no nearer the solution of many of these
problems than during feudal days.

These were strong words to utter on the occasion of a great

world's fair which had been created to celebrate the victories of industrialism.

She went on to say that it was not the province of the Board to discuss "these weighty problems except in so far as they affect the compensation paid to wage earners, and more especially that paid to women and children." And she did forthrightly discuss the problems of women:

> Of all existing forms of injustice there is none so cruel and inconsistent as is the position in which women are placed with regard to self-maintenance — the calm ignoring of their rights and responsibilities which has gone on for centuries. If the economic conditions are hard for men to meet, subjected as they are to the constant weeding out of the less expert and steady hands, it is evident that women, thrown upon their own resources, have a frightful struggle to endure, especially as they have always to contend against a public sentiment which discountenances their seeking industrial employment as a means of livelihood.

She plunged into the controversial area of woman's "sphere":

> The theory which exists among conservative people that the sphere of woman is her home — that it is unfeminine, even monstrous, for

The Last Nail

> her to wish to take a place beside or compete with men in the various lucrative industries — tells heavily against her, for manufacturers and producers take advantage of it to disparage her work and obtain her services for a nominal price, thus profiting largely by the . . . helplessness of their victim. That so many should cling to respectable occupations while starving . . . and should refuse to yield to discouragement and despair shows a high quality of steadfastness and principle.

At this she was interrupted again by applause, and was applauded once more when she said:

> These are the real heroines of life, whose handiwork we are proud to install in the Exposition, because it has been produced in factories,

workshops and studios under the most adverse conditions and with the most sublime patience and endurance.

She neatly turned the complaints about the destruction of the home through the industrial occupations of women, against the complainers:

> Men of the finest and most chivalric type, who have poetic theories about the sanctity of the home and the refining, elevating influence of woman in it, theories inherited from the days of romance and chivalry, and which we wish might prevail forever — these men have asked many times whether the Board of Lady Managers thinks it well to promote a sentiment which may tend to destroy the home by encouraging occupations for women which take them out of it. We feel, therefore, obliged to state in our opinion every woman who is presiding over a happy home is fulfilling her highest and truest function, and could not be lured from it by temptations offered by factories or studios. Would that the eyes of these idealists could be thoroughly opened that they might see, not the fortunate few of a favored class, with whom they possibly are in daily contact, but the general status of the labor market throughout the world and the relations to it of women. They might be astonished to learn that the conditions under which the vast majority of the 'gentler sex' are living are not so ideal as they assume; that each is not 'dwelling in a home of which she is the queen, with a manly and a loving arm to shield her from the roughest contact with life.' Because of the impossibility of reconciling their theories with the stern facts, they might possibly consent to forgive the offense of widows with dependent children and of wives of drunkards and criminals who so far forget the high standard established for them as to attempt to earn for themselves daily bread, lacking which they must perish.

"Great Applause" greeted this part of the speech. "They must work," Mrs Palmer said, "or they must starve." Women everywhere "in large numbers" were, she said, doing industrial work of the "lowest and most degrading" kind; they were "underpaid drudges" whose labor gave "great profit" to manufacturers and producers. It was time to turn from "the realm of fancy" to "existing facts."

> The absence of a just and general appreciation of the truth concerning the . . . status of women has caused us to call special attention to it and to . . . [attempt] to create, by means of the Exposition, a well-defined public sentiment in regard to their rights and duties, and the propriety of their becoming not only self-supporting, but able to assist in maintaining their families when necessary.

Once more she was applauded. She expressed the hope that the statistics which had been collected for the Board of Lady Managers might give an idea not only of those women who had no "natural protectors" but of those wives who were "forced to work shoulder to shoulder with their husbands in order to maintain the

family." There were two classes who wished to keep women from "actual participation in the business of the world"; these were, first, the idealists already mentioned who wished women to be "tenderly guarded and cherished within the sacred precincts of the home", and, second, the "political economists", including

THE ROLLING CHAIR.

> most of the men engaged in the profitable pursuit of the industries of the world, who object to the competition that would result from the participation of women, because they claim that it would reduce the general scale of wages paid and lessen the earning power of men, who require their present income to maintain their families. Plausible as these theories are we cannot accept them without pausing to inquire what then would become of all women but the very few who have independent fortunes or are the happy wives of men able and willing to support them? The interests of probably three-fourths of the women in the world would be sacrificed. Are they to be allowed to starve, or to rush to self-destruction? If not permitted to work, what course is open to them?
> Our oriental neighbors have seen the logic of the situation far more clearly than we, and have been consistent enough to meet it without shrinking from heroic measures when necessary. The question is happily solved in some countries by the practice of polygamy, which allows every man to maintain as many wives as his means permits. In others etiquette requires that a newly made widow be burned on the funeral pyre with her husband's body while the Chinese take the precaution to drown surplus female children.

These shocking statements were met with "murmurs of indignation." Mrs Palmer took advantage of her hearers' vulnerability to build to another wave of inspired but low-keyed oratory:

> It would seem that any of these methods is more logical and less cruel than the system we pursue of permitting the entire female population to live, but making it impossible for those born to poverty to maintain themselves in comfort, because they are hampered by a caste feeling almost as strong as that ruling India, which will not permit them to work on equal terms with men.

Again applause interrupted her. She resumed:

> These unhappy members of an inferior class must be content to live in penury, living on the crumbs that fall from tables spread for those of another and higher caste. This relative position has been exacted on one side, accepted on the other. It has been considered by each an inexorable law.
> We shrink with horror from the unjust treatment of child widows and other unfortunates on the other side of the globe, but our own follies and inconsistencies are too close to our eyes for us to see them in proper perspective.

Sentimentalists, she said, should have applied their theories by now.

They have had ample time and opportunity to provide means by which helpless women could be cherished, protected and removed from the storm and stress of life. Women could have asked nothing better. We have no respect for a theory which touches only the favored few who do not need its protection, and leaves unaided the great mass it has assisted to push into the mire. [Applause] Talk not of it, therefore, until it can be uttered not only in polite drawing-rooms but also in factories and work shops without a blush of shame for its weakness and inefficiency.

But the sentimentalist again exclaims: 'Would you have woman step down from her pedestal in order to enter practical life?' Yes! A thousand times, yes! [Applause] If we can really find, after a careful search, any women mounted upon pedestals, we should willingly ask them to step down — [laughter and applause] in order that they may meet and help to uplift their sisters. Freedom and justice for all are infinitely more to be desired than pedestals for a few.

In the midst of much laughter and applause Mrs Palmer begged leave to state

that personally I am not a believer in the pedestal theory [laughter] never having seen an actual example of it, and that I always suspect the motives of anyone advancing it. It does not represent the natural and fine relation between husband and wife or between friends. They should stand side by side, the fine qualities of each supplementing and assisting those of the other. Men naturally cherish high ideas of womanhood, as women do of manliness and strength. These ideas will dwell with the human race forever without our striving to preserve and protect them.

These admirable sentiments were once more applauded. Mrs Palmer then turned to "look at the question from the economic standpoint" in order to decide

for good and logical reasons that women should be kept out of industrial fields in order that they may leave the harvest for men, whose duty it is to maintain women and children, then by all the laws of justice and equity, these latter should be provided for by their natural protectors, and if deprived of them should become wards of the state and be maintained in honor and comfort. The acceptance of even this doctrine of tardy justice would not, however, I feel sure, be welcomed by the women of today who, having had a taste of independence, will never willingly relinquish it. [Applause.] They have no desire to be helpless and dependent. Having the full use of their faculties they rejoice in exercising them. This is entirely in conformity with the trend of modern thought, which is in the direction of establishing proper respect for human individuality and the right of self-development. Our highest aim now is to train each to find happiness in the full and healthy exercise of the gifts bestowed by a generous nature. Ignorance is too expensive and wasteful to be tolerated. We cannot afford to lose the reserve power of any individual.

"Great applause" was given this ringing affirmation of the

rights of individuals. Mrs Palmer swept on, obviously carrying the audience with her:

> We advocate therefore, the thorough education and training of woman to fit her to meet whatever fate life may bring, not only to prepare her for the factory and workshop, for the professions and arts, but, more important than all else, to prepare her for presiding over the home.

This somewhat anticlimatic statement was greeted with applause.

> It is for this, the highest field of woman's effort, that the broadest training and greatest preparation are required. The illogical, extravagant, whimsical, unthrifty mother and housekeeper belongs to the dark ages. She has no place in our present era of enlightenment. No course of study is too elaborate, no amount of knowledge and culture too abundant to meet the actual requirement of the wife and mother in dealing with the interests committed to her hands.

Mrs Palmer then extended her heartfelt thanks to the foreign ladies who had done so much to help the Board, and to the architect of the Woman's Building — and here she was interrupted by a spontaneous burst of applause from the Lady Managers, their friends, and all the men present. She "smiled pleasantly, and, dropping her manuscript, joined heartily in swelling the applause of the assemblage," and completed her address:

> We honor our architect and the artists who have given not only their hands but their hearts and their genius to its decoration. For it women in every part of the world have been exerting their efforts and talents: for it looms have wrought their most delicate fabrics, the needle has flashed in the hands of maidens under tropical suns, the lace-maker has bent over her cushion weaving her most artful web, the brush and chisel have sought to give form and reality to the visions haunting the brain of the artist — all have wrought with the thought of making our building worthy to serve its great end. We thank all for their successful efforts. The eloquent president of the commission last October dedicated the great exposition buildings to humanity. We now dedicate the woman's building to an elevated womanhood — [Applause.] — knowing that by so doing we shall best serve the cause of humanity.

Princess Schahovskoy

At the conclusion of this interesting address, the Lady Managers rose and gave the President the "Chatauquan salute." The audience then heard from Mrs Kaselowsky of Germany, who described her country's exhibit, and the Princess Schahovskoy, the Commissioner from Russia, who expressed in broken English the desire of Russian women to "stretch and clasp hands with their American sisters." The Princess had neither the time nor the ability to describe the things being done by Russian women, but she had to mention some of them:

The high class education having been open to them since 1872, more than 700 women doctors are doing a lovely mission all through the country, and when you know that 15,000,000 Mohammedans form part of our population, so that 7,500,000 women are entirely dependent on their own sex for medical help, not being allowed to see men, you will understand what a boon a woman doctor is in our country.

The response to Princess Schahovskoy was enthusiastic. Mary Trautman then approached the President, addressing her as the "queen of fame" and presented her with a silver laurel wreath. "This is our crowning day of glory," Mrs Trautman said. "When we grow old may we look back to the occasion with a pride that will never diminish." Mrs Palmer and Mrs Trautman then clasped hands and faced the audience, all the members of which stood on their chairs in an impressive silence.

Finally, Mrs Rickards of Montana presented Mrs Palmer with the golden nail, which she was to drive in a symbolic block of wood with a silver hammer.

Everybody knew without being told that the block was going to receive the nail if Mrs Palmer succeeded in hitting it on the head every time. As she placed the point of the nail on the block, Mrs Palmer paused to look triumphantly at the audience. She raised the hammer aloft, and with a smile let it fall on the yellow head of the nail. It sank to a suspicious depth in the block at the first blow. Then, while the lady managers waved their handkerchiefs, and everybody else applauded after her own fashion, Mrs Palmer dealt blow after blow until the nail had been driven its full length.

A hole the size of a ten penny nail had been driven in advance into the wood. After this the audience joined in singing "America" and a benediction was pronounced. At this point the orchestra launched into Mrs Beach's "Jubilate" to a mixed chorus. Mrs Palmer was presented with "a flag of American silk . . . carried at the head of the procession to Jackson Park during the ceremonies of October, 1892"; a piece of fringe was cut from the flag and presented to the President, who was then presented with the scissors which had cut the fringe by Mrs Solomon Thatcher:

Madame President, I have the honor to present to you the silver scissors with which the souvenir was cut from the woman's flag. These scissors, though of beautiful workmanship and purest silver, are most celebrated for their magical qualities. They came from the far east, from the land of the astrologer and the necromancer. It is said that the happy possessor of this talisman need never fear entanglement.

The Woman's Building was now officially open. Its roof garden, reached by elevator, gave an excellent view of the Fairgrounds. Directly west of the Building was the Midway Plaisance,

between 59th and 60th Streets: it had been turned into an international amusement arcade. Frederick Putnam of the Fair's Ethnology Department had wanted the Midway to have educational exhibits; the Directors had other ideas. They had spent ten million dollars before May 1, 1893 and they wanted concessions that would pay. The Midway had beer gardens, camel rides, exotic dancers, the Ice Railway and the Ferris Wheel.

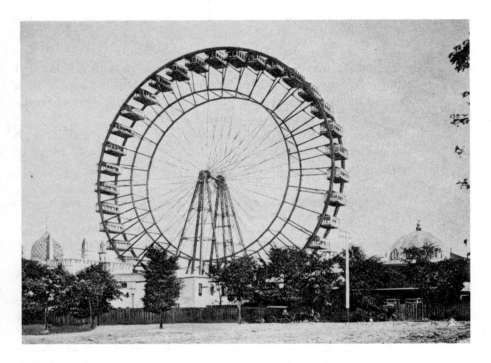

George Washington Gale Ferris was a civil engineer from Pennsylvania. At a meeting in 1892, Daniel Burnham had asked attending engineers to devise something "novel, original, daring and unique" which could be the Exposition's Eiffel Tower. For years Ferris had been planning his gigantic bicycle wheel with seats. It was 250 feet in diameter, 825 feet in circumference, and thirty feet wide. Raised fifteen feet off the ground, each of its cars was designed to hold forty passengers; the wheel could hold 1,440 people. The thirty-six cars were twenty seven feet long and were made of wood and iron, with glass windows and swivel seats. Two 140 foot towers supported the structure, which weighed 1200 tons. The Fairgoer paid fifty cents to enjoy two complete revolutions of the Wheel; on each revolution the mechanism paused six times. One stop was at the highest point of 250 feet, from which the entire Exposition could be seen dramatically. The Administration Building was the architectural focus of the Fair, but the Wheel was unquestionably the symbol which Burnham had sought.

The Woman's Building was one of the twelve major buildings of the Fair; not an afterthought as the Woman's Pavilion had been

at Philadelphia. It was rather close to the Midway. Clara Burn-
ham, in her novel *Sweet Clover: A Romance of the White City*, includes
a description of the contrast between the Midway and the Wom-
an's Building:

> You come out o' that mile-long babel . . . you pass under a bridge—
> and all of a sudden you are in a great beautiful silence. The angels
> on the Woman's Building smile down and bless you, and you know
> that in what seemed like one step you've passed out o' darkness and
> into the light.

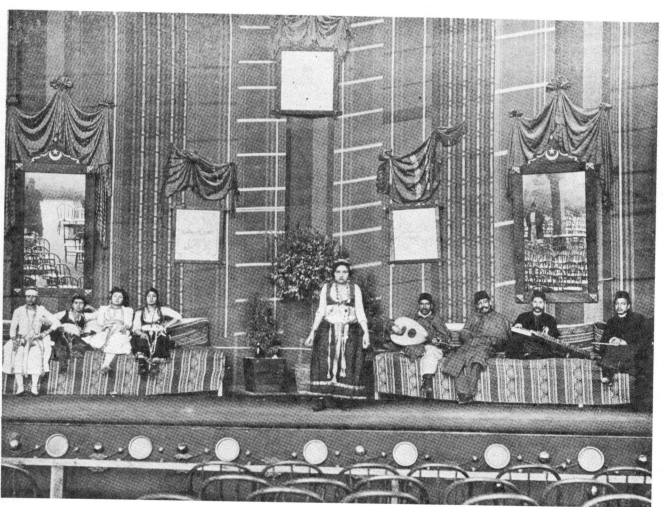

Little Egypt Theatre on the Midway

It was impossible to ignore the goings-on in the Plaisance. Just
west of the Woman's Building in the Little Egypt Theatre were
celebrated belly dancers. One newspaper reported that Mrs Palm-
er liked Little Egypt and took her friends to see the performance
in the evening. Mrs Palmer was furious; she had never entered the
doors of the theatre. She demanded that the Directors close Little
Egypt down. George Davis issued an edict that "interested conces-

sionaires'' must ''restrain all future exhibits within the limits of stage propriety as recognized in this country.'' This somewhat ambiguous statement was aimed more at Mrs Palmer than at Little Egypt; the performance was too popular to be shut down. Ida C. Craddock, an amateur historian, sent Mrs Palmer a four page article which explained the belly dance as a ''religious memorial which inculcates purity and self-control.''

Self-control was needed by the Ladies when they read some of the comments made about their Building. As early as the spring of 1892 Secretary Hovey of the Commission publicly called the Building ''practically a white elephant.'' This was a response to a loaded question posed by a member of the press: ''Has there been any application whatever for space in the Woman's Building?''

Mr Hovey said that he did not know that there was. He went on in fact to dwell upon the point that the building was practically a white elephant on the hands of the managers of the great show. Mr Hovey has come out from Boston, by invitation, to speak to the ladies of the Fortnightly Club. After he had piled up statistics on statistics to show the size of the enterprise, and had told how the buildings were getting on in the way of construction, he struck into a subject that seemed to draw out more force, and that was the question why there should be any woman's building whatever. He went over the ground pretty thoroughly and when he had finished had won his audience, not a few of whom had been prejudiced against his main argument at the outset, completely over to his side. He said the great difficulty seemed to be to find just what was going into the building. Such sculptors as Miss Anne Whitney and Miss Hosmer, artists of the same rank on canvas, other women of the highest order of attainment, had made it known flatly that they would not allow their work to be exhibited in the woman's building. They wanted to have them side by side with the work of men who claimed the same rank. Somebody, Mr Hovey said, had suggested that a large kindergarten exhibit go in the building . . . One of his auditors said that if the fair was to be so immense she had hoped to be able to see all of the woman's work in one place without having to hunt for it throughout the immense distances. To test the matter finally Mr Hovey spoke of the work of Miss [Ellen] Richards . . . in . . . domestic problems . . . The question he asked them to decide by vote was whether this exhibit should go in the large building devoted to liberal arts, or in the woman's building. And the Fortnightly Club, all the members of which are women, voted unanimously that it should be exhibited in the liberal arts building.

Ellen Richards did indeed keep her Rumsford Kitchen out of the Woman's Building. Mrs Palmer was convinced that Mr Hovey had had a hand in that. He returned to the East where he told everyone that people in Chicago were calling the Woman's Building ''a white elephant.'' And the Lady Managers did not forget the perfidy of the Fortnightly Club, of which Mrs Palmer had been a member.

The Board was on the defensive a good deal of the time, ex-

A COCKLE WOMAN.

plaining that their existence was justified not just by the Woman's Building — in which, as it happened, people were most anxious to exhibit. The Lady Managers' interests extended throughout the Fair since women were exhibiting in other buildings in thirty categories from "bread and crackers" to "machinery." A committee

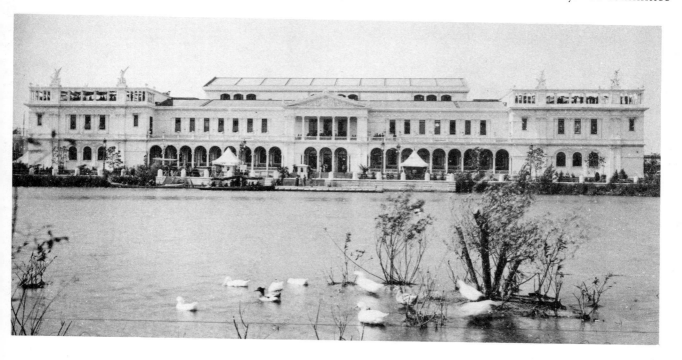

of the Board was in charge of each category; the committees were responsible for procuring and installing exhibits and for gathering relevant statistics. According to the final reports of the committees, 19% of Transportation Building exhibits were women's, 25% of Fisheries, 46% of Horticulture, with a high percentage also in the Fine Arts Palace and the Liberal Arts Building.

Rebecca Felton, who helped to run a Georgia plantation, chaired the Agriculture Committee for the Board. She was disturbed to find that "everywhere [in the Agriculture Building] the work has been credited to men." She did not see how the inevitable misapprehension could be corrected: "The work of women in the farm exhibits is so intermingled and indissolubly joined to that of men, that we might as well seek to number and classify the pebbles on the shore, or the waves on beautiful Lake Michigan." This problem of sorting out the contribution of women existed throughout the exhibits.

Factory managers had been asked to supply information about the participation of female workers in their applications for exhibit space. Only around eighteen hundred out of more than eighteen thousand applications, however, contained this information. From the small amount of information obtained, it emerged that women

were engaged in the production of a considerable number of varied products: mining machinery, toothpicks, carriages, ballot boxes, hammocks and horseshoes, to name a few. The Ladies proposed that they ticket each exhibit in the Fair with whatever facts they had, but Congress was not willing to finance this project, to which manufacturers objected.

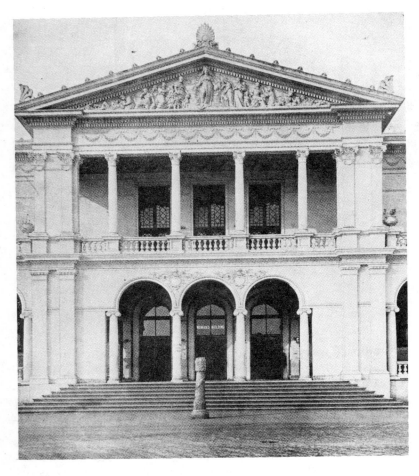

Entrance to Woman's Building

The Woman's Building therefore was necessary as a place to exhibit work done by women, who were not being fairly treated elsewhere. If men worked with women, or even if women did work for male manufacturers, the work was considered to have been done by men. Only in the Woman's Building could this be controlled. When the Board discovered that women's exhibits were being rejected from other Fair buildings, the doors of the Woman's Building had to be opened to juried exhibits. The Building was a haven for those women, most of them foreign, who were frightened to exhibit in a building with men's exhibits. Besides all this, the women needed a place for special exhibits, and for their reports and statistics. The Lady Managers wished to offer interesting subjects to the emancipated woman, and to arouse the ma-

jority of women, who were not emancipated, to an awareness of the achievements of which women were capable.

Kate Field, whose *Kate Field's Washington* was a national weekly newspaper with a circulation of 10,000, believed at first with Mr Hovey that the Woman's Building was unnecessary. Toward the end of the summer of 1893 she revised her opinion: "If all the world were enlightened," she wrote, the Woman's Building would have been a wasteful endeavor, "but the least understood being on earth is woman even to her own self. She needed a revelation and has had it."

Another kind of criticism was aimed at the Building: not criticism of what was in it, but criticism of what it was, as an architectural entity. A possibility existed that some critics might have confused the two. The *American Architect* commented that the Building was neither worse nor better than might have been expected." Its "thinness and poverty of construction" marked it as the work of a novice.

> As a woman's work it 'goes' of course; fortunately it was conceived in the proper vein and does not make a discordant note; it is simply weak and commonplace . . . The roof garden is a hen-coop for petticoated hens, old and young.

This outrageous comment was somewhat mitigated by the chivalrous words of Henry Van Brunt:

> It is eminently proper that the exposition of woman's work should be housed in a building in which a certain delicacy and elegance of

Loggia with Flowers Provided by Lady Managers

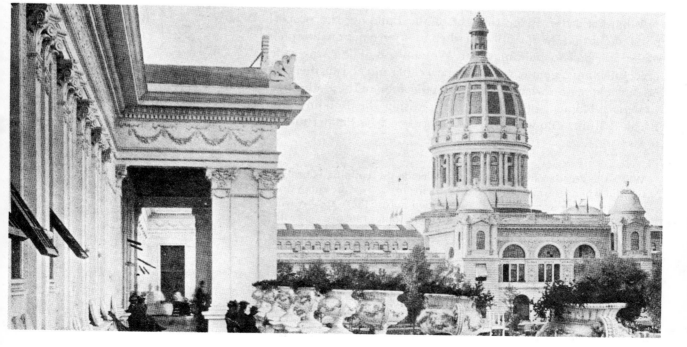

general treatment, a smaller limit of dimension, a finer scale of detail, and a certain quality of sentiment, which might be designated in no derogatory sense as graceful timidity or gentleness, combined, however, with evident technical knowledge, at once differentiate it from its colossal neighbors, and reveals the sex of its author.

The Building itself thus took on sexual characteristics. Maud Howe Elliott, the daughter of Julia Ward Howe, defended the Building in those terms in the Woman's Building catalogue:

> Our building is essentially feminine in character; it has the qualities of reserve, delicacy and refinement . . . Nothing is more significant of the difference in women's position in the first and latter half of our century than the fact that none of the eminent writers who have commented on Miss Hayden's work have thought to praise it by saying that it looks like a man's work . . . Today we recognize that the more womanly a woman's work the stronger it is.

Candace Wheeler called the Building "the most peaceably human of all the buildings . . . it is like a man's ideal of woman." *Harper's Bazar* quoted an anonymous architect to the effect that what people praised in the Building, and what made it suitable to its purpose, were actually its faults; he called it "chaste and timid."

Marie Therese Blanc, a French writer visiting the Fair, commented enigmatically that the Building, a "villa of the Italian Renaissance," had been "praised even to hyperbole for its feminine qualities of reserve, delicacy and distinction — wholly moral qualities which may not suffice when it is a question of striking from stone an idea, be it great or small."

COLUMBIAN GUARD.

Whatever Mlle. Blanc thought of the Building, she properly pointed out that the qualities ascribed to it were not qualities normally ascribed to buildings: the Woman's Building was called gracefully timid, gentle, womanly, peaceable and chaste; there was no sensible reason whatever for the application of these adjectives.

Bertha Palmer solicited a letter praising the Building from Richard Hunt, who was happy to oblige her. Mrs Palmer told the press:

> When the great architects themselves decide the building is beautiful and when it is given a medal by their jury . . . we are quite prepared to stand the criticisms of any laymen in case there are any who do not admire it . . . There are two main buildings that are generally considered inferior to the others, but the Woman's Building is not one of the two.

The one building unanimously condemned was the U.S. Government building, in which the Smithsonian curators had been visited by flood. Mrs Van Rensselaer called it "bad in design and bad in treatment"; the blame was laid squarely on government ar-

chitects, who designed ugly pretentious public buildings. The other building Mrs Palmer may have been thinking of was the Illinois building done by W.W. Boyington, a Chicago architect. The size of this building was criticized; Mrs Van Rensselaer said that it cut off the view of the Art Palace and that it had an ugly dome.

Everywhere in the Fair "women's forms divine" appeared: supporting roofs, ornamenting friezes, perching on domes. Alice Rideout's "angels" decorated the four corners of the Buildings' roof garden. The two winged designs were repeated to form eight groups: four faced the lagoon, two faced north and two south. Each group consisted of an heroic figure, twelve feet high, with two smaller figures at her feet, the whole standing on a pedestal. One worker in the Building told Maude Elliott, "I call it the flying building. It seems to lift the weight off my feet when I look at those big angels."

It was impossible for visitors to see these figures clearly from the ground. One group was called "The Three Virtues." The large figure was called "Innocence"; crouched at one side was "Charity", a matron nursing two orphans, and at the other "Sacrifice", a nun placing her jewels upon an apparent altar. One observer said that this group represented "not so much woman's angelic side, as a soaring above the petty trifling things that have for centuries formed the sum and substance of women's lives." Certainly the "Virtues" were not petty; they required a good deal of self-restraint however. The second group was called "Enlightenment"; "The Spirit of Civilization" held her torch of wisdom over a student dressed in cap and gown; a woman wearing a sort of apron slumped in the background dejectedly. To one viewer the student's face appeared to beam "with a determined satisfaction," while the aproned figure looked "downcast," indicating "forlorn hope for the advancement of women . . . to . . . intellectual attainment."

The *San Francisco Chronicle* thought that Alice Rideout could become a figure of national, and even world-wide fame. An art critic was less enthusiastic: he found the figures "reminiscent of ornaments for clocks," but added hastily that he did not know of "any young man of her age who would have done nearly so well." The pediment, he thought, was better than the groups. The pediment was a bas relief sculpture showing woman as painter, poet, musician, philanthropist, worker, teacher and housekeeper. Mary Newbury Adams called it "the poetic key to the building and its use."

The Building, though relatively small, could prove bewildering to people coming to it for the first time. For "timid and unknowing ladies" a service was provided: one could apply at the Special Services desk for one of the twenty-five young students and teachers, many of whom were at least bilingual. For seventy-five cents an hour a wicker "Rolling Chair" could be rented along with an

attendant to push it across the grounds. Guidebooks and cata-
logues were also available.

The visitor entered at the northern door, passed through the
loggia, and found herself in the midst of the American exhibit of
applied arts. Here were the pottery, stained glass and textiles. The
visitor then passed through the corridor and entered the Main
Hall below Mary McMonnies' "Primitive Woman"; directly be-
low it was the inscription, "President, Bertha Palmer 1893." The
Hall of Honor, the Rotunda of the Building, rose seventy-five feet,
and was sixty-seven and one half feet wide and 200 feet long. It
was unbroken by pillars or supports and was filled with paintings,
statuary and handicrafts, among them the valuable laces lent by
the Queen of Italy.

Not lingering, the visitor passed on to the southern pavilion,
walking under Mary Cassatt's "Modern Woman"; below which was
inscribed "Sophia G. Hayden. 1893." Here, according to the cata-

Part of Gallery of Honor, Main Floor

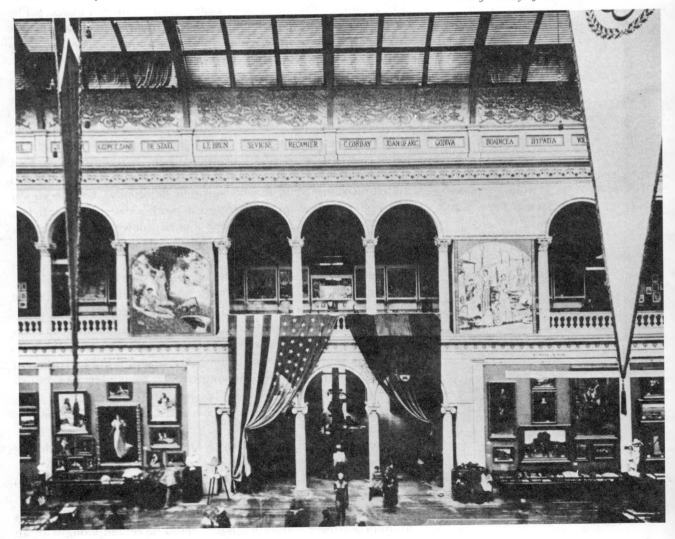

logue, were the foreign exhibits: "Spain . . . before us, India, Germany, Austria, Belgium . . . upon our left; Sweden, Mexico, Italy, France upon the right." Japan's exhibit was farther ahead, with a few smaller countries scattered about. On the west side of the hall was the Science Exhibit. Across from it, on the east side, the Inventions Room stood next to the Indian and African display set up by the Smithsonian curators. Maude Howe Elliott commented that "nowhere in the Exposition can we find so complete a history of the industries of the human race as in the Woman's Building, beginning with women's work in savagery."

An elevator carried the visitor to the second floor where the rooms were ranged along corridors opening through arches over the great Hall or Rotunda. The most important feature of this floor was the Assembly Hall, a large room on the north side of the Building. Its three stained glass windows, lighting the stage, were the work of Massachusetts women, who had donated two of them. Opposite the platform was a stained glass window made and donated by Pennsylvania women. Next to the Assembly Hall was the Model Corn Kitchen. Opening off the west corridor were the "bright cheerful Connecticut Room" and Record Room, connected to the Library. On the other side of the Library was the British Nurses Exhibit.

Rotunda of Woman's Building

The Organization Room, reached through several small rooms housing crafts exhibits, was at the south end of the corridor. South of this was the Board Room, the scene of many emotional meetings, and the offices of the President and staff. Along the east corridor were three sitting rooms: the colonial Kentucky Room, the Cincinnati Room set up as a drawing room for the Lady Managers, and the California Room panelled in redwood. At the end of

this corridor was the Japanese Parlor, filled by the Japanese Com-
missioner with a collection of painted and embroidered screens
and hangings. Every room, and every space on the stairs and the
walls of the corridors was filled with exhibits which could not be
fitted into state or national spaces, and with paintings that had
overflowed the Hall of Honor.

Special activities, which varied from day to day, were posted on
a placard at the main entrance. There were cooking demonstra-
tions, illustrated lectures, teas and receptions. Every morning
crowds tracked mud and dust throughout the chambers; dust
drifted up to the roof. Exhibitors feared that their work would be
ruined. At the end of June Mrs Palmer complained to the Direc-
tors that dirt had "come to be a crying evil." She asked for gravel
to be spread over the front walks to protect the visitors' shoes and
the floors of the Building. This solution was too expensive. The
Directors gave instructions that the floors near the entrances
should be sprinkled with water, and swept often. All morning this
was done, until noon, when the janitors had to stop this monoto-
nous work to clean up after picnickers. At midday every nook,
every bench and railing of the Building was filled with people eat-
ing. They left behind breadcrusts, fruit parings, rinds and chicken
bones. Ducks, introduced into the lagoons for their picturesque
quality, followed trails of crumbs to the Building and dropped
"feathers and other things" upon the walks.

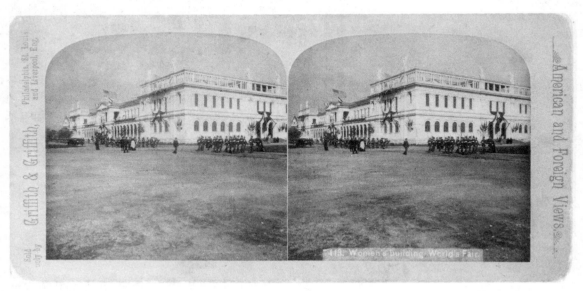

Postcard

To divert the hungry hordes Mrs Palmer made part of the third
story into an East Indian Tea House, where visitors could eat
lunches at small tables and purchase coffee, tea, chocolate and
beaten biscuits. Lines of people waiting to enter the Tea Room
grew; part of the Assembly Room had to be converted to a second
Tea House.

The roof garden, which was originally intended to be a retreat for the Building staff and Lady Managers, was soon discovered by visitors; Amey Starkweather suggested that a restaurant be set up there. E.W. Riley, a graduate of the Boston Cooking School, which Fannie Farmer was to run in 1894, was chosen as manager. Mrs Riley was not asked for rent, but she had to furnish the restaurant herself, which she did, with willow chairs, bright cushions and sturdy tables. Mrs Riley was the chief cook: her menu listed over one hundred reasonably priced dishes, from corned-beef hash to ices especially invented for the Fair. On May 1st, Opening Day, 200 guests dined in the Roof Garden Cafe; by October 2000 people crowded into the room every day. Meals necessarily became hasty and somewhat slipshod. Mrs Palmer would not limit the number who could be served, for fear that business would drop off drastically. The kitchen was too small to hold the refuse which all this cooking generated; barrels stood against the walls of the hall where guests waited to be seated. The janitors had to drag these heavy containers down three flights of stairs, since the elevator was turned off at night because of the power drained by illumination of the grounds. Spills and other unattractive things resulted. Mrs Riley invited the Fair's Grievance Committee to lunch and threatened to build a garbage chute on the roof which would deposit debris on the lawns. Amey Starkweather reported that "directly the . . . chute was built, the elevator began performing its promised duties and did so until the Exposition closed."

The waitresses were forced to abandon their white cuffs, collars and aprons because of the lack of reliable laundry services. Guests were often given paper napkins. On Chicago Day a record number of 4800 diners were served: 102 waitresses passed in and out of the narrow doorway to the kitchen so quickly that meals were served in an average of less than twelve minutes. Despite all the crowding, the Cafe was said to be the best restaurant on the Fairgrounds, as well as the cheapest. It proved to be the most successful financially. Mrs Riley made a profit of $44,000; more than any other similar concession at the Fair.

From the roof garden, which adjoined the Cafe, there was a beautiful view of the Fairgrounds, framed by vine-clad caryatids. A balcony ran the length of the Building; pots of pansies bloomed on the balustrades. Lady Managers from all over the country had provided flowering plants for the roof gardens.

Harper's Bazar said the interior of the Building had "a deft and dainty touch . . . In some way or other it seems homelike." Many of the larger buildings had a rough interior finish. In the Woman's Building, by contrast, there was a careful attention to detail. Candace Wheeler had woven the rooms together with subtle use of color. Although the Board had saved money by keeping down the dimensions of the Building, costs of plumbing, wiring and other things ate up the allotted $200,000 and threatened the

East Loggia of Woman's Building

budget. The Ladies avoided debt by appealing to the states for marbles, tiles, panels, tapestries and draperies. Although the decorators nearly drowned in the tidal wave of donations, the interior of the Building had the sumptuous feeling of an expensive private house of the period.

On the first floor where the main exhibits were, a quarter of the space was devoted to American work; the rest was divided among forty-one foreign exhibitors. Susan Cooke attempted to explain:

Small as was the area allotted to foreign exhibits, it was ample when compared with what was left to be minutely divided between the states and territories, everyone of which was represented in this section with the exception of Oklahoma.

The exhibits of New York spread through the Building; its women outdid almost everyone. The Lady Managers provided the cases for New York's Afro-American Exhibit, which was placed in a small corner room on the second floor along with Siberian furs and designs burnt in wood. The Afro-American Exhibit was a somewhat helter-skelter collection of objects: ecclesiastical embroideries from a New York church, a red silk lamp shade, gold and silver jewelry from West Africa, paintings on canvas, glass, satin and chamois, and a few volumes of verse. Some of the Exhibit was designed to show the accomplishments of black women: Mrs C. Post exhibited her bookbinding skills; Carrie Freeman specimens of "legal typewriting" and Clara S. Brown her photographic retouching. There were also a silver cup awarded by a New York hospital to Catherine Robins, a nurse, in 1852, and a pastry fork invented by Annie Mangin of Woodside, New York: it could be used as both a whipper and a flour mixer and was "the only thing of its kind known at the patent office."

The lady managers passing through the Midway Plaisance with their husbands.

Mrs Palmer had counselled women of the Western states to avoid competition with the East:

It seems to me a mistake for our western sisters to attempt to make a showing in art, embroidery, etc., as they cannot hope to compete with the older sections of the country ... Instead, photographs of scenery could be used very freely and collections of ... minerals or ... native grasses ... would be of interest ...

Most of the Western exhibits did revolve around native minerals and flora. Colorado women cut and polished stones from mines owned by women. The Woman's Board of Trade of Santa Fe, New Mexico, had a table made of petrified wood, silver filigree and turquoise. An Arizona photographer exhibited pictures of the Grand Canyon, which she had taken while suspended above it on ropes, with her camera strapped to her shoulders. There was a notable example of embroidery: an opera cloak made by "Miss Vila Fuller of North Dakota" which consisted of pearl-colored satin covered entirely with prairie chicken feathers. The older sections of the country could not compete with that.

The Southern Ladies sent bales of cotton, and little else, besides the energies of their women. Mrs Palmer attempted to be comforting; she told Helen Brayton of South Carolina, who was most discouraged by the response she received, that "in the Southern states it has been so hard to convince people that women were able to do such work." Bernadette Tobin of Texas founded a Woman's Fair Association which raised funds for the Texas Building. Credit was given the women in an address by a former governor of the state, who said the building was

> the result of the efforts put forth by her daughters and is no credit to the political government at home. It was a triumph by women and showed what kind of persons Texas women are — strong in mind and courageous to a degree that is hard to beat.

Such efforts left little energy for the Woman's Building. The women of Galveston handed a sprig of jasmine to each visitor to the Building in order to publicize their flower farms. Southern women's display of sugar cane stands, peach orchards, orange groves and cotton gins were absorbed into the displays in the Agriculture Building.

Foreign exhibits were not screened in the same way as American exhibits, because it was felt to be impossible "to establish a uniform standard and to hold foreign committees rigidly to it." Oriental embroideries could not, for instance, be judged in the same way as European; nor could educational exhibits from Ceylon or South Africa be judged in competition with those from England or America. The Board wished only that "the actual truth of the situation" should be represented by each foreign exhibit, especially since many of the exhibits "represented the first independent steps ever taken by women in certain countries."

Some of the foreign exhibits had been screened at home; some had been on public display before they were shipped to Chicago. Royal contributions of course were subject to no test. Critics thought the handiwork of the royal families of Russia, Belgium and Spain would better have been left at home. The most prominently displayed of these things were Queen Victoria's watercolors, which aroused much democratic amusement:

QUEEN VICTORIA SENT OVER SOME
THINGS.

It is a fact that the drawing of her majesty's fox terrier, Spot, needs all the labelling it has, while Prince Henry's pup dog, as sketched . . . by the Queen in a railway, would hardly receive a second glance in the sketchbook of an everyday schoolgirl. As to the watercolor "views from the Queen's windows at Balmoral," the ordinary observer feels deeply grateful to the catalogue for telling him which one means 'autumn,' which one is 'snow,' and all the other necessary points. There is encouragement, though, for the would-be admirer in the Queen's tiny watercolor copy from a life size portrait of her munshit Indian secretary, Abd-ul-Karim . . . with the exception that the soft folds of the gentleman's voluminous headdress look like spiral grooves in metal work, one can but admire it.

QUEEN OF ENGLAND'S EXHIBIT

Displayed between flags and surmounted by the British coat of arms was what a critic called "a ridiculous hat of dull green and white braid trimmed, fore and aft, with pink and white feathers." A kinder soul called this effort of the Queen's "a masterpiece of millinery," if one could curl the feathers a little, put an extra kink in the rim and imagine "a piquant face beneath the whole." The Queen sent also two napkins made from flax spun at her own wheel; these were displayed along with a coarse wool jersey knit by Princess Christian. The *Tribune* said, with self-restraint, "It is not, on the whole, an impressive display, that made by royalty, but royalty made it; let that suffice for hypercritical Americans."

Mrs Palmer wrote diplomatically to Princess Christian who had provided much of the handicraft display in the British section, that the true importance of the royal exhibits must be seen as an attempt "to ennoble the humble work undertaken by women in their efforts to make an honest livelihood."

Ireland, Australia and South Africa were included in the British section of the Woman's Building. New South Wales and the Cape of Good Hope had their own women's commissions, headed by Lady Lock and Lady Windermere respectively. Both these women were active in their local suffrage groups and had close ties with prominent women in England. Lady Aberdeen was responsible for the Irish and Scottish displays, since she was the head of the recently formed Scottish and Irish Home Industries Association. Laces and tweeds contrasted with the stuffed platypus, koala bears and kangaroos of Australia. There were many evidences of the taxidermist's art in the Building, but the work of Ada Jane Rohu of Sydney was the most exotic.

There was racial segregation in the Cape of Good Hope: in Chicago the work of white and black women was shown together. The white women sent painted doilies, shellwork and fishscale designs on velvet. The black women, leatherwork, rag dolls and underclothing. South African women had been responsible for the presence of the black women's exhibits; they hung a portrait of Olive Schreiner over their own display cases. This South African woman writer, then living in England, supported human rights as well as women's rights in her novels and non-fiction works.

The French display, called the *Salon de Regence*, did not open until June of 1893. It was an elegant room, designed to recall the *salons* of the eighteenth century which were presided over by intelligent and sophisticated women. Wax mannequins dressed in clothes designed by famous *couturieres* were placed on sofas and chairs; there was a tea table covered with a hand embroidered cloth. The walls were covered with tapestries, paintings and sketches; in Sèvres vases were silk crysanthemums made by the Comtesse de Beaudincourt. On an eighteenth century sideboard stood a bust of Sophia Arnaud, a well known operatic soprano. The bookcase was filled with handsomely bound books written by women. The French Commissioner was able to report that fascinated spectators of this display gave "utterance to the most enthusiastic and admiring exclamations." The French also sent reproductions of antique costumes: thirty gowns were shown which had been painstakingly recreated by a clothing trades union. In its final report the French board asserted that "In general, almost all the countries distinguished themselves in some special way, but France, alone among the nations outside the United States, presented an exhibit embracing all the diverse branches of women's work." The French were thinking, too, of the elaborate statistical display set up by them in the Record Rooms.

FRENCH COAT OF ARMS, GOLD AND VELVET

Algiers exhibited as a French province: chiefly embroidery and the making of couscous, a kind of steamed cereal. Part of this display was late in arriving. On July 18 Mrs Palmer received a letter from Mme Luce Ben-Aben saying that she had given to the French Committee of the Algerian Exhibition

> some works feminine and thoroughly Algerian made by my workers young and old, from twelve years to seventy-five, with express condition and under strict promise that they should be exhibited at the *Lady's Palace* and now I hear that they are at the Algerian Pavilion in the Agricultural Palace! I protest against this behavior of the French Committee . . ."

Mrs Palmer at once intervened, and the exhibit was sent to the Woman's Building.

The Spanish exhibit was put together on short notice. Diplomatic relations did not exist between Spain and the United States. Private letters had to accomplish the work of the Board:

> Immediately Her Majesty had knowledge of the desires of the American ladies, she surrounded herself with the ladies most accustomed to manage affairs of that sort and . . . in a very few days they had gathered what is to be seen in the pavilion of Spain in the Woman's Building.

Despite the diplomatic omissions the Spanish exhibit, under the patronage of the Duchess of Veragua, was a great success. The entrance to the pavilion was a copy of the entrance to the Mosque

of Cordova, with eight medallions added in commemoration of famous Spanish women. The royal house of Spain lent a portrait of Queen Isabella and many fifteenth century items, among them a jewelled sword. The Duchess of Veragua pointed out that queens could be strong leaders in Spain for "the law of the country gives equal rights to rule to men and women." They were ruler's rights, and had nothing to do with ordinary Spanish life. Working women in Spain were limited to rolling cigarettes in government tobacco factories, an ill-paid and unhealthy job. Cigarettes were displayed in the Spanish pavilion, along with the antique trappings of the nobility. There was also a portrait of Man y Palido, the first Spanish woman lawyer and one of Louisa Casagemas, a musician and composer of operas, who was at that time only sixteen years old. One observer was moved by these two portraits to exclaim hopefully that "the world moves, even in Spain."

Near the Spanish pavilion stood the Russian display. Its facade was a reproduction of the gate of a twelfth century Byzantine

Ancient Russian Headgear

church. The great oak door had been carved by women for the
Building; the gold leaf had been applied by a method invented by
the Princess Schahovskoy, who had accompanied the exhibit. She
had encouraged among peasant women the production of embroi-
dered sheepskin boots and light wool shawls with delicate snow-
flake patterns. Royal costumes from the Imperial Russian Mu-
seum cast Princess Shahovskoy's boots and shawls into shadow,
however. Mme N. L. Schabelski, the museum's curator, had
chosen from over 4500 costumes, some of which she had embroi-
dered herself. The dresses were made of splendid brocades and
velvets covered with gold and silver and fringed with pearls and
gold. *Harper's Bazar* called them "a curious mixture of Paris fashion
and barbaric gorgeousness . . . dresses like the sun or like the moon
[described in fairy tales]."

The Germans sent a sober display of educational innovations.
The Froebel kindergarten movement was illustrated by Friedrich
Froebel's educational toys and samples of pupils' handiwork. The
Froebel Institute had mounted a much more elaborate exhibit,
which proved to be too large to fit into the Woman's Building,
and was consequently set up in the Liberal Arts Building. Anna
Schepler-Lette, President of the Berlin Lette Society, brought a
prospectus of the Society's programs of domestic and industrial
education for young women, along with samples of the work it en-
gendered, from darned stockings to samples of typesetting and
architectural models.

Silks from Cyprus, laces from Belgium, painted porcelain from
Holland, embroidery from Portugal and antique hand-hammered
silver from Iceland were displayed in the relatively small remain-
ing foreign aisles. Only three official Asian exhibits were
mounted: Japanese, Ceylonese and Siamese. The Indian, Turkish,
Syrian, Persian and Chinese exhibits were small and had been
privately organized. The Japanese exhibit, in response to strong
hints from the Board of Lady Managers, had been funded by the
Empress and run by her daughter, Princess Yasu Mori.

"There is nothing that the ordinary Japanese man regards with
more horror than the prospect of Western ideas of the equality of
women with men contaminating the womankind of his own
land," *Godey's Magazine* commented in 1893. "He can scarcely
imagine a more terrible catastrophe than that of his wife claiming
equality with himself." A book widely read by Japanese women
was called *Onna Daingaku*, or *The Whole Duty of Women*. The Em-
press' Committee, which met first in May, 1892, in the Palace in
Tokyo, was made up as might be expected of aristocratic ladies:
the exhibit they designed showed two rooms furnished and deco-
rated by forty-four women artisans. The sitting-room had a small
desk, a harp and landscapes in watercolor, objects representing
the female arts of poetry, music and painting. The second room was a
dressing room; laid out upon the dressing table were cosmetics like

Japanese Screens

seaweed hairdressing and black liquid to apply to the teeth. Women's garments hung there too; *Harper's Bazar* commented that "these crepe housedresses are not the heirloom brocades these noble ladies wore at court in more splendid days."

Despite these housedresses, the exhibit was popular because it gave the illusion of access to a secret Oriental female life. The Japanese women published also a book describing their achievements in religion, education and charitable endeavor. Mrs Palmer wrote to Princess Yasu Mori:

> It was a cause of great surprise that the commission from Japan showed such composure amid the strange surroundings, and that they evinced such practical and direct methods of procedure, such complete system and order, together with the power to adopt the means to the ends which they wished to achieve. They seemed less helpless than many of the European nations . . .

Theresa and Marianne were young Ceylonese women in the Ceylonese Tea House; dressed in Indian costumes, with rings in

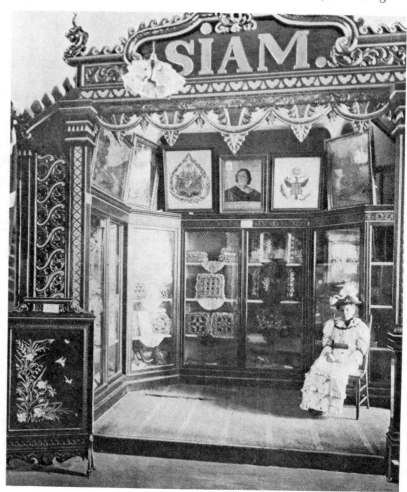

their ears and noses and wearing bangles on their wrists and
ankles, they talked about women's work on the tea plantations as
they handed around cups of steaming tea for five cents apiece.
The Ceylonese had brought their own carpenters and native
woods to Chicago, as had the Siamese, whose pavilion was a re-
production of a Buddhist temple, with golden dragons standing
before it. Inside were cloth of gold and silver, silks and jewels, in-
cluding heirlooms belonging to the Queen of Siam, valued at
$58,000. In addition the Siamese displayed a silk scarf with gold
fringe woven by the Queen herself; and cloths with elephants,
birds, palm trees and pagodas embroidered in silver thread.

If the Oriental women proved to be unexpectedly capable and
clear-headed, those from Mexico and South America were disap-
pointingly inept. Their commissions seemed unable to accomplish
anything. Of the ten commissions, two sent their exhibit so late
that there was no room left for them; they had to be installed in
the Manufactures Building. Four sent nothing. Peru, Colombia,
Chile and Ecuador were represented through the efforts and pri-
vate funds of individual women. Only Cuba, Brazil, Guatemala
and Mexico sent official exhibits sponsored by government
money.

The Board of Lady Managers had wished to avoid competition
between countries by making exhibiting in the Woman's Building
a privilege in itself. They wanted their exhibits to embody ideals of
mutual cooperation rather than competition. Despite the fact that
the Woman's Building became a site of contests for awards, an edu-
cational, idealistic tone was maintained throughout the crowded
rooms. Alice Asbury Abbot, a Chicago writer, commented:

> It is well that art and architecture have done so much for the fair-
> grounds. If it were not for the lovely exteriors and enchanting land-
> scapes, the tremendous force of the materialism expressed by the ex-
> hibits would oppress beyond belief. To the multitude there is but one
> building, and that is the woman's, which stands for an idea.

Everyone did not understand the "idea" for which the Building
stood. Francois Bruwaert, a French Commissioner, said that
where there was rivalry, woman preferred to compete with man,
rather than in "her own domain", a somewhat ambiguous re-
mark. M. Bruwaert took a narrow and somewhat sardonic view of
the contents of the Building: "only a history of the work of women
— the dead have no choice — and collections showing the char-
itable and benevolent work of women in the world." An Indian
visitor wondered why women had separated themselves from men
at the Fair. He decided that, in America men and women were at
war, while in his country, the sexes made up "a mystical whole." In
America, he decided it was natural that women should need to sup-
port themselves to provide for their lonely old age; he imagined that

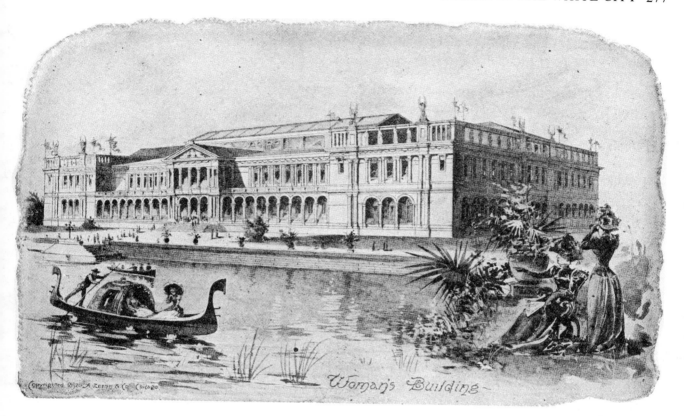

Woman's Building

the Woman's Building and its contents were the products of unmarried women, and as such, most interesting. But they did not prove that women could undertake works "requiring great physical or mental force."

By the end of October, 1893, 27,539,000 people had visited the Columbian Exposition: there are no figures for visitors to the Woman's Building alone, but it was obvious that Mr Hovey's "White Elephant" was a major attraction. The French Commission admitted that for every one person who saw their exhibit in the Manufactures Building, ten people saw the French exhibit in the Woman's Building. Kate Field wrote:

> If popularity be a sign of approval, the Woman's Building outranks all others. I never entered its portals without being oppressed by an overflow of humanity. Every woman who visited the Fair made it the center of her orbit. Here was a structure designed by a woman, decorated by women, managed by women, filled with the work of women. Thousands discovered women were not only doing something, but had been working seriously for many generations . . . Many of the exhibits were admirable, but if others failed to satisfy experts, what of it?

Mrs Stevens of Detroit did not think the Board failed in anything:

. . . so heroic was their exposition, it did not take long to convince one that all work in the Woman's Building should be rated in most cases as being above par with that of man.

Thomas Palmer did not go so far as that; he did say however that the Building represented "woman's declaration of independence; her assertion to do whatever man can do, and do it well."

Finally, the *History of the World's Fair* wrote truer than it knew:

It will be a long time before such an aggregation of woman's work, as may now be seen in the Woman's Building, can be gathered from all parts of the world again.

The honor of your presence is requested at the

Opening Exercises

of the Woman's Building of the

World's Columbian Exposition

in Chicago,

at three o'clock Monday afternoon May First,

Eighteen Hundred and Ninety-Three.

Committee on Ceremonies

Mrs. Potter Palmer. Miss Katharine L. Minor.

Mrs. John A. Logan. Mrs. Martha B. Stevens. Mrs. William Reed.

Mrs. Margaret Blaine Salisbury. Mrs. Richard J. Oglesby.

Mrs. Susan G. Cooke, Secretary.

To Mr. & Mrs. Cotten
Scotland
North Carolina.

HEN the Board of Lady Managers first attempted to define what their role would be, they said in a circular that they would not attempt to hold exhibits for women's work:

> As in some classes of work women are not credited with having arrived at a degree of excellence equal to that of men, a competition among women only would result in the award of premiums to articles which would not necessarily have been successful if entered in a general competition. . . It was thus found that not only would the best of women's work be withheld from a "Woman's Department," but the loss in amount would be equally disastrous. A moment's consideration of the facts shows that a vast proportion of the labor of the world is performed by men and women in conjunction, whose work is consequently indistinguishably blended in the finished product. We could not, if we would, separate the warp from the woof of the fabric over which men and women have toiled side by side. To exhibit what women accomplish alone would result in so meager and unjust a representation of their usefulness as to do them great discredit. The first important decision, therefore, of the Board of Lady Managers, was against having a "Woman's Department" to contain a separate exhibit of the work of women.

At the second session of the Board, the Ladies changed their minds.

> We decided at our first meeting that there should be no separate exhibit of women's work; that was the only decision we arrived at. It has since been thought by many that it would be very uninteresting to have a Woman's Building which contained no exhibit whatever, neither do we wish to have an aggregation of unimportant objects, so that persons going through the grounds would say, "Don't go into the Woman's Building; there is nothing there worth seeing."

> The decision to have a special exhibit in the Woman's Building gives a fine opportunity of emphasizing the most creditable achievements of women. Although we may be able, by some device, to indicate women's work in the main Buildings, still persons going through them may not notice this device; it is therefore proposed, where there is anything of such extreme excellence that we, as a sex, feel proud of it, that we have a duplicate of it, or another piece

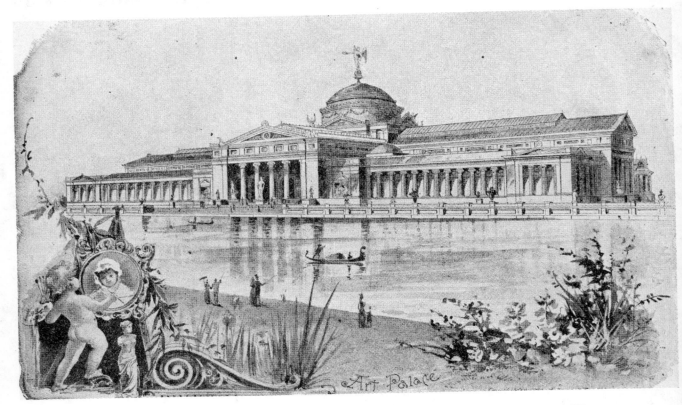

Fine Arts Palace

of work from the same hand in the Woman's Building, in order to
call attention to the fact that it is the work of woman. But we want
to keep this exhibit very choice. We must keep the standard up to
the highest point. No sentimental sympathy for women should
cause us to admit second-rate things into this gallery.

Thus, the die was cast. Mrs Palmer would create a Gallery of
Honor that would at least equal the exhibits in the Fine Arts
Palace. Her first interest was always in the fine arts. Sara Hallo-
well did not encourage Mrs Palmer in this endeavor. On January
5, 1891 she wrote Mrs Palmer, mentioning the opinions of Mrs
Schuyler Van Rensselaer, the distinguished critic, whose special
knowledge of painting centered around the American artists In-
ness, Eakins, Ryder, Whistler and Sargent, and who had studied
contemporary paintings at the Paris Exposition of 1889. Miss
Hallowell told Mrs Palmer that Mrs Van Rensselaer did not ap-
prove of a museum segregated by sex.

. . . with Mrs Van Rensselaer it is "art for art's sake" even without
regard to sex. She would be eager, glad to criticize a woman's work,
but with regard to the work and not *because* it is by a woman . . .
The fact that it *is by a woman must speak for itself*, but must not in-
trude itself, any more than a man's sex should be emphasized in
speaking of his achievements in art. As to myself, I feel that the

woman's building ought to contain a collection of such objects —
worthy of being exhibited — as are not produced by men, or that
were [if *primitive* feminine industries are shown] originally produced
by women, for they were, I believe, the original
potters. In an
exhibition of painting and sculpture by women I cannot believe, be-
cause of the weak result it must inevitably produce. There are too
few fine women artists to warrant their making a *collective* exhibition
worthy to compete with their brothers, as Mrs Hooker would say
and to me such an exhibition would only emphasize their short-
comings. . .

Miss Hallowell attempted to steer Mrs Palmer toward an
exhibition of applied, rather than fine, art. Such an exhibition as
Mrs Wheeler could put together would, she thought, "be a glory
to the sex." An "ethnological exhibition of the primitive femi-
nine industries" would prove that "woman possesses creative
powers." She suggested a Mexican or South American gallery,
one where Indian women's work — "moccasins and ornamented
skins" could be shown, or "Esquimaux women with their
papoose-cases and baskets. . ." Her ideas about what the build-
ing ought to contain were "very superficial" because she knew
little of the subject but she was firm on one point: "No woman
artist of *ability* would I believe be willing to have her work sepa-
rated from the men's."

Miss Hallowell's conviction was strong because she knew how
difficult it was for women artists to be taken seriously. Young
ladies were expected to paint, but they were not expected to be
artists: that word implied technical competence and years of
dedicated study — as well perhaps as an unladylike style of liv-
ing. Men asked sarcastically after the female Michelangelo, ig-
noring the fact that there had not been another male Michel-
angelo. Women had for centuries been forbidden to draw from
the nude; they could not learn human anatomy. By the end of the
nineteenth century the double standard was not so strictly im-
posed as it had been earlier: in 1811, for example, the Pennsylva-
nia Academy of Art set aside a "Ladies Day" when women could
view paintings and sculpture; women's work was exhibited on
that day, men were excluded from entering the galleries, and the
sculptures were draped so that modesty would not be offended.
In 1844 the Academy allowed women to enroll as "irregular" stu-
dents. Finally, in 1868 women students at the Academy were al-
lowed to draw "from the life," as drawing from nude models was
euphemistically called. In 1826 the National Academy of Design
in New York allowed women to enroll in art classes; they were
not allowed to draw from the life until 1871.

America was more advanced in this area than Europe. The
English Royal Academy did not admit women to life-drawing
classes until 1891, and then they could draw only female models.
In 1893 the first male model, his loins covered, exposed himself

— or most of himself — to female eyes. The Ecole des Beaux Arts in Paris allowed women to draw from the nude for the first time in 1890: supposedly two American women entered a class and set to work before the men could recover their wits, and stop them.

Women could always study privately, if they had the financial means and the dedication. Rosa Bonheur, who was born in 1822, had dedication but little money. Both her parents were painters. Her father sent her to the Louvre to copy Old Masters. She solved the problem of finding "life studies" by visiting the butcher, she dissected the legs of dead animals to learn their musculature, and became famous as a painter of animal studies. In 1849 her *Plowing in Nivernais* won a gold medal and was purchased by the French government to hang permanently in the Louvre.

Rosa Bonheur

Rosa Bonheur was an independent woman, strong both physically and emotionally. She often wore men's clothes, openly smoked cigarettes and said that she would never marry: she could not work if she did. She would take no man's name; she had made her own name famous. Indeed, the burdens of a family appeared to exclude most professional activities for women. Society frowned upon "the artist's life" for women. Mary Cassatt lived and worked in France, where the Salon accepted women's painting; even then she preferred to work outside the Salon, with the Independents, or Impressionists. In America, women painters were accepted generally only if their work was "charming" and confined itself to "womanly" areas.

Miss Hallowell knew all this: she was unmarried and had lived abroad and made her own way. She was a realist. Mrs Palmer was clever, resourceful and often insightful, but she had married young and led a comparatively sheltered existence. Her accomplishments for the Board were the more remarkable for the fact that in some areas of life she was an innocent. A letter she wrote to a Lady Manager in Pennsylvania in November, 1892 demonstrates this:

> . . . rather than burden yourself with implied promises to friends . . . in the most discreet and forcible way, find out yourself what things are of supreme excellence in your state and go directly to the most intelligent collectors. A few great names among the contributors . . . will set the key for the whole collection . . . Everything that is inferior will naturally fall away.

She underestimated the force of "inferior" work, and overestimated the willingness of custodians of "great collections" to part with important works. She also overestimated the accomplishment of American women artists, as Miss Hallowell had feared she would.

Part of Mrs Palmer's error may have arisen through her familiarity with those women sculptors who lived for periods of time in

Harriet Hosmer: Puck

Rome: Henry James' "white marmorean flock." As we have seen, Mrs Palmer herself had bought a copy of Harriet Hosmer's "Puck" and tried to obtain the statue of Queen Isabella for the Woman's Building. She must therefore have admired Miss Hosmer's work. Miss Hosmer was the most famous of the women sculptors who did most of their work in Rome, where marble was cheap and skilled labor was available to help finish monumental works. Vinnie Ream Hoxie had been the first American woman sculptor to receive an official commission from the United States Government: her "Lincoln" stands in the Capitol; her "Daniel Farragut" was done for Farragut Square in Washington. The American public accepted the works of these women: Anne Whitney's "Leif Ericson" was placed on Commonwelth Avenue in her native Boston; she was commissioned to do a marble statue of Samuel Adams for the Capitol. Edmonia Lewis, whose father was black and whose mother was an American Indian, had done busts of public figures like Senator Charles Sumner of Massachu-

setts; her "Hiawatha's Wooing" was presented to the Boston YMCA by Charlotte Cushman, the actress, who was a close friend of Harriet Hosmer. Miss Hosmer herself in 1860 was commissioned to do a gigantic statue of Senator Thomas Hart Benton for LaFayette Park in St. Louis.

These women were non-conformists, as might be expected: they were strong feminists and abolitionists. Most of them did not marry. But the work they did was "safe," as its official acceptance indicates. Their figures were allegorical, draped in the neoclassical mode, with perfect, blank faces. They represented heroic qualities, reflecting a national ideal, connecting the American dream with a hazy picture of the grandeur that was Rome. Their work had had its heyday in the 1870's. By the nineties neoclassic art was already dated. Even in America the public taste for heroes had been somewhat dulled by the Civil War and its aftermath.

The number of marbles available from contemporary women sculptors may have led Mrs Palmer to believe that there was a wealth of fine art available to her. The Columbian Exposition itself represented a kind of final outburst of allegorical statuary. The female figure stood everywhere, representing Faith, Virtue, Freedom, the State, and all its Endeavors.

Mrs Palmer may well have been aware of the waning of the neoclassic ideal. She may have attempted to secure Queen Isabella in order to prevent the Isabellas from securing her; or she may have wished to place the statue in the Woman's Building as a symbol of unity between the women's factions. Harriet Hosmer was vocal in her opposition to the concept of the Building, as was the sculptor Anne Whitney, who had returned to Boston in 1876. Both sculptors gave interviews to the press denouncing the Building's sexual segregation. Apart from artistic considerations, the Lady Managers thought that it was important to win over Anne Whitney: it would be a moral victory to show her work in the Building after her denunciations of it had been publicized.

C. Emily Frost, a Lady Manager from Massachusetts, bravely approached Miss Whitney's house at 92 Mt Vernon Street in 1892. Emily Frost wrote to Mary Sears, another Massachusetts Lady Manager, that Miss Whitney was "eminent" and had "a very strong and unique personality." Miss Whitney told Mrs Frost that she did not believe in the Woman's Building; she found its existence hypocritical, since the Board of Lady Managers also "preached co-education." Mrs Frost told Miss Sears that Anne Whitney was "on the skirmish line" but Mrs Frost, who believed in colorful metaphors, "staked every trump card."

Miss Whitney, in response to Mrs Frost's persuasion "became a little more plastic." Mrs Palmer, Mrs Frost was sure, "could woo and win her." She "finally tumbled enough" to entertain the

Edmonia Lewis

Edmonia Lewis: Hagar

possibility of showing her work in the Building; but "her marbles [must] not be in the same room as 'bed quilts, needlework and other rubbish.'" Mrs Frost "did not offer her the whole building" or promise her an entire gallery to herself but "in modesty and in humility, still swinging the censer, I assured her that with Mrs Palmer all things were possible and probable." Mrs Frost had apparently approached the sculptor with the right arguments; as she left, Miss Whitney asked her to come again.

On April 13, Mary Crease Sears, the other Massachusetts Lady, wrote Amey Starkweather that she too had called on Anne Whitney, who had received a letter from Washington requesting that her statue of Leif Ericson be sent to the Exposition. The Commission offered to defray all expenses of delivery and installation. Miss Whitney had apparently "tumbled" most of the way: she was not only willing to display "Leif Ericson" but offered to display two marble busts: one of Lucy Stone and one of Harriet Beecher Stowe, on which she was at present working. She hoped to have them finished by November of 1892.

Miss Whitney questioned Miss Sears closely about the Woman's Building: she was still concerned about being closeted with women's "rubbish." She wanted to be in space set aside for works of sculpture; no "drapery or bedspreads" should be in the same room. The sculpture should have good light, plenty of room and "appropriate surroundings." If all this were to be done, she would consider sending to the Building a fountain cast in bronze. It would pour fresh water, and be most attractive with ornamental plants growing from its base. "The subject is a bunch of lilies supporting a cupid, a lily resting on his head. From the center of the flower comes the water flowing down over the child and flowers. . . ."

In the end Miss Whitney's fountain stood in the center of the Hall of Honor, surrounded by display cases full of needlework. Her bronze statue of Leif Ericson stood close by; ironically, Ellen Henrotin was to complain that the statue was obscured by the fountain.

Vinnie Ream Hoxie wished also to avoid exhibiting in the Woman's Building. She was the only member of the "flock" to give up her career for marriage and a child. She married General Richard Hoxie in 1878 and had a son in 1883. Miss Hosmer had said: "Even if so inclined, an artist has no business to marry." She herself was not so inclined, although she said she waged "an eternal feud with the consolidating knot." The feud was on others' behalf, since Miss Hosmer never came close to being entangled with the knot. She did not care whether male artists married: but for the female artist "on whom matrimonial duties and cares weigh more heavily, it is a moral wrong. . . for she must neglect either her profession or her family, becoming neither a good wife

Anne Whitney: Leif Ericson

and mother nor a good artist."

Mrs Hoxie had been born in Madison, Wisconsin and had lived in Washington, D. C. from the time of the Civil War, when she was twelve years old. Before that, her family had been somewhat nomadic. On the strength of a brief sojourn in Arkansas by the Reams, Mary Eagle of Arkansas wrote in 1892 offering to pay all costs if Vinnie Ream Hoxie would exhibit some work in the Arkansas building. Mrs Hoxie's response was to write an ingratiating letter to Mary Logan, asking to be placed in the Washington D. C. building under Mary Logan's "auspices". There was no District building: only a U. S. Government building, generally considered to be an aesthetic failure. The tone of Mrs Hoxie's letter suggests an insecurity surprising in the first woman to receive a Government commission for an important statue. She assured Mrs Logan that she and her husband "still kept" their "lovely home on the corner of 17th and K" and it was their intention to "settle down there" when they were retired. "The District," she said, was her *"home,"* and she desired "to be identified with the District" as her family, her friends and "all the associations" of her life were there. "Will you be kind enough," she asked, "to let me know in what building our exhibit, that is, the District's exhibits, will be placed?" She also wished to know if there was any provision by "your Board" — meaning of course the Board of Lady Managers — "for paying insurance and freight on exhibits?" On that, would depend the number of works she would send. If she had to pay the freight herself, she would send only two works in marble; she would, however, send "busts in clay of any persons" Mrs. Logan might suggest, "or follow out any other suggestions" Mrs Logan might make. If a free car were offered she would send four smaller marble works and two large photographs of the Lincoln and Farragut statues, given her by the Treasury Department.

Mrs Hoxie's confusion about Mary Logan's "auspices" may have arisen out of Mary Eagle's inviting her to exhibit for Arkansas, when Mary Eagle was actually a Lady Manager. "The Lady Managers from Arkansas," Mrs Hoxie wrote, "have. . . asked me to send some marble works as coming from that State. . ." She therefore believed that each Lady Manager was responsible for the exhibits in the building of her own state or territory, and since Mary Logan was a Lady Manager from Washington, D. C. , and a member of the Board's executive committee, she appeared to assume that Mrs Logan would be responsible also for exhibits in the "Washington, D. C. " building. Her pleading, anxious tone suggests that she had "dwindled into a wife." Nevertheless she obviously did not wish to be associated with the Woman's Building.

Mrs Logan communicated the contents of this letter to Mrs

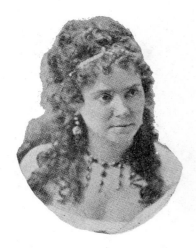

Vinne Ream Hoxie

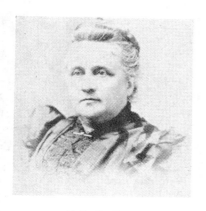

C Emily Frost

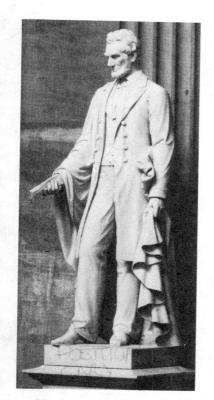

Vinne Ream Hoxie: Lincoln

Palmer, who was offended by it. She responded coldly that Mrs Hoxie was not entitled to exhibit with Washington, D.C., whether there was such an exhibit or not, since she had not lived in the District for years. Why this would not apply also to Arkansas is not clear; what is clear is that Mrs Palmer was angry at Mrs Hoxie, and Mrs Hoxie wished to avoid any involvement with Mrs Palmer and her Building. She applied for permission to exhibit in the Fine Arts Palace, although she may have been aware that Mrs Palmer's long arm could extend to that building through Sara Hallowell, Secretary to the Director of Fine Arts. Emilie Briggs, of Nebraska, who, like Mary Eagle, was a member of the Board's Sculpture Committee, hinted to Mrs Hoxie of a cabal: "I hear there is an 'art ring' that is bound to keep out all that does not fall within their personal influence. . . " Mrs Briggs promised to lay Mrs Hoxie's case before a Senator of her acquaintance. Mrs Hoxie tried to use influence too: she wrote to Director-General George Davis, and to Vice-President Adlai Stevenson, asking for help with the jury of the Arts Palace. Both Mr Davis and Mr Stevenson were encouraging: Mr Stevenson said that he had noted her "art suggestions" and would show her any courtesy that he could.

She submitted her large sculpture entitled "The West" to the Arts Jury. The West, a large woman in neoclassic draperies, wore the "star of empire" on her forehead; behind her were fields of waving corn; she trod on broken hatchets and bows and arrows, triumphant over barbarian tribes. After several months of deliberation, the Department of Fine Arts sent Mrs Hoxie a printed notice, in June 1893, informing her that "The West" had not received "a sufficient number of votes to secure acceptance for exhibition."

Negative feelings toward Mrs Palmer are apparent in a letter written to Mrs Hoxie by Emily Briggs as early as February of 1893. Mrs Palmer, referred to sarcastically as "the incomparable," had apparently visited Washington in her endless search for appropriations. In a tone that can only be described as snide, Mrs Briggs said that Mrs Palmer "wore her adorable diamond crown and other jewels . . . dashed before the bald heads of Congressional committees" and then "went out like a huge meteor." She sent Mrs Briggs "her little card . . . which proved that mite that I am, she did not forget me entirely." Although "Mrs Senator Brice had invited her to dinner" Mrs Palmer had not gotten into "the inner social circle": Mrs Brice herself was "one of the 'new ones'" without fixed social position. "Money alone," Mrs Briggs reported, "will not do it . ." She was delighted to report that the vice-president and the members of the cabinet had "kept aloof" from Mrs Palmer, who had "left all her help behind . . . Mrs Trautman, Mrs George Davis, Mrs Thomas

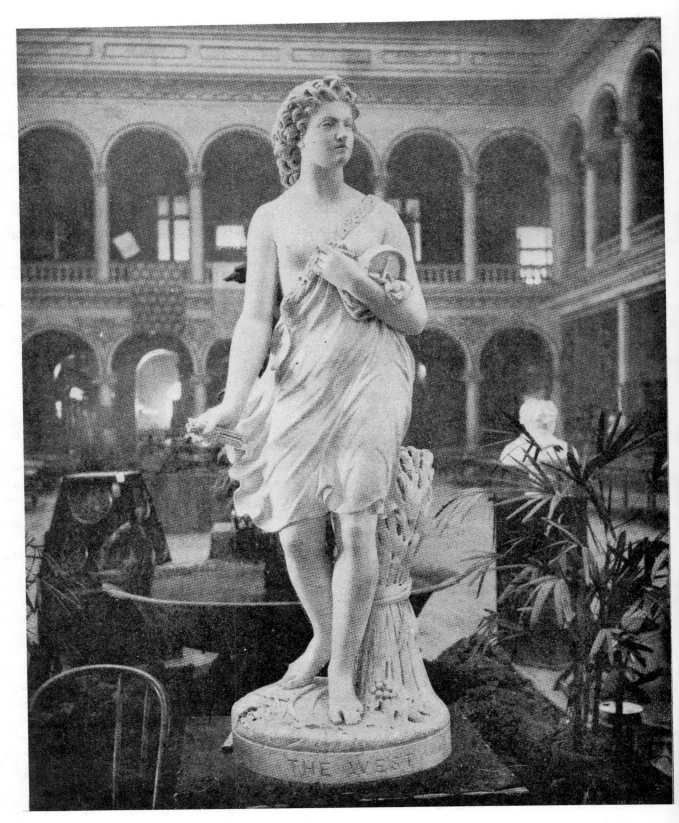

Vinne Ream Hoxie: The West

Palmer and Mrs Dickinson . . ." Mary Lockwood, a "physically very diminutive figure," had entertained Mrs Palmer.

After "The West" was rejected, Mrs Hoxie received a sympathetic note from her friend Crosby Noyes, on June 28, 1893, commenting on George Davis' failure to live up to his promises. "Fortunately your name is established beyond the reach of any of these envious spiteful little curs who have been barking at your heels all these years. . . ."

While Mrs Hoxie was brooding over her wrongs, Mary Eagle leapt into the breach and seized three large marble statues which were temporarily homeless. In addition to "The West" there were "Miriam," which celebrated the crossing of the Red Sea by the Children of Israel, and a mighty rendering of "America." By a strange twist in the comedy, Mrs Eagle deposited these treasures in the Woman's Building. Mrs Hoxie's feelings may be imagined; she had apparently thought they were destined for the Arkansas Building, the only sanctuary left to her. Mrs Eagle was much downcast to read a denunciation of herself in the Arkansas press. Mrs Hoxie announced that she was "very much displeased with Mrs Eagle" for not placing her statuary in the Arkansas Building. Mrs Eagle wrote feebly to Mrs Hoxie, telling her that the statues looked most attractive in the Woman's Building. There is no record of Mrs Hoxie's reply.

Another prominent woman sculptor of the time and member of the "marmorean flock," was Adelaide McFayden Johnson, a strong feminist who sculpted busts of the "Founding Mothers" of the woman's movement. In 1886 she had sculpted a bust of Susan B. Anthony, which was displayed the following year at the annual Woman Suffrage Convention in Washington. Comment on it was favorable, except that most people were disappointed to see Miss Anthony sculpted without her eyeglasses, which seemed to them like part of her face. Miss Johnson herself was not really satisfied with this bust. In that same year of 1887 when she went to Rome to execute busts of Mary Logan and her husband, General John Logan, she took along the Anthony bust, and made a new model of it. When she returned to Washington in 1888, and unpacked the second Anthony bust, she found it shattered beyond repair. The first model had been left behind in Italy.

Still game, Miss Johnson asked Miss Anthony to sit for her again. This third bust, modeled in clay, satisfied everybody. Miss Johnson put it aside for a while, to concentrate on other business. One morning she awakened suddenly at three o'clock to behold a message written on the "cream-tinted" wall of her bedroom: it instructed her to finish the Anthony bust at once, "within the first quarter of her seventy-second year." Having seen the handwriting on the wall, Miss Johnson buckled down to work again, as soon as Miss Anthony had arisen and had breakfast. More sit-

tings were given, and the bust was completed to everyone's satis-
faction.

In 1892 Miss Anthony was to be in Chicago for a meeting of
the National Federation of Women's Clubs. Because of this,
Frances Willard conceived the idea that Loredo Taft should do a
head of Miss Anthony for the Woman's Building. "Come and
spend a week with me in my home," Miss Willard wrote to Susan
Anthony, "while he prepares a model of that statesmanlike head,
the greatest of them all." Miss Anthony agreed to sit to Loredo
Taft. When word of this got out, some feminists were horrified.
Miss Johnson herself later wrote: "I could not stand to think that
when Miss Anthony had worked for forty years for women, her
bust would be made by a man."

Miss Anthony was seized by doubt because of the outcry. Miss
Willard urged her on:

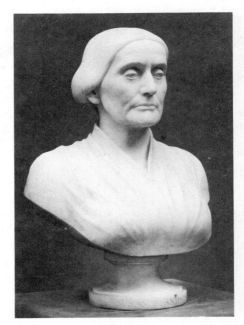

Adelaide Johnson: Bust of Susan B. Anthony

Mr Taft is the most progressive believer in woman and admirer of
you, dear Susan, that I know. He is in full sympathy with all of our
ideas. I am sure that as a friend of mine, appreciated by me as high-
ly as you are by any woman living, you will not place me in the posi-
tion of declining to have this work done. Please do not take counsel
of women who are so prejudiced that, as I once heard said, they
would not allow a male grasshopper to chirp on their lawn; but out
of your own great heart, refuse to set an example to such folly.

Loredo Taft also wrote to Miss Anthony:

I can put myself in your place sufficiently to appreciate in part the
objections which you or your friends may feel toward having the
work done by a man. My only regret is that I am not to be allowed
to pay this tribute to one whom I was early taught to honor and re-
vere . . . Come to think of it, I believe I am provoked after all. Sex
is but an accident, and it seems to me that it has no more to do with
art than has the artist's complexion or the political party he votes
with.

Miss Williard energetically offered a compromise:

Do you not see, my friend and comrade, that having engaged a
noble and large-minded young man, who believes as we do, to make
that bust, engaged him in good faith and announced it to the pub-
lic, it is a 'little rough on me,' as the boys say, for my dear sister to
wish me to break my contract? We can not have too many busts of
you, so let Miss Johnson go on and make hers, and let me have
mine, and let those other women make theirs, and we will yet have
one of them in the House of Representatives at Washington. The
other in the Senate, the third in the White House!

Dr. Caroline Winslow

A compromise was reached. Miss Anthony agreed to sit for
both sculptors. She sat for Loredo Taft during her visit to Chi-
cago, and once more at her home in Rochester, New York, for

Adelaide Johnson: Lucy Mott

Adelaide Johnson: Elizabeth Cady Stanton

Miss Johnson. Miss Anthony suggested that her lifelong friend Elizabeth Cady Stanton be sculpted for the Woman's Building by Miss Johnson at the same time; Mrs Stanton accordingly came to Rochester for that purpose. When both busts were completed, Miss Anthony, according to Miss Johnson, said that the work was incomplete "without dear Lucretia Mott with her Quaker cap" sitting between the two of them. Miss Johnson created this bust from photographs, since Mrs Mott had died in 1880. There was also a fourth bust in this grouping: Dr Caroline Winslow, a feminist homeopathic physician. The reason for her inclusion is obscure.

Miss Johnson took her four busts to Italy to be cast in marble. There all sorts of peculiar events occurred. To begin with, the street number of her studio was "13": numbers held great significance for Miss Johnson, but when she took the studio she had overlooked its number. One day she entered through a locked door to find the plaster bust of Miss Anthony "on the floor in pieces" although no one had been in the studio since she had left hours before. She rushed out to seek help and returned to the studio with a friend to find that "by some strange power or interference" the head and face of the plaster model "were absolutely ungrazed" although it had fallen from a height onto a stone floor. Even the "tip of the nose" was not damaged.

Some time later, Harriet Hosmer dropped into No. 13, and suggested that the bust, now nearly finished in marble, could stand some changes. Miss Johnson immediately abandoned it completely, and started another one, because of her "imperious will toward perfection." After this, weeks passed with what Miss Johnson called "the usual amount of unusual experiences" and one day, when the second marble bust was nearly finished, an Italian workman discovered a flaw in the marble face. Miss Johnson abandoned that bust also, and began anew. A few days later a "soft spot" developed in the face of the bust of Lucretia Mott. That too was abandoned and a new one begun.

Despite these catastrophes, which Miss Johnson was convinced had happened for some unknown purpose, all the busts were completed before the deadline set by the Fair authorities — or so Miss Johnson thought. The U. S. Government sent a ship to the port of Livorno, or Leghorn, to pick up works of art to be delivered to Chicago. Miss Johnson left the busts, "boxed and ready" and sailed for America. With her usual luck, the date of collection had, without her knowledge, been moved up six weeks. Consequently, when she interrupted her work in Washington to inquire after events in Chicago, she was horrified to discover that her crates were still standing on the docks in Leghorn. She had to have them shipped to New York at her own expense: this amounted to $120, not including "brokers' fees, incidentals and

transportation to Chicago." It cost her $27.80 to get the boxes out of customs. She found all this "very oppressive."

Eventually the busts arrived in Chicago, although not until July, 1893. With them came three white pedestals that were supposed to have remained in Washington. This caused more trouble. "None of this confusion," Miss Johnson said, "was because of any fault, failure or neglect on my part." She arrived at the Woman's Building to find that the busts were to be placed upon her pedestals. She intervened, pointing out that these pedestals were not to be part of the exhibit. Other artists, she said, had had pedestals "of uniform color and style" furnished by the Fair buildings. Her pedestals, she said, "were too delicate, too expensive, to be sacrificed" — to what, she did not say. When the "manager of the building", who must have been Amey Starkweather, insisted on mounting the busts on Miss Johnson's pedestals, Miss Johnson refused to allow her pedestals to be used.

"Well, then," Mrs Starkweather replied, "they can be placed upstairs on shelves."

Miss Johnson asked to speak with "the next in authority". This must have been Mrs Palmer, to whose "apartment" Miss Johnson was directed, to receive the same reply: "If they are not mounted on those pedestals, they can be placed upstairs on shelves."

Miss Johnson remained calm: she was, she said, "a lady and a philosopher." But her determination was "as firm as the eternal hills." "Never," she proclaimed, "while under my control, shall the portrait busts of the women who made this Woman's Building possible, who made your official relation possible, be placed upstairs on shelves."

"With this ultimatum," she said, "the situation was dramatically intense, even tragic." It can well be imagined how Mrs Palmer would take the announcement that her Building had been created by four women, one of whom had died in 1880, and another of whom was a practitioner of homeopathic medicine. The busts, still in their cases, were ordered into a side room. Miss Johnson then telephoned to James Ellsworth, the Ladies' special nemesis, who at once sent her, by messenger, a letter of introduction to Halsey Ives. "Within a few hours" Miss Johnson laid an application for admission to the Fine Arts Palace before Mr Ives. The Fine Arts jury had been disbanded, and would have to be recalled to inspect the busts. Miss Johnson says that Loredo Taft, who was on the jury for sculpture, told her that her bust of Susan Anthony was better than his: he had tried to make her real, but Miss Johnson had made her "not only real, but ideal," a somewhat mystical announcement in line with Miss Johnson's general view of things. When exactly he said this is not clear.

Anticipating acceptance by the Fine Arts Jury, Adelaide John-

son needed a permit to take the busts from the Woman's Building, and another permit to transfer them across the Fair grounds to the Fine Arts Palace. She went to the Administration Building to procure these permits, and while walking across the floor to speak to an official seated behind his desk, stepped into an open trapdoor which had "escaped" her "observation," and broke three ribs. "As this seemed to call for a pause," she was assisted home by a friend. A day later she received an acceptance of her work from Mr Ives, and at the same time learned that her busts had been placed in the Gallery of Honor of the Woman's Building, against a background of ferns. "When the persons in charge of the Woman's Building found I had secured a permit," Miss Johnson wrote later, "they flew to have the busts placed . . . and refused a permit for their removal, which was just what I wished." She makes no further reference to the pedestals. Possibly she perceived her descent through the trapdoor as another kind of handwriting on the wall, and decided to let well enough alone.

The busts were much admired. May Wright Sewall told Miss Johnson that the "busts of Lucretia Mott and Susan B. Anthony are the best of the three, I think. Mrs Stanton does not seem to me so good, but her excessive fat would I know make it very difficult to model her portrait." Miss Anthony and Lucretia Mott, on the other hand, were "naturally statuesque, and for that reason are more easily modelled." It was Susan Anthony's likeness which appeared to attract the most attention. A copy of it was accepted by the Metropolitan Museum in 1906; in 1936 it appeared on a commemorative postage stamp. Miss Johnson herself, customarily attired in a long white gown with flowing sleeves, repossessed the busts after the Exposition was over. Although as she said herself "more than two months of the Exposition had passed before they were placed at all," she was delighted with their final disposition "really in the most prominent place . . . in the whole exhibition, for the Woman's Building is the most popular of all the buildings, and in the ground floor is an enormous court called the Court of Honor . . . In the center is a fountain flanked with palms which forms the background for my fair white children so no one can enter the building from either of the four entrances without seeing the first thing the four eminent women . . . "

In 1896 Adelaide Johnson married Alexander Jenkins, an Englishman who took her name; the couple studied the occult together and ate only vegetables. It was Mrs Johnson's dream that her busts would someday rest in the Capitol. In 1921 the dream became reality: the busts were placed in a crypt on the first floor. They were the country's first statue dedicated to women, done by a woman, in honor of woman's service to woman. The dedication

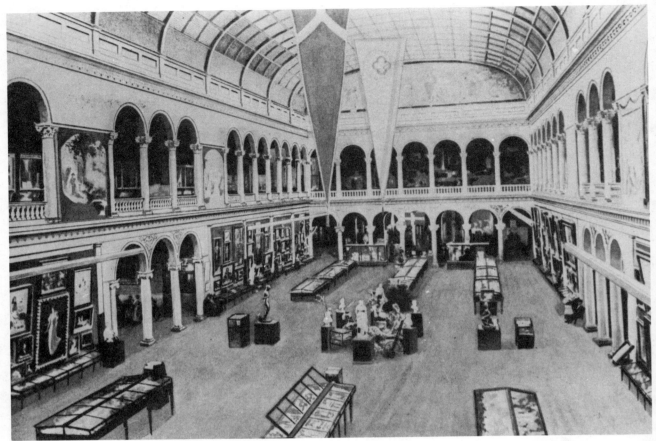

Gallery of Honor

was held on February 15, 1921, Susan B. Anthony's birthday, one year after the passage of the Suffrage Amendment. The heads jut out of a marble block weighing eight tons. They have been called "Ladies in a Bathtub" by some; to others the effect was less amusing. A male Senator commented that "the impression it makes is that the subjects are buried alive."

In 1946 Miss or Mrs Johnson was faced with eviction from the damp studio at 230 Maryland Avenue in Washington where she had worked for twenty years. She attempted to destroy the models of the original busts rather than see them sold for her debts. This attempt was basically unsuccessful: the damaged busts were retrieved by the National Woman's Party and placed in their Washington headquarters. Finally in 1955, at the age of 108, Miss Johnson gave up the ghost, the last member of "that strange sisterhood . . . who at one time settled upon the seven hills of Rome . . ."

Whether or not Mrs Palmer really wanted Miss Johnson's "fair white children", she got them, as soon as it became apparent that the Fine Arts Palace might snatch them away. The fountain in the center of the court was done by Anne Whitney, who contri-

buted also a bust of Harriet Beecher Stowe and one of Lucy
Stone. It was the wish of the women who commissioned the bust
of Lucy Stone that it be placed with Miss Johnson's busts of "the
other pioneers of the cause of Suffrage for women." This was
duly done, although Miss Stone herself made it clear that she
would have preferred the money spent on this bust to go to the
cause itself.

Blanche Nevins, who had lost the sculpture competition to
Alice Rideout, was represented in the Gallery of Honor by a mar-
ble figure of "Maud Muller," from a poem by John Greenleaf
Whittier. "Maud" was popular enough to be present also in the
shape of a plaster bust in the southwest corner of the Rotunda,
this one done by Edith Howland of "Paris, France." In that same
area could be found a marble bust of Little Nell, by Mrs Mary
P. Nichols of Denver, Colorado. In the east central part of the
Rotunda were placed three marble sculptures by Sarah Bern-
hardt, who had taken up sculpting in the 1870's: these sculptures
were sent to Chicago as part of the French exhibition. Mlle Bern-
hardt had sent a bust of a child, a bas-relief of Ophelia, a bust of

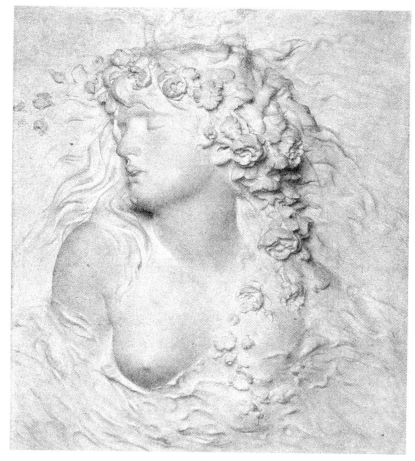

Sarah Bernhardt: Ophelia, Bas Relief

the French artist Louise Abbema, who had sent two paintings of her own, along with a painted lampshade. French artists would not work for the pittances given to American artists, but a few of them sent things to prove that their work had merit.

Mrs Palmer still believed, in 1892, that she could fill her Gallery of Honor with works "of rare merit and value." To that end, she contacted Frederick Keppel, a dealer in etchings and engravings, who was an expert in his field and had an important print collection of his own. Mrs Palmer wrote Mr Keppel that she "would greatly value his judgment" in arranging an exhibition of prints for the Gallery. Since he had "personal relations with many foremost etchers" and was known to be reliable and to take great interest "in the history of art and in making known the great artists of the past and present," she was taking the liberty of writing him in Europe so that if he wished to accept her offer he could commence work at once, while Europe's "facilities" were available to him. She added that he could display his business card at the exhibit if he wished.

Fortunately for Mrs Palmer, Mr Keppel was indeed anxious to mount an exhibit for her. He even offered to pay for glass and frames out of his own pocket; Mrs Palmer would not allow him to do that. She was grateful for his enthusiasm: Mrs Starkweather wrote on August 12, 1892, while Mrs Palmer was relaxing at Camp Elsinore in the Adirondacks, that Mr Keppel had been in "with a memorandum of questions — he is extremely anxious to make a very fine exhibit of engravings, beginning at Mary de Medici in the middle of the fifteenth century and coming down to the present date . . ."

In March Mrs Palmer also wrote to Professor de Cesnola, of the Metropolitan Museum of Art in New York, presuming upon an acquaintance with him. "I recall myself to your remembrance," she wrote:

We wish to have in the Main Gallery of the Woman's Building, only the most notable things done by women and I do not know where in the realms of art [is] a picture one would so greatly desire as "The Horse Fair" by Rosa Bonheur. This represents the highest point touched by a woman in our day, in art . . .

It would have been a coup indeed, if Mrs Palmer could have borrowed "The Horse Fair" for the Building. This painting, eight feet high by sixteen and one half feet long, was considered to be a masterpiece. Mlle Bonheur had worked on it for eighteen months, and had received a first-class medal for it, which would normally have entitled her to the Cross of the Legion of Honor. In 1855 the Cross was refused her, because of her sex; she finally received it in 1864. "The Horse Fair" was one of the most admired paintings of the century. At Queen Victoria's request the pic-

Rosa Bonheur: The Horse Fair

ture had been exhibited at an audience in Buckingham Palace. Engravings of the painting hung everywhere in America and England. It had been sold for 268,000 francs to an American and had come into the hands of Cornelius Vanderbilt, who had donated it to the Metropolitan Museum.

Mrs Palmer did not ask only for "The Horse Fair" but went on:

> The other exhibits on which we have looked with covetous eyes are the swinging screens with Egyptian textures and embroideries, which would be of the utmost value to us as illustrating the primitive industries of women . . . Two Dutch flower pieces among your old paintings are also of great interest and especially valuable as indicating the point reached by woman in past times.

She threw out a feeler for anything de Cesnola might have that could be appropriate:

> We are also anxious to rescue any portraits of celebrated women in the past, though I do not recall any in your collection.

She ended with a burst of flattery and charm:

> I trust you are not as indifferent as most New Yorkers to the Exposition which is taking shape and promises to attain such magnificent proportion. I rely upon your good will and interest in venturing to write this letter, Hoping that the favors I ask may not be impossible to grant, and that we will have the benefit of your influence and persuasive eloquence in placing this matter before the Directors of the Museum, in which case there may be only one conclusion reached.

In November Mrs Palmer received a letter from the office of the Secretary of the Museum, explaining that it was not Museum policy to lend works of art, and especially not during the summer of 1893, when many foreign visitors would be coming through New York. There were doors Mrs Palmer could not open. She did manage to divert a Bonheur work from Sara Hallowell's rooms at the Arts Palace, for which its donor had originally intended it — an act which Miss Hallowell may have foreseen — but this did not occur until two weeks before the Fair closed.

Admirers of animal paintings found themselves looking at the work of the 72-year-old Belgian artist Henrietta Ronner, who had been called "the Valesquez of cats." There were also two pictures of dogs by Queen Victoria: "Pug belonging to Prince Henry of Battenberg, drawn by the Queen in the railway, June 24, 1886" and "Spot," the Queen's fox terrier, done January 25, 1891. Mrs Palmer was not an occultist like Adelaide Johnson, but she saw the handwriting on the wall.

In February, 1893, she wrote to Candace Wheeler that she feared "the men's committee" had "already gobbled up the best things for their own exhibit." She felt that the Arts Palace had quality, while the Woman's Building would have only quantity. "Could you suggest a few really capital paintings done by women?" she asked desperately. The quantity of works had already spilt over the building:

> In explanation of the phrase "Gallery of Honor" which we used a year ago, I will state that we thought our exhibit could mainly be brought within the limits of the main, or central gallery of the Woman's Building. As foreign nations came in and applications were received from many states in our own country, we were forced to spread out and extend this gallery of honor into the two wings of the building. I make this statement as I see that old phrase is misleading.

Lady Butler: Quatre Bras 1916

The British Royal Family had sent not only the Queen's sketches of dogs and views from windows at Balmoral Castle, but her watercolor copy of a life-size oil painting of Abdul Karim, the Queen's Indian Secretary; two oil paintings by Princess Christian; a watercolor nature study by Princess Louise, and a picture by Princess Beatrice, whose husband's pug the Queen had already immortalized. These were hung in the northeast gallery.

The British did provide one outstanding painting that was placed on the northwest side of the Rotunda: this was "To the Front" by Elizabeth Thompson, Lady Butler, who had caused a considerable stir as a painter of military subjects. In 1866, at the age of sixteen, Miss Thompson had begun to study at the South Kensington School of Art; her first exhibition in 1874 at the Royal Academy created a sensation. She was widely admired. John Ruskin said her "Quatre Bras, 1916", was "Amazon's work" and "the first fine pre-Raphaelite picture of battle we have had." He found her gradations of color and shade comparable to Turner's.

Hanging in the southwest side of the Rotunda was a painting by Cecilia Beaux called "Twilight Confidences." This American artist was in her forties at the time of the Fair, and had already an excellent reputation; she had been influenced by Whistler and

Cecilia Beaux: Twilight Confidences

Sargent. In the same side of the Rotunda was "Portrait of Miss M. D. " by Anna Elizabeth Klumpke of San Francisco who had achieved recognition in the Paris Salon; she strongly admired the work of Rosa Bonheur and was to become her friend and biographer.

The most consistently admirable display of art in the Woman's Building was probably the Keppel collection of engravings and etchings. The catalogue description of the Keppel Collection is worth reprinting in its entirety.

LOCATION — West Gallery, Sections A to C.

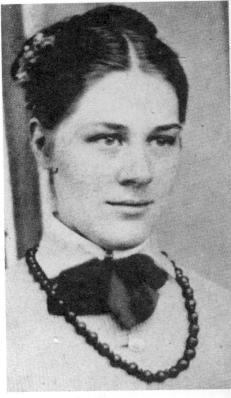

Cecilia Beaux

The aim of the present exhibition is to show, so far as space permits, what has been done by women engravers during the last three centuries. It has been gathered together with much care and owes its interest largely to the kindness of seven collectors of Europe and America and, in the case of modern work, to the hearty cooperation of the artists themselves.

Owing to the limitation of space it has been found impossible, even were it desirable, to represent all who have of late years, worked with the etching needle, but sufficient is shown to exemplify the schools of France, England and America at their best.

Until comparatively recent years a woman engraver was the exception and though we find scattered through the three hundred years that have elapsed since the birth of the art, a fair number of women who have distinguished themselves in engraving, they are there rather through the force of their own individuality than from any general tendency toward a recognition of the equality of the sexes.

Doubtless strong opposition was first to be overcome, but prejudice has lessened year by year until now the pictures by women are admitted to our public exhibitions on exactly the same basis as those executed by men, solely on their merits.

It is on this footing that the present exhibition should be judged.

In America not only have women established their right to an equal hearing with their male co-workers in the graphic arts, but in etching they can lay claim to at least three whose rank is of the highest, while in the field of wood engraving such good work has been done that it seems impossible for technical excellence to surpass it.

Exhibit
No.

Ghisi, Diana, Italy, 1535.
 Born in Mantua. Her plates date from 1581-1588. Engraved chiefly after Raphael, Tuccari and Giulio Romano. Her father and brother were also engravers.

1. The Woman Accused Before Christ. (Line Engraving after Giulio Romano. First State.)

Marie de Medicis, Queen of France. Born 1573.
 Wife of King Henry IV of France, Regent of France after his death; was afterward imprisoned by Cardinal Richelieu.

Exhibit
No.

2. Bust of a Young Woman. This wood cut is extremely rare.

Roghman, Gertrude, Holland, 1590.
Engraved some plates after her father, Roeland Roghman. Executed about twenty plates in all. Died about 1640.

3. View of Slotterdyck. (Original etching.)

Stella, Claudine, France, 1634.
Daughter of the engraver, Jacob Stella.

4. Christ before Pilate. (Line engraving after Nicolas Poussin.)

Sirani, Elisabetta, Italy, 1638.
Pupil of her father, Giovanni Sirani.
She was poisoned by her servant in 1665, but had already made for herself a famous name.

5. Madonna and Child with an Angel. (Original etching.)

Sandrart, Anna, Germany, 1658.
Born in Nuremberg, pupil of her father, Jacob von Sandrart.

6. Line Engraving after Raphael's Fresco in the Farnesina Palace.

7. The same after the same.

Del Pò, Teresa, Italy, about 1660.
Daughter of Pietro del Pò. She painted in oil and in miniature. Engraved so much in the style of her father that it is difficult to distinguish their works. She was a member of the Academy of St Luke, at Rome, and died at Naples in 1716. She executed about twenty plates.

8. Allegory in Honor of Philip IV of Spain. (Original line engraving.)

Deveux, Therese, France, about 1720.
Worked during the middle of the eighteenth century.

9. L'Abbe de la Caille. (After M'lle Le Jenneus.)

Kauffman, Angelica, Switzerland, 1741.
Worked chiefly in England, where she was highly esteemed, and upon the founding of the Royal Academy in 1768 was elected one of the original thirty-six members. Died in 1807. Many of Bartolozzi's best plates were after her paintings. They were much esteemed by other engravers also.

10. Hope. (Original etching.)

11. Girl Leaning Against a Rock. (Original etching finished in aquatint.)

12. Girl Plaiting Her Hair. (Original etching finished in aquatint.)

13. Venus with the Corpse of Adonis. (Etching finished in aquatint after Annibal Carracci.)

Prestel, Catharina, Germany, 1744.
She was the pupil and afterward the wife of Johann Amadeus Prestel, whom she aided in some of his best plates, especially in landscape. In 1786 she separated from him and came to London, where she died in 1794. She executed 73 plates after Italian, Dutch and German masters.

Marie de Medici

Exhibit
No.

14. Landscape with Castle. (Aquatint after Teniers the Older.)

15. View in Switzerland. (Aquatint after J. Wynants.)

Cosway, Maria, England, 1745.
Her husband was Richard Cosway, the famous English miniature painter. Her maiden name was Hadfield. She was of Irish parentage, but was born at Leghorn.

16. Portrait of herself and her husband. (Original etching.)

17. Grief. (Etching after Richard Cosway.)

Deny, Jeanne, France, about 1750.
She, with her brother, executed a series of illustrations to the works of Voltaire and Lafontaine.

18. A Ruined Tower. (Original etching dated 1770.)

19. Allegorical Subject. (Etching after Monnet.)

Ellis, Elizabeth, England, about 1750.
Sister-in-law of William Woollett, the famous landscape engraver.

20. A Farm-yard. (Etching after William Woollett.)

Watson, Caroline, England, about 1760.
Worked both in mezzotint and stipple. Pupil of her father James Watson. In 1785 she was appointed Engraver Royal by Queen Caroline, and died June 10, 1814.

21. Madonna and Child. (Stipple engraving after Raphael. Proof. From the Earl of Hardwick's collection.)

22. Infancy of Shakespeare. (Stipple engraving after Sir Joshua Reynolds.)

23. Portrait of William Woollett. (Stipple engraving after Gilbert Stuart.) Proof.

Carey, Regine, France, about 1770.

24. Landscape with Cattle. (Aquatint printed in colors after Rosa di Tivoli.)

Holbein, Theresa, Germany, about 1790.
Born in Gratz. Removed in 1814 to Vienna. She engraved about 30 plates, embracing both original landscapes and copies after various masters.

25. Landscape with a River. (Original etching.)

Riollet, Mlle C., France, 1798.
Married Beaunarlet, the engraver.

26. La Fecundite. (Line engraving after Rubens.)

26a. The Rich Man and Lazarus. (Line engraving after Teniers.)

Piotti, Catarina, Italy, 1800.

27. Queen Semiramis. (Line engraving after Guercino.) This beautiful engraving won the gold medal of the Academy of Milan in 1830.

Bozzolini, Mathilde, Italy, 1811.
Born at Florence, engraved only a few plates.

28. Portrait of Gaetano Filangiere. (Line engraving after Tofanelli.)

Turner, Mrs Dawson, England, about 1820

29. Portrait of Granville Sharpe. (Original etching.)

Exhibit
No.

Perfetti, Elena, Italy, about 1830.
Wife of the engraver, Perfetti.

30. Hope. (Line engraving after Carlo Dolci.)
31. The Last Judgment. (Line engraving after Fra Angelico.)

Lady Hume, England, about 1830.
Wife of Sir Abraham Hume.

32. Rembrandt's Mill. Maberly pronounces this to be a wonderfully fine copy of Rembrandt's famous etching.

O'Connell, Madame F., Germany, 1835.
Her work was done in Paris.

33. A Cavalier. Period of Louis XIII. (Original etching.)

ETCHINGS AND DRY POINTS BY ARTISTS NOW LIVING. FRENCH SCHOOL.

Abbema, M'lle Louise.

34. Portrait of the painter Carolus Duran. (Original dry point.)
35. Portrait of Charles Garnier, Architect of the Paris Opera House. (Original dry point.)

Paulier, Madame C.

36. Head of a Woman. (Etching after J. J. Henner.)
37. Woman Reclining. (Etching after J. J. Henner.)
38. Saint Sebastian. (Etching after J. J. Henner.)
39. Lady Hamilton. (Etching after Geo Romney.)

Formstecher, M'lle Helene.

40. Hunting the Hare. (Etching after Jules Gelibert.)
41. High and Dry, Vessels at Low Tide.

Bracquemond, Madam Marie.
Painter and etcher, wife of the eminent etcher, Felix Bracquemond.

42. Portrait of Madam Beraldi. (Original etching.)
43. Portrait of Monsieur Geffroy. (Original etching.)

D'Abbeville, M'lle Isabelle.
Pupil of Maxime Lalanne.

44. Head with a Fur Cap. (Etching after Bosso.)

Testard, M'lle Pauline.

45. Landscape (Etching after Corot.)
46. Landscape (Etching after Corot.)

Teyssonnieres, M'lle Mathilde (Madam Bertrand).
Daughter and pupil of Pierre Teysonnieres, the famous etcher.

47. A Reverie. (Etching after Feyen Perrin.) This plate won a diploma of honorable mention at the Paris Salon and was also shown at the Exposition.
48. The Haymaker. (Etching after Feyen Perrin.)

Poynot, M'lle Gabrielle.
A pupil of the famous etcher, Waltner; has executed a number of plates after Laurens, Benner, Henner and others.

49. A Young Creole. (Etching after Henner.)

Paintings on Main Floor

Exhibit
No.

LITHOGRAPHS BY ARTISTS NOW LIVING. FRENCH SCHOOL.

Bonheur, M'lle Rosa.
Born 1822. The eminent painter of animals.

50. Head of a Lioness. (Original lithograph with facsimile of a letter by the artist.)
51. Head of a Young Bull. (Original lithograph.)
52. Spanish Cattle. (Original lithograph; early proof bearing the artist's written directions to her printer.)

ETCHINGS AND DRY POINT BY ARTISTS NOW LIVING. ENGLISH SCHOOL.

Nichols, Miss C. M.
Fellow of the Royal Academy of Painter-Etchers, London. The paintings of Miss Catharine Nichols are well known to those who visit the exhibitions at the Royal Academy, London. Her plates are done in pure dry point and are vigorous presentations of English land-scape or architecture. She is also a writer of high merit.

53. Amidst the Pines. (Original dry point.)
54. The Stranger's Hall, Norwich, England. (Original dry point.)
55. Fir Trees, Crown Point. (Original dry point.)
56. "O'er Moor and Fen." (Original dry point.)

Gleichen, The Countess Feodora.
A Relative by Marriage of Queen Victoria.

57. In the Church. (Original etching.)
58. Peasant Woman. (Original etching.)

Halle, Miss Elinor.
59. A woodcutter. (Original etching.)
60. The Shepherds. (Original etching.)

Hamilton, Mrs L. Vereker.
61. The Harvesters. (Original etching.)
62. Study of a Peasant Girl's Head. (Original etching.)

Harrison, Miss S. C.
63. Study of a Head. (Original etching.)

Kemp, Miss Emily G.
64. Study after Vandyck. (Etching.)
65. The Coming Storm. (Original etching.)

Roberts, Miss K. May
66. Portrait of a Man. (Original etching.)
67. Prayer for the Dead. (Original etching.)

Thompson, Miss L. Beatrice
68. Portrait of an Old Man. (Original etching.)
69. A Shrine in Brittany. (Original etching.)

AMERICAN SCHOOL.

Canby, Miss Louise Prescott, Philadelphia.
70. Sunset. (Original etching.)

Rosa Bonheur: Head of a Lioness

Mary Cassatt: Perroquet. Dry Point.

Exhibit
No.
71. In the Harbor of Oswego. (Original etching.)

Cassatt, Miss Mary.
Born in Pittsburgh, Pa., resides in Paris.
One of the two large fresco paintings which decorate the
 Woman's Building is the work of Miss Cassatt.
72. Lady at a Tea Table. (Original dry point.)
73. Portrait of a Lady. (Original dry point.)
74. A French Peasant Woman with a Child. (Original dry
 point.)
75. A French Peasant Woman with a Parrot. (Original dry
 point.)

Clements, Miss Gabrielle D., Philadelphia.
76. Mont St Michel. (Original etching.)
77. The Way of St Francis. Chartres. (Original etching.)

Dillaye, Miss Blanche, Philadelphia.
78. Mist on the Cornish Coast. (Original etching.)
79. Early Morning, Dordrecht Canal. (Original etching.)
80. Sardine Wharf, Eastport. (Original etching.)

Exhibit
No.

Farrell, Miss K. Levin, Philadelphia.
81. South Dartmouth Wharf. (Original etching.)
82. Springtime of Love. (Etching after Paul Thumann.)

Ferris, Miss May E., Philadelphia.
83. Waiting. (Original etching.)

Getchell, Mrs Edith Loring, Worcester, Mass.
84. Moonrise. (Etching after Ross Turner.)
85. Old South Church. (Original etching.)
86. The Road to the Beach. (Original etching.)
 "Another attractive work is 'The Road to the Beach,' at
 Nonquit, Massachusetts, which was exhibited at the
 Paris Salon. It is very simple in theme — merely a
 stretch of low coast land with a few scattered shrubs and
 a wide road stretching away toward the slightly-lifted
 horizon line. But a great deal has been told for this sim-
 plicity. The very spirit of such a scene is caught and
 given. Even without the title we should know that there
 was salt in the air and the sea at the end of the road."
 (Mrs Schuyler van Rensselaer.)

Hale, Miss E. D., Philadelphia.
87. Study of a Head. (Original dry point.)
88. Study of a Head. (Original dry point.)

Lloyd, Miss H. H., Philadelphia.
89. A River Meadow. (Original etching.)
90. The River (Original etching.)

Matlack, Miss E., Philadelphia.
91. A Winter Morning. (Original etching.)
92. A New England Orchard. (Original etching.)

McLaughlin, Miss M. Louise, Cincinnati.
93. Woodland Scene. (Original etching.)
94. Head of a Girl. (Original dry point.)

Merritt, Miss Anna Lee.
 "Her work is essentially English in flavor, delicate and
 pleasing." — Mrs Schuyler van Rensselaer, in *American
 Etchers.*
95. Ophelia. (Original etching.)

Moran, Mrs Emily K., Philadelphia.
96. Long Beach, York Harbor. (Original etching.)
97. The Road to the Farm. (Original etching.)

Moran, Mrs Mary Nimmo, New York.
 "Mrs Thomas Moran is as yet the only woman who is a
 member of the New York Etching Club, and no name
 stands higher on its roll. Her work would never reveal
 her sex. It is above all things, direct, emphatic, bold —
 exceeding in these qualities, perhaps, that of any of her
 male coworkers." — *The Century Magazine.*
 "The Goose Pond" was the etching which procured Mrs
 Moran's election to membership in the London Royal
 Society of Painter-Etchers.
98. Summer at East Hampton, Long Island. (Original etch-
 ing.)

Anne Whitney: Fountain in Gallery of Honor.

Exhibit
No.

99. The Goose Pond, Long Island. (Original etching.)

Natt, Miss Phoebe Davis, Philadelphia.
100. Dona Nobis Pacem. (Original etching.)
101. The Child Musician. (Original etching.)

Oakford, Miss Ellen, Englewood, N. J.
102. Twilight. (Original etching.)
103. Yale Campus, Winter. (Original etching.)

Osborne, Miss H. Frances, Salem, Mass.
104. Chestnut Street, Salem, Mass. (Original etching.)
105. Solitude (Original etching.)
106. View from Derby Wharf, Salem. (Original etching.)

Penman, Miss Edith, New York.
107. An Orchard Pasture. (Original etching.)
108. Winter. (Original etching.)

Taylor, Miss M. M. , Philadelphia.
109. On Nantucket Island. (Original etching.)
110. Winter. (Original etching.)
111. The Hazy Mist. (Original etching.)

WOOD ENGRAVINGS BY
CONTEMPORARY AMERICAN ARTISTS

Beyer, Miss Clara, Brooklyn, N. Y.
112. Landscape. (After George Inness.)
113. The Knitter. (After Henri Lerolle.)

Comstock, Mrs Anna B.
[sic] The Cherry Blossoms Give a High Tea. (Original.)
114. Butterfly. (Original.)
115. Butterflies. (Original.)
116. Butterflies. (Original.)
117. Butterflies. (Original.)

Cooper, Miss Edith, New York.
Member of the Society of American Wood Engravers, to
 which was awarded the gold medal at the Paris Exposi-
 tion for excellence of work exhibited.
118. White Birches. (After Miller.)
119. Springtime of Love. (After Paul Thumann.)
120. Garrison Defilant avec les Honeurs de Huerre-Disle, 1708.
 (After Gow.)
Done for General Hawkins' report of the American Section
 of the Paris Exposition.

Curtis, Miss K. R. , Bergen Point, N. J.
121. Black to Play. (After R. M.)
122. A Fair Swede. (Original.)
123. An English Pasture. (After T. Baker.)
124. Autumn Leaves. (After Vicat Coles.)

Naylor, Miss J. A. , New York.
125. Winchester Cathedral — the Choir and Presbytery. (After
 Joseph Pennell.)
126. Zaltieri, Venice. (After Otto Bacher.)

Exhibit
No.

Naylor, Miss O. , New York.
127. Sheep. (After Doring.)
128. Winchester Cathedral — South aisle of retro choir. (After Joseph Pennell.)

Powell, Miss C. A. , Trenton, N. J.
Member of the Society of American Wood Engravers.
129. Gorilla (After Fremiet.)
130. A Bit of Sunshine. (Original.)
131. The Resurrection. (After John La Farge.)

Underhill, Miss M. J. , New Rochelle, N. Y.
132. Lord Baltimore. (After an engraving by Abraham Blothing.)
133. Old Houses on the Liffy. (After Joseph Pennell.)

Waldeyer, Mrs A. , New York.
134. Dance of the Serpent Stars. (After Taber.)
135. Tolstoi at Home. (After Repin.)
136. Japanese Girl. (After John La Farge.)
137. A Young Artist. (After A. Kobbe.)
138. Interior of St Peters, Rome. (F. Hopkinson Smith.)

Dora Wheeler Keith: Christmas Card Design

Mr Keppel had taken advantage of Mrs Palmer's suggestion that he attach his card to the display. At the end of the catalogue description of his collection is the following paragraph:

High-class engravings, etchings and water colors. Fine picture framing. Frederick Keppel & Co., 20 East 16th Street, New York; 27 Quai de L'Horloge, Paris; 24 Van Buren Street, Chicago.

It will be noted that Mary Cassatt was represented in the Keppel Collection by dry point etchings. Frederick Sweet says:

Except in two or three of her earliest prints, she never practiced straight etching, preferring soft ground, aquatint, and dry point. Her entire graphic output amounted to something over two hundred, more than one hundred of which were dry point. Two lithographs are also known, but these are rarities [Her] success with prints was due to her own indefatigable approach. She felt that printmaking was good discipline, the best of training in helping draftsmanship. It is then first and foremost as a draftsman that she took up the print medium, and because of this attitude she was especially interested in dry point and soft ground. Rich effects are obtained, for the ink not only goes into the lines or grooves made by the dry point needle, but is also held by the burr which the needle throws up at the side like the earth thrown to either side of a furrow by a plow. 'In dry point,' she once said, 'you are down to the bare bones, you can't cheat.'

In soft-ground etching draftsmanship is equally important. The design is pencilled onto a sheet of drawing paper laid over

310 THE FAIR WOMEN

the wax ground of the plate; when the paper is removed, the wax clings to the design indentations on the paper, and consequently comes away from the copper plate. Acid is then used to "bite" the design into the plate. In aquatint, the plate is covered with a ground of powdered resin and heated: blank areas of design are painted or brushed out with varnish. The design is "bitten" into the plate in acid, and prints in a gray tone. The dry or soft ground point etching is used here too, for linear elements of the design. Etching is painstaking and difficult; Mary Cassatt was an excellent draftswoman. In 1903 she described her method in a letter:

> My method is very simple. I drew an outline in drypoint and transferred this to two other plates, making in all three plates, never more, for each proof. Then I put an aquatint wherever the color was to be printed; the color was painted on the plate as it was to appear in the proof. . . . if any etchers in New York care to try the method, you can tell them how it was done.

Camille Pissarro described Mary Cassatt's colored engravings to his son, calling them "rare and exquisite" and saying that Miss Cassatt had achieved effects Pissarro's son had striven for in vain: she had "realized just such effects and admirably: the tone even, subtle, delicate, without strains on seams, adorable blues, fresh rose, etc." Pissarro considered that Miss Cassatt's methods would "be taken up by all the tricksters who . . . make empty and pretty things . . ." She was obviously a pioneer. Although Frederick Sweet suggests that some painters whom she knew may have "hinted" to her about etching methods, her own letters make it clear that she experimented: "I was entirely ignorant of the method when I began, and . . . I varied sometimes the manner of applying the color. The . . . plates were done with the intention of [imitating] Japanese methods; of course I abandoned that somewhat after the first plate, and tried more for atmosphere."

In addition to her mural and etchings, Mary Cassatt had a pastel in the southwest Rotunda; it was called "The Young Mother." Lydia Emmett of New York, another muralist, also had a pastel in the southwest Rotunda. Miss Emmett's mural, entitled "Art, Science and Literature," hung on the west side of the Gallery. Lydia Emmett and her sister Rosina Emmett Sherwood were friends of Dora Wheeler Keith, the daughter of Candace Wheeler. Mrs Keith and Mrs Sherwood, along with Amanda Brewster Sewall, had studied with Julien in Paris and with the artist William Merritt Chase in New York. Mrs Emmett had studied in Paris with Bougereau and Frederick Mac Monnies. Louis Prang of Boston held annual design competitions for his Christmas cards: in 1880 Rosina Sherwood had won the first

Rosina Emmett Sherwood: Republic's Welcome to Her Daughters

thousand dollar prize. In 1881 Dora Wheeler had won second prize and in 1882 first prize. Rosina Sherwood's mural, like her sister's was on the west side of the gallery: it was entitled "The Republic's Welcome to her Daughters." Mrs Sewall's mural "Arcadia" was on the east side of the gallery, as was a mural by Lucia Fairchild of Boston called "The Women of Plymouth."

Candace Wheeler had suggested the Emmett sisters and Mrs Sewall when Mrs Palmer turned to her in desperation, seeking muralists. "Certainly those four places should be filled up," Mrs Wheeler had responded briskly. "And if four women here in New York should consult together and follow each other's lead, they might strike out something very good. . . Dora thinks Miss Emmett could be safely entrusted with another [mural?] and she is now looking among the women painters she knows. . . ." Dora Wheeler had been assigned the ceiling of the Woman's Building Library. Her mother was delighted with the assignment, and hinted for more. "Dora is getting on so well with the ceil-

William Merritt Chase: Portrait of Miss Dora Wheeler

ing . . . and is so enthusiastic about the whole scheme, that she is willing also to do a companion panel to Mrs Sherwood, if you would like her to." Both Miss Emmett and Mrs Sherwood did illustrations for books and magazines; this, along with their Christmas card background, may explain the difficulties they appear to have had in catching Mrs Palmer's attention. Although Mrs Palmer herself approached book and magazine illustrators— like Mary Hallock Foote—for contributions, she had not intended that the Building's murals be done by that sort of artist. In July of 1892 Mrs Sherwood did not yet know where her mural was to be placed, nor what color the walls were to be. Mrs Palmer had apparently appealed to the patriotism of the sisters to avoid paying them anything. Mrs Sherwood wrote protesting her patriotism, but asking plaintively if her expenses could be paid because of her "three babies." After their murals were delivered, both sisters wrote more than once asking for money; Lydia Emmett at least received $500.

On May 11, 1893, Mary Logan wrote to Mrs Palmer, telling her to prepare herself for the criticisms of the Gallery of Honor that were bound to come. She believed that the Woman's Building would repeat the trivialities of women's exhibitions at the Philadelphia Centennial and the New Orleans Cotton Fair: these words were designed to strike Mrs Palmer to the heart. Mrs Logan believed that the women's exhibitions were insignificant in comparison with the men's; they should not have been segregated, but should have exhibited "side by side with the men in accordance with the Resolutions which we passed at our first session," she said, adding, "However that is beyond change and nothing can be done." Mrs Logan was merciless:

> Like yourself I am greatly disappointed in the 'Gallery of Honor' . . . and wish from the bottom of my heart that I could have helped you to bring this up to your expectations. The decorations at the ends of the Hall were humiliating to me, and most disappointing in every way, and when compared with the decorations by women in the Illinois building, they are almost caricature.

Amanda Brewster Sewell: Arcadia

She referred of course to the murals by Mary Cassatt and Mary MacMonnies, which Mrs Palmer had labored to bring into being. Mrs Logan said that she would not call attention to them in public, since the mention of them must be painful to Mrs. Palmer.

Miss Hallowell herself liked Miss Cassatt's mural, but she had warned Mrs Palmer that it might not be generally accepted. It can be safely said that it was not a success. Frances Willard commented that Mary MacMonnies was well known in America through "her other excellent work," while Miss Cassatt was "almost wholly unknown in her own country, and esteemed abroad, especially in France," which was what Mrs Palmer had said at the Board meeting in 1892. Miss Willard noted that Miss Cassatt was "considered by many competent critics to be the strongest woman painter of the day." But nothing could make Miss Willard like "Modern Woman". Miss Cassatt, she said, belonged to the most "extreme" school of Impressionists. She had "strangely mingled" various "vivid hues": the blue and green of the mural were "intense", as was a shade of deep purple: the "flat effect" achieved was "pronouncedly Japanese." The picture was divided by the border into three scenes. In the first were three women in pursuit of the flying figure of fame, a nude female shape, which had supposedly cast off the garments of convention. Miss Willard did not care for the female shape, commenting coldly that it was "not drawn according to the canons of art as accepted in America." After this somewhat chauvinist slap at the French, Miss Willard examined the second panel, with its assemblage of "modishly attired women" and children who had gathered in an orchard to eat the red and gold fruit which swung over their heads. Nothing in that scene appealed to Miss Willard who saved her comment for the last panel:

> The last section, like the first, contains three female figures, but is somewhat meaningless—lacking even the rather distressful earnestness of the first. One woman whisks about in an "accordian" skirt while the other two gaze at her. There are no male figures in Miss Cassatt's picture. The painting seems too trivial and below the dignity of a great occasion.

The President of the WCTU did not take kindly to modishly attired young women spending all day in orchards eating what looked like forbidden fruit; as she had told Miss Anthony she was highly suspicious of women who disliked men, and there were no men in the mural. Whisking about the place in purple skirts and staring off into space was not her style. She managed a few kind words: trivial and undignified as the mural was, it had "a singularly finished appearance and much merit from an artistic point of view."

Mary Cassatt: Detail from Central Panel Modern Woman

The *Tribune* critic found Miss Cassatt's mural to be "decidedly disappointing." While Miss Willard mentioned the painting's "vivid hues", the *Tribune* called it "dark and heavy." The figures were "out of scale with the remainder of the decoration," and the subject did not explain itself. Mrs MacMonnies' mural was "far more decorative." The colors were "light, pure and pleasing", the figures were "sufficiently large" and the "ornamental border does not detract" from the importance of the figures in the composition. In sum, "Primitive Woman" was everything "Modern Woman" was not.

Henry B. Fuller in the *Chicago Record* said that the two murals, done by two women in the same city, commissioned at the same time, showed evidence that each artist had desired to "ignore or even to repulse" the other. The two murals did not balance each other: Mrs MacMonnies presented large figures with a narrow border; Miss Cassatt small figures with a wide and massive border "and a number of heavy panels to boot." Mr Fuller much preferred "Primitive Woman":

> Mrs MacMonnies addresses the eye in a gentle and insinuating fashion; Miss Cassatt does not address the eye at all—she assaults it. Mrs MacMonnies' tone is light and silvery, while the impudent greens and brutal blues of Miss Cassatt seem to indicate an aggressive personality with which compromise and cooperation would be impossible. Indeed, Miss Cassatt has a reputation for being strong and daring; she works with the men in Paris on their own ground . . .

Mary MacMonnies: Primitive Woman

Mr Fuller could not see the art for the artist. The critic for *the Art Amateur* did not like the mural very much, but attempted to discuss it. The central panel the critic found impressive; the two end panels "more or less ridiculous." He found it unfortunate that, as all three panels dealt with the out-of-doors, the painter had not secured unity "by carrying the one landscape background behind all the figures" but had chosen to chop the mural into three separate scenes.

> The central subject is, taken separately, and as a picture, not a decoration, a very beautiful piece of work. A rich border of blue, green and orange, adapted from the Persian, and Italianized by the insertion of pretty medallions of babies and female heads in circular and lozenge-shaped compartments, completes the work.

He too preferred Mrs MacMonnies' mural to Miss Cassatt's: "Primitive Woman" was "much more decorative." Mrs MacMonnies appeared to have learned from Puvis de Chavannes "the value of a continuous landscape background. Her composition, all in one piece, is held together by long horizontal lines of river and distant wooded hills, and is agreeably divided without too much regularity. . ." This critic made a relevant point when he noted that "the dominance of greens, blues and purples, and the frankly realistic character of the design . . . sharply separate" Miss Cassatt's painting "from the other decorations of the hall . . ." The mural was too different. It stood out in the muted atmosphere of the gallery. One critic was enraged by it:

> Mural decoration is not within the competence of every good artist; but the singular failure of one of these frescoes can hardly be accounted for by any reasonable theory. The subject is supposed to be 'Modern Woman.' The artist is Miss Cassatt, and this is one of the few things in the building which has been paid for . . . The garish and primitive character of the coloring of this frescoe cannot properly be appreciated from the description, and it is hardly possible to convey an idea of what the composition is.

The outraged taxpayer was reduced to a kind of sputtering: ". . . pink frocks. . . vivid green grass. . . skirt dance . . .accordian plaited heliotrope skirt held quite up to her nose . . .degraded. . . objectionable female nude figure. . ." "The

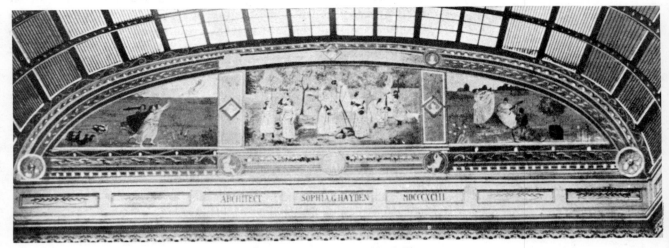

Mary Cassatt: Modern Woman North Tympanum

three hideous girls" followed by "three cackling geese" had obviously been done in a spirit of "derision"; the whole thing was a dreadful joke, played on "the enthusiastic ladies who employ her. . . " Mrs MacMonnies' work was infinitely superior, done in the "true spirit of mural decoration."

The critic for the *Illustrated American* was much calmer, speaking merely of "mural frescoes of varying merits idealizing in allegory phases of woman's life. . . " Mrs MacMonnies' was described as being "in the pre-Raphaelite style," while Miss Cassatt's was called "a 'greenery-yallery' effort that is not impressive." "Greenery-yallery" usually referred to the work of Aubrey Beardsley and the English decadents; its use here suggests that the critic for the *Illustrated American* did not know what to say about Miss Cassatt's panel, and did not wish to disturb what appears to be an attitude of self-conscious weary sophistication:

While there are pictures of undoubted merit among them and more excellent examples of portraiture, there is a gorgeous wealth of mediocrity. This was of course to be expected in art contributions where femininity was the first requisite and merit a secondary consideration . . . France shows her preeminence in the things that are essentially dainty, chic and feminine, while her constant rival, Germany, is there with her habitual stolidity . . .

In what might be termed the unkindest cut of all, Ellen Henrotin, Mrs Palmer's friend, wrote a piece for *The Cosmopolitan* magazine for September, 1893, called "An Outsider's View of the Woman's Exhibit." Mrs Henrotin's opinions were brief and clear:

The court of the Woman's Building has a frieze at each end, painted by American women, Mrs Mary MacMonnies and Miss Cassatt. Both decorations are too high to be effective and the space is too small in which they are placed . . . Mrs MacMonnies' work is reverent in tone and dignified in treatment. This frieze is not divided by sharp lines as is that of Miss Cassatt, and if hung where it could be seen to better advantage, would be the most successful example of mural decoration in the building. Miss Cassatt's panel is 'cynical,' and is the one note of discord in the harmony of color.

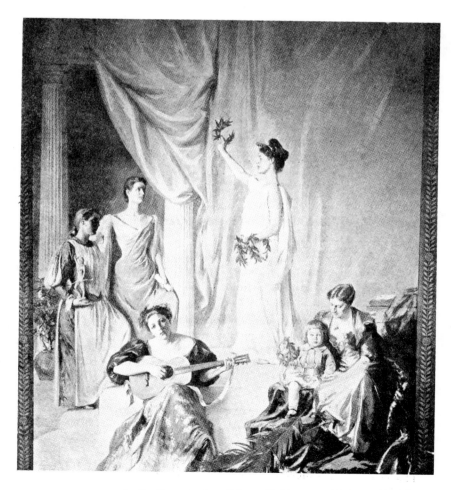

Lydia Emmett: Art, Science & Literature

Mrs Henrotin then turned to the panels painted by Rosina Emmett Sherwood and Lydia Emmett, whom she called "Emma Sherwood": while the frescoes in the main hall were too high, the Emmett-Sherwood panels were "too heroic in treatment and hung too low to be seen to advantage."

Mrs Henrotin put most of the blame on those who had arranged the displays.

Anne Whitney's statue of Leif Ericson is a masterwork of art, deserving to be placed where the nobility of the proportions may be seen. It is at present, unfortunately, hidden from view by a pillar behind it, and the fountain in the center of the rotunda in front of it.

All her comments were not negative: she admired Dora Wheeler Keith's decoration of the library. Of the pictures in the "Rotunda" she liked only "Jean and Jacques" by Marie Bashkirtseff, and Miss Cassatt's pastel.

Viewing the entire collection of paintings as a whole, they seem comparatively inferior to the other exhibits, lacking warmth, color and depth of tone. Woman has not yet (if the collection in the Woman's building is a faithful representation of her work) mastered the art of painting. The exquisite etchings and drawings by women emphasize what is lacking in the paintings, which is not woman's inability to master technique, but her inability to use color.

Mrs Henrotin's conclusion must have stabbed Mrs Palmer all over again, since it brought the discussion full circle to Miss Hallowell's original point:

The most valuable exhibits are those of the applied arts, in which tapestry, china, stained glass, mechanical drawings and fabric may be included.

A newspaper clipping preserved in the Ladies' scrapbook comments on this *Cosmopolitan* article:

Mrs Henrotin has raised a tempest in a teapot by her article . . . in which she handles art in the Woman's Building without gloves. While her denunciation of women as artists may seem somewhat sweeping from the standpoint she has taken, its truth must be acknowledged.

The general feeling of the Ladies about their own Gallery of Honor roused the *New York Times* to comment:

The women themselves are somewhat ashamed of their fine arts exhibit, and excuse themselves by saying that most of the fine painting by women can be found in the Fine Arts Palace. Yet the display is creditable. Especially is this true of the French exhibit, and is only less so of New York.

Angelica Kauffman: Girl Plaiting Her Hair

The *Times* then went on to praise "Daphne's Nymph" by Dora Wheeler Keith.

Mrs Palmer responded to all this by saying that the best works of art at the Fair could be found in the Fine Arts Palace. Dr Gould, who had been given the task of writing a summary of the exhibits for the Commission, was told by Mrs Palmer "to generalize and speak more of the remarkable productions of the past, rather than of the present." In painting and sculpture especially—a rather large area—she believed that women had "not done themselves very great credit."

Sara Hallowell made the best of a muddled job in the chapter which she wrote for the Woman's Building Catalogue. She said ambiguously that it was impossible to mention more than a few of the exhibitors, because "there are among us so many women artists whose work is serious and fine."

Mary Cassatt's mural is now lost, apparently forever. We have only some photographs, some studies, and a crudely colored lithograph. Frederick Sweet is content to accept the general contemporary verdict of the work and dismiss it, since Miss Cassatt was not working in a medium familiar to her. He believes she was out of her depth. But Miss Cassatt in the early nineties was painting at the height of her powers: there were many critics in France

I SEE DOZENS OF FOLKS WEEPIN' QUITE HARD BEFORE SOME ON 'EM.

who ranked her among the finest living painters, regardless of sex. Her work was disliked in the United States. In 1895 an exhibit of her work in New York was poorly attended and few paintings were sold. She wrote to a friend that she was "very much disappointed that my compatriots have so little liking for any of my work." The same exhibit in France in 1893, in the gallery of Durand-Ruel, had won praise and respect from her friends, the Impressionist painters who were surely doing the most important work at that time. It seems unlikely that Miss Cassatt's mural was unworthy of her. She herself had worried about the height at which it would be hung, and it is true that people had to crane their necks to look at it. It is unfortunately possible that if it had been easier to see, it would have been greeted by more disgust and anger than it elicited in its niche near the ceiling.

The blame for the failure of the Gallery of Honor fell squarely upon Mrs Palmer's shoulders. In retrospect however it would appear that she did the best she could. In the Court of Honor she hung works by Mary Cassatt, the American painter ranked with Whistler by French critics; if she failed to get "The Horse Fair" she did find three fine lithographs by Rosa Bonheur and other excellent etchings by talented women. When one examines the works of art scattered in abundance about the White City, one sees clearly that the end of the nineteenth century was not a golden age of art in America. The "gorgeous wealth of mediocrity" was not confined to the Woman's Building. In this instance one can say with sympathy that Bertha Palmer was a prophet without honor in her own country.

Main Floor Paintings

THE FERRIS WHEEL WUZ INDEED NIGH TO US, AND I FORGIVE JOSIAH
FOR HIS ARDOR WHEN I SEE IT.

HE traditional concerns of women include the care of children, and food and lodging for the footsore traveller. As the displays in the Organizations Room attested, middle-class women had, for more than fifteen years before the Fair, been increasingly concerned with the plight of poor women. Factory workers had been sheltered from the physical proximity of evil-doers by boardinghouses and clubhouses; employment services and domestic science classes had been set up to entice the girls to leave the factories for good Christian homes, not necessarily their own. The interests of female philanthropists extended from single women to what might be called the industrial family: wives and children of workingmen. It was natural that the Board of Lady Managers should try to help "industrial women" who might wish to visit the Fair. Mrs Palmer had once wanted a childhood education exhibition to be set up in the Liberal Arts Building; it was natural to think of using such an exhibition to stimulate children mentally and physically, and at the same time relieve their mothers of caring for them at the Fair. The YWCA had set up boardinghouses in large cities; the Board could follow their example and set up its own boardinghouse for female Fair visitors, at a low cost and without religious proselytizing.

The Board was interested in dormitory and childcare facilities, not only because of progressive humanitarian concern. On July 1, 1891, the Illinois Women's Board was officially funded. Mrs Palmer had lobbied hard for this Board; it was intended to be a model for state and territorial boards throughout the country. Nevertheless the feelings of the resident Chicago women were mixed. Frances Shepard was the only one of the "Chicago Nine" appointed to serve on the Illinois Board. Counting Alternates, and not counting Sara Hallowell, who was busy elsewhere, there were seventeen women in Chicago who saw clearly that their prerogatives may well have been snatched away from them by this

new Woman's Board. They needed to act quickly, to mark out an area that was their own, before they were cut out of local activities altogether.

When Mrs Palmer returned from Europe in 1891, she met with the Chicago Lady Managers and Alternates. Matilda Carse had once suggested building a Dormitory for single women. She had had invaluable experience when she supervised the construction of the WCTU Woman's Temple. Accordingly, Mrs Carse was put in charge of the Dormitory project.

Mrs Palmer swiftly resuscitated the childhood education plan, deciding that it would be best housed in a special Children's Building. Emma Dunlap, whose husband George had founded the village of Norwood Park, was the mother of six children; the welfare of children was her special interest. Accordingly, Mrs Dunlap was given the directorship of this children's project. Julia Shattuck was made Secretary for both projects, and the Chicago women plunged without further ado into these new plans, which would preserve their status as the "hostesses" of the Columbian Exposition.

Woman's Dormitory Stock Certificate

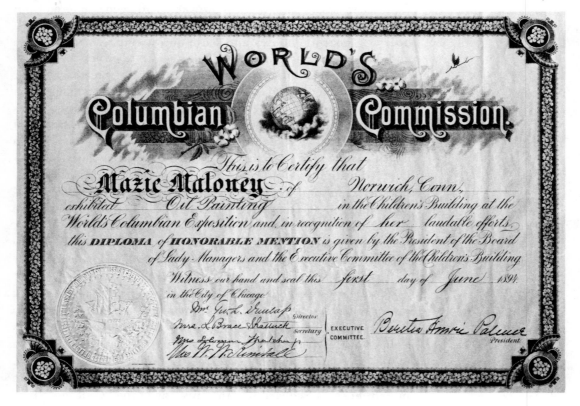

Mrs Carse formed the Woman's Dormitory Association of the Columbian Exposition. Stock in the form of engraved certificates were issued at ten dollars a share; each share included coupons for a total of twenty-five days free lodging. These coupons were worth forty cents apiece and were transferable. The rate for lodging was not to exceed forty cents a day for stockholders; non-stockholders would pay fifty cents a day. If the venture should show a profit, stockholders might collect dividends. The plan was presented not as a charity, but as an opportunity for poor women to make an investment.

A certain number of certificates were allotted to be sold by each state. "The time is short," the Lady Managers were told in a circular, "the work immense. Will every Lady Manager write and tell us if she will place the amount of stock allotted to her state." The Board's intention was to provide "for the great army of women that would visit Chicago . . . a good clean safe home at reasonable prices . . . supervised by a refined, motherly woman who will have a watchful care over unprotected girls."

The state boards entered enthusiastically into the sale of the stocks; Mrs Carse embarked on a search for a site for the Dormitory. George Pullman, the inventor of the sleeping car, was asked for the free use of some land which he owned on the lake front near the Fairgrounds. Mr Pullman agreed to lend the Ladies the land. While plans went ahead for the building, Mr Pullman underwent a change of heart and withdrew his promise. As compensation he offered the Dormitory Association a cheque for $2000. They accepted this, but told Mr Pullman that if their enterprise succeeded in becoming self-sustaining, as they intended it should, they would return his money to him.

Mrs Carse soon found another piece of land which covered an entire block on Ellis Avenue between 52nd and 53rd Streets in a pleasant section of Hyde Park. It was one mile from the Fairgrounds, and two blocks from the five cent cable car which ran on Cottage Grove Avenue. An unoccupied red brick house stood on the grounds. This could be used as a dining hall annex. Consequently the Dormitory Association leased both the land and the house, with the understanding that after the Fair they would leave the property in the condition in which they had found it, except for a fence which they would erect at their expense.

Women from the Atlantic to the Pacific were eager to become stockholders; many requested stock for members of their families. Wealthy and prominent women bought certificates and gave them as gifts to industrial women.

Plans were drawn for a simple two storey frame structure built around an inner court, with sleeping rooms for approximately one thousand women, and eight good-sized sitting rooms as well. Mrs Palmer paid for the plans herself; these were submitted to

the Board and approved before the President's departure for her second European trip in the spring of 1892.

The Dormitory, constructed of Georgia pine, was completed by April of 1893. Each room had a window which overlooked the street, the back yard, or the inner court. The eight sitting rooms or parlors had windows enough to make them bright and sunny. Four of these parlors had coal-burning fireplaces with their own chimneys, for use on cool days.

The Directors refused to use second-hand furniture in their Dormitory. They wanted everything to be uniformly designed and uniformly clean and cheerful. Each room, half of which were single and half double, was furnished with wire-spring cots, dressing tables with looking glasses, wash stands and chairs. The bedrooms were lighted by candles, but the halls and sitting rooms had gaslight.

The red brick house was taken by Mrs Clark, who was well known in Chicago for her "home cooking." Mrs Clark and her employees undertook to provide meals for Dormitory residents only: a "good generous breakfast" for 25¢; dinner with "three courses of meat" at 50¢, and a separate lunchroom or snack shop which would serve coffee and rolls during the day.

WOMAN'S DORMITORY BUILDING, AT THE EXPOSITION, 1893.

Guests were asked to make room reservations at least two weeks in advance. Although non-stockholders had to pay 50¢ a day, they could lodge for twenty-five days for $10. Children could sleep with their mothers at half rates. The Dormitory was plain, with rough wood, but the Directors emphasized that it was not a "shanty"; it would be "a place of quiet" because many of the stockholders were elderly ladies who had purchased their stock not from financial necessity, but because they wished to avoid the "noise and confusion of large hotels." The freedom, safety and cheap rates of the Dormitory attracted artists, teachers, nurses and other self-supporting women. "Industrial women" did come, but they were in the minority.

Julia Shattuck

A considerable staff had to be engaged. Here the Directors had a problem, because they could not find a woman who had run an hotel. Finally they engaged the inexperienced Sada Harrington as manageress. Her staff consisted of twenty-seven women, including a five foot, one hundred pound security guard. Two men were hired as porters to carry heavy luggage. Arrangements were made for wagonettes to travel every hour from the Dormitory to the gates of the Fair.

By April 24, 1893, when the building officially opened, the Association had received reservations for five hundred rooms, beginning on the first of May. The preparations had involved hours of gruelling work. Julia Shattuck, the Association Secretary, wrote to Mary Logan requesting that the Dormitory be endorsed as an Auxiliary to the Board of Lady Managers. She commented on the fact that some Ladies had wanted to call the building a "Family Dormitory"; this had caused some controversy, and the "Family", she said, had better be dropped. She appeared to find the suggestion frivolous. "The whole affair has absorbed too much of our energies to be lightly treated," she wrote testily. "The ladies should understand that it is an immense undertaking."

If Julia Shattuck's nerves were frayed because of preparations, they must have been in tatters after the Dormitory actually opened its doors to the public. Many of the women who had sent in reservations did not come, partly because the weather was unseasonably cold, and partly because of a financial panic caused by a sudden drop in the price of silver. Railway rates were high. Dormitory personnel were disconsolate, but were at the same time lulled into a false feeling that they were equipped to cope with the demands of patrons, despite their inexperience. At the end of June railway fares dropped: visitors swept down upon the Dormitory like a whirlwind. During the last week of June and the first two weeks of July twelve hundred women demanded accommodation in a building designed to hold one thousand. Many of these women had no other place to stay. Tempers flared. One irritated stockholder commented:

> The building itself is exactly what was promised—rough, plain, but excellently planned and with irreproachable sanitary arrangements. There all praise ends. The management is in a state of chaos. The matron who assigns rooms holds no communication with the Secretary who communicates with stockholders.
> Persons who had engaged rooms months in advance could find no accommodation. Any remonstrance at the office met with a most unnecessary discourtesy.

So much for the refined motherly caretaker. Sada Harrington cowered in her office, writing frantic notes to the Director of the

Association. People as far away as New York began to write, too, saying that they heard that stockholders were being turned away from the Dormitory. A crisis had developed. One hundred and fifty new cots were hastily purchased and set up in the parlors: this arrangement expanded accommodation without disrupting service or generating much complaint.

Things began to simmer down. The Ladies received "testimonials" from satisfied visitors. Mrs Sara J. Barnes, of the Louisville Training School for Nurses, had sold many shares of stock. Her thrifty friends, wage-earning women "who knew the value of a dollar", had but one opinion, she said: perfect satisfaction, coupled with "genuine gratitude to the courageous Chicago women who planned such a success."

The use of "testimonials" betrays the Ladies' awareness that the Dormitory was indeed an "immense undertaking," which required more preparation and capitalization that they had been able to provide for it. They went to the trouble of giving a sort of explanation:

> The Board did all in its power to make the guests of the hotel comfortable; that they sometimes failed, none regret more than the members of the Board; but it must be taken into consideration that it was a new venture for women and they were hampered by the need of great economy in the management, and the impossibility of finding women educated in the conduct of large hotels.

Some guests of course expected more for their forty cents than any big hotel would have given them at several times that rate. Mrs Shattuck wrote to Mrs Palmer in August, 1893, that a New Hampshire stockholder had written and instructed the staff to send someone to meet her train, neglecting to mention the hour of her arrival or the name of the depot. She arrived eventually under her own steam and proved to be a woman weighing nearly three hundred pounds, in an hysterical condition, who said that she had used up all her funds getting to the Dormitory, and demanded that her stock investment be refunded to her. Mrs Shattuck, referring unkindly to the stockholder as "that elephant," commented further: "As our cots are none too strong I personally felt it would be good business policy to cancel her stock."

Despite all these difficulties, the Woman's Dormitory provided shelter for 12,210 women over four months. Since the Ladies were concerned only to keep their heads above water, they considered the enterprise a financial success. The building, designed by the architect James Gamble Rogers, cost $38,688.41. Rent for the land was $2500, and the furnishings cost $11,440. Nothing went back to the stockholders. Immediately after the Dormitory closed, the Directors still faced liabilities over and above receipts.

They, and not the stockholders, were personally responsible for this money. The Dormitory was torn down and the property enclosed by a fence, as had been agreed. The dismantled Dormitory was sold for $2239.

Great quantities of hotel furniture were being dumped on the market, but the Ladies went ahead anyway and sold their furniture, getting back about $3800. Enough additional was realised from sales to make the Association solvent. The final and most important word on the Woman's Dormitory is found in the President's Report:

> There was nothing remarkable about the great building of plain Georgia pine except that the plan was evolved from the brains of women who labored without fee or reward in order that those of slender means might have the advantage of seeing the Exposition at a very small outlay. It was unique in that it was the largest building ever erected for women, by women, and entirely managed by them. While most of the World's Fair hotels, conducted by men, failed and were in the hands of a receiver long before the close of the Exposition, the Woman's Dormitory has paid every cent of indebtedness, besides returning $2000 to Mr George M. Pullman, who generously advanced that amount at the inception of the enterprise. It will be seen from the Secretary's report that a small balance is still on hand.

The approach taken toward funding of the Children's Building was different to the approach toward funding the Woman's Dormitory. Since Mrs Palmer had conceived the Children's Building originally as an educational exhibit, she felt that it should be an integral part of the Fair and went immediately to the Directors for funds.

She was told that the Directors had no money for such a purpose. If however the Ladies could guarantee that they would have the money within sixty days—that is by the first week of June, 1892—the Directors would lease them the site which they wanted next to the Woman's Building. The Federal Government was approached with a suggestion that a stamp be issued, the proceeds of which could be used to fund the Children's Building. The Government had no interest in this plan; the Children's Building seemed to them to be a wildly fanciful idea with no reason for existence. In the face of official apathy toward a plan which seemed to them to be important on both humanitarian and practical grounds, Mrs Dunlap, Julia Shattuck, Evaline Kimball and Clara Thatcher, the prime movers here, decided to ask each state to raise an allotted sum toward the $20,000 that was needed. On April 9, 1892, the *Tribune* noted that quotas had been set that ran from twenty dollars for sparsely settled states like Alaska to $2000 for Illinois, New York and Montana. A strong appeal went out to Lady Managers across the country:

In many cases it will be impossible for the mothers to visit the World's Fair without taking their children, and in so doing they all wish the little ones, as well as themselves, to take the fullest advantage of the educational facilities there offered. With these ends in view, the Children's Home has been designed, which will give to mothers the freedom of the exposition, while the children themselves are enjoying the best of care and attention.

No plan having been made by the Board of Directors for a Children's Building, and no funds having been appropriated for this purpose, the Board of Lady Managers feels it necessary to take up the work of building and equipping a beautiful structure, which shall be devoted entirely to children and their interests. The board has secured a desirable location adjoining the Woman's Building, on which to build the Children's Home, but only on the condition that the necessary funds for erecting it be provided within sixty days.

In the Children's Home will be presented the best thought on sanitation, diet, education, and amusement for children. A series of manikins will be so dressed as to represent the manner of clothing infants in the different countries of the world, and a demonstration will be made of the most healthful, comfortable, and rational system of dressing and caring for children according to modern scientific theories; while their sleeping accommodations, and everything touching their physical interests, will be discussed. Lectures will be given upon the development of the child's mental and moral nature by improved methods of home training. The building will have an assembly-room containing rows of little chairs, and a platform from which stereopticon lectures will be given to the older boys and girls, about foreign countries, their languages, manners, and customs, and important facts connected with their history. These talks will be given by kindergartners, who will then take the boys and girls to see the exhibits from the countries about which they have just heard. They can make these little ones perfectly happy, and yet give them instruction which is none the less valuable because received unconsciously, and without the coercion of the ordinary classroom.

The women of Connecticut felt that "here was something we could understand and to which we could most heartily respond." They were the first to contribute their assessment, which was for $300. Montana voluntarily doubled its quota. Helen Brayton of South Carolina advanced the entire sum requested of her state from her own pocket, and was afterwards largely reimbursed through personal solicitation of charitable friends. New York raised more than its allotment of $2000 with its extra funds specifically earmarked for the nursery and the kitchen garden. In all, thirty-two states contributed to the Children's Building. New York's contribution of $2397.01 was the largest. Wealthy states— California, Massachusetts, Indiana, Iowa, Missouri and Ohio— which had been asked for $1000 apiece, provided nothing at all. Western states like Colorado, New Mexico and Arizona raised about twenty dollars each. The resident Lady Managers of Chicago pledged to give $100 apiece.

The sixty day grace period had nearly expired, and the Ladies had only $10,000 of the $20,000 they needed. Mrs Palmer asked for and was granted a six month extension, so that the women could continue their fund-raising through the 1892 winter holidays, when people might be feeling particularly generous. Potter Palmer, George Pullman, Marshall Field and N. K. Fairbank, a wealthy manufacturer of lard, offered to guarantee the $20,000 so that work could go forward, but the Ladies wished to continue their own attempts. A Children's Day Celebration held on Columbus Day in the schools brought in $461.34. The Ladies, in conjunction with the Friday Club, a young woman's literary group founded by Bertha Palmer, Ellen Henrotin and Annie Chetlain, put on a series of fund-raising events that culminated in a "Bazaar of all Nations", which was held in Mrs Palmer's house for three days in November. This was a great success: people frankly admitted that they wanted to see the interior of what had been called "the finest residence in the West." The Bazaar took in $48,077 of which over $35,000 went to the Children's Building. Although the weather was bad, on the third day $14,000 was received in admission fees alone. The women had earned more than the amount they needed, through their own efforts. It was not necessary to take the guarantee which had been generously offered by the four Chicago men.

Work at once went forward, although due to harsh weather actual construction could not begin until February. During the fall and winter of 1892 prices of building materials and other goods went up considerably, so that the cost of the Children's Building actually exceeded $30,000. The architect was Alexander Sardier of the Construction Department, who had designed the Palais des Enfants at the Paris Exposition of 1889. The French building had been very popular and attractive, but it was built only for the purpose of entertainment; an admission fee was charged for each exhibit expressly designed for the amusement of children. The Board of Lady Managers adapted Sardier's new building to their own idea of what a children's exhibit should be: a living model of enlightened methods of child care and education. The only fee charged was 25¢ for the admission of babies to the creche, or day nursery. This day care fee included food for the children.

The concepts behind the Children's Building reflected the changing attitude toward children in the latter decades of the nineteenth century. One of the most influential was the kindergarten movement, which had begun when Frederick Froebel opened the first kindergarten in Bad Blankenburg, Germany, in 1837; Froebel established a training school for kindergarten teachers in Liebenstein in 1849. Although his own government frowned upon his educational innovations, his attitudes were

studied with interest throughout the world, and especially in America. His book *The Education of Man* was published in English in 1877; *Letters on the Kindergarten* appeared in 1891. Froebel stressed the importance in early childhood of physical exercise, of self-learning in pleasant surroundings, and of religious training without negative connotations. The wife of Carl Schurz, Margarethe Meyer Schurz, heard Froebel lecture in Hamburg in 1849, and attempted a small kindergarten class in her house in Wisconsin in the winter of 1856-57, with her daughter and a few other children. However, Mrs Schurz's contribution to the kindergarten movement really consisted of her introduction of the movement to Elizabeth Peabody in Boston in 1859. A year later, Miss Peabody opened the first organized kindergarten in America. After she went to Europe in 1867 she developed a much firmer grasp of Froebel's ideas than she had been able to glean from Mrs Schurz; these ideas appealed to her in every way, including their emphasis on the spiritual, since she was an active Transcendentalist. She returned to Boston to found the *Kindergarten Messenger* in 1873 and the American Froebel Union in 1877. The International Kindergarten Union was formed in 1892 expressly to mount an exhibit at the Exposition. The time for the kindergarten had clearly come: with so many progressive women's organizations thirsting to help and uplift everyone they could reach, it would be strange indeed if they overlooked little children. Two speeches were given on the subject at the Congress of Women: one, entitled simply "The Kindergarten" was delivered by Virginia Thrall Smith, who established the first free kindergarten in Connecticut and succeeded in having a law passed attaching kindergartens to public schools in that state. Mrs Smith emphasized heavily the Progressive doctrine of the value to the community of investment in kindergartens:

Virginia Thrall Smith

> Every community stands under a moral obligation to give to every helpless child born within its border the best possible chance to grow into honesty and virtue. The expense to the community of prevention will be far less than that of any attempt at care in all the moral diseases caused by the poverty, ignorance or vicious surroundings of its young children.
>
> The poorest children in a community now find the beneficent kindergarten open to them from the age of two-and-a-half to six years. Too young heretofore to be eligible to any public school, they have acquired in their babyhood the vicious tendencies of their own depraved neighborhoods; and to their environment at that tender age had been due the loss of decency and self-respect that no after example of education has been able to restore to them.

But it was apparently not only the vicious infants in depraved neighborhoods that Mrs Smith was after:

It is a lamentable fact that all mothers are not fitted to train up infants in the way they should go. Even in the well-to-do classes there is a lack of knowledge, of the right temper, of experience, or of leisure to give the young child the kind of discipline that ensures good manners, good morals, or the kindly development of his natural powers.

Nevertheless Mrs Smith's real interests did not lie with the well-to-do classes, except insofar as they presented a model for the beneficent kindergarten:

There is no education in the world so valuable as that unconsciously imbibed in a refined and cultivated household before the child is six years old. But what shall we do for children who do not have homes at all worthy of the name?

Sarah B. Cooper

Mrs Smith had her answer ready:

We must pick out of the swearing alleys and gutters of depraved neighborhoods the neglected, harshly treated, half-fed and half-clothed, unwashed and uncombed prattling child, whose greatest knowledge of language is of slang and profanity, cleanse it and cover it with wholesome garments; teach it how to play and how to talk and what truth is, and so, lovingly and carefully, plant the germ of good in its receptive mind, and fill its hopeful heart with happy dreams of doing something noble in the future that the results must be beneficial to a great degree to the race we are trying to save.

A talk on "The Kindergarten as Character Builder" was given by Mrs Sarah B. Cooper, who had founded the Golden Gate Kindergarten Association of San Francisco, which at that time had "trained" more than 1600 children. Mrs Cooper discussed the need for kindergartens somewhat more abstractly than Mrs Smith and avoided holding up as an example the vicious half-clothed prattler, dallying in swearing alleys with its uncombed hair:

The kindergarten concerns itself more with the development of faculty than with the mere imparting of knowledge. It recognizes the fact that all true education is learning transformed to faculty. It does not ask so much, 'What does the child know?' as, 'Has the child learned how to learn?'. . . It is teaching the little child to teach himself. It is controlling the little child that he may learn the art of self-control. The senses are sharpened, the hands are trained, and the body is made lithe and active. The gifts and occupations represent every kind of technical activity. The children must work for what they get. They learn through doing. They thus develop patience, perseverance, skill and will power. They are encouraged by every fresh achievement. . . The universal instinct of play in the child means something. It should be turned to good account. It should be made *constructive* in its income instead of *destructive*. The restless activity of the child is the foundation of the indefatigable

enterprise of the man. This habit of work must be formed early in life, if we would have it a pleasure.

Mrs Cooper encouraged sympathetic understanding of the child:

> The kindergarten does not attribute every mistake of a child to total depravity. To be perpetually telling a little child, even a very naughty child, that there is no good thing in him, that he is vile and corrupt, is one of the very best ways of making a rascal out of him if he has any spirit in him, and of making a little hypocrite of him if he is mean-spirited and weak. And this holds equally true of all children, whether they come from the palatial homes of the rich or the wretched homes of the poor. . . All education is a growth, not a creation. And to all growth belongs the element of time. We are none of us born with the "trade of conduct" learned. The primal ideal of all government should be to teach a child to govern himself at the earliest possible period. And to learn how to govern himself a child must be indulged in self-government. The true teacher will be aiming all the time at the child's enfranchisement—not in making him an unwilling slave.

Mrs Cooper's eloquence was most persuasive; small wonder that she had a happy tale to tell of her successes:

> Fifteen years ago there was not a single free kindergarten west of the Rocky Mountains. There are now over sixty in San Francisco alone, including those in orphanages and day homes. . . from San Francisco. . . they have extended in every direction, from the extreme northern part of Washington Territory to Lower California and New Mexico, and they have planted themselves in Oregon, Nevada, Colorado, and almost every large city in California. . . No city in the Union has made more rapid strides. . . than San Francisco. . . persons of large wealth have been induced to study the work . . . and have become convinced of its. . . essential value to the state. . . Mrs Leland Stanford. . . has given $174,000 to the support of these. . . schools. . . Over eight hundred children have been under training in the Stanford kindergartens the past year. . . Over $450,000 has been given to me to carry on the kindergartens of the Golden Gate Association.

The Children's Building, which did not open until June, 1893, was wedged between the Woman's Building and the Horticulture Building. Nancy Huston Banks commented that it was "an Exposition building. . . only in the sense that it is on the Exposition grounds. The directory did not appropriate a cent towards it." Mrs Banks found the building's design to be in good taste, but "so destitute of architectural pretensions that its style may be dismissed as indeterminable." The white facade was decorated only with a frieze, painted blue, in which were set medallions depicting children of different races and countries in national costume. Over the arched entranceways were inscriptions such as:

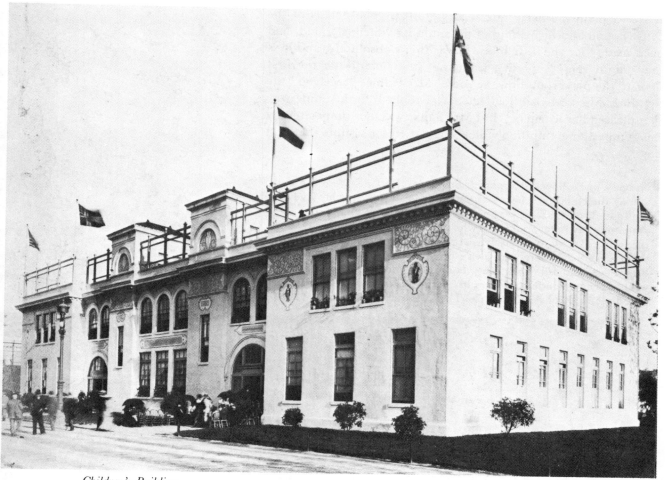

Children's Building

"The Hope of the World is in the Children." The building covered an area 150 by 90 feet, and was two storeys high. It had a 90 by 50 foot interior court which was open to the roof. In the center of this court a 70 by 40 foot area was railed off for use as a physical education exhibit set up by the North American Turner Bund, which promised to make children "strong and healthy, agile and courageous, keen, resolute and of cheerful disposition, graceful and perfect physically." Each morning, beginning at ten o'clock children were allowed to use the equipment: thousands of dollars worth, furnished free to the Board. There were trapezes, parallel bars, vaulting horses, rings, wands, Indian clubs, and more. Children impatiently waited for their turns outside the gates of the railing. Spectators could watch from the galleries above.

Nancy Huston Banks was present when the building was opened with public ceremonies on June 1. Music was played, and then came a "dedicatory speech" by Emma Dunlap, which, Mrs Banks said, "was not a speech in the accepted sense of the term.

It was a plain motherly talk." Mrs Dunlap gave details of the
construction and furnishing of the building which, she said, had
been made "for the little folks. It was theirs absolutely, and in it
they might reign supreme, from the tiniest cradle on the first
floor to the playground on the roof." Mrs Palmer "received" the
building. She was visibly affected and replied "in a simple way
that pleased her listeners." But Mrs Banks was most impressed by
the gymnasium exhibition which was put on for visitors that first
day:

> Nobody knew how it happened, but little girls only were present
> among the children. There was not a boy in the lot. It is not known
> that any discrimination was made against the little chaps who will
> vote some day in favor of those who may want to vote some day, but
> the girls had it all to themselves at the opening. And they acquitted
> themselves well. There were over a hundred of them, all pretty, with
> bright eyes and red cheeks . . . Half of them belonged to the Vor-
> warts Turngemeinde, and were in charge of Professor Henry Hart-
> ing, director of physical culture. They were dressed in pretty blue

Gymnasium in Children's Building

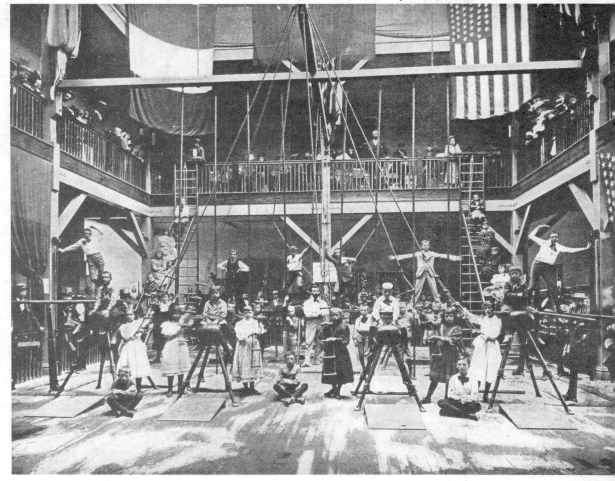

flannel suits trimmed with white braid, and could hardly wait until the older people got through talking to begin their program. . . The way those children performed was marvellous, and many a man who watched envied them. In perfect time they drilled, used the dumb-bells, and went through all the healthgiving exercises. . . They vaulted and climbed swinging-poles with exquisite grace. . .

A more motley crew used the exercise area after the building went into actual use: the children, boys as well as girls, of the Fair visitors.

When the morning's exercises were over, children could take a picnic lunch to the rooftop garden, which had a wire netting ten feet high to prevent the occupants from falling off, or from heaving the remains of their lunch onto the heads of passersby. The rooftop was ornamented with vines and flowers, and furnished with sand-piles and "low toboggans," toys, and other delights. An awning sheltered it from the hot sun or the rain. A writer mused in *Harper's Bazar:*

> There was undoubtedly much friction on the knees of stockings and the seats of trousers, but how much better it was than to wear out themselves and their mothers, dragging about looking at things they could not understand.

On the second floor in the southwest corner of the building was the room known as the "kitchen garden." Emily Huntington of New York had devised this novel method of developing in little girls a "knowledge of household duties" at the Wilson Industrial School where she had taught for twenty years. Her pupils, the children of immigrants, knew nothing about "homemaking." Her desire was to teach them, in pleasant ways. In 1875 she published *Little Lessons for Little Housekeepers* describing her methods. Shortly after this she visited a kindergarten and was inspired, in six weeks, to adapt the geometric forms which Froebel used in kindergarten play, to little pots, brooms and scrubbing brushes: a feminist's nightmare. Poor children, she said, could be taught by her method to make their homes more comfortable; they could also be fitted for domestic service. The name "kitchen garden" was a play on the word "kindergarten." Even Miss Huntington eventually took a dislike to this name.

The kitchen gardens spread throughout schools in New York. Grace Dodge, in 1880, before she had formed her first Working Girls' Club, was a volunteer teacher for Miss Huntington and organized the New York Kitchen Garden Association. By 1884 Kitchen Garden Associations were operating in Boston, Chicago, Cincinnati, Cleveland and Pittsburgh, and had found their way to Europe and Asia. Offshoots were the "cooking garden," with little cooks, and the "farm garden" which taught little boys the

elements of farming. Grace Dodge helped to organize the Kitchen Garden Association into the Industrial Education Association, which led eventually to home economics classes for girls and technical schools for boys.

The New York Board of Women Managers had early thought of supporting a kitchen garden exhibit at the Fair. On September 7, 1892, Miss Huntington was invited to the New York Board meeting to discuss the proposed exhibit. She said there was no way to show her system except by having children themselves demonstrate it every day. She asked for $2500 to cover expenses, which would be large enough for a "live" exhibit, and this was voted to her by the Board. She was given complete control of the exhibit, subject to control from the New York Board of Women Managers' Executive Committee.

The Broom Brigade, in the Children's Building.

Two rooms were assigned to her on the second floor of the Children's Building. She arrived at the end of April to find that the building was not yet ready to open. Not wishing to waste time, she had already contacted the Cook County Normal School and the Chicago Kitchen Association, two or three of the teachers of which became her assistants. Arrangements were made with the parents of twenty-five little girls to allow them to

come to the Fairgrounds every day at three o'clock, and with the Fair authorities for transportation. All the children had to be taken to and from the grounds in wagonettes. Miss Huntington drilled the children in the gymnasium of the Cook County school, so that she was ready to begin her exhibit the day the Children's Building opened.

The same twenty-five children did not have to come each day; children from the Normal School and the Mission School relieved them at stated times during the week. Miss Huntington had agreed to direct the exhibition herself during the entire six months of the Fair, but she found the work something of a strain, and went back East for two and one half months, leaving the work in the capable hands of Miss Larrabee, who had been her student years before. One hundred and seventy-five children underwent kitchen garden instruction during the Fair.

The little girls did their work to piano music and sang nursery rhymes altered for the occasion, as "O dear what can the matter be, Cook has forgotten the salt." Charmed visitors watched the children perform through large glass windows: each little girl wore a "quaint costume of white muslin cap and apron, proudly displaying a badge of miniature knife, fork and spoon crossed and tied with ribbon." In the center of their room were low tables with tiny beds on them. Elsewhere in the room were tiny brooms, dishes, washtubs and scrubbing boards. Nancy Huston Banks described their activity:

> The little beds were all mussed up and, two little girls to a bed, they started in to make them up. First the mattresses were turned and punched to a degree of softness. The sheets were spread with the hem turned the right way, the blanket put on, spread, and then came the tucking-in process. No danger of that tucking coming out. . .

The tuck, Mrs Banks said, was a "regular home-made one", not a boarding-house tuck. After the beds were made up, she said, half the people who watched wished they were tiny enough to crawl right into them.

> While the beds were being made, other little girls were sweeping the room. They did not sweep around the middle, but went into corners in a way which, if it is carried into later life, will cause some man to call them blessed. Others got down on their knees and scrubbed, and some went to the washtubs and, with sleeves rolled up over pretty little arms, made dirty doll clothes look as white as snow.

When the Infanta Eulalia of Spain visited the Children's Building she was so impressed with the "little housekeepers" that she asked for one of their badges as a souvenir, and left wearing her crossed knife, fork and spoon.

For older boys and girls—eleven to fifteen—there were wood-carving and claymodelling workshops. Mrs Quincy Shaw had paid $5000 for the workbenches, tools, materials and teacher's salaries. The supervisor was Gustav Larsson, a Swedish artist. Pauline Agassiz Shaw had founded the Sloyd Training School in Boston for teachers who wanted to use this woodworking technique in their own schools. Gustave Larsson adapted the Swedish method to the American workshop. The method was intended, he said, to combine the practical and the imaginative by "treating the hand, like the eye or the ear, as an avenue to the mind."

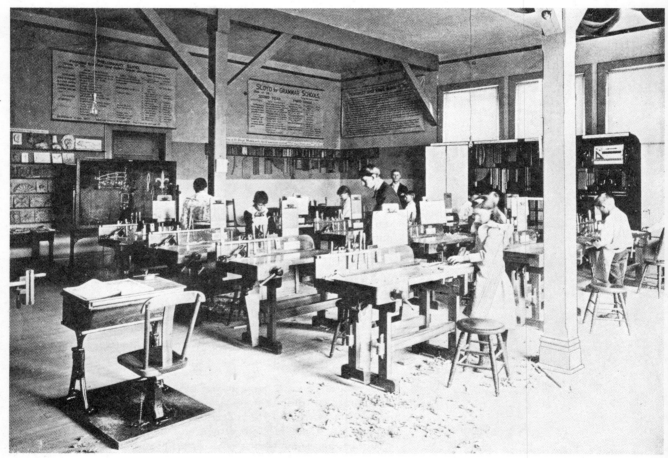

Sloyd School

The clay working sessions followed Sloyd methods, with the more flexible medium. Young people came to work there under the direction of T. M. Hollandorf of the Boston Industrial School; they were so absorbed in the work that they did not appear to notice the crowds of people watching them. Mrs Shaw was a dedicated philanthropist who supported thirty-one kinder-

gartens in Boston, Cambridge and Brookline. She had told her children that she felt her husband's fortune to be a responsibility:

> I had too much—you will all have too much and it will require great effort with God's help to determine to give rather than to hold, and to think deeply as you spend; to spend for progress and welfare rather than for pleasure or temporary amusement. . .

Mrs Shaw's exhibit was successful: among the visitors were members of the Minneapolis Board of Education, who were so impressed that they instituted similar workshops into their school system.

Another dedicated woman was Emma Garrett, who had graduated first in a class of twenty-one from Alexander Graham Bell's course for the teaching of the deaf in the Boston University School of Oratory in 1878. Lip reading was at that time an innovation; sign language was the approved method of teaching the deaf. In 1881 Miss Garrett was placed in charge of a new Oral Branch of the Pennsylvania Institution for the Deaf and Dumb. She believed firmly in the "oral method", saying that deaf children should be taught like the hearing, but must be reached "through the eye instead of the ear." In 1892 Miss Garrett and her sister Mary, who had joined her in 1889, opened the Pennsylvania Home for the Training in Speech of Deaf Children Before They are of School Age. In June 1893, just at the time the Children's Building opened, the state of Pennsylvania assumed financial responsibility for this school renaming it the Bala Home, obviously only partly because it was located near the suburb of Bala. Children were admitted to this school at the age of two, and remained in residence for six years.

Pennsylvania funded the Garretts' exhibit, which moved many visitors to tears. The children were taught with words rather than with phonetic sounds: the results were evidently so amazing that people could not believe the children were really deaf.

Despite the state's undoubtedly welcome action in taking over her school, Emma Garrett appeared to be having emotional difficulties during that summer. By July her behavior had become so erratic that Mary Garrett arranged to have her admitted to a sanitarium in Wisconsin. On July 18, the night before she was to leave, Emma Garrett committed suicide by leaping from the window of her hotel. She was forty-seven years old. She was well known enough so that a memorial service was held for her at the University of Chicago by the American Association to Promote the Teaching of Speech to the Deaf. Attending were, among others, Alexander Graham Bell, Sarah Fuller and her pupil Helen Keller. Mary Garrett continued the program at the Children's Building until September 15. She distributed 40,000 leaf-

Mary Garrett

lets describing the oral method. When she left to return to the Bala Home, Mary McCowen of Chicago took her place with classes from her School for Deaf Children. Both these exhibits helped to integrate lip-reading into the education of the deaf and to emphasize that this teaching must begin early. Mary Garrett said:

> The pupil can never make up the loss of the years before the school age, any more than hearing children could if they were deprived of all knowledge of speech and language until they are sent to school . . . it has been proved by experience that if the attention of the deaf child be directed to the mouth . . . and it be talked to just the same by everyone who is with it, that it will learn the speech and language through the eye which the hearing child learns through the ear.

Nursery Amusements.

In an alcove on the second floor was an exhibit of toys and games. The Lady Managers had requested donations from toy manufacturers all over the world. Since the Children's Building was planned and completed later than all the other Fair buildings, the response to this request was not as great as the Ladies would have liked. Foreign Commissions also did not respond to requests for information about child life abroad. However there were a great many toys sent by France; contributions came too from Germany, Russia, Turkey, China, Japan and Scandinavia. Possibly the children's own contributions made up for any dearth of manufactured items. The Ladies had not thought to request gifts from children, but they came in anyway and were placed on exhibit. A Christmas story written by a ten year old Chicago girl was sent in, with photographs illustrating it taken by her twelve year old brother. Myra Michaels, a six year old, sent a pair of dolls' stocking knitted by her, from Nova Scotia. Carleton Herrick, who was seven years old, contributed a top which he had invented and for which he had taken out a patent in Washington. There were nearly two hundred of these examples of children's work: wood carvings, embroidery, photographs, needlework, knitting, and not least "artistic paper cutting by Master V. Edgeworth Smith of Baltimore Maryland."

The creation of the building's library had required some ingenuity. The idea was originally, Emma Dunlap said, "to select the library from the child's and youth's standard, not from the point of view of the adult." Books children really liked were to be on the shelves, not books thought "suitable" by adults. Clara Doty Bates, a local writer of stories and poems for children, was asked to be librarian. She contacted public and private schools, asking that students be questioned about literary preferences. She herself asked "boys and girls of all ages" to send lists of their favorites, and received hundreds of letters. Not surprisingly, boys

wanted "fighting books" and girls asked for "stories and poetry." The most popular book with older children of both sexes was George Eliot's *The Mill on the Floss*. This *was* a surprise, and no one could account for it. Mrs Bates happily requested free copies of all these books from the publishers, who refused to send them. A good many demands had been made lately upon the resources of these firms, and the Children's librarian was too late. The publishers would send no more free books to anyone. Mrs Bates was faced with a library "of a novel kind—one entirely without books."

The Ladies would not be stopped by this sort of thing. Letters were written to authors of children's books at home and abroad, requesting autographed copies. This appeal to goodwill, to say nothing of vanity, proved "most effective," Mrs Dunlap said. "A very interesting collection of authors' copies has been made. So much for the nucleus of the Library."

To decorate the room, Mrs Bates again used ingenuity. *St Nicholas, Harper's Young People, Wide Awake* and the *Youth's Companion,* all children's magazines which had published her contributions, sent original sketches from their pages, manuscripts, autographs, and illustrations of "the various processes by which, step by step, a complete magazine is produced." Besides this, more than a hundred photographs of writers autographed whenever possible, were affixed to the walls, along with prints of drawings and paintings of them. There were also loans of manuscripts, artists' sketches for books, and photograph collections. One collection was of "views of all the haunts of Henry D. Thoreau, together with various portraits of him." Mrs Bates recognized that this writer was not "in any sense" a writer for children, but she wished to "attract their attention to his high pursuit of nature." Each month fresh copies of children's periodicals were placed out on low tables for the use of small visitors. Some illustrated books had been donated, "with the stipulation that children are to have them in constant service."

In all, the library held 600 volumes, 150 of these were signed copies sent by authors. Mothers and teachers from remote places stopped by to inquire about the best books for various age groups. Many visitors, old and young, had never seen anything like this room, with its muslin curtains, cheerfully decorated walls, and piles of books and magazines. They gazed "in rustic amazement." Mrs Bates said ecstatically:

Children from every part of the country have haunted the room . . . to lose all knowledge of outside wonders and beauties under the spell of some favorite book. They wearied of sight-seeing and pageantry, but never wearied of stories.

Emma Dunlap

Another educational amusement could be found in the Assembly Room, the walls of which were decorated with panels depicting life-size figures from Grimm's Fairy Tales. Despite these, and despite what Mrs Dunlap called "rows of little chairs," this room was designed for older children, around the age of fourteen. "Of course," Mrs Banks wrote coyly, "a girl is not a child at all when she has attained that age; but a boy sometimes is still content to remain small enough and to retain an interest in things juvenile enough to entitle him to the appellation of child." For these children, lectures were provided, with stereopticon illustrations "about foreign countries, their languages, manners, and customs, and important facts connected with their history." These talks were given by "kindergarteners," which meant of course kindergarten teachers, who took the children, after the lectures, to see the exhibits of the countries they had heard about and seen slides of. "Mr T. H. MacAllister of New York" had generously given the use "of the most approved stereopticon for this purpose, and the services of an operator of the same during the entire Exposition." This audience-room was also available for "musical, dramatic, and literary entertainments . . . carefully planned to suit the intelligence of children of various ages." Mrs Banks said that the talks were "not so 'babified' but even older people [could] enjoy them."

Wants to see the Fair with Mama.

The Children's Building was one of the most popular buildings at the Fair. And the most popular exhibit in the Children's Building was the nursery, which took up two rooms on the first floor. Mrs Banks attempted to describe it:

> They are the brightest rooms in the building . . . presided over by trained nurse girls dressed in striped dresses and wearing white caps. There are rows of cradles for very little people, rows of beds for those a little older, toys of all kinds, spring chairs hung from the ceiling, where babies can jump up and down and "go," and in the center is a place they call the pond. It is an enclosure fenced off as a playground for the little people who can only creep. Anyone who has a little tot and cannot leave it alone and cannot go to the Fair without it need not carry it around. The nurse girls are there to take charge of them, and they will receive every attention.

Prompted by who knows what consideration, Mrs Banks added: "Boys are not barred from the nursery."

These nursery exhibits were undertaken by the New York Board of Women Managers, which had already contributed its allotted $2000 to the Children's Building from its $25000 appropriation, and which was also to supply $2500 to Emily Huntington's kitchen garden exhibit. The chairwoman of the New York Board's Philanthropic Committee was Josephine Jewell Dodge, who had been appointed to the Executive Committee in Novem-

ber, 1892 after one woman's retirement. Her husband Arthur
Dodge was the founder of the Charity Organization Society of
New York; his niece was the ubiquitous Grace Hoadley Dodge.
Having married into so earnestly philanthropic a family,
Josephine Dodge chose nursery care as the special object of her
attention. She was inspired to found the Virginia Day Nursery in
1878; at that time day nurseries were modelled after the French
creches, where babies were cared for solely to ease the burdens of
working mothers. By 1888, when Mrs Dodge founded the Jewell
Day Nursery, nurseries had taken on the progressive educational
aspects of the kindergartens.

Also on the New York Women's Executive Committee was
Maria Love of Buffalo, who supervised the Fitch Creche and
training school for nursemaids in that city. Miss Love was one of
the New York Lady Managers who made a pilgrimage to Chi-
cago in 1891 to seek inspiration and advice about state work. At
that time the Children's Building was planned, although it was

Nursery

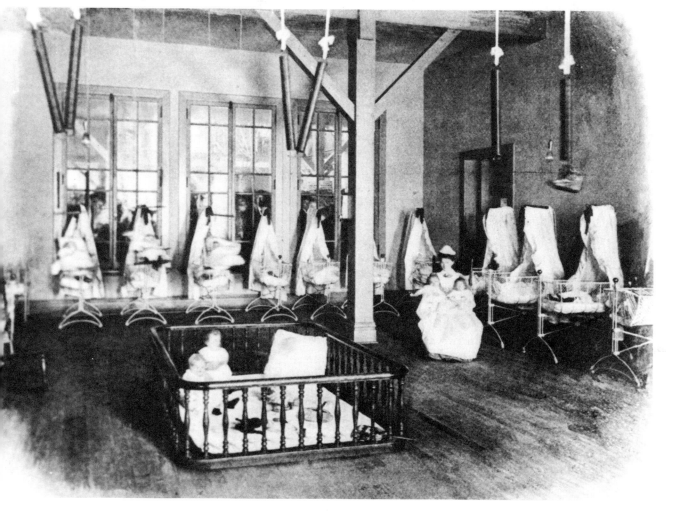

"little more than a dream." Mrs Palmer, on the eve of her first organizing trip to Europe, suggested to Miss Love that it might be a good idea to exhibit the Buffalo Creche and school, with its kindergarten, in the proposed Children's Building, in order to show "how day nurseries in large cities are managed, this being considered the most advanced philanthropic work on record, as the children are educated and the mothers rendered self-supporting."

When the Children's Building became a reality, the New York Women's Board decided to implement Mrs Palmer's suggestion by exhibiting advanced day care methods. No such exhibit had ever been made, but Mrs Dodge, as head of the Philanthropy Committee, was confident that it would be a success. Nearly eleven thousand children had attended day nurseries in every state and territory in the Union. After the Board had decided to go ahead with this exhibit, "several individuals engaged in philanthropic work" predicted that "a certain class of women" would seize this opportunity to deposit their offspring at the exhibit and vanish, never to be seen again. This prediction shook the women, but did not divert them from their purpose.

Mrs Dodge planned a complete exhibit of kindergarten methods: such an exhibit was successfully accomplished by some Chicago organizations in the Illinois State Building. However when the Kindergarten Association of New York met to discuss the matter, they could not come to an agreement about an acceptable method. Mrs Dodge was forced to abandon her arrangements, which had been nearly perfected, and settle for a much simplified program.

In order to represent the state outside of New York City, the Board decided that the methods of Miss Love's Fitch Creche and training school should be demonstrated during the first three months of the Exposition.

There was no precedent for these exhibits, so the Board did not know how much costs would be. They believed they would be similar to the costs of outfitting and setting up an "entirely new and very large nursery." Mrs Dodge asked for $2500—the same amount requested by Miss Huntington—and volunteered to pay the rest of the expenses from private contributions. Miss Love also arranged to receive private donations.

Maria Love had intended to bring the Buffalo Creche to Chicago on the first of May, 1893. This of course proved to be impossible because of construction delays in the Children's Building. She put off the journey for a few weeks, but when she arrived things were still disorganized. Both she and the Board of Lady Managers had hoped to open the exhibits during May, but this proved to be impossible. Miss Love encountered all sorts of diffi-

culties and harassments in the process of putting her display together.

One important aspect of the day nursery was the provision of food to the children. A kitchen and a cook were a necessity. There was one kitchen in the Children's Building. Miss Love took this over, undertaking the preparation of food not only for her day nursery group and the older kindergarten group, but for the twenty-five deaf children who made up the Garrett sisters' exhibition. Miss Love personally supervised the entire demonstration, assisted by her matron, Fanny Harris.

Between them they cared for about fifty children a day. Miss Harris had ten assistants during the latter part of her term.

Mrs Dodge could not visit Chicago for more than a week at a time. Consequently her exhibit was established according to her plans by her matron, Margery Hall, who took entire charge of it, with eighteen assistants. Mrs Hall had an easier time than Miss Love, having come later, when things were running relatively smoothly. Like Miss Love's exhibit, Mrs Dodge's had three actual "methods" to demonstrate: the nursery, the training school for nursemaids (Miss Dodge's training school was supplied by the New York Babies' Hospital) and a kindergarten class for older children. During Miss Dodge's term, seven thousand children were cared for; an average of one hundred a day.

A fee of 25¢ was requested for each child to cover the cost of food. Otherwise the nursery and kindergarten services were free. Fresh milk was provided by the Fair's dairy exhibits. Laundering was done by the Fair laundries. The nursery had far more business than it could accept. The limit of one hundred children was pressed every day; on some occasions it stretched to include as many as one hundred and fifty-three. The nursery opened at 8:30 every morning. As early as seven o'clock a line of parents had al-

ready formed, waiting to "check" their children for the day. There were three "checks" for each child: one was pinned to the back of its dress, one was attached to its discarded outer garments, and the third was given to the parent.

Marietta Holley commented on this checking system in *Samantha at the Fair:*

> And speakin' of babys, I met Miss Job Presley of Loontown.
> And I sez, almost the first thing, 'Where is your baby?'
> And she sez, 'It is in the Baby's Building'. I have got a check for
> her—one for her and one for my umbrell."
> And she showed 'em to me.
> 'Wall," sez I, "that is a good, noble idea to rest mothers' tired
> arms, but it must make you feel queer.'
> And she said, as she put the check back into her port-money 'that
> it did make her feel queer as a dog.'

Not only Miss Holley made merry over the nursery. The press mentioned that mothers checked their children like luggage. The nursery was called "a howling success" and a "baby farm." The Lady Managers were indignant, particularly about the latter appellation. Some of them were sorry that they had included a nursery in the Children's Building at all: it was intended to house a group of serious exhibits. Some of the nurses, the newspapers said, were forced to care for as many as seven babies at one time: "one in a jumper, two across her knee and four in the Siamese cradle."

This Siamese cradle was actually two "curious cradles" donated by a Siamese Commissioner who was interested in instituting day nurseries in his country. These cradles had deep sides made of colored knitted silk cord; they swung from "carved supports of dark Oriental wood." Each cradle was large enough for two babies. The Siamese Commissioner and his wife spent a lot of time in the day nursery, watching the nursemaids and taking copious notes.

The nursemaids, trained as they were in the latest methods of "restful care" for babies, found the situation overwhelming. Reporters mentioned "cross babies" who "cried for mama and could not be consoled," and "the little golden-haired girl" who ran weeping to her wet-eyed mother; they said that the nursery demonstrated that babies of all races behaved in much the same way. In fact there were few black babies in the nursery. This was difficult to understand, because "the color line" was "not drawn at the creche." The New York Lady Managers were the only state board with a black member.

The popular impression created by all this publicity was that the Children's Building was just for babies. Cries of "Come and see the babies!" and "Here is where they check the babies!" were

MISS JOB PRESLEY.

heard all day long. People crowded onto the little platform next to the windowed partition which separated the nurseries from the west end of the lower hall. The harassed nursemaids received "constant inquiries" about openings for babies in the neat rooms with their white enamelled bassinets hooded with white muslin; the "pound" or playpen in the center of the room was cozily carpeted with thick blankets and pillows for safety. The Oriental cradles, in which four babies slept together, stood near the outer windows.

The attendants soon reached the limit of their endurance. Every day they had to disappoint hundreds of tired mothers: the entire building could have been turned into a day nursery and still people would have had to be turned away. At first all children between the ages of three weeks and six years were accepted. But the consequent uproar was more than flesh and blood could stand. It was necessary to weed out those infants whose "objectionable age" made them the greatest nuisances. A sign had to be posted that babies between the ages of six months and two years could not be admitted to the creche.

Throughout the Fair the Chicago Children's Aid Society stood by to care for abandoned children when the prophecy of the "philanthropic individuals" came true. In fact, only one child was abandoned. At nightfall on the last day of the Fair the exhausted nursemaids were left holding little Charlie Johnson, a healthy two month old baby. Many nursing mothers had "forgotten" to return to the nursery every two hours as requested, to feed their babies; other mothers had gotten lost or distracted by exhibits and returned with their claim checks after closing hours. But Charlie Johnson's mother never turned up at all. Charlie was carted off by the Children's Aid workers and soon adopted by more reliable parents.

The Children's Building netted a profit of $17,715 from the sale of souvenir spoons and "sentiment" books for children, and other items. Three quarters of this money was put aside for the proposed Women's Memorial Building; the rest was distributed to charities for children.

In all, $130,000 had passed through the hands of the Chicago women for both the Woman's Dormitory and the Children's Building. Governor Flower of New York, guest of honor at the official opening of the Children's Building, had said that he was so convinced of the ability of the Ladies to do great works, that he was willing to resign the governorship and let them take his place. Laughter and applause greeted this extravagant compliment. But the women had done great works. As Julia Shattuck said, "with no appropriation . . . for expenses, without even a constituency, and with not a dollar in payment," they had done what their hands found to do.

CHILDREN'S BUILDING.

N 1897 a Chicagoan was heard to remark that "it was pork, not Plato, which made Chicago." Indeed, this "most American of cities" was far better known in the 1890's for its commercial vitality than for its literary interests. Chicago businessmen, however, had cultural ambitions for their city; that is apparent from Sara Hallowell's activities for instance and from the amount of money and time that was being invested in libraries: in July, 1892 ground was broken in Dearborn Park for a building to house the Chicago Public Library which had grown in temporary quarters on the top floor of City Hall to a collection of 189,300 books, ranking seventh in the country. It had begun in 1873 after the original collection was wiped out in the fire, with a nucleus of 7000 volumes donated by the people of England. At the time of the Fair, six branch libraries were opening in the city. Also in 1892 the cornerstone was laid for the Chicago Historical Society building, designed by Henry Ives Cobb. The library of the University of Chicago had been enabled by the support of local businessmen to purchase 300,000 volumes in a sale at Berlin. In addition, plans were going forward to invest John Crerar's $2,000,000 bequest to the city in a library specializing in the physical, natural and social sciences. The Newberry Library at Washington Square and North Clark Street was already in operation; its emphasis was on the humanities and music.

Hamlin Garland came to Chicago in 1893, convinced that it could become a literary center. There were local writers: Joseph Kirkland, who wrote realistic novels about rural life; Henry Blake Fuller who interrupted his romantic sagas to publish *The Cliff Dwellers* in 1893, and there were writers who published in the newspapers: Eugene Field, George Ade, and Finley Peter Dunne, among others. *The Dial*, a leading literary journal, had been published in Chicago since 1880 by Francis Browne.

Although Harriet Monroe was a resident of the city, and would start her magazine *Poetry* there in 1912 Chicagoans in 1893 did not read much poetry beyond the regulation Shakespeare, Tennyson, Browning, and the American poets Longfellow and James Whitcomb Riley. Although the Reading Room of the Chicago

Public Library supposedly handled more traffic than the British Museum, with one fifth of London's population, the question arises of what Chicagoans were reading. Apparently they were reading newspapers: there were twenty-nine daily papers in Chicago in 1892. A national survey done in 1888 showed that Chicago papers carried more editorial comment than the leading newspapers of New York, Philadelphia, Boston, Cincinnati and St. Louis, although some people believed that the literary merit of these editorial pages was questionable. The Chicago Public Library Reading Room had newspapers from every city in the country, or so it claimed. In addition to newspapers, Chicagoans read prose fiction and children's books.

Best-sellers of the time were by Thomas Nelson Page, Lew Wallace (Ben-Hur), Conan Doyle, Walter Besant, Robert Louis Stevenson and Mark Twain. Like the rest of the country, Chicagoans read Charles Dickens, Walter Scott, Fenimore Cooper, George Eliot, Oliver Wendell Holmes and Bulwer-Lytton. Popular women writers were Marie Corelli, whose *Thelma* sold well, and the formidable Mrs. Humphrey Ward with *Robert Elsmere*. Popular children's books were *Five Little Peppers and How They Grew, Heidi, Little Lord Fauntleroy* and Stevenson's *A Child's Garden of Verses*. People read *King Solomon's Mines* by Rider Haggard, *Madame Bovary* and the Uncle Remus stories, as well as *War and Peace*. William Dean Howells was popular, although not as popular as Mark Twain. In all, literary taste was comfortably eclectic.

It is not surprising that the Fair Directors included an impressive literary exhibit in the Manufactures and Liberal Arts Building. There the American Library Association, which had been formed in 1876, displayed a model collection of 5,000 volumes. Publishers, however, put on the most spectacular show. There were over six hundred publishing houses in the country in 1893: Chicago had more than fifty; about as many as Boston. Philadelphia had sixty; New York about three times as many. Manuscripts and engravings were displayed as well as books and periodicals. Harper and Brothers displayed the manuscript of *Ben-Hur*, and pages from manuscripts by Mark Twain, Bret Harte and Frank Stockton. The firm of George A. Plympton of New York showed an historical collection of schoolbooks; Funk and Wagnalls displayed dictionaries; William Wood & Company, medical books; and Tiffany & Company collections of illuminations on parchment, and copper and steel engravings. The J. Ottman Lithographing Company demonstrated the entire process of making lithographic plates and printing lithographs.

Mrs Palmer was not intimidated by this mighty exhibit in the greatest exhibition building ever built. Publishing houses were run by men, but the group referred to by Nathaniel Hawthorne as "that damn'd mob of scribbling women" had provided grist for

the publishers' mills. In addition to George Eliot, Louisa May Alcott, Mrs Humphrey Ward, Marie Corelli, Frances Hodgson Burnett and Joanna Spyri, there were popular and prolific women writers like Amelia Barr, Catherine Beecher, Mrs Burton Harrison, Mrs Southworth and Mary Hartwell Catherwood. Mary Noilles Murfree who wrote under the name of Charles Egbert Craddock, and Alice French who called herself Octave Thanet, both continued the male pseudonym tradition of George Sand (Aurore Dupin), George Eliot (Maryanne Evans) and the Brontes (Ellis, Currer and Acton Bell). There was also the redoubtable Harriet Beecher Stowe.

Women supported circulating libraries and literary clubs, which flourished everywhere. There were eighty of these women's clubs in Indiana alone, with names like "The Woman's Century," "Wit and Wisdom," "The Minerva Circle," and "Over the Teacups." One was a black club called the Phyllis Wheatley Club. In Utah a Young Woman's Mutual Improvement Society with 20,000 members sent books and magazines to reading circles in eleven surrounding states. In New York was the Wednesday Afternoon Club, and in Chicago the Fortnightly and the Friday Club, to which Mrs Palmer and Mrs Henrotin belonged. These were fashionable, exclusive groups.

It was natural therefore that the Lady Managers should plan a library, and that they should rely upon the state boards for support. Mrs Palmer wanted nothing less than a library of all women's writing from everywhere and every time. She made no little plans. Each of the state boards went about this task of supplying the library in its own way. Some did nothing at all. Nowhere was there more activity than in New York, where the Ladies took this project to their bosoms with fervor. A Committee of Literature was formed at the second meeting of the Executive Board of the New York Board of Women Managers; Blanche Bellamy was named Chair. At a subsequent meeting Mrs Bellamy reported that in her opinion any plan for exhibiting the work of women writers would be incomplete if it consisted only of a display of books. Her plan, which the New York Ladies took up with enthusiasm, was to divide their exhibit into three branches:

> *First,* an historical and chronological collection of all books written by women, native or resident of the State; *second,* a series of chronicles prepared by and representing every literary club which had been organized for more than three years, and *third,* a record of the work done in the press and periodicals; the entire exhibit to be presented afterwards to the State library.

Mrs Bellamy was able to interest three organizations in taking up the three aspects of her plan: the Wednesday Afternoon Club accepted responsibility for the book collection; Sorosis, a women's

press association, agreed to gather data about literary clubs, and the Graduates' Association of Buffalo took on the task of preparing statistics concerning women's work in newspapers and magazines. The Wednesday Afternoon Club and Sorosis set up committees with Mrs Frederick Thompson and Phoebe Ann Hanaford, a Universalist Minister, as Chairs, respectively; the Buffalo group acted as a committee of the whole, with their President, Charlotte Mulligan, as Chair. Special committees were set up in New York counties.

A vigorous correspondence was kept up, advertisements sent out broadcast, private libraries, book stores and book stalls ransacked, and every means that patience and ingenuity could devise was employed to insure the success of the work.

Circulars were sent out:

Have you on your shelves books which you know to have been written by New York women? Have you, in some out-of-the-way corner such of these books as are now out of print and which you would like to give to this library? Do you know of any women in your village, or town, or city, or countryside who have ever written anything of any kind for the papers or magazines?

At the same time that the New York Ladies were working on the exhibits for the Library, they responded to Mrs Palmer's call for help in decorating and furnishing the Woman's Building, by offering to take the physical equipment and decoration of the Library as a special project of their own. The New York Ladies were generous with their time and money: their contribution to the Children's Building alone would have been more than enough for most states. The National Board gratefully accepted their offer for the Library. A Committee on the Decoration and Furnishing of the Library was set up, with Mrs Dean Sage as Chair; Mrs Sage was the Chair of the Executive Committee of the New York Board of Women Managers. The consent of the New York Board of General Managers was obtained to an appropriation of $5000 for Mrs Sage's Committee.

One of the rooms on the ground floor of the Woman's Building was chosen by the New York women for the Library; Mrs Palmer informed them that all the ground floor rooms had been assigned to exhibits. Candace Wheeler was a member of the Library Decoration Committee: during the summer of 1892, as we have seen, Mrs Palmer was in correspondence with Mrs Wheeler, in an attempt to have her made Official Decorator of the entire Building. The New York women consulted Mrs Wheeler, seeking the best location for the Library; she suggested a large west room on the second floor. This was duly secured. Mrs Wheeler was asked in

Dora Wheeler Keith:
Portrait of Candance Wheeler

the autumn of 1892 to direct the decoration and furnishing of the Library. It was unquestionably a relief for her to have this assignment since she was still waiting for an official confirmation of Mrs Palmer's choice of her as Decorator, and under New York's auspices she could come to Chicago, with one state's official sanction. She agreed to use "her time and brain without stint in her labor of love." Mrs Wheeler later wrote:

In spite of all difficulties, my work of preparation of the Woman's Building went steadily on, constantly restrained in its scope by the knowledge that our safety lay in not doing anything unworthy. There was, however, one opportunity for artistic effect in the great room which had been assigned to New York State, and which was to be furnished and used as a library. I felt that both its purpose and place demanded the use of every appropriate means of beauty. This was easy because the New York State Commissioners were responsible for its success or failure, and I was given absolute freedom of treatment.

Mrs Wheeler was pleased with Miss Hayden's design.

After seeing the nobility of the room's proportions, and the one great window which seemed to take in all the blue of the sky and the expanse of water which lay under it, I felt that it would be an insult to this dominant color to introduce anything in this sheltered space which would be at war with it; consequently I chose modulations of blue and green for the color treatment.

In her *Principles of Home Decoration* Candace Wheeler later said that the purpose of a library was "not only to hold books" but to make people feel "at home in a library atmosphere." The color of such a room, she said, "should be much warmer and stronger than that of a parlour pure and simple." In the Woman's Building library she chose dark oak for the bookcases and upholstered furniture, to harmonize with her basic blue-green color scheme. The furniture was to be made to her design by Chicago firms which hoped to sell the pieces after the Fair.

After she planned the colors and designed the furniture, Mrs Wheeler turned her attention to "two great spaces . . . first the ceiling, an expanse of white which was overpowering in emptiness, and then a height of wall which needed to be lessened by plaster decoration of some sort to bring it within . . . reach" of the carved bookcases which would go around the whole room. This "plaster decoration" was "sufficiently easy to accomplish": she designed a plaster and gilt frieze which could be cast and moulded in Chicago. The ceiling space was more difficult: Mrs Wheeler, after some thought, "decided that a painted ceiling was required for the overhead space and in the Woman's Building it should be a woman's work." She says that "after considerable correspon-

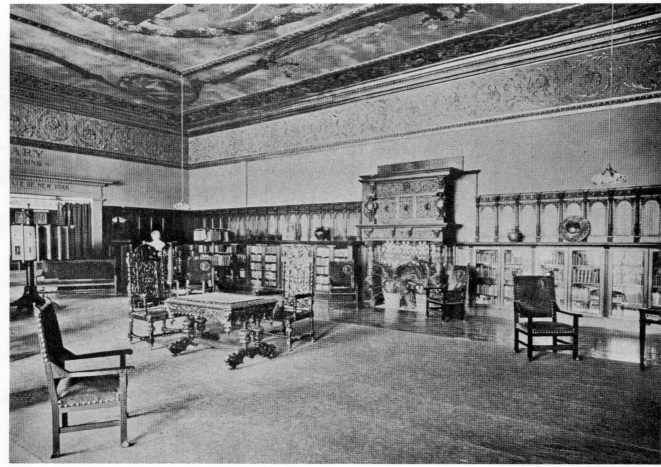

Library in Woman's Building

dence" Dora Wheeler Keith, her daughter, agreed to execute a painting for the ceiling in New York: "it could be painted in New York and mounted by the men who were coming . . . for the finish of the room."

The Library was set between two smaller rooms which the Board intended to use for the exhibition of statistics on woman's work. By autumn of 1892 the wheels were set in motion for the gathering of information in all the places where the Board's circulars had been received. The purpose of the compilation of statistics was, Mrs Palmer said, not simply to procure exhibits, but to present "a complex picture of the conditions of women in every country of the world at that moment" and particularly those women who were breadwinners for their families.

We wish to know whether they continue to do the hard, wearing work of the world at prices which will not maintain life, or under unhealthy conditions, and whether they have access to the common schools and to the colleges. . .

Mrs Wheeler had therefore to design rooms to hold statistics as well as books, and to make the main room comfortable and home-like, since the Board wanted the library to be a place where visitors could settle down for a while, and chat with the librarian. The books unfortunately could not be handled. Mrs Palmer wanted a librarian who had "full knowledge of women authors" and could talk "entertainingly on the subject" in order to interest people in establishing libraries in their own towns. Almost everything the Lady Managers planned had a lesson to teach or an example to hold up before the eyes of bemused visitors.

While the designs for the Library were going forward, the New York Board of Women Managers were receiving a satisfactory response to their request for books and articles by New York women writers. In November, however, they received word that their collection would not be preserved as a state exhibit. The National Board had decided that all the books in the Library should be catalogued by subject matter rather than by state. The New Yorkers protested that their collection would become meaningless if it were merged in with all the books received. Mrs Palmer explained to Mary Trautman, who interceded often for New York on the National Board, that a model library was what needed to be shown, not a collection of state exhibits:

> If the books are classified otherwise than by the approved library classifications, we depart from our high purpose and it becomes a matter of mere state pride in showing its literary wealth, rather than showing a systematic thoroughly classified and well-filled library of books written by women upon all lines of thought.

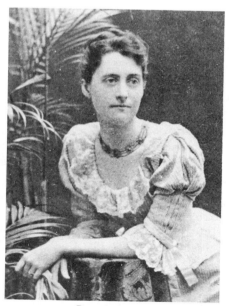

Dora Wheeler Keith

This sort of thing, which may very well have looked to the New York women as a snub aimed directly at them because of resentment of their unquestioned "literary wealth," was not to be tolerated. Blanche Bellamy, herself the author of *Open Sesame: Poetry and Prose for School-Days,* came to Chicago to reason with the Board. Her arguments were unquestionably convincing: New York had collected the lion's share of books, and was, in addition, paying for the decoration of the Library itself. If Mrs Palmer did not find this argument sufficient to allow New York to decide how its books would be exhibited and catalogued, then the New York Women could take all its books — and possibly its physical library decoration as well — to the New York State Building, where its library would find a congenial home. Mrs Palmer, never slow to respond to pressure, acquiesced gracefully: not only would the New York book collection be kept intact, but the Library itself would be credited to the Empire State. The rest of the State books were catalogued by subject.

After this victory, work went on apace in New York: the women collected 2400 volumes. The earliest was a 1752 edition of *The Female Quixote* by Charlotte Lennox, of whom Mrs Bellamy stated "[she] is said to have been the first native-born author of the province of New York." Charlotte Lennox was indeed born in New York City in 1720; she emigrated to England at the age of fifteen, however, and remained there apparently until her death at the age of eighty-four, in 1804. In London she moved in literary circles with Samuel Richardson and Dr Johnson, and most probably published her books as a result of these influences, although she demonstrates a sense of the absurd that reminds us of nothing in Richardson at least. Her novel follows the tradition of *Don Quixote;* there were many *Quixotes* (pronounced kwik-sots) written in England in the eighteenth century, stories of well-intentioned innocents whose wits were turned by excessive readings of French romances. Miss Lennox provided the only female Quixote. Her work is clever and remains amusing and readable; it had the distinction of influencing Jane Austen to write *Northanger Abbey* on a similar theme.

Mrs Bellamy described the New York collection in an article entitled "New York Literary Exhibit" in *Art and Handicraft in the Woman's Building:*

> We have attempted to make an historic, chronologic collection of all the books ever written by women either residents or natives of the State of New York. It is believed that this will prove of benefit to future students of literature and lovers of Americana. It is a collection limited by both sex and locality, but valuable because of its completeness within these limits. . . The collection contains children's books, works of fiction, science, cookery, and household economics, education, language, translation, original verse, compiled verse, travels, biography, history, art and religion.

From Charlotte Lennox Mrs Bellamy made a dizzying swoop through years of now obscure women writers:

> From this eighteenth century beginning we may trace the evolution of American fiction through the writers of the sentimental school, Mrs Ellett, Mrs Embury and Mrs Pindah; through the works of Caroline Cheseboro, Mrs Kirkland and the earlier writings of Grace Greenwood, to the novel which portrays the manners of our own day — the pleasing, graceful stories of Amelia Barr, Grace Litchfield, Mary Hallock Foote; the society studies of Mrs Burton Harrison and Mrs Van Rensselaer Cruger, and the character studies and sketches of Augusta Larned and Maria Louisa Pool. There are eighty-one volumes of children's serials; conspicuous among them are those of Mary Mapes Dodge, 'who,' Mrs Thompson says, in her Wednesday Afternoon Club report, 'slid into celebrity upon the silver skates of "Hans Brinker,"' and who has been long and honorably known as the editor of *St Nicholas*. Many valuable books command attention in the department of the 'Miscellanies.' Notable among these are 'Musical Instruments and Their Homes,' by Mrs. Julia Crosby Brown; a very complete collection of the works of Miss Catharine Beecher; a 'History of French Painting' by Mrs J.S.T. Stranhan, and thirty-one volumes of Lydia Maria Child. It is of interest to note that one of the few Afro-Americans connected with the World's Fair, in an official way, is a member of the New York State Board of Women Managers, who volunteered to collect the works of Mrs Child as a tribute from the blacks to her noble work in the anti-slavery cause.

Engraving from The Female Quixote

Imogen Howard was of course the only black woman on any women's board of the Fair. Lydia Maria Child was a native of Massachusetts who had spent only about eight of her seventy-eight years in New York; she had died in 1880. She was a dedicated abolitionist whose work, *An Appeal in Favor of that Class of Americans called Africans*, published in 1833, had caused her to become ostracized from Boston society and banned from the Boston Athenaeum. The chapter of that work entitled "Prejudice Against People of Color and our Duties in relation to this Subject" denounced laws against miscegenation, the unequal education and employment opportunities of blacks, and the segregation practiced in American churches, theatres and stagecoaches. Mrs Child had written many romances, some concerned with the plight of the Indians of the Northeast, and edited journals and her own letters. In 1860 her pamphlets against slavery received wide distribution, society having caught up with her advanced attitudes.

Catharine Beecher had gained a wide following for her elevated view of housekeeping, which she believed should fill all women's time, in *Treatise on Domestic Economy*. Juliet Corson's cookbooks contained suggestions for nutritious meals for families of modest income; her fifteen cent dinners were well known, and possibly widely adopted by middle class women. Julia McNair Wright, a temperance worker, had written seventy-eight books by the time she was fifty-three; among them *A Day with a Demon* and

Mother Goose for Temperance Nurseries. Mrs Bellamy does not mention Mrs McNair, although she sent all her works to the library.

Mrs Bellamy does mention the "interesting department" of translations and of works in "foreign tongues" by New York women:

Among these there are "The Acts of the Apostles," in Burmese, by Mrs Judson; the "Standard Dictionary of the Swatow Dialect," "The Life of Christ," and a volume of translations of some of the most familiar English hymns, in this dialect by Miss Adele Field; "The Peep of Day," in Arabic, by Ellen Jackson Foote; "Early Church History" and "Legends of Helena, and Monica the Mother of St Augustine," in Hindustani, by Mrs Humphrey; a number of books written in German by Talvi (Mrs Edward Robinson) — many of these have great literary and historical value; and one translation from English into French, entitled "Dans un Phare."

New York women doctors contributed a collection of their medical works to the Library to form a sort of science corner. In history Mrs Martha J. Lamb had written the *Standard Colonial History of New York;* Susan B. Anthony had contributed her *History of Woman Suffrage,* and from Mrs Alice Morse Earle came *The Sabbath in Puritan New England.*

All these books formed the first part of the New York collection. The second was a "showing of the work of seventy-five literary clubs and classes" in New York State, "collected and installed by Sorosis." These records were typewritten and bound in russet-colored suede covers stamped with the blue New York State seal.

Each volume contains the constitution, bylaws, list of members, and history of the club, with four representative papers, written by its members. These hang upon a standard at one extremity of the bookshelves.

On another standard hung thirty-nine folios, bound like the club folios, except that the seal was white instead of blue. This was the periodical literature exhibit, prepared by the Buffalo Graduates Club:

Two of the folios contain a list of 3000 names of the women of the State who have contributed to the press, while a third volume holds a list of editors and assistant editors. . . The field of periodical literature was analyzed and divided into its most conspicuous departments.

Women who were experts in each of these departments were asked to make collections "of the most brilliant articles written by New York women on these various subjects, the collections being as far as possible chronological." There were thirty-four of these little books, "each a charming and interesting book in itself."

Harper and Brothers published six of them as dollar miniature volumes under the title "The Distaff Series." Mrs Bellamy concluded triumphantly:

> The thirty-nine folios which hang upon this post are also an exhibit of model typewriting. This work, done by Miss Louise Conklin of New York, with expert assistants, is a most beautiful illustration of the fact that any craft may become an art through the perfection of its execution.

Harriet Beecher Stowe

It would take quite an effort to surpass New York. Massachusetts therefore did not even try. Announcing that it was emphasizing quality, rather than quantity, the Bay State sent only one hundred books. The Ladies made clear that they required a high standard of excellence and in most cases authors were invited to send only one of their works. Just so that there would be no misunderstanding about the availability of literary work to Massachusetts, Margaret Deland, the Chair of the Library Committee and a prolific novelist in her own right *(Old Chester Tales)*, sent along a catalogue she had compiled herself, to be exhibited with the one hundred books. The catalogue contained the names of 2,000 books written by Massachusetts women between 1612 and 1893.

The women of Connecticut, who appear to have been a charming and good-natured group, did not worry about being overshadowed by New York: their literary exhibit was the largest exhibit they offered; they believed that it was the most unique thing they could offer. Since their state was the home of Harriet Beecher Stowe, they decided to highlight that writer in their exhibit:

> Since we were so fortunate as to be able to claim for our own State the writer of the most marvelous work ever written by a woman, we naturally gave Mrs Stowe's Works and Uncle Tom's Cabin the most prominent place in our exhibit of literature.
> Securing permission to place a cabinet in the Library of the Woman's Building, we selected one of mahogany, elliptical in shape, with glass upon every side and glass shelves, the whole about five feet in height.

The collection of Mrs Stowe's works was lent by her children, with her permission: she was still alive, but not at all well. The contents of the Stowe cabinet were:

> . . . a copy of the first edition of Uncle Tom's Cabin in two volumes as originally bound and printed, very rare; a copy of The Key to Uncle Tom's Cabin, also rare; the latest reprint of Uncle Tom by Houghton Mifflin & Co., and a complete set of Mrs Stowe's works, in twenty volumes, a special edition bound in calf for exhibition in the library of the Woman's Building. Also forty-two (42) translations of Uncle Tom's Cabin, nearly all of which were presentation copies to

Mrs Stowe. Among the rarest of these is one in Armenian, one in Welsh with illustrations by George Cruikshank, one in Dutch, one in Italian, printed by the Armenian priests on the Island of St Lazarus, and a penny translation brought out in English.

A copy of an early portrait of Mrs Stowe and a facsimile of her introduction to her sons biography of her . . . as well as an autograph letter announcing the printing of two different editions of Uncle Tom's Cabin in the Island of Java.

A beautiful silver inkstand, a testimonial to Mrs Stowe from her English admirers in 1853, the year following the publication of Uncle Tom's Cabin . . . [representing] two slaves freed from their shackles. It is ten inches in height, eighteen inches wide, and twenty-eight in length.

From the very first, when the Board had thought it would classify the library according to subject rather than state, Connecticut was given a dispensation so that it could develop its Stowe exhibit. Close to the cabinet of books, on a pedestal of polished granite, stood a bust of Mrs Stowe in white marble, done by Anne Whitney. Isabella Beecher Hooker, who was Mrs Stowe's half-sister, had unveiled the bust in a small but effective ceremony in the Library.

In addition to this, Connecticut presented a collection of two hundred books, the work of one hundred and fifty native women writers. Catherine Beecher was represented here also: she was born and grew up in Connecticut, although she expired of an apoplexy in Elmira, New York, thus enabling Mrs Bellamy's eagle-eyed workers to pluck her for themselves. Isabella Beecher Hooker was represented with *The Constitutional Rights of the Women of the United States* and *Womanhood, its Sanctities and Fidelities.* Mrs Stowe had nineteen works besides the editions of *Uncle Tom's Cabin.* There were many novelists and historians but the women of Connecticut wished to honor also those writers of short stories who were not included in the book exhibit. Therefore the Library Committee chose selections from those writers who had not yet published a book of "either prose or verse." They wanted

simply to make a thoroughly readable book, one good of its kind, and therefore valuable . . . This was printed in a handsome volume bearing the title, "Selections from the Writings of Connecticut Women." The selections indicate only in a general way the preferences of the committee, the authors themselves, in many instances, choosing that which they considered their best story or poem.

About fifty writers were included in this limited edition, a copy of which was sent to every state in the Union, to the "chief universities", all the town libraries of Connecticut, and to the British Museum.

The decisions about contacting these writers were made at a Board meeting only two months before the Fair. The women

Bust of Harriet Beecher Stowe

worked under considerable pressure, writing about sixty letters to "all the best magazines and journals in the country" asking editors for names and addresses of their contributors from Connecticut. All of these letters were answered. In their enthusiasm the Connecticut women threw wide the doors, and a few strange visitors appeared:

We put in all the State papers, notices that the Connecticut women were to be represented by their books and writings at the Fair and a few aspiring poetesses warmed to the invitation.

One woman sent us some fifty or a hundred verses upon temperance, infant baptism, and true religion, a fireman's duty, etc., etc. She said that she had read in the newspaper that poems from the pens of gifted women of Connecticut were to be published at the expense of the state, for the World's Fair; therefore she sent us these few verses, which had called forth the greatest admiration, and she would like them printed at once in pamphlet form, entitled 'Flowers of Thought,' and as many copies forwarded to her address as we could conveniently spare.

Another woman, of whose name we had never heard, wrote to ask us this alarming question: Which of all the books she had written did we prefer? For private reasons we hastened to assure her that we should not think of placing our judgment beside her own, but would not she select for us; which she promptly did by sending them *all*.

We were not sure whether one woman had written a magazine article or whether she had written a book, but we thought she had written something, so we worded our letter very cautiously. We received a dignified and impressive reply. She was greatly complimented, we were doing splendid work, we deserved a great deal of credit, and all that. Concerning her writings: she had already given a number of volumes to a neighboring state; she could not *give* more, but all the rest — something over a hundred — she felt certain we could have for the collection, provided we would purchase them. What a narrow escape, and to think we should have fancied her the writer of one humble article!

A charming woman, whose works we have, stated that she had written a profound and exhaustive treatise on psychical subjects, more adapted to a collection of works written by *men* of deep thought, than to a woman's library.

We wrote to a woman for a history which she had written, and we had this reply from her husband: His wife had been dead for a number of years, but he had a copy of her book in the house, which he would sell to us for two dollars and a half — postage 16 cents. We roused also a second wife, the first wife having written the book: She did not think it wise to send the volume, she feared it might awaken painful associations, thanked us for having written, but would we please not pursue the subject.

Obviously the ladies in Connecticut enjoyed life to the hilt. Mrs Gregory, of the Committee of Literature, who had written the above amusing comments, added that the women were kept from flagging because of much that was interesting and fascinating in the work, and also because of a fear that they might not do credit to the Board and State.

CEILING, WOMAN'S LIBRARY

Bargains with printers, of which many of the severe things said are by far too mild; gaining permission from editors to reprint articles; reading of proofs; and replying to questions from writers, — a more important detail than you can well imagine, as we must at any cost keep them good natured, — made the month of March rather a frantic four weeks.

We came out of it with our State colors flying, however, and in the best of spirits; for the volume, which had become a sort of child to us, was an actual reality.

The Connecticut Board received an award for their exhibit in the library; certainly no award given in the Fair could have been more well deserved.

Another anthology was put together by the New Jersey Committee of Literature, chaired by Margaret Yardley. This was a *ScrapBook* of articles, written by New Jersey women, that had appeared in newspapers and magazines; it emerged in two fat volumes, despite "the very trying duty of cutting down." Margaret Tufts Yardley wrote Mrs Palmer that she felt as though she "owned" the writers who had never before appeared in book form. The material was vast: "How I am ever going to squeeze the material . . . between the two covers . . . will soon become a vital question." Two books was the answer. The New Jersey Board of Lady Managers publicized the book extensively in their state as the first collective work of the women writers of New Jersey and arranged to print five hundred copies of it. New Jersey procured two copies of books by New Jersey women writers so that they could display one copy in the Woman's Building and the second in the New Jersey building. They collected 350 books.

Edith Clarke, head cataloguer of the Newberry Library, took a leave of absence from her job to come to the Woman's Building in

April, 1893, and catalogue the Library there. Books were coming in by that time in increasing numbers, although apparently not fast enough for Mrs Palmer who, as late as June 8, 1892, was writing Charles Scribner asking for addresses of female authors and for the loan of original manuscripts of famous books as well as for original book illustrations. While Miss Clarke worked, so did carpenters and painters; the floor was being laid. For over two weeks she had only a few boxes to sit on, and to use for tables.

By June 10 Miss Clarke had a staff of two trained librarians and two copy clerks helping her with the catalogue. Both she and Mary Lockwood, head of the Board's Library Committee, were convinced that this catalogue would be an invaluable research and reference tool in future. In the meantime, however, nothing else was being done. Books could not be put on the shelves until they were catalogued, and no one had time to answer any questions. Arrangements were made with Melvil Dewey, the originator of the Dewey decimal system of library classification and President at that time of the American Library Association, to hire librarians on a "revolving" monthly basis: two each month in continual rotation, each to bring her own experience to the Library, to show books and tell the public about them.

Miss Clarke's task was made more difficult by the nature of the Library. "Woman in literature," she wrote, "to the cataloguer is a stern reality, a thorn in the flesh." The reason was woman's penchant for taking on names. Miss Clarke could not help wishing that women would not marry, or if they did that they would marry only once. Horrible examples of twice-married women were "Mrs Mary Clemmer Hudson Ames and Mrs Helen Maria Fiske Hunt Jackson," the latter being the author of *Ramona*. Because of marriages "Lady Barker, the brilliant chronicler of life in the English colonies" was unrecognizable when she became, in the card catalogues, "Lady Mary Anne Stewart Barker Broome." The rule of entering women in library catalogues under their "own personal names instead of their husbands'" was, Miss Clarke thought, universal, as was the rule of including "the name before marriage and by a former marriage, if any, as part of the entry." Only the British Museum did not include former married names. Consequently although Mrs Burton Harrison chose to sign her books with that name, she had to be catalogued as Mrs Constance Cary Harrison, a name no one would recognize because she never used it for her writing. Likewise, "Mrs E. Lindon Bates' petition that her chosen pen-name be respected in the catalogue at the Fair did not avail; but a cross-reference was ruthlessly made from that form to Mrs. Josephine White Bates, under which guise" her works appeared in the Woman's Building library. By the same token, Mrs Fred Burnaby masqueraded "under the burden of Mrs Elizabeth Alice Frances Witshed Burnaby Main," where Miss

Josephine Bates

Clarke doubted any of her readers would ever find her.

An even worse problem stemmed from the practice among Italians, Swedes, Austrians and Spaniards of either prefixing or affixing their husbands' names to their own family names:

> Whether they prefix or affix it seems to an outsider a matter of chance. Consulting Gubernatis' "Dictionnaire des Contemporains," we find two cases where the husband's name precedes — Siga. Aurelia Cimino Folliero de Luna and Siga. Sacconi-Ricci — balanced by two where the maiden name precedes — Siga. Sophie Albini-Bisi and Dona Carolina Coronado de Perry.

Miss Clarke had been told that the order of the names was decided by the marriage contract, but she suspected from "some vagaries" which she found on title pages that "the fickle writer" occasionally varied the wording of that document to suit herself.

> Siga Mathilde Bonafede-Oddo appeared on four title-pages as quoted, but on a fifth, I believe, she came out as Mathilde Oddo-Bonafede.

Instructions were to "Enter under the compound name as generally used by the author, even though it be her maiden name." But Miss Clarke had a further instruction:

> . . . I would add to that, when you find the order uncertain, do not add up all attainable samples, and divide by two, hoping thereby to attain a golden mean; but adopt the 'modus operandi of the stock exchange,' toss up a penny, enter under one form, refer from the other and do not worry.

Miss Clarke also had trouble with masculine and feminine forms of family names, "as Modjeski and Modjeska." Instructions were to use whatever form the authoress herself "chiefly" employed. In a list of forty Bohemian women writers, it struck her as curious that every name ended in "ova." Another nuisance was "authoresses who change nationality in marrying." The poetess Agnes Mary Frances Robinson "crossed the English Channel to find a husband" and turned up on her title-pages as Madame Jacques Darmester. Miss Clarke asked plaintively, "Is she Agnes Marie, or does she retain the English form of her name?" The final difficulty was to acquire the form of Mrs. in every language.

> Mme., Signora, or Dona, Fru, Mevrouw, Frau are common compared with Pani in the Bohemian, and I confess the Russian, Polish and others are still unknown to me. The British Museum gives all titles in English, and the vernacular touch so dear to the professional cataloguer's heart may be an over-refinement.

Miss Clarke was obviously painstaking. As the summer wore on, Mrs Palmer became restless. The books were not being shelved, and judging from the pace at which Miss Clarke and her assistants were moving, they would not be shelved before the end of the Fair. People were beginning to talk; Mrs Palmer was not anxious to provide Miss Couzins and her friends with fuel for criticism. It seemed to her that if there were five thousand books and a list of books in each box, it would take Miss Clarke one month, if she worked with five assistants, to finish the catalogue. There were by July actually 7000 books, and every box did not contain a list. Miss Clarke and her assistants — of which there were only four — had to unpack the boxes and then put the books into shape for cataloguing. Mrs Palmer suggested that the librarians install the books, and finish the catalogue afterward. This would entail double work, she was told, and the time element would be even more pressing because many states were taking their library exhibits back after the Fair to donate them to state historical societies and other libraries.

August came, and nearly went, and Mrs Palmer pressed Mary Lockwood. Not only was the cataloguing swallowing the library, but it was swallowing a lot of money; the whole thing was going to last only two more months anyway. Mrs Lockwood begged for only a little more time. She strongly suspected, she said, in a letter to Mrs Palmer written on August 21, 1893, that pressure was coming from

> a source that has never turned a hand to promote the well-being of our Society, but merely sits in judgment on the work others have conscientously tried to do . . . I heard Miss Couzins had some criticism to make on the library — I expect to come in for my share — in all the criticisms that have gone forth — great and small — since our work began I have no fear — the work of the Woman's Board will show for itself, and stand as a defense when the carpings and those who made them are in oblivion.

Mrs Lockwood obviously had no more patience with Phoebe Couzins; whatever she had thought in the fall of 1891 about the former Secretary's abrupt dismissal, she now had her own problems with her. Miss Couzins would attack whenever the Board gave her an opening. Mrs Lockwood wanted more time: donations from Holland, Germany, Norway and Belgium were still not catalogued. If a few more clerks could be hired, the work could be ended by the end of the Exposition. Miss Clarke, she said, would be bitterly disappointed if the work were stopped now:

> You know her idea is that the catalog would be purchased extensively by libraries . . . I appreciate the disappointment it will be to Miss Clarke to leave the work in such an unfinished state which will result in really no credit to her; a work which she has made every effort to make as near-perfect as possible . . .

Possibly Mrs Palmer saw Miss Clarke as too much of a perfectionist. In any case she wanted the Library to be completed as an exhibit, and she had no interest in paying more money to have Clarke's catalogue published, even if it could be finished. On September 18, 1893 Mrs Lockwood was forced to halt the cataloguing.

Mrs Clarke and her assistants cost the Board $1,391. All the United States books were catalogued except those of New York, which had catalogued its own, and all foreign books except those of Germany, Holland, Belgium and Norway. Germany had sent 500 books, Norway 200, Belgium over one hundred, and Holland less than the others. With one month left for the Fair, it would appear that the catalogue was not a realistic endeavor. Miss Clarke made hasty notes of the titles and authors of the remaining books and saw them placed at last onto Mrs Wheeler's dark oak shelves.

Certainly this library caused a furor among writers as well as among librarians. But writers did not take the strong stand that sculptors like Harriet Hosmer took, against the segregation implied by an exhibit in the Woman's Building. Frances Hodgson Burnett wrote to Charles Scribner, her publisher, agreeing that he could send her *Little Lord Fauntleroy* to the Fair:

> I have grown so tired of Woman with a capital W, though I suppose it is rankest heresy to say so. I don't want to be Woman at all — I have begun to feel that I want to be something like this — WOMAN. Nevertheless if everybody is sending books, I must send mine.

"Everybody" included many women connected with the Board of Lady Managers, the Congresses or one of the exhibits. Sarah Rorer of the Corn Kitchen sent her books on pickling and Philadelphia cookery; Mary McLaughlin, the potter from Cincinnati, sent *Pottery Decoration*. Rebecca Ruter Springer, the wife of Representative William Springer, whose amendment had started all this, contributed a book of poetry called *Songs by the Sea*. Kate Marsden's *By Sleigh and Horseback to Outcast Siberian Lepers* was there too. Frances Willard's *Glimpses of Fifty Years*, and *Three Girls in a Flat* by Laura Hayes, Jean Loughborough and Enid Yandell were on the shelves. Frona Waite, a western Lady Manager, donated a copy of her *Wines and Vines of California*. Grace Dodge was represented by *A Bundle of Letters to Busy Girls* which she had somehow found time to write. There was also Emily Huntington's *Advanced Kitchen Garden*. Even Eliza Allan Starr's *Isabella of Castile* had been accepted, along with a full set of the *Queen Isabella Journal*.

In *Samantha at the World's Fair*, Marietta Holley expressed the gratification that stole over an author when she found her books in the Woman's Building library:

Jean Loughborough

And right here I see my own books; there they wuz a-standin' up jest as noble and pert as if they wuz to home in the what-not behind the parlor door, not a-feelin- the least mite put out before princes, or zars . . . I felt proud on 'em to see their unbroken dignity and simplicity of mean . . . It wuz a great surprise to me, and how they got there wuz a mystery. But I spoze the nation collected 'em together and sot 'em up there because it set such a store by me. It is dretful fond of me, the nation is, and well it may be . . .

As I stood and looked at them books, I got carried a good ways off a-ridin' on Wonder — a-wonderin' whether them books had done any good in the world.

I'd wanted 'em to, I wanted 'em to like a dog . . . But I knew they had gin great enjoyment, I'd hearn on't. Why, the minister up to Zoar had told me of as many as seven relations of hisen, who, when they wuz run down and weak, and had kinder lost their minds, had jest clung to them books.

Phoebe Couzins to the contrary, the Library was a great success. Mrs Wheeler, having put her dark oak furniture with wash leather green upholstery in place against the blue-green walls, could heave a sigh of pride and relief:

The ceiling was put up, with a wide deep border and a modeled frieze that brought it to within reasonable distance of the paneled bookcases. The bookcases themselves surrounded the room, filled with books, a great army of them beginning with the very earliest utterances of women in print and following down the centuries to the present. Busts of notable women by notable women were decoratively used, and the great window, filled with leaded glass, gave a softened beauty of lake and sky. Altogether I was satisfied. I felt that the women of America would not be sorry to be women in the face of all that women had done besides living and fulfilling their recognized duties.

Dora Wheeler Keith sent her canvas for the ceiling early in 1893, and followed shortly afterward with the new baby daughter whose birth had briefly interrupted her artistic labors. Mr Wheeler, Dora Keith and the baby and nurse joined Candace Wheeler at the "little hotel" where she had been staying for two months "trying to be happy without them." Mrs Keith's painting depicted five large ovals or medallions holding groups of single figures. The central medallion held three allegorical figures: Science (male) and Art (female) with Imagination (female,) mediating between them. The medallions were connected by scarf-like draperies which were caught up at intervals by cupids, and intertwined with lilies and streamers. The whole was enclosed in a border of Venetian scroll work. The style of the work was not in any way innovative.

The carved bookcases formed a wainscoting of dark oak panelling about the room. Mrs Wheeler had borrowed an impressive chimney-piece of Renaissance design from Duveen Brothers, the

famous art antiquarians. This was placed against the main door to the Library, and proved to be a considerable hindrance as time went on and crowds increased. It was found necessary soon to raise the mantelpiece above the door so that people could enter the Library that way, as had been originally intended. Heavy blue draperies separated the main room from the north and south record rooms. Against the background of dark woods and soft deep colors, enlivened by the stained glass in the huge window facing east, Mrs Wheeler placed portraits of women authors, framed autographs and a large collection of original illustrations from books and magazines. Most of the pictures had been done for children. There were the frontier scenes of Mary Hallock Foote, a pioneer American illustrator; the pen and ink kittens of Albertine Randall, which charmed all the women, who found them "real beyond a shadow of a doubt"; four watercolors, by Kate Greenaway, of delicate children in Regency dress, from her *Book of Games*, published in 1889. Miss Greenaway always took back her illustrations after publication: she earned forty-five guineas from those which were exhibited and sold at the Fair.

There was a display of fine bindings, too. Some, in embroidered velvet and tooled leather, were by Sarah T. Prideaux, an Englishwoman who taught other women bookbinding. Others belonged to a collection gathered by G.P. Putnam, the New York publisher; Putnam's fine bindings were done by a woman and therefore lent for the occasion. The woman was Alice C. Morse, an American artist who stated, as the bookbinder's creed, that she "must not outrage any true standards of design, yet she should be able to suggest . . . in a symbolic way, the contents of the volume."

The New York Times was thrown into an ecstasy by the Library:

In the great department of women's work . . . the great Empire State occupies a position that is at once gratifying to her sons and daughters, and calculated to increase her already great importance in the eyes of the world. It may be said that New York could not have been spared in the work women have done. This work would have been especially lacking in the most essential particulars of art, philanthropy and literature but for the women of New York.

The *Times* heaped praise on Mrs Keith's ceiling mural:

There was a time when no woman would even have dreamed of undertaking a piece of elaborate mural painting. Yet a New York woman — Dora Wheeler Keith — has accomplished results in this field which may astonish even the most enthusiastic believer in woman's capabilities. It is an extraordinary achievement in its line. The Venetian border is very beautiful . . .

The *Times* described the "sixteenth century panel" which hung below the ceiling, and the furniture, which was "also in Italian

Dora Wheeler Keith: Painting on Library Ceiling

Renaissance design'' and which was carved and embossed with medallions containing the name and date of the Exposition. There was also a case of autographs "of the most notable women in history" including Catherine de Medici, Mary Queen of Scots and Mary Mapes Dodge. "The entire room," cried the *Times*, "in every detail breathes the spirit of the highest development of decorative art."

Virginia Meredith, in the *Review of Reviews*, wrote that Mrs Keith's Venetian ceiling was "perhaps as important a piece of decorative painting as has been executed by a woman in this generation." *Leslie's* magazine commented that the library was "done in a very sumptuous manner in dull blues and greens." Susan Gale Cooke reported that "the color-scheme of the room was its crowning charm, being a harmonious blending of shades of green, brown, blue and gold into a general tone that invited rest and quiet and suggested elegant, literary ease."

The Art Amateur gave a vivid description:

Done in general tones of bluish green enlivened by a good deal of gilding, contrasting with brown oak bookcases and a floor of mar-

Award Given to Connecticut Lady Managers

quetry partly covered in warm hued Turkish rugs . . . A broad frieze decorated with a vine scroll in dull gold and green, terminating in small grotesque figures of fawns and cupids, is surmounted by a frieze in moulded and gilt plaster . . . The State and National arms in stained glass alternate in simple leaded windows . . . The whole effect of the room is reposeful, quiet and cheerful . . . It must be reckoned among the very best bits of interior decoration in the Fair.

The foreign books were by and large worthy of their setting. England sent valuable manuscripts of Jane Austen, Charlotte Brontë, Maria Edgeworth, Fanny Burney, Mrs Gaskell, and George Eliot. The first page of *Adam Bede* carried an affectionate dedication to George Lewes, and was signed Marian Lewes, and dated 1859. In the same case with these manuscripts came three fine editions of the *Boke of St Albans* by Dame Juliana Berners.

The French sent 800 volumes, among which were the works of George Sand and Madame de Stael. From Germany came 500 volumes as a gift from the women. Among them was the *Hortus Delicarium*, a medieval encyclopedia by Herrade of Landsberg, an abbess of the twelfth century. It contained 344 illuminated tales, demonstrating the triumph of good over evil, and dedicated to the convent "for love of you, my sisters in Jesus." Unfortunately the original volumes had been burnt in 1870; what was sent was a Victorian rendering in black and white of the medieval illuminations.

From Sweden came a few hundred books accompanied by a bibliography of Scandinavian women authors. The best known of these was Frederika Bremer, who had visited Chicago in 1850. In 1856 she had published *Hertha*, a novel filled with complaints against the treatment of women. It achieved some notoriety. By 1893 most of the reforms urged by Frederika Bremer had been completed; nevertheless *Hertha* was considered a kind of bible of women's rights by Swedish feminists.

From Spain and Italy came priceless manuscripts and old and rare books: obviously these two countries had had to fall back on the convents: there were no contemporary writers considered worthy to be exhibited in the Woman's Building. There was some recent interest in Saint Teresa; a new translation of her *Life* was sent. The Mexicans sent only one book, commissioned especially for the Fair: a collection of poetry by Mexican women. The Board had suggested that this volume be compiled. However, the compilation was delegated to a man, Jose Vigil, Director of the National Library in Mexico City. The book was described by the Mexicans as "a monumental work embracing three centuries . . . printed in large quarto on very fine paper." One book came from Japan, which had promised fifty. This one too had been gotten up especially for the Fair. It was called *Nippon Fujin* or *Japanese Women*, and described their activities: making tea, spinning silk, writing

Kate Greenaway: The Mulberry Bush

haiku, and so on. It was illustrated by delicate line drawings.

Separated from the Library by heavy blue draperies were the north and south record rooms. The principal feature of decoration in these rooms was a row of carved wood panels, sent from various states and territories, which formed a continuous line around the walls above the glass-doored built-in bookcases. It had been requested that these panels be decorated in the style of the Italian Renaissance, to blend in with the other decorations. But the contributors had varied tastes: they wanted to express something typical of their particular part of the country. Kansas women carved the sunflower into their panels; Oregon the dogwood, California the poppy, Alabama the magnolia, Alaska the fern, Wisconsin the pine cone, and from Little Rock, Arkansas, came a panel made of sweet gumwood. The north record room was further distinguished by a tile chimneypiece designed and executed by Ruth Winterbotham of Wisconsin: its subject was the Rip Van Winkle legend. How this fit the subject was Miss Winterbotham's secret. The north record room contained mainly musical manuscripts and statistical charts from the United States.

The south record room was devoted largely to statistical charts from abroad, showing the proportion of women's work in all branches of industry. Particularly noticeable was a complete collection of statistics from France placed on the walls above the carved panels. The foreign music exhibit was in the south record room as well; it put the small, unsophisticated American musical display to shame. The foreign lists showed compositions ranging

Carved Wood Panels from Record Rooms

from the simplest tune to the most impressive forms, including operas with full instrumental scores, oratorios, cantatas and orchestral works, from Belgium, France, Germany, Italy, Poland, Mexico, New South Wales, North Wales, Norway, Spain and Sweden. These scores were in both published and manuscript form. The statistics from foreign countries were equally impressive, being sent in the form of books, manuscripts and wall charts from the Argentine Republic, Australia, Austria, Bohemia, Belgium, Canada, China, Denmark, France, Germany, Great Britain, Holland, Italy, Japan, Mexico, New Zealand, Norway, Portugal, Russia, the Sandwich Islands, Spain, Sweden, Switzerland, Syria, Turkey and the West Indies.

These statistics caused a great stir at the Fair. They were a new and daring departure in Exposition work. The French gathered the first statistics ever attempted of the part played by women in the social economy. There were a series of monographs and charts illustrating the variation in marriage dates, the longevity of women as compared to men; the number of women immigrants and emigrants; women's participation in schools and universities, and the number that won diplomas, and the kinds of merits open to them. On the philanthropic side, there were monographs on orphan homes and other houses of refuge run by the Sisters of Charity.

These statistics, both American and foreign, told a story of tremendous educational and preventive work being done everywhere by women. The philanthropic work — nurseries, hospitals, foundling homes — were a record of friendly hands stretched out in every direction toward the suffering. Mrs Palmer, of course, had

French Record Room

wanted more. She wanted facts about women workers, and their place in society, and about opportunities in education open to women. A German delegate wrote Mrs Palmer in July 1892, "You put great value on statistical material, and you may rely upon [the German women's committee] taking care that this interesting branch will not be wanting." Lina Morganstern, a well-known German philanthropist, offered to compile a book of statistics on women of her country for the Fair. She did in fact compile such a book, but the difficulties were greater than she had expected. She wrote to Mrs Palmer:

> The accomplishment of the task which I had set before myself was even more difficult and comprehensive than I had anticipated; the statistical aids and the material being secured only with the greatest trouble. Nevertheless, since I have been requested to give a report concerning the condition of women of my native land, I send you the first proof sheets of the book, which gives evidence that not only is woman capable of working in all departments of industry, but that there is a pressing necessity for her to acquire a calling by which she can earn a livelihood, in order that she may maintain her self-respect.

Drawings by M.O. Kobbe

Fraulein Morganstern, who found that there were more unmarried women than unmarried men in Germany, and that ten percent of the married women were compelled to work outside their homes to help support their families, was an amateur, as were most gatherers of statistics at that time. Only recently had questions begun to be asked and reports compiled, particularly about women. Helen Campbell, a contemporary investigator, wrote in 1893 that during most of the history of the United States women who worked considered themselves stigmatized and therefore chose not to be counted. There were no reliable statistics. Most of the information that had been gathered — in travel books, newspaper articles, trade union pamphlets, novels — was wrong. Harriet Martineau had said in 1836 that there were only seven avenues of employment open to women: teaching, needlework, keeping boarders, washing in cotton mills, typesetting, bookbinding and domestic service. This was generally considered by interested people to be the last word on female employment. But when in 1910 Elizabeth Abbot published *Women Workers in Industry*, she found three separate reports which demonstrated that at least 100 occupations were open to women in the years 1820 to 1840.

1893 was a significant year for statistical work. In 1886 the U.S. Bureau of Labor had been founded as an arm of the Department of the Interior. In 1888 the Bureau became the independent Department of Labor under Carroll D. Wright, although it did not attain cabinet status until 1913. Massachusetts had a Labor Bureau of its own, which in 1884 published a pioneering study

called *Working Girls of Boston.* This work analyzed the situation of women in large New England mill towns: the investigators, who had to invent their own methods, were surprised to find that the girls took a strong interest in the study. This book became the model for a larger study of working women in twenty-two large cities by the U.S. Bureau of Labor, which published it in 1887. Carroll Wright, who was especially interested in the problems of women workers, appointed to his department Clare de Graffenreid, who believed that the road to any real change in the status of women must be paved with facts.

Mary Clare de Graffenreid was born in Georgia in 1849 and at the age of sixteen was graduated from Wesleyan Female College in Macon with a brilliant record. Having taught Latin, English and mathematics for ten years in the Georgetown Female Seminary in Washington she entered government service in 1886 as a patents clerk, and became an agent of the Labor Bureau later that same year. She gathered data in New England and Georgia on her special area, which was working conditions for women and children. In 1892, she was sent to Brussels to study the effects of industrial training on workers' performance. It was here that Mrs Palmer tracked her down, to inquire if she could help to gather a Belgian industrial display for the Woman's Building. Miss de Graffenreid responded that she would certainly try to help the Board in any way that she could, although her schedule was "crammed to overflowing with travel and correspondence (in a foreign tongue, too)" and with work that she should have finished before she left America.

Mrs Palmer, sensing that Miss de Graffenreid was a real find, wrote back in effect that almost anything this statistician had in the way of figures would suit the Ladies perfectly. She also wrote to Carroll Wright asking in her charming way for Miss de Graffenreid's services for the Ladies when she returned to the United States. In the meantime the Ladies knocked together a series of questions which they wanted to ask manufacturers about the factory women they employed. At the end of August, 1892, the Department of Labor informed Mrs Palmer that Miss de Graffenreid was coming home to be assigned to upper New York state, and that she could co-operate with the Board of Lady Managers, although the Department's "field work is very pressing at the present time and will be through the coming year . . . we should not care to be deprived of her services very long." Miss de Graffenreid herself wrote Mrs Palmer in September that she was indeed home, and had been sent to Buffalo; Commissioner Wright had told her that 'if any opportunity presented itself' of sending her to Chicago, Buffalo was a handy departure point. But Miss de Graffenreid did not think an opportunity would present itself, and she would have to forgo her salary if she took leave. "This is a sac-

Drawings by M.O. Kobbe

rifice which, notwithstanding my interest in the Fair, I cannot make," she said.

She offered however to help the Board through the mails. She wanted to see the questionnaire which Helen Barker had written. "You need not fear to overtax me," she wrote. "Hard work will be good for me after all my playing and meandering in Europe." Mrs Palmer duly sent her Mrs Barker's questionnaire; she wrote back that it needed work. She would like to speak with Mrs Barker, but she thought the questions were too wordy.

Rosina Emmett Sherwood: Watercolor

It will be easy to retain the points on which she lays most stress. In their present form they are too lengthy and would receive less attention from manufacturers than if put in more compact shape.

In mid-October, 1892, Miss de Graffenreid did have an opportunity to come to Chicago; the Exposition paid her salary so that she could speak on her work in Brussels to the Board. At the same time she completed work on the questionnaire, which was sent out with a prefatory disclaimer:

It should be understood that the Board of Lady Managers is not making these inquiries from an inquisitorial point of view but in order to obtain, if possible, an accurate survey of the conditions under

which the working women of the world labor. It is prepared to bind itself not to disclose any information of a private character, and all names will be held in strictest confidence.

Despite this, or perhaps because they were alerted by it to find the questions offensive, or possibly because they did not want to bother, employers did not answer the questionnaire. Among the questions were these:

How many women receive the same pay as men for the same work?
Are females paid overtime?
Are seats provided for women?
Are separate water closets provided for the two sexes?
Do trade unions exist among the workmen?
How many married women, or women separated from their husbands, are among your workers?
Are women more faithful to their duties than men?
Are women given to absenteeism as frequently as men?

More successful in obtaining responses was a circular sent by the Board to Lady Managers in the states and territories:

The President of the Board of Lady Managers believes that no exhibit that can be made by the women of the nation will be of greater interest or more profitable than a full record of what women are doing in all industrial lines. Hence she desires that the ladies of each State and Territory shall prepare a chart giving full information as to the work of industrial women.
In order to assure uniformity, we would suggest the following heads:
Number of wage earners or self-supporting women.
Number employed in factories, stores, shops and offices.
Number owning and controlling farms.
Number engaged in mining.
Number engaged in horticulture and floriculture.
Number engaged in the professions.
Number engaged in domestic service.
Number of authors.
Number of teachers.
Number engaged in art work and designing.
Number engaged in literary work.
Number engaged in other lines.
If this information could be plainly and beautifully engrossed upon a large chart and hung upon the walls of each State building, it would enable us to make a national summary that would not only be of present value, but would become historical.

The Ladies of Connecticut had at first preferred not to become involved in any statistical research. That, they felt, should best be left to the Department of Labor. But when they received this circular, they changed their minds. The questions bore directly "upon the industrial conditions of women employed more especially in large manufacturing towns" and so they felt compelled

"in answer to this last most urgent appeal" to furnish as much detailed information as they could secure in the few months which were left to them before the Fair.

> Connecticut industries had an international reputation. To have taken no part in a movement which was to reach the whole civilized world, and which, if the detail asked for was at all accurate and comprehensive, promised to become of such intrinsic value, would have been a great omission. . .

The last government report on labor was still at the printer's; the Connecticut Labor Bureau could not furnish the needed information. The Connecticut women made the securing of information "a personal matter on the part of each member of the board." They set out individually to canvass each manufacturing district. They were aided by Amelia B. Hinman of the National Commission, by state legislators and by village doctors and clergymen. Much of the work had to be done in February and March when all the roads were bad: those in Hartford and its vicinity had "a certain evil pre-eminence." The women wished the world to know it, if conditions for industrial women in Connecticut were better than in other states. If they were worse, the Connecticut women wished to know that themselves. The field was canvassed with such "vigor and thoroughness" that the "statistical experts employed to collate and report upon the data secured gave to the Connecticut returns the honor of first place in value, France, that paradise of statistical fiends, ranking second."

Some of Connecticut's results are shown below:

Female population of Connecticut in 1890 376,720
No. 1. Number of females 10 years and over engaged in
 gainful occupations in Connecticut in 1890 71,380
 Number of females 14 years and over engaged in
 gainful occupations in Connecticut in 1890 *1,693
 Number of females 15 years and over engaged in
 gainful occupations in Connecticut in 1890 69,687
No. 2. Number of women in professions 4,976
No. 3. Number of women employed in domestic and
 personal service . 24,907
No. 4. Number of women employed in manufacturing and
 mechanical industries . 35,804
No. 5. Number of women employed in trade and
 transportation . 4,926
No. 6. Number of women farmers, planters and overseers . . . 683
 Farm Ownership
Number of women owning or occupying farms as
 heads of families . 2,248
Number of women as farm tenants 73
Number of women living on owned farms free
 of encumbrance . 1,762

*This figure appears to indicate an error, possibly in proofreading.

Dora Wheeler Keith: Aphrodite, tapestry

Number of women living on farms encumbered 413
Home Ownership
Number of women heads of families 28,923
Number of women heads of families owning homes
 in which they lived . 15,277
Number of women, heads of families, who were tenants . . 13,646
Number of homes free of encumbrance owned by women . 10,125
Number of homes encumbered owned by women 5,152
Mining
Number of women engaged in mining 1
Agriculture and Floriculture
Farmers, planters, and overseers . 683
Agricultural laborers . 62
Dairy women . 12
Nurseries
Owned and managed by women . 4
Wages paid women per day, 85 cents.
Seed Farms
Women employed . 85
Wages paid per day, 65 cents.
Floriculture
Whole number of establishments in Connecticut 120
Whole number owned and managed by women 5
Whole number women employed . 14
Wages paid women per day . $1.00
Total wages per year in Connecticut $4,200.00
Professions
Architects . 1
Clergy . 26
Dentists . 2
Lawyers . 1
Physicians and surgeons . 89
Authors . 153
Teachers . 3,891
Professors . 14
Artists and teachers of art . 187
Designers and draftsmen . 11
Musicians and teachers of music . 543
Journalists . 140
Actresses . 30
Other Lines
Managers and showmen . 8
Officials of government . 79
Inventors . 165
Officials of banks and insurance and trust companies 4
Manufacturing officials . 2
Bookkeepers and accountants . 705
Clerks and copyists . 1,247
Stenographers and typewriters . 310
Telephone and telegraph operators . 281
Packers and shippers . 623
Electric light and power company employees 56
Steam railway employees . 24
Street railway employees . 2
Commercial travellers . 8
Foremen and overseers . 17

Porters and helpers in stores 10
Agents and collectors 73
Watchman or detective 1
Messengers and errand girls 21

Business

Wholesale dry goods 1
Dry goods ... 9
Drugs and chemicals 14
Wines and liquors 4
Grocers ... 65
Newspaper sellers 3
Undertakers ... 3
Livery and stable keepers 2
Butcher ... 1
Teamster .. 1
Hucksters and peddlers 10

Miscellaneous

Gold and Silver Workers 176
Lead and zinc workers 11
Tinners and tin makers 31
Tool and cutlery 99
Leather goods makers 34
Gunsmiths, locksmiths, and bell-hangers 67
Electro platers 38
Engravers ... 13
Machinists .. 9
Painters, glaziers and varnishers 74
Piano and organ-makers and tuners 41
Molders ... 2
Model and pattern-makers 2
Paper-hangers ... 1
Marble and Stone Cutters 11
Potters ... 1
Brick and Tile Makers 3
Blacksmiths ... 2
Carpenters and Joiners 1
Engineer, not locomotive 1
Barbers and Hairdressers 42
Janitors .. 19
Saloonkeepers ... 28
Restaurant-keepers 26
Hotel-keepers ... 50
Saleswomen ... 1,333
Dressmakers, Milliners, Seamstresses 8,451
Tailoresses .. 440
Corset-makers 2,570
Hat and cap-makers 1,352
Cotton, woolen, and Textile Mill Operatives 13,057
Rubber factory 1,229
Brass workers .. 552
Clock and watch 558
Iron and steel workers, including molding 426
Paper mill operatives 646
Printers, engravers and bookbinders 398
Paper box-makers 1,064

Wooden box-makers . 90
Powder and cartridge-makers . 292
Housekeepers . 2,264
Boarding and lodginghouse keepers 515
Nurses and other service . 1,110
Servants . 18,833
Day laborers . 505
Laundresses . 1,375

		Single	Married	Wdwd	Divorced
1.	Farmers, planters and overseers	77	65	530	11
2.	Musicians and teachers of Music	459	44	31	8
3.	Professors and teachers	3,699	102	95	9
4.	Hotel and boarding-house keepers	64	143	340	18
5.	Dressmakers, milliners & seamstresses	6,352	1,008	964	127
6.	Tailoresses	318	42	70	10
7.	Corset-makers	2,339	119	90	22
8.	Textile mill operatives	11,389	1,180	431	57
9.	Rubber factory	1,137	49	40	3
10.	Paper mills	534	69	39	4
11.	Paper box-makers	1,005	34	20	5
12.	Stewardesses	1,028	315	852	69
13.	Servants	16,270	1,072	1,392	99

The Connecticut women wished to make it clear that they did not intend these statistics to point to the need for social revolution. Mrs Knight said the statistics were "not offered as the point of any moral"; since it was a tradition that "women have no head for figures" the Ladies did not attempt to "deduce" anything; they left that to the trained sociologists for whom the data was secured. Mrs Knight intimated that women may sometimes have been treated unfairly:

Mary Hallock Foote: Letter of Resignation

. . . women were the first among English-speaking people to appreciate the value and benefits of education, even if they were incapable of receiving them in their own persons; and we find one of them founding the first college for men as early as the thirteenth century . . . Baliol and Wadham colleges in Oxford, Clare, Pembroke, Queen's Christ, and Sidney colleges in Cambridge owed their existence to the English women of hundreds of years ago. That is something to remember when we are accepting gratefully from the men of our own times the opportunities of Vassar, Wellesley, and Smith.

But Mrs Knight did not want anyone to think she was complaining.

We discovered nothing in these statistics to prove that we were downtrodden or deprived of our natural rights. It is true that in some directions, teaching for instance, the influence of supply and demand make the salaries of women far lower than the salaries of men. In this profession there is much keener competition than in any other which men and women share, but in uncrowded lines we found that women who were capable of doing a man's work received a man's wages. In industrial lines, at piece work, women often earned more than men. In educational matters, our largest, most famous university has opened its doors to women for post-graduate studies with a hearty, ungrudging welcome.

If a sexual revolution was in the making, it was not going to happen in Connecticut:

The domestic relations of the Connecticut woman are as old-fashioned as that of the Roman matron. She, too, can both inherit and endow. She is her husband's equal in the home, and (tell it not in Gath) sometimes his superior. She is a recognized influence, uplifting and refining, heroic if necessary, patriotic always, accepting life as it presents itself, and men as they are.

Mrs Knight fell to musing prettily over some of the rather surprising occupations that women were engaged in in her state. She hoped that the female butcher simply kept shop and knew "nothing of the things big and little, especially little, which [were] condemned to death". She wondered whether the woman blacksmith was a widow, shoeing other people's horses in order to buy shoes for her children's "little feet." And the two carpenters! "What a long sought opportunity for closets and rearranged building plans!" She sobered down long enough to grant that her statistics were not simply an amusing game:

The whole question of wages is too involved and many sided, even in Connecticut . . . to be treated intelligently by a novice.
However much we may covet for our own small State the distinction of having the best prevailing conditions for working women, we cannot hope to alter suddenly the evils springing from excess of supply over demand, nor can we alter the fact that the keen competition inseparable from the superabundance of untrained labor has endless disadvantages for women.

New York women, generally more serious than their Connecticut counterparts, went after the statistics rather grimly: they wished to co-operate with Mrs Palmer, even though they believed the gathering of statistics to be a "thankless task" with "no hope of completely covering the ground in the short space of time allowed, and even if incomparably well done the . . . exhibit would only interest a small number of individuals." Anna Roosevelt was appointed Chair of the Committee on Statistics; she was assisted by Florence Lockwood of the New York Board, and also by Mary

Gay Humphreys, a newspaperwoman, and Margaret Finn, a factory inspector. The New York women, like the Connecticut women, put in a disclaimer about what it all meant:

> The question of the wage-earning power of men and women is beyond the scope of this report, but it would seem well to state what the investigations prove, that frequently the complaints made as to the higher wages given men are most unjust, as women are often the ones who cut down the wages for the whole sex. This is largely owing to the fact that many only wish to help support themselves while living at home, and constantly look forward to the probability of marriage.

This was essentially what Grace Dodge had told Mrs Palmer about the reason for low wages paid women. New York did point out that "one of the men in Washington" whom Miss Roosevelt had consulted as an authority said "that whatever her committee was able to print, so long as it was correct, would be most useful even if not absolutely full." The women were thus willing to do what they considered "an imperfect and inadequate" report. All data had to be collected by volunteers, except in reports on the insane and criminals, and arranged by volunteers. No attempt had ever been made before to make "a general and complete classification of the achievements and occupations of women." The Committee found 3,020,960 women in the state, out of a total population of 5,997,953, "an eleventh of the whole female population of the Union." New York, being "old and thickly-settled," had initiated and led many of the important women's movements of the past fifty years:

> Among the professions, the progress of the study of medicine has been peculiarly noteworthy, the first medical diploma ever given to a woman being presented to Doctor Elizabeth Blackwell in Geneva, N.Y. in 1849; the first women's hospital in the world founded in 1857 in New York city, and the first medical society to admit women members opening its doors to them in 1867. The medical educational facilities for women, with the exception of hospital practice, are better in this State than in any other State or county in the world. The number of women journalists is also noteworthy, 2,401 among whom 321 rank as editors of daily, weekly, and monthly publications.

Philanthropic movements in New York State, in which women were involved, had radically changed society. The great reformer Dorothea Dix was especially mentioned as having, with other women,

> done valuable and important work in relation to the State care of the insane, the pauper and criminal population, notably in the case of the State Charities Aid Association, which in conjunction with men,

RÉPUBLIQUE FRANÇAISE

MINISTÈRE DU COMMERCE, DE L'INDUSTRIE
ET DES COLONIES

EXPOSITION INTERNATIONALE DE CHICAGO
(1893)

PALAIS DES FEMMES

SECTION FRANÇAISE

CATALOGUE OFFICIEL
(FRENCH AND ENGLISH)

PARIS
IMPRIMERIE NATIONALE

M DCCC XCIII

Official French Catalogue

but founded by a woman, has, since its birth in 1872, made many important legislative reforms.

Singled out for praise were the Working Girls Club Association, the Training School for Nurses, the Kitchen Garden system, the Day Nursery and the Consumers League, all first started in New York by women. But there were flaws.

Its age and size, however, have formed a strong conservative element in the State, and kept practically closed many professions and checked many movements which the younger and less-fettered Western States have forwarded. For instance, the practice of law by women is practically a dead letter in New York, although the bar is nominally open to women and the legal educational facilities good; and in all questions concerning the political rights and duties of women New York holds a very conservative position, and as yet has not extended any of the privileges of the franchise (except voting for school boards) to women. The first woman member of the State Board of Charities was appointed in 1877 in New York city. In collegiate, academic and common-school education New York stands next to Massachusetts, and in special professional, technical and industrial education, leads the Union.

Good news was that the Cooper Union Art School, the Student's Art League and the Academy of Design were open to women and had assisted in the "artistic development of the nation." The bad news was that New York's female criminal population occupied "a sad pre-eminence" in the nation: her females were one-eleventh of the national female population, and "her female criminal population one-third." In all fairness, the New York women pointed out that this was partly "accounted for by the fact that New York city receives annually a large influx of low foreign emigrants."

Emigrants or immigrants (and it seemed there were so many the New York women did not know whether they were coming or going), by a logical connection the next point made was that "the first recorded gift by a woman was a silver communion service, given by Queen Anne to St Peter's Church, Albany, in 1715." It was obviously to be hoped that the fingers of low foreign types would be kept off these kinds of valuables.

Miss Roosevelt had her statistics tabulated with "all items clearly shown" on sheets of paper sized "twenty-two by twenty-eight" and mounted "and interspersed alternately with the photographs of the interiors of factories where women were at work." The standard on which all this was hung placed in the north record room.

The Indiana women issued a book called *The Associated Work of the Women of Indiana.*, edited by Ida A. Harper. It was discovered that those women who were very poor might lose their daily meals

Page from Poetisas Mexicanas

if they offended their employers, and could not consequently organize into unions, while those who worked only for "better clothes" and those who expected to marry and retire were not interested in unions at all. There were others who were ashamed of working, and did not want to go into any organization which "branded" them "before the world as working women." There was a Laundry Girls Union in Indianapolis, however, which maintained a co-operative laundry owned and managed by the women employees, and paying $2.00 more in wages — a week? — than laundries elsewhere.

Illinois worked up a handsome volume of statistics showing the number of women teachers, lawyers, physical education instructors and newspaper correspondents in the state. It was embossed by Margaret Brooks of Springfield, and bound by the women workers of Rokkers' Book Bindery in that city. Several thousand copies of this book were distributed free through the efforts of the County Columbian Club.

All this inquiring and tabulating led to the breaking of new ground, and roused general interest. Mrs Palmer herself did not at first expect as much as she eventually got in the area of statistics. She wrote to Madame de Dubuque in France in January of 1893, coyly remarking, "You may decide to visit this queer land of statistics and other impossible and uninteresting things."

The colorful French statistical exhibit, mounted on the walls of the south record room, had brightly colored bar graphs which showed Frenchwomen's occupations: they composed 49% of innkeepers and apartment managers or *concierges*, 30.3% of shopowners and retail workers, 20% of the agricultural force; 20.7% of the industrial force, 7.5% of public administrators and 3.7% of the liberal professions. Carroll Wright was struck by the French exhibit, commending it especially. The Museum of Social Economy in Chicago asked for the charts as part of their permanent collection, after the Fair was over. The Frenchwomen were aware of their valuable contribution: "independent of their present interest" the statistics, they thought, might "be of primary importance in the future, marking, as they do, in a precise manner, the state of the question at the end of the nineteenth century."

The Belgians, overshadowed by the French, sent nevertheless an impressive display: huge sheets filled with facts about different kinds of laceworkers in nine provinces: the kinds of thread used (linen or cotton were preferred); patterns employed, and wages and hours of workers. Data received from government sources were written in red ink; these were sparse. Most of the information, noted in black, was the result of a questionnaire sent out by Belgian women who were organized into the Bureau des Comite des Dames Belges, headed by the Countess de Deuterghem. Twenty-six foreign countries, including Australia and Turkey,

sent statistics on women to the Board. Sweden and Russia sent books: Sweden four volumes of reports on philanthropies, education, literature, public service, trade and business; Russia a bound report on the progress of women.

Despite the fact that Miss de Graffenreid's contribution had been less than successful, Mrs Palmer strove to cling to her as the only female professional she knew. In April, 1893, the President wrote to Carroll Wright saying the Board really needed "someone to be put in charge of these statistics who would appreciate the significance of the various sets of facts sent to us from each country, or who could group them in a picturesque and interesting manner . . . No one," she added significantly, "is more clever than Miss de Graffenreid . . ." Commissioner Wright took the hint graciously, and Miss de Graffenreid was released from her duties for the Department of Labor for the rest of the spring and summer so that she could assist the Board with their masses of information. She had done an essay on child labor in 1890 and compiled another for the Board on factory women, which was called "The Conditions of Wage Earning Women" and was published in *Forum* in March of 1893. Both these studies were later to be awarded prizes by the American Economic Association. In the "new South," Miss de Graffenreid reported, industrial government gave to "negroes, poor whites, farmers' daughters, middle class females and needy ladies alike . . . a righteous emancipation." However, in both North and South, she found filthy working places, excessively long work hours, exploitive fines and a real need consequently for protective legislation and unions for women workers. Woman she called "an industrial makeshift, rarely displacing man except at half his pay."

Clare de Graffenreid was convinced that most women were either dependent on men or wanted to be dependent on them. Even though the number of respectable occupations had grown throughout the nineteenth century, it was difficult to displace the idea that women who could find male relatives to support them should do so, or that for a woman independence was acceptable only as a grim necessity. Mrs Palmer herself wrote to Carroll Wright on February 15, 1894 about this matter:

> In a number of cases we know that the wages of the husband are entirely insufficient and have to be supplemented by those of the wife and often the children. It is a very important point to know whether the wages of men in a given industry are less effective now in providing the necessities and comforts for his family than in earlier days, before the introduction of improved machinery. It would be, of course, a very desirable thing to have women altogether withdrawn from the industries; certainly all married women who should be engaged with their home duties and the care of their children. If the proportion of married women who are working is not very large, then retirement might be effected and a fund created for the assist-

Herrade de Landesberg: Tree of Life

ance of widows and orphans, so that competition by women in the industries might be withdrawn.

My own thought is that in a vast majority of cases, married women are forced to work.

One can read statistics often as one chooses to. But the important thing was that attention was being paid to women, and to their contributions to society, whether they made them willingly or not. Mrs Palmer was justifiably proud of the statistical display, as she wrote to Madame Carnot of France in February, 1894:

Our Record Rooms were visited by statisticians and educators for the purpose of studying the graphic charts and examining the beautifully engrossed volumes which you sent. We have reason to believe that the part which woman plays in the social and political economy of every nation, will, because of the initiative taken at the Columbian Exposition, become a matter of governmental study and investigation.

The Woman's Building Library was the first American collection of women's books; the first documented collection of women's books gathered by women, as far as anyone knows. All books received by May 30, 1893, were noted; notes were taken as late as September. By May, no books had been received from Alaska, Arizona, Arkansas, Idaho, Montana, Nevada, New Mexico, North Dakota, Tennessee, Utah, Vermont, Washington state, or Wyoming. Arkansas sent one book, as did Indiana, while Iowa sent two books. Three books came from Kansas, Missouri and New Hampshire, four from Mississippi and Wisconsin, five from West Virginia and six from Kentucky. Eight books came from Delaware and Florida, nine from California and Georgia. Oregon sent eleven. South Carolina sent thirteen, and Virginia fourteen. Nebraska sent twenty books, Michigan twenty-four, North Carolina twenty-six, and Texas twenty-seven. Minnesota was next with thirty-four volumes, after which the number jumped to forty-two from Maine, forty-five from Rhode Island and forty-six from Colorado. Maryland sent fifty-six books. Alabama sixty-four and Louisiana seventy-two. Ohio sent ninety-six, Illinois, the District of Columbia and Massachusetts each sent 100. Connecticut beat them out by sending 111. New Jersey sent 350; Pennsylvania 400.

New York's 2400 was of course the greatest number. These books were all listed by the New York women, and were donated to the State Library of New York at Albany. They were destroyed by fire in 1911. Edith Clarke wanted to place the collection, which she thought could consist of as many as 4000 books, in a library in the Woman's Memorial Building which the Board hoped to build after the Fair. Thomas Wentworth Higginson of Boston, the author of *Common Sense about Women*, which had been published in

Mme Carnot

1884, had a collection of women's books which he had gathered over the years. He offered to give them to Miss Clarke for the Memorial Library. When it became apparent that there would be no such library, Mr Higginson donated his books to the Boston Public Library: there are 1000 volumes called the Galatea Collection.

After individual states like New York and New Jersey had withdrawn their books, the remainder of the Woman's Building Library was sent to the Chicago Public Library. In 1933 the International Conclave of Women Writers exhibited 2,000 books by women at the Century of Progress World's Fair in Chicago. These books were acquired by Northwestern University whose Head Librarian, Theodore Kroch, called the collection the Biblioteca Femina, after the first documented woman's library which had been founded in Italy in 1842. Soon after this, the Woman's Building collection was moved to Northwestern to be joined with the Century of Progress books. When Mr Kroch died in 1941 the Biblioteca Femina was dispersed throughout the University's holdings.

Edith Clarke said that she was asked continually, "Why have a library of women's books? Why not let them take their place side by side with the men, and be judged equally with them, instead of separating them, as if books by women were a different kind?" States, Miss Clarke said, collected the writings of their residents: colleges, books done by their graduates and faculty. The Women's Board collected books by women. Her reply, she said, amounted to "Why not?"

But the expressions of amazement and delight on the faces of visitors to the library were a more positive reason for the collection. No one who came there could believe that so many women had written so many books, and contributed so greatly to the pleasure and knowledge of the world.

A CORNER IN THE LIBRARY—WOMAN'S BUILDING.

AFTER the second Board meeting in September, 1891, the Ladies issued as a circular a "Preliminary Prospectus" which included this statement:

It is our intention to make in the Woman's Building an exhibit which will clear away existing misconceptions as to the originality and inventiveness of women ... The footsteps of women will be traced from prehistoric times to the present and their intimate connection shown with all that has tended to promote the development of the race, even though they have worked under the most disadvantageous conditions ... It will be shown that women, among all the primitive peoples, were the originators of most of the industrial arts, and that it was not until these became lucrative that they were appropriated by men, and women pushed aside ... Woman constructed the rude semblance of a home. She dressed and cooked the game ... ground the grain between the stones ... cured and dressed the skins of animals, and fashioned them awkwardly into garments. Impelled by the necessity for its use, she invented the needle, and twisted the fibers of plants into thread. She invented the shuttle ... She was the first potter ... She originated basket-making, and invented such an infinite variety of beautiful forms and decorations as to put to shame modern products ...

In January, 1891, Sara Hallowell had suggested that Mrs Palmer drop the idea of a fine arts exhibit in the Gallery of Honor and concentrate instead on "primitive feminine industries." Miss Hallowell said that she did not know much about it, but she believed that women were the first potters. Mrs Palmer did not, as we know, give up the fine arts exhibit, to her eventual sorrow, but she was interested in a "primitive feminine industrial exhibit" as well.

On August 18, 1891 Mary Lockwood wrote Mrs Palmer from Washington, D.C. that she had nearly completed an illustrated lecture on women as inventors from the industrial age to the present. She had hired an artist to create stereopticon slides and was satisfied that she could demonstrate that women were "the first decorative artists, the first geometricians, the first architects, etc." In her researches she had enlisted the aid of Professor F.W. Putnam of Harvard, who was then at the Smithsonian Institution.

Professor Putnam had intimated that he would put the resources of the Smithsonian at the Ladies' disposal. He believed firmly that the Exposition should be educational, and not solely commercial; and he also believed in encouraging women's efforts.

Mrs Lockwood was a widow and the owner of the Strathmore Arms, a hotel in Washington, D.C. She was a feminist with a special interest in history: the historical exhibits, involving the Patents Office and the Smithsonian, had been assigned to her. Her plans for the exhibit seemed attractive to Mrs Palmer, as long as emphasis was not placed upon the suffragists. The President enjoyed sketching ambitious plans in her letters, especially to Europeans. In January, 1892, she wrote with a flourish to Amelia Edwards at the Larches, Westbury-on-Thrum, England:

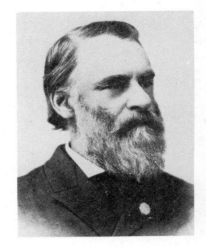

Frederick Putnam

> Our archaeologists are agreed that women were the founders of the industrial arts, such as weaving, basket-making, modeling clay into jars for domestic purposes, etc., and we are already making the commencement of a complete collection from North and South America, of the prehistoric remains of the original possessors of the land.

On March 15 Mrs Lockwood reported to Mrs Palmer that the Smithsonian owned an extensive collection of basketry and pottery, undoubtedly done by women. These things held no interest, she thought, for a "casual visitor" to the Institution, but were essential to any exhibit of women's work. She feared the museum would not send them to Chicago, however, so she was having drawings made to exhibit. Because of rumors that the city of Chicago planned to keep all the exhibits sent to the Fair, "the Smithsonian therefore had decided to send to Chicago what they could afford to *lose* and what they would be glad to get *rid of.*" The baskets and pottery were not among these dispensable items. Mrs Lockwood thought that if "someone in authority" would guarantee the safe return of their property, the Smithsonian people would be willing to send the women's work to the Government Building of the Fair.

Mrs Palmer was not interested in the Government Building. She wanted women's work for the Woman's Building. When she went to Washington in 1892 to try and wrest an appropriation from Congress, she swooped down upon Professor O.T. Mason of the Smithsonian Institution, who agreed to mount an exhibition for the Woman's Building. At least Mrs Palmer understood him to say that he would mount one; a year later she had to remind him of his promise.

The President left Washington, feeling that she had accomplished a good deal. Mary Lockwood was put out: Professor Mason had preempted her exhibit. Mrs Palmer could hardly be accused of disloyalty: after all, the grand purpose was everything. Nevertheless Mrs Lockwood wrote on April 12, 1892 to Mrs

Palmer, trying to prove that she herself was still important to the scheme of things:

> You have not heard my lecture, and could not of course quite understand its scope ... I arrived at my conclusions very much as Mr Mason arrived at his, but with different intent. My only object has been to get at the facts on record, and bring them to light, facts that could be helpful to women and that would add something to her glory at the World's Columbian Exposition. I, out of my *inner consciousness*, evolved the picture method ... I procured artists and paid them out of my own pocket to do the work. The pictures have cost something over one hundred dollars — I count that as nothing for the work has grown in my hands — outreaching any suggestions Proff [sic] Mason gave ... Except for the bare statement of some facts Proff Mason has had nothing to do with my work ... One who has long been connected with the National Museum, a person entirely reliable, who has known all about my patient work there, has

Smithsonian Exhibit: 'Tanners of the Plains'

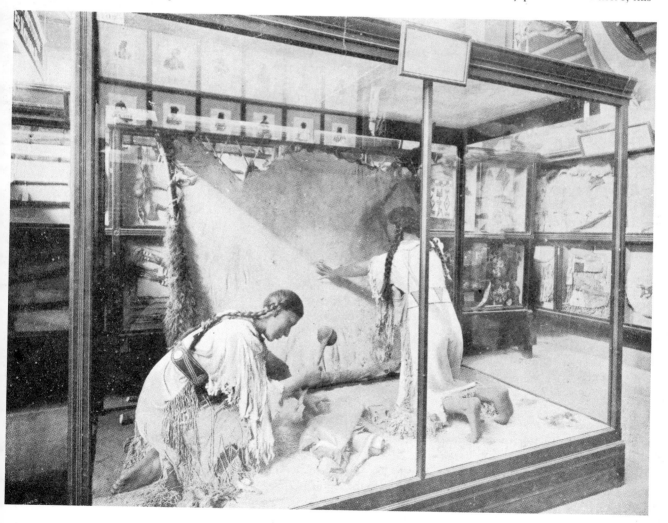

cautioned me against putting too much confidence in the Professor, and putting my special work in his hands unless I want him to appropriate the whole thing.

Mrs Lockwood told Mrs Palmer that she did not trust Professor Mason, and would not show him any of her work. Professor Goode was the man she trusted at the Smithsonian; she would confer with him when he returned from a trip to Italy. This energetic woman added, possibly in an attempt to keep Mrs Palmer's attention, that she was "taking steps" to compile "a complete catalogue of all the books written by women." She added unnecessarily that it was a big job. It could be done, she said, at the Library of Congress.

Mary Lockwood

When Professor Goode did come back from Europe, Mrs Lockwood was dismayed to discover that he and Professor Mason were planning to ship the "woman's exhibit" to the Government Building at the Fair. She was also upset to find that Charlotte Smith, still seeking funds, was talking about mounting an "industrial women's exhibit" of her own, and getting part of the Ladies' appropriation for it. Word was out that Phoebe Couzins was working with Miss Smith on this.

Mrs Lockwood wrote to Mrs Palmer on August 21, at Camp Elsinore in the Adirondacks, to tell her that she had agreed to have the woman's exhibition set up in the Government Building because Professor Goode had said that was the only basis on which the Smithsonian authorities would allow the exhibit to leave Washington at all. Mrs Lockwood thought perhaps the Smithsonian might be talked into moving the exhibit to the Woman's Building, once it was in Chicago, if "some government appointee" was assigned to look after it there. She then changed the subject somewhat:

Do you think it possible among any of the mountaineers to find any primitive implements of the kitchen or housewifery? For instance, we want a woman's kitchen knife which is the hand chopping knife, also the old line spindle something like the spindle used by Omphale when she taught Hercules to spin as we see in the pictures . . . They are rare but can be found! They are all a link in the chain . . . Thoreau said that we can find anything anywhere if we look long enough for it!

Sounding somewhat distracted she said she did not envy Mrs Palmer the calm of her mountain retreat, but

I do so long to shut out the noise of the street cars, — the whistle of the factory, the cry of the newsboys — and listen to the ripple of the mountain brook — the chirp of the birds and the singing of the katydids — and for a little while to have a sense of far awayness which has not been possible so far this summer for the work I have on hand

— I do not know why I am talking all this to you, except that I have your ear at long range — and you are not interupted by cards from somebody with an axe to grind! — at least I hope not! — I know you cannot leave all cares behind, and your heart is in your work, though rambling paths — rustic nooks . . . beguile it for a time . . .

Mrs Palmer responded on August 30:

I am sorry to hear of Prof. Goode's idea about the Smithsonian Exhibit. That was not what was understood by Prof Mason and myself . . . I think you were very wise not to discuss the question but to let it drop. If they will prepare it and do all that is possible to make an interesting collection, we can afford to wait the pressing of the exhibit until later . . .

The President made it clear that she was still working with Professor Mason, and that she did not intend to recognize Professor Goode just because Mrs Lockwood liked him. She also wanted Mrs Lockwood to stay out of the affair, and told her clearly that the women would get authorization for the loan of the exhibit from the Smithsonian at the next session of Congress. She also had no intention of roaming the countryside, poking around in hovels for primitive kitchen implements.

We might get a primitive spindle such as you speak of from our foreign committees if not in this country. It is much more probable that we could find such articles as have never been used in the United States, especially, sacredly preserved in the old countries . . .

She then graciously talked about the weather:

We are in a most delightful spot in the mountains and have the lake below us and constantly under our eyes, with the summer sun above us and the moon growing every night, with an occasional rainy day to remind us that we are still mortal and not in Paradise. I am enjoying the rest and freedom from care and shall go back with renewed zest to my desk.

In order to assure Mrs Lockwood that she was getting information straight from the horse's mouth, Mrs Palmer told her:

As you are so fully au courant with the situation, having seen and heard so much of the Board of Control, and heard all the difficulties of the situation while legislation was pending in Washington, I may say confidentially that as we have not gotten our independent appropriation, I think the Board of Control will pull the reins up a little tighter and wish to make us acknowledge their authority and supremacy. In case they do so, we can only yield without showing any displeasure, as we are very distinctly told . . . by the Senate Committee in Washington, that it had never been their intention to have us independent of the Commission, but to report to them and to be subordinate to them. That, they said, was their invariable habit in dealing with every department of work to make everything subordinate

to one Board which they hold responsible. This was the case in the Army and Navy, all of the great Departments and all of the Departments created for special work by Congress.

Mrs Palmer then bade Mrs Lockwood a majestic farewell in this typewritten letter, adding a final bit of advice:

I hope you will not overtax yourself during the warm weather but run off and take a time of quiet. Anyone who can describe the delights of the country so eloquently as yourself, would feel its pleasures keenly, and I trust that you may not work so hard as to be deprived of its refreshment.

The President was calmer about the whole thing than Mrs Lockwood. She knew that many valuable handicraft exhibits had already been promised to the Woman's Building: among them, the personal lace collection of the Queen of Italy, and the work of the Royal School of Art Needlework, promised when the President was in England in 1891. The primitive industries she was confident she could get from the Smithsonian, and, when it came to the crunch, she fell back on Representative Springer, who once again did not fail her. On March 3, 1893 Mr Springer presented a resolution, which was adopted:

Joint Resolution, S.R. 148
Authorizing the Secretary of the Smithsonian Institution to send articles illustrative of the life and development of women to the World's Columbian Exposition.
Resolved by the Senate and House of Representatives of the United States of America in Congress assembled
That the Secretary of the Smithsonian Institution be, and he hereby is authorized to prepare and send for exhibition in the Woman's Building of the World's Columbian Exposition any article now in his custody or on exhibition in the National Museum, illustrative of the life and development of the industries of women.

In addition, the Congress appropriated $211,375 for the Columbian Commission, of which $93,190 was to be used for the Board of Lady Managers, $25,000 to be made available immediately. Although Mrs Palmer had wanted the money to be appropriated directly for the Board, and not routed through the Commission, she was grateful for the amount and wrote on March 6 to thank Mr. Springer both for the appropriation bill and the Smithsonian resolution.

Susan Cooke wrote a letter to the Smithsonian on March 12, and Mrs Palmer wrote one to Professor Mason on March 16, both formally requesting the loan of the Smithsonian ethnographic material. On March 20, Mr F.W. True, Curator-in-charge, wrote to Susan Cooke:

In reply I would say that we shall probably be able to send about 80 of our standard display-boxes, which would be sufficient to occupy 20 table-cases, 2 ft. long and 3 ft wide. I regret to inform you, however, that we have no cases suitable for the exhibit. If the Board will place at our disposal an allotment for the construction of cases, we will have them made. I presume that a thousand dollars would be sufficient for this purpose.

To Mrs Palmer Mr True wrote on March 21:

Professor Mason has referred to me your letter of the 16th inst. in relation to sending cases from the Museum for use in installing exhibits in the Woman's Building. In reply I very much regret to say that it will be impossible to comply with this request, as our stock of cases is already exhausted.
I wrote to Miss Susan G. Cooke on the 20th inst., explaining that we did not have suitable cases for installing the collection illustrating women's work, which we are preparing, and asked if your Board could not make an allotment for cases.

Mrs Palmer did not waste any time with Mr True (the allegorical implications of whose name she did not accept) but dashed off a hot letter immediately to Professor Mason, against whom Mrs Lockwood had previously warned her in vain:

I am greatly surprised to have a letter written this morning signed, F.W. True, which must have been written by your direction, saying that you have no cases in which to make the exhibit from the Smithsonian Institute in our Building. When I saw you in Washington, a year or more ago, I distinctly understood that you were to prepare, mount and place in cases, the exhibits to be made in the Woman's Building. You assured me that you had sufficient cases, and that everything would be ready. Relying on your assurance, I have not exerted myself in the matter at all, and should be very sorry to find now that there is any danger of your failing us. We must have the exhibit from the Smithsonian, and you must furnish the cases in which to make it. We have no appropriation to meet this expense as it was not contemplated by us. We cannot give up the exhibit, and we must have it properly mounted and cased by your Institute.
Please let me hear at the earliest moment on this subject and greatly oblige . . .

This letter must have had the desired effect upon Professor Mason; the next letter in this series appears to be a note from Susan Cooke dated April 1, thanking him for his letter of March 26, and inquiring how much space the exhibit will require. Mrs Palmer had now effected the transference of the ethnological material to the Woman's Building, which seems to have given the Smithsonian curators a good deal of trouble. On April 15, Professor Mason wrote to R.E. Earll, the Special Agent in charge of the Smithsonian exhibit in Chicago:

I have completed my arrangements for the exhibit in the Woman's Building . . . I am to have a space 55 feet long and 25 feet wide. On this space will be six sets of slide screens, each consisting of a case and a half case fifteen inches wide. In addition to these there are to be two large cases 9 by 6, if I am correctly informed, in which are to be installed basketry and pottery. Please place at either end of my space, and as near the back lines as you can, and against the wall, one of these series consisting of a case and a half. Then divide up the intervening distance between the large cases and the slide-screens in accordance with the diagram which I send you, only Mr Ryland has pasted the little papers too far away from my back line.

I send you a diagram, and will mail you on Monday morning a full account of how each box is to be placed. Each crate which comes will be labelled "Woman's Building", and the boxes are soaped for the unit series, as indicated on my diagram. There will be some vacant space, but the extra North American material in our exhibit in the Government Building is to be transported to the Woman's Building, and other material which I will send you will take the place thereof.

Please do not worry about this change, because Mr McDonald and I have a correct record of each duplicate box, and where it goes. He is coming to Chicago also on business for his father, but he will come over and help me to relieve you of any embarrassment in the position of my material. There will come also two pillars for swinging picture frames, to be placed against the back wall opposite my basketry and pottery case in the Woman's Building. These are to hold Mr Wilson's laces.

In the matter of Mr Wilson's laces, at the same time that Mrs Palmer had written her indignant letter to Professor Mason, Professor Goode, almost as proof positive that Mrs Lockwood knew the difference between Goode and evil, had written to Mrs Palmer:

There is now on deposit in the National Museum, a very complete collection illustrating the history and methods of the art of lace making in all parts of the World. This collection is in large part the property of Mr Thomas Wilson, one of our Curators, who has been collecting materials of this kind for a number of years, and has succeeded in getting together the most complete collection in this Country. We had intended to include it in our exhibit in the Government Building at Chicago, but as it seems so appropriate for the Woman's Building it has occurred to me that possibly you would like to have it exhibited there. If so I will try to have it included with our other collections of woman's work, which, in accordance with the recent resolution of Congress, we are planning to send to you for the Woman's Building.

This kind offer Mrs Palmer at once accepted.

On April 18 Professor Mason had to write to Mr Earll again, telling him that "the order to set up 120 boxes in the Woman's Building" would "modify a little" the plan he had sent, and giving instructions about changing and shifting displays in five different instances. On April 22, Mr Mason wrote again to Mr Earll:

Standard with Italian Laces

Pombe Cups. Taveta Tribeswomen of North Afrira. Brought by May French Sheldon.

I have arranged in my mind how I should like to have the basketry and pottery installed in the two large cases in the Woman's Building. In the case for basketry we simply need a platform 12 in. high, receding from the inner margin of the case all around 18 in. In the pottery case, the platform has two steps, the lower receding 18 in from the margin of the case is 15 in high [sic]. The second platform is on top of the first, recedes one foot from the margin thereof and is one foot high. I have been advised by Mr Goode to have these platforms covered with cheap maroon cloth. The basketry and pottery have all been *packed* and are on the way to you in Chicago. I hope everything is going well with you and that all of our people are in good health and spirits. Diagrams of the Government and Woman's Exhibit were mailed to you yesterday.

On April 28 Mrs Palmer was sent a letter presumably by Mr Earll:

Mr Goode is glad to be able to say that the Smithsonian section can lend three exhibition cases to the Board of Lady Managers. It is possible that in a week one or two cases may be liberated. The cases now offered are glazed and painted, and ready for use.
The unexpected delay of cars between Washington and Chicago has interfered greatly with our plans, for the cases and exhibits, intended for the display of the special loan collection to be shown by the Smithsonian Institution in the Woman's Building, have not yet been received, although they are expected hourly.

The Smithsonian people were harassed by various misfortunes. On May 11, G. Browne Goode wrote to Edwin Willits, Chairman of the Board of Management of the Exposition:

I find that it will be absolutely impossible for me to complete the installation of the Smithsonian Exhibits before the twenty-second of May without continuing seven men from Washington now paid from the Exposition allotment. It will of course be impossible to retain them without paying their subsistence allowance and in view of the decision of the Treasury Department I am at a loss to know what to do.

I may say that the delay in completing the installation is due first of all to the fact that during April finishing work was impossible owing to the torrents of water poring [sic] through the roof over our space and the coldness of the building which interfered with effective work: to the delays of our cars containing our exhibits, several of which were three weeks in transit; to the delay in receiving back from the Madrid Exposition collections sent by the Museum, sent in accordance with the act of Congress, which were necessary for completing the exhibit here; and to the action of Congress, by law of March third, providing for an exhibit by the Smithsonian Institution in the Woman's building, necessitating the preperation [sic] of new material to take the place of products of woman's labor thus withdrawn from the exhibit already in readiness before, for display in the Government building. After the twenty-second I will ask for no more such allowances for the men on the Exposition roll, except in the case of my Chief Special Agent who in justice ought to receive an allowance during the period of the Exposition.

In an irritated footnote, Mr Goode added that he was already reducing force and had sent several men back to Washington.

Finally, in June, after the Fair had officially opened, the Smithsonian Exhibit arrived at the Woman's Building. It was called "Woman's Work in Savagery" and filled eighty cases. There was American Indian embroidery from the Nez Perce, the Chippewa, the Kiowa, the Haida; work bag fasteners, bodkins, and needle cases. There were baskets from the Apache, the Choctaw, the Attacapa, the Moki and Eskimo and Micmac and Aleut. There were African matting netting and fans, basketry from Madagascar, Guiana and Samoa, satchels from Polynesia, nets from Fiji and Australia. The Polynesian satchels, Samoan basketry and African matting had been painfully transferred from the Smithsonian Government Building exhibit to the Woman's Building exhibit. There was a case full of tapa, or barkcloth from the Polynesian Islands, and yet another filled with more matting from Africa and Polynesia. There were textiles loomed by women in Italy, Mexico, Africa, New Guinea, and by Navajo women. One case held only Navajo blankets, another Eskimo and American Indian animal skins and dolls. There was a case of spoons made by the Kiowa, and the Sioux, and dishes from the Eskimo and the Haida. There were also primitive shuttles, looms, spindles, distaffs, and awls.

As a sort of footnote to the difficulties the Ladies caused the Smithsonian's dedicated agents, there survives a heartbreaking letter from Thomas Wilson to G. Brown Goode, dated October 14, 1893:

Navajo Indian Work

In the transport and setting up of my display of laces, in the Woman's Building, at the World's Columbian Exposition, two unit cases, thirty inches square, one twelve and one three inches deep, have been lost and apparently cannot be found. I have made every effort in that direction, have asked the assistance of Mr Earll, Mr True, Brown, Horan, Stewart, and also Mrs Meredith in charge of the Woman's Building, all without the slightest trace of success. They may find them when we come to pack up and return our goods but of this I have small hope. One of these unit cases contained an elaborate lace cushion, with three or four hundred bobbins and a piece of black silk lace, four inches wide, in process of manufacture. The other, three inches deep, contained specimens of various threads cotton and linen and of needles, arranged on blue paper. In addition to asking you to keep track of this loss, may I not ask you to visit the Italian or other departments and there purchase for me, to the extent of one hundred dollars, different cushions showing the manufacture of lace, such as will make a series and a representative from different countries. There was one in the Italian Department about which I talked with Miss Perkins, proposing to purchase the peasant's costume as worn by a lacemaker. The head and hand were the work of some eminent sculptor and the price was too high, but the costume might be something advisable to have. The Italian Department of which I speak was in the Woman's Building in the southwest corner and is presided over by the Countess Di Brazza. There may be some specimens also showing the various processes or those which are pieces but partly made which would tend to illustrate the history of

lace-making. If you should find any such or any which Miss Perkins would recommend to you that come within the limit of money, I will ask you to please include them in your purchase. It is not unlikely but that you might obtain them without the payment of duty.

It is to be hoped that Mr Goode obtained these items for Professor Wilson, and that they made up to him for the loss of his laces.

In December of 1892 Mrs Palmer had made an attempt to keep all contemporary Indian work out of the Building, under the misapprehension that it was inferior. She wrote loftily to one of her suppliers, the Messrs Wursburg:

I do not think we should care for the modern designs which are not so artistic as the original Indian patterns before they were spoiled by contact with civilization and while they were true to their own instincts of the beautiful.

Lace Needles and Bobbins

Somewhat wider contact with this kind of work undoubtedly broadened the President's outlook, as did her conversations with Mrs Wheeler and other knowledgeable persons.

Supplementing the hard-won Smithsonian collection were collections of Indian handicrafts from states and territories. Alaska provided 204 exhibits; Colorado twenty-eight. Lady Managers from Colorado were given the landing of the southwest staircase for their "Indian Alcove." Against a backdrop of Navajo blankets, a Navajo weaver worked her loom; a reed shuttle flew back and forth in her fingers. New Mexico sent a collection of artifacts and one recent but authentic Indian blanket. Women from San Juan County in New Mexico had raised $150 for this blanket, commissioning an old weaver named Miranda to weave it. She was given a picture of the Woman's Building, and marked with a thorn the south window near which she was told her blanket was to hang. This blanket was pictorial, showing horses bearing a white man's brand. Pictorial blankets had begun to appear in the 1880's. Prior to that geometrical abstract patterns were the rule.

South Dakota sent an altar cloth of white doeskin embroidered with colored beads, from its Pine Ridge Agency.

An attempt was made to cluster as much primitive work as possible around the Smithsonian cases. Work from "undeveloped" countries was placed there. But Indian work became scattered about the Building. In addition, exhibits of "advanced" European countries contained some primitive handicrafts. Thus the story of woman's inventiveness was not told in the coherent, systematic way in which the Ladies had hoped to tell it. Bits and pieces of it appeared in every exhibit from every country. Needlework was the predominant theme in every collection. Candace Wheeler commented:

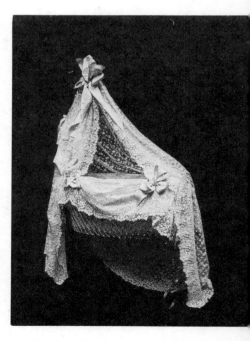

Cradle with Mirecourt Lace from France

The old and familiar art of needlework .. which began when Eve sewed fig leaves in the Garden of Eden . . . which has been the heritage of Eve's daughters in all the ages of the world, has never in history made so great a showing or illustrated so conclusively its claim to rank as one of the great arts of the world . . . There are embroideries which are precious from every point of view — from their antiquity . . . from their methods, which have long been lost . . . from the use of materials of a purity and preciousness unknown to modern manufacture, and from a color of the subtlety of which only the painting of time can give, and which no dyes can rival, One sees at a glance, almost, the first attempt side by side with the very latest development of the art. Examples of all countries as well as all times are here . . . the work of all races of women, wherever they exist or have existed, and wrought out their quiet days with the needle, sitting under palm and pomegranate.

Queen Margherita's Laces

The most excitement attached to the collection of laces sent by the Queen of Italy. They were shipped on a German steamer; since they were irreplaceable, a $100,000 bond had been secured against their safe return. From a safety deposit vault they were brought to the Woman's Building in a splendid coach drawn by gold-harnessed horses. The coachmen wore full royal livery. Nineteen guards brought the cases into the Building, where it took a week to unpack them. The wooden boxes were covered with zinc, wrapped in canvas and sealed with 250 royal seals. Despite all these elaborate precautions thirty pieces appeared to be missing from the collection when it was unwrapped. The packing list was checked against the contents: panic struck, and a telegram was dispatched to Rome. To everyone's relief it evolved that Queen Margherita had removed some of her favorite pieces at the last minute to wear during a visit from the Emperor of Austria.

The Italian laces were placed in the Gallery of Honor, behind high wrought-iron grillwork, and were guarded night and day by Italian soldiers. All the pieces were not laces. Some were mummy wrappings taken from Egyptian tombs in the time of the Caesars.

Candace Wheeler said that it was wonderful that "such treasures", even under the "careful conveyance" that they had had, should have "floated down through the centuries" and have been allowed "to drift" into the United States, which was "so far removed and undreamed of" when most of these treasures were created. Some of the laces had been preserved since the Renaissance; they were then so valued that estates had been mortgaged to pro-

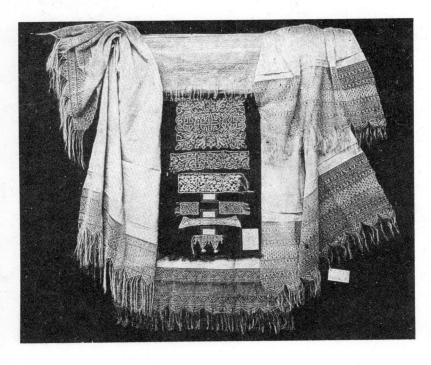

Macrame Work from Italy

vide money to buy them. There were crown laces, held by china cupids and lighted from behind to show their exquisite patterns. There were also reproductions of old pieces made in Burano, where Queen Margherita was patron of the lacemakers association.

Such associations had been established in many places in Europe and Great Britain, since 1837, when lacemaking machines were first used. The Burano association had been established in 1872 by the Countess Adriana Marcello. She was typical of many wealthy women for whom lacemakers were a favorite philanthropy. Burano, a village near Venice, had produced a famous flowered point lace. By 1872 the industry was moribund, and so was the village, whose inhabitants made their living by fishing, and who were near starvation because of an unusually cold winter. An eighty year old village woman named Cencia Scarpparola, remembered how to make some of the Burano patterns; funds were provided by the Countess so that this art could be taught anew to the village women. By 1893 about 400 women had learned various patterns, and the village was saved. The Queen, who had lent some of her laces to be used for patterns, was called by the grateful people of Burano "the Royal Angel of the House of Savoy."

The Countess Marcello did not live to see the $10,000 worth of Burano lace that was displayed at the Exposition; she had unfortunately died shortly before the opening. She would have been upset no doubt to see a letter to Mrs Palmer from Daniel Burnham, quoting a conscientious and poetic guard:

> I have the honor to quote below, for your information, an extract from a report of the Guard, dated June 27th:
> While on duty I have seen a number of mice in the exhibit of Italian laces, Woman's Building. If they should get into the cases, they will likely damage the laces.

Lace Maker

The custodian of the Italian laces was Countess di Brazza, the wife of an Italian nobleman. The Countess, an American originally named Cora Anna Slocomb, came late to Chicago, because she had gone first to visit her family in New Orleans, and was detained there by the illness of her small daughter. When she did arrive in Chicago, she did not prove amiable. She arranged an elaborate musical "tableau vivant" called "The Seven Ages of Columbus" to be presented in the Assembly Room on October 12, Columbus Day. Harriet Monroe wrote verses especially for the occasion, in addition to lending some portions of the now tattered *Columbian Ode.* Colonel Cody lent twelve Indians, and the rest of the cast was studded with stars: Zelia Nuttall was a court lady, Laura Hayes was "The Genius of Progress" and Mary Logan's niece Mary Logan Pearson appeared as "the Genius of Music." Ellen Henrotin was the Marquise de Moya, and her son Edward

played Luigi, the son of Columbus. The Count di Brazza himself represented King Ferdinand. The Grace Episcopal Church sent its male choir for this event; other music was provided by the Bendix String Quartette, the Mexican Orchestra, the Valisi Italian Mandolin Orchestra and Mr Wilson's Exposition Band. Marshall Field and Company provided draperies, and the Illinois Central Railroad Company put on an extra train for the accomodation of guests. It left the Midway Station at 12:45 A.M. and Randolph Street, stopping at all stations.

Under the circumstances, everyone was rather hurt by the Countess's unpleasant manner during rehearsals. Ellen Henrotin wrote to Bertha Palmer a week after the event:

> There was some little confusion, as was only natural . . . and the Countess completely lost her temper, stamped her feet, screamed and shrieked, in a manner which I have never before witnessed in my life. Were the Countess an Italian, I should not express my opinion of her so frankly, but as she is an American, I must say that I do not consider her a happy selection to represent the gracious and refined women of sunny Italy.

Countess di Brazza was asked to speak on the political situation of Italian women. She refused to do this, saying that she was interested in "the higher education and refinement and usefulness" of women, but she was not interested in their "emancipation." She had come to Chicago to talk about lace, and especially about the lacemaking association which she had set up on her estate in northern Italy, for which philanthropic endeavor the Italian government had recently given her an award. She did speak on this subject at a Congress in the Woman's Building, with contagious fervor:

> They are crying to you for your friendship, for your patronage . . . the frail fingers of these women and children are competing with iron rods and steam power, and yet have courage; for the laces, the homespuns into which are entwined their dreams, their prayers, their songs and their tears, are unsurpassed . . . To you I confide their future. It is safe if you grant my prayer, though it hangs upon a frail shred of lace.

The future of these skilled workers did indeed hang by a frail shred. The motives behind both the arts and crafts movement of the '80's and '90's and the cottage industries patronized by wealthy philanthropists were similar. A kind of guilty terror seized the upper classes over the encroachments of the machine: writers like Ruskin and William Morris looked back nostalgically upon the medieval craftsmen; the simple artisan was rapidly becoming extinct, and a hideous eclecticism had settled over the land.

The women's crafts associations of Great Britain were the most

Countess di Brazza & Her Daughter.

numerous at the Fair and the largest of these was the Irish Home Industries Association organized by the Countess of Aberdeen. In fact there was not enough room in the Woman's Building for Ishbel Aberdeen's exhibit. Two small replicas of Donegal and Blarney Castles were erected on the fairgrounds in the Irish Village, and in them were shown needlepoint, pillow and crocheted lace, embroideries and Kells art embroidery and Youghal point — a stitch which had been revived in the convents during the Irish famine of the late 1840's. All this work was part of the British exhibit, as were the tweeds displayed by the Scottish Home Industries Association and embroidery and quilts in the small Welsh exhibits.

When Lady Aberdeen gave a talk in the Woman's Building, she wore a crocheted blouse from Clones, a point lace handkerchief from Youghal, and a homespun skirt from Donegal — all Irish towns famous for their crafts. She wished to illustrate her claim that "skilled human fingers are still superior in many ways to the iron monsters devised by human brains." In her speech the Countess asked a pertinent question:

> Is it desirable to encourage or continue the existence of these home industries which are produced at the expense of so much more labor than the machine goods, and which in comparison cannot be paid so well for the time and outlay given, or should they be regarded even as these beautifully illuminated manuscripts of bygone days, things to be admired and treasured, but the production of which now would mean willful waste of life?

The Countess's answer to her own question was, of course, that it was desirable to encourage and continue these home industries. Aesthetically, certainly, the production of these skilled craftswomen was superior to anything the machine could produce, and the craft itself was an admirable accomplishment. But these home crafts were a dying industry; particularly the production of lace was moribund, and would be virtually extinct within the next ten years. The work was arduous and rather unhealthy; although the product was expensive the workers were poorly paid. Women like Lady Aberdeen supported these things for aesthetic reasons, and also for social ones: they did not want to see the country people migrate into the city to work in factories. The Irish Industries had lost a good deal of ground during the decades before the Fair; Lady Aberdeen believed they could be salvaged if she and others like her travelled the countryside showing women fashionable patterns, and then helping them to bring their products to distant markets.

The Irish Home Industries Association did in fact earn $100,000 from sales during the Exposition. Bertha Palmer urged the New York firm of Hollander & Company to send a represen-

Crochet Dress Panel. Jesuit Point. Irish Carmelite Convent.

tative to the new Scottish Industries shop on Wabash Avenue in Chicago and inspect the tweeds, The Russian Cottage Industries opened a showroom in New York; it carried everything from shawls and snowshoes to carved wooden cradles. Mrs Palmer herself bought $220 worth of embroidery there to help things along. She wrote to the Princess Schahovskoy, who had brought the Russian exhibit to Chicago, that she hoped the little shop in New York would serve as "a connecting link" with the exhibit at the Fair.

Bertha Palmer also helped to place in some Chicago hotels embroideries brought to America under the sponsorship of the Turkish Compassionate Fund. This Fund was established during the Russo-Turkish War of 1877 as a British relief project. The Baroness Angela Burdett-Coutts described the situation under which the Fund was established:

> The defeat of the Turks at Orkhanie . . . was the signal for a *sauve qui peut* throughout the fertile provinces to the south of the Balkan range. All the roads to Constantinople were crowded with long trains of refugees. A vast number died of starvation and the cold . . . but something like a quarter of a million reached Constantinople . . . at all times a teeming and overcrowded city. There they were fed by the thousands every day by the Commissioner of the Fund . . . Among the small possessions to which the women had clung to the last were the old embroideries of Turkey, many of which had been precious heirlooms in their families. Some women retained the rare art of making these embroideries. It occured to Mrs Arthur Hanson, one of the leading English ladies in Constantinople, that the art might be revived, the old beautiful colors reproduced, and a useful industry established among these unfortunate women, many of whom had been wealthy and comfortable. From the first Mrs Hanson's work prospered. Its success is due to two causes: first, to the untiring energy, patience . . . and artistic taste of Mrs Hanson . . . and secondly to the superb quality of the embroideries.

Constance Eaglestone, another worker for the Fund said:

Turkish Embroiderers

> The charm of this Turkish embroidery consists in the originality as well as the beauty of the designs. Many of these have been handed down from generation to generation in the Turkish harems, and so jealously were they guarded . . . that had not the fortunes of war brought the princesses from palaces in the Balkans to the level of peasant women in huts at their gates, the secret of their creation would never have been divulged.

At its peak, Mrs Hanson's project employed 2,000 women. Paris designers began to order fabrics from these workers whose "eyes . . . could count threads in a cobweb" and whose fingers "could work gold into a butterfly's wing." Unfortunately some of the princesses began to crack under the strain. Miss Eaglestone became somewhat exasperated:

The Ottoman race itself has little or no inventive powers ... They can do nothing but copy ... while orders to make even the slightest alteration ... bewilder them ... Another difficulty is that having once learned a new stitch the women seem to lose all power of re-membering an old one. 'It is gone, gone,' they repeat hopelessly ... Thus it is a serious undertaking to lead a skilled worker away from the design which her lithe brown fingers have made popular at every Court of Europe.

Despite these difficulties, the English ladies succeeded in sup-plying the French couturiers with delicate garments with invisible seams. Sarah Bernhardt began to wear them, and they became the rage of Paris. The French learned quickly how to copy them by machine at a fraction of the cost and the bottom dropped out of the Turkish market. The Fundraisers hoped that the Fair would revive this ailing industry.

In 1892 Mrs Palmer had met Cariclée Zacaroff in New York: Madame Zacaroff, a Turkish lady, was associated with the Com-passionate Fund, and had been recognized by the Sultan for her labors in its behalf. Mrs Palmer invited her to display her wo-men's wares in the Woman's Building. Constantinople had been alerted to begin production in November, 1892, not a moment too soon: lithe brown fingers flew incessantly for five months. The houses the women worked in were small and crowded, with dirt floors. A Western visitor commented, "Here women sit working at their frames, and in spite of the inconvenience, it is rare that a spot or stain is found." In good time Candace Wheeler received the work for official acceptance in the Woman's Building sales-rooms. She was impressed with the rich raised gold work, and the fine embroidery on black chiffon. "Human execution could not rise higher," she said. The stitches were finished on both sides. "So perfect is the neatness of our needlework," Madame Zacaroff wrote on November 19, 1892 to Mrs Palmer, "even on the wrong side, that many people consider that it cannot be done by hand."

Nevertheless these embroideries were not successful; after four months Cariclée Zacaroff withdrew them from the sales room. She did not think they were being properly shown. The Sales Committee for the Woman's Building was not sympathetic. Ma-dame Zacaroff then composed a plaintive plea to Bertha Palmer:

Dear Madam
I write this personal letter to you in my extreme emergency only ... 'The Turkish Compassionate Fund' has risked its existence on its elaborate preparation for the Exposition. Our hopes were great — our results, very poor, in comparison — the general "hard times" being the chief cause, of course — but not the only one.
We commenced in salesrooms of Woman's Building — some weeks ago I withdrew, as, under the circumstances, it was of no advantage to remain. I blame no one — but I think that the work I represented, and its extensive scope — have not been understood.

Cariclee Zacaroff

I have carried on the work, independently. By indefatigable labor —
and the most strenuous efforts, I have been able to meet our heavy
liabilities — up to date. I have the most tormenting doubts as to my
ability to do so to the end, or until better times come.

Our sales in the Woman's Building, under any circumstances,
would not have been sufficient to sustain the work, but properly di-
rected, they would have been a great help — especially, as being
near our two beautiful exhibits there.

Madam, I pray you, obtain for us a stand there — I no longer ask for
the stairway, as the Committee have thought it best to refuse, and at
this moment, I do not feel justified in going to the expense of making
that position attractive — but, if *you* wish it, Madam, a position can
be made for us somewhere near our exhibit in the North Wing — or
upstairs in the corridors.

I beseech you, obtain this for us quickly and without referring me to
other members of the Committee — my experience has been that
my every request so far, has been ignored or refused . . .

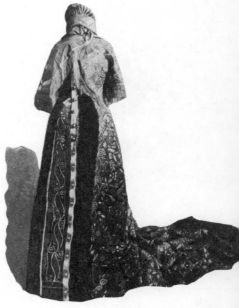

OLD TIME COURT DRESS, RUSSIA

Mrs Palmer installed Madame Zacaroff on the landing of the
northwest staircase. She was disappointed however in the Fund's
display. Madame Zacaroff replied that she had spent $104 on her
booth, and furnished her own carpet, and that was enough. She
would not display large pieces of embroidery because "the dust of
former days and the damp of the present are terrible enemies to
our delicate work." As she had predicted, sales rose dramatically
in her new location.

Russian ladies, as well as Turkish ones, engaged in philan-
thropy. *Harpers Bazar* commented that great ladies did work
among the peasants, as Lady Aberdeen did with her Irish villag-
ers.

They teach and encourage industries that will relieve the dreadful
poverty that exists in small towns and remote districts. There is
shown a white knitted woolen shawl that looks like a film for its
astonishing fineness. It weighs but 8³/4 ounces, though it is several
yards square, and is calculated to contain twenty-four and a quarter
million stitches. Excellent homespuns are shown. . .

Another observer wrote that the Russian laces were "of good
but heavy manufacture" and described the patterns as "sensuous
and meandering, distinctly Russian," whatever that meant.

From India, missionaries sent samples of the pupils' work, to be
sold in aid of the mission. Silk embroidery on cotton came from
Manipur, embroidery from the Punjab, Madras, Poona, Benares
and Assam, and, from the American Lutheran Mission at Guntur,
"exceedingly beautiful work . . . threads of burnished gold . . .
braided together by the needle or twisted in some occult way so as
to appear like drops of dew . . ." Japanese and Chinese goods
were praised as "unsurpassed." Siamese work was praised too, es-
pecially "pillows covered with embroidery resembling flowers and

foliage, cut from one solid sheet of burnished gold. Not a stitch can be defined, and yet it is an art of stitchery.'' Candace Wheeler was bemused by the traditions of the mysterious East. ''The Chinese, Japanese, Egyptian, Persian and other Eastern people,'' she said, ''seem scarcely to have changed their subjects or their methods in a thousand years.''

Mexican work included actual portraits embroidered in black thread on white silk, as fine as steel engraving. Mexican embroidery was found to lack originality, but these portraits ranked ahead of the work of all other nations. The Committee on Awards said:

> The deft Mexican fingers weave these cobwebs to the discomfiture of the needlework world . . . [The work displays] the patience of sublime docility. It is characteristic. It is national . . . The liberty of thought that has enlarged designs and made the execution of all work easier, from the work of the needle to that of the sledgehammer, has not yet penetrated Mexican conservatism.

This somewhat backhanded compliment notwithstanding, Mexican needlework took 208 medals, more than were received by any other country.

A free range of design characterized the work of the women of America and Western Europe. Their most traditional works were ecclesiastical. Many of them came from convents: altar hangings and vestments. Candace Wheeler believed that the best specimens of this work

> could not be produced except in the quiet and uneventful life of the cloister, where color and stitchery made the one interest and contrast of colorless lives, and could therefore almost monopolize the thought of the inmate that produced them. There is certainly a peacefulness and repose of subject and treatment in these convent-wrought hangings . . . greatly in contrast with other embroideries.

Needlework evoked a mixed response from the judges and critics of the Woman's Building. The virtues of tradition were extolled, its passing was lamented, and the skill of its practitioners were extravagantly admired. At the same time a perceptible shudder seemed to pass through the viewer, who was dismayed by the drudgery, the docility, the lack of innovation that accompanied the skill. There was no question that only in benighted conditions could these traditional patterns be employed. At the same time the nineteenth century critic worried over what would succeed these things. The *Art Amateur* expressed the hope ''that many of our designers will be led by these embroideries to study the chief historic styles and to master them before trying to invent something new,'' since a ''well marked ornamental style'' developed over generations was better than ''the sprawling and ineffective modern attempts at originality.''

Dressing Table with Embroidered Linen
Russian 17th Century

Indeed, many needlewomen did look to the past. France sent a copy of the Bayeux Tapestry, the original of which was attributed to Queen Mathilda of Flanders and her ladies-in-waiting. The original, embroidery on linen depicting the Norman conquest of Britain, is now believed to be of later origin than was originally thought, and to be English and not Flemish. The reproduction, which was seventy-six yards long — the length of the entire east gallery — was judged to be "more historical than beautiful."

In the French Salon was mounted a huge modern tapestry called "The Grotesque Months", which consisted of twelve panels, each three and one half yards in length. Madame Leroudier, the founder of the Lyons School of Embroidery, had worked for twelve years on this tapestry, the design for which she had found in a rare set of engravings in the Gobelin tapestry works. Since the engravings were each only two inches square, the process of enlarging the pattern had been most taxing. A journalist wrote of this work that it was difficult to believe that it was possible for one woman to accomplish it. F.G. Stebbins, a woman Exposition judge, called it "By far the most extraordinary undertaking ever attempted by a single person in artistic embroidery."

Bible Belonging to Queen Elizabeth

The Royal School of Art Needlework attempted, among other things, to revive the motifs and methods of Renaissance needlework. Its founder, Queen Victoria's daughter Princess Christian, found it remarkable that the school "sprang from nothing, and has now become one of the most important, if not the most important, school of its kind." The school had been founded in 1872 for the express purpose of helping distressed gentlewomen to learn ornamental needlework and to sell their product. Eight hundred and seventy pieces of work were sent from this school in the Kensington district of London to the Woman's Building. Of these about 500 were original designs either by students or by such artists as Edward Burne-Jones and William Morris; the rest were reproductions. One was a book cover of red velvet embroidered with gold and silver; the original had been presented to Queen Elizabeth to cover a specially printed bible.

Bertha Palmer wrote the English Board praising the Royal School for bringing to the Building "one of the most interesting exhibits . . . for we realize that this school . . . has been the means of bringing needlework up to the plane of fine art, and of reviving many of the beautiful stitches and the blending and shading of colors." But she wrote privately, "It is surprising how little the Kensington School of Needlework is doing that is original and beautiful, and I am sure that the work of our own women will come as a great surprise to those of other nations." Candace Wheeler agreed: she praised the "fresh originality" of American work and its "singing color quality." Mrs. Wheeler had first seen the work of the Kensington school at the Philadelphia Centennial

and had been greatly impressed by it. Since then, she believed that her work had surpassed the English work. "It is among our own women we find the highest grade of embroidery," she wrote.

Candace Wheeler's opinion was not universal. Marie Blanc, a Frenchwoman at the Fair, believed that "schools of industrial art in America are still far from equal to the French, in spite of their steady progress." American art embroidery was only about seventeen years old, and it "prospered" but "its workwomen lack what we have in France — stimulating competition with women of the best society, who do not scorn to devote themselves to certain kinds of manual labor . . . " F.G. Stebbins, agreed with Madame Blanc: "Generations of art culture have told upon a people of rare artistic endowment as they have not yet told upon us, for we have not yet had the time to learn." Stebbins made an exception of Candace Wheeler's firm, the Associated Artists. Its work demonstrated, she said, "great perfection of quality and beauty." In their brownstone workrooms on East 23rd Street in New York, the women of Associated Artists were able to rival in textiles the lines and colors Louis Tiffany produced in glass. Their draperies, cushions and tapestries sold to the trend-setting rich at high prices: material and design were both costly. One silk drapery called "Dawn", which was exhibited at the Exposition, inspired judge Stebbins to a lyrical description:

> All the rosy and golden and azure tints of early morning, shimmering together over the surface of the silk . . . produce a web of color which is like the dawn — like an opal — like a dream of some celestial garden.

Experimenting with the common darning stitch, Candace Wheeler had invented "needle weaving" in which silk threads were carried by a needle acting as a shuttle over and under the warp of fine twisted silk. The resulting tapestries were soft and durable; needle and thread had produced the effects of paint. The first large work of needle-weaving was a copy of Raphael's "Miraculous Draught of the Fishes," which Candace Wheeler photographed at the Kensington Museum. These photographs, joined together, became the working pattern for her tapestry. It took months, and several women working together, to complete the piece. Mrs Wheeler considered the original to be the most beautiful and difficult of Raphael's surviving biblical tapestries. Mrs Palmer told Mrs Wheeler on March 18, 1892 that this tapestry "would reflect great credit" both upon herself and her country at the Fair. It was successful, although to modern eyes Mrs Wheeler's Japanese or Art Nouveau designs are of greater interest. The Cornelius Vanderbilts lent several tapestries by Dora Wheeler Keith to the Woman's Building: among these was "Cres-

cent'' or ''The Winged Moon'', a dreamy impressionistic work.
Mrs Palmer lent ''Minnehaha Listening to the Waterfall'' by Mrs
Keith, one of a series of representations of famous American
women in literature.

Pottery ranked with needlework in artistic importance at the
Fair. Pottery and basketry were everywhere: the Smithsonian col-
lection contained two large cases of Apache baskets, Sioux jars
and Eskimo bone implements. Ceylon sent ''valatura'' baskets
with interwoven leaves of green, blue and orange, used for cen-
turies to carry fruits and vegetables to market. The explorer May
French Sheldon had brought an exhibit of utensils from Africa:
these were both beautiful and useful. The crafts of the industrial-
ized countries, on the other hand, insofar as pottery was con-
cerned, were more ornamental than useful. China painting had
been a rage for years; at the time of the Fair there were at least
25,000 china painters in America. A certain hostility was growing
toward these busy workers. Mary Louise McLaughlin, a potter
from Cincinnati, spoke to the subject at a session of the World's
Congress of Representative Women:

> Since prehistoric ages, woman has figured largely as the maker and
> decorator of the vessels in which food has been served . . . We, fol-
> lowing the line of what should be progress, are inclined sometimes
> so to decorate these articles that the original use is lost sight of. In
> this, to our shame, be it said we fall behind our aboriginal models,
> who in their simplicity never lost sight of the fitness of things, and
> whose work consequently ranks high in true artistic beauty.

Dora Wheeler Keith: Winged Moon 1882

Another speaker at the Congresses, Charles Binns of the Royal
Worcester Works, condemned American craftsmanship so color-
fully that he was asked to repeat his lecture for those who had
missed it. Mr Binns had nothing but praise for the Rookwood
Company of Cincinnati, which had been founded and originally
directed by Maria Longworth Nichols. He said that every Ameri-
can should be proud of the products of this pottery, with their
''tenderness of glaze'' and apparently inexhaustible depths of col-
or. ''If the product does not please you,'' he said fiercely, ''then I
fear you have no soul for ceramics.''

Both Rookwood work and the work of the Art Pottery Club
grew from china painting classes at the Cincinnati Art Academy
given in 1874, when they were popular among women with leisure
time on their hands. By 1876 many of these women had become
skilled potters; their best pieces were displayed at the Philadelphia
Centennial. Of these pieces, two teacups and a pitcher for choco-
late were displayed in the Woman's Building, in the Cincinnati
Room. These Cincinnati artists studied the glazing techniques of
the Japanese and the French, and eventually developed their own
method of underglaze which was professional and innovative.

Maria Longworth Nichols

Maria Longworth Nichols had opened her Rookwood Pottery in 1880, in competition with Louise McLaughlin's Cincinnati Pottery Club. Having been widowed in 1885, she had married Bellamy Storer in 1886. In 1889 she won one hundred medals for her pottery at the Paris Exposition. In 1890 she had sold the pottery to a group of men who formed a larger company. In 1890 Mrs Palmer had invited both Mrs Nichols Storer and Louise McLaughlin, whose Pottery Club was by that time defunct, to exhibit in the Woman's Building. Mrs Palmer did not know that the two women had been bitter rivals for fourteen years. Mrs Nichols Storer was not one of the original members of the china painting class; she was however invited to join the Pottery Club when it was

Maria Longworth Nichols: Rookwood Vase.

Mary Louise McLaughlin: Pilgrim Jar

Mary Louise McLaughlin: Plate

founded by Louise McLaughlin. Her invitation apparently went astray, and her resentment over this caused a deep rift between her and Louise McLaughlin, which eventually led to the ousting of the Pottery Club from the premises of Rookwood Pottery, where they had had access to the facilities.

This enmity became public when the Cincinnati Women's Exposition Board printed the following paragraph in the Fair catalogue:

Miss McLaughlin, the President of the [Pottery] Club, is the discoverer of the method of decorating under the glaze that is still used as the foundation principle of the work at the Rookwood Pottery. The same method was used at the other Art Potteries of Cincinnati during their existence.

This was in fact a true statement. But William Watts Taylor, supervisor of Rookwood Pottery, demanded that the paragraph be deleted from the catalogue. Miss McLaughlin wrote to Mrs Nich-

Mary Louise McLaughlin

ols Storer, reminding her that the paragraph was true, and that both she and Mrs Storer had years earlier successfully enjoined one Thomas Wheatly from taking out a patent on the underglaze process. Mrs Nichols Storer had at that time testified that "Miss McLaughlin used to do Limoges before Mr Wheatly ever thought of such a thing." In 1893, however, Mrs Storer had evidently forgotten her testimony. She told Miss McLaughlin, "Your reputation can rest so well on what you yourself have done, that it is not necessary that you or anyone else for you should seek it in outside things with which you have absolutely no connection." Miss McLaughlin protested that Mrs Storer was attempting to efface her "from the history of time." This did not stop the process: the paragraph was deleted. It consequently took fifty years for the American Ceramic Society to recognize Mary McLaughlin as the originator of the underglaze process.

C.A. Plimpton: Vase 1881

This cast rather a pall over the Fair for Miss McLaughlin, who consoled herself with her special Cincinnati Room exhibit of pots in various stages of glazing. She exhibited finished pieces as well: a blue plate decorated with birds and grasses done in 1877, and a vase three feet high, which was believed to be the largest vase cast in the United States. Clara Newton, another Cincinnati potter, had watched Miss McLaughlin apply the "pate-sur-pate," layers of slip brushed over the unbaked pot in a design of dull red and yellow over the natural greenish ground. She exclaimed "You are painting a regular Ali Baba Vase," and the huge vase was called "Ali Baba."

Another member of the Cincinnati group, Cordelia A. Plimpton, was considered by her associates to be "the most artistic and individual" of them all. Her work, she said, "has not been the fashion." She produced a wing vase with pierced handles of Moorish design, which illustrated her experiments with interlay. She used clay in shades of brown on yellow, from Ohio, and a black clay from Indiana. One side of the vase carried a Cairo street scene under a band of imitation "Arabic" script; the other showed an Arab mail carrier riding on a camel against geometric motifs. This vase, called "Alhambra", understandably attracted a good deal of attention in the Cincinnati Room.

The Rookwood Pottery sent ten pieces, all decorated by Maria Nichols Storer. One was a gilded vase showing strong Japanese influence in the subtle and naturalistic design that was Rookwood's hallmark. Both the Sèvres china works and the Industrial Museum of Berlin bought Rookwood. The official Prussian report on the Fair stated that the Rookwood displays (of which there were four besides the one in the Woman's Building) were among the most important displays at the Fair and were "examined by all visitors with universal wonder." The Cincinnati potters had a combined Exposition sale of $1500, and took a good many orders home.

Examples of Cincinnati Pottery

Cincinnati was a center for woodcarving as well as pottery, and had been since the early 1870's when Ben Pitman (whose brother invented the shorthand method) taught his wife and daughter (Agnes, designer of the Cincinnati Room) the art of woodcarving. It was Ben Pitman who had given the first china painting classes in 1874. All three Pitmans taught at the Cincinnati School of Design. They had displayed their carved tables, doors and mouldings at the Cincinnati Exposition in 1872, and this had started a woodcarving craze among the city's middle-class women. 247 examples of woodcarving had been contributed to the Woman's Building. Louise Kirby Murphy, Annie Cunningham and Laura Fry colaborated on a piano for the Baldwin Company; the front and sides of the instrument were covered with carved birds, lilies and acanthus leaves. Laura Fry, who was a teacher of woodcarving, believed that women could carve as skilfully as men; woodcarving she thought was as much of an art as sculpting. "Art for art's sake" had to be the motto of woodcarvers because "as a money-making work it is a failure." Materials were expensive and "the process slow." However, carving on a modest scale, "as in designing appropriate decorations for furniture," could offer women a livelihood.

Queen Victoria's younger daughters who taught woodcarving and leather embossing in the Technical School at Sandringham, sent walnut music benches to the Building. Princess Maude's stool was decorated with sunflowers; Princess Victoria's with dahlias. The press found both pieces "beautifully executed" and said that "such a pretty story of benevolence would make the chairs attractive were they half so well done." Entranced visitors were so eager to sit on these benches that they finally had to be removed from the display — the benches, not the visitors.

By 1893 women were attending technical schools like the Pratt Institute in Brooklyn and the Woman's Industrial Association in Vienna, and were entering the decorating profession. But the American public was unaware that women were bookbinders, silversmiths, leather workers, copper etchers, designers of carpets and stained glass. Candace Wheeler sponsored a show in March, 1893 at the American Art Galleries in New York for which she provided 450 of the best entries for the Woman's Building. These, together with entries from England, France and Germany, offered "enough [examples] in all lines . . . to cause surprise," she said.

Many windows of the Woman's Building were made of stained glass designed and cut by women, a fact which startled the *New York Times* into saying that "women are dangerously near man's work." The New Century Guild of Philadelphia sent Elizabeth Abel, to demonstrate the making of stained-glass in the Process Room, which had been set aside for working exhibitions of this sort. She cut, polished, and leaded pieces of glass, and answered

Princess Victoria of Wales
Leather Seat for Stool

questions. The art was so unusual that some visitors thought she was working with petrified wood or colored plaster.

Lacemakers from Minnesota worked in the Process Room, as did a Utah silk weaver, Cincinnati women with their kiln, and others. There were working exhibitions in the international sections too: a woman blacksmith from Germany worked at an anvil, a Scottish spinner made wool for Harris tweed, a Welsh-speaking weaver in traditional costume spoke as she wove yards of flannel. These handmade goods were then offered for sale in the Sales Room, which was always crowded, and which, like most aspects of the Building, had been a subject of controversy.

Some of the Ladies had felt that there should be no sales in their Building: they wished to drive the moneylenders out of the Temple. They did not want any commercialism. Others had argued that it would be an act of charity to allow women to sell their work. It was true that if small craft workers presented their wares for sale there would be a lot of paperwork, and a lot of "trash" on hand, but would it not be wrong to discriminate against the humbler skills in favor of the more ambitious and artistic? After struggling with this question at various Board meetings, the Board decided on October 25, 1892, that the work of the crafts societies represented the efforts of "breadwinners, and the articles being peculiarly feminine they will be appropriate souvenirs of woman's work in the Columbian Exposition." It was decided that a group of qualified judges would work together to

Welsh Spinner

Cartoon for Stained Glass by Marie McDowell

screen applicants. Circulars were issued to aspiring craftswomen warning them that "no sentimental sympathy for women will cause the admission of second rate objects." But by the time the Board pulled itself together to apply standards it was too late. All sorts of things had gotten into the Building. The Sales Room became a bazaar filled with entrepreneurs; it was as noisy, busy and colorful as bazaars generally are.

Lace Spread and Pillow Cover

On the Fair's opening day the Sales Room brought in only $15.65. By September however receipts were averaging over $600 a day; at the Fair's end the Room had grossed $42,882.45. But over the months the goods offered in the Room changed in quality. Inexpensive souvenirs replaced the tasteful items which Mrs Palmer preferred to sell. The exotic and expensive embroidery sent by the Turkish Compassionate Fund was, as we know, finally withdrawn; it brought in only slightly more money than penwiper dolls made by E. Stanley of Maine. The E.H. Heath Sisters of New York made flowers, bon bon boxes, glove cases, lampshades and other novelties from paper; these earned over $9,000, an amount not equalled by any other concessionaire. A percentage had to be paid to the Exposition authority, an accountant visited the sales booths several times a day to keep an eye on things. There were also the costs of transportation and, in the case of foreign exhibitors, customs duties. Another discouraging factor was that, unless special arrangements had been made, all goods,

Ancient Russian Headgear

sold and unsold, had to remain in the displays until the Fair was over: articles were ordered from "samples."

The craft workers had difficulties far beyond those which they encountered at the Fair. They could not compete with mechanized industry. Margaret Sullivan spoke for these cottage workers in a letter to Bertha Palmer on December 11, 1891:

> I was in London in 1883 and invited . . . to attend the meeting . . . where the cottage work was first organized, and afterwards visited London shops where goods were sold . . .
> The question presented to my mind was how is it possible to get these things on the American market? Duties amounting to 75% invoice value, added to handling and carriage from the cottage to the purchaser in America, left less than nothing for the cottage worker. I am convinced that sentiment does little or nothing in an undertaking of this nature . . . The poor producers of these goods make them at what cannot be more than ten cents a day. To many of them it is all that is between them and actual want. The profit to the middleman is great; . . . I am sorry to present to you so depressing a view of what it would deeply gratify me to see otherwise.

Queens and countesses could not stem the tide of industrialization which the Exposition itself in the main glorified. No one could argue with statistics gathered by various commissions and kept on file in the Woman's Building. In 1884 a French report on home needleworkers ended with the prediction that "all of these poor souls will soon have to lay aside their bobbins unless they wish to die of hunger." The Woman's Building and everything in it constituted an impressive tribute to women's skills and ingenuity. Over fifty years later the wife of Governor Harrison of Illinois wrote with nostalgia about the Columbian Exposition. She remembered the "beautiful art and craftsmanship" she had seen in the Woman's Building, she said; it was all memorable because it was all handmade, and that was "one thing that could never come again."

Screen by Countess of Tankerville

Bengta Olsson:Swedish Tapestry

HE Board of Lady Managers, afloat on a sea of painted china, bedquilts, stockings, tablecloths, candlesticks and paintings of kittens, sent out a strong call for exhibitors in "rare and interesting lines of work." The response was not overwhelming. A letter arrived from a doctor in Delaware who described herself as the inventor of a new method of embalming dead bodies. Not only was her process guaranteed to preserve these bodies indefinitely, but "all the work" could be done "by a female quite as well as a male." The doctor wanted to mount an exhibit the main interest of which would be a fresh corpse in the booth at all times. The Ladies turned her down; not without a twinge of regret. Women's energies seemed to follow the paths of least resistance. The *New York Times* for June 25, 1893, noted this in an article strangely sub-titled "Exhibits Which Prove that the Sex is Fast Overhauling Man":

> There are some men hard-hearted and cynical enough to say that the Woman's Building and all of its varied exhibits simply serve to demonstrate the superiority of man ... The exhibits ... are marvellous evidences of woman's fitness for something more than to minister to man's not always unselfish wants. The strong point ... is that the atmosphere of the entire building is not ... equal suffrage and ... woman's right to invade the domain of man, but the sublimely soft and soothing atmosphere of womanliness ... the achievements of man [are] in iron, steel, wood, and the baser and cruder products ... [while] in the Woman's Building one can note the distinct demarcation in the female successes in the more delicate and finer products of the loom, the needle, the brush, and more refined avenues of effort which culminate in the home, the hospital, the church, and in personal adornment ... It is this which redeems the Woman's Building and relegates the masculine cynic to an obscurity where his carping criticisms are utterly without point.

Kate Knight, President of the Connecticut Woman's Board, made a similar observation about the domestic nature of most exhibits in the Woman's Building. "Rare and interesting lines of work," she said, were heard about more than they were seen, although "here and there in art and science and invention one found the unusual."

Mrs Palmer had attempted to find the unusual by seeking out women inventors. On August 10, 1891, she had written to Mary Lockwood, offering her a choice of the Press or Patents Committees. "I have heard with deepest appreciation of your unswerving loyalty to the interests of our Board," Mrs Palmer wrote with some significance: this was the summer before the Board meeting at which Phoebe Couzins was to be vanquished and Mrs Palmer needed all the partisans she could get. Mary Lockwood was, as always, anxious to prove that women were filled with inventive genius. She chose the Patents Committee without hesitation, later reporting to the Board:

> When it is considered that over 4,000 patents have been issued to women from 1809 to 1892, 2,000 of this number being issued since 1888, it is manifest that the field is one from which a valuable and instructive harvest should be gathered.

The first public recognition of women inventors had been at the Philadelphia Centennial, where devices ranging from dishwashers to mowing machines had been put on view, demonstrating that some women were beginning to patent devices under their own names; patenting inventions under men's names had spared the ladies ridicule and even persecution. In the decade before the Fair an average of 229 women annually obtained patents: this was in contrast to 21,784 patents granted on the average each year to men. On the other hand, as Mrs Lockwood pointed out, more of the women's patents had been issued in the four years since 1888, than in the previous eighty years.

That at least one of these ladies had given perhaps too much freedom to her imagination is evidenced by Elizabeth Flautt who in 1854 patented a device to ease the strain of caring for invalids: à lever could be pulled by the nurse or other responsible individual which would propel the occupant out of the sickbed and onto the floor, so that the bed could be easily made up. For some reason, this device was not a financial success.

Mrs Palmer believed that the patents exhibit was in good hands with Mrs Lockwood; somehow she became convinced that Mrs Lockwood had obtained a promise from the government that it would make a special appropriation for the patents exhibit. She wrote to Mrs Lockwood in this vein, and Mrs Lockwood responded on February 12, 1892 with a terrified disclaimer:

> There is evidently quite a misunderstanding somewhere — I certainly did not wish to convey to you in my letter that I have asked or thought it possible or practicable that there should be a special appropriation for women in the Patent Office.

So strongly was she impressed with Mrs Palmer's letter that she retraced her steps, and asked the gentlemen in the National Com-

H. Chilton: Combined Horse Detacher & Brake

mission whether she had in fact asked for an appropriation; they assured her she had made "no request of that nature." She did believe that if the patents exhibit were left "for the men to bring out, the woman's share would be a dream."

She had been advised by the Commissioners to go and see F.T. Bickford of the Smithsonian, who was Secretary of the Government Exhibits at the Exposition. She did this, and spent a frustrating hour with Mr Bickford, who told her that the government planned no showing of women's inventions. If, he said, some woman had invented a needle or sewing machine superior to a man's similar invention, then the government might well include that woman in their exhibit, but that was as far as they would go. Mr Bickford then brought out the Fair's book of classifications and, turning to the pages of bonnets, trimmings, dresses and other wearing apparel, he suggested the Ladies content themselves with exhibits like that, instead of trying to mount exhibits of inventions. Mrs Lockwood offered him "a few fitting remarks" and swept out, much agitated. She did not know where to turn.

Mrs Palmer wrote a calm and dignified letter to Mr Bickford, explaining that the Board desired "to ascertain what proportion of patents have been issued to women." Secretary Bickford immediately sent memos to appropriate offices, requesting that they cooperate with the Board. In the summer, Mrs Palmer, who seemed to be forced to act over Mrs Lockwood's head, received a letter from Mr Simonds, a Patents Commissioner, telling her that there were more than 3,000 patents on file by women, and suggesting that it would be best for the Board to make its own selection. Mrs Palmer passed this information on to Mrs Lockwood, suggesting that she weed out the most worthwhile patents:

> Will you not send me a list of those patents that it would be worth while for us to "crow over". I felt rather discouraged about having a collective exhibit when I saw you last in Washington, and would much prefer to make no note of the inventions of women unless it is something quite distinguished and brilliant. We must not call attention to anything that will cause us to lose ground and if their inventions are merely confined to simple processes, it would be better for us to show only the few remarkable things than a mass of uninteresting ones. Please let me hear, consequently, what you consider important enough to call attention to. Perhaps your plan of sending the one hundred best with drawings and specifications would be the best.

Mary Lockwood, left to her own devices, wrote to inventors and asked them for their work, but many of them could not afford to send anything at their own expense, especially if the inventions were large and bulky. On the other hand, many women sent relatively small items; so much then for Mrs Palmer's desire to show only "the few remarkable things." The Inventions Room, when

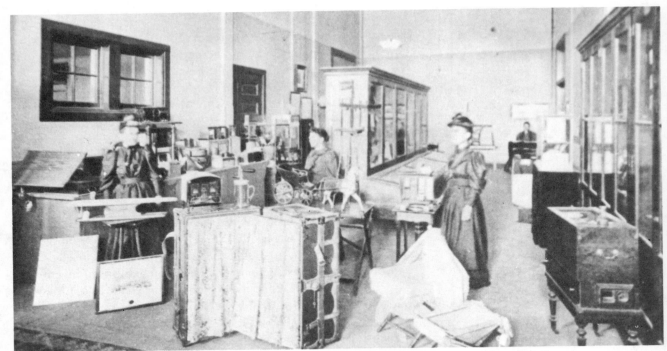

Inventions Room

the Fair opened, was crammed with cake beaters, beef manglers, flour sifters, carpet dusters, ironing boards and scissors sharpeners. Mrs Lockwood, somewhat mortified, published a pamphlet in 1893 called "The Woman's Building and What is to Be Seen in It" in which she blamed the government's penny-pinching for deficiencies in the inventions exhibit.

An opportunity was missed . . . of making an exhibit never undertaken by any government, which in itself would have been unique, instructive, and a complement to the educational exhibit of the Smithsonian Institute . . . Many inventors were unwilling to ship [their models] at their own expense, and their own risk; as a result the Woman's Building was crowded with an odd assortment of smaller items, and in many cases, simply drawings.

Ellen Henrotin was disappointed in the Inventions Room, as she was in the Gallery of Honor. In the same *Cosmopolitan* article in which she attacked the work so close to Mrs Palmer's heart, she noted that "none of the most valuable and scientific inventions are shown . . . and it seems such a pity . . . when the patent books of the U.S. show such hundreds of women's names . . ."

The inventors themselves were proud of the exhibits in the little room on the first floor of the Building. Caroline Westcott Romney, for instance, claimed to have "more articles of domestic utility on exhibition, all inventions of her own brain, than any other man or woman at the Fair." Mrs Romney, a widow who came from Colorado, was editor of a journal for the porous earthenware industry. She experimented with cellular brickware, which was

MRS. CAROLINE WESTCOTT ROMNEY.

(No Model.)

J. G. COCHRANE.
DISH CLEANER.

3 Sheets—Sheet 2.

No. 512,683. Patented Jan. 16, 1894.

made of a mixture of clay, sawdust and asbestos and which provided insulation for two of her fourteen inventions: an ice-less milk cooler and a dinner pail guaranteed to keep soup or coffee hot all day. Several of the women seemed partial to double-duty contraptions: there was a combination sofa and bathtub; a dress stand which could become a fire escape, and a thing which acted both as a carriage brake and a horse unhitcher.

Josephine Cochran's dish-washing machine was not only on exhibit, but in actual use in nearly all the large restaurants at the Exposition. Harriet Ruth Tracy, of New York, had invented a rotary shuttle, lock, and chain-stitch sewing machine — whose lower bobbin carried more than a thousand yards of thread — "an achievement," it was said, "that has baffled a generation of masculine inventors." That was certainly an invention that would have won praise from Mr Bickford. Mrs Tracy had baffled another gentleman with her gravity elevator, which was installed in the Woman's Building. This man had applied to have his aluminum elevator accepted, "although," he said, "it seems presumptuous for a humble man like myself to attempt the elevation of woman." The Board reported that Mrs. Tracy's elevator had the safety advantage of "automatic platforms that keep the shaft constantly closed, and prevent any person falling through it, or flames ascending it."

Also present in the Inventions Room was Olivia P. Flynt of Boston, who had begun life as a dressmaker and in 1873 had become so overwrought from viewing "the evils resulting from tight lacing," which were constantly before her, that she invented the "True Corset" or "Flynt Waist" for which she received a bronze medal at the Philadelphia Centennial. Its inventor described the Flynt Waist as

A scientific garment which proves more than a substitute for other corsets, for it not only obviates the necessity for several other under garments usually worn at the same time, but it comfortably and perfectly sustains the heaviest bust from the shoulders, thus relieving the individual from the discomfort of its weight . . . While the Waist permits natural circulation, perfect respiration, and freedom for every muscle, it imparts an artistic contour and elegance of motion, that all corsets utterly destroy. From its construction every Waist is a Perfect Shoulder Brace, a fact of great importance to growing girls and children.

Mrs Flynt was not above giving Nature a helping hand:

For thin ladies, we are prepared to improve the figure in a manner exceedingly satisfactory to first-class dressmakers, and place the burden and weight of the clothes where most conducive to health and comfort. The Flynt Bust Improving Waist is constructed the same as the Bust Supporting Waist, only that a very nice provision is made for the insertion of extra fullness where sufficient development is wanting.

Harriet Tracy: Safety Elevator

Mrs Flynt won a bronze medal at the Columbian Exposition, and received many orders from an advertisement she placed in *Campbell's Fair Weekly*.

Several of the inventors in fact did well at the Fair. Six hundred people ordered the Harris refrigerator; 900 wanted the Eberhard bread pan, 300 the Bay pressing board, but the winner was the Hambell egg and cake beater, which received a whopping 60,000 orders.

There was one invention which was important enough to qualify for Mrs Palmer's original plan to limit the exhibit to "distinguished and brilliant" inventions. This was a system of night signals which had been devised by Martha J. Costen, the widow of a nautical engineer. In 1893 these signals were already in use all over the world. Mrs Costen had begun to work on the signals thirty years earlier, when she was twenty-one years old, and her husband suddenly died and left her penniless, with three little children. He left also a box of sketches, from which the Navy had produced a signal system which had been tried out and pronounced "good for nothing." These signals were intended to serve the same purpose at night for which flags were used by day. Mrs Costen spent years perfecting a chemical recipe for flares, and finally developed a powder which produced brilliant white, red and green flames. The Navy tested her signals in the early 1880's and reported that they were "a perfect case of night signals. They offer precision, fullness, and plainness, at a less cost for fireworks than it is thought we now pay for confusion and uncertainty." The Board of Lady Managers were able to honor Martha Costen in the Inventions Room and she was able to provide them with one impressive inventor, at least.

If Mrs Palmer seemed less than excited about an inventions exhibit, she did not think at all about a science exhibit, until October of 1892, when Ada P. Davison of Oberlin College made "so interesting and forcible a statement concerning this unusual field of labor" to the Board "that it was determined at once to have an exhibit." There were only seven months left in which to mount that exhibit. Ada Davison, who was a geologist and the President of the Woman's Science Club, suggested that Sarah Angell, whose husband was President of the University of Michigan, be made Chair of the Science Committee, on the assumption that Mrs Angell's connections would make it easy for the Board to find women scientists at universities. But this did not prove to be the case. Neither Miss Davison nor Mrs Angell could scare up a sufficient number of women scientists; they seemed to be scarce indeed. On the last day of January, 1893, Mrs Palmer was writing to Miss Watson, the assistant secretary of the Association for the Advancement of Science, and asking her for the names and addresses of prominent women scientists from anywhere in the world. Mrs

IMPROVED UNDER-CLOTHING.

FLYNT WAIST OR TRUE CORSET.
Patented Feb. 15th, 1876.

FRONT VIEW.

BACK VIEW.

Maria Mitchell

Palmer wanted "valuable specimens collected by women" for the science exhibits.

She was as always nervous about being swamped by tides of mediocre exhibits. In February she wrote to Miss Lee of Massachusetts that what the science room should have were

> small collections, representing a genus or family, as products of a special locality, each collection to be thorough as far as it goes, illustrating fully, however, the various scientific pursuits that have been carried on by women with any degree of success . . .

In the end the Ladies wound up with only one real star, and she had unfortunately died in 1889. Nevertheless an exhibit was mounted in her honor in the Woman's Building. This was Maria Mitchell, a professor of astronomy and director of the Vassar College Observatory, who had discovered a new comet in 1847. Miss Mitchell, the daughter of Massachusetts Quakers, had never attended college. She had taught herself mathematics, German, French, Latin and ancient and modern astronomy. Matthew Vassar had persuaded her to come to teach in the college he founded in 1865. She did not give grades or mark attendance. She told her women pupils to "Question everything." In 1873 she founded the Association for the Advancement of Women, a national organization of moderate feminists, professional women and reformers. She was concerned that there were so few women scientists. "Nature made woman an observer," she said. "The schools and schoolbooks have spoiled her."

Watercolors by Minnie R Sargent

Miss Mitchell, whose father was an astronomer with an observatory at Nantucket, had received a gold medal from the King of Denmark for her discovery of Mitchell's Comet, and a copper medal from the Republic of San Marino. She was the first woman elected to the American Academy of Arts and Sciences. She received honorary doctorates from Hanover in 1882 and from Columbia in 1887. Women, she had always thought, would do especially well as geologists and botanists, because of their powers of observation.

There were women geologists and botanists, if the Board could only find them. Sarah Angell later wrote:

> The knowledge of the work that women have accomplished in the Natural Sciences was, previous to the Columbian Exposition, limited to a very small circle comprising the friends of each worker, and a few scientists in the department in which the work was done.

Susan Ashley of Colorado discovered by accident that women geologists sketched original plats, or maps, of Denver mining claims from rough notes made by surveyors. She found ten women doing that work, and mounted an exhibit of their sketches in the Science Room.

Many women were interested in botany: the objects of study were all around them, and they could indulge themselves in sketching and pressing specimens with society's approval. Rossiter Johnson, in his *History of the World's Columbian Exposition*, commented that "the preservation of flowers, ferns and mosses" was "a favorite feminine occupation . . . judging by the great quantity of herbarium exhibits" which he saw in the Woman's Building. Apart from Vassar, there were few schools where women could study botany. Consequently the Board received many applications from amateur naturalists. It was pointed out in *Art and Handicraft in the Woman's Building* that women "were often led to study in a more or less isolated way for their own satisfaction." The Board therefore had displays of ferns from Canada, medicinal plants from Spain and the Bermudas, seaweed from Africa, and algae from California's Pacific coast. The state of Colorado paid travel expenses to Alida P. Lansing so that she could dig up and preserve one thousand examples of the state's flowers. The Lady Managers of Oregon framed their native flora on pillars of Oregon oak. All this was not precisely what the Board had in mind for their science exhibit, but it had to do.

Susan Ashley

Reception Room California Building

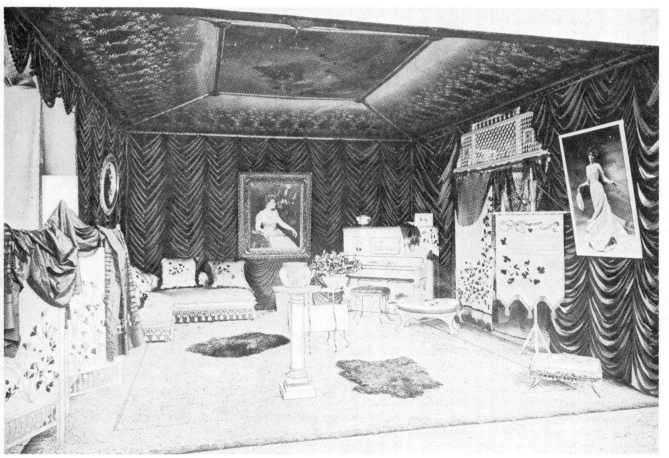

A surprising number of women seemed interested in taxidermy: there was a virtual menagerie of stuffed animals, from Iowan owls to Australian kangaroos. Women, with no access to laboratories, catalogued and collected.

Harriet Russell Strong of California was an unusual exhibitor. She had been born in New York in 1844; her family had migrated to Nevada, and she had married a rather unstable man with interests in mining and moved with him to California. After her husband's suicide in 1883 Mrs Strong devoted her considerable energies to recouping his fortune, mostly from 220 acres of land near Whittier, California which became known as the "Strong Ranch." Mrs Strong planted walnuts — a relatively innovative crop — and pampas grass, which was widely used for decoration and which had been grown mostly in Germany. Harriet Strong studied marketing, irrigation and flood control; in 1887 and later in 1894 she patented designs for storage dams that would hold back water and irrigate as well. She was the first woman member of the Los Angeles Chamber of Commerce and was known as the "Pampas Lady." She exhibited her water storage inventions in the Science Room, and also built a building entirely out of pampas grass for the California Pavilion. It was set up as a tribute to Queen Isabella; its dedication was suspended until Harriet Hosmer's statue of the Queen arrived, and was placed in front of what was called the "Pampas Palace." At the Fair Mrs Strong spoke on the importance of business training for women, and was elected President of the feminist Business League of America. She continued to be a cultural and political force in California after the Exposition.

An entomological exhibit was set up by Anna Botsford Comstock, who was an illustrator of scientific textbooks and a naturalist. She was born in New York state in 1854; like Maria Mitchell she had a Quaker background. She left Cornell University, where she was studying languages and literature, in 1877, after two years of study, having met John Comstock, a Cornell entomologist, in a zoology class. In 1878 they married, and Mrs Comstock became her husband's assistant, making drawings of scale insects through a microscope. These drawings — which appeared in 1880 in Professor Comstock's *Report of the Entomologist* — were much admired, and Mrs Comstock's career as an artist was launched. In 1885 she returned to Cornell to earn a degree in natural history. At the same time she learned wood engraving in order to illustrate her husband's book *An Introduction to Entomology*, published in 1888. Eventually she studied wood engraving at Cooper Union in New York. As a result of the praise heaped on her engravings she became one of the first four women to be initiated into Sigma Xi, the national honor society of the sciences and she was the third woman to be elected to the American Society of Wood Engravers. Mrs Comstock later wrote:

Engraved by Anna B. Comstock

Mr John P. Davis, my teacher in New York City, had urged me to engrave a block for the World's Columbian Exposition and I had promised to do so, although I had begrudged the time. The subject was night moths, and as there were several, I called it "A Moonlight Sonata." In May, 1893, I had the pleasure of taking Mother and Father to Chicago to see the World's Fair. It was a great occasion for them and for me. Of course, I hunted up the wood engraving exhibit and had the thrill of seeing my "Moonlight Sonata" and many of my moths and butterflies hung with the work of the great masters. However, when it came to giving awards, the judges eliminated me from the competition, together with the bank note engravers, because of the specialization of our work. I thought this fair enough.

The Board of Lady Managers were so impressed with her work that it was placed in the Gallery of Honor instead of in the Science Room.

The Fair helped Mrs Comstock's reputation, as it did others; she went on to become an important figure in the nature study movement. In 1899 she became Cornell's first woman professor. She was demoted to lecturer in 1900 because of sex prejudice, but reinstated in 1913, although as assistant professor. In 1920 she finally became a full professor. She published several books, some with her husband, who fully supported her work, as she did his. She was a pioneer in nature study, and an associate director of the American Nature Association. In 1923, seven years before her death, the League of Women Voters named her one of the twelve greatest living American women.

Zelia Nuttall was an archaeologist whose work was catalogued by both the Science and Ethnology Committees, but was displayed in the Science Room. Miss Nuttall, who was born in San Francisco in 1857, was the daughter of an Irish father and a Mexican mother. In 1884 after a brief marriage which ended in divorce and left her with a small daughter, Miss Nuttall went to Mexico to study some terra cotta heads at an Aztec site. This resulted in her first archaeological paper, published in 1886 in the *American Journal of Archaeology*. She had no formal education, but the paper, which offered evidence for the revision of the dates of the heads, won her an honorary special assistantship at Harvard's Peabody Museum, through the good graces of Frederick Putnam, who also helped her to become a Fellow of the American Association for the Advancement of Science in 1887. In 1890 she discovered an important Mexican codex in Florence: this was a record, on deerskin, of ancient Mexican military and religious history; it was published by the University of California in 1903. She later discovered another Mexican codex, this time in the form of a folded screen which she traced to England from a Florentine monastery. This was published in 1902 as the *Codex Nuttall*. The commentaries on these codices, which established them as historical documents, were her most important work. She herself would have considered

Aztec Calendar Zelia Nuttal

her books *A Note on the Ancient Mexican Calendar System* (1894) and *Fundamental Principles of Old and New World Civilizations* (1901) as important; the large charts which she exhibited in the Science Room illustrated her theories about Aztec stone calendars and the astronomical and mathematical knowledge of the Aztec peoples whom she connected with Middle Eastern and Egyptian civilizations. But her theories, received with mixed reactions when they came out, have been discredited.

In their final report the Committee on Science attempted to put the best possible face on their meagre exhibit. "The Scientific Exhibit was very late in being installed, and many interesting exhibits were lost on account of the limited time which we could allow exhibitors for preparation." The truth was, of course, that women were largely excluded from the centers of scientific activity; they were not taught scientific methods. They were forced in the main to exercise their scientific curiosity by stuffing animals, pressing rose leaves, or drawing natural phenomena. They rode hobby horses, or they acted as librarians and illustrators. Maria Mitchell was obviously an unusual woman, but even she reached eminence by attracting the attention of a man who happened to be opening a college for females. In 1848 she became the first female Fellow of the American Academy of Arts and Sciences, but the next female Fellow was not appointed until 1943. Anna Comstock's depressing see-saw in the natural history department of Cornell demonstrated clearly the status of women in the sciences. And Anna Comstock herself was lucky to have a husband who was an accepted academician.

Mushrooms. Watercolor by Princess Mary of Denmark.

The chapter called "Woman in Science" in the Board's *Art and Handicraft* book was written by Louisa Parsons Hopkins, the author of *Elementary Science, A Hand-Book of the Earth* and other elementary texts. Mrs Hopkins wrote enthusiastically about the situation of women in the sciences: "There is . . . a vast amount of work of a high order and great value done by women as assistants in the scientific departments of our universities," she wrote. Women, she said, were acting at the Natural History Society and the Marine Biological Laboratory of Massachusetts "as students and co-workers with the curators and professors." This rather dismal comment was reinforced by Mrs Hopkins' triumphal ending. She wished to close her paper with "some flower of scientific expression, some emblem of the spirit of womanhood beautifying even the dry technicalities" of her theme:

> May we not assure ourselves that whatever woman's thought and study shall embrace will thereby receive a new inspiration, that she will save science from materialism, and art from a gross realism; that the 'eternal womanly shall lead upward and onward'?

Victorian women could move away from their stereotyped lives more quickly as individuals not dependent upon institutions. May French Sheldon was one woman who progressed firmly along "rare and interesting lines of work." She was born into a wealthy American family in 1848. She married young, but had no children. Having met Henry Morton Stanley at her father's house, she determined to travel in Africa, and to that end studied geology and medicine. Little is known about whether she actually qualified as a doctor or not. She did run a publishing firm, with offices in New York and London, where her husband had business interests. And she did translate Flaubert's *Salammbo* from the French, and

write a novel called *Herbert Severance,* published by Rand McNally in 1889. She could shoot, swim and climb, and she studied Swahili for eight years. In 1891, at the age of forty-three, she departed for Africa, to travel to Masai country which lay north of Mount Kilimanjaro. The Masai were a dangerous and war-like people. She wished to study Masai customs and collect examples of weapons and handicrafts. She wished also to prove that a woman could travel without male assistance in the African wilderness. Her female protagonist in *Herbert Severance* was made to say, "Personal independence to a capable woman is a trait no sacrifice is too severe . . . to secure. We seek work for another reason — we like to create something."

At Zanzibar, the traditional port of entry for travellers to East Africa, Mrs Sheldon overcame a good deal of hostile opposition from the Imperial British East African Company, which finally assisted her to outfit a caravan with 150 porters, and sufficient headmen and interpreters. She carried beads and cloth for trading, a spangled ball gown and a blonde wig for ceremonial occasions, and her Palanquin, a large basket-like affair in which she slept or sometimes rode. She travelled roughly a thousand miles with her caravan, putting down a mutiny among her porters by pulling her pistol and shooting a vulture in flight before the men, whom she then compelled at gun point to take up their loads. She dined each evening in a silk dress, with different dishes for each course. She reached Lake Chala, on the slopes of Kilimanjaro, circumnavigating it in a copper pontoon from which she flew the American flag. In German territory on the north-east side of Kilimanjaro, she was refused passage by a chief suspicious of a white woman. Undaunted she passed straight through his property. Shortly afterward, the Palanquin proved its worth:

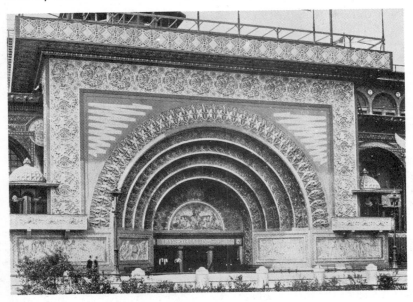

Transportation Building. Adler & Sullivan

One night, experiencing great fatigue, I fell in a profound slumber . . . in my Palanquin within my tent, when suddenly I awoke with a shuddering apprehension of danger . . . involuntarily seizing my knife and pistol, I cried out, 'Who is there?' No answer. I called out for the *askari* on guard . . . when I became aware . . . that a cold, clammy moving object was above me on the top of my Palanquin, the rattans of which were cracking as if under the pressure of a mangle. I was struggling to slide out of the Palanquin without rising . . . to avoid touching the thing, when the alarmed *askari* entered, carrying a lantern, to my abject horror revealing to me the object I had intuitively dreaded. My blood fairly seemed to congeal in my veins at the sight: it was an enormous python, about fifteen feet long, which had coiled around the top of the Palanquin, and . . . was ramping and thrusting its head out, searching for some . . . projection around which to coil its great, shiny, loathesome length . . . A dozen stalwart porters pitched . . . upon the reptile, slashing and cutting its writhing body into inch bits. I am not ashamed to confess it was the supreme fear of my life, and almost paralyzed me. I came very near to collapsing and relinquishing myself to the nervous shock; but there was not time for such an indulgence of weakness; there were other sequences to be considered.

They began to penetrate the borders of Masai-land, where she secretly planned to go. But her chief headman refused to take her there, since he had sworn to the Sultan of Zanzibar that he would protect her, and he consequently bared his breast to her and demanded she shoot him for insubordination. She ordered him from her tent, saying she would "go into Masai land at sun-up" the next morning, whether he went or not. However, the next morning at daybreak the headman, Hamidi, begged her pardon and offered to go with her, saying he "might as well be killed one place as another." In this way Mrs Sheldon avoided a contest of wills and was able to back off:

And this fine man, as heroic and chivalrous and loyal as any white defender of a leader could possibly have been under the circumstances, succeeded in dissuading me from what would have been not only a most hazardous undertaking, but would doubtless have resulted in the entire looting of my caravan, and annihilation of the Zanzabaris, no matter what might have happened to me.

On the way back, a bridge collapsed beneath her; she and her Palanquin fell into the river. She developed fever and dysentery, and was carried to Zanzibar where her "voyage of horrors" more or less ended. Her husband, murmuring "Does she live?", awaited her at Naples.

A warm welcome was given her in London where in 1892 she became one of the first women to be made a Fellow of the Royal Geographical Society, on the strength of her navigation of Lake Chala. In that year her book on the adventure, *Sultan to Sultan*, was published, dedicated to her husband Eli Lemon Sheldon who had died during the year.

She was to travel to the Belgian Congo in 1894 on the second and last of her safaris, but in 1893 she was in Chicago where a large audience gathered to hear her speak in the Woman's Building. She began her lecture by saying that she was constantly asked why she had embarked on her adventure; she said it was because both men and women had denounced her "unique" and "innovative" plan as "a mad scheme" and "flouted" in her face "the supercilious edict that it was outside the limitation of women's legitimate province." She determined, therefore, "to accomplish the undertaking. Success resulted." She had also a deep curiosity about the home lives of Africans which she did not feel had been adequately discussed by explorers like Stanley. She brought back a treasure of artifacts for which she had traded her beads and cloth: wooden mortars, harem rings, ornaments of bone, brass, copper and iron, spears, charcoal-fired knives, and utensils made of gourds on which were traced with heated wires "Persian and Arabesque designs." She had so great a zeal for these artifacts that she herself removed the leg bracelets from the "stark stiff body" of a Masai woman "nosed out in the bush." She brought back also a beaded belt given her by an old medicine woman who had "initiated" her in secret female rites. In fine, she said,

African Women's Coiffure.
Photograph by May French Sheldon.

without bloodshed, without loss of but one man, who was killed by a lion, by peaceful, tactful human measures, it has been my privilege to traverse the country of thirty-five African Tribes, and return to the coast with all my porters, leaving behind a record women need never blush to consider.

She had gone to great lengths to preserve peace. Her men were forbidden to shoot even at wild animals while she was arranging her purchases, and she herself thoughtfully removed her dark glasses so that she would not frighten the natives.

Mrs Sheldon's Ethnographic Exhibit was in the Woman's Building; her publishing exhibit was in the Manufactures Building; her Palanquin and tent were set up in the Transportation Building, where a reception was held in her honor to which the Lady Managers were invited. Mrs Sheldon wore the elegant satin ball gown in which she had received African chieftains, although she dispensed with the blonde wig. "Women are not likely to have a strong purpose in life," she told a women's club audience thirty years later, "and a great purpose is the greatest force in life. With a strong purpose and an indomitable will one can triumph over anything."

Another woman who was a Fellow of the Royal Geographical Society was honored by the Exposition: this was Kate Marsden. She and May French Sheldon were two of the twelve women named Fellows in 1892.

The question of the admission of these women had exploded

the peace of the Society like a bomb; lifelong friendships had been broken because of it; resentments had been aroused which took years to subside. The uproar had begun in 1887 when, on the Jubilee of Queen Victoria, a suggestion had been made by the President of the Society that perhaps ladies might be admitted. Some daring souls had suggested that ladies might be made Fellows. The outrage of more conservative members had caused the idea to be dropped. However in 1892 the question arose again when Isabella Bird Bishop was invited to read a paper to the Society. Mrs Bishop had been made a member of the Scottish Geographical Society, which had admitted women on the same terms as men from its inception in 1884. In 1892 the Scottish Society had established a London branch. Some fear of rivalry between the two Societies existed, and this was exacerbated when Mrs Bishop, who had just returned from the borders of Tibet, refused the invitation to read a paper, saying that she did not see why she should appear before a Society which barred her from fellowship when she already belonged to another Society which was anxious to hear her.

This statement reawoke the woman question to members of the Royal Geographical Society. Its President, Sir Montstuart Grant Duff, made a motion in Council that women should be admitted on the same terms as men, and this was carried unanimously. Twelve qualified women were elected by the Council, which had faith in its legal right to act. On November 28, 1892 the women were installed as Fellows: Maria Vere Cust being the first, in alphabetical order, since Mrs Bishop was not present.

Dissident Fellows refused to accept the right of the Council to elect women. The columns of the London *Times* were flooded with letters both approving and disapproving of the election. George Curzon, just returned from travels in Asia said,

> We contest the general capability of women to contribute to scientific geographical knowledge. Their sex and training render them equally unfitted for exploration and the genus of professional female globe-trotters with which America has lately familiarized us is one of the horrors of the latter end of the nineteenth century.

On April 24, 1893 it was necessary to call a special meeting to discuss the question. A compromise offered by Admiral Sir E. Inglefield, that women could be elected as Fellows but barred from office in the Society, satisfied no one. The President, saddened by all this fuss, said that the Council ought to refrain from further election of ladies. The question continued to a July, 1893 meeting, in which the members were asked whether women should be admitted as ordinary Fellows and "wherever required in the regulations words importing the masculine gender only shall include the feminine gender." This was voted against by a majority of fourteen members. Consequently a resolution was passed "That with-

May French Sheldon

Kate Marsden

out expressing any opinion as to the status of these ladies already elected by the Council this meeting of the Royal Geographic Society considers it inexpedient to admit ladies as Fellows.'' No more women were admitted to the Society until 1913, when Lord Curzon, now President of the Society, reversed his stand on the sex. A proposal in favor of women members was adopted by one hundred thirty to fifty-one.

Kate Marsden, the author of *On Sledge and Horseback to Outcast Siberian Lepers,* was a trained nurse and Evangelical missionary who had made a journey called by *Harper's Bazar* "the strangest and most self-sacrificing undertaking of the present day." She had been born in England in 1859 into a prosperous family of eight children; poverty struck when their father died, and Kate thus took up nursing while she was still in her teens. In 1877 she went to Bulgaria with a party of nurses to tend to Russian soldiers injured in the Turko-Russian War. Here she saw lepers for the first time; the sight of them remained with her. Thirteen years later,

when she was invited to Russia to receive a medal from the Red Cross, she determined to devote her life to helping lepers. After discussing the disease with Louis Pasteur in Paris, she was received by the Princess of Wales and given a personal introduction to the Czarina. In March of 1890 she went to Moscow and was promised all the support she would need to help her alleviate the lot of those tragic outcasts of society. She then visited Jerusalem and Constantinople, and, on her way back to Moscow, stopped in Tiflis in the Caucasus, where she learned that Siberian lepers were the most neglected of any in the world, and where she heard that there was an herb in Siberia which might cure leprosy.

In February of 1891 she was back in Moscow, with all the official documents she needed for her travels to Siberia. The Empress helped her; Kate spoke no Russian and no one could understand why she wanted to go to Siberia, unless she were a spy. The Trans-Siberian Railroad was at that time in the planning stages; it was necessary for Miss Marsden and Anna Field, a Russian-speaking friend, to travel beyond the Urals by sledge. Apart from the cold, the women encountered frozen roads filled with potholes, lice, drunken drivers, wolves, public rest houses and wet snow for part of the trip; for the last part of it Kate encountered intense heat with mosquitoes, forest fires, bogs and bears. Miss Field gave up at Omsk. For the last thousand miles Kate Marsden rode a wild pony on a rough wooden saddle; she was escorted by Cossacks, fascinated by her mission. She had to wear "full trousers to the knee," and carry a whip and "a little travelling bag, slung over her shoulder."

She reached the lepers, whose situation was more horrible than anything she could dream of. These people had literally no homes, but were forced to exist somehow in the woods, exposed to the freezing weather, and finding their food mostly from garbage heaps. Many were already blind and limbless; this was a frightful scene, but Miss Marsden walked among them. She dispensed food and medicine to them, and it appeared that her coming had aroused the local authorities to a sense of responsibility for these sufferers which had been totally lacking before her arrival. Her trip back was more ghastly even than her trip out, since she was in a weakened condition. Through her efforts a hospital village for lepers was established at Viliusk in 1897, which admitted a maximum of seventy-six patients in 1902, but continued to exist until recently when the disease was vanquished.

Miss Marsden mounted an exhibit in the Woman's Building which included several relics from her journey: the primitive wooden saddle on which she had jounced to her destination; the foul dry bread which she would have eaten if she had not brought along plenty of plum pudding; the letter of introduction from the Princess of Wales to the Czarina; and a model leper village in miniature, with white cottages surrounding a church, and two

RELICS OF KATE MARSDON.

large hospitals and workshops. In addition, Kate Marsden's book, which had just been published, was sold at a Woman's Building booth to raise money for this leper village. Her exhibit was officially opened at a ceremony on Saturday, July 17, at one in the afternoon, by a Bishop of the Russian Greek Orthodox Church, who had asked permission of the Board to consecrate that section. Present as admirers of Kate Marsden were the Russian Princess Schahovskoy and Ethel Gordon Manson Bedford-Fenwick, a former nurse who had established the *Nursing Record* and helped to form the British Nurses' Association in 1887. Miss Marsden was justly famous. Queen Victoria had given her a gold pin in the shape of an angel. Her book was to go through twelve English editions in two years. However, she had enemies. There were people who refused to believe the story which she told.

Model of Kate Marsden's Leper Hospital

Mrs Palmer, during the Fair, received a letter from Isabelle Hatgood of New York , telling her that she had heard rumors that Miss Marsden was a fraud. Mrs Palmer, always nervous before the court of public opinion, wrote back to Mrs Hatgood, telling her that "Princess Schahofskoy, Prince Volkonsky and M. Gloukhovskoy, the Imperial Russian Commissioner" had been at a reception given for Miss Marsden by Mrs Bedford-Fenwick and "spoke warmly of her work."

The rumors persisted, and grew so strong that in September of 1894 mention of them was made by the *London Times*. Mrs Palmer was sent a clipping of the item and, thanking her correspondent for it, immediately threw Miss Marsden to the wolves. "I regret to say that her work has recently been discredited," she wrote, "and we have been officially informed that she has confessed that she misused the money given to her." To what official source Mrs Palmer is referring here is not at all clear. In 1906 Kate Marsden was presented at the Court of Edward VII, an honor she could not have had if her reputation were under a cloud. In 1916 she was nominated a Free Life Fellow of the Royal Geographical Society. The "official" source could not have been English. The Russians were still grateful to Miss Marsden: in 1904 a monograph on leprosy was published in Moscow in which the Englishwoman was praised as having "virtually settled the destiny of the leprous Yakuts." Therefore "official" Russia still admired her. Mrs Palmer was unquestionably reacting to some slurs against Miss Marsden; she had of course never "confessed" anything. In 1921 she published *My Mission to Siberia: a vindication* in which she spoke of having been "persecuted". "What I did — I did," she wrote, "and no slander in the world can ever alter that fact."

Among the "malicious calumnies" which she wished to dispel were statements that she had never gone at all to help the Siberian lepers, or had gone only part of the way and had bribed couriers to invent the whole story; that she had not ridden any of the two thousand miles on horseback; that she had squandered her life "in

riotous living" in Siberia; that she had stolen the money collected for the lepers; that she had "invented" her election to the Royal Geographical Society and that her entire book was "in fact . . . one tissue of lies and inventions." Miss Marsden printed testimonials in her book from Harry de Windt, a Fellow of the Royal Geographical Society, the only man who had made that "terrible journey" and who had seen her Leper Colony with his own eyes, from Douglas Freshfield, then President of the Royal Geographical Society, who attested to her election, from the Chief of the Sredni-Viluisk district, and from the lepers themselves. All these accusations, which had made her life miserable for twenty-seven years, she now put to rest.

> The Lepers, at any rate, thank God, were able to have their Colony built, with houses and hospitals to shelter them, with Sisters to attend them, and so live in comparative comfort, as, through my lecture, after my return, a considerable sum of money was sent to my London Committee, who in due time forwarded it to M. Pokedonosteo, the Procurator of the Holy Synod in Petrograd, and so on to the Governor of the Yakutsh Government.

She gave credit for help also, to the "interest aroused by their Imperial Majesties" as well as the Greek Orthodox Church, the Russian government and "the generous Russian people." So much for Isabelle Hatgood and Mrs Palmer, obviously among many others, who had slandered her for reasons which seem incomprehensible.

May French Sheldon in Her Palanquin

I TOOK IT AS BEIN' A COMPLIMENT TO MY SECT THE WAY THAT FOUNTAIN WUZ LAID OUT—
TEN OR A DOZEN WIMMEN AND ONLY ONE OR TWO MEN.

Kate Marsden was a nurse at a time when nursing as a profession was in its infancy. Most of the 40,000 nurses and midwives listed in the census of 1890 had no formal training; there were perhaps 500 trained nurses in America. In 1893 nurses' associations in Europe and the United States were asking for formal accreditation for nurses; their displays in the Woman's Building were intended to bolster their case for professional accreditation. Consequently space for medical displays was desirable and there was competition for it.

In September, 1892, the Board was petitioned for space in which to set up a working hospital ward staffed by women. The Illinois legislature had granted $6000 for this project to a group headed by Dr Julia Holmes Smith. The group planned a fully equipped emergency room, with two smaller rooms for patients. On October 4, 1892, Mrs Palmer responded to Miss Flower, an associate of Dr Smith:

Julia Holmes Smith

> I would feel embarrassed in giving twice as much space to the work done in Illinois by the women physicians, surgeons and trained nurses, as we have given either to England, France or Germany for their entire exhibits, although these countries are pressing earnestly to have more space in which to show what their women are doing. It might seem such a piece of partiality toward our women who are here on the ground so to speak . . . Members from various states have been urging exhibits of women's hospitals and trained nurse systems from their sections, all of which have been excluded, and this might be the basis of some antagonistic feeling. For myself I feel it is better to make a thorough representation of the different new lines of usefulness open to women, than to show miles of well manufactured articles.

Dr Smith wrote on October 10 to say that her group had expected the plan would be approved without difficulty, and had written to doctors all over Illinois asking them to cooperate in this woman-controlled exhibit of "trained nurses in actual service." Nevertheless this exhibit was rejected; Dr Smith's connection with the Isabellas could not have helped her case with Mrs Palmer. An appeal was made to the Directors, and in the spring of 1893 Harlow Higinbotham approved the construction of an Illinois

Women's Hospital & Pharmacy

Woman's Hospital Pavilion on the Fairgrounds, paying for extra costs from his own pocket. Construction on the building began on April 4, 1893; it was completed by April 28. During the summer this facility, consisting of an emergency ward and a pharmacy, provided treatment for approximately 3000 visitors who suffered various accidents and illnesses in the course of their holiday.

Mrs Palmer had stretched the truth when she wrote Miss Flower that other state nursing exhibits had been excluded from the Building. In the Education Room a dozen New York and Philadelphia hospitals set up exhibits of their nurses training programs: there were photographs of clean, orderly wards, and a heavy reliance on dolls wearing the uniforms and caps of each nursing school. Presbyterian Hospital arranged a model ward with miniature beds, doll patients and doll nurses brandishing tiny bedpans and basins.

Both New York and Philadelphia could be proud of their pioneering work in nurses training. In 1873 both the Bellevue Hospital in New York and the Woman's Medical College of Philadelphia had begun these training programs. The Bellevue program was modeled closely on the principles of Florence Nightingale; Bellevue differed from her only in the exclusion of uneducated or illiterate women. Miss Nightingale believed that a kind heart and good intentions could make up for educational deficiencies; American hospital authorities doubted that. Bellevue had a two year program with one year of training and one year of work in the wards, after which the nurse was awarded a certificate qualifying her for work in hospitals or wherever she was needed. Before the establishment of its training school, Bellevue, like all other hospitals in large cities, was forced to rely for nursing upon convicts or other unsatisfactory persons. Sanitation, hygiene and patients were sadly neglected.

Exhibit: New York Training Schools for Nurses

It was Florence Nightingale who had attacked the conscience of the British public through her work at the military hospital at Scutari in the Crimea in 1854. The intense suffering of British soldiers, in the first major war since Waterloo, had dramatized the ineptitude of British hospital administration. By 1856 Miss Nightingale and her band of 125 dedicated women had cut the disgraceful mortality rate at Scutari; she returned to England to spend the rest of her long life working for hospital reform, which was her consuming passion. She became a permanent invalid. Nevertheless a steady stream of papers and reports issued from her bedside. She revolutionized hospital administration.

Miss Nightingale put great emphasis on the personal character of nurses. In one year of training the women had to learn principles of personal cleanliness, hygiene and proper diet, as well as sobriety, gentleness and the keeping of accurate records. During their learning year, the women heard lectures and worked in the wards. Miss Nightingale saw the doctor as one who often needed to interfere brutally with the functions of the body, performing operations and amputations. The nurse, on the other hand, worked with nature, helping the healing process. Both doctor and nurse were needed, working together to keep patients alive and aid their recovery.

The Nightingale system spread to America, as well as to other countries in Europe. During the American Civil War the Army medical establishment proved to be as obtuse as their English counterparts. The creation of the Sanitary Commission brought the influence of American women to Army camps and hospitals. Dorothea Dix, nearly sixty at the time, was appointed official superintendent of women nurses. The qualifications she attempted to set were strongly reminiscent of Miss Nightingale's: "matronly persons" between the ages of thirty-five and fifty, in good health and with "habits of neatness, order, sobriety, and industry" were required. Miss Dix wanted also experience, good conduct, superior education and serious disposition. The Army regulations called for one nurse to ten beds, and a nurse ratio of two male to every one female. Since the war was being fought on home ground, and not miles away over the sea as the Crimean War had been, it was impossible for Miss Dix to enforce her standards. Women flooded in; they were badly needed and there was no time to monitor them. Unsuitable women, neither sober nor industrious, worked in the hospitals, infuriating doctors prejudiced against female nurses. But many of these 3000 women were hardworking and self-sacrificial enough to make an impression not only on the sick and wounded but on the hospital administrators. Clara Barton, who was to found the American Red Cross, became a nurse almost by accident while she was visiting in Washington D.C. A regiment from her home state of Massachusetts arrived in the capital with many wounded, and without supplies. Miss Barton was a self-appointed supply and nursing depot and went on from there. This was true also of Mary Ann Bickerdyke who began to work in hospitals without pay or any official recognition. She took over the administration of Army hospitals by herself and did for them what Florence Nightingale had done at Scutari: she even travelled north to bring back cattle for food for suffering soldiers in Tennessee. She was appointed an agent of the Sanitary Commission and given a free pass by General Grant. The men called her "Mother Bickerdyke," although she was only forty-four at the time.

The South was more resistant to women in Army hospitals. After a year and a half of nursing they were finally given official sanction to work in hospitals. But there never was a Confederate Director of Nursing. Jefferson Davis appointed Sally Tompkins a Captain of cavalry so that her private hospital could qualify as an Army hospital and be allowed to remain open. When the war ended Davis said that the Hospital Department was the only department of the Confederate government which was efficient and did not become demoralized. That was a tribute to women volunteers.

Several American hospitals can lay claim to the establishment of the first nurses training schools, among them Bellevue Hospital

WOMAN'S MEDICAL COLLEGE OF PENNSYLVANIA.
The first building erected in the world, in which women could take up the study of medicine.

in New York, Massachusetts General in Boston where the Women's Educational Association set up a school, Blockley Hospital and the Women's Hospital in Philadelphia, and the New England Hospital for Women and Children, where Linda Richards earned her certificate and became the first American trained nurse. When Bellevue Hospital established its training school in 1873, Miss Richards became its night superintendent. Blockley Hospital, a former workhouse, was notorious for its bad conditions; in 1840 Sisters of Charity had been called in to impose order on the chaotic wards; they tried, but were forced to retreat in disarray. It was a Nightingale nurse named Alice Fisher who imposed Nightingale standards on the Blockley wards, between 1885 and 1888.

Despite its antiquated organization Blockley was the first American hospital to admit women interns. Strangely enough women were allowed to become doctors in the United States before they were allowed to become nurses. The Women's Medical College opened in Philadelphia in 1860 to rival Blockley was a training ground for women physicians. The Women's Medical College was founded so that women medical students might have "absolute right of study;" a right that had obviously been impinged upon in other places. The College was staffed completely by women physicians and interns; men were not involved in its man-

agement. Although nurses' training was included in the hospital's charter, and pupils were admitted in 1861, it was 1873 before a formal sixteen month nurses' training course was established. This shortly became a two year program.

By 1890 there were fifteen American training schools for nurses, most of them in the Northeast.

Philadelphia Hospital would not allow the first nurses graduated from the Medical College to work in its main surgical wards. However they were allowed to work at the Pennsylvania Hospital, where the authorities were so impressed by their performance that they adopted the Medical College system of nurses' training. The impressive record of this first women's hospital naturally drew attention to its display in the Woman's Building. A description of the exhibit appeared in the *Woman's Journal:*

> Screens, each composed of four leaves, stand six feet high and are covered with beautiful dark green cloth. On the surface photos and reports are tastefully tacked with curious little gilt nails . . . Statistics are dry things, but when they are arranged so conveniently for quick reading and worked so adroitly between these pleasing photographs, it is like reading a bit of history . . . one . . . learns that . . . the hospital has treated in the house 8,727 patients, in the dispensary 110,826, that 24,623 patients were visited in homes, and 282 nurses had received training in the school, of which number 170 had duly graduated.

Thus the Woman's Medical College Hospital had been able to graduate an average of eight or nine nurses a year. Even if the number of nursing students increased as the years went on, this rate of graduation was not impressive. Doubtless the exclusion of uneducated women kept the number of nurses down: with candidates carefully screened, it would be difficult for the very poor, many of whom were immigrants, to qualify. But even in Britain, where Miss Nightingale's principles held the doors open to all interested women, there were not enough trained nurses to fill the need. In addition, there was no system to weed out unqualified nurses. Since anyone could call him or herself a trained nurse, the stigma attaching to the work could not be quickly erased. In the 1880's 70,000 Britons called themselves nurses: of these about 6000 were men who looked after mental patients. Only about one third of these 70,000 had any training at all.

It was to everyone's interest, it would seem, that Britain adopt uniform standards and some sort of national public registration system so that qualified nurses could reap the benefits of their education: the unfit would be weeded out, and more competent women would be attracted to the profession, because then it would be a real profession. The 1890 British census still classified nurses as "domestic help." British nurses wished to be classified as "medical workers" instead. Through the upgrading of nursing,

apart from the real benefit to the sick and helpless, credit would be reflected on women everywhere. Ethel Bedford-Fenwick, a leader in the battle for registration, said: "The Nurse question is the Woman question pure and simple."

At the age of twenty-four Mrs Bedford-Fenwick had introduced a three year nurses' training course into St Bartholomews Hospital in London, where she was a matron. Before going to St Bartholomews, she had been a Sister at London Hospital, to which she had come from the Manchester Royal Infirmary, her second post. She had begun her career as a "paying probationer" at the Nottingham Children's Hospital. In 1887 she married Dr Bedford-Fenwick and gave up nursing to work for the establishment of a nurses' register. She founded the British Nurses Association, which asked for a national register of all nurses who had completed a required number of courses at a recognized hospital. Nurses who had had three years of continuous experience and could provide adequate testimonials to their capability would be added to the register for twelve months. After that grace period had ended, the register would be permanently closed to everyone except nurses who had earned professional certificates after three years of prescribed study. Admission to the register would thus be desirable and enviable, and the profession would be closed to those who had not the proper credentials. If nurses were guilty of malfeasance of duty, they could be suspended from the register or even permanently removed from it. This plan was approved by the British Medical Association.

By 1888 the British Nurses Association had 2,500 members, among whom were the matrons of half the large hospitals in England. At this point, when things were going very well, Miss Nightingale voiced her opposition to the register. Henry Bonham-Carter, secretary of the Nightingale Fund, issued a pamphlet in which he argued that the Association plan was too rigid: many women would not be able to pass complicated examinations, but these women were respectable and their moral quality and kindness could not be measured by examinations. They were however essential to the nursing profession. Miss Nightingale obviously feared class discrimination. The Chairman of the London Hospital supported Miss Nightingale's position, although possibly not from the same motivation. He said that the main value of a nurse lay in her "good temper, manner, tact, discretion, patience and unselfish womanliness." Governesses and housemaids, he said, needed the same qualities, and they did not ask for registers. Among other opponents to the register who stood with Miss Nightingale were country doctors who feared that they might be replaced by trained nurses and hospital matrons who thought they might not be found adequate to run nursing schools, or who wished to avoid possible supervision of their work from outside authorities.

The sympathies of the Queen were with Mrs Bedford-Fenwick. In 1893 the Princess Christian accepted Presidency of the British Nurses Association, which was granted a Royal Charter. Mrs Palmer wrote Mrs Bedford-Fenwick in June, congratulating her upon the attainment of her desires. The congratulation was unfortunately premature: opposition to the Association was too powerful even for Queen Victoria. Instead of the register, they were given a voluntary "list." Ethel Bedford-Fenwick was therefore in need of public support in the summer of 1893. She was given a whole room on the second floor of the Woman's Building for her exhibit. On display, under a large portrait of Florence Nightingale, were, in addition to the usual uniformed dolls, padded splints, syringes, thermometers and "the hygienic clothing which the Royal British Nurses Association recommends to its nurses, all of the finest wool." There was a pair of steel-reinforced shoes with rubber soles, invented by Mrs. Bedford-Fenwick for silent prowling through the wards.

Mrs Bedford-Fenwick used the medium of the Board's book *Arts and Handicrafts in the Woman's Building,* to propagandize her cause while ostensibly describing her exhibit:

How different a class of woman is now intrusted with the sacred task of nursing the sick, one has but to examine the exhibit to realize. The neat, suitable uniforms of the British nurses, the appliances they use, the various inventions they have made for the sick-room, can not fail to prove to the most careless observer that the profession to which these things appertain is both honorable and scientific. Attention is called to the medical and surgical dressings, the bandages and belts arranged by Mrs Walter Lakin, the hygienic clothing for nurses made by Miss Franks, the splits padded by nurses, the model of a hygienic room for the instruction of nurses designed by Mrs Lionel Pridgin Teale, the nurse's toilet basket and the glass appliances for sterilized surgical dressings designed by Mrs Bedford-Fenwick. The surgical models, designed and made by Sister Marion Turnball of the London Homeopathic Hospital deserve notice, as do Miss Simpson's basket, used by the "Princess Christian's Nurses," and the bag used by the "Queen's Nurses."

These exhibits are not only interesting in themselves, but are instructive evidence of the immense strides made in nursing during this century. Twenty years ago, nursing as a profession for women was practically unrecognized. Very few . . . could be induced to undertake it . . . today we see women of all classes anxious to enroll themselves in the band of trained workers . . .

Mrs Bedford-Fenwick at this point came out strongly for the register:

At present there is no uniformity of training in Great Britain . . . nothing to hinder any woman from putting on a uniform . . . and calling herself a trained nurse. To protect the public from untrustworthy persons of this type, an association was formed about five

years ago . . . called the Royal British Nurses Association, which
undertakes to register all nurses who have undergone *three* years in-
struction in the practice and theory of nursing . . . Thus, at a mo-
ment's glance, anyone can satisfy themselves as to the qualifications
of the nurse they wish to employ . . . not only the educational process
. . . but . . . her character and antecedents as well. There is no doubt
that under the aegis of a royal charter [the registration board] will
exercise a powerful influence of an educational nature on profes-
sional and public opinion . . . for those further advances in the orga-
nization and training of nurses which it is the main object of the
association to promote.

Mrs Bedford-Fenwick pointed with pride to the fact that "Her
Royal Highness Princess Christian" was at the head of her Nurses
Association. It is most odd, therefore, that in the opening para-
graph of her essay she comments that the "pleasant room leading
from the gallery in which the [nurses] exhibit is installed is
graced" not only by "a portrait of Her Majesty the Queen, which
bears her signature" but by a "portrait of H.R.H. Princess Chris-
tian of Schleswig-Holstein, and one of the Princess Helena" who,
she says, "is president of the Royal British Nurses Association."
Since the Princess Helena was also Princess Christian of
Schleswig-Holstein, a title she assumed after her marriage, the
suspicion arises that some untutored soul had tampered with Mrs
Bedford-Fenwick's copy, possibly from an innocent desire to fill it
with as many Royal names as possible.

The Lady Managers conferred an award upon the British
Nurses Exhibit, which they called "one of the most instructive in
the Woman's Building . . . from an educational and philanthropic
standpoint." Mrs Bedford-Fenwick did not immediately reap the
benefit of her triumph at Chicago. In 1894 she and her husband
resigned from the Association as a result of disagreements with its
policies. In 1896 the Association, obviously sliding downhill, re-
solved that the nurses' register was not only "of doubtful benefit"
but might even injure the standing of trained nurses. Mrs
Bedford-Fenwick fought on: she founded the Matrons' Council
and in 1899 at the meeting of the International Council of
Women in London, helped to organize the International Council
of Nurses, which was the first international organization of pro-
fessional women, as well as the first organization of medical
workers.

Each year the battle for registration went on, and each year it
failed in Parliament. Finally, in 1919, after the Great War had
revolutionized attitudes toward women and dramatized once more
society's desperate need for qualified nurses, Mrs Bedford-
Fenwick saw the end of what she called her Thirty Years War.
The Nurses Registration Act was passed.

For American nurses the road was easier: whether from the in-
spiration provided by the British Nurses at the Exposition or from

plain American know-how, it is hard to say. In 1894 the Society of Superintendents of Training Schools for Nurses was established in New York City; this Society evolved into the American Nurses Association. By 1910 twenty-seven states had passed laws controlling the certification of registered nurses.

Nursing was not the only old profession which presented a new look in the Woman's Building. The Columbian Association of Housekeepers attempted to transform the most traditional of female occupations into something interesting, if not rare. The slogan of these domestic militants was "The emancipated woman is a housewife too." Their propaganda was aimed at those complacent souls who were "far too willing to drift along in the old way, not recognizing that housekeeping is one of the fine arts and can only be acquired by study and patient work." The Housekeepers had formed in 1891 as an offshoot of the Household Committee of the World's Fair Congress. They dreamed of doing for home economics what the Philadelphia Centennial had done for art. But they roused little interest at the Fair. It seemed to them that most women were more interested in medieval art or the study of Sanskrit than in the facts of plumbing, or in learning how to wash dishes in "the most skillful and artistic way." They made the mistake of saying that "untrained servants demand absurdly high wages and resent any interference with their wasteful methods." Although this comment had been made in all innocence, as part of the Housekeepers' master plan for opening training schools for domestic workers and establishing an equitable wage for them, some household workers became incensed and rumors arose that servants were banding together to refuse services to Housekeepers and their supporters.

The Housekeepers attempted to make clear that they desired the elevation of "household labor to the dignity it deserves." They wished to educate mistresses of households so that they could deal more wisely with their employees and to set up an exchange bureau so that "wants and needs" of employer and employee could be discussed "in every department of home and social life." Among other things they wished to give Housekeepers "a more scientific household knowledge of the economic values of various foods and fuels, a more intelligent understanding of correct plumbing and drainage in homes, as well as a need for pure water and good light in a sanitarily built house." They wanted not only "better trained cooks and waitresses" but also people who could do "plain sewing and mending," for which there was an increasing demand.

The Columbian Housekeepers spilled over into the Building's Model Kitchen, which was all that was left of the Board's ambitious scheme to build a Model Home. In January, 1892, Mrs Palmer wrote to Juliet Corson, a cooking school teacher in New

Juliet Corson

York, asking her to secure "the very best from manufacturers . . . to represent the best system of drainage, ventilation and wall and floor finish." Mrs Palmer wanted also "the most practical and useful kitchen tables, cupboards. cooking utensils, stoves" and all manner of labor-saving devices. At the same time the Illinois Exposition Board had decided to exhibit maize or Indian corn in order to promote its use as food for humans rather than for animals, as it was generally used. It was a simple step to combine the Model Kitchen with the Illinois Corn Kitchen.

From Philadelphia the Ladies recruited Sarah Tyson Rorer, the author of *The Philadelphia Cookbook* and the founder of the Philadelphia Cooking School. Mrs Rorer frequently did her cooking in a silk dress to demonstrate that cooks need not dribble sauce all over themselves. Juliet Corson immediately withdrew from involvement in the kitchen when she heard of Mrs Rorer's coming; she had no desire to take a back seat to that redoubtable lady.

From 10:30 to 12:30 every morning except Sunday, demonstrations of recipes made from corn were given. In the afternoons Mrs Rorer gave cooking lessons not limited to corn cookery, to a group of twenty girls whose age varied from twelve to sixteen years. This group, which changed each month, received instruction not only in cooking, but in marketing and the lighting of fires. Mrs Rorer, like most of the women associated with the Fair, had ambitions for the public good: she wished adoption by public schools of instruction in preparation of meals. For the corn cookery demonstrations she used every source she could find, including her own fertile brain. Frank Hamilton Cushing of the Smithsonian Institution, supplied her with recipes for Zuni Indian dishes made with corn.

Mrs Rorer demonstrated the preparation of soups and meats on Mondays, yeast breads on Tuesdays, pastry on Wednesdays, johnny cakes, griddle cakes and such on Fridays, and desserts on Saturdays. Samples of all cooking were given to visitors, 225,000 of whom visited the kitchen. Some people returned many times, and after the demonstrations visitors clustered about Mrs Rorer to ask questions. She had to enlist the help of Emma Crane, one of her cooking school graduates, to help with the afternoon classes so that she could give her attention to these dawdlers. In addition to food samples, a free souvenir booklet entitled *Recipes Used in Illinois Corn Exhibit Model Kitchen* was given to visitors; a quarter million of these were carried away. Mrs Rorer herself rarely left the Kitchen before four o'clock in the afternoon.

The Kitchen was located in a large room adjoining the Assembly Room. On a raised platform covered with white tile stood an "improved kitchen table, invented by a woman, in which apartments are made for all necessary utensils." At the rear of the platform was a range, refrigerator and gas stove. The fittings, contrib-

Mrs Rorer

uted by dealers, "represented the best and latest improvements in articles of this kind." The stove, a "Jewell Range" came from Clarke and Co. of Chicago; china and cutlery from Burley & Co., also of Chicago; wooden flour bins from the Ohio Flour Bin Co.; waffle irons and ironware from the Wagner Co. of Ohio, and the Ridgway Refrigerator from Rolo, Pennsylvania. William Lee & Sons of Wilmington, Delaware, donated all the maize, flour, meal and hominy, while other manufacturers gave staples like spices and cocoa.

Above the white tiling on the walls, courtesy of the Dibble Company, hung a "corn panel" which illustrated varieties of corn. *The New York Times* was awestruck by what Mrs Rorer did with this humble cereal: "To persons who can think only of yellow and white mush, johnny cakes, pones and Indian pudding, it is a revelation merely to read the list of dishes." These included cream of cornstarch pudding, strawberry shortcake, strawberry meringue plunkets, strawberry float, hominy flourandine, pilau, Brunswick stew, fried cream, mush croquettes, cream pie, Boston brown bread, Victoria corngems and corn dodgers. Mrs Rorer was not ashamed to make hominy grits: "We have discovered that hominy grits, made into a custard and frozen with the addition of whipped cream and a comport (sic) of fruit, is one of the most elegant desserts we have ever used." She was proud to say also that she had used not one ounce of wheat flour in her Kitchen; she got by with corn flour, corn starch and shaved corn.

The Illinois Woman's Board was delighted with its promotional activities:

THE MODEL KITCHEN.

Directors of cooking schools and of schools of domestic science both
at home and abroad visited this kitchen and listened to its teachings
and it is impossible to estimate its wide influence . . . Samples . . . of
corn . . . were sent to Sweden and Japan upon the suggestion of their
official commissioners.
It is known that the kitchen was reported on at length in a Japanese
newspaper. Last, but not least, the millers report that since the Expo-
sition they have had an unexcelled demand for corn.

The Baroness Rappe, a Commissioner from Denmark, went
home with a head full of information and started a corn cooking
school in Copenhagen. Mrs Stuart of South Africa took home
large samples of the maize preparations to begin her own demon-
strations. Lady Gilbert returned to England with bags of maize,
hoping to introduce this product to the tenants on her estate; she
believed it was cheaper and more nutritious than meat.

The Kitchen, the first in any exposition, was furnished with a
Model Pantry filled with fig preserves, raisins, bottled olives,
homemade wine, mango chutney, catsup and sweet potato flour.
Visitors could buy pickles, jellies and cakes. On display were
women's inventions: the Wilcox range-and-heater, a cooking
cabinet, a bread kneader, a dishwasher and an ironing-table-
clothes-rack that converted into a seat.

Mrs Palmer had wanted a scientific restaurant as well as a
Model Kitchen. She had asked Ellen Swallow Richards, who
taught sanitary chemistry at the Massachusetts Institute of Tech-
nology, where she had been the first woman student, to exhibit in
the Woman's Building "the scientific principles you were first to
apply in the preparation of food . . ." Mrs Richards, inspired per-
haps by sinister Eastern gossip about the Woman's Building as a
"White Elephant," had chosen instead to set up her Rumsford
Kitchen near the Liberal Arts Building, which contained exhibits
on nutrition. Mrs Palmer was hurt by Mrs Richard's lack of sym-
pathy for the Board, but Alice Freeman Palmer, although a Lady
Manager, was delighted with the Rumsford Kitchen, where "the
new domestic science," which she found a threatening word, was
"set forth admirably" and "where a capital 30¢ luncheon was
served every day, composed of just those ingredients which the
human frame could be demonstrated to require."

Fernald Frederick, in "Household Arts at the World's Fair,"
wished that there had been more exhibits of domestic science in
the Woman's Building:

It might have been expected that under the direction of the Board of
Lady Manager some systematic representation of this important
occupation would be found. But no; the women of America have
preferred to be represented by their books, their paintings, their so-
cieties for inducing other people to become wiser and better, their
work as hospital nurses, by paper lampshades and indescribable

things . . . by anything in fact that is either pretty on the one hand or mannish on the other, and is remote from everyday affairs.

Many people would have disagreed with this churlish opinion. Alice Freeman Palmer said that crowds of "despairing housekeepers," studied "numberless means of increasing the health, ease and happiness of the household with the least expenditure of time and money" which were available to them at the Woman's Building. Many, she said, were undoubtedly bewildered, but "many, too, went away convinced that the most ancient employment of women was rising to the dignity and attractiveness of a learned profession."

THE ADMINSTRATION BUILDIN' HOVE UP DIRECTLY IN FRONT OF US.

 espite Mrs Palmer's dislike of commercialism, and of the products of the assembly line, the Salesroom in the Woman's Building provided inexpensive keepsakes for the visitor. Mrs Palmer's likeness was woven into silk bookmarks and printed on playing cards and postcards. The bookmarks were woven by the firm of John Best and Company, of Paterson, New Jersey, who made it a practice "not to weave any Picture of a Lady without first having received consent to do so." John Best had woven a picture of Frances Folsom Cleveland, the wife of the President. Mrs Palmer was taken with Mrs Cleveland's likeness and accordingly sent the standard lithograph of herself in left profile, wearing her famous pearl choker, along with a note congratulating the company on its silk work, but also demanding assurance that "the portrait will not be used for advertising purposes," and requesting a sample of the resulting bookmark for approval before distribution. If it was as good as Mrs Cleveland's, Mrs Palmer said, she would be "entirely satisfied." It was apparently as good; it was widely distributed. Mrs Palmer's head floated above a reproduction of the Woman's Building, the whole picked out in blue threads against a white background, and finished off with golden fringe.

The first American commercial picture postcards were produced for the Columbian Exposition. Sets of cards had been offered for sale at the Centennial celebration: these were the same size as postcards, but were designed to be pasted in albums and not to be mailed. The new Columbian cards set off a rage for postcards which reached a height in 1906 in Atlantic City where there were ten stores which sold nothing but postcards. Although at least five companies produced postcards for the Exposition only Charles Goldsmith of New York was the "official" postcard agent. Mr Goldsmith sold four cards at two for five cents in vending machines in Chicago as advance publicity before the Fair

opened: these cards showed the Agriculture Building, the Battle-
ship Illinois at the U.S. Naval Exhibit, the Fisheries Building with
an inset picture of Columbus, and the Woman's Building with an
inset picture of Mrs Palmer. These "pre-official" cards did not
have the official stamp of the Exposition, nor the facsimile signa-
tures of Fair officials as later sets of Goldsmith's cards did: these
later sets were sold in tens and twelves and showed most of the
Fair buildings. The "pre-officials" were well received, except for
the picture of Mrs Palmer, which was not particularly flattering.
On June 14, shortly before the official editions were to be issued,
Mr Goldsmith wrote Mrs Palmer an apologetic note: he had
heard that "not a few officers of the Exposition" had ventured the
opinion that Mrs Palmer would not like the picture. Mr Gold-
smith offered an excuse on the artist's behalf that limited time had
interfered with the execution of the "miniature portrait." Mrs
Palmer had her name removed from the official card of the Wom-
an's Building; she was nevertheless recognizable in left profile set
in the midst of a miasma of pink ribbons and orange blossoms.

Mrs Palmer's likeness was also impressed onto various parts of
souvenir spoons. The first American souvenir spoon had been pat-
ented by Daniel Low in 1890: it was a souvenir of Salem, Massa-
chusetts. Mr Low had begun a spoon collection on a recent Euro-
pean tour, and had returned to bring the fad home. Seven thou-
sand of the "witch spoons" were sold. After that, towns began to
produce their own spoons and it became the custom to bring
home souvenir spoons from all sorts of excursions. At the time of
the Fair the spoon mania was at its height: more spoons were
made to commemorate this Fair than for any other reason in his-
tory. The Woman's Building was immortalized by at least fifteen
different spoon designs; some were sold individually and some in
sets with other buildings.

Mrs Palmer sensibly decided that if these things were to be
sold, the Woman's Memorial Building Fund might as well profit
from them. On February 27, 1893, she wrote a straightforward
letter to Tiffany's:

> . . . I would suggest that you prepare several designs for a souvenir
> [silver] spoon to be sold in the Woman's Building, and I wish to
> make as large a profit from it as possible, as it will be sold for the
> benefit of the Memorial Building. I trust . . . that you will . . .
> make us a very artistic design that will find a ready sale at a reason-
> able price, which will afford us an ample margin of profit. Perhaps
> your designer could submit several designs at an early date, as we are
> anxious to have the spoon put in hand at once. If you will kindly sub-
> mit the design full size, with the price you would charge for making
> the spoon, I shall be glad to consider it. We want something that is
> appropriate and that has some relation to the great occasion.

Mrs Palmer bought her butter plates and hatpins from Tiffany, and presumably she did not dicker about terms; but when negotiating for the Memorial Fund she was a tough customer. Tiffany was rejected on March 11, presumably because they would not agree to let the Ladies have exclusive rights to the sale of the spoon. The spoon order went to the Chicago wholesale jewelry firm of B.F. Norris, McAllister and Company of 113-115 State Street. They agreed to donate 42% of profits to the Memorial Fund and to restrict sales of the spoon to the Woman's Building. Mrs Palmer was pleased enough with this firm to award them also a contract for a companion "Children's Home" spoon to be sold in the Children's Building. Both spoons were advertised to the trade in the July 19, 1893 issue of the *Jeweler's Circular*:

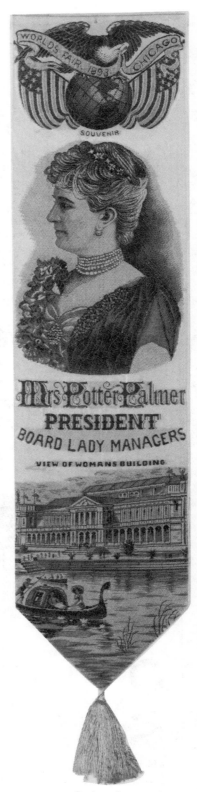

Bookmark

The Woman's Spoon has, at the end of the handle, a woman seated clothed in classic drapery and holding distaffs in her hands. Her feet rest upon a globe at the side of which is a large distaff, the handle extending downward toward the shank, which bears the words Columbian Exposition. In the bowl is a finely etched reproduction of the Woman's Building with the lagoon and picturesque gondolas in the foreground. On the reverse of the handle is a miniature Santa Maria sailing on oxidized waves with the figures 1492-1893 on either side and the name of the ship beneath. Below this in a circle the size of a three-cent piece, is the American eagle and shield surmounted by a caravel. Further down is a bust of Queen Isabella. The obverse side of the handle is bordered by a floral design . . . The Children's spoon on the obverse of the handle has a fine likeness of Mrs Potter Palmer, the dies having been submitted to that lady and approved by her. Next the likeness is a cluster of roses and then an eagle surmounting a globe depicting the western hemisphere. The words Chicago, Ill. are on the shank of the spoon and the Children's Home at the Fair is in the bowl. The reverse of the handle has a unique design—a little girl with shopping bag in arm, holding up an open umbrella surmounted by the inscription, Going to the World's Fair. Below are laurel leaves, an American shield and a hemisphere showing the eastern continent. In the shank are the notable dates 1492-1893. The execution of both spoons is excellent . . . No spoon collection is complete without this set . . . which are made in tea and coffee sizes.

Mrs Palmer was not content to rest on spoons. She sought also an eight inch replica of the Building to be used as a jewelry chest or inkstand; designs for paper cutters and card cases, and "a Japanese fan which should be both cheap and pretty." The inkstand did not work out, since no acceptable model was presented. Frank Millet offered his opinion:

Regarding the model of the Woman's Building, left at my office by you, I beg to say that, in my judgment, it has no artistic merit whatever; and therefore I think no further comment necessary.

Richard Howland Hunt, who was shown the model in his fath-

er's absence, commented that he "would not recognize it as a model of the Woman's Building, as it was utterly worthless in every respect."

Mrs Palmer thereupon substituted "a little aluminum box, with an impression of the Woman's Building; a card case with a silver corner, also bearing a design of the Woman's Building, one book and several other small articles."

At the last minute booths were set up at the four entranceways and in the main gallery, for the sale of guide books. Other booths for the hawking of souvenirs appeared in the northwest chambers off the Rotunda, in the midst of the checkroom, restrooms, guide services, the post office, the telephone exchange and the information bureau. Not only Mrs Palmer, but the "Last Nail" driven into the Building by her, were exploited for profit. There was a nail-shaped brooch and a nail-shaped mechanical pencil. The Woman's Building itself was stamped onto silver trays, coasters, paperweights and lids of powder puff and toothpick holders.

Books sold well in the Building, perhaps better than knick-knacks, many of which were rather expensive. Laura Hayes' *Three Girls in a Flat* sold out; on the second printing the title was changed to *The Story of the Woman's Building.* Anyone who could think of a way to sell something in the Woman's Building came to Mrs Palmer or to Mrs M.N. Gordon, who was put in charge of the salesrooms in June. Mrs Palmer was not always encouraging. On January 11, 1893, Carrie Shuman submitted a proposal for a *Columbian Autograph Souvenir Cookery Book:*

> With a view to furnishing the wherewithal to women who could not otherwise find means sufficient to pay the expense of a trip to the World's Exposition next summer, I desire to publish a book . . . at my own expense and place it in the hands of women who will sell it and visit the Exposition upon their share of the profits.
> All over the country are found mothers of families with limited means . . . who will dream longingly and hopelessly of the Exposition. While these women have not business training, yet they may be quite capable of selling books in their immediate neighborhood. The book I have in mind is to contain two autograph recipes contributed by each of the Lady Commissioners. The recipes will be printed in type with a facsimile of the contributor's autograph attached.
> Rand McNally & Co. estimate the cost of an edition of 5000 copies at $3,012. (60 cents a copy) and I propose to allow a commission of 50¢ per copy to the seller. The cost of handling is estimated at 25¢ a copy. As the price of the book is $1.50 per copy, it will be seen that it is not to be published as a speculation . . .
> I have laid my plans before Mrs Virginia C. Meredith, Vice-Chairman of the Executive Committee, and in response have received a recipe. She has also kindly written me a letter, a copy of which I take pleasure in enclosing to you, as an assurance of good faith in this enterprise.
> I would request that you give me a recipe for the article designated

Gorham Sterling Corner
on Leather Card Case

With a merrie Xmas for my dear Colonel Durrett — Enid Yandell /92

THREE GIRLS IN A FLAT

Illustrated by....

HELEN M. ARMSTRONG
A. B. WENZELL
C. GRAHAM
TRUE WILLIAMS
J. H. VANDERPOEL
A. F. BROOKS
HUGH TALLANT
WALTER TALLANT OWEN

BY

ENID YANDELL, of Kentucky
JEAN LOUGHBOROUGH, of Arkansas
LAURA HAYES, of Illinois

Title Page, Three Girls in a Flat

on the blank herewith enclosed, to avoid duplication, and that you give me another of your own choice upon the other sheet, signing both of them so that the signature can be reproduced in facsimile . . .

Mrs Palmer was not delighted with Mrs Shuman's project; she objected that the women who sold the book would get only 50 cents; the rest of the money would go to Mrs Shuman and Rand McNally. The Ladies however wrote "charming letters of encouragement" to Mrs Shuman and sent her their recipes. Even Frances Willard sent her mother's recipe for lard doughnuts; she herself "never knew anything about cooking or had a particle of taste for it." Isabella Beecher Hooker, at the age of seventy-one, sent a picture of herself taken when she was forty-six, with a note:

The recipe I send for sponge cake was constantly in use twenty-five years ago, when this picture was taken, and so might well be used in connection with that recipe, which is the only one in which I find a personal interest. It gives me pleasure to oblige you, and I am cordially yours for womankind, also for mankind . . .

Mrs Hooker pointed out that the secret of her cake's success lay in the "cutting of the flour and in the baking. But few people will believe this and cannot reach my standard. I have made this cake for forty years with uniform success." Her recipe called for ten eggs. She was outdone by Mrs Kidder, whose "Sally White Cake" required fifteen eggs. In the face of all this enthusiasm, Mrs Palmer put aside her objections to Mrs Shuman. By February 28, 1893, the book was nearly finished. Mrs Shuman had wanted it to go on sale the first week in March. She wrote Mrs Palmer that the book needed only her photograph and favorite recipe.

Mrs Palmer replied coldly that she had not been "attending to the household lately" and had no recipes to send. Mrs Shuman replied sweetly, "As you are so busy, would you let me use for you a tried recipe of mine for Roman punch from Miss Parlor's Cookbook."

This punch, she said, was "very dainty, refreshing and palatable." Mrs Palmer wrote back that she would prefer the substitution of "a simple ice or frozen pudding, as I would rather not incur the possibility of comment by endorsing a recipe for punch." This request was ignored: the book was published with "Mrs Palmer's Romaine Punch" which called for one gill of sherry and two tablespoonsful of Jamaica rum. Any comment by the WCTU or other anti-rum faction has not been recorded.

Mrs Palmer was alert to the possibility that women "on the make", to use Julia Ward Howe's phrase, would attempt to profit personally through the Woman's Building. For this reason she attempted to monitor the production of the official handbook, which was to be called *Arts and Handicrafts in the Woman's Building.*

REVISED EDITION.

OFFICIAL CATALOGUE OF EXHIBITS.

WORLD'S COLUMBIAN EXPOSITION

Woman's Building

MRS. POTTER PALMER President Board of Lady Managers

PRICE, 25 CENTS.

1893

W.B. CONKEY COMPANY, PUBLISHERS TO THE EXPOSITION CHICAGO

FOR THE TABLE.

Prairie Chicken.

.From Mrs. E. S. Thomson, of Maryland, Lady Manager.

Do not wash prairie chickens. Cover the breasts with very thin slices of bacon, or rub them well with butter; roast them before a good fire, basting them often with butter. Cook twenty minutes, salt and pepper them, and serve on a hot dish as soon as cooked.

Sauce for the above — First roll a pint of dry bread crumbs and pass half of them through a sieve. Put a small onion into a pint of milk and when it boils remove the onion and thicken the milk with the half pint of sifted crumbs; take from the fire and stir in a heaping teaspoonful of butter, a grating of nutmeg, pepper and salt. Put a little butter in a sautée pan, and when hot throw in the half pint of coarser crumbs which remained in the sieve; stir them over the fire until they assume a light brown color, taking care that they do not burn, and stir into them a pinch of cayenne pepper. For serving, pour over the chicken, when helped, a spoonful of the white sauce and on this place a spoonful of the crumbs.

E. S. Thomson

from Columbian Autograph Souvenir Cook Book

She wanted this to be a volume worthy of the Board. She chose Goupil and Company of Paris, as publishers; they were a company specializing in "fine art" publishing, and had recently been taken over by Boussod Valadon and Company. She convinced Andrew MacNally to award the book to the French firm, putting "artistic excellence" over "favorable terms." Mrs Palmer then entered in to a lively correspondence with Wilbert Smith, the New York rep-

resentative of Goupil-Boussod Valadon, over photographs to be included in the book, and over the text, which was planned as a series of essays by qualified women on various exhibits in the Building. Mrs Palmer was to "pass upon" the women's qualifications before they were asked to write their sections of the book. On December 30, 1892, Mr Smith, in the course of a long letter, mentioned that he was already in communication with "Mrs John A. Logan of Washington" who, along with Sara Hallowell and Candace Wheeler, had been suggested by Mrs. Palmer to write the Arts and Literature sections of the book.

On January 5, 1893, Mrs Palmer replied to Mr Smith, urging him to be "discreet" in asking permission from foreigners to print photographs of their exhibits in the book, since there was a feeling in some countries that "as we have a high tariff we are simply inviting foreigners to this country in order to get their patterns and designs." She said that Mr Smith "must drop the matter at once" if there were "the smallest reluctance" to allow publication of these exhibits. Then, after some discussion of whether Mrs Van Rensselaer could be induced to contribute a section, she came to the heart of her letter:

I did not mention Mrs Logan's name to you, but I have received a letter from her on the subject. What part of the text does she propose to prepare?

On the same day Mrs Palmer wrote more frankly to Miss Hallowell, marking her letter "Confidential":

I have received a note from Mrs Logan saying that she is in correspondence with Goupil in reference to furnishing the text for an illustrated publication which they propose to issue.
I cannot say to Goupil & Co. directly what perhaps you can intimate indirectly, in case you are willing to do me this very great service. When Mr Smith was here he insisted on my writing an article and other members of the Board writing articles for this publication, showing that he wished to get . . . names which he considered influential without reference to their special fitness to write on the topics assigned. Our idea is not . . . to have prominent women used as advertising cards to sell the book, but . . . to have the text written from a serious standpoint by expert authorities in each line of work.
I do not know which article Mrs Logan is able to undertake. From her letter to me I fancied she wanted to get a general contract to furnish the text which she would then farm out to the various experts desired, making herself a pecuniary profit by the transactions. I have no objection in the world to her doing this . . . but we want no text written by any but acknowledged authorities and experts. Mrs Logan's ability you know as well as I and that her experience has not been such as to fit her for just this work. This is a most delicate matter because I think that Goupil wants her name in the book, because they think it would make the pecuniary profits larger.
Would you be willing to go and see them and say in an indirect way . . . whatever you think necessary.

Mrs Logan had been considered by envious Board members to
be one of the "favored few" because of her position as Chair of
the Receptions Committee and her apparent closeness to Mrs
Palmer. It is obvious from this letter that Mrs Palmer had chosen
to allow Mrs Logan, who was influential as the wife of a war hero
and the editor of the *Home Magazine,* to take some of the power she
wanted, while at the same time considering her to be one of the
women "on the make" against whom Mrs Howe had warned her.
Mrs Palmer wished to avoid making an open enemy of Mrs
Logan, whose specialty appeared to be the stirring up of trouble.

In other matters related to *Arts and Handicrafts in the Woman's
Building,* Mrs Palmer vetoed outright Mr Smith's suggestion of
Ellen Swallow Richards for the science section of the book, be-
cause of Mrs Richards' refusal to set up her restaurant in the
Woman's Building. Mrs Palmer suggested they find someone
"more sympathetic than Mrs Ellen Richards for science." She
herself approached Mrs Burton Harrison, the novelist, about writ-
ing an essay describing the American and European exhibits.

In the end, however, Maud Howe Elliott, Julie Ward Howe's
daughter, wrote the essays describing the Building and its decora-
tion, the Belgian exhibit, and the Library. Laura E. Richards
wrote the Literature section and Louisa Parsons Hopkins the less
than inspired Science section. Sara Hallowell wrote on Art, and
Candace Wheeler on Applied Art. Angela Burdett-Coutts did Phi-
lanthropy, Mrs Bedford-Fenwick did Nurses and the Duchess of
Veragua wrote on Spain. Mrs Palmer herself wrote an essay enti-
tled "The Growth of the Woman's Building." Mary Logan's
name did not appear in the book.

As the number of visitors to the salesrooms grew, so also did the
number of items for sale. There was too much to choose from.
Some manufacturers were disappointed. Joy & Seliger, a company
specializing in aluminum and silver-plated novelties, were pleased
by a substantial reorder for their trinket boxes. They made up a
sample tray with a representation of the Building stamped on it
and sent it to Mrs Palmer, whose response was not fast enough for
them. On August 17 Mrs Palmer received a plaintive letter:

Some time ago we sent samples of World's Fair Novelties to you. As
we have heard nothing from you, we would thank you very much to
inform us if you cannot see your way clear to send us an order for the
same. Or if you would put them on sale, we would send a small
amount on memorandum. Regarding the small Trinket Boxes with
the Woman's Building on the top, we have not received an order for
quite a while. We have from 8 to 10 gross of them on hand. Has the
sale of them dropped entirely, or what seems to be the trouble?

On that same day Mrs Gordon, the salesroom manager, re-
ceived a sad note from C. Murphy and Sons, manufacturers of
medallions bearing the likeness of Queen Isabella:

Title Page, Art & Handicraft in the Woman's Building

Official Postcard

While in Chicago last week you promised to let me know how the Queen Isabella medals were selling, but I suppose that owing to the many calls upon you the matter has escaped your attention. I hope that you will see that the medals are properly displayed in the booths. While in the building it was with considerable trouble that I was able to find where they were exhibited and then only *one* was in view. If it is at all possible to place them so that they can be seen easily I have every reason to believe that a large number will be sold, thereby making it profitable to the Woman's Memorial Building and Miss [sic] Cooke.

The restricting of sales items to buildings like the Woman's Building cut down the numbers of possible sales for the manufacturers, and also made it impossible for them to compete with "unofficial" salesmen hawking items in the streets of the Fair, at the entrances to it, and at hotels and shops all over the city. Norris, McAlister & Co., whose spoons were in the Woman's and Children's Buildings, and who had the commission for an official "Columbian spoon" on the Fairgrounds, complained repeatedly to the Directors that their contracts were being violated all over the place. Under the circumstances they wished to alter their arrangement which granted 40% of the profits to the Exposition Company and 42% of the spoon profits to the Lady managers. They finally demanded damages, since the Directors did nothing to expel the unofficial hawkers, and a reduction of both profit per-

centages to 15%. After a long argument a settlement was reached: the Exposition Company reduced its percentage by 6 ⅔%, retroactive to June 10. Nearly $4000 was due Norris, McAlister. The Woman's Building was penalized nearly $600 and the Children's Building almost $200. Everyone was satisfied with this arrangement, except Mrs Palmer, who was not told of it. She immediately jumped to the conclusion that she was being cheated, and sent Norris, McAlister a strong letter threatening to transfer their sales rights to another spoon company. As a result Adolph Nathan, the Chairman of the Exposition Committee on Adjustment, was forced to write Mrs Palmer on September 22, asking her to reconsider the threats made in her letter. He explained the settlement:

> . . . under the circumstances, we considered [it] a very good settlement for the Exposition Company and for you . . . had we not adjusted with them as above, [the result] would have been that they would have paid no percentage to the Exposition on the sales of any spoons, and the Exposition would have had no percentage to pay over to you. It was understood at the time that the Department of Collections should fully explain this matter to you, which apparently was not done, or the explanation did not come to you personally. Should you take action as indicated in your letter to Messrs Norris McAlister & Co., it would simply result in claims for heavy damages, on their part, in their refusing to pay you further percentages until the matter is adjusted, and the loss to you would be far heavier than any possible benefit.
> Under the Contract between the Exposition Company and Messrs Norris McAlister & Co. the course that you indicate in your letter would be a direct and positive infringement of their Contract, as the sale of souvenir spoons by other parties is not to be permitted under any circumstances, within the Grounds, and the Exposition has been at a large expense and trouble, to stop the sale wherever they have been carried on.
> In view of the above facts, and of the situation, will you kindly withdraw your letter of the 20th to Messrs Norris McAlister & Co. . . .

Playing Card

It was the spoons which brought the greatest return to the Ladies' coffers—unless one considers a more ambitious project as a souvenir: that is, the Ladies' Queen Isabella commemorative quarter. This was the first American coin to bear the likeness of a female historical personage. Isabella's likeness on three Columbian commemorative stamps marks the first appearance of a female on American stamps, as well. In addition, the "Isabella" remains the only commemorative quarter struck by the Mint.

On August 5, 1892, the Commissioners were authorized by Congress to strike a Columbian half dollar, in honor of the Exposition. A month later, Dr Sarah Hackett Stevenson of the Queen Isabella Association decided that the Ladies should have a coin too, and that it should honor Isabella, for womanhood and for the Queen herself, whose adherents Mrs Palmer had effectively stifled. Since Dr Stevenson was not a Lady Manager, she enlisted

the aid of Mary Logan to introduce her resolution at the Board meeting. The resolution called for a souvenir coin "bearing on one side Queen Isabella and on the other Mrs Potter Palmer—in case Mrs Palmer positively declines, the alternate to be Martha Washington." Mrs Logan read the resolution, requesting two or more thousand dollars as the amount of the appropriation for the coin, and eliminating Mrs Palmer, since it was illegal for a living person to be portrayed on a coin. Mrs Logan, living up to her reputation as unpredictable, to say the least, then argued against the resolution, ensuring its defeat. Dr Stevenson was moved to write Mrs Logan on October 28, 1892:

> I was grieved and greatly surprised when I learned about what was done with my resolution. Had you told me that you were not in favor of it and should vote against it I should have asked someone else to present it, for of course there is no surer way to kill a resolution than for the mover to oppose it. I was told that . . . you did it evidently with malice of forethought. My dear friend, I did not wish my name to appear—that is not the motive I had in mind. I knew the Women's Department needed money. I thought this a dignified and popular way of seeking it. You could sell an almost unlimited number of such souvenir coins. Mrs Palmer was enthusiastic.

Mrs Palmer was indeed enthusiastic, whatever Mary Logan may have thought. On December 12 at a Subexecutive Committee session she resurrected the idea, reading aloud a letter she proposed to send to Congress about the coin. Clara Thatcher of Chicago then offered a resolution similar to the one offered by Mary Logan, but suggesting the Woman's Building rather than Martha Washington for the reverse of the coin. On March 3, 1893, Congress authorized that $10,000 of the Board's annual budget appear in the form of Isabella quarters.

Because the Mint wished to exercise some control over these commemorative coins, the final bill provided that "the devices and designs . . . shall be prescribed by the Director of the Mint, with the approval of the Secretary of the Treasury." This provision appeared because the people at the Mint were just recovering from an unpleasant entanglement with the National Commission over the Columbian half dollar. The Commission had given the design of the coin to a sculptor named U.S.J. Dunbar who prepared a plaster model of Columbus for the obverse, or major, side of the coin. The Mint registered objections to the bust and demanded Mr Dunbar be removed as designer. The Mint's chief engraver, Charles Barber, then modeled another head of Columbus, which he took from a Spanish medal. The Commission wanted for the reverse, or secondary side, of the coin, a representation of the Santa Maria, the flagship of Columbus' fleet, sailing above two globes. When this design was submitted in plaster Charles Barber again objected, with some point, this arrangement being later

Columbian Half Dollar

lampooned as the "ship on wheels." Mr Barber's assistant engraver George T. Morgan did this model over again. In order to placate ruffled feelings at the Mint Congress gave final approval of the Isabella Quarter to E.C. Leech, the Director of the Mint.

Mrs Palmer was annoyed at this turn of events. She wrote Mary Logan in the capitol, to find out "at once from the Secretary of the Treasury how far his control extends over the Director of the Mint" and also if the Bill's wording gave the Director "sole power to judge of designs

> as it is a foregone conclusion that whatever sketch we may submit, would be refused if he has the right to do so . . .
> Unless we get some support from the Secretary of the Treasury, the Director of the Mint will undoubtedly throw out our design, and we would like to have the credit of being the authors of the first really beautiful, and artistic coin that has ever been issued by the government of the United States.
> I cannot impress upon you too strongly the urgent necessity for haste, as it will be impossible even now to get our coin designed and minted before June, and any delay would be fatal.

On the same day she wrote to Mrs Logan, Mrs Palmer received a telegram from Director Leech, in which he offered to come to Chicago to consult with her about the quarter. Mrs Palmer wrote him a hurried letter which was intended to stake out the design of the coin as the Board's prerogative, and to warn him off:

> I hasten to say that we have a decided idea as to the design we wish to have placed upon the souvenir coin. It was the intention to commemorate by this issue the helpful part taken by Queen Isabella of Spain in the discovery of America, and also the action of Congress in having created the Board of Lady Managers. We have been consulting with one or two friends as to the most rapid manner of securing something that will be highly artistic, and I am very greatly obliged, consequently, for the generous spirit you manifest in allowing us to satisfy our whims about this matter.

Director Leech, however, was not the man to be won over easily by a combination of queenly dignity and girlish flirtation. He replied:

> If a head of Isabella is to be selected for one side it will only be necessary to forward her effigy to me. It is not necessary to employ any sculptor or modeller.

Even before the bill authorizing the coin was passed, Mrs Palmer had been seeking for a suitable artist. She consequently wrote, over Mr Leech's head, to the Secretary of the Treasury:

> We have understood this was our opportunity to call attention to the progress made by women in the Arts and Industries, and we have

*Caroline Peddle: Sketches
for Isabella Quarter*

found that Congress and the country sympathized with us in this effort. We are naturally desirous therefore that this coin should bear the impress of a feminine hand, as does everything else connected with our department of the Exposition.

At the risk of testing the amiability of the Director of the Mint we wish to have the coin modelled by a woman, and would sincerely hope that you may sympathize with and approve our plan, which we know is quite out of the ordinary routine.

Mr St Gaudens gives the highest endorsement to one of his pupils—Miss Peddle—with whose work he is of course thoroughly familiar. She would model this coin in clay, cast it in plaster and send it to you at an early date.

We very much hope that you will approve of our making this effort to secure an artistic coin made by a woman, as we are most anxious to emphasize the work women are capable of doing in a new and perfectly legitimate field.

Caroline Peddle was twenty-three years old and had gone from her home in Terre Haute, Indiana, to study first for a year at the Philadelphia Academy of Design, and then for two years with Augustus St Gaudens at the Art Students' League in New York. Her model of the Virgin Mary, executed by Louis Tiffany's studio, was on exhibit in the Arts Palace, a signal honor. Mrs Palmer gave Miss Peddle the commission for the coin on March 22, 1893. For the obverse, which was to honor Isabella, she sent Miss Peddle engravings of the Queen. For the reverse, which was to commemorate the congressional act of creating the Board of Lady Managers, Mrs Palmer, unable to think of a suitable illustration, offered an inscription:

Commemorative Coin Issued for the Board of Lady Managers of the World's Columbian Exposition by Act of Congress, 1492-1892.

Charles Barber: Plaster Casts of Two Isabella Busts

At the same time she informed Secretary of the Treasury Carlisle of her decisions concerning the coin. On March 28 he wrote to her, attempting to dissuade her from using the inscription:

. . . with a strong desire to comply with your request I have been constrained to come to the conclusion that it will be impossible to put so much lettering upon the coin as you propose without wholly destroying its artistic merit and giving it the appearance of an ordinary advertisement, such as tradesmen have been in the habit for some years of issuing.

The space upon the surface of the coin is so small that the letters of the inscription . . . would necessarily be very small and liable to be defaced by the least wear; and besides they exclude all ornamentation of any kind.

The words 'United States of America' must under the law go upon the coin at some place, while the words 'World's Columbian Exposition', or something indicating that it is issued for that institution, ought also to be on the other side. After this is done there will be very little space . . . and if the reverse of the coin is left entirely without

ornamentation, containing only an inscription in letters, it seems to me that the appearance of the coin would not be at all attractive.

Although she had grave doubts about the artistic taste of government officials, Mrs Palmer was willing to have her inscription shortened; but the four words "Board of Lady Managers" she felt she must have.

I would call your attention to the fact that the World's Columbian Exposition has previously been given a coin bearing an appropriate motto and that the present issue was especially voted by Congress for our Board, which fact is so gratifying to me, that we naturally are anxious that some indication of it be made on the coin itself.

Mrs Palmer told Miss Peddle on March 31 that the inscription should be dropped, and the original idea for the reverse—a representation of the Woman's Building—should be used instead. By a twist of fate, Miss Peddle did not receive this letter, and consequently was struggling to fit Mrs Palmer's gargantuan inscription onto the coin. She sent a rough sketch of the inscription to Director Leech at the Mint with a note:

Does this coin, as an especial case, necessitate the use of the words 'By Act of Congress'? Any shortening of the inscription would be a good thing as a longer one would bring the letters when reduced to almost microscopic size.

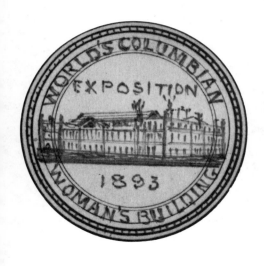

*Charles Barber: Rough Sketch
of Woman's Building for Isabella Quarter*

Later the same day she sent Mr Leech her sketch of Isabella, with another note:

I shall have to ask a few more questions before beginning the modelling. Mrs Palmer spoke of having a figure of Isabella on the face, and I have made a rude sketch from the print she sent me. This, it seems to me, would make a handsomer coin than a head unless it would not reduce well. It is in the same proportion as the seated Liberty on the older quarters. My sketch is not placed correctly, of course, on the circle as I did it very hastily, merely to show you the size. If you will telegraph your decision as to this point, I will commence work at once.

The people at the Mint were not disposed to give Miss Peddle any advice, or any quarter either, to coin a phrase. Charles Barber did some sketches to prove that Mrs Palmer's inscription would not fit on the coin, a point that everyone conceded already. Mr Barber submitted his own sketches to his supervisor, O. C. Bosbyshell, with a note:

You no doubt have seen it is quite impossible to put all the reading matter furnished by Mrs Potter Palmer on as small a coin as a twenty-five cent piece and therefore the question arises how much shall be used, that is to what extent is the Director of the Mint will-

ing to comply with the request of the ladies, and it is more to ascertain this point that I submit the designs than anything else.
United States of America must I think be placed upon the coin. In regard to the other inscriptions I would gladly have the expression of the opinion of the Director.

Mr Bosbyshell agreed that a motif of some kind would be better than "reading matter." When Caroline Peddle's Isabella sketch arrived in Philadelphia, both Mr Barber and Mr Bosbyshell disliked it. Mr Bosbyshell wrote to Mr Leech in Washington:

> We think here a head would be very much better than a sitting figure. Arranged as Miss Peddle has it, it would scarcely have any significance at all reduced to the size of a quarter. The foreshortening of the limbs from the waist to the knees would be very unsatisfactory.

Miss Peddle was informed by the Mint that their engravers would do the reverse. She was much put out by this high-handed attitude, and the lack of guidance. She announced that in that case she would cease work on the obverse because she "could not consent to do half a piece of work." She telegraphed a similar sentiment to Mrs Palmer, who had anxiously been awaiting word of progress. Mrs Palmer wrote her, "I was exceedingly sorry to infer from your telegram that little or nothing had been done." She told Director Leech that she thought it "most unfortunate" that he, she and Miss Peddle were "at three points of a triangle, instead of having come together for full and satisfactory conference to decide finally about the design, finish and inscription of the proposed coin." Now time was growing short and with it Mrs Palmer's temper. She wrote Miss Peddle:

Isabella Memorial Quarter

> It will require two months to make the dies after the model is finished. We must have the coin by the first of June or we will lose the opportunity to make the sales necessary during the Exposition, and consequently I have counted upon you to give it to the authorities as soon after the first of April as possible.

She asked Sara Hallowell to go and see Miss Peddle; she urged "conciliation" upon the Mint. Director Leech's response was a letter telling Caroline Peddle that she could model the reverse from Mr Barber's design. However this peace offering was cancelled by an enclosure from Mr Bosbyshell:

> You notice that the Director desires that you should model a head of Queen Isabella from the best portrait you can obtain. This head should be without a crown, as a crowned head on an American coin would, in my judgment be exceedingly unpopular and offensive to the teachings of our republican institutions. Isabella should be represented as the patron of Columbus and not as a Queen, according to my notion.

Our engraver is modelling a reverse for the inspection of the Direc-
tor and Secretary so that if acceptable to them I do not think it would
be necessary for you to remodel it as suggested in the Director's let-
ter. Anything we can do here to assist you will be cheerfully done.

Mr Barber wrote Mr Bosbyshell on April 8, to demolish the La-
dies' suggestion for the reverse:

I am not in favor of using any building for a coin, coin relief being
too low and consequently unsuitable for the proper display of build-
ings.
The building being a long low structure I fear to use it in its entirety.
It would look a mere streak across the coin.
To show you what I think would be the appearance of this building
on a coin I enclose a medal with a very similar building and on a
piece of about the same size.

Neither Mr Barber's nor Mr Bosbyshell's comments were men-
tioned in the conciliatory telegram sent by Director Leech to Mrs
Palmer on April 8:

Miss Peddle has been instructed that she can proceed to model the
head of Isabella and certain lettering for the obverse or face of the
souvenir quarter. The design for the reverse will be prepared by the
designer of the Mint, that is a sketch will be submitted to me and if
approved by the Secretary, will be forwarded to you for your opin-
ion. Miss Peddle can then make the model of the reverse, if you care
to have her do so.

Miss Peddle, under the impression that the Mint refused to
allow her to model the reverse of the coin, sent her official resig-
nation to Mr Leech, who immediately fired off another telegram
to Mrs Palmer:

Miss Peddle declines to model souvenir quarter. Please request her
to to forward head of Isabella which you have selected for obverse to
Mint at Philadelphia and I will have model prepared and forwarded
to you for your examination and will also have a model of reverse of
coin forwarded to you. This will save considerable time.

Mrs Palmer was exceedingly angry at Caroline Peddle. She
wrote to St Gaudens that she was "very much annoyed with Miss
Peddle and her action." She enclosed the two recent telegrams
from Director Leech as proof that Miss Peddle had "frustrated"
their plans. She also found fault with the young artist's manners:

I consider it a direct discourtesy to me for Miss Peddle to have ever
communicated directly with the Treasury Department. She was en-
gaged by us to do this modelling and her communicating with Mr
Leech and arranging terms with him or anything else was in very
bad form and by her ill advised action, she has not only injured her-

self and deprived herself of what would have been a beautiful opportunity, but she has given a blow to . . . having recognition given to women in every department of the Exposition. I feel it very keenly because it has been necessary to use some diplomacy in order to secure consent for a woman to model the model.
I do not write directly to Miss Peddle because I feel annoyed with her and simply wish to explain to you that the whole matter was arranged and we were quite able to take care of ourselves and take care of Miss Peddle, and the result is not because of any failure on our part, but because of Miss Peddle's unwise action.

Mrs Palmer's annoyance was increased when St Gaudens replied that he knew of the resignation already, and had sanctioned it:

I am very much annoyed at the turn things are taking but when Miss Peddle told me the reverse of the medal was to be modelled by the incompetent designers at the Mint I agreed with her that it would be more dignified to refuse.

The Mint had successfully fended off Mrs Palmer's artist. Director Leech wired Mrs Palmer on April 21 to give him the exact wording she required for the inscription on the coin, "omitting the distinction of sex, which the Secretary holds is improper on a coin of the United States." He wished the words "Board of Lady Managers" to be dropped. Mrs Palmer had no intention of allowing this: she appealed to Secretary Carlisle, who gave permission for "Board of Lady Managers" to circle the coin.

Instead of the Woman's Building, Charles Barber offered a design for the reverse of a shield emblazoned with the American eagle, encircled by a wreath of oak leaves. Mr Leech, possibly foreseeing Mrs Palmer's reaction, vetoed this idea. He preferred an earlier design of Barber's: the full figure of a kneeling woman winding flax on a spindle. In her hand she held a distaff which, as Director Leech explained to Mrs Palmer, "is used in art to symbolize patient industry, and especially the industry of women." Mrs Palmer approved the sketch. For the obverse the Mint chose a head of a young Isabella wearing a crown. It was "impossible", they said, "to properly represent Isabella from the engraving furnished without a crown." Mrs Palmer approved that too.

All difficulties melted away when the Mint's engravers were allowed to work directly with the Board. Director Leech was delighted with the designs. He told Mrs Palmer that he felt quite sure "that the designs selected will be both suitable and artistic and will make a very beautiful coin." The Columbian half-dollar had suffered from the sacrifice of high relief to considerations of economy; Leech promised this would not happen with the Isabella quarter. It would be "struck especially, in as high relief as possible—and on polished plauchets, so as to give as beautiful a lot of coins as the mint is capable of executing."

To MAKE good Chocolate is not easy. One's own taste must be the guide regarding strength. Soften and smooth the chocolate with cold water in a jar on the range; pour in boiling water, then add milk, stirring constantly. Serve as soon as it boils. When each cup is filled with the chocolate, place two tablespoons of whipped cream on top.

from Columbian Autograph Souvenir Cook Book

When Alden wooed the fair Priscilla, for his friend
In sixteen twenty six by Plymouth Rocks environs
The course of true love, rough at first, was at the end
As smooth as if they'd used the Enterprise Sad Irons.

Trading Card

But after all this, the Ladies themselves did not like the coin. They did not think the image of a woman on her knees holding a distaff was a promising symbol of the New Woman. *The American Journal of Numismatics* had not liked the Columbian half-dollar, and it did not like the Isabella quarter:

Of its artistic merit, as of the harmony which is reported to have prevailed at the meetings of those Managers, perhaps the less said the better; we do not know who designed it . . . If the two coins really represent the highest achievements of our medallists . . . we might as well despair of [the] future [of our national coinage] . . .
The figure on the reverse is mournfully suggestive of the old anti-slavery token 'Am I not a woman and a sister'!

The Ladies had 40,000 of these mournful tokens to dispose of. Mrs Palmer, in a speech at the fourth session of the Board, rearranged history to give the impression that the unfortunate reverse had been forced on her:

The design for this figure we did not consider typical of the woman of the present day, as the woman is represented kneeling with a distaff in her hands, but the necessity for haste forced us, while recording our objection, to ask that the minting of the coin be proceeded without waiting for other sketches.

The Isabella quarter, like the Columbian half-dollar, sold for a dollar. There was thus built-in price resistance: why buy a quarter for a dollar, when you could buy a half-dollar as a souvenir and get a coin worth twice as much? By October of 1893 only half the coins had been sold. Department stores and banks were persuaded to sell the coin. Tiffany's sold a good many, and was encouraged to auction issues: the first, four hundreth, 1492nd and 1892nd, accompanied by certificates of authenticity.

People said, 'They ask too much—who is going to give a dollar for a coin worth only 25¢?' To this there was the obvious reply that the coins were historic, that they represented a sentiment and also an era and were also artistic and valuable because they were the only memorial of the work of the Board of Lady Managers that was enduring and that anyone might possess . . . But as the fact stares me in the face that the coins still remain in my possession I must think it will be wise to offer them for sale at the reduced price of 50¢.

Before they would allow the price to drop, the Board tried harder to sell them. They announced that "collectors from every country are sending for [coins] as no collection is complete without one of these unusual issues recently struck by the United States Treasury." The government, meanwhile, unaware of the Board's attitude, melted down a batch of Isabella coins. Mrs Palmer wrote to her friend William Curtis in Washington:

I am shocked that any of the coins were sent to Philadelphia and re-melted. We have had the funds for a long time to withdraw them, but considered them absolutely safe in the sub-Treasury, and as it was an unfortunate time to advertise and attempt to sell them, we have waited for brighter days . . . I do not like the odd amount now re-maining; there were originally 40,000 coins minted; of these you say you have remelted the value of $950.25, which would make 3825 coins. This subtracted from 40,000 leaves 36,175. We wish to state how many were issued, and as this is a very odd amount, I think the 175 had also better be put in the melting pot, leaving only a round number of 36,000.

That letter was written November 1, 1894. On November 2, Mrs Palmer wrote again, saying that she had changed her mind and Mr Curtis had better see that all remaining coins were pre-served, as it was "too embarrassing to make a statement con-cerning the remelting of these coins."

A year later it was obvious that interest in the coins was as dead as the White City itself. Reluctantly Mrs Palmer negotiated with a coin agent to sell the remaining quarters at a discount. During this process, a New York dealer refused to buy the coins at 60¢ apiece. He said he had already bought eight or nine hundred of them at 40¢; he refused to say from whom. The Board was much dis-turbed, since they believed they themselves controlled the majority of the coins and they had not sold any large lots. Possibly the dealer had bought stolen or counterfeit coins.

Mrs Palmer wrote at once to the Treasury Department. An in-vestigation was held, but the results were inconclusive. At the last reckoning, in 1895, there were 1,439 quarters at the Merchant's Bank in Chicago, 300 at a fair in Atlanta, and 100 had been sto-len, 354 given as mementoes to the Exposition judges, pages and Lady Managers, and 22,007 had been sold for one dollar. 15,809 coins could not be accounted for: the Board believed them to have been remelted. There should be approximately twenty-four thou-sand Isabella quarters in existence today. There are roughly two million five hundred extant Columbian half dollars.

In *Numismatic Art in America,* Cornelius Vermuele comments on the Isabella quarter:

Nowadays the coin seems charming for its quaintness and its Victo-rian flavor, a mixture of cold Hellenism and Renaissance romance. Perhaps one of its greatest joys is that none of the customary inscrip-tions, mottoes and such, appear on it.

HE Board of Lady Managers were well aware of the value to society, and to themselves, of women's organizations. They waxed eloquent on the subject in one of their early circulars, pointing out that since woman's arts were

essentially the arts of peace and progress, her best work is shown in the numberless charitable, reformatory, educational, and other beneficent institutions which she has had the courage and the ideality to establish for the alleviation of suffering and for the correction of many forms of social injustice and neglect and for the reformation of long-established wrongs. These institutions exert a strong and steady influence for good, an influence which tends to decrease vice, to make useful citizens of the helpless or depraved, to elevate the standard of morality, and to increase the sum of human happiness . . .

Apart from all this, which was undeniable, the women's organizations gave the women themselves an outlet for their considerable energies, and a weapon in numbers against the innumerable evils of male-dominated society. Mrs Palmer turned at once to the women's organizations for fodder for her work, and spoke at an astonishing number of meetings. The YWCA, for instance, mentions Mrs Palmer's contribution as a "distinguished guest" at its convention in 1891:

Mrs Palmer spoke particularly of the Woman's Building in which exhibits of woman's work of all kinds were to be collected and displayed, and urgently asked for an exhibit from the Associations in the International Conference, that the Exposition, which would in any case be an important moment for women, might become an inspired one for the sex.

Mrs Palmer obviously intended to use organizations like the YWCA; she was not sure exactly how. The Ladies thought perhaps a few of the larger groups could mount exhibits of some of their accomplishments. In the spring of 1892, the Board decided it might attempt to sort out women's organizations: no directory of women's groups had been issued in the United States since Aubrey Smith of Philadelphia had compiled a book of women's

charities for the Centennial. England, France and Germany had current directories of women's organizations. The Board agreed that such a directory could be placed on display and used by visitors to the Building.

Helen Barker of South Dakota, a woman "of earnest conviction and strong and forceful speech" who had run campaigns in her state for both suffrage and temperance, was chosen to compile the directory. She was trying to solicit information about working women's organizations for the Industrial Department of the Board; she was asked to extend her inquiries to all associations of women. Accordingly Mrs Barker drew up a circular announcing "a woman's encyclopedia" which would be "the most complete record ever given to the public."

Recipients of the circular were asked to supply the name of their organization, the date it had formed, the names of officers, the address of both the headquarters and the corresponding secretary, the number of charter members, the number of the present membership, the aims of the group, the educational features of the group, if any, the source of the group's income, the group's annual expenditures, and any remarks they might care to make. "No band of women is too large or too small to find a place in this historic record," the circular said.

The response to the circular was good, but surprising. The Board had sought only statistics. On August 13, 1892, Susan Gale Cooke wrote to Mrs Palmer: she did not know how to deal with requests for space that were coming in. The General Federation of Women's Clubs, for instance, wanted "several suites" set aside for their members, and for recruitment activities. The Women's Relief Corps had requested a headquarters in the Woman's Building where emergency help could be given in case of illness and accident. These inquiries opened interesting possibilities, but there really was no time or space to work things out in advance. Therefore the Board decided on October 26, 1892, to set aside one room for all interested women's organizations. Mrs Palmer was happy to give the job of coordinating this to Rebecca Felton, who always felt left out and was constantly complaining.

Mrs Felton was pleased with the assignment. Her Organizations Room was in the south gallery. It was enlarged to hold two centers, with spaces around them like the spokes of a wheel. The spaces were divided from one another by curtains in robin's egg blue silk, hung from brass rods three feet high. These could be moved to provide more or less space, according to the size of the organization. All spaces would face aisles.

In the middle of May, 1893, Teresa Dean, a reporter for the Chicago *InterOcean*, visited Mrs Felton's domain and found a welter of brass rods, packing cases, robin's egg blue silk, and irritated clubwomen. The Order of the Eastern Star, the women's aux-

iliary of the Masons, was established in its booth, which was equipped with curling tongs, crimping pins, chamois skins and talcum powder. The Masonic Ladies wished to provide an oasis in which weary Fairgoers could restore themselves. Around them surged members of other groups, trying to get something done. One woman told Teresa Dean:

> I have danced a regular jig around this room, and now I am going to sit right here until I find out which one of these managers has some authority . . . Here I am delayed in my work because Mrs ———— has decided that I cannot have this space, but must take another, and where that space is, or is going to be, is a question. The Lady Managers are drawing six dollars a day, and nothing done, and I am spending six dollars a day while I am waiting for them.

Another exhibitor was very angry because she had been given only a few feet of space, and she told Miss Dean she represented "one of the most important organizations in the world." The manager of the room had told her that she did not need any more space; her society was not really important. "Just think of her saying that to me!" she cried, "Simply because in the narrow circle in which she moves we are unknown. [Her remark] proves to me how unimportant she and her circle are, and yet I am obliged to take this space, while clubs that are nothing but toadying admiration societies have a space like that one over there."

Mrs Leander Stone of the YWCA, one of the early members of the Woman's Department, commented indignantly on the behavior of clubwomen who at the moment were not attempting to increase the sum of human happiness:

> It makes me writhe to see all these organizations clamoring their selfishness to the world, not caring whether others get their allotment . . . The youngest of them with stolen funds appropriated from the hard work of their elders grumbling at their small space allotted . . . each knowing they are a committee, not even an organization . . . Well, you as a committee have well and faithfully acted your parts and it gives me pleasure to say so to all the grumblers.

The difficulty was that Mrs Stone had been forced to grumble herself: the International Board of the YWCA, which had its headquarters in St Louis, had made a terrible fuss about the space it had been given. In all the excitement Mrs Springer, the President of the St Louis organization, had relinquished all her space, and had been rather rude about it. She was going into the Liberal Arts Building. Mrs Stone had to go to Mrs Palmer and ask her to use her influence to induce Mrs Felton to accept the apologies of the Y, and to give back the space. Mrs Cooke had told Mrs Stone that the St Louis ladies had made "childish complaints" and their "desires" had degenerated into "demands."

Organizations Room

Floods of letters and telegrams had poured in from St Louis.

Mrs Felton was induced to forgive them; their space was returned to them. Mrs Stone was grateful to Mrs Felton, but still rather irritated with Mrs Springer who, she said, "might have consulted the *Chicago member* of the Committee before deciding for the whole Committee and giving up the place among Organizations, where we properly belong . . ." Mrs Stone had written Mrs Springer a hot letter, and received a hot letter back. Mrs Springer was "a good Christian woman," but she had attacked Mrs Felton's committee; Mrs Stone had defended it; Mrs Springer then attacked Mrs Stone, who retaliated by telling Mrs Springer that she made too many decisions herself. "Well," she said, "we are good friends—or shall be when we get back the space . . ."

The St Louis group borrowed $1000 from a bank so that Mrs Springer could furnish the retrieved space with carved mahogany settees. Several members of the YWCA made slighting remarks about this extravagance, so Mrs Springer presided over the booth herself without even reimbursement for her travel expenses. The aim of the YWCA was to "care for the temporal, moral and religious welfare of working girls." Along with the settees, pictures were displayed of the boardinghouses which the organization, then known as the Ladies Christian Association, had begun to build in 1860 in New York "because large numbers of working girls were found in the attics of houses whose lower

storeys were filled with young men.''

The Y had its hands full, keeping girls out of young men's houses during the Fair. Mrs Stone's Chicago group noted that in 1893 "all local work became World's Fair work"; women Fair-goers created an emergency:

> Young women from all parts of the world rushed to this city, determined to see the Fair, believing that work with large salaries and unlimited leisure was easily obtained. They came only to discover that thousands of others had entertained the same opinions, and instead of their Eldorado, found themselves, in many instances, stranded, and in others with positions hardly affording them a living.

The International Board of the YWCA built a boardinghouse on the waterfront, and called it Hotel Endeavor. It offered sleeping rooms for three at one dollar a day. Soon after it was built an annex was added because of the flood of women looking for work at the Fair. The Board of Lady Managers themselves had received ten thousand applications for the one hundred jobs they had open: clerks, guides and concessionaires. Before the Fair opened, they had to resort to printed letters of rejection.

The Chicago YWCA opened an employment office, leased five boardinghouses, and set up its own house at 5930 Rosalie Court, near the Fifty-Ninth Street entrance to the Exposition. During the course of the Fair three hundred and seventy-five women from twenty-four states and twelve foreign countries had found shelter there—sometimes without paying at all. YWCA Traveler's Aid workers waited at Chicago railway depots and steamship docks to get "hold of a large number of girls before sinfully disposed persons could do so." There were a goodly number of sinfully disposed persons about: the ladies of the YWCA found advertisements in the newspapers which could lure "unsuspicious, restless, imprudent girls" from small towns into the cities, to stay at what were actually "disorderly houses". If they escaped from these, the restless and imprudent girls could become the prey of pickpockets or, at best, ticket scalpers.

The Traveler's Aid women were prudent and suspicious: they wore bright blue badges so that the frenzied victims of the sinfully disposed could pick them out of a crowd. Female Fairgoers were admonished to carry only enough money for immediate needs, and put the rest in a money belt, to buy a map of Chicago and try to remember exactly where they were at any given time, to memorize landmarks and keep identification on their persons along with names of local friends, if any. Although it is difficult to believe, apparently these basic points needed to be made. The wearers of the blue badges were occasionally applauded by visitors.

Another group devoted, more indirectly and less maternalistically, to the welfare of self-supporting women, was the suffragist group. In 1890 Susan B Anthony and Elizabeth Cady Stanton's National Woman Suffrage Association had joined forces with Lucy Stone's more conservative American Woman Suffrage Association to form the National American Woman Suffrage Association, of which Miss Anthony became President in 1892. Both suffrage groups had helped to found the National Council of Women in Washington, D. C., in 1888, on the fortieth anniversary of the Seneca Falls Women's Rights Convention. Fifty-three organizations had joined together to form the National Council of Women and the International Council of Women in 1888; their leaders included, besides Miss Anthony, Mrs Stanton and Mrs Stone, Frances Willard, of the National Woman's Christian Temperance Union, who was the Council's first President, May Wright Sewall, its second President, Clara Barton, the founder of the American Red Cross Society, Julia Ward Howe of the Association for the Advancement of Women, and Jennie C. Croly of Sorosis. The National Council had understandably asked for a good deal of space in the Organizations Room, both for itself and for those of its affiliated organizations which wished to exhibit under its wing. Although the Council had begun with a celebration of Seneca Falls, which stood for suffrage and equal rights, the interests of the Council members obviously included many things besides women's political rights: Miss Barton's presence testified to that, as did the presence of women like Kate Moore of the Christian Women's Board of Missions, Laura McNeir of the Ladies of the Grand Army of the Republic, Edna D. Cheney of the New England Hospital for Women and Children, Amelia S. Quinton, of the Woman's National Indian Association and Frances Willard herself, among others. Nevertheless, Mrs Palmer did not want the Organizations Room to have what she saw as an overwhelmingly suffragist cast, and Miss Anthony was prevailed upon not to request space for her newly merged suffragist organizations, but to exhibit instead in the space given to the National Council of Women. For that purpose, Miss Anthony was told, the National Council would be allotted a considerable space which it could then divide among its affiliates according to the size of their memberships or in any other way they liked. Miss Anthony reluctantly agreed not to seek space for the National American Woman Suffrage Association.

Mrs Palmer, as we have noted from time to time, was a cautious woman; both emotionally and officially she maintained a distance between the suffragists and herself. At the same time she consistently attempted to avoid any kind of confrontation. In the late summer of 1891 Lucy Stone noticed that no provision had been made for a suffragist committee by the Board. She came to

Mrs Palmer's office to complain. Mrs Palmer was at her charming best; she understood and sympathized. Mrs Stone, who edited the *Woman's Journal,* was convinced that Mrs Palmer was "fully aware of the gravity, the magnitude, the importance of the situation." Mrs Palmer suggested that Mrs Stone address the second full session of the Board in September, so that she could impress upon the Ladies the importance of suffragism.

Mrs Stone was at that time seventy-three years old, and nearing the end of her career. She had been married since 1855 to Henry Brown Blackwell, but had always retained her own name, with the correct prefix. She had been speaking in public since 1847, on women's rights and abolition, often before hostile audiences. She did speak, with her customary power, before the Board at the September meeting: she pointed out that nowhere was there a provision for a committee on "the political status of women." She then addressed herself to the injustice being done fourteen million American citizens; the Ladies were moved and applauded her enthusiastically. *The Woman's Journal* stood four-square behind Mrs Palmer, even during the unpleasant Phoebe Couzins episode and the difficulties with the black women.

Many of the Lady Managers were aware of Mrs Palmer's ambiguous responses to the suffrage question. Mary Lockwood, who wished to give a slide presentation of the history of women, wrote to Mrs Palmer in December of 1891, to ask her whether it was all right to discuss Susan B Anthony in her lecture. Mrs Palmer replied:

> I can see no reason why you should not do justice to her work in your lecture. I will say frankly that I do not like to have her name mentioned in connection with our Board as we do not want to risk antagonizing anybody and our movement has nothing to do with politics, but aside from that I should agree with you that there is no possible harm in telling of a woman who has tried to do so much for her sex.

Miss Anthony herself seemed genuinely fond of Mrs Palmer; the veteran suffragist was at that time in her seventies, only two years younger than Lucy Stone. Her Cause was already becoming more respectable, as the union of her group with Lucy Stone's group testified. She was not a cantankerous or pugnacious woman; nor was she narrow, despite the intensity of her lifework. She was certainly as capable of "handling" Mrs Palmer as Mrs Palmer had been of "handling" Lucy Stone.

In April of 1893 Miss Anthony found it necessary to write to Mrs Palmer, pointing out that although the suffragists had agreed not to ask for space in their own name, they had discovered that there had been a "misunderstanding" about the amount of space given to the umbrella National Council of Women:

Our national organization did consent to ask for separate space, but it was with the expectation—the promise of ample space within the rooms to be allotted to the National Council—which I now learn is to be very limited—but my dear Mrs Palmer—while I shall feel very sorry not to have the space we need—I shall surely make the most and best of what you are able to give us.

She was determined that Mrs Palmer should give them something at that late date, since obviously a promise had been broken. She would make a visit to Chicago herself, she announced, to "settle on" the space.

In early June, Lucy Stone's daughter Alice Stone Blackwell visited the Organizations Room. She described it for the *Woman's Journal:* "The floor was all fenced off into queer-shaped little pens, each dedicated to some society." In early June the NAWSA had no "little pen" of its own. A few weeks later, it was assigned space next to the space given the National Council of Women; Miss Anthony had arrived and "negotiated" with Mrs Palmer. Miss Anthony's niece, Lucy E. Anthony, was installed as the manager of the exhibit. The public were invited to sign a petition for woman suffrage, and to take home as a souvenir a replica of the desired suffrage amendment, or a stack of leaflets which sold for ten cents a hundred: there were "Woman's Rights Fables" by Lillie Devereux Blake; "Eminent Opinions of Woman Suffrage" by Lucy Stone, and "Twelve Reasons Women Want to Vote" by Alice Stone Blackwell. Lucy Anthony hoped that college students in particular would take leaflets, which she called "suffrage ammunition with which to slay the opponents." Also for sale was a Susan B. Anthony Souvenir Spoon. The booth was decorated with a portrait of Susan B. Anthony and one of Miss Anthony's ubiquitous busts. On the wall was a flag embroidered with the words "Woman Suffrage Association" and three stars, two small and one large.

Lucy Anthony said: "These stars call forth many questions, and you may be sure that I take pleasure in explaining the meaning of them to all who ask, and to many who do not." The two small stars represented Kansas and Michigan, where women held the right to vote in local elections. The large star stood for Wyoming, where women had complete suffrage. Our friend William Springer had, as we know, argued passionately against the admission of Wyoming as a state, precisely because its constitution permitted woman suffrage. In actual fact the admission of Wyoming was a foregone conclusion for purely partisan reasons and in June of 1890 Wyoming became the first state in the Union which granted women unlimited suffrage. Lucy Anthony could point to an article that had run in the *Laramie Sentinel* the summer before, which described the salutary effects women had had on the voting process in Wyoming:

To any old pioneer who witnessed the one election which occurred here before woman's suffrage was inaugurated, and saw the drunkenness and quarrels, the threats and flourishing of revolvers . . . this improvement alone will be . . . enough to fully justify woman suffrage . . . It has not been attended with any of the evil results which the Eastern old fogies and conservatives predicted. Women have not been unsexed or demoralized, their children and family duties have not been neglected, no discords in the family relations have grown out of it . . . It has not materially purified the ballot box; it has not always kept bad men out of the offices; it has not eradicated, or materially lessened, intemperance and the social evil. In Wyoming, as in all new countries, women have constituted so small a per cent of the population that their political power and influence did not count for much. When our last census was taken, it showed nineteen men to one woman; and further, as is usual in new countries, the proportion of good women to bad ones is not as great as in older communities.

Whether women were important there or not, the admission of Wyoming to the Union helped Lucy Anthony win recruits to her cause in that summer of 1890. One was a newborn baby named Muriel Adelaide Jones, whose mother wired from Grand Rapids, Michigan, requesting her enrollment. Nevertheless the suffragists were small in number. "I will tell you frankly and honestly that all we number is seven thousand," Susan B. Anthony said to a meeting of the Women's Congress at the Fair. Her colleagues she said, had kept up what Daniel Webster called 'this rumpus of agitation,' . . .

with less money to carry on its work than any other organization under the shadow of the American flag . . . We have known how to make the noise, you see, and how to bring the whole world to our organization in spirit, if not in person. I would philosophize . . . it is because women have been taught always to work for something else than their own personal freedom; and the hardest thing in the world is to organize women for the one purpose of securing their political liberty and political equality. It is easy to congregate thousands and hundreds of thousands . . . to stay the tide of intemperance; to try to elevate the morals of a community; to try to educate the masses of the people; to try to relieve the poverty of the miserable, but it is a very difficult thing to make the masses of women, any more than the masses of men, congregate in great numbers to study the cause of all the ills of which they complain; to organize for the removal of that cause; to organize for the establishment of great principles that will be sure to bring about the results which they so much desire . . .

Miss Anthony said it was difficult to bring the masses together for suffrage; she did not say it was impossible. Shortly before her death in 1906 she said specifically, "Nothing is impossible." And indeed by 1919 the National American Woman Suffrage Association had grown to a membership of two million.

EQUAL SUFFRAGE LEAFLET.

Published Bi-Monthly at the Office of The Woman's Journal, Boston, Mass

Vol. VI. Entered at the Boston Post-Office as second-class matter. 4.

Subscription, 25 cents per annum. JULY, 1893. Extra copies, 15 cts.] 100, postpaid.

Twelve Reasons Why Women Want to Vote.

BY ALICE STONE BLACKWELL.

1. Because it is fair and right that those who obey the laws should have a voice in making them, and that those who pay taxes should have a voice as to the amount of the tax and the way in which it shall be spent. Harriet Beecher Stowe says: "If the principle on which we founded our government is true, that taxation must not be without representation, and if women hold property and are taxed, it follows that women should be represented in the State by their votes. I think the State can no more afford to dispense with the aid of women in its affairs than can the family."

2. Because it is the quietest, easiest, most dignified and least conspicuous way of influencing public affairs. It takes much less expenditure of time, labor and personal presence to go up to the ballot-box, drop in a slip of paper and come away, than to stand all day at the polls offering coffee and entreaties to a mis-

the worse for liquor. The politicians of his party did not care. When his term was out, they re-nominated him. A man came home from the caucus, and his wife asked him who the candidate was. He told her. "Why," she said, "that man cannot possibly be re-elected." "Why not?" asked her husband, in surprise. The wife made no answer, but she put on her sunbonnet and went out and talked with the woman next door, over the fence. The woman next door then put on her sunbonnet, and went out and talked with her next neighbor, and so they passed the word all through the town. The women held no caucus, made no public demonstration, but when election day came, the intemperate candidate found himself defeated. He knew he had done nothing to make him lose caste with his party, and he could not understand his defeat until one of his lady friends said to him, very quietly, "We could not let you go back; you were setting a bad example to our boys." In Wyoming, both parties have ... recognize th...

In 1893, however, it still looked easy to "stay the tide of intemperance"; judging at least, from the number of women who had joined the Woman's Christian Temperance Union. It had more space than any other in the Organizations Room, as befitted a Union with 400,000 members, symbolically tied together by a knot of white ribbon which represented the purity of the home. It was the largest and most successful woman's organization. Its members no longer smashed saloon windows and broke beer barrels in the streets with axes, as they had done at the Union's inception twenty years before. They no longer needed that "rumpus of agitation." But their hatred for the demon drink remained constant. Josephine Allen of Oregon had volunteered to serve on the Board's Viticulture Committee, because of her green thumb, but she said, "If serving would necessitate my testing wines I would have to be excused. My temperance principles are absolutely inflexible." She was placed on the Agriculture Committee.

Mrs Palmer, who disliked excessive zeal, said that she herself was "not a teetotaler" but that she was sympathetic to the WCTU. Frances Willard, who had helped to organize the Union

in 1874, and become its President in 1879, was an Alternate Lady Manager from Evanston, Illinois. Rebecca Felton had joined the Union in 1886, and had spoken many times in public about the sufferings of women with drunkards for husbands. Since she was in charge of assigning space in the Organizations Room, subject always of course to a little manipulation by the President of the Board, it is surprising that some WCTU members should confide their somewhat paranoid uneasiness to the *Chicago Tribune* as early as April 16, 1893:

> Mrs E. Louise Demarest, Commissioner for the WCTU, was here a short time ago arranging for the exhibit of that body, and while expressing disappointment at the small amount of space secured, admitted that the Lady Managers had been as liberal to her organization as the circumstances of the case would permit. She said their great mistake was made in the beginning in not securing ground for a building of their own. This measure was advocated by Mrs Josephine R. Nichols [WCTU Superintendent of Fairs and Expositions] who apprehended that the organization might be so restricted in space in the Woman's Building as to be practically excluded. She stated her fears and proposed erecting a building of their own at the meeting of the national convention in 1890, but the ladies were so enthusiastic over the beautiful Woman's Building that they could not hear of being represented elsewhere . . .

The women of the WCTU, determined not to be overlooked, hung hundreds of dollars worth of banners in their booth, and set up a huge globe plastered with cards pledging lifelong abstinence which had been signed with careless optimism by the children of forty-four countries. The ladies believed that temperance should be taught along with reading and writing, and that all nations were cursed alike by alcoholism. A huge tank of ice water stood in the booth, next to piles of pamphlets: the Union provided "pure water and pure literature."

The literature came from the presses of the Woman's Temperance Publishing Association, founded in Chicago by Matilda Carse in 1886. A hundred employees provided over 230 million pages of WCTU propaganda in 1893. Ten thousand copies of a special souvenir edition of the WCTU weekly *The Union Signal* were distributed to Fairgoers.

The WCTU women's complaint that they would "only be able to indicate in a limited way the widespread activity in which the various branches are engaged" is understandable when one realizes that their interests, in 1893, were not limited to the prohibition of alcoholic beverages. Frances Willard, who appeared at times to be endowed with boundless energy, had noticed on a trip to San Francisco in 1883, that that city's Chinese section was filled with opium addicts. She immediately added opium to alcohol as a menace and recruited missionaries to go to the Far East

to preach against it. A memento of this crusade hung in the booth, and was noticed by Mrs Mark Stevens, a writer from Michigan:

Here . . . was the WCTU liberty bell . . . with this inscription upon it: 'This bell was cast in the City of Tokyo, Japan, December 19th, 1892, by Tsuda Sen. It is made from the metal of tobacco pipes of more than a thousand men, once slaves, now freemen.' The bell hung upon a frame. It possessed no clapper, but was sounded by tapping upon it with a metal rod, and gave forth a deep-toned toll, charming to hear. It was presented by Tsuda Sen, an enthusiastic temperance worker of Japan, to Miss Frances Willard, who, after the Fair, placed it in the Temperance Temple at Chicago. The bell was first tolled by a Japanese woman at the funeral service of Mary Allen West, who died shortly after entering this field of work . . . Through her influence the opium and tobacco pipes of copper were given her by over one thousand converted Japanese to be melted down and cast into this bell. She was an energetic worker for all that was good, and the originator of the expression, 'In order to succeed, a white ribboner must have grit, grace and gumption.'

Miss Willard's interests spread. By the nineties her policies included:

Anti-Narcotics, Child Welfare, Christian Citizenship, Evangelistic Fairs and Open-Air Meetings, Flower Mission, Franchise, Health and Heredity, Institutes, Kindergarten Legislation, Loyal Temperance Legion, Literature, Medal Contests, Medical Temperance, Mercy, Purity, Parliamentary Usage, Peace and International Arbitration, Penal and Reformatory Work, the Press, Purity in Literature and Art, Sabbath Observance, Scientific Temperance Instruction, School Savings Bank, Sunday School, Temperance and Labor, Temperance and Missions, Bible in the Public Schools, Work Among Colored People, Work Among Foreigners, Work Among Indians, Work Among Lumbermen and Miners, Work Among Railway Employees, Work Among Soldiers and Sailors, and Young Women's Unions.

It would appear that if she were allowed to, Miss Willard could swallow the entire Organizations Room. In the interests of Sabbath Observance, if not of Sunday School, she had already convinced the Board of Lady Managers to vote against Sunday openings for the Fair, and at the Parliament of Religions, she had espoused woman suffrage, saying "Woman is becoming what God intended her to be, and Christ's gospel necessitated her being the companion and counselor, not the incumbrance and toy of man."

Miss Willard evinced a certain restlessness that was making some people nervous. In 1890 she provoked "a rift within the lute" by making a political endorsement. The Nonpartisan WCTU broke off from Miss Willard's organization to become independent. The Nonpartisans had their own smaller spaces, and

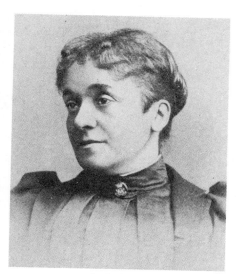

Lady Somerset

chose to turn their back on their mother organization and refer hopeless cases, if any staggered into the Organizations Room, to the booth of the Temperance Rescue Department, which broadcast the conviction that "inebriety is a disease and can be cured by Dr Keeley's Double Chloride Gold Remedy." According to the report of the Temperance Rescue Department made to the Organizations Committee, more than one hundred persons entered the "Keeley Institute" as a result of the Rescue Department's activities in the Organizations Room.

Despite all this, and despite the fact that many people saw Miss Willard drifting toward "socialism," she was much admired: the WCTU booth displayed both her portrait and her bust. Miss Willard found time to visit the booths; she admired the "cool greyish blue tints" of its "spacious walls" and said that "within it lies the impressive representation of the noblest work of women." She spent much of that summer in England, resting in Hertfordshire at the home of Lady Somerset, the divorced President of the British Woman's Temperance Union. Her absence gave rise to more criticism and discontent. But she managed to control it and when she died in 1898 and lay in state at the Woman's Temple, 20,000 people filed past her casket. That was the last time the WCTU used its Temple; Miss Willard's death marked the end of the expansion of the organization's interests.

Not surprisingly, since the church had always been the approved center for women's activities outside the home, over one-third of the groups in the Organizations Room had religious affiliations of one kind or another. Ida Ball, of Delaware, who chaired the Organizations Committee, commented in her final report to the Board:

> If, as some assert, religion is meant only for women and children, surely . . . women will take what is given them and will make what is a valueless thing to the men who acknowledge no obedience to the Supreme Head of the Universe, a lever with which to lift the world. . .

"The field [of church work] is indeed the world," Mrs Lyman Abbot said in the *Ladies Home Journal* in December of 1892.

There were seven missionary societies in the Organizations Room: their members attempted to uplift the Chinese, Japanese, Siamese, Turks, Brazilians, Indians both East and Red, and the Zulu. Some women believed that Christian charity began at home: the United States was the domain of the 60000 members of the Methodist Women's Home Missionary Society, which reported:

> In the frontiers where the population increases so rapidly, where the saloon and its accompaniments of vice are poisoning the sources

of social life and in the rapidly growing cities where the masses are becoming more reckless and corrupt, the methods and agencies of yesterday are inadequate to meet the demands of tomorrow. Every success achieved deepens the obligation. . .

Amelia Stone Quinton

The philosophy of the church worker was that there was "no escape from the obligation of service," although there was "absolute freedom in the choice of labor." The missionaries had plenty of "grit and gumption": the Women's National Indian Association had been founded in 1881 to bring enlightenment to the "barbarous tribes of the West." By 1893 it had penetrated nine tribes spread over the area of the great plains. The Association had opened teaching hospitals from which Indian women had received medical degrees, lent money to Indians so that they could build "civilized and Christian homes," and lobbied to increase government appropriations for Indian education. Amelia Stone Quinton, the President of the Association, and one of the founders of the National Council of Women, was critical of Government policy toward Indian tribes:

> They were subject to enforced removals from their own lands; they were constantly robbed by marauders and ruffian frontiersmen; they were under agents possessing despotic power, who could forbid trade among them, and suspend their chiefs. . . They might be banished to reservations where farming was impossible though farming was required and . . . were deprived of arms and ammunition for hunting, their only source of substance.

Mrs Quinton gave years of her life without pay to an attempt to shine "the electric light of Christian teaching, influence and example" on the "wholesale wrongs still endured by some of the tribes" so that "our civilization" would feel shame at its indifference toward them. She was a force behind the Dawes Severality Act of 1887, the purpose of which was to grant individual land holdings to Indians, in an effort to break up tribal attachments. H. L. Dawes of Massachusetts, the Chairman of the Committee on Indian Affairs of the House of Representatives, was the instrumental agent. The intention was to reform and eventually abolish the reservation, and to absorb Indians into the mainstream of American life. Because of deeply complicated factors, and the damage already done by ignorant politicians and bureaucrats, the activities of Mrs Quinton and Mr Dawes could only increase the difficulties of Indian life.

One of the problems with all these dedicated women was that they knew little or nothing of the delicate attachments which their well-meant and often patronizing zeal could damage beyond repair. They were insulated from the world. In the Organizations Room these women could be seen at work, not just doling out pamphlets and ice water, but making nosegays to be given

out as "educators as well as comforters to humble homes and sickbeds"; sewing "plain garments" for orphanages and hospitals; offering thousand dollar life insurance policies to those visitors who would join their "Christian benevolent" organization. And there was a group waiting to lead "erring women" who visited the Organizations Room to "truth, purity, name and family."

There were many women—Mrs Palmer, for instance—who found this Christian benevolence somewhat narrow. These women turned to the women's clubs which had been growing in size and influence for thirty years. One of the oldest was Sorosis, which had been founded in 1868 by Jennie C. Croley, a reporter for the *New York World,* in a spirit of vengeance against the New York Press Club which had refused her a ticket to its Charles Dickens Dinner because of her sex. In 1889 Sorosis, already a member of the National Council of Women, celebrated its twenty-first birthday by holding a sort of convention of woman's clubs around the country. This culminated in the formation of a Federation of Women's Clubs. These clubwomen had no desire to be mistaken for their busy Christian sisters, as their report to the Board indicates:

> Women's societies for the promotion of missionary and charitable objects and for reforms of all sorts had existed for years, but an organization of national and international character, with no reformatory, religious or political tests, which united all women of thought and influence, no matter how contradictory their views or how varied in life and surroundings; to bring thousands of such women into loving sympathy and sisterly cooperation in the pursuit of social, intellectual and ethical culture, was hitherto a consummation that seemed as difficult as it was desirable.

These women did not want a political or suffragist identity, any more than they wanted a religious one. The writer Charlotte Perkins Gilman who was not a suffragist either hailed the woman's club movement as

> one of the most important sociological phenomena of the century,—indeed of all centuries,—marking . . . the first timid steps toward social organization of these so long unsocialized members of our race. . . Now the whole country is budding into women's clubs. The clubs are uniting and federating by towns, States, nations; there are even world organizations. The sense of human unity is growing daily among women. The movement is restoring a new heroism to modern life, filled as it is with cowardice and self-seeking.

That the women's club movement was basically a forward-looking one, and not conservative, despite the clubwomen's anxiety to avoid alliances which might cause "public scandal"—like one with Susan B. Anthony, for instance—is evidenced by an article in *Harper's Bazar* for July, 1893:

There are still, here and there, conservative women to be found who look with doubtful eyes on the Woman's Club . . . Antagonized by the name "club", which [they think] carries with it . . . a suggestion of dissipation, of drifting away from old moorings and of neglecting home life and duties, they decline invitations to clubs . . . These good gentlewomen . . . are somewhat in error and a little out of date, and are not . . . aware that . . . clubs are only the outgrowth of such innocent affairs as . . . sewing circles which date back to the primitive days of Christianity.

The *Bazar* denied that the clubs were frivolous in any way. They were educational, and devoted to uplift:

Our women are, above everything else, conscientious, even to severity, and they feel quite naturally that after the social luncheon or before the afternoon cup of tea they should in some way devote themselves either to the improvement of their minds or the amelioration of certain ills . . .

There were benefits to the woman, for once, in addition to benefits to the community, of which women had always thought first:

A charming feeling of sisterhood is fostered by the amenities of club life. Women get to know one another better, to appreciate one another more, by the meeting and touching hands in comradeship. The friction of mind with mind is very stimulating. Women talk more entertainingly, their conversation covers more topics, is less limited to domestic affairs and to dress, children and servants than it once was . . .
Parliamentary usage, formerly a hopeless and puzzling mystery, no longer distresses the woman who belongs to a club; she has studied its rules, and she practices them.
Instead of condemning a club out of hand, the conservative woman should first investigate, then consider, then ask herself whether the club has not something to give her . . .

It was a new idea for women: that they should desire benefits for themselves as individuals, rather than think only of striving selflessly to raise the level of the world. It was obviously an attractive idea: the Federation of Women's Clubs occupied a space in the Organizations Room second only to the WCTU. A club display was a new idea in 1892 and 1893. Jennie Croly writes:

The question of club exhibits . . . occasioned lengthy discussion and a wide correspondence. What should they consist of? There were only yearbooks and pictures, which were principally photographs of club officers, to make an exhibit out of, and fears were entertained lest an attempt of this kind should fail to do club work justice.

At least half of the 278 clubs in the Federation sent exhibits to the Organizations Room: basically the exhibits were books of different kinds. A club in Dubuque, Iowa provided a history of itself, bound in blue vellum stamped with blue and gold decorations. A club in Jackson, Michigan sent a book of essays bound inside carved wood covers. The niece of the President of the Federation supervised the booth: she answered questions, helped people to look through albums, and gave away stationery. Julia Ward Howe, a rather critical lady, found the books provided by the clubs "well worth examining. Some . . . are adorned with fine watercolor illustrations and decorations . . . all give evidence of the good work which the clubs are doing." Jennie Croly said:

> It was found that club women and others from all over the country spent hours and even days in the study of the volumes . . . Thousands of Federated women visited the Exhibit, wrote their names and addresses in the Book of Records, and took . . . notes of the attractive features in club manuals that were new to them.

The Chicago Woman's Club was one of the most innovative groups in the Federation. Mrs Palmer and Mrs Henrotin, as we have seen, were both members. Ellen Henrotin appointed several hundred women from the Chicago Club to her various committees for the World's Congress Auxiliary. When, undoubtedly because of her exposure at the Exposition, Mrs Henrotin became President of the Federation in 1894, she brought the Chicago spirit to it, saying at the convention in 1896 that "bodies of trained housekeepers shall constitute the guardians of the civic housekeeping of their respective communities." The Chicago ladies had a tale to tell visitors; they wore special identifying badges.

One project of theirs at the Fair was the Protective Agency on World's Fair Work which sent out 30,000 letters warning "unprotected girls" of the pitfalls that awaited them in Chicago. The Club had set up a separate booth for its newly formed Society for the Promotion of Physical Culture and Correct Dress which protested fashion at whose whim "over the course of twenty years, a woman assumes every shape under heaven except her own." In its booth were displayed statues of Greek goddesses and pictures of women "ideally clothed over ideal bodies." In 1894 Frances Russell, who chaired the Dress Committee of the National Council of Women, wrote for a symposium on "The Rational Dress Movement" in *Arena* Magazine:

> There was, all summer, at the Columbian Exposition, an exhibit which I much desired to see, but which no one whom I have questioned seems to have observed—the dress exhibit of the Physical Culture and Correct Dress Society [sic] of Chicago. On the propor-

tions of the Venus de Medici were shown a working dress and apron, a street suit, a reception gown, and several evening dresses—these designs intended to emphasize the beauty of women's form when unbound by the corset. This exhibit was in the room of societies in the Woman's Building. There was no dress exhibited short enough to clear average streets . . .

It would appear that the "average street" is always the same height: Miss Russell presumably meant that the dresses exhibited were too long for the wearers, not the streets. She may have been basically a confused thinker: despite her comment that no one whom she has questioned "seems to have observed the dress exhibit", the Society itself reported that 1100 people had registered with it at the Fair and that it received letters of interest after the Fair. Frances Willard had stopped at the booth. Then again Miss Russell does not tell us whom she has questioned. They may have been people on their way to the Keeley Institute in search of the Double Chloride Gold Remedy.

Like the Federation of Women's Clubs, the Daughters of the American Revolution was barely three years old. It had been formed as a counterpart to the Sons of the American Revolution; the Sons soon shrank to insignificance before the vigorous advance of the Daughters, who were well aware of their own worth. They had not requested space in the Organizations Room: indeed, when Mary Lockwood, who was one of the founders of the group, attempted to present the invitation from the Board of Lady Managers, she found an "instant and Victorian" response:

From all parts of the house rose objections, if not downright opposition. One lady feared it would commit the society to the suffrage movement. Another said the society might be placed in an embarrassing position as to declarations concerning other societies. Others objected to the publicity such a gathering would draw DAR members into. The very atmosphere was charged with a feeling of conservatism which amounted to timidity.

Overwhelmed by such vocal timidity, Mrs Lockwood withdrew her invitation. She left the new idea to stew, and when a resolution to the same purpose was presented at a later date it passed without dissent.

The Daughters' booth displayed the group's accomplishments and goals, which were to assemble genealogical records, collect relics of the Revolution, restore historic buildings and find and mark forgotten graves. The first grave the Daughters found was that of Abigail Adams; it was duly marked to commemorate her standing as the wife of John Adams and the mother of John Quincy Adams. Her correspondence was not yet published. The Daughters of the American Revolution held a reception in the Woman's Building on June 17, 1893, the anniversary of the Bat-

tle of Bunker Hill. Badges were distributed by Laura Hayes, the chairwoman of the DAR Badge Committee. For this occasion she wore white gloves and a knot of white flowers. All the Daughters were asked to sport these items — and still do on special occasions.

A group with a slightly wider perspective than the Daughters, was the Association of Collegiate Alumnae, which had been founded in the eighties as a help to women college graduates who could only drift into schoolteaching if they did not marry. Marion Talbot, who had helped to found this organization, became Dean of Undergraduate Women at the University of Chicago in 1892, after receiving a second degree from MIT. She had been graduated first from Boston University. Miss Talbot's Chicago Association was one of thirteen national branches of the ACA. There was an elitist cast to this Association; Miss Talbot explained to the Board that it had been set up for young women who,

trained, while in college, in definite aims and in habits of constant and persevering industry, found themselves on graduation, cut off by this from the power to live on easy or companionable terms with women less systematically educated.

Marion Talbot

Although they already found it difficult, apparently, to communicate with people like Mrs Palmer or practically anyone else at that time, these women attempted to cut themselves off also from female graduates of educational institutions where aims and habits might not be up to snuff. The ACA had rigid standards: only the lucky graduates of fifteen schools could qualify to join. Among these were in addition, obviously, to MIT and Boston University, Wellesley, Vassar, Cornell, the University of Wisconsin and Northwestern University. Miss Talbot's branch, existing as it did in the neighborhood of Hull House, had helped to sponsor Julia Lathrop's work among the unemployed in 1893. The group had also attempted to destroy the notion that college study was dangerous to the health of young women, and might cause them to become sterile. 705 college alumnae were polled by the ACA, which, with the help of the Labor Bureau of Massachusetts, published the results: after four years of college, the health of 20% had improved, 20% deteriorated and 60% noticed no difference. In response to this survey the public mood remained calm.

Mrs Palmer appealed personally to Miss Talbot in 1891 to exhibit at the Woman's Building. Miss Talbot noted in her *History of the Chicago Association of Collegiate Alumnae* that this exhibit held "a very absorbing interest" for her. She was in the process of instituting campus housing for women at the University of Chicago: this enabled her to provide dormitory space for mem-

bers of her society who would thus avoid falling into pitfalls or be forced to memorize maps or look out for disorderly houses. Members registered at the ACA booth as soon as they arrived at the Fair, and the atmosphere was one of muted college reunions. Some of the women, emboldened perhaps by Miss Lathrop's experiences at Hull House, were beginning to suggest that the ACA's emphasis should shift from academic excellence to forms of community action. In 1921 the Association merged with the Southern Association of College Women to become the American Association of University Women.

Educational institutions by and large did not exhibit in the Woman's Building but in the Liberal Arts Building, where Mrs Springer had tried to take the YWCA. Bryn Mawr, Mt Holyoke, Vassar and Wellesley exhibited there, where they could have the opportunity of juried awards. Jane Addams' alma mater Rockford College exhibited in the Organizations Room, as did Lasell Seminary in Auburndale, Massachusetts: its booth was fitted up to look like a gabled cottage, with panelled pictures illustrating its academic specialties.

It was easy to find organizations of middle and upper class women. Women industrial workers naturally had no time or opportunity to join anything much. The Board of Lady Managers wished to do what they could to bring these women into the public eye.

Helen Barker of South Dakota was given the rather thankless task of finding information about women industrial workers. She began by contacting local organizations connected with the Knights of Labor. This idealistic organization had begun in Philadelphia as a tailors' guild in 1867, founded by Uriah S. Stephens. It achieved national importance in 1878, but it was not until 1881, when it abandoned its "secret society" characteristics that its growth accelerated. Its concerns were with industry: its motto was "An injury to one is the concern of all," and it attempted to live up to that concern by admitting women and, after 1883, black workers. Employers were welcomed, but bankers were excluded, as were lawyers, gamblers and stockholders— people considered to fatten themselves on the sufferings of others. In 1884 and 1885 the Knights had noted victories in strikes on the Union Pacific and the Wabash Railroad respectively. In 1886 it reached its height of 702,000 members under the presidency of Terence V. Powederley. However in that year the Knights were involved in an unsuccessful strike against the Missouri Pacific Railroad and were also unfairly attacked in the press because of the Haymarket Riot in Chicago. In 1888 Leonora Barry brought the women Knights of Labor into the National Council of Women, but the group's days were already numbered. Factional disputes had sprung up between members of the crafts unions,

and those who wished to extend union membership to all workers.

These disputes, along with the loss of money from unsuccessful strikes and a resentment of power retained by the heads of the organization had caused its membership to drop to 100,000 in 1890. The Knights stood for an eight hour day, the abolition of child and convict labor, the elimination of private banks, and equal pay for equal work. They also stood for "co-operation" between employer and employed, which may have doomed it from the start. In the interests of equal pay for equal work, and its own motto, which it took seriously, the organization had initiated investigations into the conditions of working women, and had attempted to compile records. By the time Helen Barker went to search things out, she found that interest had dropped off, and the Knights of Labor were already subsumed by the American Federation of Labor, which did not share its vision of the role of women in industrial unions. The Federation preferred women to remain at home, or at any rate out of competition with men.

Mrs Barker found that the women's assemblies of the Knights of Labor no longer had much relevance. She attempted then to approach women directly in laundries and sweatshops in Chicago. But this was hopeless: women could be fired for speaking with her, and since there was no organization there was really nothing anyone could tell her beyond individual experience. The few women's unions were secretive and fragile. Since they received no support from men's unions they had no bargaining power.

There were women who claimed to represent female factory workers. One of these was Charlotte Smith, President of the "Women's National Industrial League", who had as we have seen been vocal in her hostility to the Board since its inception.

She said that the Ladies' Congressional appropriations should have gone to her and the industrial women she appeared to represent. In 1892 Phoebe Couzins left her duties on the Beekeeping Committee to help Miss Smith draft a request for $50,000 for her League, to be taken from the $110,000 the Board had for that fiscal year. This request was presented to the Labor Bureau. It was rejected, but the resulting publicity implied that the Board had no interest in factory workers.

Further unpleasant publicity resulted from a bizarre encounter on March 17, 1892, at the Pittsburgh Grand Opera House where Madame Yale, a "priestess of cosmetic art" who was president of a $500,000 corporation which sold cosmetics all over the country, was giving a talk on beauty secrets to an overflow crowd. When she spotted Charlotte Smith in a box close to the stage, Madame Yale told the audience that she and Charlotte Smith had recently been in Washington lobbying on cosmetics

legislation. Madame Yale then cried, according to the *Pittsburgh Leader:*

'I see that famous woman of whom you have all heard, Charlotte Smith, in one of the boxes, and I extend the courtesy of this stage to her. Miss Smith, I ask you to come forward and define your position as you did before the house committee in Washington.' The unexpected challenge caused a tremendous sensation in the huge audience. . .

The *Leader* described the dramatic difference between Madame Yale, "young, pink and white, with masses of soft blond hair, a black velvet gown with an Elizabethan collar of ostrich tips," and poor Charlotte Smith, who was

large and rather stout [in] a black wool gown, her plain black bonnet pulled slightly awry in the excitement of the moment, a flushed determined face . . . Her every thought and purpose has evidently been given to her noble life work, that of elevating the condition of the wage-earners of her sex and compelling from employers equal pay . . . but in becoming a fanatic to the great cause, she has let slip all the merely pretty feminine ways and graces, with which most of her sister women occupy themselves . . .

Miss Smith came to the podium, protesting all the way. Madame Yale had taken her by surprise, she said. She had returned from a business trip to Washington the night before, and had merely dropped into the Opera House out of curiosity, never dreaming anyone would recognize her. She knew nothing, she said, of cosmetics. Nevertheless she could not help pointing out that she herself had been pounding on the doors of Congress for years, to get help for working women, and no one had responded. And then "a beautiful lady" appeared, tapped softly, and the doors opened. "What the country needs," Miss Smith announced, "is fewer ladies and more women." She then went on to say that Mrs Palmer had refused Madame Yale a stall in the Woman's Building, giving exclusive cosmetics sales rights to a French firm of her own choosing. She had refused to allow Madame Yale to exhibit her invention in the Woman's Building, and yet there was no question that Madame Yale had invented a sweating machine; Miss Smith pointed dramatically to a "steaming apparatus for the removal of wrinkles and other disfigurements which was merrily puffing and steaming away during the entire talk."

Miss Smith ended her talk to a storm of applause, and Madame Yale then attacked Mrs Palmer in her turn. She said that Mrs Palmer had denied before a Congressional committee the charge that she had refused to allow Madame Yale to exhibit in the Woman's Building. "This," cried Madame Yale, "brought

INCORPORATED UNDER THE LAWS, OF THE STATE OF NEW JERSEY.

Capital Stock $300,000

OFFICES:
New York City, N.Y.
Chicago, Ills.
Boston, Mass.
Washington, D.C.
Denver, Col.
Philadelphia, Pa.
St. Louis, Mo.
San Francisco, Cal.

MAIN OFFICES:
37 W. 14TH ST. N.Y.
146 STATE ST, CHICAGO, ILLS.

Branch Stores in all
the principal Cities of the U.S.

Chicago Sept. 30, 1893. 189____

Mrs. Potter Palmer,

 City,

Dear Madam:-

 Your kind favor dictated by you and signed by Mrs. Susan
Gale Cook, duly received. I thank you for the advice contained
therein even at this late date. It will mean a great deal to me as
a business woman, if my goods are placed on sale in the Woman's Bldg.,
and knowing that you are interested in the progress of women in every
direction, I feel that you must fully appreciate my efforts in aiding
them to make the most of their appearance and retain their youth.

 I would ask, in the name of all women, that you use your
influence in having these goods brought before the women of the world,
by allowing them to be placed on sale in the Woman's Bldg. I have
carried out the instructions in your letter, namely- by writing to
Mrs. Belle M. Perkins, Vice-Chairman of the Committee on Sales, who

the whole controversy to a question of veracity between Mrs Palmer and me!" She flourished a letter, which she said she had just received from Miss Smith: this letter, Madame Yale said, "completely vindicates me." The *Leader* reported that "notwithstanding that everybody was expecting to hear its contents," Madame Yale did not read the letter aloud. She then returned to her announced talk about the transformations that could be expected from the application of her products.

A month after this scene, a large visitor appeared in the Board offices. After some hesitation, she told Mrs Starkweather that her name was Smith. Mrs Starkweather then asked her her Christian name, and "she looked so queer" that Mrs Starkweather immediately guessed who it was. Miss Smith had evidently been lured to the Board offices by tales of the Ladies' frustration in the matter of female industrial workers. She wished to speak with Mrs Barker, who was present. Mrs Starkweather, attempting to deal directly with Miss Smith, told her that she was glad to see her because she wanted to explain things to her; she felt she had been misinformed. "The French cosmetic individual," Mrs Starkweather said, had not been granted space. Mrs Palmer had ruled out all cosmetic exhibits of any nationality: rouge, false hair and powder were "not things we shall wish to dwell on or emphasize in the Woman's Building."

Miss Smith was not really interested in the cosmetics issue, apparently. She had other things on her mind. Mrs Starkweather, who was nothing if not shrewd, said, "Charlotte talked until the tears rolled down her cheeks and we all concluded that she had a bee in her bonnet. She utterly refused to give any list of industrial associations of women. She said she had worked for years to get it herself, and is out over $800 in postage, and was not going to give it away for nothing." The atmosphere in the offices was rather tense. Miss Smith, who appeared to be greatly concerned with money, told Mrs Barker that she had already spent $75,000 of her own money in the interests of women. Mrs Barker lost her temper and called Miss Smith a "bloated bondholder." Mrs Starkweather drew a veil over the scene; it was most unpleasant. The effect was so strong that a little later, when Amey Starkweather read in the papers that Miss Virginia Penny, another woman concerned with women factory workers, was in Chicago, she made some discreet inquiries first and then decided to avoid Miss Penny. ". . . as I learned that she, too, was a woman with not only one grievance, but many, I concluded that perhaps we could do as well without the information."

Madame Yale popped up again, however. In late summer of 1893 she sent Mrs Palmer some samples of her products, packaged in gold foil decorated with pictures of the Woman's Building, along with a letter:

Even at this late date, it will mean a great deal to me as a business woman if my goods are placed on sale in the Woman's Building, and knowing that you are interested in the progress of women in every direction I feel that you must fully appreciate my efforts in aiding them to make the most of their appearance and retain their youth.

If Madame Yale had a short memory, Mrs Palmer did not. The President had decreed that there were to be no cosmetics sold in the Building, and if she were to change her mind, she would hardly encourage a woman who had called her a Francophile and a liar, in that order.

The Ladies were thus frustrated by women with bees in their bonnets: these bees appear to have been propagated by a certain natural eccentricity in combination with a desire for self-aggrandizement. Charlotte Smith and her "Women's Industrial League" are murky indeed—hardly less so to us than to the Board of Lady Managers. The Ladies found more co-operation from a philanthropic New York woman who had established "working girls' clubs" to help young women working in the textile mills of the Northeast.

Grace Hoadley Dodge, born in New York City in 1856, was the heiress to a copper fortune. She was the great granddaughter of David Low Dodge, the reformer from Connecticut, who had established the New York Peace Society in 1815 and directed the American Peace Society from 1828 until 1836. Miss Dodge's family thus had a tradition of earnest and idealistic public service, despite its wealth. She began her good works by teaching Sunday School to factory girls; from this grew, in 1881, a small discussion group of factory girls of Miss Dodge's age, held in the Tenth Street tenement flat of a silk worker. In 1884 this group had grown into a formal club, with a regular meeting place of its own. These clubs spread: by 1893 there were nineteen clubs in New York, one in Massachusetts and one in Pennsylvania. The girls had a comfortable place to spend their free time in return for a small fee. Books, furniture, and pianos were brought in; a female physician was provided. Classes were given in typing, dressmaking, cooking and sewing.

Discussions were held, about literature, social behavior and household matters. "The leader sits in the middle of the group," Miss Dodge wrote in 1893 in *The Churchman*, "some enjoy sitting on the floors, the hallways and stairs are utilized . . ." Each was expected "to think and give ideas." Men were often the subject of discussion, as they were a source of continuing interest to the young women, and to the somewhat puritanical women who were their mentors. Miss Dodge gave advice: a mixture of Ways to catch your man, Ways to conform to Victorian etiquette, and Ways to avoid ending up in a Workhouse. If Miss Dodge told the

girls that they should not accept presents from young men to whom they were not engaged, nor visit young men at their places of business, nor associate with atheistic young men, she also told them that they could not reform young men by marrying them, a piece of advice which remains pertinent, and that they should keep away from men who drank. Under the circumstances that advice was realistic.

In November, 1891, Mrs Palmer invited Grace Dodge to take space in the Woman's Building "to present what a few women have done for the better moral and physical development of their sisters." Mrs Palmer, who always threw in a comment or two on what the exhibit would do for the exhibitor, told Miss Dodge a display in the Woman's Building would further the clubs' "rapid increase" and "beautiful influence." Miss Dodge accepted the invitation with enthusiasm, but she was dismayed when Mrs Palmer then asked her to fill out the Board's questionnaire on the status of working women. She did not consider herself an expert on the subject; she was a philanthropist with other interests besides the Clubs. She replied to Mrs Palmer that she could not deal with the questionnaire:

> To reply to it satisfactorily would require an investigation of some weeks, and correspondence throughout the state, and unfortunately I am so pressed for time that it is impossible for me to do this. I have consulted with several ladies interested in working women and who work among them, and all agree with me that it is not possible for us to answer the questions such as 'The number of wage earning women in New York and the lines of their industries? Their social and financial status? How these wages compare with those of men in the same work? The names of the firms where the women work?' I would not be willing to give any opinion on such broad questions, without as I say thorough investigation, for women are in every line of work, receive every degree of wages from $1.50 to $50 per week, and their wages differ from those of men, according to the various industries.

Indeed, the Board's questions demonstrate a certain innocence about conditions in the garment industry in New York City at least, where immigrants huddled in cellars and attics everywhere, and sweatshops sprang up unmonitored in tenements and warehouses everywhere.

Mrs Palmer was willing to settle for less than the questionnaire. She suggested a display of the factory women's work, with some elaboration on their jobs, in July, 1892:

> It would seem strange . . . if we could not provide more service to those who so much need the moral support which comes from an enlightened public sentiment, than merely to collect the material results of their work.
> We feel that if the associations of working girls would discuss the

Grace Dodge and a Working Girls Club

subject, they would come to some tangible and profitable conclusions which could be presented to us for action. . . We regard that end as the most sacred trust that has come to us with our organization and opportunities.

Miss Dodge had her own club, to whom she spoke about the plight of the working woman. She wrote Mrs Palmer in August:

These girls feel that little can be done except along three or four lines . . . equal pay for equal work, payment for hours in work after the usual closing time, some enforcement of the laws providing proper sanitary conditions, seats, etc. Also that in some way employers themselves may arrange to hear complaints.

It is small wonder, after reading this brief list, that Miss Dodge and the women themselves found their predicament overwhelming. Miss Dodge went on to try to explain to Mrs Palmer the most basic problem with attempting to get "equal pay for equal work": too many people were fighting for too few jobs. "Employers when they know that there are so many others who will work for less pay or who will submit to injustices are hard to reason with." Miss Dodge made another point: "Women will work for pin or dress money accepting lower wages than those who are dependent upon daily bread for their own exertions. This fact has lowered wages in many instances. . ." Miss Dodge herself could not think of any way out of this morass, except to hope for an uplifting of human nature:

If only the great doctrine emphasized in the Golden Rule could be brought out, and employers as well as employed learn the principle of sisterly and brotherly relations in business there would be a very different condition of affairs. . .

Miss Dodge resigned from the Association of Working Girls' Societies in 1896. She later became President of the YWCA, and was a moving force behind both the New York Travellers Aid Society, and the founding of the Teachers College of Columbia University.

Another exhibitor in the same area was the Women's Educational and Industrial Union of Boston, founded in 1877 to help young New England women adjust to city life. In 1892 Mary Kewhew became President. Mrs Kewhew was a spirited reformer who believed that women should fight for their rights; she brought Mary Kenney, a labor activist somewhat more quick-moving than Charlotte Smith, to Boston to help her to organize trade unions for women. She enlisted the aid of the press in a campaign to expose people who fraudulently advertised good-paying work to be done at home in return for an investment. In the Organizations Room the Union decorated their booth with a

seven foot high imitation bronze standard topped with an urn, and photographs of the interiors of working girls' clubhouses. Under Mrs Kewhew's guidance, they were moving beyond the clubhouses to a more active role with factory workers. The Union exists today on Boylston Street in Boston where it provides training for daycare workers and career placement for women returning to the workforce. Its organizing days are over.

There were actual women workers at the Woman's Building, although unfortunately a group of these—the National Association of Women Stenographers—found that their umbrella organization, the National Council of Women had not been given enough space to spare for them. After persistent pleading, they were given space by the Board on the first landing of the main staircase where they exhibited "rapid stenography" and typewriting and where they naturally attracted a good deal of attention.

Space was granted to the National Press League of Chicago, the members of which had no time to use it. Teresa Dean reported that "dust had gathered in the chairs and desks allotted them, since they were necessarily active workers." One reason they got the space may have been that their President was Mary Kraut, an Alternate Lady Manager from Crawfordsville Indiana, who was the Editor of the "Woman's Kingdom" department of the Chicago *InterOcean.* Mary Lockwood belonged to a similar group, the Woman's National Press Federation of Washington, D. C. Aurelia Hadley Mohl had brought the Woman's National Press Association into the National Council of Women in 1888.

There was one group of professional writers in the Organizations Room which was militant. Mrs Mark Stevens had an encounter with a member:

One day, when in the booth of the 'Authors Protective Association,' also called 'The United Association of Publications,' we conversed for a short time with Katherine Hodges, the author of 'Twenty Years a Queen.' She showed us her book, which title had been changed from the original one to read like this, 'Queen Victoria's Reign for Twenty Years,' by K. Hodge. She said, 'I am in litigation with the publishers who have stolen my hard work from me, and I expect to be beaten in the contest for my just rights.' This short explanation, she said, was sufficient to show the reason why an organization had come into existence called the Authors' Protective Association, which is now located in the Woman's Temple, Chicago. If a writer joins this association, his or her work is published and protected as much as it is possible to do so, until this matter has been thoroughly legislated upon.

Miss Hodge intended that her exhibit should "leave no doubt of the great wrongs being suffered by the authors of this country who are in a large measure pillaged of their property, and who are as helpless in their bondage in this state of wrong as any help-

less thing can be." And indeed, the copyright law of 1891 protected no one. The Authors' Protective Association had an authoritative ring, but American books were not protected until 1909; foreign books received protection then, too, if they were properly registered.

There were odd groups in the Room: the National Science Club of Oberlin, Ohio, headed by Mrs Davidson, who had agitated for a science exhibit in the Woman's Building; the Columbian Association of Housekeepers, a group growing out of the Fair which hoped, like many after them, to "professionalize" housework; and the Nebraska Ceramic Club, a group of women potters. The only foreign group was French, although some American organizations, like the WCTU, included work of foreign affiliates in their exhibits. The French exhibit probably resulted from the work of Madame de Morsier who had spoken in Paris to Mrs Palmer about a French philanthropic exhibit and had sent a batallion of statistics to the Record Room on Frenchwomen's organizations. Mme de Morsier was President of the Work for the Women Liberated from the Prison of St Lazare. Mrs Palmer had been impressed with her, although she was irritated with Frenchmen at the second session of the Board:

> The French government stipulated that the Congress, although composed entirely of women, should be presided over by a man, M. Jules Simon, and that the programmes be submitted for his approval before plans were definitely settled. They did not have sufficient confidence in our sex to leave it altogether in their hands. . .

The display, set up by L'Union des Femmes de France, also called Le Croix Rouge, was a model of a field hospital. The American Red Cross, an affiliate of Le Croix Guerre, had been set up in 1881 by Clara Barton, who spoke at the Congress of Women.

The British charitable organizations did not exhibit in the Organizations Room, but in the British section of the Woman's Building.

One display was a Cabman's Shelter in the form of a doll's house, conceived and decorated by the London Flower Girls' Mission. The Mission is described by Lady Henderson in *Woman's Mission:*

Model of London Cabman's Shelter

> This is specially a work for women by women. It was, however, started in 1886, by Mr Groom, who organized some classes for the benefit of flowersellers. A few ladies taught the girls reading and sewing in a room near Covent Garden, and in time a free evening school and a penny bank were started. In 1879 I organized the Flower Girls' Brigade for flower-sellers between the ages of thirteen and fifteen, and arranged that they should have special stations

where they could safely carry on their trade. An artificial flower factory was also opened, and in a shelter close by the girls were taught sewing, cooking, etc. A few years ago a Flower-Girl Guild was started, under the patronage of the Princess of Wales, for honest and sober girls. Rooms are provided for rest and refreshment, and evening classes and entertainments given. By means of the 'Emily Loan Fund,' instituted in memory of Emily, Countess of Shaftesbury, loans of potato-ovens, coffee-stands, etc., are made to the women in winter.

One group which might be said to have been given impetus for creation by the Columbian Exposition, but which did not exhibit in the Organizations Room, was the Colored Woman's League of Washington, D. C., which was founded by the eloquent Hallie Q. Brown. In 1896 this group merged with the National Federation of African-American Women, which had been started in Boston in 1895, to form the National Association of Colored Women. These women campaigned against lynching and also encouraged "model homemakers" who had "pictures on their walls, flowers growing in their yards, strings no longer wrapped around their hair." Hallie Quinn Brown served as President of this organization from 1920 to 1924. At that time the membership was about a thousand. This organization now has 25,000 members, and has moved into areas of philanthropy, education and social service.

On October 28, 1893 women gathered at 11:30 a.m. in the Assembly Hall of the Woman's Building to hear speakers from the organizations. Bertha Palmer opened the meeting by delineating its purpose:

It has been the desire to push forward that recognition for woman and her work at the Exposition that she has long deserved and these organizations have set the pace. . . We wanted to hear reports from them so that we may show that the women carry on their affairs as well as the men.

Mrs Palmer then introduced Susan B. Anthony, the first speaker, as the head of the National Woman Suffrage Association, which as we know had merged out of existence in 1890. Miss Anthony gracefully picked up the name:

I am glad Mrs Palmer introduced me as the executive of the organization formed fifty-five years ago to work for the suffrage of women. It is the central pivot around which all the other bodies are revolving, and in time you will all join with the so-called strong-minded representatives of the sex in their demand for equal rights. I believe Mrs Palmer doesn't agree with us now, but she will some day. The movement which I have the honor to speak for today was first promulgated forty-five years ago at the little town of Seneca, New York, when a small band of women declared that suffrage belonged to women as well as to men, and made demands on the government for their rights. We declared that no human being

could have and enjoy the freedom vouchsafed by the Constitution unless he held the ballot in his hand. We have gone up and down the length and breadth of this land an almost despised band, but never faltering in our determination that women should be recognized as the equal in all things with the men.

Miss Anthony then moved on to her own part in the Exposition which, as we have seen, is rather blurred. Her comment neatly tucked the Woman's Building into the Suffrage Association's accomplishments, and undoubtedly alienated Mrs Palmer even further from the suffragists, with whom she had done battle from the Board's inception:

I made a fight for the equal representation in the management of this Fair and I am proud today of the grand showing that has been made. It demonstrates the capability of women to conduct affairs outside the kitchen, the parlor, and the sewing circle. The Woman's Suffrage Association still exists, and it will continue until the women of this country are enfranchised.

She concluded with extravagant praise for the small space she had had to work hard to secure; there may well have been some irony in her remarks.

Our exhibit here has done more in six months to help the cause than anything else could have done in twenty-five years. I am glad to see that you are all on the right road and will land at last at my headquarters.

She received "loud applause" and retired, an indomitable and unbending figure, having won affection at last with her white hair and familiar spectacles. Mrs Palmer's reaction must have been mixed, as indeed it was when Julia Holmes Smith, the ophthalmologist and Isabella, rose to offer a "eulogistic resolution" praising Mrs Palmer on behalf of the Fortnightly Club:

The Club has not forgotten that she was one of its earlier members and that it felt honored in having such distinction conferred upon her.

Members of the Chicago Woman's Club were irritated by what they considered an attempt to shine in borrowed raiment. Sarah Hackett Stevenson later commented to Bertha Palmer that the "eulogy" should have been offered at an earlier time:

The Fortnightly has never lifted a finger to help the Fair or the Congresses in any way and it seemed rather curious that it should gain representation upon the very last day when only the workers were supposed to have representation.

Laura De Force Gordon rose to praise Mary Lockwood's activities for the Woman's National Press Association:

> When the Exposition was projected one little but energetic woman in Washington commenced agitating the scheme of having a headquarters for the Association and that woman was Mary S. Lockwood. She succeeded in getting space and establishing thereon a place where all the press clubwomen of the world who came to see the Fair received a warm welcome.

Many speakers echoed Susan Anthony's sentiments about the value of the Organization Room to their groups. Mrs Leander Stone said that the YWCA exhibit had "enabled the Association to accomplish many desirable results since the Fair opened which it could not otherwise have obtained." Mrs Dennis of the Woman's Educational and Industrial Union said the space had been of "incalculable value." Mrs. E. J. Nichols was glad her exhibit had furthered the work of the WCTU in "girdling the earth with its white ribbon." Grace Dodge of the Association of Working Girls' Societies did not speak at this meeting. Later however she told the Board that "so far the Association has seen no benefits from the exhibit."

The speeches went on until well after three p.m. Teresa Dean, the reporter who had been present at the chaotic beginnings of the Organization Room, was present at the end: "Only eight minutes were given to each, but it seemed ample time for each woman to make one strong point and that was the importance of the society, club or organization to which she belonged. . ."

Within days the Room was dismantled. All that remained of the "crazy quilt" was the organizations directory which, in an unfinished state, held a place of honor in the Organizations Room. At the final meeting of the Board, in early November, Helen Barker reported on her work, called officially *Encyclopedia of the Organizations of Women*. It was now not national in scope, but international. Mary Eagle, who was collecting manuscripts and photographs for a book to be called *Congress of Women Held in the Woman's Building*, offered a resolution that Mrs Barker's *Encyclopedia* should be published in two volumes, one domestic and the other foreign, and that the American volume should be published first. Mrs Barker asked that that motion be tabled.

By the end of December she had finished the manuscript, which ran to 576 pages. On December 29, 1893, Mrs Palmer told William Curtis of the Treasury Department that "an encyclopedia of organizations of women throughout the world had been completed and is ready for publication." She had ready an estimated print cost for the government of $3000. On January 9, 1894, Mr Curtis sent the government's regrets: the Treasury Department could not foot the bill. It is not known whether an

Mary Eagle

Page from Encyclopedia of Women's Groups. Colorado Organizations.

attempt was made to interest a commercial printer, as Mrs Eagle did with her volume on the Congresses. In September, 1897, and for the third time in December, 1902, Mrs Palmer reminded the government that this valuable document still lay waiting to be published.

In 1919 Rebecca Felton, now eighty-four years old, and still somewhat annoyed about her experiences with the Fair, wrote in her book *Country Life in Georgia*:

> I had abiding interest in the Organizations Room because I had sufficient foresight to understand that they would not only survive the Exposition, but would continue to rapidly increase, as has happened, after every vestige of the 'White City' had vanished

She mentioned the *Encyclopedia*, the non-appearance of which she characteristically had to blame on something or someone. The book, she said,

has never yet been published owing to the fact that the gigantic undertaking [the Exposition itself] consumed not only the allowance provided by the Act of Congress but also took over the savings of the Woman's Board to settle the debts which we had no share in piling up.

The manuscript, wrapped in brown paper, is shelved in the Chicago Historical Society: piles of lined paper covered with names, addresses, statistics and goals, written out laboriously in faded ink. The Ladies knew that the "mass of statistics" would not be inviting but explained that they felt "the necessity of showing this beautiful influence and the advance which it has caused, although the most valuable part is spiritual and there is a difficulty in showing progress in abstract things . . ." The document, they thought, would take on beauty "when intelligently and sympathetically read." Few, to be sure, have read it. But the Organizations it listed have either survived in one form or another, or faded away when the functions they served ceased to be needed. The *Encyclopedia* is a part of history, as is the "White City" which engendered it.

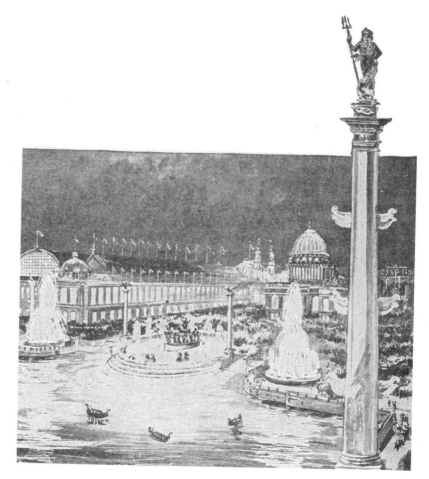

IN THE SALT WATER WUZ SHARKS, TORPEDOES, DOG-FISHES, GOOSE-
FISHES, WEAK-FISH, AND STRONG ONES, TOO, I SHOULD THINK.

THEY WUZ COVERED WITH BONE INSTEAD OF SCALES.

I DREMPT OF FISH ALL NIGHT.

HE idea of having Congresses at the Fair had been suggested to the Directory in 1889 by Judge Charles Bonney of Chicago. The Directory's response was enthusiastic: a prospectus was mailed to every reachable part of the globe, claiming that these Congresses would address "great themes"; the crowning glory of the Fair would not be exhibits of "material triumphs, industrial achievements and mechanical victories . . . however magnificent". The glory would be "still higher and nobler" than industry and invention. The Congresses would address questions of language, literature, domestic life, religion, science, art, industry, education, economics, poverty, insanity, crime, international law and copyright, immigration, and arbitration as prevention for war. These discussions would reflect "the enlightened spirit of the present age." The motto for the Congresses was "Not Matter but Mind; not Things but Men."

In October of 1890 Charles Bonney and Lyman Gage were appointed to run the World's Congress Auxiliary; on March 25, 1892 this organization, by an Act of Congress, was made independent of both the National Commission and the Directory. The Auxiliary contained a Woman's Branch, which was separate but equal. Although there were no mixed committees of men and women, President Higinbotham said that "on all subjects suitable for the co-operation of women, committees of women were appointed, and these constituted, in the aggregate, the Woman's Branch" of the Congress Auxiliary. Bertha Palmer was appointed President of this Branch, and Ellen Henrotin, Vice-President. Others named to the Branch's board were Frances Willard, Myra Bradwell, Mrs Leander Stone and Dr Sarah Hackett Stevenson, an Isabella.

It was the responsibility of Mrs Palmer and Mrs Henrotin to commission women speakers on approved topics; Judge Bonney and Mr Gage were responsible for male speakers. Subject committees for each sex were established, the members of which were answerable to the male and female Presidents and Vice Presidents respectively. Both the male and female Congress Auxiliaries had religion committees, science committees and literature committees, chaired by experts in those fields.

The Woman's Branch had a special Women's Congress Committee for speeches on topics of interest to women. May Wright Sewall was responsible for this Women's Congress Committee. Mrs Sewall was a former schoolteacher who had founded the Indianapolis Equal Suffrage Society in 1878 when she was thirty-four years old. The suffrage society of Indiana was allied with Lucy Stone's moderate group; Mrs Sewall's Equal Suffrage Society allied itself with Miss Anthony and Mrs Stanton's more radical organization. When the Anthony and Stone factions merged, Mrs Sewall resigned her executive position in the Indiana group and devoted her energies to the National Council of Women, formed in 1888 in Washington, D.C. In 1889 Mrs Sewall was the only American delegate to the Women's Congresses of the Paris Exposition; in Paris she made plans with other feminists to found the International Council of Women. It had been decided that the first meeting of this new Council would be in London, but when Mrs Sewall heard about the projected Columbian Exposition Congresses, she immediately contacted Charles Bonney. She suggested—and Mr Bonney agreed—that the International Council should meet in Chicago rather than in London, and that its first meeting should take the form of an Exposition Congress. Thus the Women's Congress Committee existed before the organization of the Woman's Branch and before the appointment of Mrs Palmer and Mrs Henrotin. They inherited the special Committee, and Mrs Sewall with it.

Harlowe Higinbotham

Mrs Palmer, too busy to devote much time to the Congresses, was happy to leave the responsibility to Ellen Henrotin, who, although not a Lady Manager, was active in the Chicago Woman's Club, from the membership of which she drew heavily for her Congress committees. Jane Addams headed the philanthropy committee, Myra Bradwell the law committee, Sarah Hackett Stevenson a surgery committee, Sara Hallowell a fine arts committee, and so on. Mrs Henrotin was progressive in her views, but she was not a suffragist. She wanted the women in the congresses to speak, not primarily as women, but as lawyers, teachers, voters, social workers, to demonstrate that "woman is becoming as capable as man to take her part in this highly centralized and highly specialized civilization." She did not like the idea of a congress limited to the "Woman Question," or to a historical presentation of women's role.

Mrs Sewall, on the other hand, wanted just that: discussions of every subject in relation to the Woman Question. Thus Mrs Palmer and Mrs Henrotin found themselves inextricably enmeshed with a woman whom they considered a radical feminist, and an organization—The International Council of Women—which seemed to them extreme in its views on the place of women in the world.

The summer of 1892 Mrs Sewall spent in Germany, Belgium and France, recruiting women to come to her congress, which she called the Congress of Representative Women. While she was gone the congress work was done by Rachel Foster Avery, an avid feminist and Secretary of the National Council of Women, who was close to Susan B. Anthony; Miss Anthony playfully referred to her as her "niece." Mrs Avery consulted with Miss Anthony and with Frances Willard, and carried on voluminous correspondence with the officers of women's organizations both at home and abroad.

It is not surprising that Mrs Henrotin should be suspicious of all these organized, dedicated suffragists working busily, supposedly under her direction, but without her actual supervision. They were promoting the International Council of Women; it would not have occurred to them not to do so.

In September, 1892, Mary Logan who was a leader of the Woman's Relief Corps, received a letter from Mrs Sewall, written on stationery of the National Council of Women. Mrs Sewall was writing to tell Mrs Logan that the CALL, the National Council's publication, was about to appear; that it would contain a list of all member organizations of the National Council, and that it would be worth Mrs Logan's while to add the Woman's Relief Corps to the list. Mrs Logan, who seemed to be involved in every agitation, often on both sides, made Mrs Sewall's letter available to Mrs Palmer and Mrs Henrotin. It read in part:

This seems to me a most auspicious time for a National Organization to enter the Council, for the following reasons: the National Council has really been given charge of the World's Congress ... the National Council will have head-quarters in Chicago, during the ... Exposition; this head-quarters will probably be in the Woman's Building. Whether in the Woman's Building or elsewhere, every National Organization belonging to the National Council, will have desk room in the head-quarters, and will necessarily have many advantages not open to organizations outside of the Council.
I know that you are a woman accustomed to considering large views, and entertaining large ideas, therefore, it is unnecessary for me to present arguments for bringing the Relief Corps into the Council. Such arguments will present themselves to your mind more rapidly and more clearly than I could present them to you.
I think it important that action should be taken on this matter now, because the second "Call" for the Congress is soon to be issued, and in this "Call" an announcement will be made of all organizations belonging to the Council, and the Presidents of all such organizations will be made members of the Advisory Committee for the World's Congress. I send you a copy of the first "Call" of this Council, and also mail the copies to you under another cover, together with ten copies of the Constitution of the National Council, that you may distribute them among the members ...

May Wright Sewall

As may be imagined, this letter went down very badly with the President and Vice-President of the Congress Auxiliary. They resented the statement that the National Council had "really been given charge of the World's Congress" which was a wild exaggeration, apart from anything else; they were annoyed that Mrs Sewall was nakedly using the Congress to tub-thump for the Council, and they were angry at what they saw as coercion of women's organizations to join the Council in return for special treatment at the Fair.

Early in September Ellen Henrotin wrote Mrs Palmer that she and Mr Bonney had decided that only she and Mrs Palmer should send out circulars and letters to women's clubs. She had already been approached by Charlotte Emerson Brown, who wished representation at the Congresses for the Federation of Women's Clubs. That was as it should be; she preferred to be approached herself as Vice-President of the Woman's Branch of the Congress Auxiliary. She did not want "hastily written and crude productions" to go out to clubwomen from the National Council. Mr Bonney and Mrs Henrotin made it clear to Mrs Sewall that they did not want the National or International Council of Women involved directly or officially with the Women's Congress Committee. Mrs. Sewall accepted this, replying that she would inform Mrs Avery that she was not to send out any more Council circulars nor use the Council letterhead for Congress mailings.

Rachel Foster Avery

Mrs Palmer wrote Mrs Henrotin on September 30 that she was sorry the Council had ever been allowed to become involved with the Exposition; she wished that they were simply going to hold their own private meeting in Chicago. Both she and Judge Bonney had had to write to all officers of large women's clubs, telling them not to be intimidated or coerced by the Council, and assuring them that they had a right to representation at the Congresses without having to be Council members. Mrs Palmer was afraid that Mrs Sewall might be emboldened to take over the Congresses because the National Council were paying expenses for foreign women who wished to attend them. She told Mrs Henrotin that she had confided this fear to Mr Bonney:

> I said that I was afraid that some of our power might have been given away, as Mrs Sewall had not consulted or reported to me, and he said, 'Certainly not, you stand at the head.'

On December 16 and 17, 1892, a meeting was called for the Committee of Arrangements for the World's Congress of Representative Women. Mrs Henrotin wrote to Mrs Palmer on Friday, December 11, asking her as a special favor to preside at this meeting:

> My anxiety is very great to secure a full representation from every Association which merits such representation, and that no feeling

should arise that this Congress is specially in charge of the officers of the National Council. Three members of that Council work together, and as the three are powerful women, exerting tremendous influence over the whole country it requires great tact to keep them in line and retain the control. The three women are Miss Willard, Susan B. Anthony, and Mrs Sewall. The three possess such remarkable executive ability that I consider myself most fortunate to have them pledged to my cause, but at the same time I do not desire to serve their causes. By presiding over this meeting when it first convenes you will convince them of the active interest you have taken in their Congress, and it will have a great effect. Your gracious ways conciliate all elements . . .

Mrs Palmer as President of the Woman's Branch of the Congress Auxiliary would naturally take precedence over Mrs Sewall who was only the Chair of a committee of that Auxiliary. Bertha Palmer agreed to go to the meeting; at 10:30 on Friday morning she went to prepare her speech in Mrs Henrotin's office in room 216 of the Home Insurance Building at Adams and LaSalle Streets.

At the meeting in the afternoon, Mrs. Henrotin was not present. She had received some disquieting letters from New York about the Council's further activities. Mrs Palmer was consequently alone in the midst of a nest of suffragists: Mrs. Sewall, Isabellas Dr Julia Holmes Smith and Dr Sarah Hackett Stevenson, Mrs Avery, and Matilda Carse, representing Frances Willard who could not come. Mrs Palmer gave her gracious talk, and remained throughout the business meeting, after which she withdrew.

At the meeting Mrs Sewall said that the minutes were incorrect because they had been taken by Mrs Henrotin's private secretary. She then reported on her trip abroad the previous summer. She said she was asked many times, "How will the addresses at the

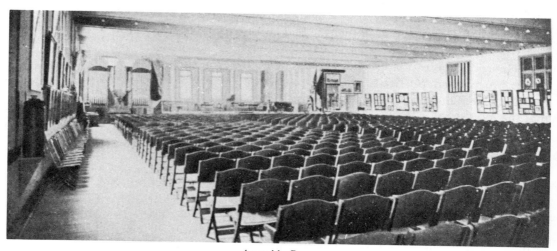

Assembly Room

World's Congress of Representative Women differ from the addresses made by women at the General Congress?'' Mrs Sewall said that she responded unofficially that the object of her Women's Congress was "not to discuss the subject per se, but to discuss the relation of the women of the world to the subject.''

In her own defense she said that she had received no printed stationery or in fact no printed word to prove that her "mission" was supported by Congress until December 10, one week before the meeting. This was her excuse for using National Council stationery to communicate with women's organizations. However the excuse was somewhat lame, because material was still going out with the name and address of the Council, recruiting women for the Congress. The day after this meeting Mrs Henrotin wrote Mrs Palmer, that she had to go to New York to try to dampen the rage generated there by receipt of these circulars and letters. The "Eastern women" would gladly have co-operated with the Council if Mrs Palmer or Mrs Henrotin were communicating with them, they said, but they wanted nothing to do with Mrs Sewall. Mrs Sewall had not "kept faith''; she continued to send out National Council circulars. Grace Dodge had written to say that the Working Girls Clubs would happily participate in the Congress, but not if Mrs Sewall were associated with it.

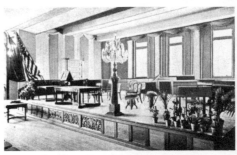

Speakers Stand in Assembly Room

Mrs Henrotin wrote also to Mrs Sewall on the same day, saying that she feared that the Congress of Representative Women would be a failure: she had found the National Council to be "most unpopular "throughout the East and the South; the International Council had "an existence only on paper.'' She said that Mrs Sewall must see to it that the International Council constitution be no longer sent out, and no more letters or circulars be sent under the aegis of that organization. Lady Henry Somerset had herself written to Mrs Henrotin urging her to use her influence to stop these International Council circulars, since there was a strong prejuduce among Englishwomen against the Council. Mrs Henrotin reminded Mrs Sewall that she had promised to stop Mrs Avery from sending out these circulars. Grace Dodge had shown Mrs Henrotin one of the circulars she had received: on the envelope was printed "Office of the International Secretary of the International Council of Women.'' Miss Dodge had announced that the Washington Working Girls' Club would now withdraw support from the Congress; she had received the impression that only organizations which were members of the Council were entitled to representation. Mrs Henrotin said she had to insist that the Women's Congress Committee have a Secretary who resided in Chicago, and who would be under Mrs Henrotin's direction, and no one else's. At the meeting on Friday at which Mrs Henrotin had not been present, Dr Stevenson had moved that a committee of three women living in Chicago handle correspondence and or-

ganization for the Congress. Dr Julia Holmes Smith had objected to this, saying she preferred the Chair and the Secretary handle these sensitive things. Mrs Sewall still lived in Indianapolis. Mrs Avery was in Philadelphia.

Mrs Palmer mulled over the problem: on December 20 she wrote her own letter to Mrs Sewall, attempting to reason with her. She pointed out that Mrs Henrotin was prompted only by a desire that Mrs Sewall's Congress be a success:

> You, on your part, are equally interested in showing that all bodies of women can work freely with the National Council without any danger of the smaller being swallowed up by the greater, or the very radical tendencies of some of the members being forced upon, or in any way oppressing those who have a reluctance to ally themselves with those theories. In other words, that the National Council does not propose to endanger the liberty, or hurt the sensitiveness of the most helpless or conservative organization.
> The main result to be attained is the full representation of all lines of thought connected with the progress of women, in this one Congress, through the prominent women representing each thought, and to show that all organizations can come together with perfect freedom and entire harmony and discuss the problems presented, even from divergent points of view, with the utmost friendliness, and without the few being suppressed and crushed out by the many.

Mrs Palmer pointed out that a conciliatory attitude on the part of the Council would promote the growth of their organization:

> It is against your interest to speak for the Council, giving the impression that the Congress of Representative Women is only the meeting of the International Council under another name. By doing this you make no new allies, and no new friends. Your lines are drawn in the same way as though you were holding your International Council, and you gain nothing by the broader plan adopted. Your friends will of course stand by you, but those who are doubtful will hold aloof.

After this velvet glove treatment Mrs Palmer revealed the iron hand for a moment by requesting that Mrs Sewall send copies of official letters to her, along with replies received and sent. She was going to monitor correspondence.

With the hideous example of Phoebe Couzins before them, the suffragists fell back. They had visions of public disagreement, angry resignations: they wanted to avoid scandal at all costs. The General Federation of Women's Clubs had arisen at the same time as the National Council of Women; the clubwomen were generally indifferent to the suffrage issue, or more interested in other issues. The last thing the Council needed was an open break with these clubwomen.

An attempt was made to put a good face on things, so that the Council and the Women Congress Auxiliary could work together.

The Auxiliary announced its purpose in a way which would include nearly everyone's attitudes:

> This branch is intended to embrace the whole scope of Woman's Work and Progress, and is planned to present to the world, in the series of Congresses to be held in connection with the Columbian Exposition of 1893, a more comprehensive and complete portrayal of women's achievements in all departments of civilized life than has hitherto been made . . . The special object . . . is to show the capabilities of women for more varied employments, greater usefulness and higher happiness than she has hitherto enjoyed.

Since it was expected that large crowds would be attracted to the Congresses, the Directory decided to hold them on a site away from the Fairgrounds. The Directory's desire for a lakefront setting for some of the Fair activities had not entirely died away. Now by a happy coincidence the site of the Crystal Palace, on Michigan Avenue at Adams Street, and facing the Lake, became available. The Crystal Palace, which had housed the Interstate Industrial Expositions since 1873, had outlived its usefulness, at the same time that the Chicago Art Institute had outgrown its quarters. The City offered the Crystal Palace site to the Art Institute, which raised $400,000 for its new building, and the Fair Corporation paid $200,000 to the Art Institute for the right to use the new building, to be temporarily called "the Art Palace," for the Congresses during 1893. After November 1, the Art Palace would become the new Art Institute.

The main structure, completed in July, 1893, consisted of two large assembly halls: The Hall of Columbus on the north end, and the Hall of Washington on the south end. On the east side of the building were two large wings, containing thirty-three smaller halls. The building was designed to seat a maximum number of 12,000 people.

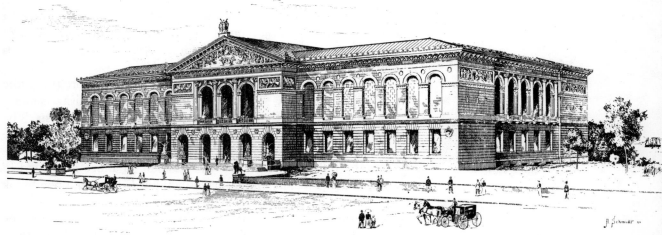

ART INSTITUTE

The Congress of Representative Women began on May 15 and ended on May 21 inclusive. It was the first of the Congresses. During its week three hundred and thirty scheduled speakers, and nearly as many unscheduled ones, appeared at eighty-one sessions. As many as eighteen sessions were held at once in separate halls. Its success was equalled only by the success of the Parliament of Religions, which was held August 27-October 15, and which spawned, among other things, the National Council of Jewish Women.

The Council's Congress was successful partly because of the energetic activity of the dedicated suffragists who created it, and partly because of the controversial nature of some of the topics of discussion. Mrs Henrotin's Congresses were successful too, although spread somewhat more widely and thinly. Her committees, staffed by 400 members of the Chicago Woman's Club, secured speakers for thirty-six departments: Education, Temperance, Moral and Social Reform, Literature, etc. Fifty thousand people participated in these Congresses.

On Sunday, May 15, the Congress of Representative Women was scheduled to convene at 11 a.m. Throngs of women began to arrive as early as nine o'clock. It was a pleasant day: the *Tribune* said that the "sun came out for the occasion." Hordes of women, among whom the elderly and middle-aged predominated, converged on the Hall of Columbus, which was filled by ten o'clock. Still streams of women poured into the building; lines formed before the registration desk, where guests were asked to sign a card. The entrances were blocked by crowds.

In the Hall of Columbus Susan B. Anthony sat in a front seat; she smiled and held a small reception on her own account. She was much loved and respected. When Mrs Palmer entered, the audience—which included women like Clara Barton—rose as one to get a glimpse of her. Her opening address was brief; she turned the meeting over to Ellen Henrotin who made the principal welcoming address, and, in her turn, gave the podium to May Wright Sewall. Mrs Sewall said that her intention had been to work "for fraternity and womanliness." She welcomed women "of different views" and "members of the colored race." Mrs Sewall, representing the Council's Committee on Dress Reform, was wearing a close-fitting dark blue serge dress, the full skirts of which stopped eighteen inches from the floor. Below the dress blue gaiters encased her shoes. The *Tribune* commented on Mrs Sewall's energy, as well as her eccentric style of clothing. She whisked along the corridors in her flight from meeting to meeting.

About Susan B. Anthony the press said,

The untiring energy with which she made opening addresses and closed speeches was nothing short of miraculous. And wherever she went the cause of woman's suffrage screamed. Indeed all other subjects sank into insignificance beside this burning one.

This was not the kind of comment Mrs Palmer and Mrs Henrotin wanted. Indeed Mrs Palmer had made every effort throughout her Fair work to avoid it. However, they could take comfort from the glowing review of the *New York Times* on May 16:

> Over twelve months of labor involving correspondence in every part of the globe culminated this morning in one of the most brilliant gatherings of women ever assembled . . .
> A wonderful, impressive gathering of brainy women.

Public response was so great that Mrs Sewall had to prepare a double program for the rest of the week. Both great Halls were used.

The subject that received the most publicity was Dress Reform. This seemed to the Council an ideal issue to emphasize at the Fair, where dressing for "ease, comfort and freedom of movement" was a practical desire, and where the "cosmopolitan atmosphere" might encourage an innovative spirit. The members of the Council's organizations, whom the *Tribune* called "diverse but all reformatory," were asked to wear "reformed" clothing at the Fair. Frances E. Russell, head of the Dress Reform Committee, had been working to reform women's clothing for thirty-six years; she was anxious to persuade the public that the Council was "not making a crusade in the interest of the odd and ugly."

The idea that women wore uncomfortable and even dangerous clothing was not an eccentric one. Warnings were issued about the dangers of long trailing skirts, which swept the ground and picked up germs, at the same time retaining dampness which could lead to rheumatism or influenza. The *Tribune* itself had run an article in September, 1891 saying the women "had compressed beyond all healthful bounds the flesh of their arms, retarding circulation and inviting pneumonia and other ills." In addition freedom of movement of the arms was restricted; ladies were compelled to put their bonnets on before attempting "the painful ordeal of getting into their glove-fitting dress waists." Even *Harper's Bazar* recognized that women needed practical, comfortable clothing—within limits. On October 1, 1892 an article appeared, headed "The Common Sense Skirt:"

> I have made up my mind that my skirts for street wear shall not in future touch the ground; they shall clear it fully. There is no comfort in walking when one hand must, forever, hitch up . . . the hem of one's garment lest it come in contact with vileness and mud.

The new skirt lengths were "just short enough to escape the ground." The *Bazar* was amused at "simpletons" who paraded about in trailing skirts: "Fancy the teacher going to and from her

Rachel Foster Avery in American Costume

room in robes in which the boys might play tag . . . Fancy the cook trailing around in a tea gown over her sauces and spoons.''

The March 18, 1893 issue of the *Bazar* carried an article headed "Dress for the Columbian Exposition. What shall I Wear?" The answer was "A travelling dress by all means . . . a smart gown of light weight wool very simply made, with the skirt clearing the ground all around by one inch." Also recommended was a walking dress of blue whipcord with a black satin vest and "drooping" sleeves with black satin cuffs; the skirt was four yards wide and escaped the floor by one inch, a length that the *Bazar* was obviously determined to push, as a daring innovation. In its May 13, 1893 issue the *Bazar* was still recklessly advocating sensible dress, telling its readers to leave their white petticoats at home and to bring "knitted cotton and light wool and silk" underthings to the Fair "to avoid laundry bills."

As an indication of the differences between fashionable publications and the advocates of dress reform, the Council called for hems at least one foot and in some cases eighteen inches from the floor. To cover the intervening length of leg the dress reformers wore gaiters, a covering for the instep, ankle and "lower leg" which often encased the shoe, and was made of leather or cloth.

On May 16 at a Dress Reform Congress in the Arts Palace Rachel Avery read the report of the International Council Committee on Dress Reform. She was wearing the Council's "Syrian" costume, designed in England: this consisted of a dark blue wool jacket worn over a full silk blouse, a modified skirt pegged like Turkish trousers, and blue gaiters. The audience listened to the report with increasing signs of restlessness. According to the *Chicago Tribune* the next day:

> women were standing on chairs and twisting their necks in bowknots in frantic attempts to see the apostles of modern bloomerism clad in the grotesque garments their creed imposed on them.

The spectators finally lost their patience and their manners and shouted "On the table!" at Mrs Avery, who obliged them by scrambling up and reading her entire report while standing on a table top.

The *Tribune* found Mrs Avery attractive, and commented that "the Syrian" had only one thing in its favor:

> It is so immediately and appallingly ugly that no woman with proper regard for her duty towards man will yield to it. Even Mrs Rachel Foster Avery of Philadelphia is not able to come out of the ordeal with flattering success.

Mrs. Avery was joined on the table by Annie Jenness Miller, editor of a dress reform magazine. Her costume, called "The

American,'' had an Eton jacket over a full silk blouse and a short round skirt which looked "suspiciously divided.'' Her gaiters were neatly buttoned. She said that her costume was easy to make, but that its skirt length "demanded leggings.'' She appealed to ladies of fashion to adopt the style, since working women would not adopt it without their example. Toward the end of her talk, she asked all gentlemen in the audience to leave the room while she went more deeply into the mysteries of her garb. The gentlemen obliged, with backward lingering glances.

The *Tribune's* comments on "The American" were hardly gentlemanly, and included a really nasty personal attack on Mrs Miller:

> On a woman with a straight lithe figure it might create a pleasant sight . . . advancing down the street. The rear view is less felicitous and unless Mrs Miller can invent means to present a more agreeable display of contours it is not likely that any woman will wish to profit by her suggestions.

The *Tribune* thought that the "American" might cause a reversion to hoopskirts. But both dresses were found to be "not only unnecessary but positively ill-advised." Their chief features were "brevity of skirt" and the disregard of their designers for "attractiveness." It was impossible to "reconcile hygienic clothing with Paris dress."

The "gymnastic costume" was already in use in physical educational classes at Mount Holyoke and other women's colleges. It was not intended for outdoor wear. Its advocate, Alice Stone Blackwell, had suggested that "if it were necessary to go outdoors, a long apron could hide all peculiarities." The *Tribune* did not care whether this costume were worn in or out: it would be "a distinct shock to any woman of fine sensibilities . . . Why a woman of taste and refinement should hop along the terraces of the Fair in a gymnasium suit is a mystery to the most reasoning individual."

Professor Ellen Hayes of Wellesley College delivered an address on woman's dress from the standpoint of sociology, pointing out satirically the shortcomings of fashionable clothing:

> The wearer of these garments cannot be a person of much activity, either physical or mental. Surely, she cannot travel, making either long or short journeys, because the prevailing systems of transit are not adapted to anyone so tied up and helpless. The street, the garden, the marketplace are obviously to be avoided. Housework, such as sweeping and cooking, could be done only with much difficulty and fatigue. Going up and down stairs would be dangerous, especially if she were to attempt to carry an important burden, such as a baby or a lamp. How limited must be the employment, how resisted the pleasures of one who wears this modern costume.

MRS. ANNIE JENNESS MILLER'S "AMERICAN COSTUM

In November of 1889 Frances Willard had commented on the same thing with more acerbity for the *Woman's Journal*. Miss Willard, referring to "bandaged waists . . . street-sweeping skirts . . . camel's hump bustles," said tartly:

> She has made of herself an hour glass, whose sands of life pass quickly by. She walked when she should have run, and sat when she should have walked. A spitted goose and a trussed turkey are her most appropriate emblem.

Professor Hayes dwelt on the importance of pockets, to which she gave a symbolic importance. Woman, she said, should demand pockets. "Pockets mean power and independence," she said, "because they mean possession." To Mrs Palmer, who was to inherit her husband's fortune, and to increase it through her shrewdness, this must have been an amusing concept. Professor Hayes not only condemned the purse but the entire way of life of Mrs Palmer and most of her friends:

> [Woman] expects to take the same course of study that man does; to hold her own in a progression; to assume a business role. These things she attempts while handicapped by a dress imposed upon her during the dark ages. Costly gems, rare laces, exquisite fabrics cannot cover up the fact that this dress, in its fundamental ideas, is the dress of the half-civilized, and not that of one who is master of herself or of the world. In domestic societies, removed from every kind of competition with man, believing that her empire was to please, woman has had neither occasion nor encouragement to improve her dress.

Professor Hayes herself wore a blue serge suit with ten pockets in it.

The last of the speakers on dress reform was Lucy Stone, who wore a Quaker Cap and gown, and was one of the first American women to ignore public censure by making public speeches on controversial subjects. For years Mrs Stone had travelled and lectured in the costume named for Amelia Bloomer, who was not the first to wear it but who publicized it in her feminist paper *The Lily* after seeing it worn in Seneca Falls in 1850. It was said that the costume had been invented by Annie Jenness Miller. In any case, Mrs Stone finally gave up the bloomer, because she could no longer bear the interest it aroused. Susan Anthony had gotten up enough courage to wear the thing shortly before Mrs Stone gave it up. Miss Anthony wrote her in dismay:

> But Lucy, if you waver, why then who may not? If Lucy Stone, with all her reputation, her powers of eloquence, her loveliness of character that wins all who once hear the sound of her voice, cannot bear the martyrdom of the dress, who I ask, can?

This anguished question was hardly likely to inspire Mrs Stone to change her mind. She discussed the bloomer at the Congress:

> The bloomer costume was the lightest, easiest, and cleanest dress I have ever worn. I adopted it when I was young and perhaps a trifle ignorant. I was disgusted with prevalent dress and I said, 'When women see a sensible gown, they'll adopt it.' They didn't adopt it, but I had a good time with it for a little while. I could go upstairs without stepping on myself and downstairs without being stepped on. I could walk in mud and come out unspotted. But it was a dreadful dress in one way. It was so conspicuous. The torment to the spirit was greater than the ease to the body, I found. So I gave it up. But still I regard the bravery of those who were for it awhile as the beginning that has resulted in such a meeting as we are holding here today.

There was much enthusiasm for all these costumes on the part of the spectators, who crowded round the speakers, and requested patterns. The Dress Reform Committee had endorsements from the WCTU, the Kindergarten Union and 1500 individuals, among whom were Lady Isabel Somerset, Clara Barton, Harriet Beecher Stowe, despite her generally moribund condition, Mary Livermore and Elizabeth Stuart Phelps.

However, if Lucy Stone and Susan Anthony could not bear "the martyrdom of the dress" it is not likely that the average woman could do it. In May, 1893 *Godey's Magazine* stated the facts as dress designers saw them:

> When we speak of choice in dress and decoration, we must of course exclude all that is not in vogue. Fashion must set her seal upon all . . . To choose something unfashionable would be to make oneself not pleasantly, but unpleasantly conspicuous. It would be to deny an authority that is absolute, in many cases it would be to incur the risk of being considered eccentric, perhaps cranky.

And in fact both the Council and the Chicago Woman's Club, which had also experimented with a dress reform committee, found that women could not bear indefinitely the strain of being unduly conspicuous. In addition, it was difficult to find dressmakers who grasped the point of view of dress reformers. Most women who were attracted to the movement chose discretion as the better part of valor and decided to conform to fashion and at the same time try to maintain standards of health and comfort, an almost impossible task at the time. Grace Greenwood, writing in *The Arena*, did not expect a sudden change for the better in women's dress. She was however more farsighted than she knew:

> I hope that within the new century, at the latest, a reformed, easy, sensible, unburdensome, unshackling dress for women may come in and come to stay; and I believe that before the new century is old

Annie Jenness Miller

Mt Holyoke Girls in Gymnasium Dress

French and American corsets and English stays will be forgotten barbarisms, only to be found in museums, classed with 'ancient instruments of torture.'

On May 18 four well-known suffragists appeared in the same hall: Susan Anthony, Lucy Stone, Julia Ward Howe and Helen Gardner. The crowds were unmanageable: Helen Gardner was so distressed by the crush that she fainted. Miss Anthony, who was thirty-three years older than she, vigorously cleared a way for the others. Miss Anthony read a speech written by Elizabeth Cady Stanton, who had remained at home at Glen Cove, Long Island, during that summer:

[Women] already find in the complexity of life, numberless demands upon thought and strength. Their aspirations for increased knowledge and culture, their aesthetic cravings, urge them to the limits of physical and mental endurance, and they feel they can undertake nothing more . . . A woman must be versatile, and ready to fill any niche at a moment's notice. She must sew on a button or write a poem, must roast herself in the kitchen or receive guests in the drawing room, with equal grace and facility, and what with keeping up her geography and accomplishments she will beg to be excused from what she thinks the dry and uninteresting subjects of business, current events and politics. It takes courage to go against the stream . . . if women somewhat by nature and certainly by education are lacking in such fiber, we cannot be surprised at their slowness in rising to the emergencies of the hour.

This speech indicated that Mrs Stanton was tired, and she had in fact said, "Our movement is belated, and like all things too long

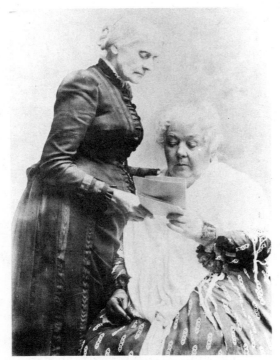

Susan B. Anthony & Elizabeth Cady Stanton

postponed now gets on everybody's nerves." Mrs Stanton was a married woman, who had had children. Miss Anthony, never married, retained her energy and sparked her speeches with it. She recalled a lecture she had given forty years earlier attended only by the janitor of the meeting hall:

> Women came as far as the door—I could see the tips of their gowns but they seemed afraid to come into the presence of that monster called a woman's rights woman, so they peeped in and stole away.

She quoted a preacher who had come up to her after one of her speeches years before and said, "Miss Anthony, both in manner and in matter your speech was unexceptionable . . . I would rather see my wife and daughter in their coffins than addressing a public meeting."

Miss Anthony's enthusiasm infected her audience; she made them feel that great progress had been made for women. The press commented that "the day of jubilee has come for that plain, tough, staunch, clear-headed and steel-nerved old lady, Miss Susan B. Anthony."

The next day, May 19, there were even more women crowding in to the halls. Teresa Dean of the Chicago *Inter Ocean* said "They tore lovely lace, lovely jet, and lovely roses off my dress. They

FOR EARLY SUMMER.

smashed my umbrella and ran their own into my ribs . . . They trod upon my feet . . ." She said that when she finally got into the hall, she found desperate suffragists "crying for men to come in and take care of the crowd." She escaped "without waiting to hear Susan B. Anthony's brainy and spicy arguments. And that is the nearest I ever came to being a suffragist."

On May 20 Anna Howard Shaw, a Methodist minister who had left her calling to become a lecturer for suffragism, after picking up an M.D. degree along the way, delivered a speech on "The Fate of the Republics." Dr Shaw did not stress the common humanity of the sexes, but their differences. Men made their contribution to society through "business enterprise and inventive genius, their aggressive spirit and warlike nature," she said. Women, on the other hand, represented "morality and purity, temperance and obedience to law, loyalty to the teaching of religion and a love of peace." If women's qualities could be integrated into masculine government, the Republic could avoid the decay and death which all great governments had suffered. As an illustration she attacked the popular painting, "The Landing of the Pilgrim Fathers" with heavy irony:

> Between ship and shore is a man carrying what seems to be a woman in his arms, on the beach kneel a company of people . . . They look like men and women . . . Read the inscription beneath the picture to learn that it is not a company of men and women at all, but is a representation of the Landing of the Forefathers. You instinctively exclaim how kind the forefathers were to carry each other ashore, and how much some of them resemble mothers, but they were not mothers, they were fathers, every mother of them.
> . . . Pilgrim fathers, Plymouth fathers, forefathers, revolutionary fathers and church fathers, fathers of every description—but, like Topsy, we have never had a mother. In this lies the weakness of all republics. They have been fathered to death.

Dr Shaw was amusing and angry; this anger, most similar to the anger of later feminists, was not helpful in the matter of suffrage. Dr Shaw was to run into trouble when she became President of the National American Woman's Suffrage Association in 1904; she alienated men and upset women.

One woman at the Congresses who did not rebel against traditional feminine roles was Emma Ewing, a home economist who helped Sara Rorer in the Model Kitchen. She gave a practical demonstration of bread-making. Another was Mary Coleman Stuckert who delivered a paper on "Co-operative Housekeeping." She had been attempting for fifteen years to build a co-operative house in Denver. She showed a plaster model of this building in the Woman's Building: it was the size of a city block and would house forty-four families; included in the building would be a communal kitchen, laundry and kindergarten. Food could be pur-

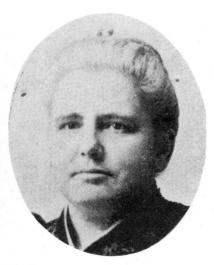

Rev Anna Howard Shaw

chased communally at wholesale prices, and servants, Mrs Stuck-
ert thought, could be hired "communally". This last idea carried
horrid possibilities for trouble, but the newspapers reported that
the plans for this Denver co-operative were greeted with interest
and respect.

The problems of individual households were more immediate,
of course. Jane Addams addressed herself to "Domestic Service
and the Family Claim". Factory labor, she said, had been compet-
ing with household labor since the beginning of the industrial
revolution of the eighteenth century. With the exception of inva-
lids and mothers of small children, all untrained women who
sought employment had to decide between the factory or the
home. Stupidity had nothing to do with this choice, Miss Addams
said:

> There are few women so dull that they cannot paste labels on a box
> or do some form of factory work; few so dull that some perplexed
> housekeeper will not receive them, at least for trial, into the house-
> hold.

Household labor, then, had to compete with factory work in
hours, in permanency of employment, in wages, and in the advan-
tages of "family and social life." The factory certainly had the ad-
vantage in hours.

> The average factory hours are from seven in the morning till six in
> the evening, with a chance of working over-time, which, in busy sea-
> sons, means until nine o'clock. This leaves most of the evenings and
> Sundays free. The average hours of household labor are from six in
> the morning to eight at night, with little difference in seasons. There
> is one afternoon a week, with an occasional evening, but Sunday is
> never wholly free.

However, despite the tempting amounts of leisure time open to
the factory employee from nine in the evening until seven in the
morning, job security was greater in the home, as were wages

> if we consider not alone the money received but also the opportunity
> offered for saving money. This is greater among household em-
> ployees because they do not pay board, the clothing required is sim-
> pler, and the temptation to spend money in recreation is less fre-
> quent.

However, opportunities for increased wages exist in a factory: a
forewoman could earn "a permanent salary of from fifteen to
twenty-five dollars a week" as opposed to the four dollars a week
earned by the average factory girl, and the wages for household
work, which ran from two dollars and fifty cents to six dollars a
week. If the factory girl lived at home, her costs for board were

Jane Addams

minimal, and she could put her salary toward helping her family. By contrast the domestic worker is cut off from her family, and is required to meet the whims of her employer, who sacrifices the cook's family life to the cause of her own family, which she considers sacred. Miss Addams pointed out that the poor are gregarious: "The girl is born and reared in a tenement house full of children." At school she is "in constant companionship with forty other children." The parties she goes to "are mostly held in a [crowded] public hall." Working in a factory, she "walks home with many girls . . . and mingles with [young men] in frank economic and social equality."

> If she is a cloak-maker . . . she will probably marry a cutter, who is a man with a good trade, and who runs a chance of some day having a shop of his own. In the meantime she remains at home, with no social break or change in her family and social life.

> All this changes if she takes a household job.

> The individual instead of the gregarious instinct is appealed to. The change may be wholesome for her, but it is not easy, and the thought of the savings bank does not cheer us much when we are twenty. She is isolated from the people with whom she has been reared, with whom she has gone to school, with whom she has danced, and among whom she expects to live when she is married. She is naturally lonely and constrained.

On top of all this there appeared to be some feeling against domestic workers "in the minds of young men". A nurse-girl will attract only "coachmen and unskilled laborers" and would have to wait twenty years until she was a housekeeper before a "skilled mechanic" would pay court to her.

> I have long since ceased to apologize for the views and opinions of working people. I am quite sure that, on the whole, they are just about as wise and just about as foolish as the views and opinions of other people; but that this particularly foolish opinion of young mechanics is widely shared by the employing class can be demonstrated easily. It is only necessary to remind you of the number of Chicago night schools for instruction in stenography, in typewriting, telegraphy, bookkeeping, and . . . similar . . . office work, and the meagre number provided for acquiring skill in household work.

Miss Addams then pointed out "the better social position of the office girl and the advantages" she shared with "factory girls, of lunch clubs, social clubs, and vacation homes." All this the domestic worker is excluded from by her hours, her "geographical situation, and a curious feeling" that she is "not as interesting as factory girls." On this minor note Miss Addams ended her talk;

she could hardly be accused of taking sides. The "office girls" crept into her talk at the end of it, a curious breed. They would not presumably marry cutters or coachmen. Perhaps "skilled mechanics" who repaired typewriters?

In a never-ending attempt to get a handle on female factory workers, the women heard Mary Kenney, of the American Federation of Labor, speak on the subject of organized working women. Kate Bond of New York said:

> It is a pitiful fact that instead of protecting wage-earning women by our recognition of them as members of a whole of which we too form a part, we too often pass them by and are heedless of their injuries.

This was not perhaps fair; the Ladies had been scouring around everywhere to find some working women to recognize. Miss Addams had presented these women as pasting labels on bottles in a jolly surge of comradeship and popping off to dances, social clubs, lunch clubs and vacation homes in their interminable leisure time. It was a relief to offer a sympathetic ear to the plight of Bohemian field workers and waitresses as related by Karla Machova:

> A woman working twelve hours in the fields earns 35 kreutzers a day . . . every rainy hour is deducted from her small earnings . . . Women occupy a very unfortunate position in manufactures, for more than seventy percent are paid wretchedly . . . A pitiful life is led by women in restaurant cafes . . . In the world famous Karlsbad and Franzenbad, waitresses must pay hotelkeepers, who are millionaires, one gulden and twenty kreutzers [for broken dishes] . . .

Kate Schirmacher, the secretary of a German women's rights organization, spoke on "Poor Marriage Prospects in Germany." There were not enough husbands to go around in Germany, and the ones that were available were no prize packages either. Any woman with any self-respect would want a man who was her equal "in strength of will and tenacity of purpose." Surrounded by a lot of absentminded, apologetic male incompetents,

> She supports herself, so need not marry in order to obtain the regard due to a useful member of society.

Alice Timmons Toomey of California took a somewhat different tack: she thought that women could improve their marriages by becoming self-sufficient. She spoke without regard to class, although she implied that she spoke of middle-class women who could choose to work or not. Professional women had, quite naturally a strong hand in the Congresses: lawyers, ministers, businesswomen, writers, educators and—an innovation—actresses.

Georgia Cayvan

Julia Marlowe

The social position of the actress was still a question; the Congress organizers therefore might have been considered daring to schedule talks on "Women and the Drama." The first speaker on this subject was Georgia Cayvan, who had taken leave for two nights from a St Louis engagement in *Americans Abroad* and whose chief asset was her "own sweet personality." Miss Cayvan said that it was the duty of the public to "demand and endorse legitimate drama rather than the sensational, the degrading, the sensual," and "to distinguish between talent and notoriety . . . to honor gifted womanliness rather than brainless beauty." She had commented earlier on the Woman's Building and her hope that it would awaken men to women's abilities but had made it clear that she did not want the vote. "I love a womanly woman," she said, sweetly, "one whose respect and love for her sex leads her to every effort to improve the condition of her sisters." In what could be called a contradictory statement, she said proudly at the Congress that the stage "was the pioneer in granting to women the privileges which in other intellectual callings they are still striving to compass; the first to rise above the narrowness that makes sex a barrier to success." The women of the stage, she said, had "by their convincing genius . . . made a breach in the wall of prejudice." It was a hard struggle, but it had begun earlier than the other fights for women's rights, and so actresses had the advantage of other professional women.

Clara Morris, a forty-five year old star of domestic melodramas was "in an agony of anxiety all day" before her speech. When it was over she wrote in her diary "Fine—lovely day—so happy to be free." Another nervous actress was Julia Marlowe who had not yet achieved great fame as a Shakespearean actress. The night before her Congress speech she played Imogene in *Cymbeline* in Chicago: Frank Millet sent her a congratulatory telegram and gave her a guided tour of the Fair.

The actresses spoke on the history of women on the stage. Helen Modjeska was no exception—she talked about the medieval drama. However two days later she gave a talk on women in Poland, which was one of the most memorable given at the Exposition. May Wright Sewall asked Miss Modjeska to speak because the delegation of Russian Polish women who were supposed to speak in a series of national addresses, were frightened of saying something inimical to their government, and sent a few "statistical notes" instead of coming themselves. Madame Modjeska described the experience:

Mrs Sewall, who for years has been my friend, put such pressure on me that I finally consented.
I had only half a day to get ready. I scrambled through some of the statistical material of Poland and made a synopsis . . . The auditorium was packed, and I had some difficulty in reaching the platform.

The beginning of my speech was an excuse for the absence of my countrywomen . . . I explained that they could not do anything so independent as speaking freely upon the situation of Polish women under the Russian and Prussian government, and then I sketched a few pictures of our existence, such as I knew and had read about. Warmed up on the subject, and trying to arouse the sympathy of the brilliant audience for our cause, I was probably not careful enough in the choice of my expressions, but I said such words as my heart prompted me.

Helena Modjeska

The audience was moved; her speech, which she gave wearing the red and white Polish colors, was praised by the press, which made "scathing comments" upon Russia. When Madame Modjeska's words reached Europe, a Polish nationalist called her

. . . not only a meteor of artistry . . . but our Joan of Arc. She is the new Pulaski, risking her life for the freedom of the homeland . . . Poland cannot thank her enough for daring to speak out for the oppressed.

The actress sent a volume of collected Congress speeches to her niece in Poland; since it never arrived she believed it had been confiscated by the authorities. The text of her speech was sent to the Czar, who did not take kindly to it; she was banished from Poland for life.

Many women from countries with oppressive and backward governments were asked to speak at the Congresses. Callirrhoë Parren of Athens described the exclusion of women from public office and industrial employment in Greece, where women had no political rights and had only recently been admitted to the universities. For seven years Madame Parren had published a newspaper which discussed women's issues and which was read by men and women alike. Undeterred by reproaches and insults, she discussed unjust laws; she had just completed the first volume of a projected twelve volume history of distinguished women. She represented ten Greek women's organizations which indulged in philanthropy; she considered this the path of the future, and constantly "exhorted women to energetic work, by which alone complete happiness can be secured in this world." She detested particularly the "pernicious class" of dilettante or unemployed upper middle-class women. American women, she believed, were the most progressive in the world.

Delegates from some Latin and Oriental countries did not admire America's lead in this regard. Catalina D'Alcala of Spain said disdainfully that in her country protection was more significant than rights. "The fact that so many women are self-supporting in America does not argue favorably for the gallantry or ability of the men," she said, getting it all wrong. Martha Sesselberg, of Brazil said emotionally that Brazilian women were born to be

Callirrhoe Parren

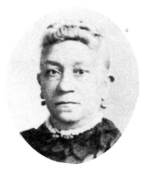

Sarah Early

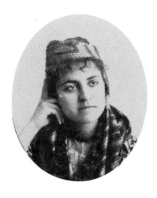

Hanna K. Korany

"homemakers, housewives and mothers. Their home is their world; for that they live, and for that they could die." Hanna K. Korany of Beirut was another apostle of negativism; clad in Syrian garments, she demanded to know why women wished to push into the world of men where they were not wanted; woman, she said, "should be thankful and happy in her place in creation . . . it would never do to have the sexes labor in the same field of action." Madame Korany herself spoke excellent English; she was an author and lecturer and was in charge of her country's exhibit at the Woman's Building. She spent many of her evenings at the Oriental Café's in the Midway Plaisance.

Black women spoke at the Congresses. Fanny Jackson Coppin, the ex-slave who had graduated from Oberlin College, and had had bitter words to say about the performance of the Board of Lady Managers in connection with women of her race, gave a soft and optimistic speech:

We, as you know, are classed among the working people, and so when days of slavery were over, and we wanted an education, people said, 'What are you going to do with an education?' You know yourselves you have been met with a great many arguments of that kind, 'Why educate the woman—what will she do with it?' An impertinent question, and an unwise one. Rather ask, 'What will she do without it?' We are getting a better education all through America. I cannot think that the selfishness, the discourtesy, that would push down a poor, weak, innocent creature because it could not protect itself will long remain in America. It is bound to succumb to the better education that is everywhere being given, 'til people will call it after awhile by its right name, vis: very bad manners.

This rather bizarre description of racial hatred was calculated to raise the hackles only of the most recalcitrant Southern women. The general tone of the black women was uplifting: Fannie Barrier Williams spoke on "The Intellectual Progress and Present Status of the Colored Women of the United States since the Emancipation Proclamation." She wished to demonstrate "the steady and sure development from a degraded peasantry toward a noble womanhood" in what she called "the next phase of the Negro question." A more interesting speech on "The Organized Efforts of the Colored Women in the South to Improve their Condition" was given by Sarah J. Early; Hallie Q Brown was present to lead this discussion.

On May 21 the Congress of Representative Women came to a triumphant end with a concert given by an all-woman harp orchestra. Eighteen ordained women ministers delivered the closing prayers.

In the Woman's Building a series of small Congresses had begun on May 15. Mary Eagle was the Chair for these speeches, which had been planned, like the World's Congress Auxiliary, to

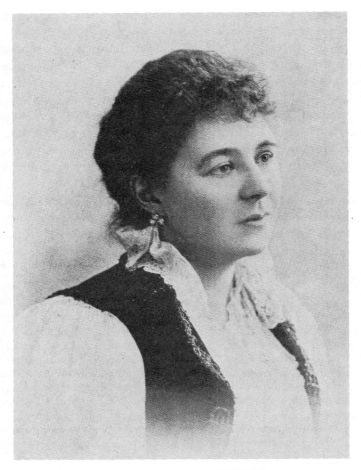

THE COUNTESS OF ABERDEEN.

add intellectual flavor to the circus atmosphere of the Fair. Mrs
Eagle, whose husband was the Governor of Arkansas, said, "Hun-
dreds of people, weary with seeing the marvels of material handi-
work shown at the Exposition, were glad to find a quiet seat in our
pleasant Assembly Hall." Mrs Eagle found the speakers, arranged
schedules and publicized the events. The speakers came from
thirty-five states and twenty-four countries; their topics ranged
from "Assyrian Mythology" and "Cholera in Hamburg" to "A
Turkish Bath in Every Home." Women were culled from the Fair
itself: May French Sheldon spoke on "An African Expedition";
May Wright Sewall on "Culture: Its Fruit and its Price"; Annie
Jenness Miller on "Dress Improvement", a subject which appar-
ently could not be exhausted; Lady Aberdeen on "The Encourage-
ment of Home Industries"; Ellen Henrotin on "The Financial
Independence of Women"; Mary Newbury Adams on "The Influ-
ence of Great Women of the Past"; Vinnie Ream Hoxie on "Lin-
coln and Farragut", her two subjects for statues; Kate Marsden
on "The Leper"; Mary Garrett on the education of the deaf; Julia

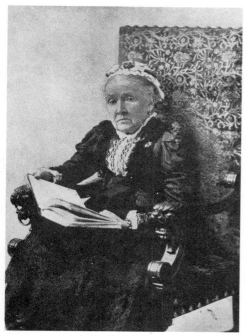

Julia Ward Howe

Laura DeForce Gordon

Ward Howe on "Woman in the Greek Drama"; Sarah Hackett Stevenson on "The Women of Chicago" in which she grimly expressed the hope that certain Chicago women would not let a lot of adulation go to their heads, and Lucy Stone on "The Progress of Fifty Years."

In addition to these, there was another series of lectures in the Building in the afternoon arranged by Helen Barker of South Dakota as part of the industrial exhibits. These were half hour talks of a practical nature, geared to working women. Julia Ward Howe had suggested them. They were modeled after her popular "Twelve O'clock Talks" eight years before at the New Orleans Fair; at that time all the speakers were not women.

Mrs Eagle noted that almost any topic served as a variation of the theme of "Woman's Sphere." She said tongue in cheek, "Not one of these women undertook to define man's sphere or keep him in it." Laura DeForce Gordon spoke in the Woman's Building Congresses on "Woman's Sphere from a Woman's Viewpoint." She disliked the domestic sphere and its "innocuous desuetuede." Henceforth, she said, "and forever, woman's sphere in life will be defined and determined by herself alone."

A certain amount of defining went on behind the scenes. Laura Hayes, always ready with a quip at someone else's expense, had reported to Mrs Palmer the year before that "Mrs Cooke thinks it unfortunate that Mrs Barker is to speak." Quoting Mrs Cooke, Miss Hayes said Mrs Barker was "rather uncultivated and uses such queer expressions." Of course, Laura Hayes added, she herself disagreed with this nasty evaluation: she thought Mrs Barker was a good speaker. And in fact Mrs Barker's talks were well received. Mrs Henrotin was considered to have a "clear but monotonous voice" and Emma Dunlap had an "unfortunate manner."

Lucy Stone's speech at the Congress in the Woman's Building was her last. She was to return in August to address the Auxiliary's Suffrage Congress, but by then she was too ill to come; her husband Henry Blackwell took her place. She died on October 18, 1893, of cancer at her home in Dorchester, Massachusetts. She was seventy-five. The Board of Lady Managers sent a telegram to her family: "The world is poorer for the departure of one who has enriched humanity by the grandeur of her spirit." Floretta Vining, a disciple of Mrs Stone's, put fresh white roses around the base of her bust in the Woman's Building every day for the remainder of the Fair.

Lucy Stone's speech reflected optimism. She pointed with pride to the growth of charitable organizations run by women, new colleges for women, laws which gave married women the right to own the copyrights of their own published works: "These things," she said, "did not come about by themselves. They could not have occurred except as the great movement for women has brought them about."

Fifty years ago [she said] the legal injustice imposed upon women was appalling. Wives, widows and mothers seemed to have been hunted out by the law on purpose to see in how many ways they could be wronged and made helpless. A wife by her marriage lost all right to any personal property she might have. The income of her land went to her husband, so that she was made absolutely penniless. If a woman earned a dollar by scrubbing, her husband had a right to take the dollar and go and get drunk with it and beat her afterwards. It was his dollar. If a woman wrote a book the copyright of the same belonged to her husband and not to her. The law counted out in many states how many cups and saucers, spoons and knives and chairs a widow might have when her husband died. I have seen

Lucy Stone

many a widow who took the cups she had bought before she was married and bought them again after her husband died, so as to have them legally. The law gave no right to a married woman to any legal existence at all. Her legal existence was suspended during marriage. She could neither sue nor be sued. If she had a child born alive the law gave her husband the use of all her real estate as long as he should live and called it by the pleasant name of "the estate by courtesy." When the husband died the law gave the widow the use of one-third of the real estate belonging to him, and it was called "the widow's encumbrance." While the law dealt thus with her in regard to her property, it dealt still more hardly with her in regard to her children. No married mother could have any right to her child and in most of the states of the Union that is the law to-day. But the laws

in regard to the personal and property rights of women have been greatly changed and improved, and we are very grateful to the men who have done it.

Mrs Stone traced the beginning of the woman's movement to the fight for abolition, when the Association of Congregational Churches issued a "Pastoral Letter" against the public speaking of women, and

the press, many-tongued, surpassed itself in reproaches upon these women who had so far departed from their sphere as to speak in public. But, with anointed lips and a consecration which put even life itself at stake, these peerless women pursued the even tenor of their way, saying to their opponents only: 'Woe is me if I preach not this gospel of freedom for the slave.' Over all came the melody of Whittier's:

'When woman's heart is breaking
Shall woman's voice be hushed?'

MEETING AT THE OPENING OF THE WOMAN'S CONGRESS.

Sallie Cotten

XXI THE SUMMER SESSIONS: NOT ENOUGH OF THE DUCHESS

 he resentments and irritations which had been boiling through the Board of Lady Managers for months were exacerbated by the opening ceremonies of the Fair. At a Board meeting on April 28 Katharine Minor offered a proposal, intended to help dispel some of these angry feelings, which was a revised version of the proposal she had unsuccessfully offered in October of 1892: that the Committee on Ceremonies should have a revolving membership so that all the Ladies could have a chance to meet distinguished visitors, and charges of favoritism would be dropped. The revised proposal called for a division of the Board into six sections, each of which would be on official duty one month for the six months of the Fair. Thus the entire Board would not have to meet again, although a meeting of the entire Board during the summer was provided for by Congress in the budget for 1893. Those funds could be returned to the Commission. Miss Minor's motion was seconded by Isabella Beecher Hooker.

Adoption of this motion would wipe out the Committee of Ceremonies. Mary Logan, as Chair of that Committee, had objected the previous October to the first Minor proposal and had offered an alternative at that time: that the President appoint a standing committee equal in number to the Committee on Ceremonies, which would "co-operate" with the Committee "in matters of ceremony at the opening of and during the Exposition." Mrs Palmer was to be ex-officio chair of this new committee. Mrs Reed had seconded Mrs Logan's alternative proposal and it had been adopted by the Board in place of Miss Minor's.

Now Miss Minor had come back again with another proposal aimed at destroying the Committee on Ceremonies and Mrs Logan's enviable position, since it appeared that the Ladies would never be at peace as long as the Committee existed. Once more, in April as the previous October, Mary Logan rose to object to the Minor proposal. A rancorous discussion broke out. Mrs Logan

rose once again to say that in the interests of harmony she was withdrawing her objection. There was an easing of tension and Miss Minor's resolution passed. For a moment it seemed that difficulties could be resolved. Then Mary Logan rose to speak again. She said that Miss Minor's resolution called for a meeting of an augmented Committee on Ceremonies; some of the money voted by Congress for a full meeting of the Board would have to be spent on this augmented committee. But Mrs Logan did not think that money voted by Congress for one purpose could be used for another purpose: in her opinion use of congressional funds for this revolving membership would be illegal.

Tension built up again; arguments broke out. Mrs Shattuck of Chicago asked that Miss Minor's resolution be reconsidered in the light of Mrs Logan's comment. The Ladies did not wish to do this, however; Mrs Shattuck's motion was voted down.

On May 1 opening ceremonies were held. Board sessions were suspended. Feelings were not suspended, however: all the Ladies could not ride with the Duke of Veragua and his party in the official procession, nor lunch in the Administration Building with the President of the United States, nor sit in a special place with visiting royalty and the wives of officials at the opening ceremonies of the Woman's Building.

Accordingly the air was electric on May 2 when the Board session recommenced. Virginia Meredith, one of the "favored few", chose the beginning moments of the session to rise and move that the entire action concerning Miss Minor's resolution be stricken from the minutes, on the grounds that her resolution was a violation of the privileges of the Board. Tempers flared; Mrs Meredith was voted down. Mary Trautman rose to move that the question should be considered. The Ladies agreed to this, but the general mood was not agreeable. Against a background of hostile murmurs and unpleasant comments, Mrs Reed, another of Mrs Palmer's friends, moved that the Board had better go into executive session for this discussion. Mrs Palmer accordingly asked the sergeant-at-arms to go through the room and make sure that all visitors left. Although this was done it was too late: the press was fully informed about the discord. On May 3 the *New York Times* noted that "a row was brewing" among the Ladies because "there was not enough of the Duchess of Veragua to go around."

With the room cleared, and only members and alternates present, Katharine Minor's resolution was read again. Mrs Straughton of Idaho then read Mary Logan's objections to the Minor resolution. At this point Mary Cantrill rose, trembling, and said that her request to meet the Duchess of Veragua had been ignored. Mary Cantrill had once been quite close to Mrs Palmer; she had fallen out of favor, possibly because of her ineptitude in the matter of the black women. Her voice quivered and broke as she sought

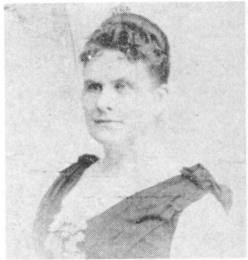

Katharine Minor

to enlarge on her wrongs, but it did not matter. She could no longer be heard. Her words had set off the violent outburst which had been gathering for months. Parliamentary procedures were forgotten: women shouted and screamed insults at one another. Everyone who had not been included in the luncheon with President Cleveland was bitterly hurt. A request had been made that a separate luncheon honoring the Duchess of Veragua be held at the Woman's Building with the entire Board in attendance. This request had been refused. Favoritism and cliques were destroying the Board. Mrs Palmer and Mrs Logan were accused of trying to run everything themselves; they had allowed only their "favorite few" to meet the Duchess. Mrs Logan always hogged the entertainment of distinguished guests. Some Ladies were doing all the hard work while certain others were getting all the honors.

Mrs Palmer, who was at least partly responsible for this unfortunate scene, sat appalled. Finally, pale and shaken, she pulled herself together and spoke above the uproar:

> I presume that all this discontent cannot have existed without some reproach upon me . . . I do not wish to make any defense or plea. Good intentions count for nothing . . . Congress is paying these ladies a per diem for their subsistence and I felt that for us to send a bill to Congress for a luncheon . . . would savor of junketing and that we had no right to do it. . .
> My time is too valuable, your time is too valuable, to be wasted in this way . . . We have thought we were working together as a band of women for something fine, representing the interests of women . . . that we mark an epoch . . . If I am mistaken in that estimate and we are all torn up and pulling hair over an introduction to a duchess, I have nothing to say to this Board except that I feel deeply humiliated.

With her uncanny instinct for the right word at the right time, Mrs Palmer broke the rage of the women: there was "an unparliamentary rush of weeping delegates to the speaker's stand." Despite the fact that the number of Couzins adherents had grown greatly during the past few weeks, and despite the general feeling of irritation with Mary Logan, a vote of confidence was given to Mrs Palmer and the Committee on Ceremonies.

Phoebe Couzins sat apparently unmoved during all the excitement. She had been described by the press as "the obdurate St Louis woman who never cries." Still existing at least verbally in the world of Edgar Allan Poe, she had told reporters that her treatment at the hands of the Board had caused her mother to die of a broken heart. She would never take the hand of a Board member until she had avenged her mother's death, she said. Miss Couzins' hollow presence cast a considerable pall over the sessions. Sitting around her were her devoted followers: Florida Cunningham, Cora Payne Jackson her former aide, Clara McAdow

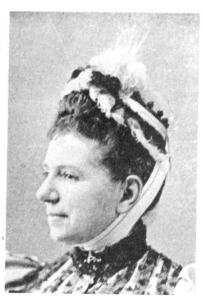

Duchess of Veragua

and Frances Dickinson. Her supporters included Mrs Brayton, Ida Ball, Matilda Carse, Rebecca Felton and often Isabella Beecher Hooker.

The Couzins faction created constant difficulties. On May 3 Clara McAdow introduced a resolution that 104 members of the Board be added to the Committee on Ceremonies; in addition, all members should, on their arrival in Chicago, register their names in the Secretary's office and note the length of time they planned to spend in the city. This suggestion carried a strong implication that some people were spending an inordinate amount of time in Chicago at the government's expense. Ida Ball added a motion that whether the Exposition were open on Sunday or not, the Woman's Building should close for the Sabbath. The response to these inflammatory ideas was muted; Mrs Palmer had broken the back of the rebellion.

Mary Kraut, an alternate from Chicago, wrote in the *Inter Ocean* that the Couzins dissidents were jealous of Mrs Palmer's "conceded ability, of her beauty, of her wealth and of her popularity . . . They could not sacrifice themselves to this Fair or anything else," and consequently they could not understand "in the slightest manner" Mrs Palmer's unselfishness. In fact Mrs Palmer had exhibited a regal side of her nature which could not help but gall the rugged individualists on the Board. One example of this was the manner in which Mrs Cleveland had been invited to the opening ceremonies at the Woman's Building. Mrs Reed and Mrs Logan, both believed to be "favorites", had called at the White House to present the invitation to the President's wife. On a white satin cushion lay a cream-colored Russian leather portfolio with silver corners and the words "Board of Lady Managers" embossed on it in silver. Inside the portfolio was the invitation, engraved on a plate of solid silver.

On several other occasions Mrs Palmer might have been criticized for taking her "queenly" status too seriously. On July 24, 1893 Charles P. Willard, a builder of steam launches and yachts, wrote to Potter Palmer, obviously defensively:

On Saturday afternoon as one of our steam yachts . . . came up to the Naval Pier the Captain was handed a note, stating that Mrs Palmer desired the yacht for a private party at 10 o'clock in the evening and instructions were given the Captain to hold his boat there ready to receive the party.

. . . the Captain waited until half past eleven when the lights were put out on the grounds and the gates on the Naval Pier were locked and everything indicated that the people had gone home. Presuming this to be the case . . . he started home to the North Side, only to find on his arrival at Pearson Street the carriages awaiting the party. As much as we regret this circumstance, we cannot feel that our Captain was entirely at fault as after waiting an hour and a half he naturally supposed, in the absence of any notification by messenger . . .

Mrs Palmer Leads an International Dance

that the boat would not be required. He of course would have waited
there all night if he had been advised the party was coming . . . We
were compelled to decline a number of passengers who wanted to
come home because we held the boat . . . for a private party. Regret-
ting the disappointment to Mrs Palmer but offering the above in
vindication of our own position, we remain. . .

Despite these lapses the President was popular. She was praised
for the manner in which she had handled the insurrection. The
Tribune cried, "Well done, Mrs Palmer!" On May 9 Henry Smith
of the Treasury Department sent his congratulations for the "suc-
cessful termination of the cyclone which was threatening." He be-
lieved the air had been cleared. The Ladies, he said, must now
realize that it had been necessary to remove Miss Couzins from
the Secretaryship; she had openly revealed herself as "a disturbing
element which would have practically disrupted the Board and
prevented the . . . magnificent results that have been achieved."

The fourth session of the Board had officially ended on May 5,
having commenced on April 26. Thus Mr Smith could safely con-
gratulate Mrs Palmer on having survived the difficulties of a con-
tinuing session which had encompassed the dangerous moments
of the opening ceremonies.

On May 11 Mary Logan, whom Phoebe Couzins had once
called "a marplot in petticoats," wrote to Mrs Palmer. Mrs Logan

was most decidedly not a member of the Couzins faction, but her attitude toward the President was ambiguous. As when she wrote Mrs Palmer about the "humiliation" she suffered at the sight of the murals in the Gallery of Honor, Mrs Logan's letter seemed designed to wound the recipient. She said that she had agreed to Miss Minor's "absurd" resolution only because she wanted Mrs Palmer to know that she would "surrender any opinion or wish of [her] own for the sake of harmony." She went on to imply that Mrs Palmer had made a hash of her job, mostly because she had neglected to ask Mrs Logan's advice:

> There were many things I wished to say to you touching the materialization of promises that might have been made to the public as to what women would do, and hoped that I might aid you in formulating some plan to meet the criticisms that are bound to come up in the future. Not from Miss Cousins, but from the public who have anticipated so much from the Women's Board, but I gave it up as hopeless and thought the kindest thing was to leave you alone.

May of 1893 was a month filled with tension for everyone connected with the Fair. Three hundred thousand people were expected to arrive for the opening week. Electric launches, rowboats and gondolas manned by genuine Venetian gondoliers floated on the lagoons; an electric train circled the Grounds on thirteen miles of track; the first Bureau of Comfort in the history of expositions provided first aid stations, public water closets and lounges. However, because of the bad economic situation, attendance at the Fair on May 2 was only 10,000. A few days later two Chicago banks failed. The Panic of 1893 had begun. The Directors asked that work crews be cut down. In order to encourage attendance, Frank Millet was made Director of Functions, taking over the duties of the Committee on Ceremonies. He arranged for parades, firework displays and special "days" to honor a mixed bag of groups and individuals: college fraternities, stenographers, "colored people", the shoe trade, the cities of Chicago and Brooklyn, Isaak Walton, North Dakota, Italy and the Ottoman Empire. Despite these actions, the average daily attendance for May came to fewer than 33,000. This was a fraction of what was expected, and needed: the prospect of financial failure was a very real one.

Although the effects of the Panic were to go on for months, the situation at the Fair began to improve by the middle of June. Admissions doubled. Ticket sales passed the million mark. By September more than two million dollars in tickets had been sold; in October more than three million. By Chicago Day, October 9, when more than 700,000 people came to the Fair, its financial success was assured.

As interest picked up, the Ladies and their staff were very busy indeed, since the Woman's Building was one of the most popular.

Mrs. Palmer's Office

In June the Board's offices were moved to the Administration Building so that the staff would not be distracted from correspondence and other work by events in the Building. Mrs Palmer remained in her Woman's Building office, which was decorated with the work of New Jersey fisherwomen who had been refused space in the Fisheries Building. There were stuffed fish, landscapes made of fish scales, clay models of women making eel pots and, over the President's desk, a huge fish net canopy. From here Mrs Palmer kept a close watch on her minions through telephone calls and the circulation of memoranda. She felt personally responsible for the performance of the Board. The Couzins-Isabella factions harped on the use of taxpayers' money: by 1893 Congress had given the Ladies $239,100, and organizations outside the government had entrusted them with $369,914.

Mrs Palmer was anxious that everyone should earn her salary or allowances. One Saturday she phoned the Administration Building from her fish-netted office and received no answer. Immediately she dashed off an agitated memo to Susan Cooke, demanding an explanation for the absence of the staff. Mrs Cooke

replied that Mrs Palmer appeared to have forgotten that the secretaries had been given a half-holiday on Saturdays, and pointed out that the clerks went without lunch, as a rule, and stayed after hours, typing reports and acting as stenographers at committee meetings. They were also swamped by piles of mail which had to be opened at once and often answered immediately. Saturday afternoon was the only time they had to see the Fair themselves.

Mrs Palmer, apparently unabashed, continued to be scrupulous about expenses. She remembered that in July, 1892, shortly after Miss Couzins testified before the House sub-committee on World's Fair expenditures, William Springer had assured Secretary of the Treasury Charles Foster that "the best interests of the Exposition will be served by allowing the ladies to control the expenditures . . . You will find the ladies much more economical in their expenditures and . . . better entrusted with the funds appropriated for their use, than any other Board or Commission." Mrs Palmer wished to live up to these expectations: when the Directors sent an expensive table to her offices, she asked them to bill her personally and remove the amount from the books. She wished the accounts of her Board separated from those of the profligate Commission; she did not want credit for her parsimony to go to the Commissioners rather than the Ladies. "The credit of a good business administration," she said, "would appear to belong to the Commission rather than to the Board itself." Henry Smith of the Treasury did succeed in disentangling the finances of the two organizations, but not until September, 1893.

Mrs Palmer did not want to have a second summer session in 1893; she said it was too expensive. But here the majority of those Lady Managers who had not been able to spend time in Chicago were annoyed. They were entitled to six dollars a day and the enjoyment of their accomplishments. They did not see why those women who worked in the Board offices should hog all the glory and the per diem emoluments too. Katharine Minor replied to these complaints that no one should envy the poor slaves on the Committee of Ceremonies. Ten women, with the assistance of a single clerk, who had to be shared with the Music Committee, had to write out 13,000 invitations and act as official hostesses to many times that number of visitors. In addition, they were under the strain of observation of complicated protocol and logistics. Every week it was necessary to rearrange the Building for a reception or a party of some kind.

Mrs Minor's defense could only rouse envy rather than soothe it. Lady Managers across the country were seething with the desire to write out invitations and serve as hostesses; to grapple with protocol and meet princesses and presidents; to rearrange furniture and hold receptions and to go to parties.

And indeed the Woman's Building was a center of hospitality.

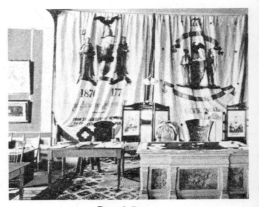

Board Room

MISS KATE FIELD.

"I SALUTE YOU IN THE NAME OF JONESVILLE AND AMERICA."

Apart from formal entertainments it provided, at the least, public benches and comfortable reception rooms. Kate Field had noted that the Building was "more receptive to people than [to] exhibits"; this was a slap at the crowded exhibit rooms but a compliment to the comforts the Ladies provided. The *Illustrated American* noted this, too: "The women alone break through the rule of repelling the public, and provide seats for their guests."

On May 19 the Board held a formal reception in honor of the Congress of Representative Women, then in session. Six hundred invitations were sent to Chicago women's clubs, and foreign and state officials. Dinner was served in the Corn Kitchen. On June 7 Sophia Hayden was honored at a ceremony attended by 200 people: she was given a commemorative pendant which she received with "charming diffidence." Mrs Palmer expressed the Board's appreciation for the architect's accomplishment, which she called "a lasting monument to her genius and a source of pride to women for all ages to come." On July 31 a reception was given in the Assembly Room for Secretary Carlisle and his wife. One thousand people were invited, the Assembly Room was garlanded and elaborately decorated, a Mexican string band was hired and refreshments were served once more in the Corn Kitchen. On the afternoon of August 4 a group of "Vikings" were honored; they were Norwegian seamen who had crossed the ocean in a "frail bark" approximating a medieval Viking ship. Their purpose was to celebrate the journeys of Leif Ericson, whom they wished to remind people had preceded Columbus in the discovery of America. Phoebe Couzins left her Mining and Beekeeping duties to give the address of welcome. On August 25 there was a banquet for men and women judges on the awards juries. Tables were set up in the Assembly Room. In this same room a reception was given for Frederick Grant, the son of the President, and his wife Ida Grant Mrs Palmer's sister; both had helped Mrs Palmer with Austrian negotiations from the Embassy in Vienna.

On August 25 the government allowed West Point cadets to leave their camp for only the second time in its history, to visit the Exposition. The Ladies held a grand ball for them and all members of the military available in Chicago. The Gallery of Honor was cleared for dancing. Music was provided by the West Point and Exposition bands. The exterior of the Building was illuminated by electricity and decorated by Frank Millet with patriotic bunting. Dance cards bore the U.S. flag. It was an elegant evening, with officers dancing with ladies in full ball regalia. Two thousand invitations were sent out. The evening closed with the inevitable refreshments from the Corn Kitchen.

Despite all this activity, the great event of the season was the reception given for the Infanta Eulalia. The Infanta, representing the Queen of Spain, was the highest ranking royal personage to

visit the Fair. Republican sentiments were severely strained as the Committee of Ceremonies prepared to receive this lady. On June 7 more than 6000 spectators crowded into the Building to see the Infanta bow graciously to the Lady Managers, and bear herself graciously to bystanders. She visited the Spanish section of the Building, which was festooned in satin ribbons in the colors of Spain. The Infanta's behavior was impeccable.

On June 9 Mrs Palmer gave a reception for Eulalia at the Palmer house on Lake Shore Drive. Mrs Palmer had naturally pulled out every stop for this occasion: a magnificent banquet was planned, to be attended by the cream of Chicago society and all the available dignitaries of the Fair. Mrs Palmer had even set up a sort of throne on a dais for the Infanta to sit in.

The Infanta, however, had other ideas. She had spent the previous day wandering incognito through the Midway Plaisance, smoking cigars, and was tired of official appearances. Besides, she was staying at the Palmer House and, having inquired about the similarity in names, had been told that Mrs Palmer's husband owned the hotel. Annoyed, she announced that she could not be received by "an innkeeper's wife." This remark swept swiftly through the city, causing embarrassment to her diplomatic aides, who finally prevailed upon her to make an appearance at the reception. It was pouring rain: Eulalia arrived late, with wet white satin slippers, and in a foul temper. She sulked through the supper, snubbed Mrs Palmer, made hostile remarks about Chicago's weather and social climate in general and left early, to everyone's relief.

Mrs Palmer knew quite well that although everyone sympathized with her, many were delighted to see her get what they would consider a deserved comeuppance. When she recovered sufficiently, she wrote to Mr Gresham, a State Department official whom she knew socially, compaining about Eulalia. Mr Gresham replied on June 19:

Infanta Eulalia

Your letter of the 15th instant, just received, confirms the impressions I had formed as to the Infanta's conduct at Chicago . . . If you are invited to a friend's house, it is not expected that you will inform him in advance how it will be agreeable to you to be received and entertained. To be frank, I did not give you all the real impressions as to the Infanta's character. I did not wish to prejudice you against her. While she is rather handsome, graceful and bright, she is effusive and insincere. Certain things had occured before your reception which convinced me that neither I nor Mrs Gresham should be present. The Queen's minister, if not the Queen herself, is not above playing small tricks, and inasmuch as I am writing confidentially, I might include the Infanta in that remark. The Infanta treated you and the other Chicago people with gross impoliteness, and I feel indignant about it. You have done your whole duty and more, and have nothing to regret. The Duke of Veragua is a common cheap fellow. In short, I have no desire to again take any part in the reception and entertainment of Spanish guests.

Wall of Board Room

Mrs Palmer could take heart from this letter, and also from the undisputed fact that she was one of the most popular officers of the Exposition. She remarked once, with amusement, that she had been told that she was the next Fair attraction "after the Ferris Wheel." She was asked for scraps of her dresses to be sewn into quilts and to be used, along with locks of her hair, for the creation of Bertha Palmer dolls. A Lady Manager wrote her that a doll dressed by Bertha Palmer would bring more money "than one dressed by any other lady in the U.S. or any land." Mrs Palmer refused however to provide dolls for charity or to give tombstones to the poor, or to endorse feather mattresses, face creams, baking powder, rolled oats, or plans for city sewers or bicycles. She was not grim about it. On December 1893 she wrote to an acquaintance:

> I was very much amused to see that some Cuban manufacturer had done what I had always refused to American manufacturers, and that was to use my name on the brand.

She requested some boxes of these cigars for her "personal gratification and amusement" and to give to friends as a joke.

Songs, plays and books were dedicated to her. Demands for her photograph were incessant; she rarely had an extra one to give to a friend. Her picture appeared in fashionable magazines and other journals. Babies were named after her. She wrote to Mr Curtis in March, 1894, that she really had had no time to enjoy the Exposition:

> One of my great regrets in connection with the whole Exposition is that my time was so taken up with tedious routine work that I had very little opportunity to enjoy the Exposition . . . Many of the principal Exposition buildings I was never in; in fact I was in only three or four of them and then by chance or to meet appointments with commissioners or individuals.

Possibly this was another reason, apart from finances, that Bertha Palmer did not want another session of the full Board held that summer. All reports, she said, could be presented at a final session in October. The Ladies protested that they had to appoint jurors for the awards juries. The atmosphere was tense. Rebecca Felton wrote her husband that "Mrs Palmer is showing favoritism and particularity." Reluctantly, with foreboding, the President heeded the call of her constituents and called a general meeting for July 1893.

One of the delegates who came to this session was Sallie Sims Southall Cotten, an Alternate from North Carolina. Mrs Cotten was typical of many Lady Managers. Her husband was a wealthy planter. Before the Exposition she had tended her six children,

A Corner of Board Room

contributed homemade pickles to local fairs, and run a school for
plantation children. She kept a journal, during her time in Chi-
cago, which offers a lively first-hand account of the Fair. She had
given the Woman's Building a desk made of white holly from
Roanoke Island; it was called the Virginia Dare Desk in honor of
the first English child born in the New World. In 1901 Mrs Cot-
ten was to publish a book called *The White Doe or The Legend of Vir-
ginia Dare,* dedicated to the Colonial Dames of America, "whose
patriotic work" had "stimulated research into an important and
interesting period of the history of our beloved country." The Vir-
ginia Dare Desk was placed in the Board Room where the Ladies
held their stormy summer sessions. Mrs Cotten attended them all.
She was somewhat removed from the quarrels, but her sympathies
lay with Mrs Palmer in the main. For the rest, she enjoyed the
Fair:

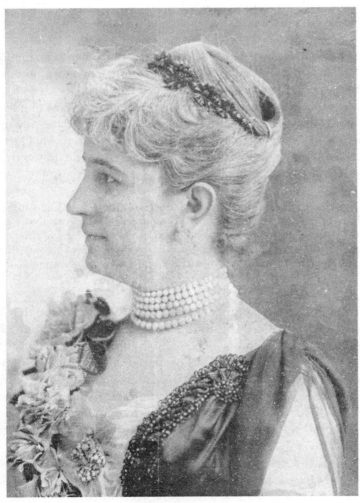

Bertha Palmer

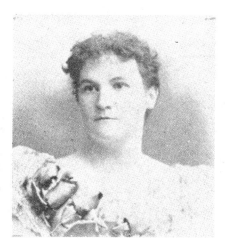

Florence Kidder

July 7, 1893

. . . Here I am! again in Chicago to attend a special session of the Board of Lady Managers, where I have the privilege of again serving in Mrs. Florence Kidder's place. I am indeed a fortunate Alternate in so often being permitted to enjoy the privileges of my principal. Arrived via C&O R.R. at 6:30 A.M. Attended meeting of Lady Managers at noon in spite of my fatigue.

I find that the object of the call is that the Board may confirm the names of women nominated for the Juries of Award.

No words can ever describe the wonder of the Exposition as I find it here. I shall not attempt it, but will try to jot down each day what I do and where I go so that in after years it may bring back to me some of the pleasures of my stay in the beautiful White City in Lake Michigan.

Saturday July 8

. . . At the meeting of the Board, Mrs. Wilson's name was called among the jurors. I spoke and endorsed it, and found afterwards that she was in the room and heard me. So for once an "eavesdropper" heard good of herself. Miss Cunningham of South Carolina made personal remarks about Mrs. Kidder which made me mad, but all the others say lovely things about her.

Heard the Leiderkranz Club [a singing society] in the Assembly Room. . .

COLUMBUSES OWN RELATION ON HIS OWN SIDE, WITH HIS WIFE AND DAUGHTER.

I find my Virginia Dare Desk looks well in the room where the Lady Managers meet and attracts attention and is much admired. I am satisfied with its position. Mrs Bartlett and I are growing great friends, and our attraction for each other at the first meeting is ripening into genuine friendship. I explained the desk to her and she explained to me the beautiful silver table she has in the Woman's Building from New Mexico. That wonderful Woman's Building — it is full of beautiful things, and the Lady Managers have cause to be proud of it, and they are proud of it.

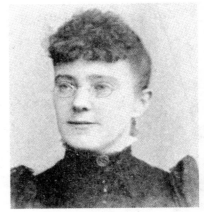

Mrs. Edward Bartlett

Monday July 10
. . . Attended a meeting of the Board which was *stormy*. We were interrupted by news of a dreadful catastrophe — the burning of the cold storage warehouse — on the grounds — and a dreadful loss of life. [Later went to the] New York Building where I met the Princess — from Bombay . . . to me simply a negro woman, wearing a singular type of dress, yet having a gentle voice and good English accent — I do not know why N.Y. was giving her a reception. . .

Tuesday July 11
. . . Attended meeting of the Lady Managers at 1 P.M. Stormy debate about appointments for the Juries.

Wednesday July 12
. . . Lady Managers held another turbulent session. Souvenir Quarters were distributed to the Lady Managers. After Board adjourned . . . attended reception in the *tent* of Mrs. May French-Sheldon — the great African traveller. Had the privilege of drinking iced champagne from the cup which she used through all her travels. Mrs. Sheldon is a fluent talker, a deep thinker, a brave actor, a good true woman.

Thursday July 13
. . . Went at the invitation of Mrs. Price [of North Carolina] to help her arrange her room [the "Homespun Room" used by women of the press] in the Woman's Building.

Friday July 14
. . . In Lady Managers meeting we confirmed women jurors. Stopped with Mrs. Bartlett at New Mexico House, after which we went to see the trained animals on Midway.

July 15 Saturday
. . . The Board went to see 'Buffalo Bill' by special invitation. Enjoyed it very much. After the performance went with Mrs. Wise [of Virginia] to Col. Cody's tent and met him and his wife in their real personality.

This visit to the Wild West show was the indirect result of the Board's discussion about whether the Fair should be closed on Sundays. Frances Willard took the position that the Sabbath should be remembered, to keep it holy. Susan B. Anthony, however, representing the suffragist "radical" faction, believed that

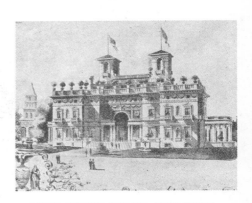

NEW YORK STATE BUILDING.

Infanta Eulalia

the Fair should be open on Sunday so that working people could
attend. Miss Anthony, although not a Lady Manager, was often
mobbed by women at the Fairgrounds who were anxious to shake
her hand. She was asked whether all this hand-shaking did not
tire her. She replied that it did tire her, but "not half so much as it
did thirty years ago to stand alone with no hands to shake at all."
While the Sunday closing argument went on behind the closed
doors of the Board rooms — where the Ladies were to eventually
accept Miss Willard's point of view — Miss Anthony, was ap-
proached in the hallway by a clergyman who was filled with indig-
nation by her stand. He asked her whether she would like a son of

hers to go on Sunday to Buffalo Bill's Wild West show? She replied that she would, and that she thought "he would learn far more than from the sermons in some churches."

Colonel Cody, amused by this story, offered Miss Anthony a box at any performance she chose of his show. She hesitated, but was urged to attend by her friends. Anna Howard Shaw, one of these friends, later described the event:

> Others heard of the jaunt and begged to go also, and Miss Anthony blithely took every applicant under her wing, with the result that when we arrived at the box office the next day there were twelve of us in the group. When she presented her note, the local manager said, 'A box only holds six.' Miss Anthony, who had given no thought to that slight detail looked us over and smiled her seraphic smile. 'Why, in that case,' she said cheerfully, 'you'll have to give us two boxes, won't you?' The amused manager decided he would, and handed her the tickets. When the performance began, Cody entered the arena, rode to the boxes, and swept his hat to his saddle bow in salute. Aunt Susan rose, bowed in turn, and for a moment as enthusiastic as a girl, waved her handkerchief at him, while the big audience wildly applauded.

Miss Anthony had a good time at the Fair. Her diary entry May 1 reads

> World's Fair opening — I found many friends in the Woman's Building — Mrs Palmer's address very fine — covering full equality for women.

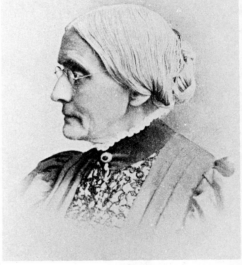

Susan B. Anthony

She did not note that Mrs Palmer had omitted to mention the franchise. Miss Anthony went to dinner at Hull House, to parties at the home of suffragist Lydia Coonley, rode on a steam launch and saw the Fair sights. She was invited to parties given at Mrs Palmer's house and shown every courtesy by the President of the Board. Miss Anthony was aware of Mrs Palmer's attitude toward suffragists; nevertheless she felt that Bertha Palmer "proved herself preeminently the one woman in the country for this place [as President]. Her record . . . is one of the most remarkable ever made by any woman."

As the summer wore on it was apparent that not everyone agreed with Miss Anthony. Sallie Cotten records on Tuesday, July 18:

> Interesting meeting . . . We completed confirming names of domestic jurors . . . in spite of Miss Couzins' protests and Miss Cunningham's 'noes'. After adjournment we all went to the Dairy Building at the invitation of Mrs Worley — one of our new jurors. Then with Mrs Mason of Tenn. to the Ethnological Building where we witnessed the unwrapping of a Peruvian *Mummy*. At 9 o'clock the Lady Managers gave a reception in the Assembly Room to Sec and Mrs Carlisle. Met another of our jurors — Miss Emily Sartain, an artist.

Besides Emily Sartain, who was principal of the Philadelphia School of Design for Women and who engraved mezzotints, the jurors included Zelia Nuttall, the discovererer of the Mexican codes, and Mary Hollock Foote the illustrator whose pictures hung in the Library. Also Augusta Chapin, a minister, and Laura de Force Gordon, a lawyer, both whom spoke at the Congresses. Mrs Palmer had urged Mary Cassatt to agree to become a juror, but Miss Cassatt disapproved of artists' competitions, and would not allow her name to be entered. Another who did not apply for the jury was Rebecca Felton, who was always seeking employment, but whose husband wanted her at home. She wrote to him:

Your harsh words took all the life out of me and I want to go home ... I thought I saw a good chance to make some money but I shall not seek it — and there are thousands after it...

Mrs Felton was for once in an equable mood, but her husband put a damper on her spirits:

Except being obliged to stand in the cars and to see and smell cigar smoke at restaurant tables, I have nothing to complain of — I have my badge that ensures me protection anywhere. I feel so sorry to hear Dr Felton get in such tempers — and if I were not used to it and kept in perpetual dread of his doing and saying something unpleasant I should be heartsick all the time at home and abroad. I shall not apply for the jury place. It would be utter misery to have such letters coming here and every mail as the one I said.

Sallie Cotten went blithely on, enjoying her social engagements. On Wednesday, July 19:

... the reception at Mrs Cyrus McCormick's ... I went with Mrs Doolittle, Clark and others. Mrs McCormick is a lovely character but very deaf and uses an instrument. Her home is palatial but she is gracious and affable. Of course we are especially invited, as a Board, to this reception—else I should not note it here.

Thursday, July 20th
... Saw Venetian glass blowing — and they gave me a Souvenir *glass pen handle.* Saw the German Village, the Constantinople Bazaar, etc. After an exciting meeting, the Lady Managers attended the celebration of Queen Margarethe's Day in the Assembly Room.

Friday, July 21st
... Heard Mrs Brody of Texas deliver a fine address ... I am quite proud of the responsibility shown by our Southern women.
Nothing but endless discussion in the meeting of the Lady Managers. Discontent seems to grow from day to day and no one can see the end. I hope we will not disgrace womanhood in our debates.
I asked Mrs Palmer about my paper on a Virginia Dare Memorial Training School for Girls and she *has not even read it.* Well, she is busy

and much harrassed and does not care to read it, so I will not insist. I will push on without her, and see what I can do for girls. The Board of Lady Managers is so disintegrated by discontent and feelings of outraged justice, that perhaps it is just as well not to make it a board work. . .

Donegal Castle in the Irish Village

The President was indeed much harassed; the Board appeared to be disintegrating around her. The meetings on jurors and awards were inevitably discordant because Virginia Meredith was President, and Ida M. Ball of Delaware was Secretary of the Committee on Awards. Mrs Meredith was a friend of Mrs Palmer, and one of the "favored few." Mrs Ball, on the other hand, had always been a Phoebe Couzins partisan. Thus wrangling went on constantly over the appointment of jurors. Mrs Cotten was still relaxed and happy on Saturday, July 22:

> . . . Heard Mr Frank Cushing [of the Smithsonian] talk about *Corn* in the Corn Kitchen . . . heard a fine talk from a Mrs Monroe on 'Making American Citizens in the Public Schools.' Old Mrs Hooker gave an extemporaneous Suffrage speech—They say she does it everytime she can get a few minutes to talk in.
> . . . After the Board adjourned we had our entertainment on the roof—where Commissioners had been invited but very few attended. Mrs Cantrill was in her element as 'Toast Mistress' . . . Col. Fred Grant and wife [Ida Palmer Grant] were present and we had quite a pleasant time, although but a few gentlemen were present, and Mrs Palmer declined to respond to her toast.

The fighting over foreign jurors went on. The foreign countries had asked for foreign judges, saying that there would be suspicions of bias if only American judges were appointed. Fifty-nine foreign judges were therefore added by the Ladies, making 116 women judges instead of the original fifty-seven the Ladies were to have. As it was, the Ladies wanted still more foreign judges. It was necessary for William King, Vice Chairman of the Commission's Committee on Awards, to speak sharply to the Ladies on July 25, 1893:

> The allotment made to your Board is more than liberal on the basis of one woman as judge to every five and seven-tenths men judges.

The Ladies accepted the fifty-nine foreign judges "under strong protest." The Commission was growing impatient with them. The foreign appointees included Princess Marie Schahovskoy of Russia and Adele Depuy De Lome of Spain.

Mrs Cotten continued her activities:

Saturday, July 29
Attended reception in Lady Aberdeen's Irish Village—Blarney Castle—but did not kiss the Blarney Stone . . . With Mesdames

"I HATE TO HAVE YOU SMOKE, ULALEY—I HATE TO LIKE A DOG."

Bartlett and [Parthenia] Rue [of California] went to the Turkish Theatre as the guests of Madame Korani. The dancing is a wonderful gymnastic performance . . .

Tuesday, August 1st
This has been an unusually pleasant day . . . Attended in the evening to the Reception to Mrs Palmer. Lots of new Jurors were out—adorned with their new badges of honor. It is a great honor to have been a *woman* Judge in this Exposition. Woman is advancing very rapidly.

Wednesday, August 2nd
Went to the meeting of the Board at one o'clock. The Memorial Building was discussed but nothing settled . . . After adjournment we remained at Mrs Palmer's request—to have an *informal* friendly conference. A thrilling little episode! because Mrs Jackson withdrew and refused to enter a confidential conference. This action proves she intends to make public everything she knows.

Parthenia Rue

Mrs Palmer's intention in the "friendly conference" was obviously to close ranks against unpleasant publicity; it was too late for that. Mrs Cotten nevertheless had a good time again that Wednesday:

After nightfall Mrs Brown of Minnesota and Miss Ives of Conn. and I went down to the moving sidewalk to see the fireworks . . . The continual shifting beauties of the fireworks, reflected in the lagoon—the sparkling fountains, with continual changing showers of color flying into the air—the gondolas floating on the waters, with electric lights flashing everywhere . . . made a picture never to be forgotten . . . while the Ferris Wheel outlined in light against the sky looked like some magic wonder . . .

Thursday, August 3rd
Attended meeting of the Board. At 2 o'clock we adjourned to attend the Russian Concert in honor of Empress Marie—we having received invitations from Princess Schahovskoy . . .

Friday, August 4th
The meeting of the Board today was a very exciting one. The trouble between Mrs Ball and Mrs Meredith was the subject of debate. No result reached . . .

It was no longer possible to control the enmity between Mrs Meredith and Mrs Ball. Florida Cunningham of South Carolina, a Phoebite, charged that her state had been left out of the awards jury through Mrs Meredith's "malice." Anger and bitterness broke to the surface again: Mrs Meredith made a "scathing arraignment" of Mrs Ball, and Mrs Ball retaliated with a severe attack on Mrs Meredith. The Couzins factions vocally supported Miss Cunningham; the Palmer followers grouped under the Meredith banner.

Frances Ives

Mrs Palmer, harrassed indeed, had been working behind the scenes since late July, to have the Board session ended. She had written to that end to Henry Smith, her ally in the Treasury Department. On August 1 Mr Smith wrote Mrs Palmer that he had told Secretary of the Treasury Carlisle that "the work of the Lady Managers was practically ended, and there remained nothing but hair-pulling and wrangling." Mr Carlisle had responded "with decided firmness, 'Well, if that can be stopped, I shall do that also.'" He did nothing at once, however. Mrs Palmer was most dispirited. She wrote to Mary Logan:

> The questions over which the opposition makes so much trouble are never the same, but come up in a new form at every meeting, and we may always be prepared for a violent onslaught in regard to whatever is done.

Mrs. H. F. Brown

Miss Couzins, she said, wished to be restored as Secretary to the Board and be paid her cumulative salary. The juror appointments had caused "some feeling." Mrs Logan had been sympathetic; she appeared to think that Mrs Palmer might be driven to resign the Presidency. "You have been through an ordeal unparalleled," Mary Logan wrote to her on August 3. She said that if Mrs Palmer "had been permitted," she would have presided over the Board with "much credit to womanhood" and without such personal cost. Mrs Logan reminded Mrs Palmer that she had been "willing to lay aside any personal ambition for your sake," a reference apparently to the fact that Mrs Logan had been nominated for the Presidency and had stepped aside for Mrs Palmer.

The *New York Times* for August 6, 1893 carried a story under the kind of heading which Mrs Palmer had dreaded to see: "Lady Managers Disagree."

> The Board of Lady Managers indulged in another decidedly unpleasant wrangle today. It lasted about two hours, and in that time many unpleasant and disagreeable things were said, tears were shed, and many of the ladies gave vent to their feelings by hissing and uttering strange noises.
> Mrs Ball of Delaware, Secretary of the Committee on Awards, read a long complaint of Mrs Meredith, Chairman of the Committee. She frequently referred to Mrs Meredith as the "arrogant chairman of the committee" and said that when she could not attend she sent her sister to act as overseer, when the sister had no right to a seat in the committee. At frequent intervals the women expressed their surprise loudly.
> But the sensation came last when Mrs Ball said: 'and now, in conclusion, I desire to say that Mrs Meredith is an arrogant, malicious, ungenerous, vindictive woman.'
> Before she had finished these expletives half the women in the house were on their feet, many shrieking wildly. Others hissed and stamped their feet and some wrung their hands in despair. Mrs

Ida Ball

Palmer used her gavel vigorously, and called in vain for order, but the excited females paid no heed to her.

'Take that back! Take that back! Take that back!' shrieked one large woman.

'Put her out!' screamed another, and so the excitement continued. During all the uproar Mrs Ball, who is a pretty, black-eyed little woman, stood perfectly calm and smiled sweetly on the turbulent women who surrounded her. When, at length, order was restored, Mrs Ball repeated the sentence.

The uproar was renewed and continued for some time.

Mrs Ball then took her seat and in an instant Mrs Meredith was on the floor.

'So far as any difference that exists between Mrs Ball and myself is concerned,' she began in a tremulous voice, 'we can settle it ourselves. But when she says I sent my sister to preside as the committee head she tells that which is absolutely false.' Here the speaker broke down and began to sob hysterically. Then there was another scene of wild confusion. Everybody wanted to talk at once. Motions were made by the dozen, but nothing was done until Mrs Palmer, pale with excitement, succeeded in restoring the meeting to order.

Clara McAdow

Sallie Cotten noted events in her abbreviated fashion:

August 5th
The meeting of the Board of Lady Managers today was exciting—the difficulty between Mrs Ball and Mrs Meredith was again discussed. It is sad to see one woman try to pull down and injure another as Mrs Ball is doing. I deplore greatly, and the public I fear will *never* understand. . .

August 7th
They still had the matter of the Ball and Meredith trouble up and we voted that Mrs Ball be excused from the Committee. I felt that it was my duty to the Board to vote against her, while I was sorry to do so. . .

The *New York Times* reported that Virginia Meredith had in hand a letter to Bertha Palmer signed by every Lady Manager asking that Ida Ball be removed from the Committee on Awards. Mrs Meredith's announcement to the Board of this letter brought on another debate that lasted for three hours, and ended, as always inconclusively.

Thursday August 10th
Miss Couzins as usual 'protested' and 'challenged' but gained no ground. She is a great filibuster [sic]—and threatens to do much worse tomorrow.

Tonight with Mesdames Lockwood, Shattuck and Bartlett—went to see the Dances of Indian Nations, by Calcium Light—on a float out in the lagoon. It was under the management of Prof. Putnam and we had the pleasure of being in the boat with his wife.

Florida Cunningham

On August 8th a delegation of women—Persian, Greek and Arab—from the Midway Plaisance came to see the Board in session and to reap the benefit of "the society of civilized women." They walked into the arguments which had been going on for days. Their unusual clothes caught the attention of the Lady Managers who quieted down and attempted to behave in a civil and ceremonious fashion.

On August 12th the Secretary of the Treasury acted at last to stop the session, which had gone on for thirty-six days, longer than all the other sessions combined. The Couzins faction was not happy to see the session end; Florida Cunningham protested strongly, as did Cora Payne Jackson. Susan Cooke wrote to Mrs Palmer on August 11:

> A few moments after I met you I chanced to run into that Jackson woman in the Art Palace. She was belligerant as usual—and among other things told me that "they" had telegraphed Mr Carlisle to send the money belonging to the Lady Managers to Chicago. While I did not think for a moment Secretary Carlisle would listen to any such demand without a proper authority I felt that you ought to know.

At the last meeting the Chair stated that the Board of Lady Managers on August 8, 1893, had approved the request, signed by every member of the committee, that Mrs Ida Ball be excused from further service on the Committee on Awards. This request for removal came because of an article written and published over the signature of Ida M. Ball, which unjustly reflected on the competency and integrity of the Committee and its Chairman. "The charge of malice and incompetency, as expressed in this published article, was without cause, and the publication of the article itself, was in direct violation of a resolution adopted by the Board of Lady Managers on September 8, 1891." Mrs Ball had preferred charges against the Chairman of the Committee on Awards "all of which charges were unjust in spirit and false in detail." She had expressed the determination to support the Commission's Committee on Awards "right or wrong" without regard to the interests of the Board of Lady Managers.

On Saturday, August 14th Sallie Cotten noted in her journal:

Cora Payne Jackson

> The Board of Lady Managers adjourned *sine die* today. It was a great relief to many of us. I do not think the cause of women has been materially advanced by this session, although we appointed women jurors to act jointly with men, to do the same work and receive the same compensation. This is a great work and marks an era in women's progress, but other things which the Board has taken cognizance of—petty personal differences forced upon it—have really had a tendency to lower our standing as a body of advanced intelligent women working honestly for a specified object. It is all over now for

a season. The Board will probably meet again in October.
Mrs Bartlett returns to New Mexico tomorrow. I shall miss her very much—and many others.

The women were much embarrassed by their public quarrels. *The Woman's Journal* attempted to laugh it all off by commenting that worse things happened in the British House of Commons:

Paintings in Board Room

Members fell and were picked up by their friends to fight again. The whole space between the front benches was filled with a struggling, cursing mass of members, striking, clawing and upsetting each other.

Furthermore, it was said that when a Lady asked a reporter who had described a matronly delegate as "pitching into" another matronly delegate, the question, "How can you so misrepresent our meeting?" he replied with a knowing smirk, "If we don't report you that way, you won't be reported at all."

Mary Eagle said that the National Commission meetings were less than decorous. The women had been under special scrutiny, as women always were, but "the Commission owes us a vote of thanks for claiming public attention, when, except that a woman's board was more novel, that body could have furnished much more sensational reading." Teresa Dean, the *Inter Ocean* reporter, said that she was sorry the women's sessions had ended and she had only the men's to report. The Commissioners were so disorganized that she could sit for hours without hearing a point of order raised, while the Lady Managers were sticklers for parliamentary procedure. These Ladies often sacrificed themselves countless times out of respect for the law, "and that too," she added ambiguously, "in the midst of their sometimes using the machinery of the Board for personal motives."

Despite all this attempted face-saving, the Couzensites were unrepentant. On August 26 Florida Cunningham wrote a letter to Secretary of the Treasury Carlisle:

At the conclusion of [Mrs Palmer's address on the closing of the session] I arose and said, 'I move that we communicate with Secretary Carlisle and ask why it is that his *subs* take the liberty of sending these official telegrams purporting to dictate to us at the instigation of the Secretary of the Treasury, an immediate adjournment *sine die*. I protest against the use of such matter and under such circumstances.' My motion met with no second and a few minutes afterward we adjourned.
I voted against an adjournment for pertinent reasons. We had received only an approximate report of the condition of our finances, which was unsatisfactory, and which it was impossible for some of us to accept or approve. For without a detailed statement of the drain upon our Exchequer we could not legislate intelligently or in justice to ourselves. And I feel that it is our right and privilege to remain in

session as a Committee of the Whole as the official hostesses of the nation, representing the sovereign States and Territories that form this mighty government.

The problems with the session were obviously insoluble. And this despite the real knowledge of parliamentary procedure that the Ladies had gained during the years that they had been struggling with it. Kate Field reported that a National Commissioner had said of the Ladies: "They have done better work than we, and more of it."

Mary Logan's *Home Magazine* appeared just as the repercussions from the adjournment were beginning to die down. In this issue Mrs Logan tore into the whole proceeding:

Mary Logan

By their unparliamentary and unladylike course [the Lady Managers] have set back the cause of women a century, and have given additional evidence to the truth of the assertion that women will not work together without betraying their petty jealousies and rivalries . . . The separate exhibit of work both at Philadelphia and New Orleans proved fatal to the claims of women's superiority over men's work, and called attention to the insignificance of her achievements in the arts and sciences. At the very first session of the Board of Lady

Managers we heard much of the great opportunity offered to the women of the world by the noble men of America and that there would be no separate exhibit by women— that the Woman's Building would be used for the admission of articles of such preeminent merit that they would immortalize the genius of women—that all other exhibits were to be placed side by side with those of men, with perhaps a card here and there calling attention to articles in the production of which woman's labor had largely entered . . . This would have accomplished what turbulence, abandonment of plans, wrangling and the littleness of women have prevented, and instead demonstrated clearly the power of the minority to neutralize that of the majority . . . If the malcontents who unfortunately got into the Board had allowed Mrs Palmer and the noble women of this and all other countries to show what women have done and can do, womankind all over the globe would have been assured for the next century . . . Our reward is withheld because we could not withhold or reject the rebellious mercenary spirits from our Board.

This editorial did nothing to help the situation. Since names were not given many Ladies took offense. Mary Lockwood wrote to Mrs Palmer about Mary Logan:

She has never by word or deed done one stroke to help the work on . . . I have known her many years intimately and it has never occurred to me to give her the credit of helping women—in all these years I cannot recall one instance. My honest conviction is that Mrs Logan has done more injury to our Board than forty Phoebe Couzins could have done.

Mrs Palmer, upset at this latest blow from what she had once thought was a friendly quarter, turned for sympathy again to Henry Smith of the Department of the Treasury, who expressed his feeling that the article was shocking:

It is certainly a very astonishing production and I heartily join in your expression of astonishment and regret that it should have been written. It is very hard to feel that when you have done your best you should be attacked by your friends, or at least, made the victim of their wrath on others.

When the session ended, some Ladies stayed on in the city on the Board payroll. Mary Eagle was busy with the Congresses in the Woman's Building, Mary Lockwood with the Library and Amey Starkweather with numerous duties, among them the salesroom for crafts. Rebecca Felton, as we have seen, was forced to go home by her husband. Sallie Cotten's husband Robert was more well-disposed; she stayed on in a new post as custodian of the colonial exhibit mounted by North Carolina in the Government Building rotunda. On September 8 her husband joined her in Chicago. Together they had dinner on the Woman's Building roof, and visited the Midway.

Thurs Sept 14
[My companions] all went up in the Ferris Wheel but I remained below and waved to them as they rose on their aerial journey.

Sunday, Sept 17
After lunch Mr Cotten and I went out to Lincoln Park but there is not much to see after all. I am afraid that *everything* will seem small and insignificant after seeing this World's Fair.

Tuesday Sept 19th
Mr Cotten left today so I did not go to the Grounds until after he was gone . . . I feel quite lonely without my husband.

Monday Sept 25th
It was so very cold at the Fair today that I had to leave and come downtown and buy some flannel underwear. I have put it on too. I was afraid I would take cold . . . I also got me a fur cape and hope to be more comfortable. This staying from home so long is a very trying experience after all.

Monday, Oct 2nd
In spite of the rain (been raining all day) I went to the Woman's Building to see the Album presented to Mrs Palmer which was sent by the Queen of Siam. Very nice ceremony and followed by a nice "Tea" in the Tea Room—lately fitted up in the Woman's Building . . . The Album is beautiful—the embroidery on the cover was done by the Queen of Siam herself. It contains photos of the Royal Family and the principal buildings of Siam.
Met Col. Roberts—author of Roberts' Rules of Order—and we had lots of fun introducing him to Lady Managers . . . He is very clever

East India Tea Room

and entered into our jokes about our adopting his rules and then not
going by them. We were all introduced to the Siamese commissioner
and his wife, but it was very very formal as she cannot speak a word
of English.—The decorations were in white and red, Siam's colors,
and red flags with the sacred white elephant on them abounded.

Tuesday Oct 3rd
The Lady Managers will come again next week and I shall be very
glad to see them.

Wednesday Oct 4th
I hear today that Miss Couzins is very ill with pneumonia. The
Board meets next week.

Friday Oct 6th
Went to Mrs Cooke's office to see about my vouchers being paid as I
am now entered upon my third month's service and have not yet re-
ceived a cent of money.

It can be imagined with what trepidation Mrs Palmer looked
forward to the October sessions of the Board. Isabella Beecher
Hooker expressed what may have been a general feeling when she
issued a statement later in the month.

She said that if the Board should proceed without general ac-
tion there would

arise a complication that will involve a disagreement and perhaps
controversy. In such a controversy I do not feel inclined to partici-
pate. In view of this state of things I have decided not to attend the
meeting but to simply send in this protest. . .

Thus Mrs Hooker neatly protested and at the same time
avoided the tiresome wrangling that would inevitably ensue on
any protest. However the passions of the summer had died down.
The October meetings, which marked the end of the Fair, were
filled with a sense of ending that allowed the Board of Lady Man-
agers to perform their final duties with some shreds, at least, of
dignity.

Marie Blanc commented on the Board sessions during the Fair:

Let us overlook the petty rivalries which, if we are to trust the revela-
tions of an indiscreet press, arose between certain delegates from
various States; this does not lessen the proofs of devotion and zeal af-
forded by the majority, of the final result attained. The avowed ob-
ject of the exhibition was to permit women to help one another, and
each one of them to help herself; it also aimed to give a clear and
precise idea of the universal condition of woman in our day. This
double end was attained.

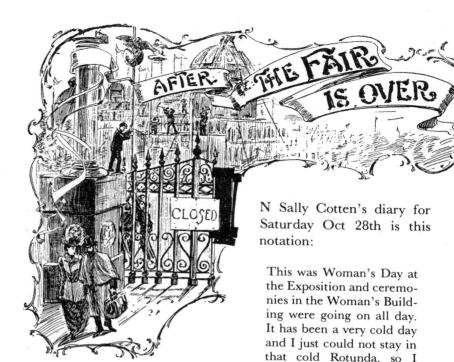

I N Sally Cotten's diary for Saturday Oct 28th is this notation:

This was Woman's Day at the Exposition and ceremonies in the Woman's Building were going on all day. It has been a very cold day and I just could not stay in that cold Rotunda, so I went over to the Woman's Building and enjoyed myself with the other ladies . . . There was a Reception and Concert at night and we all stayed. It was very nice and I had the pleasure of sitting by Mrs Palmer. Before the entertainment was over we heard the dreadful news of the Assassination of Carter Harrison, the Mayor of Chicago. We could not believe it, but coming home it was all confirmed and papers were selling on the street telling about it. 'Tis a sad climax to the great World's Fair.

Carter Harrison had been shot and killed by a disappointed office seeker. The Mayor had been elected for the fifth time; he was generally popular and was a friend of the Potter Palmers'. On the 29th and thirtieth of October flags on the Fair grounds were at half-mast. Festivities were cancelled and replaced by memorial services. A band concert which had been scheduled for the thirtieth was replaced by an orchestra playing Beethoven's Funeral March. This dismal atmosphere underscored the sense of an ending pervading the magnificence of the White City: dead leaves drifted past the carved facades, already cracking and blurring in the cold Lake winds, to pile in neglected corners and float with other debris on the waters of the lagoons.

Tuesday Oct 31st

The great Fair is over and the work of demolition has commenced . . . The Lady Managers met to-day and the Committees began their final reports. Soon we will all part never to meet again I fear. There is something sad about it.
Mrs Palmer to-day made her closing remarks in the Woman's Building and the portrait of her which was ordered by the Board of

Lady Managers for the Permanent Building was unveiled with a nice ceremony in the Assembly Room.

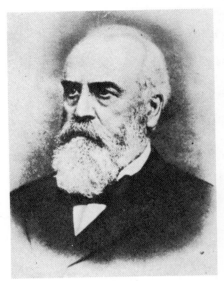

Carter Harrison

The commission for Mrs Palmer's portrait had been given to the Swedish artist Anders Zorn whose work was exhibited in the Arts Palace. Many members of the Board had objected to this commission being given to a man. Mrs Palmer herself wanted Zorn; his portraits are Impressionist in style, with an element of fantasy and idealization. Mary Eagle lifted the Oriental tapestry covering the painting: in it Mrs Palmer appeared as a vision. The gavel in her hand glowed like a fairy wand. Mrs Eagle, for reasons best known to herself, announced to Mrs Palmer: "This day of sorrow we would turn to joy, and make it our coronation day. If we cannot crown our Queen, we will present to you our Queen already crowned." Mrs Palmer said that the "artistic qualities" of the picture were "brilliant," although she added modestly that she could not judge the quality of the likeness. Both Sara Hallowell and Candace Wheeler addressed the ladies on the excellence of Mr Zorn's work. Mrs Wheeler was especially pleased that the painter had caught Mrs Palmer's unique charismatic smile. "I have watched this wordless thought make its greeting and receive its instant response many times," she said, "but I never expected to see it painted."

The President, with her enchanted likeness beside her, gave her closing speech to the Lady Managers. She returned to her belief, expressed before in letters and comments, that women worked outside their homes only because of necessity.

We have heard for years of the incompetent wife and mother, but it occurs to me that we have heard singularly little of the incompetent husband and father. It would seem . . . that comparatively few marriages would occur if women were not able to assist in maintaining the home, and we constantly see girls, trained to self-support, marry and continue their avocations as a matter of course.

She wished to emphasize that women were not rebelling against their traditional role:

The filling up of the factories, shops, schools, offices and every avenue of fairly paid employment with women, does not, therefore, result from a revolution on their part against their role as wives and mothers. Those who theorize about a possible changed relation between the sexes because of the so-called emancipation of women, and fear that the world will no longer be replenished and that the peoples will fade away from the earth have only superficially studied or understood the facts under their eyes.

Mrs Palmer attempted in this speech to present the employment of women as a foregone conclusion and not as a threat to the established order.

Anders Zorn: Portrait of Mrs Palmer

Should men discover at any time in the future that they are capable of assuming the entire maintenance of the home, women can undoubtedly be persuaded to give up the tedious and wearing grind of the factory, the shop and the office, to turn to higher service. Until that fortunate moment arrives the wise course would seem to be the acceptance of facts as they exist. We are not able to see how far-reaching may be the result of this period of change and experiment. We feel urgently impelled to follow the highest law known to us, that of evolution and progress. We must abandon ourselves blindly to the instinct which teaches us that individuals have the right to the fullest development of their faculties and the exercise of their highest attributes. We reassure ourselves with the thought that there can certainly be no great harm in doubling the intelligence and the mental and moral forces of the community.

It would seem that the only way to assist in the rapid solution of the problem is to put within the reach of women technical training and the education which is necessary to promote their ends, and to hope that the unreasonable conditions which force them to work, yet condemn them for doing so, and withhold from them proper training as well as just compensation for their labor, may be swept away. We hope that no woman may henceforth be forced to conceal her sex in order to obtain justice for her work.

Thus Mrs Palmer attempted to bind together the disparate attitudes of her hearers. Women worked in the main because of the incompetence of men, the natural providers. No one need fear the dying out of the race. If men would assume their responsibilities, women would stay home and tend to their "higher service." That "fortunate moment" being probably only a beautiful dream, the reality exists: women must be trained for their work, and paid just compensation. At the same time the President paid fleeting respect to the right of women to develop their faculties and exercise their attributes. Only through the failure of men to support their women and children might "the intelligence and the mental and moral force of the community" be doubled. Certainly, she said, there was no harm in it.

On Wednesday, November 1st, Sally Cotten noted in her diary:

The transformation of the Fair Grounds is complete. The World's Fair is dead! Merry bustle and packing are everywhere. We packed the Colonial Exhibit today and will try to ship it tomorrow to N.C. Nothing more remains for me to do but to pack the Virginia Dare Desk and then I can go home. This I can do as soon as the Lady Managers adjourn.

On Thursday November 2nd she wrote: that she "went to the meeting of the Lady Managers" and "heard only reports from the various Committees." She spent the evening packing her trunk; she was "trying so hard to get off home." Her hotel was already closed, but she was allowed to keep her room. She ate where she

chose—"generally at the Grounds."

The final session of the Board ended November 2nd. It was filled with an impressive documentation of the women's work. The routine was broken only by a few songs sung by the Cecelian Ladies Quartette, the announcement of gifts of raisins and Indian tea for the Lady Managers, and continuing protests from Phoebe Couzins, who had only recently recovered from pneumonia to return to the Building and try to make trouble for the President. That hardly mattered now; Mrs Palmer had steered her frail craft into harbor. Soon the mutineers would be dispersed. Their voices had already been expunged from the records of the Fair which Mrs Palmer had overseen. There will be "four or five always in bitter opposition," she said philosophically. "It would be impossible to expect that a number of women could at once fall into the same way of looking at things, and I fear there is too little time before us now to smooth out all the rough places."

The Beekeeping Committee, to which Miss Couzins had been banished reported that 50% of the women beekeepers at the Fair came from Venezuela and 25% from Missouri. The Mining Committee, the "propriety or necessity" of which the Columbian Commission had questioned, reported happily that there were at least one hundred women mine managers and owners in the United States. Among them was a devoted follower of Phoebe

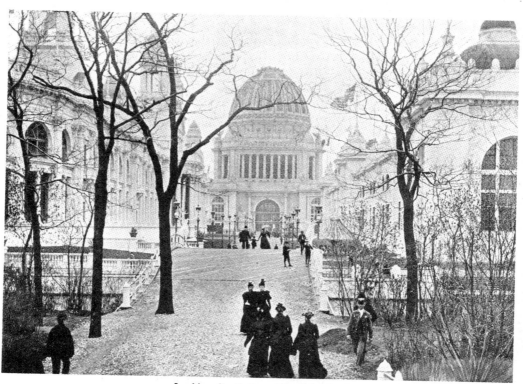

Looking South from Wooded Island

Couzins, Clara McAdow, who mined gold-veined quartz in her Spotted Horse Mine. The Electricity Committee, on the other hand, were downcast: they had little to report except that telephone operators were mostly women, "doubtless because of the lower wages at which women can be employed." The Machinery and Transportation Committee reported apologetically that the only exhibit they found was Caroline Romney's footwarmer for railway carriages. The Breads Committee (encompassing Spaghetti, Salted Meat, Soup, Soap, Cotton and Fertilizer) admitted that "from the very nature of the case, our information is very meager and sometimes wholly conjectural." The Breads Chair said vaguely, "Whatever heights have been attained in biscuit and pastry-making, women have blazed the way; crackers are turned out from thousands of factories the world over, and usually men furnish the brains."

In contrast, the reports of the Committees on Charity, Paintings, and Decorative Needlework were so voluminous that they had to be condensed. The Literature Committee had an impressive fourteen-page report, giving state by state data on women newspaper editors and compositors, magazine writers, and authors and their outstanding works. Mary Lockwood, who chaired this committee, was still disappointed that only 4,000 of the Library's 7,000 books had been catalogued with biographical annotations on authors.

The total sum spent for Edith Clarke and her cataloguers was not more than $1,391. Mrs Lockwood estimated that the work thus cost about 23¢ a book. The annual appropriations for the Woman's Building came to a total of $239,000; of this Susan Gale Cooke announced on October 31, 1893, there was left over $61,573.88. Most of this money went to the Commission to pay its debts. The Board's appropriations were for administrative costs only. But Mrs Lockwood was aggrieved that some of the money had not gone to the bibliography of Library books; the directory of women's organizations also went by the Board, so to speak. Mrs Palmer wanted, it is true, to show "a good record of economy" for the women. But these projects were also time-consuming and more ambitious perhaps than the Ladies had realized. The catalogue of Library books was not only expensive; it would have prevented the books being shelved before the end of the Fair.

On Friday November 3 Mrs Cotten noted the end in her diary:

... at the Palmer House ... we found everything ablaze—ready for the great banquet for Mrs Palmer which comes off tonight.
... There is no more duty for me to do here. How happy I am to go home—How thankful to have had my health the whole time.
Goodbye Chicago! Goodbye White City. The World's Fair is dead, but memory will keep it bright, and the future results will be its real lustre.

Mrs Cotten could go home, her duty done. But for others an enormous task remained. Eighty thousand exhibits had to be returned to the four corners of the earth. In October the Board had issued a circular to all its exhibitors:

> The breaking up of a great Exposition is a momentous time, fraught with confusion . . . In order that time, steps, strength and confusion may be saved, each woman should come with her own hammer and nails, screwdriver and screws, glue, packing paper, scissors, pins, strong string, labels, marking ink . . .

In due time replies to this circular came back, indicating those who would pack up their own exhibits and those who chose to pay a fee and let the Woman's Building management pack up and ship for them. Since there were quite a few of the latter, Amey Starkweather was grateful that she had persevered with her elaborate checking system—all the red tape which had so exasperated eager exhibitors in the spring. "We have one golden opinion of our system," Mrs Palmer said; other Fair buildings, lacking that system, were in chaos. In the Woman's Building a few dishes were broken and a small fox rug disappeared. That was the extent of the damage if one does not count poor Mr Wilson's laces, which seem to have disappeared before the Building closed down.

Throughout the interminable procedure of dismantling, Amey Starkweather worked in the Building which was as cold and damp as it had been when the exhibits arrived. A stove company lent her a small kerosene stove, but it was inadequate on windy days. Then the Exposition authorities provided her with a large coal stove which helped only in her office; nothing could protect her from the cold when she made her rounds in the great barn of a building which was already in decay. Mrs Starkweather later reported with her usual wry humor:

> That the few who were engaged in this work escaped fatal illness is a matter of congratulations, as for some unaccountable reason poorer facilities for heating fell to the lot of those engaged in the dismantling of the Woman's Building than to those engaged in the same work in the other exhibit buildings of the World's Columbian Exhibit.

Perhaps Mrs Starkweather thought that Mr Ellsworth was pursuing her to the bitter end. It is difficult to believe that the Smithsonian agents, who had already been subjected to floods and other catastrophes in their wretched Government building, were more comfortable at this time than she. In view of the fire hazard, the Directors were unwilling to increase the number of coal stoves in these temporary buildings. In January Mrs Palmer, Mrs Cooke and Virginia Meredith left their offices in the Administration

Building and moved into the Masonic Temple at Randolph and Halsted Streets, their final base of operations. Mrs Starkweather remained behind to freeze, and to labor over a final map of installations in the Building.

"I had supposed that long before now I would have thrown off the harness and been free to follow my own wishes," Mrs Palmer wrote on January 16, "but we seem to grind on forever." The government required detailed reports of all aspects of the Fair work. In addition the important business of granting awards had not been completed, due to the reputed bungling of the Awards Managers, who were of course all men. The Board had smoothly appointed minimally eminent jurors in every field, from the book illustrator Mary Hallock Foote to the Reverend Augusta Chapin, with a few princesses thrown in for good measure. These women had taken responsibility for diverse reports on ceramics, art embroidery, sanitation, Mexican archaeology, the German postal system, lace, linen, mineral water and wigs. They did so well that men on at least four different Boards of Judges passed official resolutions commending them. In the Ethnology and Agricultural Departments, women were praised for their unexpected knowledge; in Manufactures the gentlemen rose to their feet affirming a resolution praising the ladies; in Liberal Arts a resolution was passed on September 11, 1893, that

Rev Augusta Chapin

the experiment of placing women upon the Board of Jurors in the Liberal Arts has been successful. The women have exercised their delicate duties with as much care, fidelity and ability as have the men.

The women thought their performance was more careful, faithful and able than the men's. They were receiving complaints from abroad, inquiring after awards and certificates. The Ladies wrote soothingly back, and tried to stir the men to action. Some of the complaints concerned incompetent judges. Leah Ahlborn of the Swedish Royal Mint was denied an award for her display in the Woman's Building. Mrs Palmer told Governor Hoyt: "She is one of the celebrated medalists of the world and the man from Missouri who failed to give her an award, only showed his ignorance." Mrs Palmer recommended that Daniel Paris, President of the Numismatical and Archeological Society, be appointed to judge the medals once more. This Society, she said, had a "full line of Miss Ahlborn's medals. They learned with astonishment that she has been refused a medal as she is one of the great living workers in this especial branch."

In the end Mrs Palmer triumphed as she so often did; Leah Ahlborn received her official bronze award medal, and so did 1,500 other women exhibitors.

There had been an earlier struggle with the Awards Management. In January of 1893 Mrs Palmer had introduced a resolution that the artisans who helped to produce an award-winning exhibit be given a facsimile certificate. She explained to Thomas Palmer on October 23, when the resolution had not been passed, that this award, "being conferred upon the otherwise unrecognized but really effective workers, without whose skill the present grand results must have been impossible, would inaugurate a new era in the history of world's exhibitions." A bill was passed by Congress allotting $5000 for the printing of these facsimile certificates; but no arrangement was made for their actual distribution. Mrs Palmer attempted to push the necessary approval for distribution through committees; to her surprise she found the whole force of the Exposition against her. Objections were raised: it was impossible to determine accurately where credit was due; a facsimile would undermine the value of the original certificate and might even be easily counterfeited; it was an unwarranted intrusion into the affairs of capitalists to distribute awards without their approval; it was preposterous for women to ask for awards of merit for work of which they knew nothing.

The Lady Managers admitted that there might be some holes in their plan, but they insisted that the principle behind it was a sound one. They dropped the controversial word "facsimile" and

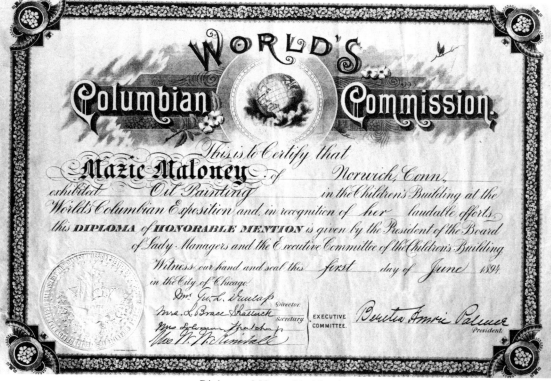

Diploma of Honorable Mention

asked for "Diplomas of Honorable Mention" instead, calling once more on their Knight in shining armor, William Springer, to rescue the plan. He did his best. Unfortunately the measure did not reach the President's desk until nearly the end of the Congressional session; opponents said that the measure had died with the Congress. At this critical juncture labor leaders were informed of the diploma and came forward with a petition:

> The [established] awards very properly confer due honor upon the manufacturer whose capital and enterprise prepared and installed the exhibit, but fail entirely to recognize the industry, skill, and expert knowledge of the individual man or woman whose hand produced and perfected what brain and capital proposed . . . The efforts of the Board of Lady Managers . . . deserve the support of every member of Congress who desires to ennoble labor.

The Bill was signed when Congress reconvened in December of 1893. Mrs Palmer was amused to find that some manufacturers were applying for the Diploma of Honorable Mention designed for their workers. After the diplomas had been dispatched, it was learned from "a tourist recently returned from Japan" that everywhere he went he came across "diplomas issued by the Board of Lady Managers, which formed the principal ornament in numberless homes of the skilled artisans of that country."

Early in the spring of 1894 Mrs Palmer's thoughts turned to the Woman's Memorial Building. A permanent monument to the activities of women had been planned by the Ladies almost from the time their Building was being completed. A memorial fund had been set up; tough bargains were driven so that a percentage of profits from the Building's concessions could be put into the fund. Mrs Palmer had wrested a pledge of $335 a month from the Ceylonese Commissioner for the Ceylon Tea House in the Building, despite the man's anguished protests that the proceeds would not cover half his expenses.

Ceylon Tea House

By October 1893 the fund had accumulated $40,000 from concession percentages, souvenir sales and the surplus money from the Children's Building. Some people's preference for the Memorial Building was to rebuild the Woman's Building itself, but the size made the expense prohibitive. The $40,000 was needed for operating expenses of the Memorial Building.

The state of New York offered the women its State Fair pavilion designed by McKim Mead and White. But the park authorities refused the Board's request that this building be allowed to remain in Jackson Park. The Ladies could not afford to move it anywhere, nor could they afford to cover its exterior with marble as its architect requested. On October 31, 1893, when everyone was depressed about the prospects of the Memorial Building, Mrs Palmer announced that her husband had offered to do-

nate $200,000 to their fund. Potter Palmer had been approached about funds for the erection of a Columbian Museum, but had decided he would rather give the money to memorialize the women's work which his wife had so wholeheartedly directed: "I have had this idea in my head for the last two years," he told the *Tribune* on November 1. "The women have been raising money for such a building but it was slow work. With a building furnished them, however, they will be able to carry the scheme to a successful termination."

Mrs Palmer described the projected building to the *Chicago Times;* Potter Palmer had said modestly, "My wife can tell you all about the World's Fair news better than I can." Mrs Palmer said that the first floor of the Memorial Woman's Building would be devoted to a museum; for this purpose many exhibits from the Woman's Building had been donated to the Board of Lady Managers. The upper floor would contain a large assembly hall, smaller committee rooms and a library. The President stated confidently that "if no difficulty is encountered in perfecting the arrangements, we expect that it will be built and ready for occupancy within a year."

Sophia Hayden, despite her past difficulties with Mrs Palmer, had expressed the desire to design the Memorial Building. In the early spring of 1894 she completed the architectural plans and sent them to the President, who wrote her on April 5:

> It now seems very possible that the permanent building will be on the lake front near the Art Institute and I think perhaps you can make your facade somewhat in accordance with that.
> The bulkhead on the top of the skylight might be less prominent perhaps. I hate to trouble you further about this but the question of the architecture will have to be settled soon. Your plans for the interior are satisfactory, but if this building is to be near the Art Institute, I think it would be well to have the architecture of the two buildings conform.
> Thank you for your kindness in submitting the plans.

The tone of this note lacks Mrs Palmer's famous graciousness. She was growing rather tired of making plans and writing letters. A month or so earlier she had been approached by Juana A. Neal, a San Francisco insurance agent who had spoken at the Congresses on the subject of insurance as a promising new career field for women. Mrs Neal had devised a scheme in which women could take out insurance policies and their premiums be put into the fund for the Memorial Building. Mrs Palmer wrote Mrs Neal on March 19, 1894:

> I do not feel that I wish to insure my life for the benefit of the permanent building. We have already, Mr Palmer and myself, done much toward making possible the consummation of our hopes in this direction and I do not feel that it is necessary or desirable for me to tax myself further financially.

Sophia Hayden

She nevertheless gave Mrs Neal a qualified endorsement:

> Mr Potter Palmer having given 200,000 dollars to make a memorial of their progress through this the "Woman's Century," Mrs Juana Neal has an inspired dream that this may become national in scope. I'll give my endorsement on the condition that the naming of the trustees to administer the fund be left to me, and details of the fund expenditure be left to the Board of Trustees and myself.

Mrs Neal went off to New York; word of her trickled back to Mrs Palmer. Uneasy about Mrs Neal and her scheme, Mrs Palmer wrote her, telling her to stop holding public meetings, since most women could not afford to pay insurance premiums, and the suspicion might arise that Mrs Neal was using the Memorial Building to sell policies. The signatures of a few wealthy and respected women would give the plan solidity. Stories from the East that Chicago was "passing the hat," increased Mrs Palmer's nervousness. She told Mrs Neal to make it clear that this Memorial Building was to be devoted to the work of women, and was not concerned with Chicago itself.

She learned shortly afterward that Mrs Neal was talking about recreating the whole Fair, and not just the Woman's Building: the Court of Honor and the MacMonnies fountain were being mentioned to prospective insurance investors. This was really too much. On June 20, 1894 she wrote Mrs Neal:

> I am positively unwilling to mortgage my whole life to any cause and to take away from myself absolute freedom to travel or to make such use of my hours as seems good to me at any time.

The eyes of the world were no longer on Chicago; Bertha Palmer did not want to work steadily for what resembled a municipal project. The year of 1894 was economically grim; the effects of the Panic of 1893 had not been mitigated. Three and one half million people were out of work. In Chicago labor unrest exploded in the Pullman strike. Mrs Palmer agreed with Eugene Debs that workers should have a voice in factories. She asked George Pullman to arbitrate the strike; he preferred quicker and bloodier means to end it. This ended also the friendship between the Pullmans and the Palmers. Mrs Palmer, like many progressives, was fearful of the effects of labor uprisings on the social order. She told Juana Neal in July that this was no time to start ambitious building projects: "I am sure that you must agree with me that any talk of improvements on a large scale at this juncture would be received with coldness and absolute refusal."

In September she finally wrote to Juana Neal that she could not continue to back the plan. "My own income has suffered material depletion during the summer as my tenants have been unable to

pay and I could not turn them into the streets," she said. Indeed, one Chicago mortgage company had recently foreclosed five thousand mortgages. Mrs Palmer had also decided that Mrs Neal's plan was harebrained; she asked her to drop it since "I have a certain reputation for good sense which I wish to maintain." She regretted with Mrs Neal "this second vanishing vision of the White City."

In October Mrs Neal announced triumphantly that she had sold a policy to J.P. Morgan. Mrs Palmer hastened to dampen down this spurt of activity:

> I find that I am so depressed by the long-continued strain that I have been under that I have no elasticity in rising to meet the new obligation, which your scheme presents to me, and that I am depressed rather than otherwise at the prospect of its being successful.

The next day, October 17, Mrs Palmer wrote again to Mrs Neal, telling her that the donors of the exhibits would have to bear the burdens of the Memorial Buildings; she herself was finished with it. At the same time she hated to sever herself completely from the plan and was still thinking about it when she wrote to Jane Addams on October 28:

> Do you think it would be feasible to introduce into such a building a sort of club room for poor women who could spend their days or evenings there accompanied by their children? . . . There is no reason why the whole roof shall not be available in the summertime as a comfortable and healthy resort for mothers who find no seats or other conveniences elsewhere in the park . . . It would be frightful to erect [the building] and to find that it did not come close to the wants of the community and serve a useful purpose as its apology for being.

In November Bertha and Potter Palmer left the city for an extended world tour. At this time the items donated to the Memorial Building were under the supervision of Frances Shepard, who was supposedly also looking after furnishings and decorations from the Woman's Building. Everything had been stored at first in the Art Palace, which was the sturdiest building on the Fairgrounds. In February of 1894 Harlow Higinbotham expressed his anxiety that everything should be removed from the grounds. Mrs Palmer then requested that a corrugated iron shed be put up in the courtyard of the Art Institute to shelter the women's possessions. This request for an unsightly addition to the new building was understandably refused. The Board of Lady Managers were forced to rent space, at the rate of a penny per cubic foot a month, in the Hiram Sibley Warehouse at 16 North Clark Street. There the boxes and crates were delivered in March by the Adams Express

Company, and entered in Bertha Palmer's name. Among the stored items were the two panels painted by Rosina Emmet Sherwood and Lydia Emmet which the Board had purchased from the artists for the Memorial Building at a cost of one thousand dollars apiece. According to the inventory records, the Cassatt and MacMonnies murals never reached the warehouse.

The two huge murals already belonged to the Board. On December 1, 1893, Mrs Palmer had written dutifully to President Higinbotham to tell him to make sure that these paintings were saved from the wrecker; her comment lacked enthusiasm:

> They are very enormous in size, and it is doubtful that they can ever be used anywhere, but I think they are about worth the cost of salvage, and I am willing to take them down and store them just to preserve them.

Obviously she had no intention of putting these paintings on display in her Memorial Building, or anywhere else, although the MacMonnies mural had been generously praised. The whole episode was painful to her. A few days later she wrote Mr Higinbotham again and mentioned the murals, saying she was "very anxious about these decorations, although they may prove too large to be used in any building in the future."

The necessary permits were secured for the murals' removal from the Building, but Mrs Palmer apparently did not know where they were taken. On January 30, 1894, she wrote to Mrs Starkweather, who was still freezing in the empty Woman's Building, to inquire after them: "Who is storing the Cassatt and McMonnies paintings and why? These paintings are not dutiable, being the work of American artists, and they should be released and put with the things stored by Mrs Shepard." On March 21 she wrote again to Mrs Starkweather, saying that she was "satisfied with the disposition of the storage bills" for the two murals, referring to a check for $3.74 to a Mr Basserman. But no further clue is given to this "disposition"; the murals have disappeared. It has been suggested that Sara Hallowell dispatched them to Paris: a doubtful suggestion because of the expense their great size would have entailed. Possibly they were destroyed in a fire. It has been suggested even that Mary Cassatt herself destroyed her mural; a far-fetched suggestion. These two murals were not the only items missing; the list of "Goods in Sibley Storage Warehouse on September 6, 1895," which is the last Board record of the items, includes Japanese paintings on silk, books, carved wooden panels, Bohemian embroideries, a bronze electrolier, fish nets, stained glass windows, the Sherwood and Emmet murals, and the frieze from the Cincinnati Room.

When Mrs Palmer returned from Europe, she did not take up again the subject of the Woman's Memorial Building. No one

knows what happened to the goods in the Sibley Warehouse: they may have been returned to their owners, sold for salvage or thrown out. No one knows either what happened to the $40,000 Memorial Fund; the $200,000 grant by Potter Palmer obviously remained in his coffers. It was not a lack of money that killed the Woman's Memorial Building. Announcing the fulfillment of a dream to a jubilant Board of Lady Managers was one thing; carrying out the elaborate mechanism of accomplishment was another, especially since the event to be commemorated was already dimming in everyone's memory. By June 2, 1895, Laura Hayes—now Laura Fuller and already a mother—was writing to tell Mrs Palmer that she could hardly remember the Fair. "How beautiful and how brief it all was! The stately pleasure domes, like those of Kubla Kahn, seem to have vanished like bubbles."

Suggestions had been made for preserving the White City. But on January 8, 1894, incendiaries burned the Casino, Peristyle, and Musical Hall. Then on the evening of July 5, 1894, the Terminal Station caught fire. The *Chicago Herald* reported on July 6 that the flames "travelled faster than man could walk and devoured the magnificent edifices as if they had been so many barns stuffed with hay." Casualties included the Administration, Mining, Manufactures, Agriculture and Electricity Buildings. The *Scientific American* for October 3, 1896 said:

> Most of the little angels from the Woman's Building, the symbolic figures, reliefs and so forth, were put in the Electricity Building, where it was intended to exhibit them prior to putting them on sale—the fire came and swept them all away.

The Woman's Building itself was part of a demolition effort by the World's Columbian Exposition Salvage Company spread over two and one half years: from the summer of 1894 to the fall of 1896. Even the skeletons of the buildings vanished; grass reclaimed the site.

Mrs Palmer decided that not a tangible display, but rather the network of women which had worked so well, should be salvaged from the Fair. On April 21, 1894, she wrote to Bey Jakkey, a Turkish Commissioner, on the subject of women's clubs in Moslem countries:

> We hear that secluded in the harems are women of great distinction and great intellectual ability . . . Their life could be equally secluded, but [through women's clubs] they [could be] more intelligent and capable of inspiring great thoughts and actions, which after all is the great end in life.

The Bey's reply to this suggestion is not recorded, but history indicates that the harems remained as before. In July Mrs Palmer still thought her idea had merit. She wrote to Ellen Henrotin, who was now President of the Federation of Women's Clubs:

I have always felt that it was a pity for the Board of Lady Managers to dissolve and the superb organization which it had effected to go to nothing. As a Board we were of course confined to work for the Exposition and I do not know that its membership would be especially desirable as individuals in creating a new organization . . . I feel that there is an opportunity for something very useful provided the women of other countries are not repelled by our advocating, before they are ready to accept it, suffrage, a change of religion, or any other radical departure from what they consider desirable and good form. In other words, I should never propose to the inhabitants of foreign countries to accept our civilization and all of its customs, many of which are disadvantageous even from our own point of view, but should only advocate their advancing to a higher degree of perfection on their own lines.

Sarah Hackett Stevenson

Mrs Palmer worked with reform groups in Chicago, and became Vice-President of the Chicago Civic Federation, a group formed to alleviate the hardships of the Panic and depression. Dr Sarah Hackett Stevenson was a member of this group; she and Mrs Palmer attempted to eliminate discrimination against women and children by the Relief and Aid Committees. Jane Addams belonged to the Civic Federation: her special interest was protective legislation for women workers—legislation which is considered by many to have prevented women workers from achieving equal status with men—and she enlisted Mrs Palmer's aid in this cause. Mrs Palmer worked with the Women's Trade Union League, and helped to organize the Chicago millinery workers, finally finding some real working women close to home.

But her energies were not completely involved in this good work. While she retreated from publicity behind a household staff of nearly thirty people, and even her friends had to make appointments to see her, she could not forget the glory that had been hers. Alice Freeman Palmer, a member of the Massachusetts Fair Board and the second President of Wellesley College, stated that she believed one of the more lasting effects of the Fair was the impressive way in which women "showed organizing ability on a huge scale; they developed noteworthy leaders; what is more they followed them . . ." In May 1895 Mary Linde wrote to Susan Cooke to say that the "more I recall of the Fair, the more highly I realize how great a mother it was [sic] and how much it means for woman's power for large things, and how largely that is due to Mrs Potter Palmer [the more I] rejoice over the providence that maintained her through it all."

On March 11, 1894, Governor John Altgeld of Illinois wrote from Springfield to tell Mrs Palmer that the cause of women's rights had been advanced a century by the Columbian Exposition; he assured her that posterity would call "the delicate hand that directed this work the hand of a genius." Mrs Palmer must have asked herself the question raised by an admirer in July 1893: "Will

society, home and rest fill the void, fold the expanded wings and stifle the cry of genius?''

During her travels with her husband in 1894 and 1895 she attempted to recreate the tours she had made for the Fair in 1891 and 1892. She spoke with aristocratic women in Egypt and Turkey, as well as with philanthropists in Europe. Through her political connections she attempted to procure a diplomatic title that would enable her to move officially in foreign societies. In 1895 this was impossible. In 1900, however, President McKinley appointed her the only woman commissioner from the United States to the new Paris Exposition, as May Wright Sewall had been in 1889. She and Potter Palmer rented a house in Paris and gave elaborate entertainments. She helped to secure places for women on the awards juries, asked for more representation for them at the Congresses, and overrode objections from the French Directors to have Jane Addams appointed to a post in the Department of Philanthropy. Through this experience she achieved what may have been her finest hour: she was awarded the medal of the Legion of Honor, given before her only to Rosa Bonheur and Florence Nightingale.

After that, it was difficult for Bertha Palmer to find a cause to call her own. Her attention was divided between women's problems and her own social aspirations. She spent as much time and money trying to break into the closed society of Newport as she had in the interests of women.

Ellen Martin Henrotin was not as easily distracted by frivolous concerns as Mrs Palmer. In her four years as President of the Federation of Women's Clubs she helped to double the number of such clubs and to form twenty new state federations. She channeled the energies of the club members into work for labor reform and for suffrage. These clubs won respect and admiration from a public that often ridiculed the activities of women. In 1904 Mrs Henrotin became President of the National Women's Trade Union League.

Susan Anthony said that the Fair had done more for the cause of woman suffrage than twenty-five years of agitation, giving it "unprecedented prestige in the world of thought." Helen Barker had told the *Woman's Journal* on August 19, 1893, that as a result of their work on the Board of Lady Managers

the women composing it had become impressed with the idea that they are there to see that they have equal representation in the Fair with men. That is the principle of woman suffrage, and so, many of the women who would have been shocked to be considered as identified with the woman suffrage movement are working in this very direction. The result is that our noble president, Mrs Palmer, has declared herself openly in favor of equal suffrage, and many Southern women have declared themselves converted to the same opinion.

Ellen Martin Henrotin

And that is not the end. These women will go back to their several states to advocate among their friends and neighbors these same eternal principles.

There was truth in Mrs Barker's statement, although she wrenched it a bit when she put words in Mrs Palmer's mouth. As late as February 5, 1894, Mrs Palmer wrote to Mrs Reed of Baltimore, "I think our Board was wise in keeping out of politics and the suffrage question." Certainly the "question" had been aired in the Woman's Building; women from all over the country were exposed to it. Sallie Cotten had mused in her diary on July 31, 1893:

Attended address in the Woman's Building. I hear lots of addresses which bear on the subject of suffrage for women—but as yet I am not converted to the wisdom of such action. She has a *right* to vote— certainly under certain circumstances, but it may be *wiser* for her not

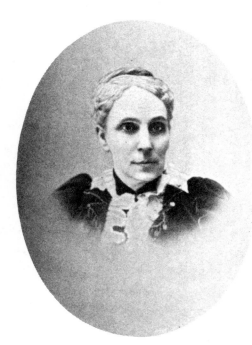

Helen Barker

to *claim* or use that right. Such power may elevate or it may deprave. It remains to be seen . . .

Thus the pervasiveness of the idea that woman was a higher being than man, called to higher duties than the mundane exercise of the franchise. Mrs Cotten returned to North Carolina after the Fair, and organized the North Carolina women's club movement which she was to lead for the rest of her life. In 1928, at her last public appearance, when the suffrage issue was settled for good, she was introduced as "the Julia Ward Howe of the South."

Candace Wheeler was asked by a reporter from the *New York Times* in May 1893 what she considered the greatest results of the Fair to be. She replied that it was "women's recognition by Turkey, China, Japan and other governments which heretofore have withheld such recognition. The condition of women must be improved by this." Mrs Wheeler's comment, alas, contains more hope than truth in the light of the exhibits sent, at least, by China and Japan. Mrs Wheeler said, possibly with more substance, that the Fair had accelerated women's entry into the decorative arts professions and widened their money-making opportunities in general.

Adelaide Johnson, the renowned bust sculptor, said at the International Women's Congress, held in Berlin in 1904, that the days were over when women artists were "looked upon with curiosity, classed and perhaps indulged as freaks . . . The great impetus in the United States of America that ushered so many women into active work as professionals in the plastic forms of art, came with the Columbian Exposition at Chicago in 1893."

In 1895, when the Woman's Building was becoming a distant dream, and the Memorial Building was forgotten, another Woman's Building arose at the Cotton States and International Exposition in Atlanta. Elise Mercur of Pittsburgh submitted the winning design over thirty other applicants: hers was a domed renaissance structure in which was space for exhibits and congresses. Rebecca Felton, achieving attention at last, was appointed Chair of the Atlanta Board. To raise money for the building's construction, Mrs Felton brought out a special woman's edition of the *Atlanta Journal*. Sallie Cotten and Lily Irene Jackson of West Virginia once more became Lady Managers on a Board of forty-two women. But the glories of the Columbian Woman's Building were not repeated. That first splendid experience was never repeated; nor could it be, in all the international expositions with all the women's boards and women's buildings which have appeared since that time.

In 1898 at the Trans-Mississippi and International Exposition in Omaha a board of twenty-seven women presided over a Boys' and Girls' Building, a Congress Department and a few exhibits of women's work dispersed through the Exposition. In Paris in 1900

a "coterie of progressive Frenchwomen" raised funds for a modest Building in which Jane Addams, through Mrs Palmer's intercession, was able to exhibit a settlement house display. At the 1901 Pan-American Exposition in Buffalo, an existing clubhouse was pressed into service as a woman's building. Its architecture clashed painfully with that of the rest of the Fair. In 1904 the Louisiana Purchase Exposition in St Louis allowed the twenty-three Lady Managers to meet in a building which became Washington University's Hall of Physics, endowed by a woman, and the National Council of Women ran a Woman's Anchorage as a shelter for visitors. In 1907 The Jamestown Tercentennial of Norfolk, Virginia, housed a woman's building in a plantation house built of wood. In 1915 in San Francisco the Panama Pacific International Exposition was held: it was called the Jewel City. The women's appropriation was $104,000, unfortunately appropriated so late that the women had no chance to spend it for a woman's building. They built a monument to the pioneer mothers of California, instead, and furnished their rooms in the California Building to "entertain every available person."

In 1933 in Chicago at the Century of Progress, the National Council of Women mounted a woman's display in the Hall of Social Sciences. They included a mural sixty feet long illustrating the milestones of women's history; one milestone was the Congress of Women of the Columbian Exposition. Susan Anthony's red shawl was displayed, and Amelia Earhart's flying glasses. There were Women's Congresses in Chicago, and a woman's library that was added to the remnants of the Woman's Building Library. Minna Schmidt of Chicago gathered a display of mannequins in period costume. Among them was one of Bertha Palmer, who had died of breast cancer on May 5, 1918 at The Oaks, her home in Florida.

At the New York World's Fair of 1939, it was announced by the Director of Women's Participation that "Women's participation was a first thought in the planning of the . . . Fair." But this planning, involving forty-eight committees "geographically, religiously, racially and politically" balanced, centered around essay contests and goodwill tours. In 1964 at the New York World's Fair there was a Woman's Hospitality Center on the roof of the Better Living Center where women's groups could hold teas. It was sponsored by the Purex Corporation.

In 1893 Kate Field had predicted that "if . . . the next international exposition be deferred 25 years, the Woman's Board will not have a successor. By that time co-operation of the sexes will be so firmly established as to put women beside men in management and make two boards an extravagant anomaly."

Alice Freeman Palmer in an article in the *Forum* entitled "Some Lasting Results of the World's Fair" had come to virtually the same conclusion:

. . . here women found an opportunity to prove their ability as a banded sex . . . But the very triumph does away with its further necessity. Having amply proved what they can do when banded together, women may now the more easily cease to treat themselves as a peculiar people. Henceforth, they are human beings. Women's buildings, women's exhibits, may safely become things of the past. At any future Fair no special treatment of women is likely to be called for. After what has been achieved, the self-consciousness of women will be lessened, and their sensitiveness about their own position, capacity, and rights will be naturally outgrown.

Obviously Alice Freeman Palmer's crystal ball was clouded. She had good reason to think what she thought about the future; one cannot, however, close the story of these remarkable women on this note. The triumph of the "banded sex" did not, unfortunately, do away with the necessity for future banding together. Women were still to be treated as "peculiar people." One must end, therefore on another note. Most fitting, perhaps, are Bertha Palmer's own words of farewell to the Lady Managers:

When our palace in the White City shall have vanished like a dream, when grass and flowers cover the spot where it now stands, may its memory and influence still remain as a benediction to those who have wrought within its walls.

ACKNOWLEDGEMENTS

Sigurd E Anderson II: Mary Cassatt, Sketch, Ch 12. Daniel Burnham Archives, Ryerson Library, Art Institute of Chicago: Woman's Building in various stages of construction, Alice Rideout at work on pediment; Collection of Art Institute of Chicago: Anders Zorn, "Mrs Potter Palmer", Ch 22. Courtesy Trustees of the British Museum: Angelica Kauffman, "Girl Plaiting Her Hair", Ch 12. Chicago Historical Society: Lake Street, Potter Palmer, Field & Leiter's establishment, Ch 1; Mary Livermore, Ch 2; Frances Dickinson's engraved Commission, Ch 4; Theodore West, caricature of Daniel Burnham, Ch 8; Two women on Loggia, Ch 10; Stock Certificate in Woman's Dormitory, Ch 13; Diploma of Honorable Mention, Ch 22. Chicago *Tribune*: Mary MacMonnies, Mary MacMonnies at work, Sketch for "Primitive Woman", Ch 9; Flax spinner, Ch 15. Cincinnati Art Museum: Cordelia A. Plimpton, Vase (Gift of the Women's Art Museum), Ch 15. Courtesy Cincinnati Historical Society: Maria Longworth Nichols, Ch 15. Courtesy Cleveland Museum of Art: Wm Merritt Chase, "Miss Dora Wheeler", Ch 15. Mark Twain Memorial, Hartford, Ct: Candace Wheeler, Ch 10. Courtesy Maria Mitchell Ass'n, Nantucket, R.I.: Maria Mitchell, Ch 16. Courtesy The MIT Museum & Historical Collections: Sophia Hayden, Ch 8. Courtesy Metropolitan Museum of Art, N.Y. Mary Cassatt, "Le Perroquet" (Gift of Arthus Sachs, 1916), Ch 12; Adelaide Johnson, marble bust of Susan B. Anthony (Gift of Mrs Murray Whiting Ferris), Ch 12; F. Holland Day, platinum print of Mrs Potter Palmer, c. 1890 (Courtesy of the Alfred Stieglitz Collection), Ch 3. Rare Prints Room, N.Y. Public Library: Rosa Bonheur, "Head of Lioness", Marie de Medici, "Self Portrait", Ch 12; Courtesy Newberry Library, Chgo: Marie Bashkirtseff, "Jean et Jacques", Ch 12; Courtesy Pennsylvania Academy of Fine Arts: Cecilia Beaux, "Landscape with a Haystack & Breton Women", Ch 12. Smithsonian Institution: Cecilia Beaux, Ch 12. Schlesinger Library, Radcliffe College: Isabella Seal and Clubhouse; Harriet Hosmer, "Queen Isabella", photograph, Ch 4. Sophia Smith Collection, Smith College: Cover *Queen Isabella Journal*, Ch 4; Lucy Stone, Ch 20. Manuscripts & University Archives, Cornell: Anna Botsford Comstock, Butterfly Engraving, Ch 16. Alma Lutz Collection, Vassar College Library: Susan B. Anthony & Elizabeth Cady Stanton, Ch 20. Nat'l Board, YWCA Archives: Grace Dodge & Working Girls Club, Ch 19. U. of Ill. Library at Chgo Circle Campus, Jane Addams Memorial Collection: Jane Addams, Ch 20.

NOTES & SELECT BIBLIOGRAPHY

Space is at a premium here. Where the source of a statement is clear in the text I have eliminated pedantic references. Bibliography is combined with notes in order to save space. The single most important source of information is in the Library Manuscripts Division of the Chicago Historical Society. These are letters and other documents relating to business of the Board of Lady Managers which were kept by Bertha Palmer. Unless otherwise stated, all quoted letters may be assumed to be from this collection.

PRELUDE: THE CENTENNIAL

Background information for this chapter is from Elizabeth Gillespie, *A Book of Remembrance* (1901); Elizabeth Cady Stanton, *Eighty Years and More Etc* (1898) and Ida Husted Harper, *The Life and Work of Susan B. Anthony* (1895). See also Judith Paine, "The Women's Pavilion of 1876" in *The Feminist Art Journal* 4 Winter, 1975-1976.

CHAPTER I: THE QUEEN OF THE WEST

See Bessie Louise Pierce, *A History of Chicago*, Vol. III 1871-1893 (1957) and *As Others See Chicago*, (1933). Also Ishbel Ross, *Silhouette in Diamonds*, (1960).

Chapter II: GOVERNMENT DISCOVERS CHICAGO

Information on the struggle for the Fair site comes from Francis L. Lederer II, *Genesis of the World's Columbian Exposition*, written for the requirement of MA in History, for the University of Chicago, 1967. See J. Christopher Schnell, "Mary Livermore and the Great Northwestern Fair" in *Chicago History* IV (Spring, 1975), 34-42, and Herman Kogan, "Myra Bradwell, Crusader at Law" in *Chicago History* III (Winter 1974-1975), 132-140. See also "The Isabella Idea", a typescript in the Minerva Parker Nichols papers at Schlesinger Library, Radcliffe College.

CHAPTER III: THE GOVERNMENT DISCOVERS WOMEN

For general sources see James B. Campbell, *Campbell's Illustrated History of the World's Columbian Exposition*, (1894); Julian Ralph, "Woman's Triumph at the Fair" in *Harper's Chicago and the World's Fair* (New York: 1893), 161-170. See also Rossiter Johnson, *History of the World's Columbian Exposition*, Vol 1. Comments by Frances Willard, pp 35-36, are to be found in her essay "Woman's Department of the World's Fair" in *The World's Fair, Being a Pictorial History Etc*, 1893, ed. William Cameron, 448-470. Eliza Allen Starr's book *Isabella of Castile, 1492-1892* was published in Chicago in 1889 by C. V. Waite and Co. It should be noted here that sources generally put the number of Lady Managers at 115. But two Lady Managers from forty-four states and five territories should add up to 117 Ladies, including the eight at-large delegates and the Chicago Nine. The Board's minutes put the number at 115.

CHAPTER IV: THE CHIVALRIC CHIMERA

Information for this chapter comes from the Lady Manager papers at the Chicago Historical Society. Mary Newbury Adams' essay "The Board of Lady Managers and its Work" in *The Story of Columbus and the World's Columbian Exposition*, (1892) was revised by the book's editor Tryon Edwards to exclude the Isabellas. Mrs Adams removed her name from the chapter. A copy of the book, with Mrs Adam's marginalia, is at the Newberry Library, Chicago.

CHAPTER V: PHOEBE COUZINS

Phoebe Couzins' and Mrs Palmer's testimony is reprinted in *Report of the Appropriations Committee on World's Columbian Exposition Expenditures*. Rebecca Felton's letters are among her papers in the Rare Books and Manuscripts section of the University of Georgia Libraries.

CHAPTER VI: PARIAN AND EBONY

See Ann Massa, "Black Women in the 'White City'", *American Studies* VIII, pp. 319-337.

CHAPTER VII: CIRCLING THE GLOBE

For information on Connecticut's activities, see *Connecticut at the World's Columbian Exposition*, (1898). The Connecticut board met first on April 19, 1892. The first president was Mrs Morgan G. Bulkeley, the wife of the governor. She resigned in January, 1893 and was replaced by Kate Knight, who continued as secretary as well. For Iowa women see "Report of the Department of Women's Work" in *Report of the Iowa Columbian Commission*, ed. by James O. Crosby, (1893), p. 192.

CHAPTER VIII: THE LADIES LOVELY CHILD

See Susana Torre, ed., *Women in American Architecture Etc*, (1977), and Charles Moore, *Daniel H. Burnham: Architect, Planner of Cities*, (1921), and Thomas S. Hines, *Burnham of Chicago: Architect and Planner*, (1979). Louise Bethune's comments on p. 147 and p. 154 come from "Women and Architecture" in *Inland Architect and News Record* XVII (March, 1891), 21. Brief biographical sketches of Enid Yandell can be found in James L. Collins, *Women Artists in America: 18th Century to the Present* (1973); Mantale Fielding, *Dictionary of American Painters, Sculptors and Engravers* (1926) and the *Art Institute of Chicago Catalogue 1909-1919, Vol. I*. The letter from Sarah Angell to Bertha Palmer concerning Sophia Hayden's visit to Ann Arbor had been misfiled during the writing of this chapter. It was dated Nov. 14, 1892. Among other things, Mrs Angell wrote, "I took her [for] a long drive . . . she was . . . difficult to make talk. I fancied she did not feel at ease with me. I asked her if her hostess was a relation and I think she said not at all. She said nothing about her family, in fact she said very little anyway. She spoke with more enthusiasm about Mr Burnham and his family than about anything else. I should say she was fond of them and felt indebted to them. She expressed no kind of annoyance about any member of the Board. In only one remark did she say anything that led me to think there was any possible disappointment. We were talking about the Interior of our Building and about the scheme of color that Mrs Wheeler would probably suggest, and she said I had my plan but it was not thought best to carry it out. After a little pause she asked me if it was true the Ladies were going to build a Permanent Building. I said a Memorial Building is talked of . . . She said she must write you and see if she could get the privilege of making the plans. I said if you should be the architect how fitting and pleasant it would be. She laughed a little laugh which was hardly joyous and said nothing. If I had met the young girl without any knowledge of her I should have thought her very reticent, quiet with no marked interest . . .

CHAPTER IX: THE DECORATORS

Information about Mary Cassatt, including the letters on pp. 206-207, comes from Frederick Sweet, *Miss Mary Cassatt: Impressionist from Pennsylvania*, (1966). Sweet mistakes Mrs Palmer's second European trip for her first. For information on Sara Hallowell, which is scarce, see John D. Kysela Jr., "Sara Hallowell Brings Modern Art to the Midwest" in *Arts Quarterly* XXVII (1964), 150-167, and "Mary Cassatt's Mystery Mural Etc." in Arts Quarterly XXIX (1966), 128-145, and Joseph Faulkner, "Painters at the Hall of Exposition of 1890" in *Chicago History* (Spring, 1972), 14-17. Letters from Mary MacMonnies to Mary Cassatt are in the Cassatt Archives, and her letters to Sara Hallowell are in the Burnham Archives in Ryerson Library, Art Institute of Chicago.

CHAPTER X: PRODIGIES OF PREPARATION

For Harriet Monroe's reminiscences, pp. 221-223, see her autobiography, *A Poet's Life* (1938). Candace Wheeler's musings on Mrs Palmer, p. 224, come from her book *Yesterdays in a Busy Life*, (1918). For the Englishwomen's exhibits see the Chicago *Tribune*, April 23, 1893, p. 25. For Mrs Palmer's greetings to the Lady Managers, see the *Tribune* for April 27, 1893, p. 2.

CHAPTER XI: WOMEN IN THE WHITE CITY

Descriptions of the opening ceremonies come from Ben C. Truman, *History of the World's Fair*, (1893). The unchivalrous remarks on p. 261 come from *The American Architect and Building News* XXXVIII (Nov. 5, 1892), 86. Mr Van Brunt's comments on pp. 261-262 are to be found in the *Century* for September, 1892, p. 729. The *Harper's Bazar* quotation on p. 262 appears in the issue for August 27, 1892, p. 698. Candace Wheeler's remark was printed in *Harper's New Monthly* for May, 1893, p. 836. For Marie Therese Blanc see her book *The Condition of Woman in the United States*, (1895), pp. 32-43. *Harper's Bazar* comments on p. 267 appear in the issue for August 19, 1893, p. 674. Comments on p. 276 are to be found in Bessie Pierce's *As Others See Chicago*. Mrs Mark Stevens comments on p. 278 come from her small book *Six Months at the World's Fair*, p. 191.

CHAPTER XII: A GLORIOUS WEALTH OF MEDIOCRITY

For general background see Clara Erskine Clement-Waters, *Women in the Fine Arts Etc.*, (1905); Karen Peterson & J. J. Wilson, *Women Artists: Recognition and Reappraisal Etc.*, (1976); Elsa Honig Fine, *Women and Art*, (1978). See also William H. Gerdts Jr, *The White Marmorean Flock Etc: Catalogue of Exhibit, Vassar College Art Gallery, April 4-30, 1972* and *American Neoclassic Sculpture: The Marble Resurrection*, (1973). Also Margaret Thorps, *The Literary Sculptors*, (1965). Adelaide Johnson's "Sculptor's Notes" are to be found among her papers in the Library of Congress. Henry Fuller's criticisms on pp. 316-317 appear in *The Chicago Record's History of the World's Fair* (1893), p. 106. The enraged critic on pp. 317 is Florence Fenwick Miller in the *Art Journal* (Fair Supplement, 1893), p. xiv.

CHAPTER XIII COTS AND CRIBS

The circular on The Children's Building is reproduced in *Connecticut at the Columbian Exposition, 1893*. Speeches on the kindergarten are to be found in *Congress of Women in the Woman's Building*. Nancy Huston Banks' comments are in her book *The World's Fair As Seen in 100 Days* (1893).

CHAPTER XIV MOB OF SCRIBBLING WOMEN

For background see *Connecticut at the Columbian Exposition 1893* (1898) and *New York at the World's Columbian Exposition* (1894). Also Mrs J. G. Gregory, ed. *Selections from the Writings of Connecticut Women* (1893). Also Blanche Wilder Bellamy, *List of Books by Women, Natives or Residents of New York State* (1893). Fanny Palmer, *List of Rhode Island Literary Women 1726-1892 Etc.* (1893). Edithe Clarke, *List of Books Sent by Home and Foreign Committees to the Library of the Woman's Building* (1894). The Distoff series (1893) are miniature editions of Anna Brackett, *Woman & the Higher Education*; Alice M. Earll and Emily E Ford, *Early Prose and Verse*; Mrs Burton Harrison, *Short Stories*; Kate D. Wiggin, the *Kindergarten* and Candace Wheeler, *Household Art*.

CHAPTER XV WOMEN IN SAVAGERY
See the Exposition Records of the Smithsonian Institution and the United States Museum 1875-1916 at the Smithsonian Institution, Washington, D.C. See also Anthea Callen, *Women Artists of the Arts & Crafts Movement* (1979) English title *The Angel in the Studio Etc* (1979).

CHAPTER XVI RARE AND INTERESTING LINES OF WORK
For Kate Knight's comment on p. 427 see *Connecticut at the Columbian Exposition* (1898). For inventions see Mary Anderson, *Women's Contributions in the Field of Invention: A Study of the Record of the U.S. Patent Office. Bulletin of the Women's Bureau, No 28.* Government Printing Office, 1923.
See Olivia P. Flynt, *Manual of Hygienic Modes of Underdressing for Women and Children* (1882).
For Martha Costen see her autobiography *A Signal Success Etc* (1886).
For Maria Mitchell see Helen Wright, *Sweeper in the Sky Etc* (1949).
For Anna Comstock see *The Comstocks of Cornell Etc* (1953).
See also June Helm, ed. *Pioneers of American Anthropology* (1966).
For information on May French Sheldon and Kate Marsden (as well as others) see Dorothy Middleton, *Victorian Lady Travellers* (1965). See also May French Sheldon, *Sultan to Sultan: Adventures Among the Masai and Other Tribes of East Africa* (1892); Henry Johnson, *The Life of Kate Marsden* (1893); Kate Marsden, *On Sledge and Horseback to the Outcast Siberian Lepers* (1892) and *My Mission in Siberia: A Vindication* (1921). See also Hugh Robert Mill, *Record of the Royal Geographic Society, 1830-1930* (1930), 107-112, 182; *The Geographical Journal I* (Jan., 1893) 77-78, II (July, 1893), 73 (Aug. 1893), 183.

CHAPTER XVII REFINED AVENUES OF EFFORT
See Brian Abel-Smith, *A History of the Nursing Profession in Great Britain* (1960); Stella Bingham, *Ministering Angels* (1979); Cecil Woodham-Smith, *Florence Nightingale.* (1951).
See also Emma Seifrit Wrigley, *Sarah Tyson Rorer Etc* (1977).
Frederick Fernald's unkind comments appeared in *Popular Science Monthly* XLIII (October, 1893), 803-812. Alice Freeman Palmer's more optimistic remarks were in "Some Lasting Results of the World's Fair" in *Forum* XVI (Dec., 1893), 522.

CHAPTER XVIII Mementoes of an Emancipated Era
For general information see Howard M. Rossen and John M. Kaduck, *Columbian World's Fair Collectibles, Chicago 1892-1893* (1976). Carrie V. Shuman, ed. *Favorite Dishes: A Columbian Autograph Souvenir Cookery Book: Over Three Hundred Autograph Recipes, and Twenty-Three Portraits, Contributed Specially by the Board of Lady Managers of the World's Columbian Exposition.* Chicago, R.R. Donnelly & Sons, 1893. Laura Hayes, Jean Loughborough, Enid Yandell, *Three Girls in a Flat.* Chicago, Knight, Leonard & Co., 1892. Impressionistic study of Mrs Palmer in a chariot on the half-title and last page of this book have been taken from it, along with the photograph of the Palmer mansion, and some ornamental initials. Maud Howe Elliott, *Art & Handicraft in the Woman's Building.* Goupil, Paris, 1893. Rand McNally, Chicago, 1894. Editions of this book vary somewhat. The Rand McNally edition lacks Goupil's colored frontispiece; selection of photographs vary. Copies of this book were sent free to royalty around the world. The Ladies earned from it $544.71 for the Memorial Fund.
For spoons see Isabel G. Schrader, "Spoons of the World's Columbian Exposition 1893" in *Antiques Journal* XII (April, 1957), 36-37; Albert Stutzenberger, *The American Story in Spoons* (1953); Anton Hardt, *Souvenir Spoons of the Nineties* (1962); Dorothy Rainwater and Donna Felger, *American Spoons: Souvenir and Historical* (1968).
Correspondence between Sarah Hackett Stevenson and Mary Logan on Dr Stevenson's coin resolution (Sept. 3, 1892; Oct. 28, 1892,) in the Logan papers, Library of Congress. For Congressional approval see the *Congressional Record* (52nd Congress, 1891-1893) 1593.
News of Caroline Peddle, *Chicago Tribune,* April 9, 1893, p. 33. For correspondence between Miss Peddle, E.C. Leech, Mr Bosbyshell and Mrs Palmer (April 3-24, 1893) see Records of the Mint, National Archives, Washington D.C. St Gaudens' letter to Mrs Palmer (April 18, 1893,) in Daniel Burnham Archives, Ryerson Library, Art Institute of Chicago. See also Don Taxay, *An Illustrated History of U.S. Commemorative Coinage* (1967), 13; Cornelius Vermeule, *Numismatic Art in America Etc* (1971); "The Isabella Quarter Dollar" in *American Journal of Numismatics* XXVIII (1893), 40.

CHAPTER XIX ORGANIZATIONS
Some general sources: Eleanor Flexner, *A Century of Struggle Etc* (1959) and Judith Papachristou, *Women Together: A History in Documents of the Women's Movement Etc* (1959). A full list of the organizations exhibiting in the Organizations Room is to be found in Rebecca Felton's papers at the University of Georgia Libraries, Rare Books and Manuscripts, and in the Lady Manager papers at the Chicago Historical Society. For Marion Talbot see her book *History of the Chicago Association of Collegiate Alumnus 1888-1917* and Roberta Frankfort, *Collegiate Women: Domesticity and Career in Turn of the Century America* (1977), Chapter 6.
Report on Charlotte Smith and Madame Yale comes from the *Pittsburgh Leader,* March 18, 1892.
The clipping for Grace Dodge's *Churchman* article is in the YWCA National Board Library.
Mrs Mark Stevens comment on p. 515 is from op.cit. *Six Months Etc,* 199.

CHAPTER XX: NOT THINGS BUT WOMEN: THE CONGRESSES

See May Wright Sewall, ed., *World's Congress of Representative Women* (1894), Vols I & II. For speeches in the Woman's Building see Mary Eagle, ed., The Congress of *Women Held in the Woman's Building* (1894), containing 190 speeches in full. See also Rossiter Johnson, "Congress of Representative Women" in *History of the World's Columbian Exposition* Vol. IV (1897). Also H.N. Higinbotham, *Report of the President to the Board of Directors of the World's Columbian Exposition* (1898). See May Wright Sewall, *Genesis of the International Council of Women Etc* (1914), also *Dynamic Story of the International Council of Women Since 1888* (1966). Ellen Henrotin's papers are at Schlesinger Library, Radcliffe College.

Actresses: Clara Morris' diary is among her papers at Schlesinger Library. See Helen Modjeska's autobiography, *Memories and Impressions Etc* (1910), 512-513. Also Marion Moore Colman, *Fair Rosalind: The American Career of Helel Modjeska* (1969).

For Lucy Stone see Alice Stone Blackwell, *Lucy Stone: Pioneer of Woman's Rights* (1930).

CHAPTER XXI THE SUMMER SESSIONS: NOT ENOUGH OF THE DUCHESS

Sallie Sims Southall Cotten's diary, "World's Columbian Exposition Journal", an unpublished manuscript is in the Southern Historical Collection at the University of North Carolina Library, Chapel Hill, N.C. It covers July 7-November 3, 1893.

Marie Blanc's comment on p. 578 is from *The Condition of Woman in the United States*, already cited.

Mrs Leander Stone's letter to Mrs Felton on p. 490 is also at Georgia.

Teresa Dean's lively comments are in *White City Chips* (1893) published in Chicago by Rand McNally.

For YWCA material see Elizabeth Wilson, *Fifty Years of Association Work Among Young Women, 1866-1916; A History of Young Women's Christian Associations in the United States Etc* (n.d.) 20-22; *Journal of the Twelfth Biennial Conference of the International Board of the Women's and Young Women's Christian Association* in the YWCA National Board Archives, and the *Seventeenth Annual Report of the YWCA of Chicago for Year Ending November, 1893*, in the Midwest Women's Collection at the University of Illinois Library, Chicago Circle Campus.

On the suffragists: Miss Anthony's letter to Mrs Palmer on p. 494 is to be found in the Susan Brownell Anthony Collection at the Chicago Historical Society. Lucy Anthony's description of the Organizations Room in the *Woman's Journal*, "Suffrage Headquarters", appeared July 15, 1893, p. 220.

On WCTU: Mrs Mark Stevens' comments on p. 498 are from her book *Six Months at the World's Fair* (1895), 201. For comments on Frances Willard, see Inez Haynes, *Angels and Amazons Etc* (1934), 201. See also papers at the Frances Willard Memorial Library in Evanston, Illinois. A letter to Miss Willard from Harriet B. Kells, editor of the *Union Signal*, May, 1893, calls Miss Willard's absence from the Congresses "a calamity to our cause," and quotes gossip that Miss Willard was not ill, but suffering from "a bad case of Lady Henry."

On Women's Clubs: Charlotte Perkins Gilman's comments on p. 501 are from her book *Women and Economics Etc* (1918), 164, 166. Jennie Croley's comments on pp. 502-503 are from her book *History of the Woman's Club Movement in America*, 133-137. See also *The New Cycle* for June, 1893, in the Archives of the General Federation of Women's Clubs, Washington, D.C. Also Henriette Greenebaum and Frank and Amalie Hofer Jerome, eds., *Annals of the Chicago Woman's Club 1876-1916* (1946), 109. Mildred W. Wells, *Unity in Diversity: The History of the General Federation of Women's Clubs* (1953), 26. See also Martha Streyer, *The DAR: An Informal History* (1958), 24.

CHAPTER XXII AFTER THE FAIR IS OVER

For Anders Zorn see Gerda Boethius, "Anders Zorn, the Artist in Chicago," in the *Swedish Pioneer Historical Quarterly* VII (Jan., 1956), 3-10, and her book *Zorn* (1959).

Interviews with the Palmers on p. 589, the *Tribune* and the *Times* for Nov. 1, 1893. Comments from Candace Wheeler on p. 597, *New York Times*, May 4, 1893, p. q.

Adelaide Johnson's comments on p. 597, see her "Paper for Internat'l Council Congress at Berlin, 1904" in her papers at the Library of Congress.

For a general history of worlds' fairs see Roberta Fleming Roesch, *World's Fairs: Yesterday, Today and Tomorrow* (1962). For information on fairs mentioned pp. 597-598 see Walter Q. Cooper, *The Cotton States & Internat'l Exposition Etc* (1896); *Rand McNally Handbook to The Pan-American Exposition Buffalo* (1901); *Official Guidebook to the Trans-Mississippi & Internat'l Exposition of Omaha* (1898); *Bd of Lady Mngrs of the Louisiana Purchase Exposition: Report to the Louisiana Purchase Exposition Commission* (1905); *The Official Blue Book of the Jamestown Ter-Centennial Exposition* (1909); Anna Pratt Simpson, *Problems Women Solved: Being the Story of the Woman's Board of the Panama Pacific Internat'l Exposition* (1916); Nat'l Council of Women, *Women Through the Century: A Souvenir of the Nat'l Council of Women Exhibit, A Century of Progress 1933*; Monica Barry Walsh, "Women's Participation" in *Cultural & Social Aspects of the New York World's Fair, 1939*, 10-11; *Official Guide: New York World's Fair 1964-1965* (1964).

Alice Freeman Palmer, "Some Lasting Results of the World's Fair," in *Forum* XVI (Dec., 1893) 518.